A ROGER FRY READER

Edited and with Introductory Essays by

CHRISTOPHER REED

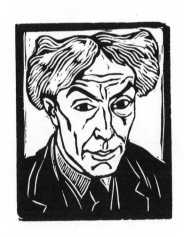

THE UNIVERSITY OF CHICAGO PRESS

Chicago & London

CHRISTOPHER REED has taught at Yale University, the University of Michigan, and the University of Pennsylvania.

THE UNIVERSITY OF CHICAGO PRESS, CHICAGO 60637
THE UNIVERSITY OF CHICAGO PRESS, LTD., LONDON
© 1996 by The University of Chicago
All rights reserved. Published 1996

Printed in the United States of America

05 04 03 02 01 00 99 98 97 96 5 4 3 2 1

ISBN (cloth): 0-226-26643-5

Title page illustration: Roger Fry, *Self-portrait,* from *Twelve Original Woodcuts,* 1921.

᛭ 1003095405

Library of Congress Cataloging-in-Publication Data

Fry, Roger Eliot, 1866–1934.
 A Roger Fry reader / edited and with introductory essays by
Christopher Reed.
 p. cm.
 Includes bibliographical references and index.
 ISBN 0-226-26643-5 (alk. paper)
 1. Art. I. Reed, Christopher. II. Title.
N7445.2.F77 1996
700—dc20 95-43742
 CIP

CONTENTS

ACKNOWLEDGMENTS

THIS volume is dedicated to the memory of Denys Sutton, whose careful editing of Fry's selected correspondence served as both an inspiration and an ideal for this project. This book would also not have been possible without the work of Donald Laing, whose annotated bibliography of Fry's writings sets a standard of conscientiousness and completeness. This work is an extension—worthy, I hope—of the accomplishment of these two dedicated Fry scholars.

I am also anxious to acknowledge the personal and professional influence of Robert L. Herbert, my advisor during graduate school, and beyond. The model of his 1964 anthology, *The Art Criticism of John Ruskin*, was always before me in the preparation of this manuscript. I owe a great debt of thanks as well to Richard Shiff, whose reading of my text was at once critical and supportive. I also want to thank Annabel Cole for her frank but gracious comments on my writing, and, of course, for her permission to print Fry's texts.

For help locating documents, I am very grateful to Becky Conekin, Jonathan Perkins, the staffs of the King's College Library and the Tate Gallery Archives and Library, and especially to the miraculous Adrienne L. Andrews of the University of Southern Maine Library. For help in preparing this text, I want to thank David Kendrick, Lisa Nelson, Katherine Luber of the Philadelphia Museum of Art, and the editorial staff of the University of Chicago Press.

Financial support for this project came from a Mellon Fellowship in the Humanities from the University of Pennsylvania. I am particularly grateful to Christine Poggi and David Brownlee at Penn for their encouragement.

Finally, this work would not have been possible without the consistent and thoughtful support of my parents, Gervais and Mary Katherine Reed, and of Chris Castiglia, my partner in all things.

EDITOR'S NOTE

THE following anthologized texts are presented in their entirety. All original illustrations are given, using the original image-numbering nomenclature and captions—with the following exceptions, all in chapter 7. First, the two posthumously published essays, "Rembrandt: An Interpretation" and "The Double Nature of Painting," on their first appearance in the 1960s were lavishly illustrated, in many cases with images inferred from Fry's words, although not necessarily the slide he showed to accompany his text. I have therefore provided illustrations only of works that are indubitably the images referred to, are cited in some detail, and are not otherwise readily available. Second, because Fry's *Henri Matisse* was published in different editions, accompanied by different sets of illustrations, I have added footnotes giving up-to-date information on the titling and location of works mentioned, and I have provided illustrations of works cited in a way that makes a black-and-white visual reference useful to the reader.[1] Where, in this text, I have deleted bracketed figure numbers, I have substituted the modern title and location of the works. Finally, in "The Meaning of Pictures," I have provided an illustration where Fry's text is explicit in referring to an image that, he explains, he was denied permission to reproduce.

1. For the publication history of this text, see Donald Laing, *Roger Fry: An Annotated Bibliography of the Published Writings* (New York: Garland, 1979), 23–24. In addition to the French version of the 1930 edition, which Laing notes carries a totally different essay by Florent Fels, there was also a German version with an essay by Gotthard Jedlicka; all three texts introduce the same selection of illustrations.

∽∾

CITATIONS

Sources cited in the text are collections of writings by Roger Fry:

Cézanne *Cézanne* (1927; reprint, Chicago: University of Chicago Press, 1989)

Letters *Letters of Roger Fry*, Denys Sutton, ed. (London: Chatto & Windus, 1972)

Trans *Transformations* (London: Chatto & Windus, 1926)

V&D *Vision and Design* (London: Chatto & Windus, 1920)

INTRODUCTION

"IN so far as taste can be changed by one man, it was changed by Roger Fry."[1] More than a half-century after Kenneth Clark's tribute to Fry's influence, a few qualifications seem in order. The taste Fry influenced was primarily that of the anglophone world, and his success lay largely in alerting an educated public to a compelling version of recent artistic and critical developments of the Parisian avant-garde. Even thus qualified, however, Fry's accomplishment was no mean feat. Through his exhibitions, lectures, translations, and critical writings, he introduced English speakers to not only such quintessential modernists as Matisse and Picasso but also to a theoretical justification for the emphasis on abstract form that became the hallmark of "modern art."

It was Maurice Denis who in 1890 famously proclaimed that "a picture, before it is a warhorse, a naked woman, or some anecdote, is essentially a flat surface covered by colors assembled in a certain order."[2] But it was Fry, following Denis, who propelled the English codification of "formalism" around 1910 in essays that challenged the prevailing standards of mimetic and narrative art with bold assertions about the "reality" and "classic" quality of abstract form. As the primary organizer behind two exhibitions that brought the new French art to London in 1910 and 1912, Fry became the English spokesman for modernism. Even the term "Post-Impressionism," still in common use, was coined by Fry, reportedly in a last-minute bid to devise a title broad enough·to include artists ranging from Cézanne, Van Gogh, and Gauguin to Matisse and Picasso.[3] It would be difficult to overstate Fry's contribution to this century's "common knowledge" of art.

Yet Fry's influence, impressive as it was, failed to fulfill his vision, in which new artistic ideas were linked to broader movements toward a new way of life. This characterization of Fry's ideals challenges common assumptions about formalism's separation of what Fry called, in the title of a well-known essay, "Art and Life" (1917). Here, Fry's highly influential argument was for art as a realm apart from life, subject to its own evolutionary logic, its "rhythmic sequences of change determined . . . by its own internal forces—and by the readjustment within it, of its own elements" (*V&D*, 9). By the

1950s this reasoning permeated the art world and was repeated everywhere from introductory art history textbooks to painter's studios.[4] Yet, as the pieces in this anthology show, this article is not representative of most of Fry's writing. As I discuss more fully in the introduction to chapter 7, Fry's close friend and Bloomsbury colleague Virginia Woolf was the first to note that the division of art and life in this essay stems directly from its wartime context, as Fry scrambled to salvage some optimism for art from the general collapse of European society at that time. Fry's essay "helps to explain how it was that he survived the war," Woolf wrote. But she notes that Fry's argument here is contradicted both by his other writings and by his own life, in which Fry matched the objective "detachment" he aspired to in the contemplation of art.[5]

Fry's connection of aesthetic and social imperatives reveals his roots in the reform-minded artistic movements of the Victorian age. Born in 1866, Fry long outlived John Ruskin, William Morris, and their contemporaries, but although he dedicated his career to promoting and defending a younger generation of modernists, he never lost the Victorian aspiration to connect new ways of art with new ways of life. Sadly, the breadth of Fry's ambitions for modernism may be best measured by his frustration. Despite his success in popularizing modernist art and formalist philosophies, much of Fry's writing is tinged with despair over his ineffectiveness. In 1920, looking back on his career, Fry ruefully assessed the opening decade of his professional life when he first made a name for himself as an art historian (essays from this period are included in chapter 1 below). The "cultured public," he finally realized, appreciated his work only as one of its many "social assets":

> To be able to speak glibly of Tang and Ming, of Amico di Sandro and Baldovinetti, gave them a social standing and a distinctive cachet. This showed me that all along we had been labouring under a mutual misunderstanding, *i.e.* that we had admired the Italian primitives for quite different reasons. (*V&D*, 291)

Although Fry abandoned this public for another, more avant-garde audience, simple misunderstanding and outright exploitation have continued to characterize the reception of his work.

To some extent, Fry's work was a victim of its own success. The phenomenal growth of interest in the modern artists he championed in the years around World War I meant that his most formalist writings quickly entered mainstream artistic discourse, and—often oversimplified—became the common knowledge of modernism. During the modernist heyday at midcentury, Fry was hailed as a harbinger of abstract art, though references to his ideas

are often so vague that one suspects his work was more often cited than actually read. Now, for a generation that styles itself "postmodern," veneration has turned to vitriol. Yet again Fry's work is more often vaguely cited than thoroughly examined, for Fry was a much more complicated thinker than the single-minded champion of abstraction who emerges as the object of current critiques.

In this anthology I seek to increase awareness of the variety and range of Fry's writings. The first chapter includes a selection of early writings, documenting Fry's first engagement with the arts around the turn of the nineteenth century. The second and third chapters reprint little-known essays from the heady prewar period of the Post-Impressionist exhibitions. Chapters 4, 5, and 6 deal with topics less commonly associated with Fry: architecture, the decorative arts, literature, dance, and the institutional structures of art exhibition and teaching. The final chapter offers an overview of Fry's postwar writing, in which the dogmatism—or mere bluster—of pieces like "Art and Life" gives way to a more complex appreciation of varieties of art and aesthetic response.

Many of these essays appear in this anthology for the first time since their original publication in scholarly journals or art magazines. A few have never been published. None is reprinted in any of the books Fry authored or the anthologies he oversaw: the popular *Vision and Design* of 1920, the 1926 *Transformations,* and the barely posthumous *Last Lectures.* My goal was to present essays not offered in these easily accessible sources. This preliminary criterion for selection coincided happily with my sense that the changing concerns of the current moment dictate a different selection of Fry's work than would have been likely a half-century ago (or, perhaps, will be made a half-century hence). For each chapter, an introduction gives historical background for the anthologized essays, so that I may avoid the necessity of annotation and present Fry unfettered by commentary: thus, notes in the texts are part of the original publication (the one exception is the 1908 lecture "EXPRESSION AND REPRESENTATION IN THE GRAPHIC ARTS," which I transcribed for this anthology from Fry's notes, and which includes as footnotes both marginalia and the citations that might have accompanied a published text).

The chapter introductions also suggest a critical context in which one might read Fry's essays today. These are intended to match the provocative—even contentious—spirit of Fry's writings. The introduction to chapter 1 argues that Fry's sense of social mission was present from his earliest writings on art, and in chapter 2 I highlight the broad cultural agenda Fry associated with his promotion of modernist art. The introduction to chapter 3 contex-

tualizes Fry's writing on Post-Impressionism within the debates of the day, exploring—and contesting—subsequent commentators' analysis of his position and strategy. In introducing Fry's writings on design, chapter 4 details his often ignored roots in the activist avant-garde of the late Victorian era: the Arts and Crafts movement and Aestheticism. Chapter 5 details Fry's efforts to force the practical application of his ideas through the reform of museums and schools. Chapter 6 contrasts the later formalists' emphasis on the purity of each artistic medium to Fry's eclectic—and, perhaps, self-defeating—ambition to break down the barriers between the arts by bringing dance and literature into his aesthetic philosophy. Chapter 7 extends the argument of this introduction by looking at late essays, largely ignored today, in which Fry, ever anxious to avoid the ossification of his criticism into dogma, rejects some of the central tenets of his earlier formalism in order to forestall the isolation of art from life.

Throughout these introductory essays, I am concerned to describe Fry's activism in its historical context, with reference to the concerns and interests associated with postmodernism. The point of this analysis is not, of course, to help Fry, whom mortality has transported well beyond the range of critics' slings and arrows. It is, rather, to view our own moment from a somewhat longer historical perspective than is often the case, to see the debates and controversies of our own day in reference to their earlier manifestations, and thus to enable a more nuanced assessment of the possibilities and perils of socially engaged approaches to art. It is simply wrong to see modernist aesthetic theory as always already corrupted by the interests of the dominant culture in some way that postmodernist theory is not. For unless we accept the very dubious premise that our generation is inherently smarter or morally better than Fry's, our dismissiveness of modernism risks obfuscating the ways in which our own avant-garde personalities and strategies can be (and are) easily co-opted and trivialized by the institutional and ideological structures they originally sought to critique.

Rather than rejecting Fry as the figurehead of a discredited age, then, this volume offers both a new selection and a new interpretation of Fry's work. It is my hope that a new generation of readers may find in Fry's doubt, in his sense of social purpose, or in his iconoclastic relation to authority, the makings of a more sympathetic figure than the ponderous "Father of Formalism" handed down to us by previous admirers. Perhaps we too, on encountering Fry in a less familiar way, may be attracted, as were his original readers, by the breadth of his interests, the fervor of his enthusiasm, and his evident passion to communicate his vision to as wide an audience as possible.

NOTES

1. Kenneth Clark, introduction to Fry's *Last Lectures* (Cambridge: Cambridge University Press, 1939), ix.

2. Maurice Denis, "Définition du néo-traditionnisme," *Art et critique*, August 1890; reprinted in *Théories, 1890–1910*, 4th ed. (Paris: Rouart et Watelin, 1920), 1–13. Fry translated Denis's essay on Cézanne for *The Burlington Magazine* in 1910; his INTRODUCTORY NOTE to this translation is in chapter 2.

3. "Oh, let's just call them Post-Impressionists; at any rate, they came after the Impressionists," Fry is reported to have said. See Desmond MacCarthy, "The Art Quake of 1910," *The Listener*, February 1945, 123–24, 129; reprinted in *Memories* (London: MacGibbon & Kee, 1953), 178–85.

4. Ad Reinhardt, to choose a typical example from the avant-garde, in 1950 asserted that "the reality of the everyday world and the reality of painting . . . are not the same realities"; quoted in Charles Harrison, "Abstract Expressionism," *Concepts of Modern Art*, 2d ed., edited by Nikos Stangos, 169 (London: Thames & Hudson, 1981). By 1959, Helen Gardner's *Art through the Ages*, 4th ed. (New York: Harcourt Brace, 1959) carried an introduction warning that, although the search for "relationships between historical events" or for "patterns of culture" may be "fascinating and rewarding," "the historian of art remembers that each work of art is unique, that it is its own embodiment of truth . . . each must first be comprehended by itself and for itself alone" (4).

5. Virginia Woolf, *Roger Fry: A Biography* (1940; reprint, New York: Harcourt Brace Jovanovich, 1968), 214–15.

1

BEFORE FORMALISM

ECAUSE Fry's name is so strongly associated with the promotion of Post-Impressionism in the early teens, it is easy to forget that he was forty-three years old in 1910, when his first groundbreaking exhibition of modern art opened in London. Fry's career as Britain's foremost champion of modernism, in fact, seemed to many observers a betrayal of two decades of his earlier work as a guardian of the past. Fry, since the early 1890s, had been known as a promising art historian and curator; specializing in fifteenth-century Italian painting, he had turned his training in science to the apparently empirical methods of "scientific connoisseurship" pioneered by the Italian medical doctor Giovanni Morelli.[1] Yet an 1894 essay, "The Philosophy of Impressionism," written for the *Fortnightly Review* but never published, reveals that Fry, from the beginning, was anxious to defend contemporary art from the reproaches of the prototypical "indignant spectator, repenting of the shilling he paid at the door." Fry's scholarly training in biology is here evident in his strong focus on the scientific bases of Impressionism,[2] which is barely tempered by a conclusion insisting that beauty, not science, is the ultimate justification of art.

Despite such impulses, however, Fry was best known as a connoisseur. His first book was an 1899 Morellian analysis of the fifteenth-century Venetian painter Giovanni Bellini. Here Fry combined a conventional art-historical presentation of art as an expression of the spirit of its times with a new connoisseurial focus on the details that supposedly betrayed the author's identity—"the obtuse insertion of the thumb which gives to the large metacarpus a regular pentagonal form"[3]—to argue for the attribution of certain paintings to Bellini, thereby enabling scholars to define his total oeuvre.

Fry's second major publication was similarly conventional: a 1905 critical edition of Joshua Reynolds's *Discourses*. Despite its historical focus, however, the Introduction to the *Discourses* anticipates much of what distinguished Fry's particular brand of modernism. Establishing a clear social context for his aesthetics, Fry begins with "Reynolds the man," describing the "moral qualities" that make his criticism worth attending. The phrases here ascribed to Reynolds's character—his "completeness," "sweet reasonableness,"

his "detachment," and his "freedom from all that is petty and narrow,"—
anticipate many of the most characteristic terms Fry and his Bloomsbury
colleagues would use to define the properly "modern" attitude they associated
with their own way of life. Similarly, Fry's claim that Reynolds based his
aesthetic on an appeal to "unity" as an "expression of human experience," as
opposed to a mere "mechanical trick of imitation," foreshadows the central
argument of his 1909 "Essays in Aesthetics" (V&D, 16–38), generally taken
to be the first exposition of formalism. Finally, the detailed application of
Reynolds's theories to a comparison of Rubens and Van Eyck grounds Fry's
generalizations in the kind of formal analysis of particular paintings that later
made his defenses of modern art so compelling.

Fry's youthful admiration for the eighteenth-century Reynolds may be
contrasted with his relationship to a much closer progenitor, J.A.M. Whistler.
At first glance, Fry's antipathy to Whistler seems puzzling, since Whistler's
art-for-art's-sake doctrines anticipate formalism much more directly than do
Reynolds's theories. Indeed, the record of Fry's commentary on Whistler
opens him to charges of the rankest hypocrisy. In his 1903 "MR. WHISTLER,"
Fry professed his skepticism at Whistler's "astounding theory" that

> the recognition of the objects [represented in painting] was not part of
> the game. The forms presented were to have no meaning beyond their
> pure sensual quality, and each patch of colour was to be like a single
> musical note, by grouping which a symphony, as he himself called it,
> could be made.

By 1920 Fry was writing

> There is no difference between landscapes and other subjects: in general
> in painting I try to express the emotions that the contemplation of forms
> produces in me. . . . These fundamental relationships are recognised by a
> kind of sensual logic. It's exactly like music. . . . It's all the same to me if
> I represent a Christ or a saucepan since it's the form, and not the object
> itself, that interests me. (*Letters*, 496–97)

Yet Fry's conversion to formalism occasioned no new interest in Whistler.
On the contrary, after his groundbreaking "Essay in Aesthetics" Fry's com-
mentary on Whistler dwindled from a stream to a trickle.[4]

In 1920, just as he was paraphrasing Whistler to describe his own aes-
thetic philosophy, Fry used a retrospective essay on his own career to explain
what he took to be Whistler's failure. Whistler's "purely decorative idea of
art," Fry said, attempted "perhaps too cavalierly, to sweep away the web of
ethical questions . . . which Ruskin's exuberant and ill-regulated mind had
spun for the British public" (V&D, 287). Since Fry, even in this essay, could

counter Ruskin's ethical defense of realism with nothing better than "mysticism" (*V&D*, 302), it appears his quarrel with Whistler was a matter, not so much of ideas, but of attitude: Whistler is too cavalier. In the 1903 essay anthologized here, Fry regretted the way Whistler "refused to persuade" his public, but instead "took a vicious pleasure in being misunderstood." And it is true, the main points in Whistler's famous "Ten O'Clock" lecture often seem lost in convoluted jibes at the critics, at art historians, teachers, "the taste of the tradesmen," and even the Swiss. Subsequent commentators have suggested that Whistler's alienating and acerbic manner minimized his influence on the "earnest intelligentsia" of England, which was used to the "seriousness and sincerity" of Arts and Crafts movement advocates.[5] In contrast, Fry, with his background in the Arts and Crafts guilds of C. R. Ashbee and A. H. Mackmurdo (see chapter 4), aspired to a standard of edifying discourse and constructive social engagement, explaining his aesthetic ideas in measured, easily accessible prose, and, as Virginia Woolf said, "spend[ing] half his life, not in a tower, but travelling about England addressing masses of people, who'd never looked at a picture and making them see what he saw."[6] Kenneth Clark, looking back on Fry's career, observed

> In a sense, Fry was only giving systematic statement to ideas which had long been current in the parrot cry of "art for art's sake." But his deliberate candour and his constant appeal to experience are so different from the paradoxical and poetical treatment of his predecessors, that the general impression of his [first formalist] essay is one of great originality.[7]

If Fry's originality lay more in the presentation than in the substance of his formalism, however, the difference is a crucial one.

In his 1905 "WATTS & WHISTLER" Fry bemoaned Whistler's "corrosive wit," which made him "a negative Mephistophelian figure" who "spoke only ephemeral witticisms in the press." Fry here contrasts Whistler's self-imposed isolation to the French Impressionists, among whom "in spite of vivid contrasts of temperament, we find a tendency to formulate a common style, to fight a common battle, to combine forces in a 'movement.'" Fry's clear aspiration to model a Post-Impressionist movement on what he saw as the collaborative nature of the French avant-garde clashes directly with Whistler's isolation and suggests how Fry could have forsaken his most immediate progenitor for less obvious figures: Reynolds, Watts, or, in *Vision and Design*, Tolstoy (*V&D*, 27, 292–93).[8]

In short, Fry's early writings offer inklings of what was to come: an interest in new art; a fascination with scientific empiricism; an aspiration to the role of the broad-minded teacher, artist, and critic; and a concomitant exas-

peration with the avant-garde posture of isolated genius. Yet it is only in hindsight that these themes stand out. Taken at face value, Fry's early essays are far from revolutionary. Diligent and fluent, they quietly contribute to the mainstream art-historical discourses of the era. Accepted figures from the past and prominent contemporary practitioners are examined and praised, firebrands like Whistler are respectfully reproved for their excesses, and the fundamental assumptions of the discipline are gently reinforced. Few would have guessed that within the decade Fry would have transformed himself into a rebel, attacking the theoretical basis of his previous practice in order to propose a new aesthetic and a corresponding new canon of artistic accomplishment.

⤜∽⤛
NOTES

1. Giovanni Morelli's two-volume study, first published in German in 1874 and 1889, was translated as *Italian Painters: Critical Studies of their Works* (London: J. Murray, 1892–93). Especially as understood by Fry's mentor, Bernard Berenson, Morelli's method was to determine the authorship of paintings by analyzing the depiction of details, such as earlobes, which, because they were insignificant, served as the artist's unconscious signature. See Richard Wollheim, "Giovanni Morelli and the Origins of Scientific Connoisseurship," *On Art and the Mind* (Cambridge, Mass.: Harvard University Press, 1974), 177–201.

2. A similar impetus to join art and science is evident in the title of a thesis Fry in 1889 submitted (unsuccessfully) for a Cambridge fellowship: "On the Laws of Phenomenology and Their Application to Greek Painting." For a late comparison, see Fry's introduction to his own translation of Charles Mauron's *The Nature of Beauty in Art and Literature* (London: Hogarth Press, 1927).

3. Fry, *Giovanni Bellini* (London: At the Sign of the Unicorn, 1899), 14.

4. According to Donald Laing's *Roger Fry: An Annotated Bibliography of the Published Writings* (New York: Garland, 1979), Fry published twenty-two essays dealing with Whistler. After 1909, in addition to the comments in "Retrospect" (*V&D*, 287; quoted here) and a dismissive remark in *Reflections on British Paintings* (London: Faber & Faber, 1934, 121), there are only three passing references to Whistler in Fry's articles (see Laing, 160, 177, 201).

5. S. K. Tillyard, *The Impact of Modernism, 1900–1920* (New York: Routledge, 1988), 40. Tillyard unfairly removes Fry from this "earnest intelligentsia," although his reaction to Whistler conforms to the pattern she ascribes to followers of the Arts and Crafts movement.

6. Letter from Virginia Woolf to Benedict Nicolson, 13 August 1940, in *The Letters of Virginia Woolf*, vol. 6, edited by Nigel Nicolson and Joanne Trautmann (New York: Harcourt Brace Jovanovich, 1980), 414.

7. Kenneth Clark, introduction to Fry's *Last Lectures* (Cambridge: Cambridge University Press, 1939), xv.

8. Compare "Blake and British Art" in chapter 3. Fry's assertion of his debt to Tolstoy, whose name appears virtually nowhere else in his essays or correspondence, can be understood as an attempt to ally his aesthetics with the Russian writer's seriousness and moral purpose. For a more sustained discussion of Bloomsbury's relationship to Whistler and Tolstoy, see my "Making History: The Bloomsbury Group's Construction of Aesthetic and Sexual Identity," *Journal of Homosexuality* 27, nos. 1–2 (1994); reprinted in *Gay and Lesbian Studies in Art History*, edited by Whitney Davis (New York: Haworth Press, 1994), 189–224.

THE PHILOSOPHY
OF IMPRESSIONISM

Il n'y a de vrai que les rapports, c'est à dire la façon dont nous percevons les objets.

<div align="right">Gustave Flaubert, Correspondences</div>

WHETHER by advertisement or merit, the ideas which are vaguely grouped under the word Impressionism have undoubtedly "caught on," as the phrase goes. People no longer ask of an artist, Does he paint beautiful pictures, but, Is he an Impressionist? The very bitterness of the attacks on it show that it is a movement too strong to be killed by neglect; and now scarcely a single newspaper article on painting or any kindred subject can come safely to a close without an allusion to or a sneer at Impressionism. That there is something puzzling and obscure about the fundamental ideas on which it is based is clear from the difficulty which even the sympathetic layman finds when confronted with the works of this school—a difficulty which is scarcely lessened when he comes in contact with its prophets, who have an unsatisfactory habit of claiming as representative Impressionists any Old Master whom they personally admire.

That Velasquez and Reynolds were Impressionists perhaps need not surprise us. But I have even heard Botticelli claimed by an enthusiast as the archetype of Monet and Degas. If, as some hold, the word Impressionism is really a useful one, accurately describing a certain definite tendency in art, it may be worth while to investigate it from a scientific standpoint in order to redeem it from a misuse which would render it valueless—a misuse which is due to the fact that artists, who chiefly use it, are to-day, as they were when Socrates annoyed Parrhasius, wisely indifferent to the philosophy of their art and unable to give a reason for the faith that is in them. Indeed the mere fact that artists are likely enough to repudiate the ideas with which I am going to credit them ought not to be taken as a proof that they are not unconsciously working under their influence.

The Times about a year ago published an article in which the author,

Unpublished article originally written for the *Fortnightly Review*, 1894, and made available by the Fry Estate from the Roger Fry Papers, King's College Library, Cambridge.

while condemning alike all the tendencies of modern art, alluded with a sneer to a school of painting which seemed intended to demonstrate Heraclitean theory of the flux of phenomena.[1] He could not have stated better the most salient features of Impressionism. The Impressionist realises above all things the truth that absolute rest and absolute identity are mental abstractions and have no counterpart in external nature. He realises that he cannot paint the same river at two different times any more than Heraclitus could step down twice into it. And it is in this way of envisaging external nature that Impressionism presents a curious parallel to the tendencies of modern thought. In that the dominant note is the idea of the world as a process—in metaphysics, in politics, in ethics, in science—we have exchanged the static for the dynamic position. The species is no longer a fixed and unchangeable type, ethical codes are regarded as part of the varying modes of adaptation of the human species to varying conditions, and no modern politician would venture in search of an absolute system of government good alike for all time and all peoples.

But moreover the world-process is regarded as due not to the interaction of separate and self-contained objects, but of objects whose very nature lies in the relations to other things. And hence it follows that all our knowledge of the objects of external nature is not really a knowledge of those objects but only of the mutual interaction that takes place between them and ourselves. We are always partly responsible for any quality which we attribute to an external object, and it is only on such conditions that we know anything about the object. Hence we can never know anything about "things in themselves." The metaphysician has long ceased to attach any meaning to the idea of the existence of things apart from a self-conscious being that perceives them, but the scientific man has until lately clung with childish tenacity to his pet toy of matter and is only at last convinced that it is a vague and indefinable abstraction, and no solid basis on which to construct an explanation of the universe.

Now the results which I have attempted to summarize above have been arrived at not so much by an analysis of the *objects* of experience as by an analysis of the nature of experience itself, and I think it may be shown that in the art of painting a similar process (that is, the analysis not of objects of sight but of the nature of visual sensation) has led to curiously analogous results. For, just as empirically and for ordinary scientific purposes we assume the existence of matter external to and independent of our sensations, so for the ordinary purposes of life we build up the never ceasing flux of visual

1. "Culture in a Hurry," *The Times*, 13 December 1893.

sensations into percepts which we regard as having an independent and absolute existence, which we conceive of as limited by fixed and determined surfaces and which we call "things." Such a view, the view of everyday life, was naturally enough accepted by the earliest painters who endeavoured to represent things, not by analysing their own sensations but by examining the things themselves. And as in science we have come to the conclusion that matter is something about which we can predicate nothing at all, and that science is a classification not of the external world itself but of the reaction to it of the human mind; so in painting there has been from the period of the revival of the art a gradual development in the same direction. In the direction, that is, of preventing the mind from making the step from sensations to things—a step so natural, and, owing to the needs of everyday life, so necessary as to have become quite instinctive. Painting then, tends more and more to rest on the solid basis of appearances, which are for its purposes the only ultimate realities, and refuses to become entangled in the hypothetical abstractions of ordinary life. It is ceasing in fact to attempt the impossible feat of eliminating the human factor in experience. And it is to Impressionism that we must turn to see the culminating point in a process which has been going on, though with many fluctuations, ever since the revival of painting in the fourteenth century.

Among the first clearly marked steps was the recognition of linear perspective. It is difficult now to realise what a bold effort it was,[2] what an outrage on the common sense to draw the house halfway down the street only half as big as the house in the foreground, when the artist *knew*, when every good citizen *knew* that they *were* precisely the same size. Yet the step was accomplished and the foundations laid of a science which has grown so little that it has never had a name given to it, the science of appearances.[3] From our present, very limited, point of view painting may be regarded as the record of advances made in this science, which, except as regards the theories of colour vision, has never been studied for its own sake.

A further step was Leonardo da Vinci's enunciation of the principles of aerial perspective in which he included tone values (that is, the alteration of lights and shadows through distance) and colour values (that is, the gradual loss of local colour through distance). These he only stated very generally and to this day they have never been reduced to scientific laws. But although Leonardo da Vinci investigated aerial perspective it was not fully accepted in

2. So outrageous did it appear to the Japanese that at one time a law was passed forbidding painters to draw in perspective.

3. Dr. Waldstein has suggested that the word "phenomenology" might be borrowed from the metaphysicians for this purpose.

painting till long after his time. But these discoveries involve a further out-
rage on common sense; they imply, for instance, that an artist will be content
to paint a tree which he knows to be green, a bluish grey, merely because it is
in the middle distance. Leonardo da Vinci moreover perceived what Goethe
afterwards failed to perceive, the nature of the colour of shadows, that is, that
shadows are not absence of light, but only light of another colour arising
either from a secondary source different in colour and intensity from the
main light or by reflections from surrounding objects.

It is by an application and extension of the principles first stated by
Leonardo da Vinci, though never practised by himself or his successors, that
Impressionism has earned the ridicule if not the censure, of respectable com-
mon sense. "What?" says the indignant spectator, repenting of the shilling he
paid at the door, "Paint a shadow on a sail bright violet when everyone
knows it is a white sail," and he feels hurt as by a personal insult.

But let us examine more in detail what are the chief changes in the way
of regarding external nature that characterize Impressionism and what they
have rendered impossible. For herein we see the revenge taken by common
sense on the artistic sense: common sense, having accepted any innovation,
such for example as linear perspective, will not allow the artist to go back on
his own traces, will no longer, for instance, tolerate false perspective on the
grounds that one Giotto, a celebrated painter, ignored it. And so the history
of painting viewed from this standpoint (an exceedingly limited one, let us
repeat) is the history of a series of new realms of nature created at each
successive step by some original genius and gradually opened up by his dis-
ciples for the convenience and delight of the average public. In this sense the
paradox of art making nature is nothing but a serious and sober truth. Paolo
Ucello did not introduce perspective into painting only; he introduced it into
nature. And so with everything that concerns the appearances of things; they
only exist when they are perceived, and they are never consciously perceived
by the ordinary eye until attention has been called to them by the trained
observer—for of the infinite number of sensations falling on the retina only
those that training or habit has prepared us for, stir up any response in
consciousness.

But to return to the points of difference between Impressionists and their
predecessors. The human figure will serve as an example. To the older
painter the human figure was a separate entity to be studied anatomically and
constructed on any part of the canvas amid any surroundings—a separate and
self-contained object. A model was observed in the studio; it was drawn with
a complete outline enclosing every part and cutting it off from its environ-
ment; it was then coloured more or less as it appeared in the studio. Let us

suppose the model posed for a picture of Sappho on a Lesbian promontory; forthwith the painter proceeded to surround his figure with the appropriate landscape, a dark headland against a sunset sky (for she was in a romantic mood); the setting sun lit up the cloudy sky with orange and golden green; the headland became a shady mass of purple, but Sappho stood unchanged with the diffuse light of the studio revealing every beauty of form and every gradation of modelling. The perfect contour of her feet nowhere lost itself in the rocks on which she stood and the rosy finger nails remained clear and precise. And this, or something of which this is no unfair caricature, went on for generations—nay, still perpetrates itself on the walls of certain exhibitions.

An actual instance of a picture exhibited some two or three years ago occurs to me. The scene was sunset in the Arctic regions—red and lurid—on the ice floes were two polar bears whose glossy surfaces reflected nothing but the grey London sky that illumined them for the painter in the Zoological Society's Gardens. But to the Impressionist, what in common parlance we call the same human figure, is not the same inside the studio that it was outside, is not the same at 5 P.M. that it was at 2 P.M. It is in each case only a momentary group of sensations in the perpetual flux, existing in necessary relations to its surroundings and an inseparable part of them.

This keen perception of the close and inevitable relation of every object to its surroundings which comes of ceasing to view each object as a separate entity has led Impressionists to aim at a new unity of colour harmony in their pictures. As opposed to the unity which was dictated by the choice of a certain decorative scheme of colour or was sometimes merely superimposed by a final glazing of bitumen, the Impressionist aims at a unity perceived in nature itself, a unity brought about by the all-pervading influence of the colour and quality of the atmosphere at the particular moment he has chosen to represent. I do not mean to insist that this was not aimed at and often attained to by the finer observers among older painters: I only pretend that this unity of interaction and inter-reflection is more strenuously grasped and more clearly kept in view than ever before.

Now of colour it must be noted that the colour which reaches the eye from any part of a given object is made up of several factors, first there is what we call the local colour of the object, secondly the colour of the incident light at that point, thirdly the angle at which the light strikes the surface (for the further from a right angle that it falls, the less will the local colour affect the light which is given off from the object) and finally there is the alteration of the color by the atmosphere lying between the object and

the eye.[4] Now for the purposes of ordinary life, we are only interested in the local colour; it is by that we know that our meat is sufficiently cooked, it is by that that we choose our clothes; and so we naturally find that the more primitive painters are entirely absorbed by it and are rendered unable to appreciate the enormous changes due to the other factors. And throughout the development of painting we may trace a gradual decline in the tyranny of local colour. From Fra Angelico to Paolo Veronese is a great step, and a repetition of it brings us to Mr. Sargent. (This is not to say that Mr. Sargent is a greater artist than Paolo Veronese, for we are discussing only the scientific basis of art.) If any one wishes to judge of the predilection of the untrained eye for local color, let him go to the National Gallery on a student's day and watch the avidity with which the copyist, having grasped the fact that a robe is blue, proceeds to make it all blue, merely varying the intensity. There is atavism too in the evolution of art.

Before leaving the question of colour it may be worth while to examine one or two typical cases in which the Impressionist, by accepting only the total visual impression and freeing himself from the ordinary bias in favour of local colour, has shown us appearances that strike the unobservant layman as glaringly untruthful. There is one effect that has been much aimed at by naturalistic painters of late years which will serve as an example. A late afternoon sun is shining across a landscape: in the foreground we will suppose there is the figure of a woman with white bonnet and pink dress gleaning in the stubble field across which her shadow is cast. What will surprise the spectator, unaccustomed to Impressionist ways of looking at nature, will be, among other things, the intense blue violet colour on certain parts of the white bonnet—the blue green and violet cast shadows and the intense purple of certain shaded parts of the pink dress. Now let us consider the illumination of this figure. The sun which is nearly horizontal casts an orange light owing to the thickness of atmosphere through which it shines. This of itself will tend to make everything that is not directly illuminated by it of a bluish colour, because the eye becoming tired of the orange sensation naturally tends to see things coloured with the complementary blue.[5] If it is objected that it is merely subjective and the result of a defect in the structure of the eye, I would reply that the Impressionist accepts the human factor in experience, at all events, when, as here, it is a universal factor and not due to a

4. This is far more than most people would be likely to believe, the difference made by the addition of a few feet of air can be perceived by the trained eye, and may be measured (as regards intensity) by a simple instrument.

5. See *The Principles of Psychology,* W. James, Vol. II, p. 14 *et seq.*

peculiar malformation. But more than this, all those planes of the bonnet, dress and field which are placed nearly horizontal will reflect to the eye, like imperfect mirrors, the colour of that part of the sky from which light falling on the object makes the angle of incidence equal to the angle of reflection. And as we have already mentioned in the case of obtuse angles this reflection is very complete—that is to say at those angles the ray is not very materially altered in the pitch of its vibration by undergoing reflection even from a highly coloured surface. The top of the bonnet then will appear on the shaded side almost pure blue and from the close juxtaposition of the orange sunlit portion it may seem even bluer than the sky itself, for here we have no local colour to cause alteration. On the other hand in the shaded parts of the pink dress which are turned at the proper angle to reflect the sky, we shall receive a sensation of purple which is due to the blue incident light having been modified by the pink local colour; and similarly, in the stubble field it will be greenish, owing to the yellowish local colour. It is true that even the sunlit portions may also be illuminated by the blue sky, but here the intensity of the main source of light is so great as to obscure the secondary source which only makes itself sensible when the main source of light is cut off. When we consider again other planes of the shaded parts of the figure, which are turned so as not to receive light from the sky, we shall find a warmer light falling on them—perhaps this tertiary source of light may be the ground itself, or if we suppose a red cloak to be lying on the ground we shall get a very warm colour indeed on those planes which are so turned as to reflect it. But in each case the important thing is to regard a shadow not as the absence of light, but as illumination from a source of light which is so weak as only to make its peculiar colour manifest when the source or sources of greater intensity are cut off. Now the older painters in all these cases, keeping their minds fixed on the local colour of the various objects, regarded the shadow as a deepening merely of that colour, or at all events never gave themselves up entirely to the immediate sensations of the moment.

If any one who is sceptical about the truth of this view will go out on a sunny afternoon and observe the influence of the sky and of the colour of surrounding objects on any object which is without strong local colour, a sheep for instance (noting the pale blue on a shaded part of its back, and the green on its underside reflected from the grass), he will have the key to a new world of colour in which objects that are ugly and repulsive in themselves will often be transformed into sources of the keenest pleasure.

Let us proceed from colour values to tone values (amount of light and dark). Here again the Impressionist has proclaimed the importance of the change produced by atmosphere, its levelling tendency, making the lights less

vivid, and throwing a film of bluish light across the deepest shadows. And for this unifying effect of the medium through which we see, he has been willing to sacrifice something of solidity, to forego the full rotundity and insistent modelling of the older painters. And here more than anywhere he is at loggerheads with robust common sense. For our representative of common sense does not know how little he sees of *things*—how fluctuating, evanescent and fantastic are the actual visual impressions of objects, how they melt and glide into each other; in fact he is always importing into the sense of sight the results of experiments made by the sense of touch, and begun in earliest infancy.[6] To these he adds memories of the same object seen over and over again from innumerable points of view, nor has he ever arrested himself for an instant, and said to himself, What do I see and see only, apart from memory? And so nothing pleases him so much, if his tastes by healthily uncultivated, as to look at a picture in which by the sense of sight alone he can find out as much of the nature of the objects represented as he could if they were before him to see, hear, smell, taste and touch.

There is one other point on which some Impressionist painters lay much stress and that is that a picture shall be painted with a single focus.[7] That is to say that it shall be a representation of all that comes within the frame of the picture as seen when the eye is fixed on a single point, the centre of interest. It is well known that it is only that part of a large object which is focussed on a certain small part of the retina that is clearly perceived, and in ordinary life we immediately turn the eye so as to receive the image of that part of any object we wish to examine on this spot, paying scarcely any attention to the blurred images that surround it. For instance, in reading, we only clearly perceive a very few letters at a time. Now by an effort of will the Impressionist, or rather those who hold this particular view, keep the eye fixed (or nearly so, for the area of clear vision is so limited that even the most devoted doctrinaire must allow his eyeballs considerable movement) and at the same time does not neglect to give their proper relative importance to the blurred [impressions] of surrounding objects, and subsequently represents those impressions on his canvas. Thus if he is painting a portrait he keeps the face in focus and only represents the vague and generalised impressions that he receives from the sitter's boots. I cannot help thinking that this is only a scientific excuse for a method arrived at on aesthetic grounds, induced by the very proper desire not to allow the surrounding accessories to interfere by their obtrusive detail with the really interesting portion of the picture.

6. See [George] Berkeley's "Essay towards a New Theory of Vision" [1709].
7. In this and many other branches of the subject I am indebted to Mr. F. Bates's pamphlet, "The Naturalistic School of Painting."

Indeed a similar treatment was adopted by many Old Masters who never formulated it as a scientific creed.

To sum up then, we may say that in so far as the Impressionist aims at truth he aims at truth to visual impressions only and renders no allegiance to the truth of external facts. For him the instantaneous photograph is of no value; it may be a record of what happens; it is not, owing to the imperfect structure of the eye, a record of what appears, and with that alone he is concerned. Whether a variety of the human species which thus carefully deprives itself of the warning which sight gives us of the nature of objects with which we are surrounded, must not in the end be submerged in the struggle for existence, I leave to the speculative evolutionist.

But we have still to consider how far even truth to visual impressions is a just aim for the Impressionist, and it must strike the reader that though we have inquired into the nature of Impressionism we have left both art and beauty on one side. Are we then to accept Keats's famous line and, saying that truth is beauty, leave the art of painting as an ingenious and useless branch of the science of optics? I think not. To the Artist—and even the Impressionist lays claims to the title—there is only one justifiable aim, and that is beauty. For him the highest morality is sternly to leave on one side both science and morals. And accordingly if the Impressionist is wise he will defend his use of the peculiar methods of regarding nature which we have investigated above, not on the ground that they are truer than the older methods, but that they afford him the opportunities of new and more complex harmonies. In thinking that this is so he may be right or wrong, but as an artist he would throw aside the claim to greater scientific accuracy, which we have seen to be justified, and would admit that the only advantage of any particular way of envisaging nature lies in its power of suggesting to him, beautiful, that is, satisfactory, arrangements of line, tone, and colour. Nature to him is after all only the storehouse of experimental combinations of these—the artist owes her no duty except to reject the unsuccessful ones, and the only excuse for a picture's being truthful is that it is nevertheless beautiful.

MR. WHISTLER

THE penalty of perpetual youth is premature death, and Mr. Whistler's death, whenever it had occurred, must have seemed premature, for to the generation of artists who came under his spell it was impossible to conceive of Mr. Whistler as an elderly man. When, some years ago, Mr. George Moore found him too old to fight a duel with, we started with amazement, for we had formed the habit of regarding him as young. His attitude of pugnacious antagonism to all that savoured of middle age caused the illusion. He seemed to be always inaugurating a revolution, leading intransigeant youth against the strongholds of tradition and academic complacence. And all the time, without our noticing it, he was becoming an old man, and now, too soon, he is an Old Master. For, whatever may be thought of his theories, his rankling and sometimes cruel witticisms, whatever may be thought of him as a friend and as an enemy, his work will remain even more interesting to posterity than his interesting and whimsical personality. His work is already seen to have scarcely a trace of that whimsicality and *gaminerie* with which his own writings invested it when it was new. Himself the most serious of artists, he injured himself by his Quixotic tilt against the dull-witted cunning of the "serious" charlatan. For of all the artists of our time he has stood out most emphatically for artistic probity.

There are certain things which are of the essence of the painter's craft, and whoever neglects these in order to point a moral, or to indulge a craving for cheap sentiment, or to satisfy an idle curiosity, is guilty, however unconsciously, of an imposture. It was these essential qualities of pictorial art that Mr. Whistler insisted on to a generation that demanded bribes to the intelligence and the emotions before it could pocket the insult of pictorial beauty.

This is not to say that other artists of the time have not practised this, the most difficult, as it is the cardinal virtue for a modern artist. But with some of them—Mr. Watts, for instance—it has not been so critical a question, since they have ranged themselves more readily in line with contemporary ideas. But Mr. Whistler's mordant humour turned for him the vague ideal-

Reprinted from *The Athenaeum*, 25 July 1903, 133–34.

ism and the sentimental romanticism of his day to utmost ridicule. He found himself singularly alone in his generation, and his pugnacity and his bitterly satiric vein increased his isolation and his consciousness of his own superiority. Irritated at the incapacity of the public to recognize certain truths that were self-evident to him, he refused to persuade them, and took a vicious pleasure in being misunderstood; so that, though severely critical of himself, he missed the boon of sympathetic criticism from outside—of adulation and contempt he had enough and to spare. Thus it came about that, in his hatred of the accursed thing—of the trappings in which art seeks to recommend itself to an inartistic public—Mr. Whistler threw over much that belongs to the scope of pictorial art, and narrowed unduly his view of its legitimate aims. Along with sentimentality, which he rightly saw was the bane of our age and country, he denounced all sentiment, all expression of mood in art, until he arrived at the astounding theory, enunciated in his "Ten O'Clock," that pictorial art consists in the making of agreeable patterns, without taking account of the meaning for the imagination of the objects represented by them—that, indeed, the recognition of the objects was not part of the game. The forms presented were to have no meaning beyond their pure sensual quality, and each patch of colour was to be like a single musical note, by grouping which a symphony, as he himself called it, could be made. The fallacy of the theory lay in its overlooking the vast difference in their effects on the imagination and feelings between groups of meaningless colour-patches and rhythmical groups of inarticulate sounds. As a protest it was, or might have been, valuable, since it emphasized that side of art which, when once realistic representation is attainable, tends to be lost sight of; but as a working theory for an artist of extraordinary gifts it was unfortunate, since it cut away at a blow all those methods of appeal which depend on our complex relations to human beings and nature; it destroyed the humanity of art. What Mr. Whistler could not believe is yet a truth which the history of art impresses, namely, that sight is rendered keener and more discriminating by passionate feeling—that the coldly abstract sensual vision which he inculcated is, in the long run, damaging to the vision itself, while the poetical vision increases the mere power of sight.

Moreover, the painter himself could not act up to his own theories. As Mr. Swinburne pointed out at the time, he infringed them flagrantly by expressing in his portrait of his mother a tenderly filial piety which transcends the facts of an arrangement in black and grey. Still, on the whole, his theory coloured his art, and led him to treat his sitters with an almost inhuman detachment. When he was engaged on the portraits of two sisters, in his communications with their parents he never got nearer to recognizing their

personalities than was implied in calling one the arrangement in grey and the other the arrangement in white. There was something almost sublime in his inhuman devotion to the purely visible aspect of people, as of a great surgeon who will not allow human pity to obstruct the operations of his craft. To him people and things were but flitting, shadowy shapes in the shifting kaleidoscope of phenomena—shapes which served no other purpose than in happy moments to adjust themselves into a harmonious pattern which he was there to seize.

But, indeed, he reaped to the full the benefit of his detachment, for in an age when the works of man's hands were becoming daily uglier, less noble, and less dignified in themselves, he found a way to disregard the squalid utilitarianism which they expressed. If to him nothing was in itself noble or distinguished, neither was anything in itself common or unclean. Mean Chelsea slums, ignoble factories by the Thames, the scaffolding and *débris* of riverside activity, all might afford to his alert perception at a given moment the requisite felicitous concatenation of silhouettes and tones. This point of view he shared, of course, with other Impressionists, but what was singular to him, what he scarcely shared even with Manet, to whom he owed so much, was the exquisite tact, the impeccable taste of his selections. To the public at large he appeared at times as an impostor, who would make them accept meaningless scribbles as works of fine art, and from the point of view of mere representation there was much that served no purpose in his work; but from the other point of view no artist was ever more scrupulous in what he rejected, more economical or more certain of the means by which he attained his end. Every form, every tone, every note of colour in his pictures, had passed the severest critical test, it could only be there for its perfect and just relation with every other element in the scheme. Nothing was allowed on merely utilitarian or representative grounds. Critical taste rather than creative energy was his supreme gift, and his taste was that of a Greek vase painter or—and he was the first to seize the likeness—that of a Japanese worker in lacquer.

In all this he was the very antithesis of Rossetti, in whom a creative poetic energy controlled and harmonized every faculty; and yet in his early years in London even Whistler came under his spell. A few early drawings and etchings and one or two pictures, such as "At the Piano" and the "Girl in White," betray something of the Pre-Raphaelite influence; but already they show a preoccupation with the surfaces of things rather than with their inner meaning—already they show that exquisite sense of the beautiful qualities of paint which dominated his art. Indeed, from some points of view these early pictures, with their rich but fluid impasto and vigorously designed silhou-

ettes, were never surpassed. But it was in Japan that Whistler soon learnt to find the most congenial expression of that purely pictorial, that non-plastic view of things which suited his temperament, and under this influence his technique changed so that he learnt to give to oil paint almost the freshness and delicacy of touch of the Japanese water-colour on silk. The problem which he set himself, and which he solved most completely in the portrait of Miss Alexander, was how to give the complete relief and the solidity of tone of an oil painting together with this flower-like fragility and spontaneity—to give the sense that this undeniable and complete reality was created, like the blossom on a fan, in a moment, almost at a single stroke. It was a feat of pure virtuosity which only an Oriental could have surpassed, and it meant not only amazing nervous control, but also an untiring analysis of the appearances, a slow and laborious reduction of forms and tones to the irreducible minimum which alone was capable of such expression. In such works he pushed the self-denying art of concealing artifice to its utmost limits, and few can guess at the strenuous labour which underlies these easy productions. They have, too, a flawless and lacquer-like perfection of surface which was an entirely new beauty in oil painting, and which none of his pupils or imitators have understood or approximated to in the least. But such an acrobatic feat required a perfect functioning of the whole man which could not long be maintained. In his later pictures he lost much of his sense of beautiful quality, and his work suffered the decay which was inevitable to one who was not upheld by any generous imaginative impulse. The negative and critical side of his art ended by killing the source of its own inspiration. It was too much a matter of nerves, too little sustained by spiritual energies from within, which in some men can, by their continued development, supply the place, and more than cover the defects, of failing physical powers.

Still in the achievements of his prime he will, we think, live as a great painter—above all, as a great protest and an amazing exception. A French American he may have been, but England was the home of his finest work, and it was to English seriousness that he preached his gospel of gaiety and indifference. It is for us, rather than for any other people, to do justice to a great man. As we pointed out lately, it is a monstrous injustice that none of his pictures was acquired for the Chantrey Bequest. It is to be hoped that, now that he is dead, even our officials may give to his works a tardy recognition. Merely from the point of view of worldly wisdom, Burlington House should this winter arrange for a representative collection of the works of Whistler the Old Master, to whom as a living man they grudged the barest recognition.

WATTS AND WHISTLER

IT has been no small good fortune to Londoners to have had this winter three great exhibitions open at the same time, which, by their juxtaposition, emphasised so many points of contrast and together symbolised so clearly the close of a period in modern art. During the last quarter of the nineteenth century the art represented in these three galleries has been as stimulating, as vehemently canvassed, and often as violently decried as any. Now, for the first time, even those who took a share in the discussions of the day can look at what our age produced with a steadier gaze, and can say what they feel without fear of offence and without the exaggerated fervour of partisanship. It is true that some of the great men of the French Impressionist school are still happily alive; but their battles are over, they have entered into their heritage of fame; and it is possible even to some who have always opposed their aims to recognise their achievement as simply and unhesitatingly as if they had been old masters. What that achievement was we do not intend to discuss here; but it will be impossible, in talking of Watts and Whistler, to avoid occasional glances at contemporary art in France by way of contrast and comparison. For, if we take Watts and Whistler as in some ways typical of English art, we are at once struck by their extraordinary unlikeness, while in the French group, in spite of vivid contrasts of temperament, we find a tendency to formulate a common style, to fight a common battle, and to combine forces in a "movement."

The French, with all their supposed "intransigeance," their theoretical love of revolution, are in many ways more traditional than we are. The tradition of Ingres lives in Degas; and how far back through Poussin does not that take us? It would be almost impossible to find a French artist who renounces Poussin and Claude; while, among contemporaries, the opportunities of friendly intercourse are better cultivated, the solidarity of all genuine workers is more readily acknowledged. On the other hand, the characteristics of a nation with a hundred creeds and only one sauce make themselves felt even in our art. Our individualism is so innate and so extreme that our great men

Reprinted from *The Quarterly Review* 202 (April 1905): 607–23.

tend to isolate themselves from any close spiritual intercourse with their kindred. Like Watts, they go their own way so directly and so unconscious of their lonely progress that they do not even proclaim their dissent; or, like Whistler, they find in their isolation at once a source of inspiration, by the sense of superiority it gives, and of irritation, so that they cry aloud the grounds of their disagreement.

Our English masters, then—and after all Whistler was more English than French—are alike only in their segregation. And indeed Whistler will be found to agree less with the French Impressionists than Watts does; for the French painters loved life, and they followed nature with an almost pathetic faith; and Watts, though from quite a different approach, also had a sympathy for life and a reverence for nature. For him, too, art was an organic part of human life, affected by its conditions and expressive of its needs. But Whistler's creed was absolute and unbending. He asserted the unique nature of the sense of beauty, its uselessness, its separation from all other human faculties, and its supreme claims.

Whistler, the pamphleteer, the journalist, the dandy, the pugnacious litigant, was always in evidence. One might have supposed then that here at least was the man who, loving publicity and the stir of city life, would have been able to say, in a sparkling and witty idiom of his own, something about life. Even if he had not interpreted its deeper significance, we might have expected from him some close and convincing statement of its fashions and its follies. But no artist ever shrank from life more than Whistler. No one approached it with more haughty and self-contained reserve. He was never really on terms with life; his keen intelligence made him alert to detect fallacies in the proverbial philosophies of his day, and his corrosive wit made his exposure of them bitterly resented. He became a negative Mephistophelian figure; his geniality shrivelled, his sympathies were crushed both from within and from without. But the very fastidiousness of taste, both intellectual and aesthetic, which thus set him in opposition to life, prevented him from giving vent, as a Swift or Carlyle, to the rage of his heart. The fire burned within him, but he spoke only ephemeral witticisms in the press; he never painted the satires that he conceived; for the root of all his quarrel with life lay in the one really deep emotion he possessed—the love of pure beauty.

If there be such a thing as a religion of beauty, Whistler was its hierophant. To an unbelieving and sentimental generation he proclaimed its severe and unaccommodating dogmas with all the paradoxical insolence of a true prophet. The world laughed; and the terrible irony of his situation lay in the fact that, on the main issue, a stupidly emotional world was right and the prophet wrong. For beauty cannot exist by itself; cut off from life and human

realities it withers. It must send its roots down into other layers of human consciousness and be fed from imaginatively apprehended truth, as in religious art, or from human sympathy, as in dramatic art, or from a sense of human needs and fears in the face of nature, as in all great landscape art. But Whistler, like Oscar Wilde—who was in some ways a similar product of the same moment in modern life—wanted beauty to be self-contained and self-sufficing. In both there was something heroic, in the insolent haughtiness of the protest they made, in their refusal to come to terms with the common intelligence of the age, in their demand for martyrdom. Wilde, as "De Profundis" has so eloquently proved, did, through the revelation of pain, learn the truth of humility, the artistic meaning of sorrow, but Whistler, embittered and saddened though he was, was never forced to amplify his theories.

His theory, then, that the aesthetic emotion is entirely distinct and self-sufficient, made it a point of honour for him to eliminate from his painting all that indignation with a gross generation which might conceivably have inspired in him an art of terrible denunciation like Daumier's. His fiery and militant spirit concentrated itself on the perfection of beauty, on the search for it in its purest aspects, where its elements could be seized apart from any possible meanings they might connote. He made almost a fetish of the artistic conscience. His negations and exclusions became more and more exacting, his points of contact with life rarer. In his early picture of the "Piano," objects have their solid relief; they are enveloped in a warm atmosphere; the figures live and are capable of motion and tender human feeling. But, in the face of all that had beset English art, and was once again, with the waning of Pre-raphaelitism and the growing ascendency of Millais, overwhelming it in a flood of commonplace sentiment and obvious narrative, Whistler became more and more Quixotic in his chivalrous defence of the artist's point of honour. Real beauty, he recognised, must be always something medicinal to the mass of mankind; and he protested against diluting the drug with sugar and water, against any attempt at making it immediately palatable. For beauty of a striking and original kind has always, at least since the *bourgeoisie* ruled, appeared in the light of a personal insult.

It is now unintelligible to us that Whistler's Nocturnes should have appeared to spectators in the seventies meaningless or chaotic; to us their language is as simple as Tennyson's; but the generation that found "In Memoriam" hopelessly difficult, found neither sky nor water nor bridge in Whistler's "Battersea by Night." Nor could they pass it by unheeded; to them it was the impudent imposture of a charlatan. When we blame Whistler—and his later life was calculated often to exasperate his most generous admirers—we ought to remember what the shock must have been to a man who saw in

his own Nocturnes all that we now see, and who heard them derided by the
leading critics of the day, by Tom Taylor and Ruskin, and by all the shouting
mob. He was "Athanasius contra mundum"; he hardened his heart and cir-
cumscribed the limits of the artist's faith, making his creed narrow, pedantic,
and inhuman.

The creed was exposed once and for all in Swinburne's eloquent reply to
the "Ten o'clock"; but Whistler never consciously gave it up, and he worked
on the assumption that beauty existed in and for itself. He believed that
design meant a perfectly harmonised pattern, that certain colour combina-
tions pleased the eye more intensely than others. He refused to see that the
mere beauty of a pattern could be heightened if it were at once a pattern and
a drama, that the chord of colour would vibrate more richly to the eye if at
the same time it woke an echo in the imagination. For him a picture was a
flattened-out porcelain jar, in which we look primarily for the highest and
most subtle stimulus to a sense of sight, trained by long apprenticeship to
appreciate the most delicate perfections of quality. He realised Taste in its
highest development. For him it became no mere casual predilection, but a
separate and highly refined activity, which, if not actually a function of the
intellect, implied at least a constant discrimination and selection, and re-
quired a disinterested effort similar to that of intellectual apprehension. For
its perfection it required too a scrupulosity and *ascesis* which made it analo-
gous to moral purity. He carried it about with him as a prophylactic against
the contaminations of a vulgar age; he lived by it as a religious by his rule; he
almost sank the genius in the man of taste.

He showed it, too, in a certain scrupulous exactitude and finish in the
minor affairs of life. The world could not but recognise that he left a stamp
of completeness upon the most trivial and casual affairs. He showed it, for
instance, when, some few years ago, he was asked to contribute to the show
of old silver held at the Fine Art Society's in Bond Street. The whole show-
case in which he had confided his treasures expressed the man almost as
clearly as a picture by him. Collectors generally reveal something of them-
selves in what they gather round them, but much remains inexpressive, the
result of the mere chances of the market or the desire to get what is ac-
claimed as authentic; but Whistler seemed to have himself designed every
one of the pieces, a hundred years old or more, which he showed. So rig-
orous had been the selection, so exclusive the choice, that what remained was
pure Whistler; it had his sense of proportion, his austere elegance, his un-
mistakable perfection.

For Whistler, then, this educated discrimination which we call taste was
the great artistic function; and this he found exemplified in the art of the Far

East as nowhere else, with the doubtful exception of Greece. There, in China and Japan, the tact and self-restraint that taste implies were almost national characteristics; and Whistler's importance for the art of Europe consists not a little in his introduction of Japanese canons. It may even be that the difference between the disgust with which his "Battersea Bridge" was once received and the enthusiasm it now arouses is due to the fact that, in the meanwhile, we have become accustomed to the Japanese angle of vision. Certain it is that what was most original in Whistler's art was in part due to his powers, not as a creator, but as a connoisseur. He discovered, not Battersea Bridge, but the Bridge of Kioto; and Hiroshige, rather than nature, taught him the perfect harmonies of his Nocturnes.

We are at last beginning to treat the classic art of China and Japan with the same reverence that we have long extended to Greek art. But as, in the case of Greek art, pioneers like Winckelmann worshipped Graeco-Roman copies that we now despise, so Whistler stopped at the threshold to admire as the authentic divinity the comparatively trifling and decadent work of later Japanese artists. To us for whom, thanks in part to Whistler himself, roads have been opened up in this new country, it is now clear that, in the great classic art of China and Japan, design does not mean mere agreeableness of pattern, but embraces that perpetual play of two motives—the motive of form as a delight to the eye, and of form as directly expressive of moods and images to the feelings and the intelligence.

It was partly through Rossetti, that great explorer of new kingdoms of delight, that Whistler was started upon his quest of Oriental beauty; and, having once started, he went to lengths which brought him into opposition with Preraphaelite doctrines; for he came to side with the Eastern artist as against the Western in his views upon relief. It is this perhaps more than anything else which made him so singular, so isolated a figure in the art of the nineteenth century. For the West has always loved to give to its painted images the utmost possible effect of solid relief. The Greeks knew the joy of this power of relief and used it, if we may trust their critics, for the vulgarest effects of illusion, as in Theon's picture of the hoplite; and the love of relief in painting is endemic in the West, for the whole art of the Renaissance shows a continual struggle with the rebellious flatness of the painted surface. But the Eastern artist has always felt that the proprieties of an art of design on the flat demanded a more symbolic treatment; that relief in painting is a vulgar emphasis by the artist on that which the mind of the spectator is supposed to embody in response to his delicate indications. We need not decide here which is right; the Western ideal is certainly more difficult, and more dangerous, in that it lets in more non-aesthetic elements, and may, in

fact, obscure the whole meaning of the art of design; but, at the same time, it may lead to more imposing, more irresistible triumphs.

In any case, Whistler took sides definitely with the East, and, in the middle of a society which was enamoured of the crudest actuality in art, insisted on painting large pictures in oils like the "Mother" and the "Carlyle," the whole point of which was the negation of relief, the reduction of the figure to its value as a flat, scarcely modelled silhouette. And how exquisitely the silhouette is elaborated! Who but Whistler would have thought of getting what he did out of Carlyle, letting the coat fly open at the breast, buttoning it tight round the hips in a way which threatens to turn Carlyle into his own "Dandiacal Body," throwing out the hand as an embroidery of the line. As pure pattern it is a masterpiece; and with what subtlety too is the substance of the paint wrought so as to become at once lovely in itself and subordinate to the desired flatness. Whistler once said to an artist whose water-colours he admired, "Why don't you paint in oils?" The artist replied, "I don't know how. I have no technique." To which Whistler answered, "Nor have I. Do as I do: paint oils like water-colours." And this is true. In his early pieces, like the "Piano" or the "Building of Westminster Bridge," he used paint for its relief-values, for the expressiveness of rich impasto and transparent shade; but, after he had once conceived the idea that the flat silhouette was the highest expression of pictorial design, he painted with an even thinness; and pictures such as the "Mother" and the "Carlyle" are in fact *gouaches* done in oil. For this purpose he developed a technique of thin lacquered surfaces which has rare beauty and of which he alone knew the secret.

But taste, which thus led him to refine on life and reject its invitations, however chaste, is, like asceticism, a negative and cloistered virtue; and its too exclusive cultivation led Whistler to expose himself to his enemies, led him even to justify in some sort their accusations. He arrived at the point where the calligraphy of his celebrated signature came to seem almost a sufficient assertion of his power. So that in many of his lithographs and not a few of the later etchings he gives us only a few brilliant scratches just sufficiently adumbrating a scene in Venice or a blacksmith's forge at Lyme. Worst, and most pathetic of all, the calligraphy of his strokes is here no longer superlative; and not only is the execution slight, but too often the idea is trivially pretty or utterly banal.

What comes out for us most at the present time is the isolation of Whistler. People were fond of calling him an impressionist, and so, in a sense, he was, in that he tried to confine himself to the visual impression, to exclude from his work the associated ideas of objects. But the gulf which separates him from men like Degas, Monet, and Renoir is immense. They nod recog-

nition to Watts behind Whistler's back, for they are all interested in life, ironically, scientifically, or lyrically, as their temperaments incline. They may protest that they hate literary art, and class Watts as a *littérateur;* but their pictures belie them. Whole pages of Zola are in Degas' "Washerwomen"; a story by de Maupassant is in every Renoir; and Watts is so far of their company that, in his grandiose abstract manner, he too felt the warm attraction of human life, he too interpreted, though through the thicker veils of English convention, something of that femininity which inspired Renoir. But Whistler stands alone untouched by the imitations of life, protesting that beauty exists apart, that the work of man's hands is fairer than all that nature can show. He is a monument to the power of the artist's creed in its narrowest interpretations, and to the unbending rectitude of the artistic conscience, a lonely, scarcely a lovable, but surely an heroic figure.

Watts presents at almost every point the completest contrast to Whistler. His temperamental optimism grew and expanded in the atmosphere of distinguished and aristocratic life with which he was surrounded. The shocks and disillusionments of life were powerless to affect it; he clung always with a genial pertinacity to what was hopeful and elevating. He was positive and generous where Whistler was negative and cynical. His easily kindled enthusiasm for what was noble silenced the critical and discriminating faculties of the intellect. Where Whistler was moved to scornful indignation by the hasty assumptions of a superficial and facile philosophy, by the easy-going generalisations which were current at the time, Watts's imagination responded with glowing enthusiasm. For this aspect of his character the "Hope," hackneyed and commonplace as it now appears to many of us, is indeed admirably expressive of the central fact of his temperament—of its irreducible optimism, its illogical and instinctive clinging to what is exhilarating and consoling to the spirit, its refusal to recognise the reality of what is adverse to its aspirations. To his genial, assimilative nature the harsh abstraction of Whistler's artistic Calvinism, with its insistence on perfection, had no meaning. For him perfection, as the result of deliberate and critical choice, of rejection and exclusion, had no attractions. He created by inclusion and absorption, by identifying himself with some great and elevating idea which gathered to itself, as it grew, what was necessary to its sustenance, careless even if it included some accidental and unnecessary accretions.

We are not, then, to look to Watts for perfection; each picture of his was a struggle to express some idea which stirred his emotions. He was bound to be experimental and tentative in his efforts to find for this the expressive symbol. And the very importance of the ideas to him, the high duty which he believed lay upon him to utter them to the world, prevented him from a

curious preoccupation with the mode of their embodiment. So that, beside the clear-cut perfection of some of Whistler's designs, Watts's work must often seem hasty and unfinished.

If we stand before one of Reynolds's greater portrait groups and admire the matchless skill of design which it displays, and ask ourselves if Watts could have done thus, we must almost certainly answer no. And yet Reynolds refused to attempt the grand style as beyond his powers. Where Reynolds hesitated Watts stepped in. He, almost alone of English artists, if we except Haydon's forlorn hope, and Stevens' too rare essays, has attempted the grand style, and on its highest planes. Was he justified? That is the question that posterity will answer; we can hardly do more than make a plausible forecast. But we may say already with confidence that, whether he attained complete success or not, there was nothing arrogant or absurd in his endeavour. There is nothing to make us think that Watts might have cultivated to perfection some little circumscribed plot, that he ever mistook his vocation, or sacrificed a small talent in the endeavour to make it a great one. His spirit moved at ease in a large orbit; his ears were attuned to majestic strains; he had to be grandiose or nothing. He had to be grandiose, moreover, in an inopportune age. To have been a second Michelangelo in the nineteenth century he would have needed far more than Michelangelo's genius. The attempt might have seemed altogether too hazardous if Watts had had a clearer understanding of its difficulty; fortunately he seems to have lived by the dictates of a sound instinct rather than by self-conscious theories.

Immense as the difficulties were, it is not well to exaggerate them. His age was one in which painting in this country sank to its lowest depths; but, for all that, it was really more propitious, or, let us say, less unpropitious, for this particular essay than some others. Painting in Reynolds's time was far better understood; there was a sound tradition of technique, a general eleva-tion of taste; but, for all that, Reynolds may have been right to refrain, and Watts, less accomplished, less perfectly equipped as a painter, right to at-tempt. For the imaginative temper of the eighteenth century was too slack to prevent the grandiose from degenerating into the turgid and rhetorical. Reynolds's own attempts are a sufficient proof; but between Reynolds and Watts came Blake, Shelley, Wordsworth, Keats, and thence such an inten-sifying and rekindling of the poetic sense as made the grandiose no longer seem a dangerous affectation. Even the scientific movement of the Victorian age, while it made life uglier and diminished the artist's opportunities, did in fact help this enlargement of the mental horizon. It was, after all, a great age, and might well inspire here and there one generous soul to attempt great

things in art also. In all humility and all seriousness Watts made the attempt; that, at least, is a part of the inspiration of his life-work.

No one could enter the galleries at Burlington House without feeling that here was the impress of a great spirit, that this work was inspired by a great and noble ambition, in which anything like self-assertion and bravura was cast out by a higher pride. The classic amplitude of the movements, the heroic self-possession and repose of these figures, implied a creator who had succeeded in living in a serener atmosphere than belonged to his time. This is indeed the great mystery of Watts's work—not that he did not paint as Michelangelo or Titian, but that he succeeded in expressing himself in the grand style at all. That in an age of exasperating and nervous activity, greeted on all sides by the jerky briskness of the modern man, in an age of daily increasing ugliness and squalor, he did not despair of humanity; that he could still think of the human form as capable of large and stately gesture, of grave and lofty mien; that he could express once more the pagan ideal of perfect individuals and forget the alert cunning of the man of business—this was success beyond anticipation.

As we passed round the walls and traced his career from his earliest days, we followed with something of the interest of a romance the innumerable dangers which Watts encountered, the hair-breadth escapes, the perilous temptations, and the happy ending of each chapter. Every false canon of taste lay in wait for Watts. There was the primness and respectability of early Victorian life; and he painted one portrait that might pass for the work of any of the nameless dullards of the period. There was the theatre; and in the "Watchman" and "Ophelia" one may guess how nearly its cheap sentimentality caught him in its toils. There was always the attraction of fashionable prettiness; and the society in which he lived must have pressed its claims upon him with some exigence. Then the Preraphaelites must have tempted his generous sympathies to share their struggle, their triumphs, and their collapse; finally, his own idealism, the immense importance he attached to vague and nebulous theorising, again and again brought his art to the verge of incoherency. But even from that he recovered; and his latest works have firm, well ascertained designs, a deliberate and calculated geometry.

What was it that saved him? Not the society he kept; for he was surrounded by adulation enough to have killed a dozen ordinary geniuses; nor did he seek the society of men whose criticism might have braced him and turned back his vagrant fancy. Scarcely his intellect, for this seems always to have been subordinate to his emotions. His worship of Titian, Veronese, and the Elgin marbles seems to have been his salvation; and this came about by

reason of his robust good sense, his instinctive belief in the rightness and nobility of all the functions of the complete man, in short his paganism. Against this, all that was warped, one-sided, neurotic, or merely ephemeral, appealed in vain. All his idealism, all his speculations about the soul, never made him doubt the importance of the body; and it was the healthy vigour of this creed that saved him from the aberrations of an intellect that may often have been caught by specious sophistries. Fortunately he had the sense to trust his instincts, and to these he always returned. It was indeed the beautiful simplicity and absence of ostentation of his character that enabled him to do this; and it is in this sense true that his art is moral. We feel instinctively that the mind which conceived these heroic figures was moved by no petty vanities, was accustomed to generous and sympathetic impulses.

That other sense of his work being didactic, of which so much has been made both for and against, may be set down at once as an amiable and not altogether unfortunate delusion. Both the praise and the blame which Watts has received on this score seem to be the result of confusion. The praise, so curiously like that which Browning received from earnest souls, who, if they had read him with more understanding, ought rather to have been shocked, implied that Watts's greatness consisted in his power of making a rebus in paint of certain moral platitudes which could have been put more concisely in words, such, for instance, as that "Love is the chief support of Life," or that "Love cannot postpone the day of Death." Those who blamed were equally at fault in that they likewise assumed that the content of the pictures was only such as could be conveyed by these bald literary statements.

But the accusation that they were literature and not painting is not really justified. It might be urged, perhaps, against such symbolism as Mr. Sargent employed in his decorations for the Boston Public Library. There is a sun-god from which emerge rays ending each one in a hand. Now this is a symbol which can have no direct meaning for a modern man; it can only touch him if it is explained by means of literary annotation; but the point of most of Watts's pictures requires no such annotation. The symbolism is, as a rule, of broad universal acceptance; it belongs to our popular mythology; and, whereas rays ending in hands cannot possibly arouse any emotions unless we have the clue to their meaning, most of Watts's allegories readily yield nearly all their pictorial and imaginative significance.

There are, it may be admitted, exceptions to this statement. There are cases—the "Dweller in the Innermost" may be taken as an example—in which Watts, refusing the assistance of any recognised personifications of abstract ideas, endeavoured to externalise directly the nebulous and formless metaphysical notions in which he indulged. There is no reason to suppose

that these were ever clear in his own mind, much less that he ever conceived them sufficiently clearly to find for them definite visual symbols. In such works he becomes mystical merely by being misty. The language of art, being formal, cannot hope to transcend the material by becoming formless, but only by the discovery of forms which symbolise the spiritual. But, for the most part, Watts's allegories do convey a definite idea in purely pictorial language by relying on the associated ideas of the objects represented; and these ideas gain immensely in their appeal to the emotions by the manner in which they are rendered, that is to say, by purely pictorial and not literary elements in the work of art. In fact, the objection to literary art, if pressed, would rule out all the ready-made material of the imaginative life, would exclude representations of biblical scenes and all dramatic and historical painting, and would confine us to renderings of things actually seen.

At the same time it may be allowed that Watts's allegorical pictures are not as a rule his best. They are for the most part rather thin in design; the lines tend to repeat a weakly, sinuous curve; they lack the vigour and antithesis and the firm geometry that we find in pictures where the subject supplies more definite material to his imagination. So that, among the creatively imaginative works, exclusive, that is, of portraiture and landscape, Watts's great triumph lies in what used to be called historical painting. One or two of his biblical scenes will stand out as memorable interpretations, such, for instance, as the "Prodigal Son" and the nobly dramatic composition of the "Jacob and Esau." Among these we would scarcely venture to put the "Jonah," one of the rare cases in which theatrical traditions imposed themselves upon his sentiment for the dramatic.

But it is in his interpretations of classical mythology that the finest, most central qualities of Watts's genius find expression. That, after Titian and Veronese had had their say, he could still conceive a Europa which, if not so great as Titian's, is not only original but more near to what one may fancy of Apelles or Zeuxis than either, more entirely in the Greek spirit and yet not without a modern tenderness and sympathy; that he should have given us an Ariadne which is essentially Greek in design, but yet interprets the story for us again more humanely, more intimately than ever before, a Psyche that counts with Keats's ode to make good the lack of "antique vows," and a "Childhood of Zeus" which has some breath of Olympian air—to have done this will ensure a lasting fame, even if future ages should refuse to disentangle the meaning of his more abstract allegories.

Watts was so many-sided in his activity that it is impossible here to discuss more than the general aspects of his genius. That he devoted so much of his energy to portraiture was not of his own choice. He wanted to be a

decorative designer, to cover the walls of our public buildings with frescos expressive of national and public themes. Two figures, "The Sisters," and the "Story from Boccaccio" at the Tate Gallery, show what he might have done had his wish been granted. We may even believe that, had he spent his life on work which demands above all else a design built up on firmly asserted contours, that vagueness of modelling and incompleteness of content, which just prevents his work from attaining the highest level, would have disappeared. Fresco being denied him, he found that the only great service he could render to the nation lay in portraiture.

Watts's portraits are coloured by this sense of a public function. They show no great psychological penetration. There is no intimate revelation of character; his sitters appear rather in the character they had for their age; they are what we might expect of them; they are never revealed to us suddenly in a new and unexpected light, by which we recognise their real essence. But, for all that, they live, not intensely, not in any close personal way, but in their public capacity, bearing on their faces the stamp of their office. A few of them, moreover, are of surpassing beauty both in colour and quality; among the finest we might name the "Joachim," the "Lord Shrewsbury," and the "Recorder of London." These indeed may be taken as the completest refutation of the idea that Watts could not paint well. The fact is that no one of our time has known so much as Watts of the technical possibilities of paint, or has mastered more various and more difficult manners. Scarcely any of the methods of the earlier masters was unfamiliar to him. The glowing enamel-like quality of the "Aurora," which reminds one of French painting of the eighteenth century; the heavy glazes and loaded impasto of the "Joachim," which reminds us of Reynolds and Rembrandt; the constant reminiscences of the technique of Titian and Veronese, show that it was certainly not incompetence that led Watts finally to adopt that rocky, dry, and crumbled quality which has given rise to the curious legend of his incompetence. Even in these later works, unsympathetic though their surface may be, he shows incomparable skill, using these dry rubbings and scumblings of pigment so as to produce colour which has mystery and infinity, and, most wonderful of all, transparency; so that when, last year, he showed one of his latest works, the "Lilian," at the Academy, it turned everything else there by comparison to opaque and discoloured dullness.

Watts's work as a landscape painter, though he did comparatively little, is by no means the least remarkable of what he has left, for he shows here a surprising originality. He is indeed almost the only modern landscape painter of consequence who has beaten out entirely new paths and found his way to real compositions, not mere transcripts of nature, without unconsciously ren-

dering homage to Claude. He found the way to treat landscape with a new simplicity, to abstract more completely, and to reduce his theme to a few elements and one main contrast of tone. He treats thus a cumulus cloud cut by the bare edge of a hill or the gaunt silhouette of a mountain peak; or he makes his picture of the portrait of a single tree-trunk; or, most remarkable of all, he renders a distant, mist-enveloped prospect and obtains relief without any of the recognised means, without *repoussoirs* or strongly contrasted foregrounds. In these landscapes he shows the power of fixing on one idea, of getting the central emotion of the scene, and rendering that and that only without any explanatory accessories. In no other work does he show a higher power of concentration. And this concentration is the result of the imaginative intensity with which he has grasped the significance, for him, of the landscape.

We may return now to the question with which we started, the attempt to forecast Watts's position among the great artists of the world. The difficulty is, in his case, far greater than with Whistler, for Whistler accomplished something which had never been done before, accomplished it finally and definitively. It is something palpable and evident, but it scarcely claims the very highest rank. But Watts calls up perpetually the memory of the greatest creators, of Michelangelo, of Titian, of Rubens; and, if we are perfectly frank, his work will not quite stand the test thus inevitably applied. This explains, no doubt, the frequent change of attitude which even those who sincerely admire Watts undergo, now feeling that he is among the Olympians, and now confessing to a shy but persistent doubt. We have endeavoured to consider the grounds on which Watts's achievement is to be judged; as yet it would be unwise to do more than hazard a personal opinion as to the conclusion to be drawn. To the present writer it seems that Watts belongs to the race of the great improvisers, the race to which Tintoretto, Blake, and El Greco belong, rather than to the race of the supreme creators, the kindred of Titian or Rubens whom he emulated. The distinction lies in this, that the great creators revealed some new aspect of form, and discovered some new rhythm. They expressed great conceptions in forms moulded anew specially to fit them, while the improvisers modified and adapted to the expression of their own conceptions material that had already been quarried.

In the artists of both classes we find an extraordinary wealth of invention; images pass perpetually across their inward vision; but with the improvisers these crowd upon one another so rapidly that the artist's whole energy is devoted to recording their general aspect. In the supreme creative designers, in Michelangelo, Titian, or Rubens, there was greater control over the images; they could be held long enough and securely enough for the artist to

embody them more completely; and, most important of all, they allowed of a greater content. Michelangelo and Titian, in particular, were able to come to close terms with nature without weakening the unity of their idea. They could observe with penetrating insight and fill out the design to its utmost extent, straining the scheme with the mass of material it was made to contain, but never breaking it by casual, indifferent, or curious statements. Watts stopped short of this penetrating intelligence of form. He felt keenly the main scaffolding of his design, the weight and protrusion of a limb, the curve of a torso; and thus far he is not only noble, grandiose, and impressive, but masterly; but he could not go on to fill out the main masses with a content expressive throughout its whole texture. The design in its main lines is almost always grand, but it is not compactly woven. With him generalisation means too often abstraction.

To make a form that shall be generalised and typical, not merely particular and individual, implies in an artist great imagination; to give to this form the same cogency and completeness that can be given to some rendering of the particular, to realise its infinity and variety as fully as its unity—this is, after all, the supreme problem of the grand style; and the fact that it so far exceeds in difficulty and impressiveness all other artistic performances is the reason why we give almost divine honours to the few who have attained to it. Watts and Puvis de Chavannes are the only artists of our day who have laid serious claims to these honours. Their canonisation may be deferred; but an age and country are illustrious that have produced even one claimant.

INTRODUCTION TO THE
DISCOURSES OF SIR
JOSHUA REYNOLDS

O F Reynolds the man there is no need to speak here at length; the
outlines of his character are so simple, so familiar, they have been
retraced so often by his contemporaries and successors, and that with such a
remarkable uniformity of commendation—if we except a few spiteful phrases
in Cunningham's Life and the singular view of his actions taken by Sir
Walter Armstrong—that to repeat them here again would be superfluous.
One need only refer to the rounded completeness and harmony, the delibera-
tion and method he showed in all his undertakings, and the freedom from all
that is petty or narrow, which distinguished him in life as much as in art, and
made each so nicely complementary to the other. And as a critic his moral
qualities, his sweet reasonableness, his elevation and detachment of mind,
and—to put down his limitations as well—a certain eighteenth-century cau-
tiousness which sometimes gives the appearance of coldness—profoundly af-
fect his work. It is to them he owes the power to hold the balance true
between praise and blame—the nice poise of mind which for just criticism is
so necessary, and yet so rare, a complement to keenness of perception and
quick sensibility. In any case, it is not a little to these moral qualities that the
Discourses owe their permanent value. The geniality of the man arouses our
affection, and, disarming all querulous and captious opposition, inclines us to
a favourable attitude for learning.

Of Reynolds as an artist also this is not the place to speak in detail. But
since it affects the value of his teaching we must consider briefly the charge
of inconsistency brought against him. Cunningham in his Life says: "Barry
was a proud artist and a suspicious man. . . . He followed his own ideas in
the course he pursued, but probably he reflected that he was also obeying the
reiterated injunctions of Sir Joshua, who, constantly, in his public lectures
and private counsels, admonished all who loved what was noble and sublime
to study the great masters and labour at the grand style. This study had
brought Barry to a garret and a crust; the neglect of it had spread the table of
Reynolds with that sluttish abundance which Courteney describes, and put

Reprinted from *The Discourses of Sir Joshua Reynolds* (London: Seeley, 1905), vii–xxi.

him in a coach with gilded wheels and the seasons painted on its panels."
The fact is as true as the implication of motive is unfair. Reynolds found by
his own failures in poetical composition that he had not the particular gift of
invention, without which such work falls into turgid rhetoric, and though he
continued from time to time in such endeavours he probably never concealed
from himself his real failure. He saw that his imagination was interpretative
rather than creative; that it was stimulated by definite objects before his eyes
rather than by poetical ideas; and he conceived that his real work lay in
giving to portraiture something of the representative and universal character
which is the mark of the greatest creations. Still more, he saw that it might
be enriched by all the beauties of what he defined as the ornamental style.
Thus it comes about that he scarcely ever attempted the Michelangelesque—
the Mrs. Siddons as the Tragic Muse is, indeed, almost the only work which
gives palpable proof of Reynolds' prolonged study of the Sistine Chapel. On
the other hand, he found the beauties of the Ca[r]racci more within his
range, and in several works, notably the St. John the Baptist, in Sir Frederick
Cook's collection, he strove to surpass Lodovico's quality of colour, and to
approximate to his refinement of design. No less marked at times is the
influence of Guercino in the general lighting and disposition of his portraits,
and of Guido Reni in the movement and expression. But Reynolds must
have been aware that he never could compass mastery in draughtsmanship,
and that for him expression must take for the most part the way of chiar-
oscuro and colour. He studied Rembrandt, and still more Tintoretto, for the
former, and Titian above all for the latter, while his feeling for Rubens
amounted at times to enthusiastic admiration. The notion that Reynolds as a
critic ought to have bound himself within the limits of his own talent as an
artist, that he was to recommend others to do no more than he had done
himself, is palpably absurd. It is just because he had the gift, an unusual one
among artists, of rising to a general view of art as a whole, and of regarding
his own performance with objective impartiality, that he is so remarkable as a
critic. He was, moreover, intensely optimistic about the future of art in En-
gland, and he, therefore, looked forward to a generation which should surpass
himself as much, or more, than he had surpassed Hudson and Richardson.
That he put before the rising generation ideals higher than he himself could
compass is a sign only of his generosity and detachment from personal feelings.

In considering Reynolds as a critic we come to the crucial question of the
value of Reynolds' Discourses for the artist and amateur of to-day. The
present edition has been undertaken from a belief that their value still per-
sists, that the Discourses are not merely a curious and entertaining example

of eighteenth-century literature, but that they contain principles, and exhibit a mental attitude, which are of the highest value to the artist. The artist can make as little use of the pure aesthetics of professed philosophers as the practical engineer can of the higher mathematics; what he requires is an applied aesthetics, and it is rarely indeed that a writer has at once the practical knowledge and the power of generalisation requisite to produce any valuable work in this difficult and uncertain science. Reynolds was one of the first, and he remains one of the best, who have attempted it. He keeps, as a rule, close to the point at which the artist must attack the problems of aesthetics, and he succeeds in proportion as he does so. When he endeavours to find support in abstract philosophical principles he is less happy, though he never fails to be ingenious and suggestive. It results from this—from his approaching the subject with the artist rather than with the philosopher—that his methods will often be found of real value even when the greater knowledge and greater critical insight which our generation may justly claim, invalidate his conclusions.

Reynolds' limitations are obvious enough to us; for him classical sculpture was summed up in the Apollo Belvedere and the Portland Vase, and Italian painting began with Michelangelo and Raphael. To suppose that this argues a lack of critical power on Reynolds' part is unfair; he was the child of his time, and his caution prevented him from venturing on what would have appeared impossible paradoxes to his contemporaries. Rather, one may well be surprised at the many small indications of his appreciation of primitive art. It is not improbable that in his Discourses he may have minimised this admiration out of deference to contemporary opinion, for the strongest expressions of it are found in his more intimate notes on a "Journey to Flanders and Holland." There we find a genuine admiration of Hubert van Eyck's altarpiece at Ghent;[1] and a comparison between Jan van Eyck's altarpiece at Bruges with two heads by Rubens to the disadvantage of the latter. Elsewhere he admires pictures by Pieter Breughel[2] and Quentin Matsys.

Again, in his Italian sketch-book, now in the British Museum, we find,

1. "It contains a great number of figures in a hard manner, but there is great character of truth and nature in the heads, and the landscape is well coloured."

2. "This painter was totally ignorant of all the mechanical art of making a picture; but there is here a great quantity of thinking, a representation of variety of distress, enough for twenty modern pictures. In this respect he is like Donne, as distinguished from the modern versifiers, who, carrying no weight of thought, easily fall into that false gallop of verses which Shakespeare ridicules in *As You Like It.*"

"It is much more entertaining to look at the works of those old masters than slight commonplace pictures of many modern painters."

as Mr. Laurence Binyon was the first to point out,[3] studies from Mantegna's
Eremitani frescoes. In his own collection were to be found two Holbeins, a
Dürer, a Quentin Matsys, a Lucas van Leyden, a Pieter Breughel; nor was he
blind to the beauties of Memlinc, since he bought for a patron the exquisite
Madonna now in the Goldschmidt Collection in Paris. We are rather, then,
forced to the conclusion that Reynolds was ahead of his generation in critical
acumen; that he was, in fact, on the verge of making the discovery of primi-
tive art, and that had he thought fit in the Discourses to give free rein to
these inclinations instead of repressing them he would have appeared as a
pioneer in art criticism.

As it is, however, the difference between his survey of art and that which
we now command is great enough to make it a question for us how far it
destroys the value of his teaching.

The two great discoveries made since Reynolds wrote are the discovery of
Greek as opposed to Graeco-Roman art, and the discovery of the art of
the Middle Ages and early Renaissance. These discoveries both make in the
same direction—the discovery of Greek art has dissipated for our eyes the
over-blown beauties of that art which kindled the enthusiasm of Win[c]kel-
mann and Goethe. The discovery of Botticelli and Van Eyck, though it has
not lessened our love for Michelangelo, and has hardly interfered with Ra-
phael's fame, has made us unfairly indifferent to the beauties of seventeenth-
century Italian art. Moreover, we now recognise the essential kinship be-
tween Greek and Gothic sculpture. Classic and Gothic have ceased to be
opposites, and the frontier has become one of time rather than place. The
degree of development of an art, not the race or the religion that produced it,
has become the essential point. Our warmest affections have turned from a
later to an earlier stage of that development; we love sincerity and intensity
of feeling more than the artifices of a careful rhetoric.

And hence arises a question which must be faced. It is impossible for us
to doubt that the beauties we find in Mantegna and Van Eyck are real artistic
beauties, and yet most of Reynolds' precepts are directed towards a kind of
beauty which is at least very different from theirs, possibly incompatible with
it. There runs throughout the Discourses a constant appeal to the student to
aim, above all, at unity. He is to look with the "dilated eye," to seize the
general effect, to avoid all detail which will interfere with this; to subordinate
and sacrifice parts, however excellent and expressive in themselves, to this
general agreement and coherence of the parts in the whole. Reynolds does

3. Catalogue of Drawings by British Artists, preserved in the Department of Prints and
Drawings in the British Museum. By Laurence Binyon, vol. iii, p. 206.

not deny that other methods are possible to the artist, as his unstinted praise
of Jan Steen declares, but he appears to deny that any other method is com-
patible with the lofty key of great imaginative art. And in so far as he does
this we are bound, I think, to differ from him, and to admit the possibility of
another kind of unity, even in the grand style.

There are, in fact, two contending principles in art—one of which makes
for richness of content, the other for unity of expression. Some kind of bal-
ance between these seems to be necessary for a great work, since, on the one
hand, a chaos of unrelated forms, however beautiful in themselves, would
distress us by the impossibility of bringing them together; and, on the other
hand, a skilfully arranged composition of vapid and meaningless forms could
only arouse a languid interest in the artist's dexterity. Two examples may
make this clear. As an example of such a unity as Reynolds had in view we
may take the Rubens' altarpiece of St. Augustine at Antwerp; for our other
the Worship of the Lamb, by Van Eyck, in St. Bavon's at Ghent.

In Rubens's picture, almost before the eye has had time to realise what
the forms represent, it is struck by the completeness and unity of the pattern
they make. The great spiral curve of figures which descends from the Virgin's
throne, and ends in the nude figure of St. Sebastian, is reinforced again by a
second variant of the main theme in the great diagonal of the bishop to the
right; higher up, the extraordinary figure of St. John the Baptist seems to
find its only explanation in the admirable way that it takes up again the line,
and carries it into the clouds, whence it re-enters the composition by the
diagonal of the curtain. In such a composition the unity is so self-contained,
the lines return so completely into the pattern, that we cannot imagine its
being continued outside the limits of the frame. The parts cohere like the
atoms in a molecule, so that we feel that the detachment of one part would
break up the whole conformation. Now, such a disposition affects the mind
vividly, and predisposes the imagination to be moved by the images which
present themselves to the eye with such a single impact, but it can hardly be
accomplished without sacrifices. Even a Rubens, exuberant inventor and vital
delineator as he was, in order to accede to the demands of so vigorous a
scheme of pattern, has to give to some of his figures more strained and more
theatrical poses than either their character or the situation quite demand—
and that precisely because, in those rhetorical gesticulations of arms and legs,
there is a greater flexibility and flow of contour than in poses more self-
contained. These figures have vitality, extraordinary vitality, and some of
them have even noble character; but it is not the life or the character that
quite agrees with the finest conception of such a scene: the character cannot
here be rendered in its profounder aspects. Amid all this turmoil of con-

volved forms only the salient and obvious distinctions can be seized, and these must be so underlined, in order that they may tell at all, that there is no room for finer shades. There is not one of these saints that seizes the imagination deeply enough to join that circle of ideal characters which dwells permanently in our minds and becomes a part of our life.

Let us turn now to our example of the opposite tendency in art, in which wealth and intensity of content is aimed at before formal unity.

In Van Eyck's altarpiece we have an open stretch of undulating country, fertile and intensely green, with here and there thickets and bosky dells. Through this land there converge in a central space bands of holy men and women, coming forward to where the Lamb stands on an altar by the Fountain of Life. With all this mass of detail; these crowds of people, each one carefully and separately realised; these thick woods, where each branch, each leaf, is perfectly delineated, we can scarcely expect to find any large pattern in the forms, any dominating silhouette, any of those leading lines and large contrasts, which bound together Rubens' design. We find a generally symmetric arrangement of the groups of figures, one nearer and one more distant group on either side of the central altar and fountain; but there is no apparatus by which these are summed up, there is no system of subordination by which the eye can deal with a whole group as a single mass, and count it as a single unit in the design. Each of the foremost groups contains nearly fifty figures, and each figure is realised as an end in itself.

And yet, though there is no unity in Reynolds' sense, if we examine the picture in detail we shall find the most marvellous sense of relationship in the parts—not a face of all these hundreds but has that stamp of uniformity which makes for us a definite character, not a fold of drapery that does not fall harmoniously with its neighbours, not a spray of foliage which fails of the rhythm expressive of organic life. As the eye follows along any contour it will be conscious of purpose, and singular rightness of purpose, in each minutest change of form; it will find that down to the smallest atomic divisions of the parts the pervading sense of creative purpose informs and animates the design. Now, this implies a highly-developed sense of relationship and rhythm, and these are the essentials of that unity which Reynolds so rightly praises. What are we to say, then, of Van Eyck's failure to attain the same visible unity in his whole composition which the separate parts discover so unmistakably? The answer is that his parts cohere by reason of a different principle. Visibly, indeed, they cohere only by the general symmetry of disposition, which is here a weak and negative force, affording, as it were, an intellectual approval of order rather than any strong visual gratification or assistance. But we must consider that the unity is here essentially poetic and imaginative,

and not visual. It lies in the conception of all these kings and heroes, saints and virgins, gathering from all parts of the earth to adore the mystic Lamb. That, it is true, might have been visibly realised in an arrangement of large silhouettes and strong chiaroscuro—we can imagine Tintoretto treating it as he treated the story of the eleven thousand virgins—and such an arrangement would have conformed to Reynolds' conception of unity. But this would have been at the cost of telling us only that a number of people came together to worship the Lamb, and Van Eyck wanted to tell us who these people were, and in what a place, adorned with what miraculous beauties of fruit and flowers. To do this he was obliged to give to each part the fullest possible detail; and when he has told us who each of these men and women were, given us a sense of the reality and the nobility of each saint and hero— a reality almost as insistent as that of a character in Shakespeare—the fact that these great, and to us now intimately known, men and lovable women have gathered around the Lamb has an altogether richer and more stimulating effect on our emotions than any mere representation of a scenic effect, however imposing.

It would appear, then, that the unity of a picture may lie in its perfect conformity to a poetical idea, as well as in the subordination of its parts to a single easily-apprehended pattern; and that where, as in Van Eyck's picture, that poetical idea can only be strongly aroused by the complete and independent realisation of all the parts, this may yet acquire such a hold upon the mind that the enjoyment of each part is indefinitely heightened by the consciousness of its relation to that ideal whole. So that, although we can get no very intense feeling, if we regard the picture with the "dilated pupil," the eye being constantly baffled by the multiplicity and insubordinate equality of the parts, yet as we examine it in detail, as we in imagination walk over the enamelled meadows, and address in turn each of these profound and stately, but intensely human, spirits, we experience an intense imaginative satisfaction at finding them thus brought together, and at finding in so delectable a place such fit inhabitants.

Some such reflection as this seems needful if we are still to apply Reynolds's doctrine of unity and yet retain our new-found admiration for that primitive art which at first sight seems to contradict it so palpably.

If, then, Reynolds' value as a critic is not altogether impaired for us by his ignorance of certain aspects of art with which we are now familiar, we shall certainly be ready to admit his value as a teacher. Nor has there ever been a time since their first publication when the main tendencies of his teaching were likely to be better understood than the present. Reynolds' contention was that art was not a mechanical trick of imitation, but a mode

of expression of human experience, and one that no civilised human society could afford to neglect; that this expression required for its perfection serious intellectual effort, and that, however diverse the forms it might take, it depended on principles which were more or less discoverable in the great traditions of past masters. He regarded this tradition as embodying, approximately, these fundamental principles somewhat as the actual laws of a country embody the ideals of jurisprudence. Finally, he maintained a belief in the possibility of an organised co-operative advance in the knowledge of these principles of artistic expression comparable in some degree with the advance in scientific knowledge.

That his hopes in these respects have not been fulfilled is no proof that they are altogether vain. There have been times when tradition did secure this community of knowledge, this gradual building up, step by step and generation after generation, of positive acquisitions in the knowledge of how to find artistic expression for feelings and ideas, and there is nothing chimerical in hoping for their recurrence.

It must, however, be conceded that the history of nineteenth-century art has been uniformly unfavourable to such hopes. Tradition may, indeed, degenerate into complete sterility, for the laws of artistic expression differ in this from those of science, that their value is not fixed once for all—it depends upon the ardour and force of conviction with which they are accepted. For want of this a complete bankruptcy of tradition was reached in the first half of the nineteenth century, and the subsequent history of art has been the story, not of a gradual process of construction, but of successive revolutions, each illuminated by one or more heroic figures, and each ending without establishing more than a provisional government. The greatest art of the period has been an art of revolt, and it bears the trace of its origins in its extravagant individualism, its feverish and quickly exhausted energy, its waste of power in fruitless experiment, and its small actual accomplishment. We have tried, in fact, every alternative; denied, in turn, every principle that governed the act of the past, and nearly always the genuine artist has been among the iconoclasts.

But this process has left us almost paralysed, without faith, and with no very certain notion of how a work of art is made. Everyone has to build for himself from the foundations for want of that organised and collective experience without which no complete human creation can be brought into being. Ten years ago the revolutionary forces were still strong; it still seemed worth while to destroy and to liberate; but the rising generation of artists, especially in England, is turning with a new reverence to the art of the past; is beginning to realise that there are definite things to be learned, a positive

knowledge to be acquired and handed on from master to pupil; that there are problems in art the solution of which requires the persistent application of intelligence rather than the improvisation of genius. We are tired of a too self-assertive individualism; the cult of genius has passed its climax with the death of Whistler; and we are ready to listen with profit to the sage counsels and constructive policy of Reynolds.

Whether we accept his indications of the laws of artistic expression or not—and he himself would have welcomed investigation and correction—we may at least admit that he remains one of the few writers who have approached the subject from the artist's point of view, and that he more than any other has suggested the lines along which profitable generalisations may be deduced from past experience. The mere belief in the existence of law in an activity which is assigned, by romantic enthusiasts on the one hand, and by contemptuous sceptics on the other, to caprice, is already much, and in that belief Reynolds never faltered. His creed may be defined in Goethe's words: "The genuine law-giving artist strives for artistic truth; the artist who knows no law, but follows a blind inner instinct, strives for natural verisimilitude."4

4. "Der echte, gesetzgebende Künstler strebt nach Kunstwahrheit; der gesetzlose, der einem, inneren, blinden Triebe folgt, nach Naturwirklichkeit."

2

FORMING FORMALISM: THE POST-IMPRESSIONIST EXHIBITIONS

THE essays collected in this chapter address what has come to be the best-known episode in Fry's career: his sponsorship of the two "Post-Impressionist" exhibitions that introduced London to Parisian modernism and the concomitant promotion of formalist aesthetics as a way of approaching the new art. Fry's "An Essay in Aesthetics," first published in the *New Quarterly* in April 1909, remains the clearest early statement of the basic formalist belief in the existence of "emotional elements of design" in art, independent of the depicted subject matter. Reproduced in Fry's often reissued first anthology, the 1920 *Vision and Design* (16–38) and reprinted or excerpted in many subsequent textbooks on aesthetics,[1] the essay has become a keystone in the edifice of modernism. The historical importance of this essay lends special interest to Fry's unpublished draft of a lecture for a philosophical society at Oxford University, in which he developed many of the thoughts—and even inaugurated certain of the phrases—that later appeared in "An Essay on Aesthetics."

Fry's lecture, titled "EXPRESSION AND REPRESENTATION IN THE GRAPHIC ARTS," anticipates Fry's invocation of Plato, Tolstoy, and the notorious "Hon. John Collier R.A." in the essay—though the latter's name is discreetly omitted in the published version.[2] Beyond these similarities, however, digressions and imaginative examples of many points enliven the preliminary lecture version of Fry's piece. For the scholar, they cast light on the development of formalism, often bringing a new specificity to ideas that remain abstract in the published essay. In this vein, my parenthetical notations of what Fry crossed out in revising his text show him from the beginning coping with problems that would continue to beset formalism, especially the difference between the merely "decorative" and the formally significant.[3] For the more casual reader, "EXPRESSION AND REPRESENTATION" offers a hint at the charm of Fry's speaking style, which, Virginia Woolf recalled, "conveyed what was not so perceptible in his writing—the tolerance, the wide experience, that lay behind the hob-goblin mask of the man who had the reputation of being either a crack-brained theorist or the irresponsible champion of impossible beliefs."[4]

Whatever Fry's rhetorical charms, however, neither his 1908 Oxford audience nor the 1909 readers of "An Essay in Aesthetics" could have had any idea of the ultimate influence of the ideas they then encountered. Indeed, the essay occasioned so little notice when it first appeared that Fry responded with delight to a critique sent by the American philosopher Henry Rutgers Marshall (*Letters*, 323). Typically, what captured the art world's attention was not theory in the raw, but the unconventional applications the theory made possible. It was the controversy surrounding Fry's 1910 exhibit, *Manet and the Post-Impressionists*, that catapulted his theories to the center of the public arena.

With hindsight it is possible to see the germs of Fry's iconoclastic championing of modern art as early as "THE LAST PHASE OF IMPRESSIONISM," a letter he published in the *Burlington Magazine* in March 1908. The trend is even more pronounced in the INTRODUCTORY NOTE Fry wrote for the *Burlington* to accompany his 1910 translation of Maurice Denis's essay on Cézanne. In the early letter, Fry compares artists like Cézanne and Gauguin to the Byzantines, who, he said, supplanted the weak Impressionism of Roman art with a strong new style rooted in "a well-considered co-ordination of the simplest elements." The same idea is brought forward in the introduction to Denis's essay, where Fry speculates about Denis's assertion of Cézanne's debt to El Greco: "Was it not rather El Greco's earliest training in the lingering Byzantine tradition that suggested to him his mode of escape into an art of direct expression?" This historical revisionism applies the principle asserted in "EXPRESSION AND REPRESENTATION": what is perceived as the awkwardness of "primitive" painting can make for more expressive art than what is merely mimetic.

This idea became a touchstone of the aesthetic philosophy Fry propounded to defend his first Post-Impressionist show. Organized over the summer of 1910, *Manet and the Post-Impressionists* was designed to introduce contemporary French art to London. No such comprehensive survey of Parisian modernism had ever been seen in the British capital, where artists like Cézanne, Van Gogh, and Gauguin were recognized only by experts, and Matisse and Picasso were virtually unknown.[5] Although Fry, a month before his show opened, gleefully anticipated "a huge campaign of outraged British Philistinism," Virginia Woolf reports that he was "amazed" as well as "amused" at the vehemence of the reaction.[6] "I have been the centre of a wild hurricane of newspaper abuse from all quarters over this show," he reported to his father at the time (*Letters*, 338). Not all the reviews of *Manet and the Post-Impressionists* were hostile, but particularly in the dailies many of the critics attacked Fry by name.[7] The *Morning Post*'s Robert Ross "regret[ted] to

say" that Fry was behind the exhibition, and professed "a certain feeling of sadness that distinguished critics whose profound knowledge and connoisseurship are beyond question should be found to welcome pretension and imposture." This rebuke was especially personal, for Ross in 1903 had been the first dealer to organize a successful show of Fry's own paintings.[8] The *Times* scolded Fry for misusing his authority as a "distinguished scholar and critic" to promote artists like Matisse, whose sole aim was to "*Épater le bourgeois*."[9] In "POST IMPRESSIONISM," the published text of a talk Fry delivered at the closing of the exhibition, he alluded to a lecture (also published as an article) in which a prominent superintendent of insane asylums condemned the new art—and its critical champions—as mentally diseased."[10] Other critics, according to Fry, seemed to believe, "that all the pictures . . . should be burned, and that I myself should be offered up upon the holocaust as a propitiation of the outraged feelings of the British public."

During the run of his controversial exhibition, Fry wrote a series of articles in which he tried to meet the objections of his critics. Clearly phrased as responses to an ongoing debate, these essays were not among those he later selected to anthologize. Nevertheless, these pieces are vital to understanding both the origins and the influence of Fry's formalist aesthetics. As a record of his thoughts, developing quickly in the face of attacks from various quarters, these essays provide an invaluable record of formalism's historical development. In addition to their importance in documenting Fry's intellectual development, these essays have a broader historical importance, for they record the way his ideas first reached a wide audience. The controversy over *Manet and the Post-Impressionists* sent journalists, scholars, artists, and gallerygoers scurrying for, at least, the catalog essay, titled "THE POST-IMPRESSIONISTS," which was written by the exhibition's secretary following Fry's scribbled notes. There they read that the Post-Impressionists were united in refusing to take "a passive attitude towards the appearances of things." Instead, they sought to express the "emotions" evoked by what they painted: "to put a line round a mental conception of the object," to render "the 'treeness' of the tree."

The paradoxical nature of these elegant and influential phrases has been noted, both at the time and since. Post-Impressionism was supposed to express the artist's personal emotion, and, at the same time, to communicate a universal mental concept.[11] The new art did not "attempt to represent what the eye perceives" in the look of objects, yet it claimed to be "rendering their real significance." Finally, the new art was "modern," "*Post*-Impressionist" (and the essay establishes Impressionism as post-everything-else), the product of avant-garde artists "pushing their ideas further and further"; at the

same time, it was "a return to primitive, even perhaps . . . a return to bar-
baric art." Personal and universal, unrealistic and real, advanced and primitive
—the paradoxes of Post-Impressionism were seized upon by the critical
press.

To counter his critics, Fry wrote a series of three essays for the *Nation* and
gave a lecture, "POST IMPRESSIONISM," at the Grafton Gallery; all these texts
are republished here. The three *Nation* essays form a series: "THE GRAFTON
GALLERY—I" renews the formalist theoretical argument, "THE POST-
IMPRESSIONISTS—II" treats the artists featured in the exhibition individually,
and "A POSTSCRIPT ON POST-IMPRESSIONISM" responds to hostile letters to
the editor. The lecture, delivered at the closing of the exhibition and re-
printed in the *Fortnightly Review*, offers a broader overview of the issues and
stands as the most comprehensive record of Fry's aesthetics at that important
moment in the founding of formalism.

In all of the articles written to defend the Post-Impressionist show, Fry
attempts to balance the claims of abstraction and of representation. In "POST
IMPRESSIONISM," the lecture at the Grafton, Fry acknowledges that "a certain
amount of naturalism, of likeness to the actual appearances, of things is nec-
essary, in order to evoke in the spectator's mind the appropriate associated
idea." The mere play of form and color here is not sufficient. Rather, Fry
focuses on the way such formal gestures work with representational subject
matter to create a response in the viewer. He suggests that "sentiments and
emotions which centre round the trivialities of ordinary life" will be best
conveyed by realist art, while "those feelings which belong to the deepest and
most universal parts of our nature" will find their expression more abstractly.
Nor does Fry posit abstract art's timeless superiority over what he calls "pho-
tographic vision." It is not that abstract art is always better, it is that abstrac-
tion is appropriate *now*. The rules of realism—what Fry terms "the too
elaborate pictorial apparatus which the Renaissance established"—were, in
their day, devised "with passionate zest and enthusiasm." By the nineteenth
century, however, they had become a "corpus of dead fact, alien to the imagi-
nation." Artists like Cézanne and Manet, therefore, abandoned "the science
of representation" in favor of "the science of expressive design." Their primi-
tivism marks an inevitable turn of the great wheel of history, as it cycles
between the discovery and rediscovery of systems of visual signification, and
we recognize that each turn "gained new possibilities of expression and lost
other possibilities."

Fry's claims—especially as they are phrased here in tones of even-handed
reasonableness—seem almost platitudes today. Fry, however, confronted an
art world where the qualitative superiority of Renaissance art was almost

unanimously accepted. Fry's Grafton lecture sought to denaturalize such as-
sumptions, presenting them as the crutches of academic art instructors who
seized on this era's "fairly steady progression towards the more complete sci-
ence of representation" as "a thing capable of easy and lucid demonstration,
one upon which one may even set examination papers and give strictly judi-
cial marks." With Renaissance standards seen as just one possible model, the
observation that avant-garde art draws historical justification from, in Fry's
terms, "primitive or, as it is derisively called, barbaric art," is no longer
grounds for condemnation. Fry cites his generation's appreciation of early
Renaissance—and, to a lesser extent, Byzantine and Gothic—art as evidence
of widespread "changes in the feelings and sentiments of humanity" that
were bringing the modern age back to its "primitive" roots.

Later, especially in such texts as Clive Bell's 1914 *Art*, formalism took on
a more dogmatic tone. In these first defenses of Post-Impressionism, how-
ever, Fry's relativism softens the apparent paradox of primitive modernism.
The tension between the personal and the universal, however, only grows
tauter through Fry's elaboration of his beliefs. In the second Grafton essay,
Fry praises Cézanne for his "supreme spontaneity as though he had almost
made himself the passive, half-conscious instrument of some directing
power." To make oneself passive, to be half-conscious and half-embodied by
a universal force—this is the contradiction at the core of Fry's formalism, for
Cézanne is established as "the great genius of the whole movement." The
overview lecture, "POST IMPRESSIONISM," perpetuates the confusion. Al-
though Fry mocks as pseudoreligious "casuistry" the view that the "distortion
[that] is inevitable and . . . even desirable" in art must be "always unwilling
and unsuspected" on the part of the artist, he nevertheless invokes the
"strange and unaccountable originality" of Cézanne working "almost uncon-
sciously" to derive the "non-representative and expressive art" of Post-
Impressionism from the merely representational practice of the Impression-
ists. A similar contradiction plagues the first, more theoretical, essay in the
series, where Fry suggests that the impersonal "sciences" of representation
and expressive design are realized through personal emotional commitment.
"Facts," Fry says, must be "passionately apprehended" to be of use to artists.
The ultimate justification of an art work's value, then, seems to rest not on its
success in exploiting the expressive possibilities of realism or abstraction, but
on its maker's state of consciousness. Elsewhere, of course, Fry distinguishes
art criticism sharply from biographical modes of interpretation (*V&D*, 257),
yet his consistent reference to biography—initially Reynolds's, but most of-
ten Cézanne's—along with his tendency to promote artists whose lives pro-

voked an empathetic response, are rooted in this Romantic belief that the artist's sincerity and passion ultimately justify the work of art.

The social foundation for Fry's promotion of modernism is evident not just in his references to artistic personality but also in his reactions to criticisms of the exhibition. Appropriating the charges of anarchism launched at the show by the conservative *Morning Post* and *Times*,[12] Fry welcomed this characterization of the Post-Impressionists, saying, "Like the Anarchists, with whom they are compared, they are not destructive and negative, but intensely constructive." The final Grafton essay, responding to specific critics, shows Fry relishing the opportunity to clash with the "conventionally cultured." Their taste, he suggests, is—like the German emperor's—an expression of an imperial ambition, and Fry challenges their "contemptuous view" of "the work of the Benin artists" with whom by implication the "primitive" Post-Impressionists are allied.

It is in this context that Fry's tepid defense of Gauguin should be interpreted. Many of the critics attacking Post-Impressionism had exempted Gauguin, whose exoticism, sinuous line, and brilliant flat color could be reconciled with the precedent of the English Pre-Raphaelites; Ross, for example, admired Gauguin's echoes "of the pattern and invention of Beardsley."[13] Fry's statement in the second *Nation* essay that "one must make excuses and concessions" for Gauguin takes on new meaning when the third essay records that "Gauguin naturally gets rather good marks from" a critic whose critical vocabulary "suggests an odd idea of the artist's function, as purveyor to the conveniences of the middle classes." Fry expresses his doubts about Gauguin's sincerity, citing the "rhetorical element" in his work, and his "desire to impress and impose." These are the characteristics Fry associated with the storytelling academic art of his day. It was in contrast to this topical painting that Fry developed his notion of the "classic" as "pure art without any rhetorical emphasis, art which expresses a sensation without wishing to impose it" (*Letters*, 502).[14] Ultimately, Fry is emphatic in claiming Gauguin as a Post-Impressionist, praising him both for his formal accomplishment—"his astonishing talent as a designer, his creation of new possibilities in pattern, and his unrivalled power of complex harmony"—and for his "sympathy with primitive instincts." To the limited extent that Gauguin affords conventional narrative pleasures, however, Fry insists it is a shortcoming. He has no desire for a meeting of the minds with conservative critics over their estimation of this artist.

For Fry, Post-Impressionism was the art of a new era, in which outdated conventions were struck down. Reverberations of the controversial sociolo-

gist, Thorstein Veblen, echo in Fry's denunciation of art that flaunts the meticulous craft of its maker as proof of its owner's power to squander so much labor. Fry insists, "If by some miracle beauty could be generated without effort, the whole world would be the richer."[15] Ultimately, Fry rejects all cultural conventions about "what a picture ought to be and do," urging the reader instead to free art from its role in the current social order and "allow his senses to speak to him instead of his common sense." Positing a realm of the senses beyond social convention, Fry assures his readers that, in transcending their current social moment, they will discover color harmonies and patterns that "like the works of the early primitives, and like the masterpieces of Oriental art, . . . suggest visions to the imagination" and create "a general sense of well-being."

This attempt to ally art and change, to make art the expression of a utopian promise of a better world, is extended in Fry's presentation of *The Second Post-Impressionist Exhibition* two years later. Fry's catalog essay on the French artists in the show (which he reprinted in *Vision and Design*) presents them as "modern men trying to find a pictorial language appropriate to the sensibilities of the modern outlook" (*V&D*, 238). This is the new art of a new generation with new ideas. Again in Veblen's vein, Fry downplays "ostentation of skill," and his essay foregrounds the story of Henri Rousseau, a lowly customs officer with no academic training in art, who nevertheless was one of the featured artists (*V&D*, 237–38). As Fry explained in his INTRODUCTION to this catalog, the follow-up Post-Impressionist exhibition was designed to demonstrate the spread of Post-Impressionism beyond France by adding sections on contemporary Russian and English art. The latter group was curated by Fry's Bloomsbury colleague, Clive Bell, and included the Bloomsbury painters Vanessa Bell and Duncan Grant. Bell's essay introducing the English section demonstrates the same kind of social inflection that characterized Fry's presentation of Post-Impressionism. For Bell, the English Post-Impressionists are "revolutionary": "in choice of subject they recognize no authority but the truth that is in them." The contrast here is to the Royal Academy painters, with their endless series of official portraits and subjects that—to borrow a phrase from Virginia Woolf—"preach doctrines, sing songs, or celebrate the glories of the British Empire."[16]

In "THE GRAFTON GALLERY: AN APOLOGIA," published to coincide with the opening of the second Post-Impressionist show, Fry is clearest in opposing Post-Impressionism to what he calls "British Philistinism." Describing how mainstream critics who had attacked the first Post-Impressionist show now affected to admire Cézanne while continuing to dismiss younger modernists, Fry drew a comparison to the newspapers' "recent hurried canonisa-

tion of Gladstone," the deceased Liberal prime minister known as the Great Radical—despite these publications' opposition to his successor, David Lloyd George. Post-Impressionism and the formalist aesthetic theory that supported it were, then, in their inception, explicitly inscribed as part of a broader leftist worldview.

The memoirs of Fry's Bloomsbury colleagues attest to the interrelation of artistic and social ferment around the years of the two Post-Impressionist exhibitions. Leonard Woolf has written of how "exciting [it was] to be alive in London in 1911," connecting "the feeling of relief and release as we broke out of the fog of Victorianism," the sense that "militarism, imperialism, and antisemitism were on the run," and "the profound revolution of Cézanne, Matisse, and Picasso." Vanessa Bell described the moment as "a time when everything seemed springing to new life—a time when all was a sizzle of excitement, new relationships, new ideas. . . . Perhaps I did not realize then how much Roger was at the centre of it all."[17] Today, when critics often assume a relationship between formalist aesthetics and conservative politics, it is worth emphasizing the social context of its initial deployment.

Even more than the "sizzle" of a reform-minded new era, however, what may remain most striking in Fry's early formalist essays are the quieter moments, in which he concentrates on a single image. Fry always insisted that his "direct sensitivity before a work of art" was the basis for his aesthetic theorizing (*Letters*, 502; cf. *V&D*, 285). He pinpointed the origin of formalism to a moment in 1906, when, "to my intense surprise I found myself deeply moved" while looking at some of Cézanne's paintings, an experience that shifted his attention from subject matter to form (*V&D*, 289). Just as Fry grounded art making in the "passion" of the artist, so too the viewer's emotional experience was central to formalist theory. "In art we know nothing for certain," Fry is quoted as saying: "Consider the enormous reputation of Landseer amongst highly educated people in the nineteenth century. Were they mad, or have we misjudged him? I might be equally wrong about Cézanne [and then, following a long pause,] But really I don't think I am."[18]

The grounding of formalism in subjective belief, rather than in an authoritative canon of taste, remained a consistent emphasis in the Bloomsbury critics' writings—Clive Bell's *Art* announces in its introduction than "the starting point for all systems of aesthetics must be the personal experience of a peculiar emotion."[19] Bell might have been thinking of Fry (indeed he cites him as an example) when he describes how "good criticism" avoids "merely imparting to others the opinions of the critic"; rather, the critic's role should be one of "infecting others with their enthusiasm" so that "they, too, can experience the thrill of aesthetic comprehension."[20] When, in his published

lecture on POST-IMPRESSIONISM for the first show, Fry draws attention to the differences between the shapes of the rims of the foreshortened fruit dishes in paintings by Cézanne and Manet, one can still today feel the infectious power of his visual enthusiasm. By the second show, the intensity of Fry's enthusiasm shifted to Matisse, and to the monumental *Dance* in particular. The description of this work in "THE GRAFTON GALLERY: AN APOLOGIA" literalizes Fry's desire to sweep his viewers into active participation in his vision. He writes

> The rhythm is at once so persuasive and so intense that figures that pass in front of it seem to become part of the rhythmic whole. The rhythm passes out of the picture and imposes itself on its surroundings. Matisse has himself noticed this, and again and again in subsequent compositions, parts of the "Dance" are woven into the background.

To some, such claims may seem facile or obfuscatory. Today, the very idea of formal pleasure is critiqued for the way its emphasis on the personal experience of pleasure overrides "all other pleasures and . . . all other physiological, perceptual or psychological interactions with objects of reality and their material transformation, in the process of labor, or learning, and in the production of knowledge." In this view, such specialization is just another prop supporting "the increasing need for the division of labor" in advanced capitalism, and the "prisonhouse of modernism" is explicitly an institution of reactionary social control.[21]

While the escapist tendencies of formalism may lend it to this kind of cultural use, aesthetic pleasure does not necessarily preclude other forms of commitment, nor is the aspiration to transcendence necessarily coercive. Arguably, the aspiration to rise above the material conditions of one's current position underlies any vision of change, and notions of aesthetic transcendence have often carried this implication. In Bloomsbury's case, formalism's reliance on subjective aesthetic response was not just a vague utopian impulse, but a considered attempt to wrest art from the imperatives of capitalist consumerism and the control of the dominant classes served by conventional aesthetic judgment.

In a series of essays in *Vision and Design*, Fry contrasts the aesthetic gaze explicitly with the gaze of the consumer and with the interests of the ruling class. Aesthetic vision is not the vision of the discriminating purchaser, seduced by "all the ingenuity and resource which manufacturers put into their business" so that they can recognize "the minute visual characteristics that distinguish margarine from butter" (*V&D*, 48). Likewise, beauty is not the nostalgic pleasure afforded when the "incurable optimism of memory" associ-

ates the artifacts of bygone eras with a romantic aura of the past—and here
Fry is quite specific in condemning this process as it functioned in relation to
the Victorian ruling class "to build a quite peculiar little earthly paradise out
of the boredoms, the snobberies, the cruel repressions, the mean calculations
and the rapacious speculations of the mid-nineteenth century" (*V&D*, 43).
And finally, for Fry, aesthetic hierarchies are explicitly opposed to social sta-
tus. Looking back on the period of the Post-Impressionist exhibitions, he
argued that the reason his brand of modernism met with "so violent an en-
mity" from "the cultured public" was exactly because it cut through class
lines. Unlike the knowledge "of Tang and Ming, of Amico di Sandro and
Baldovinetti" that offered its bearers "social standing and a distinctive ca-
chet," Fry said, "to admire a Matisse required only a certain sensibility. One
could feel fairly sure that one's maid could not rival one in the former case,
but might by a mere haphazard gift of Providence surpass one in the second"
(*V&D*, 291).[22]

If the dominant culture's eventual accommodation, and outright celebra-
tion, of Matisse suggests that formalism's "revolutionary" potential was over-
estimated by its friends and foes alike, this does not negate the fact that
Fry conceived his aesthetics as a part of a broader movement of reform. As
Raymond Williams has argued concerning Bloomsbury's faith in the subjec-
tivity of individuals:

> The paradox of many retrospective judgments of Bloomsbury is that the
> group lived and worked this position with a now embarrassing whole-
> heartedness: embarrassing, that is to say, to those many for whom "civil-
> ised individualism" is a mere flag to fly over a capitalist, imperialist and
> militarist social order; embarrassing, also, to those many others for
> whom "civilised individualism" is a summary phrase for a process of
> privileged consumption.[23]

To return to the texts concerning Fry's promotion of Post-Impressionism
is to return to a moment when a rhetoric of individualism could be conceived
as a radical act. Fry's conclusion in his catalog essay for the second Post-
Impressionist show is explicit in inscribing formalism as an element of oppo-
sition culture. Responding to still-lingering charges of chicanery, Fry empha-
sized the Post-Impressionists' embrace of aesthetic emotion, saying, "it would
be rash for us, who as a nation are in the habit of treating our emotions,
especially our aesthetic emotions, with a certain levity, to accuse them of
caprice or insincerity" (*V&D*, 242–3). The implication is that critics on
guard against triviality and hypocrisy need look no further than the norms of
middle-class English life.

For Bloomsbury, transcendent emotional experiences before works of art were the essence of modernism. The new art seemed to propel its viewers into a freer world, unconstrained by the insincerity and sanctimony of Victorian tradition. The lectures and articles Fry wrote to promote the art he brought to London were part of a broader drive to change the way people see, think, and act. The scope of Fry's ambition is demonstrated in the essays grouped in the following chapters, which apply his theories to both contemporary and historical figures, as well as to architecture and the decorative arts. These are followed by a section of essays devoted to the social organization of the arts. What most clearly connects these texts to the pieces published to explain and defend Post-Impressionism is their author's missionary zeal, his desire to persuade his readers to change the way they see. Whether laying out the theoretical structure of formalist aesthetics or offering an impassioned description of a particular painting, Fry's prose never loses its exhortatory quality. That the art works he defended to a largely hostile audience are today among the most conventionally celebrated monuments of Western culture is some testament to the success of these essays.

<center>❧</center>

<center>NOTES</center>

1. For a partial listing, see Donald Laing, *Roger Fry: An Annotated Bibliography of the Published Writings* (New York: Garland, 1979), 150.

2. Fry's source is John Collier, *A Primer of Art* (London: Macmillan, 1882).

3. My transcription of Fry's draft records only such meaningful revisions. Where revisions were purely stylistic or grammatical, I give his final edit without comment.

4. Virginia Woolf, *Roger Fry: A Biography* (1940; reprint, New York: Harcourt Brace Jovanovich, 1968), 262.

5. The critic Robert Dell, during the summer of 1910, mounted a large but unfocused exhibition of French modernists in Brighton (*Exhibition of the Works of Modern French Artists*, 10 June–31 August 1910, Brighton Public Art Galleries). An anonymous review in *The Times* (11 July 1910), attributed to Fry, anticipates his defense of the Post-Impressionists as "expressionists" who seek to "present a mental image" rather than "a direct impression of a real scene" (reprinted in J. B. Bullen, ed., *Post-Impressionists in England* [London: Routledge, 1988], 88–92).

6. V. Woolf, *Roger Fry*, 157.

7. S. K. Tillyard's *Impact of Modernism, 1900–1920* (New York: Routledge, 1988) argues that reviews of the first Post-Impressionist exhibition were almost equally divided pro and con, although to reach this conclusion she assesses satires as neutral and counts as positive reviews those (like Walter Sickert's) that admired some works even while criticizing Fry (92–131).

8. Robert Ross, "The Post-Impressionists at the Grafton: Twilight of the Idols," *Morning Post* [London], 7 November 1910; reprinted in Bullen, 101. On Ross, see Frances Spalding, *Roger Fry: Art and Life* (London: Granada, 1980), 75–78.

9. C. J. Weld-Blundell, "Manet and the Post-Impressionists," *Times* [London], 7 November 1910, 11–12.

10. Fry's talk was delivered at the Grafton Galleries on 9 January 1911. His reference is to T. B. Hyslop, "Post-Illusionism and the Art of the Insane" (*Nineteenth Century*, February 1911, 270–81; reprinted in Bullen, 209–22). Imputations of insanity run through many of the other attacks on the exhibition, and were made personal to Fry in W. B. Richmond's "Post-Impressionists" (*Morning Post*, 16 November 1910; reprinted in Bullen, 114–17). Despite the attacks on Fry by the medical establishment at this moment, within two years the aesthetic theories he proposed were appropriated by psychologists. Edward Bullough's influential "Psychical Distance" (*British Journal of Psychology* 5 [June 1912], 87–117) appropriates Fry's ideas without acknowledgment. Through the years psychoanalysts have credited Bullough in such standard texts as Ernst Kris's *Psychoanalytic Explorations in Art* (New York: International Universities Press, 1952), which at the same time perpetuates Hyslop's argument that abstract art is pathological (97).

11. D. S. MacColl, "A Year of Post-Impressionism" (*Nineteenth Century*, February 1912, 285–302; reprinted in Bullen, 263–85). A sophisticated recent critique is phrased as a contradiction between "finding" an impression and "making" an emblematic rendering (see Richard Shiff, *Cézanne and the End of Impressionism* [Chicago: University of Chicago Press, 1984], 143–61).

12. See Charles Ricketts, "Post-Impressionism" (*Morning Post*, 9 November 1910; reprinted in Bullen, 106–8); see also Weld-Blundell.

13. Ross, "Post-Impressionists at the Grafton" (reprinted in Bullen, 103).

14. On Fry's concept of the classic, see chapter 3. For a later restatement of Fry's position, see "On a Composition by Gauguin" (*The Burlington Magazine*, March 1918).

15. Compare Veblen's famous *Theory of the Leisure Class* (1899; reprint New York: Macmillan, 1988), which argues: "The requirement of conspicuous wastefulness is . . . a constraining norm selectively shaping and sustaining our sense of what is beautiful, and guiding our discrimination with respect to what may legitimately be approved as beautiful and what may not" (128). Fry's *Art and Commerce* (London: Hogarth Press, 1926) and *The Arts of Painting and Sculpture* (London: Victor Gollancz, 1932) mention Veblen by name.

16. Virginia Woolf, *Collected Essays*, vol. 1 (London: Hogarth Press, 1966), 324. For more on Woolf's connections to Fry's formalism, see chapter 6. V. Woolf is quoted in Clive Bell, "The English Group," in The Second Post Impressionist Exhibition (London: Ballantyne, 1912; reprint, Bullen), 349.

17. Leonard Woolf, *Beginning Again: An Autobiography of the Years 1911–1918* (London: Hogarth Press, 1963), 36–37. Vanessa Bell's unpublished memoir is quoted in Judith Collins, *The Omega Workshops* (Chicago: University of Chicago Press, 1984), 8.

18. Fry quoted in Quentin Bell, *Roger Fry* (Leeds: Leeds University Press, 1964), 5.

19. C. Bell, *Art* (New York: Frederick A. Stokes, 1914), 6.

20. C. Bell, *Since Cézanne* (London: Chatto & Windus 1922), 155.

21. Benjamin Buchloh, "Since Realism There Was . . . (On the current conditions of factographic art)," in *Art and Ideology* (New York: New Museum of Contem-

porary Art, 1984; reprinted in *Postmodern Perspectives: Issues in Contemporary Art*, edited by Howard Risatti, [Englewood, N.J.: Prentice Hall, 1990], 92–93).

22. This analysis appears earlier in a lecture Fry prepared to accompany an exhibition, *The New Movement in Art*, which he helped organize in 1917. Scribbled notes for the lecture, titled "Applied Art and the New Movement," are among Fry's papers at the King's College Library, Cambridge University. Here Fry wrote:

> Now the cultured have had leisure and time to acquire a knowledge of and familiarity with the art of all periods, and this knowledge is a social asset. So that to *know* the difference between Louis XV and Louis XVI furniture is one of the easily distinguished marks of a lady or gentleman—even more so in America than here. . . . This kind of archeological pedantry has become of the utmost social value, and the great advantage of this sensibility [to pure form] is [that] though it can be cultivated [it] is a grace—a grace that one's sculley may have in greater degree than oneself. . . . Hence the violent opposition to all creative ideas of the cultured classes.

23. Raymond Williams, "The Significance of 'Bloomsbury' as a Social and Cultural Group," in *Keynes and the Bloomsbury Group: The Fourth Keynes Seminar held at the University of Kent at Canterbury, 1978*, edited by Derek Crabtree and A. P. Thirlwall, (New York: Holmes & Meier, 1978), 40–67.

EXPRESSION AND
REPRESENTATION IN THE
GRAPHIC ARTS

YOUR secretary in writing to me about my paper asked me to put my conclusions as far as possible in metaphysical terms. I replied that I would do my best. Now I know quite a number of terms used by metaphysicians, I am familiar with quite a large vocabulary, my only difficulty is that I do not know what the terms mean, and this I have found an almost insuperable difficulty in my endeavour to comply with your secretary's very natural request. I am willing to plead to a quite exceptional pusillanimity in being thus deterred by an obstacle which I know many writers have overcome, but the fact is I have had exceptional opportunities for discovering my own incapacity for metaphysical thought. For I have known intimately several metaphysicians and have been compelled frequently to join in their discussions, and therefore I think that if I had had any dispositions for metaphysical thought they must have been elicited by such a process. I am afraid that my attitude to aesthetics is essentially a practical and empirical one. I go about the world continually looking at works of art, endeavouring to train myself to appreciate them and using the faculty of appreciation thus developed to test their relative values. In carrying out this work of comparison I find myself obliged from time to time to sum up my results in a theory of aesthetic which I always regard as provisional and of the nature of a scientific hypothesis, to be held until some new phenomenon arises which demands that the terms of the theory shall be revised so as to include it. It is only such a purely inductive aesthetic that I can offer you tonight. Perhaps you will be able to show me what metaphysical forms can be given to my results or in what way they must be corrected to suit metaphysical accuracy of statement.

As a point of departure—quite immediate and indignant departure—let me take a definition of the art of painting which occurs in a book on that subject by the Hon. John Collier R.A. "The art of painting," says that gentleman, "is the art of imitating solid objects upon a flat surface by means of pigments." There one has the imitative theory in all its naked simplicity. It is

Unpublished lecture, written in 1908, made available by the Fry Estate from the Roger Fry Papers, King's College Library, Cambridge.

the theory unconsciously held and rigourously applied by nine-tenths of the public who annually crowd the rooms of Burlington House to enjoy the works of the Hon. John Collier and his esteemed colleagues. But it has of course a respectable antiquity, indeed quite a surprising list not only of artists but of art critics might be made whose expressions indicate a tacit assumption that the representation of natural objects is the aim of the graphic arts. It is implied in Plato's condemnation of graphic arts, Pliny's criticisms are as a rule based on it. Though in one or two passages he shows that other views of the nature of art were current in his day, though he himself apparently did not understand them. Coming down to Vasari and all the criticism of the Renaissance we find constantly recurring such phrases in praise of a work of art that it seemed not to be art but nature itself. While even vulgar deceptions and trompe l'oeils are cited as proof of an artist's power. Even today you will find artists as distinguished as Rodin lending colour to this theory by saying that nature exceeds in beauty all they can attempt. It was Rodin who said of a beautiful Greek statue, "C'est aussi déconcertant que la nature" [It is as startling as nature itself].

Indeed I suppose that most artists today if asked what their art consisted in would reply that they endeavoured to imitate nature but would admit that some unconscious processes took place which modified this imitation.

It may seem then in the face of such an ancient tradition of criticism with regard to graphic art and so widespread a preconception not only in the general public but among those who occupy themselves with it—it may seem rash to say that the *aim* of the graphic arts is entirely unconcerned with the appearances of nature and that what we call beauty in nature is entirely distinct from what we call beauty in art, and yet to such conclusions I believe one is inevitably driven by the induction method of studying art, which I have described.

In the first place one would find it hard to accept a theory of graphic art which isolated it so completely from the other arts, since in no other art could the imitation of nature be proposed as the end pursued. Secondly one is made suspicious of the imitative theory by the relative amount of pleasure given by the original and the imitation. The pleasure given by a picture may very roughly be measured by its price. And where we find that we can buy a saucepan for two shillings and that an imitation of that saucepan on a flat surface by means of pigment when done by one Chardin would cost us more than two hundred pounds—when we reflect too that Chardin's saucepan, like the imitative theory itself, will not hold water—we are forced to wonder whether some quite new element has not entered in to bring about this surprising difference in value set upon the two objects. It is evident that there

is some great pleasure to be got from the contemplation of Chardin's saucepan which we cannot derive from the most prolonged contemplation of the saucepans which adorn our own kitchens. Nor can it be maintained that this new element for which we pay so much, this added source of pleasure is the mere dexterity of the counterfeit because [*crossed out:* many more striking and surprising feats of dexterity may be] this is infinitely less apparent in good than in mediocre art.

Then again we find that no test of accuracy in the imitation of the appearances of nature will ever suffice to distinguish between what we find to be great works of art and inferior ones. Take as an example the rules of perspective. The appearances of nature always present themselves to our eyes according to these laws and no imitation of nature can be considered as approximately accurate unless these laws are observed, yet we find that laws of perspective adequately observed in the illustrations in our halfpenny journals which are scarcely works of art at all, and we find them almost entirely ignored in some of the greatest masterpieces of painting.

Similarly it used to be assumed that correctness of anatomical structure in the rendering of the human figure might supply a canon for the acceptance or rejection of works of art. Yet here again a dispassionate enquiry would reduce the principle to absurdity by allowing Sir Frederick Leighton to pass the test and excluding Botticelli, Ingres, and Michelangelo.

And so on I believe in turn with every test of accuracy one can apply. So much so that one might say without any desire for paradox that no good drawing could possibly be a correct one and vice versa no correct drawing good.

Discarding then the imitative theory of art as inadequate to the facts let us take a quite different point of view. It is propounded by an artist whose work is described loosely as realistic and yet it cuts at the roots of the imitative hypothesis. I allude to Tolstoi's "What Is Art?" The purport of that book is to show that what we call beauty is a thing altogether adventitious to art—something accidentally attached to art owing to the fact that the Greeks were at once great artists and inordinately addicted to beauty, a combination which appears to arouse no suspicion of causal connection in Tolstoi's mind. He proceeds then to give his own view of art, which is that art is the means of communicating emotion from one human being to another. That it is in short nothing but the language of emotion, as opposed to science which is the language of intellect. He gives an instance. If, he says, a boy is chased in the forest by a bear and escapes and comes to his village and says, "I was chased by a bear and escaped," that is a mere scientific statement of fact. But as he describes the shock of the sudden appearance of the bear, his terror at

its ferocious approach, and the alternations of fear and hope as he fled, so as to arouse similar emotions in his hearers' breasts, that is already art. He has communicated his emotions. Starting from this, Tolstoi sets up an evaluation of works of art based entirely upon the values for life of the emotions communicated. The results are almost grotesquely perverse. If I remember right he approves in modern art only of such picture as might be supposed to arouse emotions leading to active philanthropy and praises particularly the pictures of a Mr. Kennedy who made a speciality of "doing" orphan street boys taking shelter upon the doorsteps of [*crossed out:* rich men's] houses in Cromwell Road.

But perverse as Tolstoi's results are I believe he came near to the truth. Let us return for a moment to the boy who escaped from the bear. If the object of his communication of his emotions was, as likely enough it would be, to arouse the villagers to go out at once and shoot the bear then his harangue while it used the methods of art was not in itself pure art, but if in after years in order to distract and amuse his family of a winter's evening he told over again the story of his adventure, or better still, if he invented the whole episode for the same purpose then his story would be a pure work of art. For it will be found, I believe, that the essence of art is that the emotions aroused do not at once translate themselves into action, but are, as it were, dammed up and allowed to stagnate.[1] Art is of the nature of play and is its own justification.[2]

And herein I suppose lies one explanation of the ugliness of advertisements. Were they pure works of art they would be ends in themselves and would not prick and spur us on as they are intended to do to the action of purchase. We should rest satisfied in the contemplation of their beauty and do nothing.

Art then is in this sense at least definitely non-moral and Tolstoi's great mistake was the attempt to drag it forcibly into the moral atmosphere of life.

Now let us see whether with the correction I have suggested Tolstoi's depiction of art is not a fruitful one. "Art is a means of communicating emotions regarded as ends in themselves."

I believe that this definition will explain a great many apparent inconsis-

1. A note, not in Fry's handwriting, is appended to the text of this essay. It reads:
 Surely *stagnate* strikes a wrong note. "Accumulate while they repose"?
 "intellectualize"
 "strain themselves clear"
 I know stagnate is what you mean but all its suggestions are wrote [error for "wrong"]. Art is *less* stagnant than nature.
2. In *Vision and Design*, Fry changed the justification of art as a sphere outside morals from "play" to spirituality through a comparison to religion (21–22).

tencies in art, a great many difficulties insuperable to other modes of approach. It was always customary, for instance, in the older aesthetic when once men had passed beyond the stage of a crudely imitative theory to approach the explanation of art from the point of view of beauty. Fixing their attention almost exclusively on a rather dull academic period of Greco-Roman figure art, the older critics arrived at the idea of a beautiful type distilled, as it were, from innumerable actual examples, each of which diverged from the beautiful norm in some way. Meanwhile they failed to notice how important a part the ugly played in art, what great artists, what whole periods and schools of great art were entirely innocent of any desire for this normal and typical beauty, and were devoting themselves instead to cultivating the characteristic even to the verge and beyond of the grotesque.

With our wider outlook the whole type theory of beauty as stated for instance by Sir Joshua Reynolds has broken down, though we can still explain I believe why types are valuable organs of artistic expression. Our definition will I believe account for the preoccupation of artists both with beauty and with ugliness. Is it unfortunate that the word beauty has to serve for two ideas which are not by any means identical. We say that a thing is beautiful when we pass upon it a favourable aesthetic judgement. This is one sense. But we also use the word beauty in a number of vague senses to imply fitness for purpose, formal regularity, or sensuous charm. It is I think doubtful whether, [in] any of the ordinary cases in which we use the word beautiful of things or persons in actual life, a definite aesthetic judgement is implied and consequently whether beauty, as applied say to a woman or a horse, has more than a distant analogy to *beauty* as applied to a picture by Rembrandt.

Beauty then in the one sense that of aesthetic approval is essential to all works of art. Beauty, in the sense of sensuous charm, is likely to occur largely since, as we have seen, the emotions communicated by the work of art are regarded as ends in themselves. They must therefore be in their whole effect pleasurable, and among emotions which are pleasurable those which refer to sensuous charm are likely to find a large place. Particularly will this be so with artists whose mode of expression being through visual images will be apt to possess a peculiar sensibility to those emotions. But it is most important to remember that this beauty is merely ancillary and incidental and that whenever the pursuit of it interferes with expression of the central emotional idea the great artist will abandon it without hesitation.

This sensuous charm is of two kinds in the work according as it belongs to the imagery used by the artist or to the material in which that imagery is presented. Sensuous charm of the first kind is so frequent in art that one need scarcely adduce instances, but I think it may safely be said that it is

always more sought after by the public than the artist, and thus its appeal is rarely consistent with the highest modes of aesthetic beauty. Still a Capitoline Venus, an Antinous, a Sistine Madonna suffice to prove that beauty in this sense is one of the great organs of expression of aesthetic beauty, while on the other hand the gargoyles of Notre Dame, nearly all Rembrandt's and Velasquez's portraits, and nearly all Oriental art will prove how entirely absent its appeal may be from works of high aesthetic beauty.

The other kind of sensuous beauty, that of the material in which the image is revealed, is one to which the public pays scarcely any conscious attention, though undoubtedly they respond unconsciously to is influence. It is, however, a more constant accompaniment of the aesthetic appeal than the first kind of sensuous charm, and it would be hard to find any example of a great work of art in which it was entirely neglected. It is hardly necessary to give an example, but perhaps certain early Chinese paintings would give us the contrast between the two kinds of beauty we are discussing as well as anything: Imagine then a painting of a demon in which everything that is antipathetic, repulsive, or terrible in animal nature is combined with subtle skill, which has the bloated surface of a toad, the venom of a snake, the grossness of a hog, the mean ferocity of a wolf. Such a compound image would be as far removed as possible from all that has sensuous charm in actual life, and yet in the hands of an Oriental artist it might attain to the very highest limits of sensuous charm in the manner of its representation. The silk on which he paints will have been chosen for the perfection of its fibre and its weft, his colours will be laid upon it so as to have, here the texture of the petals of the Camellia, there the translucence of a gem, and finally its charm may be heightened by all that centuries of tradition have taught the craftsman of the beauty inherent in burnished and lacquered gold.[3]

It is in early art especially, and most of all in religious art, that this quality of the sensuous charm of the material reaches its highest perfection. In the history of any period of artistic development it tends always to be more and more replaced by other aspects of beauty, by an intensified appeal of the emotions [*crossed out:* or by a simple decorative unity] through completer realization of the imagery.

All this sensuous beauty of the material which occupies so large a part of the artist's thoughts, and to which in proportion as he is deeply moved he devotes his most concentrated and patient labour, all this research for mate-

3. Fry's enthusiasm for Asian art draws on the work of his friend Laurence Binyon; see his *Painting in the Far East* (London: E. Arnold, 1908).

rial excellence is explained by our definition for the moment that the emotions to be conveyed are regarded as ends in themselves; the artist will seek to give them any recommendation of which material beauty in the medium of expression is capable.

If it is possible to account for beauty in the work of art by our definition, that definition has also the advantage already hinted at that it freely admits ugliness as a part of aesthetic beauty. Since, as we have seen, the work of art must in its totality be pleasurable, beauty may be admitted for its own sake. Ugliness on the contrary will not be admitted for its own sake, but only as allowing of the expression of an emotion so intense and pleasurable that we accept without demur the painfulness inherent in the ugly image. Ugliness, like a discord in music, will have to be resolved in any perfect work of art. But inasmuch as our most poignant emotions are connected with the struggle of life, the cruelty and indifference of fate, and the contrasting warmth and consolation of human sympathy, and inasmuch as all these forces of life tend to produce distortions from formal regularity, ugliness is a method of appeal to the emotions which is likely to be used by the artists who penetrate deepest into the human heart.

It is with regard to the problem of the ugly and painful in art that I feel most the need of metaphysical aptitude to explore the relations of art to other parts of our human experience, because it seems to me to indicate the kind of lines on which a solution of the discords of experience might be anticipated. For in our aesthetic experience evil becomes actually transmuted into a good. It is the very force of our terror and repulsion that the great tragic artists use to arouse the highest, most poignant satisfaction of which the imagination is capable. So that I surmise that Robert Bridges' phrase, "This world is unto God a work of art," expresses the highest possible of our optimistic aspirations.

It will be seen that our definition of the work of art leaves the artist's attitude to nature entirely undefined. The extent to which he follows or contravenes the laws of natural appearances will be explained entirely by the mode of his appeal to our emotions. It will simply depend upon where he finds his leverage upon our emotions whether he accepts the most complete realization possible or expresses himself by means of abstract or entirely unreal forms. Our definition implies no confusion either way and thus enables us to include all the infinite diversities of artistic practice in this respect. Thus seen, the laws of natural appearance cease to be what they have been supposed to be in the past, laws of artistic practice; they become organs of artistic expression where adoption or rejection is to be decided entirely by the end which the artist proposes to himself.

Take for instance the laws of linear perspective. The artist has, or ought to have, the choice of accepting or rejecting them. If he accepts them, his disposition of his figures and their relation to their background is determined by the conditions of actual three dimensional space. These conditions may interfere with the expression of important ideas. They hinder in particular narrative painting, where the sequence of events is most fittingly symbolized by sequence in the composition, or they may make unduly difficult the proper isolation and prominence of the protagonists in a dramatic event. On the other hand, perspective may be used as a powerful organ of emotional expression, by it the artist can give a sense of towering height above the spectator, of impending menace, or of infinite distance away from him which may arouse emotions of awe and wonder.

Similarly with the laws of light and shade. Our recognition of the forms of objects is of course due to their obstruction of light, so that light and shade is an essential of any approach to correct representation. But for many emotional effects it is essential that the contrast between the lightened and shaded side of an object should be suppressed. While on the other hand the mere alternations of light and shade have a peculiarly powerful effect upon the spirit, so that for certain effects it will be necessary immensely to exaggerate the actual appearance of light and shade, to treat it as itself an object of representation rather than as a mere means of revealing form. In this case, it would not be difficult to classify the various psychological conditions to which these various modes apply. Thus in hieratic art, light and shade is almost inevitably suppressed as being too poignant and too agitating to the mind, while in certain kinds of dramatic art it becomes the main organ of expression.

This result of our definition I think is of real importance for its effect upon our attitude in criticizing works of art. When once we regard the greater or less life-likeness of the image, the greater or less naturalism of the figures, as merely a question of mechanism, to be judged entirely according as it serves its purpose well or ill, we are relieved from that tyrannous obsession of the idea of progress in art. It is this idea which has made so many critics speak apologetically of all primitive art as something incomplete in itself and only admirable as a foretaste and adumbration of greater triumphs achieved by later masters. Whereas in truth such primitive art does in the hands of great masters supply a medium for the expression of the highest [*crossed out:* imaginative] emotional content. The gradual acquisition of the science of complete representation does not, from the point of view of our definition, imply necessarily any fuller attainment of the end of art; it only supplies a richer means of expression. But with each such enrichment, there follows

increased restriction and a certain compensating loss of power of the earlier modes, e.g., light and shade.

To take an example, you cannot impose full chiaroscuro without losing much of the expressional value of the contour. And it would I think be a mistake to assume that the richest language was necessarily the most forcible or adapted to conveying the highest ideas. The artist's attitude to nature, then, is that he uses it for communicating emotions. And, moreover, in doing this he draws upon the conditions of our [crossed out: physical] situation in the universe, upon the condition of our physical being, to arouse emotions which are normally dormant. We have in ordinary life but little emotion about the force of gravity or about mass. The artist continually evokes our latent perception of these things, and enables us to grasp their imaginative significance. Similarly, he evokes emotions about spacial relations [crossed out: sex instincts,] and social instincts. As for instance when he arouses in us a sense of the kingliness of a king that we might scarcely get from an interview with any reigning monarch.

We must now consider the question of the unity of a work of art in relation to our definition. That works of art have as a common property a certain unity has of course been noticed from the very earliest days of criticism, and a great deal has been discovered about the way in which this unity is brought about by the analysis of great works of art. There are many tests, all of them more or less difficult of application, for discovering the value of a work of art. And by no means the worst is that of the richness of its content combined with the completeness of the unification of that content.

We might I think have deduced the necessity of unity in a work of art from our definition, though I doubt if it could be deduced from Tolstoi's, since it depends upon our amendment that the emotions be regarded as ends in themselves. We have seen that implies that the total effect of the communication should be pleasurable. Now any presentment in which unity was obviously lacking would prevent that sense of finality, that self-contained repose which [is] necessary [crossed out: if we are to regard the emotions aroused as an end in themselves] to pleasurable contemplation. Any apparent lack of unity will at once stir the mind to an undesirable activity, the activity of seeking in the world outside the work of art for the missing and complementary elements.

Indeed I rather think that impure works of art, problem plays, novels with a purpose, and rhetorical appeals do in proportion as they are successful fail to perfect artistic unity. In the graphic arts, this unity may be regarded as of two kinds. There is the unity of emotion communicated since if the artist desires to arouse any emotional intensity he will be careful not to confuse or

lessen his effect by introducing conflicting or divergent emotion at the same time. This is the mood or *stimmung* of the work of art, which is unmistakable in all great works of art.

Secondly there is the unity in the mode of presentment, that which for want of a better word I will call the *decorative unity* of the picture, and though these two kinds of unity become inextricably interwoven in the texture of a work of art and are largely dependent upon one another, they can yet be regarded as at least separate aspects of the unity of the work of art. I can explain myself as regards graphic art by a very simple experiment. The purely decorative unity is that which is perceived when the picture is seen upside down, when the imagery by which the emotions are conveyed is not yet grasped and only the directly sensuous appeal is apparent. This unity belongs then in part to that general atmosphere of sensuous charm by which the artist seems to recommend and enforce his emotional message. But it belongs also to the nature of the emotional communication itself, and for different moods different methods of constructing the unity are employed. Thus for the expression of hieratic solemnity the unity will be arrived at by symmetry—for conveying the intensity of a dramatic conflict by the sublime balance of two opposed poles, for giving the mood of lyrical exuberance by a pattern of intricate sinuosity and so forth. Thus we find that much that is usually classed as merely decorative in aim is in reality profoundly expressive of the emotional content.

An elaborate system of what we may call aesthetic dynamics has been evolved recently by Dr. Denman Ross of Harvard,[4] explaining the principles upon which unity is attained in works of graphic art, and his theory of pure design is a most important contribution to aesthetics, but he has studied it from the point of view of purely sensuous satisfaction, while I wish to insist that the unity created by the artist is coloured throughout by the emotional values attached to every element of the design. While I am discussing unity I should like to propound a view which has not I fear any direct connection with the title of this paper, but which I may treat as a footnote to the theory of unity.

The question has long puzzled me as to whether *composition*, the general disposition of masses so as to produce unity, depended on the same aesthetic principles as *drawing*. Whether the pleasure derived from a drawing was not of the same kind, the perception of congruity of minute parts, as the pleasure derived from the whole work of art, the perception of congruity in

4. Denman Ross, *A Theory of Pure Design: Harmony Balance Rhythm* (Boston: Houghton, Mifflin, 1907). Fry visited Ross in Boston in 1905, and the following year they met in New York.

the main divisions. I have until lately, while feeling them to be distinct, failed to find more than one principle involved. Now it appears to me that they are distinct, that there are two kinds of perception of unity involved in our appreciation of a picture, which I will call *immediate* and *successive*. When we look at a picture as a whole we perceive its unity immediately. The eye grasps at once the relations of each division to the whole interwoven pattern of forms. It is the possession, or rather the predominance of the immediate unity which distinguishes the graphic arts. In poetry for instance and music, it is only at the end of the performance or in retrospect that we get a glimpse of such an immediate and instantaneous unity. In these arts we are for the most part occupied by a perception of successive unity. We perceive, that is, at each moment the congruity of each word or note with what has preceded it and at the same time we are led to anticipate the next.

I believe that after all this kind of unity counts also for much in graphic art, and that when we admire a drawing our eye passes along the line appreciating at each point the perfect relation of each element in the curve to what preceded and to what follows it.

In this way, we may explain the fact . . . [Here the text ends.]

THE LAST PHASE OF
IMPRESSIONISM

To the Editor of The Burlington Magazine

Sir,—

A S A CONSTANT reader and frequent admirer of your editorials on matters of art I should like to enter a protest against a tendency, which I have noticed, to treat modern art in a less serious and sympathetic spirit than that which you adopt towards the work of the older masters. This tendency I find particularly marked in an article with the above heading. The movement which is there condemned, not without a certain complacency which to me savours of Pharisaism, is one that surely merits more sympathetic study. Whatever we may think of its aims, it is the work of perfectly serious and capable artists. There is, so far as I can see, no reason to doubt the genuineness of their conviction nor their technical efficiency. Moreover in your condemnation you have, I think, hit upon an unfortunate parallel. You liken the pure Impressionists, of whom we may take Monet as a type, to the naturalists of the fifteenth century in Italy, and these Neo-Impressionists to the "now-forgotten Flemish and Italian eclectics." Now the eclectic school did not follow on the school of naturalism; there intervened first the great classic masters who used the materials of naturalism for the production of works marked by an intense feeling for style, and second, the Mannerists, in whom the styles of particular masters were exaggerated and caricatured. The eclectics set themselves the task of modifying this exaggeration by imbibing doses of all the different manners.

Now these Neo-Impressionists follow straight upon the heels of the true Impressionists. There has intervened no period of great and then of exaggerated stylistic art. Nor has Impressionism any true analogy with naturalism, since the naturalism of the fifteenth century was concerned with form, and Impressionism with that aspect of appearance in which separate forms are lost in the whole continuum of sensation.

There is, I believe, a much truer analogy which might lead to a different

This letter to the editor is reprinted from *The Burlington Magazine*, March 1908, 374–75.

judgment. Impressionism has existed before, in the Roman art of the Empire, and it too was followed, as I believe inevitably, by a movement similar to that observable in the Neo-Impressionists—we may call it for convenience Byzantinism. In the mosaics of Sta Maria Maggiore as elucidated by Richter and Taylor ("The Golden Age of Classic Christian Art") one can see something of this transformation from Impressionism in the original work to Byzantinism in subsequent restorations. It is probably a mistake to suppose, as is usually done, that Byzantinism was due to a loss of the technical ability to be realistic, consequent upon barbarian invasions. In the Eastern Empire there was never any loss of technical skill; indeed, nothing could surpass the perfection of some Byzantine craftsmanship. Byzantinism was the necessary outcome of Impressionism, a necessary and inevitable reaction from it.

Impressionism accepts the totality of appearances and shows how to render that; but thus to say everything amounts to saying nothing—there is left no power to express the personal attitude and emotional conviction. The organs of expression—line, mass, colour—have become so fused together, so lost in the flux of appearance, that they cease to deliver any intelligible message, and the next step that is taken must be to re-assert these. The first thing the Neo-Impressionist must do is to recover the long obliterated contour and to fill it with simple undifferentiated masses.

I should like to consider in this light some of the most characteristic painters of this movement. Of these M. Signac is the only one to whom the title Neo-Impressionist properly applies. Here is a man feeling in a vague, unconscious way a dissatisfaction at the total licence of Impressionism, and he deliberately invents for himself a restraining formula—that of rectangular blobs of paint. He puts himself deliberately where more fortunate circumstances placed the mosaic artist, and then he lets himself go as far in the direction of realistic Impressionism as his formula will allow. I do not defend this, in spite of the subtle powers of observation and the ingenuity which M. Signac displays, because I do not think it is ever worth while to imitate in one medium the effects of another, but his case is interesting as a tribute to the need of the artist to recover some constraint: to escape, at whatever cost, from the anarchic licence of Impressionism.

Two other artists, MM. Cézanne and Paul Gauguin, are not really Impressionists at all. They are proto-Byzantines rather than Neo-Impressionists. They have already attained to the contour, and assert its value with keen emphasis. They fill the contour with wilfully simplified and unmodulated masses, and rely for their whole effect upon a well-considered co-ordination of the simplest elements. There is no need for me to praise Cézanne—his position is already assured—but if one compares his still-life

in the International Exhibition with Monet's, I think it will be admitted that it marks a great advance in intellectual content. It leaves far less to the casual dictation of natural appearance. The relations of every tone and colour are deliberately chosen and stated in unmistakable terms. In the placing of objects, in the relation of one form to another, in the values of colour which indicate mass, and in the purely decorative elements of design, Cézanne's work seems to me to betray a finer, more scrupulous artistic sense.

In Gauguin's work you admit that "some trace of design and some feeling for the decorative arrangement of colour may still be found," but I cannot think that the author of so severely grandiose, so strict a design as the *Femmes Maories* or of so splendidly symbolic a decoration as the *Te Arii Vahiné* deserves the fate of so contemptuous a recognition. Here is an artist of striking talent who, in spite of occasional *boutades*, has seriously set himself to rediscover some of the essential elements of design without throwing away what his immediate predecessors had taught him.

And herein lies a great distinction between French and English art. (I am speaking only of the serious art in either case), namely, that the French artist never quite loses hold of the thread of tradition. However vehement his pursuit of new aims, he takes over what his predecessors have handed to him as part of the material of his new formula, whereas we in England, with our ingrained habits of Protestantism and non-conformity; the moment we find ourselves out of sympathy with our immediate past, go off at a tangent, or revert to some imagined pristine purity.

The difference is one upon which we need not altogether flatter ourselves; for the result is that French art has a certain continuity and that at each point the artist is working with some surely ascertained and clearly grasped principles. Thus Cézanne and Gauguin, even though they have disentangled the simplest elements of design from the complex of Impressionism, are not archaizers; and the flaw in all archaism is, I take it, that it endeavours to attain results by methods which it can only guess at, and of which it has no practical and immediate experience.

Two other artists seen at the International deserve consideration in this connexion: Maurice Denis and Simon Bussy. Against the former it might be possible to bring the charge of archaism, but he, too, has taken over the colour-schemes of the Impressionists, and in his design shows how much he has learned from Puvis de Chavannes. His pictures here are not perhaps the most satisfactory examples of his art, but any one who has observed his work during the past five years will recognize how spontaneous is his sense of the significance of gesture: how fresh and genuine his decorative invention.

M. Bussy is well known already in England for his singularly poetical

interpretation of landscape, and though at first sight his picture at the International may strike one as a wilful caprice, a little consideration shows, I think, that he has endeavoured to express, by odd means perhaps, but those which appeal to him, a sincerely felt poetical mood, and that the painting shows throughout a perfectly conscientious and deliberate artistic purpose. Here again the discoveries of Impressionism are taken over, but applied with quite a new feeling for their imaginative appeal.

I do not wish for a moment to make out that the works I have named are great masterpieces, or that the artists who executed them are possessed of great genius. What I do want to protest against is the facile assumption that an attitude to art which is strange, as all new attitudes are at first, is the result of wilful mystification and caprice on the artists' part. It was thus that we greeted the now classic Whistler; it was thus that we expressed ourselves towards Monet, who is already canonized in order to damn the "Neo-Impressionists." Much as I admire Monet's directness and honesty of purpose, I confess that I see greater possibilities of the expression of imaginative truth in the tradition which his successors are creating.

I am, Sir, etc.,

ROGER E. FRY

INTRODUCTORY NOTE TO
MAURICE DENIS, "CÉZANNE"

ANYONE who has had the opportunity of observing modern French art cannot fail to be struck by the new tendencies that have become manifest in the last few years. A new ambition, a new conception of the purpose and methods of painting, are gradually emerging; a new hope too, and a new courage to attempt in painting that direct expression of imagined states of consciousness which has for long been relegated to music and poetry. This new conception of art, in which the decorative elements preponderate at the expense of the representative, is not the outcome of any conscious archaistic endeavour, such as made, and perhaps inevitably marred, our own pre-Raphaelite movement. It has in it therefore the promise of a larger and a fuller life. It is, I believe, the direct outcome of the Impressionist movement. It was among Impressionists that it took its rise, and yet it implies the direct contrary of the Impressionist conception of art.

It is generally admitted that the great and original genius—for recent criticism has the courage to acclaim him as such—who really started this movement, the most promising and fruitful of modern times, was Cézanne. Readers of the *Burlington Magazine* may therefore be interested to hear what one of the ablest exponents in design of the new idea has to say upon the subject. M. Maurice Denis has kindly consented to allow his masterly and judicious appreciation of Cézanne which appeared in *L'Occident,* Sept. 1907, to be translated for the benefit of a wider circle of English readers than has been reached by that paper. Feeling, as he did, that he had expressed himself therein once and for all, he preferred this to treating the subject afresh for the *Burlington Magazine.*

The original article was unillustrated, but seeing how few opportunities English readers have for the study of Cézanne's works, especially of his figure pieces, it has been thought well to include here some typical examples, excluding the better known landscapes and fruit pieces. It is possible that some who have seen only examples of Cézanne's landscapes may have been misled

Reprinted from Maurice Denis, "Cézanne—I," translated by Roger Fry, *The Burlington Magazine,* January 1910, 207–8.

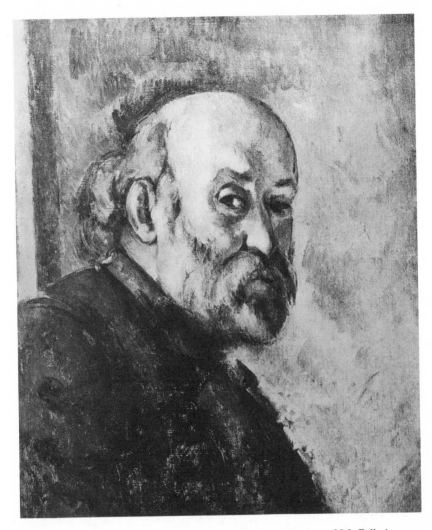

PLATE I: *Portrait of the Artist,* by Cézanne. In the collection of M. Pellerin

by the extreme brevity of his synthesis into mistrusting his powers of realiz-
ing a complete impression; they will be convinced, I believe, even in the
reproduction by Cézanne's amazing portrait of himself, Plate I. Before this
supremely synthetic statement of the essentials of character one inevitably
turns for comparison to Rembrandt. In Plate II, fig. 2, the *Portrait of a
Woman,* we get an interesting light upon the sources of Cézanne's inspiration.
One version of the El Greco which inspired this will be familiar to our
readers from its appearance at the National Loan Exhibition. M. Maurice

PLATE II, fig. 1: *L'Enfant au foulard blanc,* by Cézanne. In the collection of M. Tabbri

Denis discusses at length the position of El Greco in the composition of Cézanne's art. One point of interest, however, seems to have escaped him. Was it not rather El Greco's earliest training in the lingering Byzantine tradition that suggested to him his mode of escape into an art of direct decorative expression? and is not Cézanne after all these centuries the first to take up the hint El Greco threw out? The "robust art of a Zurbaran and a Velazquez" really passed over this hint. The time had not come to re-establish a system of purely decorative expression; the alternative representational idea of art was not yet worked out, though Velazquez perhaps was destined more than any other to show its ultimate range.

Plate II, fig. 1, *L'enfant au foulard blanc,* is another example of Cézanne's

PLATE II, fig. 2: *Woman with a Boa* [Portrait of a Woman], by Cézanne. In the collection of M. Bernheim Jeune

astonishing power of synthetic statement. The remaining illustrations, *The Bathers* and *The Satyrs*, Plate III, figs. 1 and 2, show Cézanne in his more lyrical and romantic mood. He here takes the old traditional material of the nude related to landscape, the material which it might seem that Titian had exhausted, if Rubens had not found a fresh possibility therein. Rubens at all events seemed to have done all that was conceivable, so that Manet only saw his way to using the theme by a complete change of the emotional pitch. But here Cézanne, keeping quite closely within the limits established by the older masters, gives it an altogether new and effective value. He builds up a more compact unity by his calculated emphasis on rhythmic balance of directions.

PLATE III, fig. 1: *The Bathers,* by Cézanne. In the collection of M. Bernheim
Jeune; fig. 2: *The Satyrs,* by Cézanne. In the collection of M. Bernheim Jeune

THE POST-IMPRESSIONISTS

T HE pictures collected together in the present Exhibition are the work of a group of artists who cannot be defined by any single term. The term "Synthesists," which has been applied to them by learned criticism, does indeed express a quality underlying their diversity; and it is the principal business of this introduction to expand the meaning of that word, which sounds too like the hiss of an angry gander to be a happy appellation. As a definition it has the drawback that this quality, common to all, is not always the one most impressive in each artist. In no school does individual temperament count for more. In fact, it is the boast of those who believe in this school, that its methods enable the individuality of the artist to find completer self-expression in his work than is possible to those who have committed themselves to representing objects more literally. This, indeed, is the first source of their quarrel with the Impressionists: the Post-Impressionists consider the Impressionists too naturalistic.

Yet their own connection with Impressionism is extremely close; Cézanne, Gauguin, and Van Gogh all learnt in the Impressionist school. There are pictures on the walls by these three artists, painted in their earlier years, which at first strike the eye as being more impressionist than anything else; but, nevertheless, the connection of these artists with the Impressionists is accidental rather than intrinsic.

By the year 1880 the Impressionists had practically won their battle; nor is it likely any group of artists will ever have to fight so hard a one again. They have conquered for future originality, if not the right of a respectful hearing, at least of a dubious attention. By 1880 they had convinced practically everybody whose opinion counted, that their methods and ideas were at any rate those of artists, not those of cranks and charlatans. About this date the reaction against Impressionism, which this Exhibition represents, began to be distinctly felt. The two groups had one characteristic in common: the resolve of each artist to express his own temperament, and never to permit contemporary ideals to dictate to him what was beautiful, significant,

Reprinted from the catalog, *Manet and the Post-Impressionists*, 1910, 7–13.

and worthy to be painted. But the main current of Impressionism lay along the line of recording hitherto unrecognised aspects of objects; they were interested in analysing the play of light and shadow into a multiplicity of distinct colours; they refined upon what was already illusive in nature. In the pictures of Seurat, Cross, and Signac here exhibited, this scientific interest in the representation of colour is still uppermost; what is new in these pictures is simply the method of representing the vibration of light by painting objects in dots and squares. The Post-Impressionists on the other hand were not concerned with recording impressions of colour or light. They were interested in the discoveries of the Impressionists only so far as these discoveries helped them to express emotions which the objects themselves evoked; their attitude towards nature was far more independent, not to say rebellious. It is true that from the earliest times artists have regarded nature as "the mistress of the masters"; but it is only in the nineteenth century that the close imitation of nature, without any conscious modification by the artist, has been proclaimed as a dogma. The Impressionists were artists, and their imitations of appearances were modified, consciously and unconsciously, in the direction of unity and harmony; being artists they were forced to select and arrange. But the receptive, passive attitude towards the appearances of things often hindered them from rendering their real significance. Impressionism encouraged an artist to paint a tree as it appeared to him at the moment under particular circumstances. It insisted so much upon the importance of his rendering this exact impression that his work often completely failed to express a tree at all; as transferred to canvas it was just so much shimmer and colour. The "treeness" of the tree was not rendered at all; all the emotion and associations such as trees may be made to convey in poetry were omitted.

This is the fundamental cause of difference between the Impressionists and the group of painters whose pictures hang on these walls. They said in effect to the Impressionists: "You have explored nature in every direction, and all honour to you; but your methods and principles have hindered artists from exploring and expressing that emotional significance which lies in things, and is the most important subject matter of art. There is much more of that significance in the work of earlier artists who had not a tenth part of your skill in representing appearance. We will aim at that; though by our simplification of nature we shock and disconcert our contemporaries, whose eyes are now accustomed to your revelations, as much as you originally disconcerted your contemporaries by your subtleties and complications." And there is no denying that the work of the Post-Impressionists is sufficiently disconcerting. It may even appear ridiculous to those who do not recall the

fact that a good rocking-horse often has more of the true horse about it than an instantaneous photograph of a Derby winner.

The artists who felt most the restraints which the Impressionist attitude towards nature imposed upon them, naturally looked to the mysterious and isolated figure of Cézanne as their deliverer. Cézanne himself had come in contact with Manet and his art is derived directly from him. Manet, it is true, is also regarded as the father of Impressionism. To him Impressionism owes much of its power, interest, and importance. He was a revolutionary in the sense that he refused to accept the pictorial convention of his time. He went back to seventeenth-century Spain for his inspiration. Instead of accepting the convention of light and shade falling upon objects from the side, he chose what seemed an impossibly difficult method of painting, that of representing them with light falling full upon them. This led to a very great change in the method of modelling, and to a simplification of planes in his pictures which resulted in something closely akin to simple linear designs. He adopted, too, hitherto unknown oppositions of colour. In fact he endeavoured to get rid of chiaroscuro.

Regarded as a hopeless revolutionary, he was naturally drawn to other young artists, who found themselves in the same predicament; and through his connection with them and with Monet he gradually changed his severe, closely constructed style for one in which the shifting, elusive aspects of nature were accentuated. In this way he became one of the Impressionists and in his turn influenced them. Cézanne, however, seized upon precisely that side of Manet which Monet and the other Impressionists ignored. Cézanne, when rendering the novel aspects of nature to which Impressionism was drawing attention, aimed first at a design which should produce the coherent, architectural effect of the masterpieces of primitive art. Because Cézanne thus showed how it was possible to pass from the complexity of the appearance of things to the geometrical simplicity which design demands, his art has appealed enormously to later designers. They recognise in him a guide capable of leading them out of the *cul de sac* into which naturalism had led them. Cézanne himself did not use consciously his new-found method of expression to convey ideas and emotions. He appealed first and foremost to the eye, and to the eye alone. But the path he indicated was followed by two younger artists, Van Gogh and Gauguin, with surprising results. Van Gogh's morbid temperament forced him to express in paint his strongest emotions, and in the methods of Cézanne he found a means of conveying the wildest and strangest visions conceived by any artist of our time. Yet he, too, accepts in the main the general appearance of nature; only before every scene and

every object he searches first for the quality which originally made it appeal so strangely to him: *that* he is determined to record at any sacrifice.

Gauguin is more of a theorist. He felt that while modern art had opened up undiscovered aspects of nature, it had to a great extent neglected the fundamental laws of abstract form, and above all had failed to realise the power which abstract form and colour can exercise over the imagination of the spectator. He deliberately chose, therefore, to become a decorative painter, believing that this was the most direct way of impressing upon the imagination the emotion he wished to perpetuate. In his Tahitian pictures by extreme simplification he endeavoured to bring back into modern painting the significance of gesture and movement characteristic of primitive art.

The followers of these men are pushing their ideas further and further. In the work of Matisse, especially, this search for an abstract harmony of line, for rhythm, has been carried to lengths which often deprive the figure of all appearance of nature. The general effect of his pictures is that of a return to primitive, even perhaps of a return to barbaric, art. This is inevitably disconcerting; but before dismissing such pictures as violently absurd, it is fair to consider the nature of the problem which the artist who would use abstract design as his principle of expression has to face. His relation to a modern public is peculiar. In the earliest ages of art the artist's public were able to share in each successive triumph of his skill, for every advance he made was also an advance towards a more obvious representation of things as they appeared to everybody. Primitive art, like the art of children, consists not so much in an attempt to represent what the eye perceives, as to put a line round a mental conception of the object. Like the work of the primitive artist, the pictures children draw are often extraordinarily expressive. But what delights them is to find they are acquiring more and more skill in producing a deceptive likeness of the object itself. Give them a year of drawing lessons and they will probably produce results which will give the greatest satisfaction to them and their relations; but to the critical eye the original expressiveness will have vanished completely from their work.

The development of primitive art (for here we are dealing with men and not children) is the gradual absorption of each newly observed detail into an already established system of design. Each new detail is hailed with delight by their public. But there comes a point when the accumulations of an increasing skill in mere representation begin to destroy the expressiveness of the design, and then, though a large section of the public continues to applaud, the artist grows uneasy. He begins to try to unload, to simplify the drawing and painting, by which natural objects are evoked, in order to recover the lost expressiveness and life. He aims at *synthesis* in design; that is to

say, he is prepared to subordinate consciously his power of representing the parts of his picture as plausibly as possible, to the expressiveness of his whole design. But in this retrogressive movement he has the public, who have become accustomed to extremely plausible imitations of nature, against him at every step; and what is more, his own self-consciousness hampers him as well.

The movement in art represented in this exhibition is widely spread. Although, with the exception of the Dutchman, Van Gogh, all the artists exhibited are Frenchmen, the school has ceased to be specifically a French one. It has found disciples in Germany, Belgium, Russia, Holland, Sweden. There are Americans, Englishmen, and Scotchmen in Paris who are working and experimenting along the same lines. But the works of the Post-Impressionists are hardly known in England, although so much discussed upon the Continent. The exhibition organised by Mr. Robert Dell at Brighton last year has been our only chance of seeing them. The promoters of this exhibition have therefore thought it would be interesting to provide an opportunity for a greater number to judge these artists. The ladies and gentlemen on the Honorary Committee, though they are not responsible for the choice of the pictures, by lending their names have been kind enough to give this project their general support.

THE GRAFTON GALLERY—I

HAVING been asked to advise on the choice of the pictures and their arrangement in the present exhibition, my remarks on it must be taken rather as explanatory—in the nature of an apologia—than as the expression of entirely independent criticism. The reader, thus duly warned, may discount my judgment to whatever degree he thinks fit. I have been accused of a strange inconsistency in admiring, at one and the same time, the accredited masterpieces of ancient art and the works here collected together, which are supposed to typify the latest and most violent of all the many violent reactions against tradition which modern art has seen. Without being much interested in the question of my own consistency, I believe that it is not difficult to show that the group of painters whose work is on view at the Grafton Gallery are in reality the most traditional of any recent group of artists. That they are in revolt against the photographic vision of the nineteenth century, and even against the tempered realism of the last four hundred years, I freely admit. They represent, indeed, the latest, and, I believe, the most successful, attempt to go behind the too elaborate pictorial apparatus which the Renaissance established in painting. In short, they are true pre-Raphaelites. But whereas previous attempts—notably our own pre-Raphaelite movement—were made with a certain conscious archaism, these artists have, as it were, stumbled upon the principles of primitive design out of a perception of the sheer necessities of the actual situation. At once the question is likely to arise: Why should the artist wantonly throw away all the science with which the Renaissance and the succeeding centuries have endowed mankind? Why should he wilfully return to primitive or, as it is derisively called, barbaric art? The answer is that it is neither wilful nor wanton but simply necessary, if art is to be rescued from the hopeless encumbrance of its own accumulations of science; if art is to regain its power to express emotional ideas, and not to become an appeal to curiosity and wonder at the artist's perilous skill. The fundamental error that is usually made is that progress in art is the same thing as the much more easily measured and estimated

Reprinted from *The Nation*, 19 November 1910, 331–35.

progress in power of representing nature. All our histories of art are tainted with this error, and for the simple reason that progress in representation can be described and taught, whereas progress in art cannot so easily be handled. And so we think of Giotto as a preparation for a Titianesque climax, forgetting that with every piece of representational mechanism which the artist acquired, he both gained new possibilities of expression and lost other possibilities. When you can draw like Tintoretto, you can no longer draw like Giotto, or even like Piero della Francesca. You have lost the power of expression which the bare recital of elementary facts of mass, gesture, and movement gave, and you have gained whatever a more intricate linear system and chiaroscuro may provide in expressive power. But the more complex does not really subsume the simpler: it replaces it by a new unity, in which the old elements of unity are lost sight of. Even if they are there, they are no longer put forward so as to make their full appeal; they are muffled and shrouded in the new elaboration.

Now, modern art had arrived in Impressionism at a point where it could describe everything visible with unparalleled ease and precision, but where, having given to every part of the picture its precise visual value, it was powerless to say anything of human import about the things described. It could not materially alter the visual values of things, because the unity cohered in that and in that alone. To give to the rendering of nature its response to human passion and human need demanded a re-valuation of appearances, not according to pure vision, but according to the pre-established demands of the human senses. It is this re-valuation of the visual that Cézanne started (or, rather, it already began in Manet). He discovered distortions and ruthless simplifications (which are, of course, distortions, too) of natural form, which allowed the fundamental elements of design—the echo of human need—to reappear in his representations. And this has gone on ever since his day in the group of artists we are considering. More and more regardlessly they are cutting away the merely representative element in art to establish more and more firmly the fundamental laws of expressive form in its barest, most abstract elements. Like the Anarchists, with whom they are compared, they are not destructive and negative, but intensely constructive. This does not mean that they will not destroy much that we cling to still. Growth, and not decay, is the real destroyer, and the autumn leaf falls, not because the wind and frost attack it, but because next year's bud has undermined its base. And so if all the accumulated science of representation, all the aids to perspective, all the anatomical diagrams, all the lore about atmospheric values goes, it will, no doubt, be built up again one day, but with passionate zest and enthusiasm, as it was once before; only we to whom it has been transmitted as a corpus of

dead fact, alien to the imagination, must press on to the discovery of that difficult science, the science of expressive design. No artist can profitably use a single fact beyond what his imagination can grasp; every fact that he uses must have been passionately apprehended. We have become so accustomed to accepting masses of dead, undigested facts, facts of observation, and not re-creation, that we must begin at the beginning, and learn once more the ABC of abstract form. And it is just this that these French artists have set about, with that clear, logical intensity of purpose, that absence of all compromise, of all regard for side issues, which has nobly distinguished the French genius.

And there is at least this consolation, if we must surrender that too complex language of complete naturalistic representation, which, to tell the truth, very few artists in all these centuries since the Renaissance have been able quite evidently to master—namely, that the biggest things demand the simplest language, and Cimabue could tell us more of divine, and Giotto more of human, love than Raphael or Rubens.

From another point of view, moreover, the effect of discarding the actual illusion of three-dimensional space—of losing chiaroscuro and atmospheric color—is not without its compensations. I believe that anyone who will look, without preconception, merely at the general effect of the walls of the Grafton Gallery must admit that in no previous exhibition of modern art has the purely decorative quality of painting been more apparent. If only the spectator will look without preconception as to what a picture ought to be and do, will allow his senses to speak to him instead of his common-sense, he will admit that there is a discretion and a harmony of color, a force and completeness of pattern, about these pictures, which creates a general sense of well-being. In fact, these pictures, like the works of the early primitives, and like the masterpieces of Oriental art, do not make holes in the wall, through which another vision is made evident. They form a part of the surface which they decorate, and suggest visions to the imagination, rather than impose them upon the senses.

I should like also to appeal against another misconception of the aim and purposes of art, which often hinders spectators from a true perception of beauty, namely, the idea that the artist takes refuge in certain formulæ merely to avoid trouble, and that he thereby cheats us of his part of the contract.

This is surely importing moral considerations into a field where they do not apply. What, indeed, could be more desirable than that all the world should have the power to express themselves harmoniously and beautifully— in short, that everyone should be an artist. The beauty of the resulting work has nothing to do with the amount of effort it has cost. While no effort is

vain that is needed to produce beauty, it is the beauty, and not the effort, that avails. If by some miracle beauty could be generated without effort, the whole world would be the richer. As a matter of fact, many of the artists whose work is shown at the Grafton have already proved themselves accomplished masters in what is supposed to be the more difficult task of representation. That they have abandoned the advantage which that professional skill affords is surely rather a sign of the sincerity of their effort in another direction. No doubt the acrobatic feats of virtuosity always will appeal to our sense of wonder; but they are better reserved for another stage. If only an artist has genuine conviction, he rarely lacks sufficient skill to give it expression. And as things are at present, with our gaping admiration for professional skill, we are in less danger of finding a prophet whose utterance is spoiled by imperfect articulation than of being drowned beneath floods of uninspired rhetoric.

THE POST-IMPRESSIONISTS—II

IN my first article I tried to urge one or two points of general consideration about the group of painters shown at the Grafton Galleries. I will now try to discuss the artists separately. And first let me admit, in reply to the flamboyant diatribes of those who wish to see me burned together with the pictures which I arranged with such effrontery to insult the British public, that the collection is far from being perfect as an expression of this movement in art. Anyone who has tried to collect so large a body of pictures in a short time will know how many accidental obstacles occur to prevent one's getting just those pictures on which one has most set one's heart, and how often in despair one has to accept a less perfect example of such and such an artist. One kindly critic is quite right in saying that there are too many Gauguins, and that there are Van Gogh's which it would have been most desirable to add. Then again, Matisse, owing to the absence of a well-known collector, is quite inadequately represented, and Picasso should have been seen in bigger and more ambitious works. But at least the exhibition has given an opportunity to the British public to judge of a great movement of which it had hitherto remained in almost total ignorance, and it has given Sir W. B. Richmond the opportunity to express publicly his shame at bearing the designation of artist. That is perhaps even more than one had ventured to hope.

Another confession—the Manets are not, on the whole, good examples, and perhaps establish an unfair comparison with Cézanne. I always admired Cézanne, but since I have had the opportunity to examine his pictures here at leisure, I feel that he is incomparably greater than I had supposed. His work has the baffling mysterious quality of the greatest originators in art. It has that supreme spontaneity as though he had almost made himself the passive, half-conscious instrument of some directing power. So little seems implied at first sight in his apparently accidental collocation of form and color, so much reveals itself gradually to the fascinated gaze. And he was the great genius of the whole movement; he it was who discovered by some

Reprinted from *The Nation*, 3 December 1910, 402–3.

mysterious process the way out of the cul-de-sac into which the pursuit of naturalism *à outrance* had led art. As I understand his art, and I admit it is exceedingly subtle and difficult to analyse—what happened was that Cézanne, inheriting from the Impressionists the general notion of accepting the purely visual patchwork of appearance, concentrated his imagination so intensely upon certain oppositions of tone and color that he became able to build up and, as it were, recreate form from within; and at the same time that he re-created form he re-created it clothed with color, light, and atmosphere all at once. It is this astonishing synthetic power that amazes me in his work. His composition at first sight looks accidental, as though he had sat down before any odd corner of nature and portrayed it; and yet the longer one looks the more satisfactory are the correspondences one discovers, the more certainly felt beneath its subtlety, is the architectural plan; the more absolute, in spite of their astounding novelty, do we find the color harmonies. In a picture like *L'Estaque* it is difficult to know whether one admires more the imaginative grasp which has rebuilt so clearly for the answering mind the splendid structure of the bay, or the intellectualised sensual power which has given to the shimmering atmosphere so definite a value. He sees the face of Nature as though it were cut in some incredibly precious crystalline sub-stance, each of its facets different, yet each dependent on the rest. When Cézanne turns to the human form he becomes, being of a supremely classic temperament, not indeed a deeply psychological painter, but one who seizes individual character in its broad, static outlines. His portrait of his wife has, to my mind, the great monumental quality of early art, of Piero della Francesca or Mantegna. It has that self-contained inner life, that resistance and assurance that belong to a real image, not to a mere reflection of some more insistent reality. Of his still life it is hardly necessary to speak, so wide-spread is the recognition of his supremacy in this. Since Chardin no one has treated the casual things of daily life with such reverent and penetrating imagination, or has found as he has, in the statement of their material quali-ties, a language that passes altogether beyond their actual associations with common use and wont.

If Cézanne is the great classic of our time, Van Gogh represents as com-pletely the romantic temperament. His imagination responds to the call of the wildest adventures of the spirit. Those who have laughed at this great visionary because he became insane, can know but little of the awful adven-tures of the imagination. That Rembrandt saw as far into the heart of pity and yet remained sane is true, but that should rather be imputed to Rembrandt as his supreme greatness and good fortune. To laugh at a less fortunate adventurer is to ignore the perilous equilibrium of such genius, to

forget how rare it is to see God and yet live. To Van Gogh's tortured and morbid sensibility there came revelations fierce, terrible, and yet at times consoling, of realities behind the veil of things seen. Claiming his kinship with Rembrandt, Van Gogh became a portrayer of souls; souls of broken, rugged, ungainly old women like the *Berceuse*, whose greatness yet shines in the tender resignation of her folded hands; souls of girls brutalised by the associations of utter poverty, and yet blazing with an unconscious defiance of fate. And souls of things—the soul of modern industrialism seen in the hard splendor of mid-day sun upon the devouring monsters of a manufacturing suburb; the soul of the wind in the autumn corn, and, above all, the soul of flowers. Surely no one has painted flowers like Van Gogh. We know how deeply Van Gogh's own predecessors of the seventeenth century sinned in their thick-skinned cleverness and self-assurance, using flowers as a kind of animate furniture. But modern European art has almost always maltreated flowers, dealing with them at best but as aids to sentimentality until Van Gogh saw, with a vision that reminds one of Blake's, the arrogant spirit that inhabits the sun-flower, or the proud and delicate soul of the iris. The gibe of insolent egotism was never more misapplied than to so profound, so deeply-enduring a genius as Van Gogh's; for his distortions and exaggerations of the thing seen are only the measure of his deep submission to their essence.

Of Gauguin I find it harder to speak. With him one must make excuses and concessions if one is to be perfectly honest. Of his astonishing talent as a designer, his creation of new possibilities in pattern, and his unrivalled power of complex color harmony, these pictures tell plainly enough, and to that I must add a real sense of nobility and elemental simplicity of gesture, and at times a rare poetic insight. But I do not always feel sure of the inner compulsion towards the particular form he chooses. I cannot shake off an occasional hint of self-consciousness, of the desire to impress and impose; in fact, of a certain rhetorical element. The mere statement of this seems to exaggerate it; perhaps it only means that he is a Parisian, and that certain turns of his whimsical wit strike us as having a tinge of perversity. Yet all this must be unsaid before his greatest designs, before the touching and entirely sincere *Agony in the Garden*, before his *L'Esprit veille*, with its sympathy with primitive instincts of supernatural fear and its astounding physical beauty, before landscapes of such fresh and rare beauty as No. 44a, and perhaps, above all, before his splendid flower-piece, No. 31.

I know that to dismiss Gauguin thus is unfair, but space is wanting to deal with so much new material fully. Henri Matisse is, as I have said, but poorly represented. As I understand him, he is an artist not unlike Manet,

gifted with a quite exceptional sense of pure beauty—beauty of rhythm, of color harmony, of pure design; but at the same time perhaps a little wanting in temperament, without any very strong and personal reaction to life itself, almost too purely and entirely an artist. The *Femme aux yeux verts* strikes me as a more convincing and assured creation every time I see it. To my eye, it appears singularly perfect in design, and at once original and completely successful in the novelty, frankness, and bravery of its color harmony. In his drawings, of which a considerable number are shown, he proves I think, beyond doubt his masterly sense of rhythmic design and the rare beauty of a handwriting which, in its directness and immediacy, reminds one more of Oriental than European draughtsmanship. That the plastic feeling in painting is by no means dependent upon light and shade, but may be aroused quite as surely by line and color, might be guessed indeed from his paintings, but is made evident by the examples of his bronze statuettes. Whatever one may think of his figure, *Le Serf*, as an interpretation, it cannot be denied that it shows a singular mastery of the language of plastic form.

Picasso is strongly contrasted to Matisse in the vehemence and singularity of his temperament. In his etching of *Salome* he proves his technical mastery beyond cavil, but it shows more, a strange and disquieting imaginative power, which comes at times perilously near to the sentimental, without, I think, ever passing the line. Certainly, in the drawing of the *Two Women* one cannot accuse him of such a failing, though its intimacy of feeling is hardly suspected at first beneath the severity of its form. Of late years Picasso's style has undergone a remarkable change, he has become possessed of the strangest passion for geometrical abstraction, and is carrying out hints that are already seen in Cézanne with an almost desperate logical consistency. Signs of this experimental attitude are apparent in the *Portrait of M. Sagot*, but they have not gone far enough to disturb the vivid impression of reality, the humorous and searching interpretation of character.

One or two of the younger artists must just be mentioned here: Othon Friesz appears in the three canvases here shown as inclining towards Impressionism, but he has carried over much that he has learned in his more synthetical designs; his color has an extraordinary gaiety and force, and he shows how much more vivid to the senses and imagination are interpretations of sunlight like these than anything achievable by direct observation.

Vlaminck is a little disconcerting at first sight, by reason of the strangely melancholy harmonies he affects, but he has the power of inventing admirably constructed and lucid designs, a power which is perhaps even more clearly seen in his paintings upon *faïence*. I would call special attention to

these, since, if the group of artists here exhibited had done nothing else, their contribution to modern art would be sufficiently striking, in that they have shown the way to the creation of entirely fresh and vital pattern designs, a feat which has seemed, after so many years of vain endeavor, to be almost beyond the compass of the modern spirit.

A POSTSCRIPT ON
POST-IMPRESSIONISM

I AM asked by the Editor to reply to some of the critics of the Post-Impressionist Exhibition and of my remarks about it. Mr. Robert Morley says that all the abuse of the Post-Impressionist which has come from certain quarters is more than justified. Having thus thrown the great weight of his name into the scale against these unfortunate artists, all that I can do is to pile on to the other scale such names as Degas (who owns several Gauguins), Dr. von Tschudi, Mr. John S. Sargent, and Mr. Claude Phillips (at least as regards Cézanne), Mr. Berenson, Mr. Herbert Horne, and Mr. Charles Loeser, in the faint hope that the balance may be redressed. I ought, in fairness, to allow Mr. Morley the German Emperor as a fellow-passenger. Having done this, I must leave posterity to read the verdict. Such weighing of names does not appeal to me as a very useful proceeding, but there is, alas, no other way of meeting Mr. Robert Morley's *ipse dixit*. Had he condescended to argument, I might have opposed him more profitably. He is quite right, by-the-by, when he compares their pictures to the work of the Benin artists, but then I must differ quite as strongly from his contemptuous view of these.

Next comes Mr. Sadler, who is temperate and reasonable, and whom it would require much space to answer completely. I fear the difference between us lies quite as much in our estimate of Cimabue as it does in our reaction to the Grafton Gallery. I cannot find Cimabue's technique "defective", on the contrary, it seems to me masterly to the highest degree. I do not think his art "struggles into defective expression." I think it is complete and perfect expression of something which no one else, either before or since, has ever said. In fact, his pictures (among which I agree with Mr. Sadler in counting the Rucellai Madonna) are works of art. That is to say, they are final and complete expressions of certain spiritual experiences. What is defective in Cimabue is not technique, but representative science. He has enough of this to say what *he* wants, but not enough to say what Mr. Sadler, with Titian and Velasquez impertinently intruding from the back of his mind,

Reprinted from *The Nation*, 24 December 1910, 536–40.

demands. Our habitual way of looking at early art historically, with a table of dates in our mind, tends, unless we take special precautions, to make us unable to see the work of art itself. If only our art historians would look at the old masters as though they were contemporaries, we should probably get some very instructive criticisms and some very frank admissions of a kind to horrify the conventionally cultured.

When Mr. Sadler goes on to ask whether Van Gogh "burned with the same passion as Cimabue?" I must certainly answer no. No two artists burn with the *same* passion, their passions are aroused by different things, and colored by their different personalities. If he means, Is Van Gogh's passion as pure and as intense as Cimabue's?—the question becomes one of great delicacy and scarcely to be answered off-hand. I should be inclined to say that it was as intense, but much less simple, much less serene, more troubled by the conflicts and ironies of modern life, more tortured and less healthy. This may amount to admitting either that the conditions of Van Gogh's life were less felicitous than Cimabue's, or that his temperament was less harmoniously composed, or, perhaps, both. This admission may even make me go further and say that I think Cimabue's achievement the more noble of the two, but that does not prevent me from being grateful that, in an age of vulgar commercialism in art, so passionate a spirit as Van Gogh's did arrive at beautiful expression.

Mr. Sadler finally contends that Mr. Augustus John has succeeded in doing all that the Post-Impressionists did without any open breach with tradition. Now I have always been an enthusiastic admirer of Mr. John's work. In criticising the very first exhibition which he held in London I said that he had undeniable genius, and I have never wavered in that belief, but I do recognise that Mr. John, working to some extent in isolation, without all the fortunate elements of comradeship and rivalry that exist in Paris, has not as yet pushed his mode of expression to the same logical completeness, has not as yet attained the same perfect subordination of all the means of expression to the idea that some of these artists have. He may be more gifted, and he may, one believes and hopes, go much further than they have done; but I fail to see that his work in any way refutes the attainments of artists whom he himself openly admires.

Next let me take Mr. Henry Holiday's letter, though I should prefer to leave it unanswered.

Mr. Holiday criticises Cézanne's *Bathers* entirely from the point of view of representation. He thinks nothing can have justification in a picture which does not happen in nature. From this point of view Cézanne's *Bathers* deserves all that he says, but unfortunately Mr. Holiday proves too much. Al-

most all that he says would apply equally to a drawing of the Virgin and Child by Raphael. Who ever saw, Mr. Holiday would say, if he were to maintain his position with unfailing consistency—who ever saw a woman with two or three lines round the oval of her face, who ever saw the line of the skull under the hair, who ever saw a number of parallel black scratches across her cheek? Such or such like would surely have to be Mr. Holiday's criticism. He forgets that Art uses the representation of nature as a means to expression, but that representation is not its end, and cannot be made a canon of criticism. I believe that there is no symbol for natural appearance employed by the painters at the Grafton Gallery which is one whit more disconcerting than the symbols of the shaded pen drawing with which we have fortunately become so familiar that they cause us no inconvenience. We have learned to read them with perfect ease, and I feel sure that the same will happen as regards the paint symbols used by Van Gogh, though I am not the least surprised that their unfamiliarity makes them a stumbling-block for a time.

Mr. C. J. Holmes, the Director of the National Portrait Gallery, has put out a little pamphlet on the exhibition which I believe is on sale at the Grafton Gallery. Of this, thanks to his courtesy in sending me an advance copy, I can speak here. It is welcome as being a quite sincere and open-minded effort at a just appreciation of the works on view, and of the artists, so far as they are represented at the Grafton Gallery. But Mr. Holmes seems to me too much of the schoolmaster. He goes round with a set of principles, applies them in turn to each of the pictures, and reads off the result. He finds Cézanne clumsy, frequently incoherent, and, though a sincere artist, of modest rank. I confess the idea that Cézanne is clumsy surprises me. His feeling for facets of color prevents him from using a flowing or sinuous brush stroke which would inevitably break up the severe architecture of his planes, but I see no evidence of clumsiness, given the particular feeling for form which is personal to him. On the contrary, the quality of his pigment seems to me singularly beautiful. As the director of one of the largest Continental picture galleries once said, "You know, we really like El Greco's handling, because it reminds us of Cézanne's." I cannot withhold admiration for the courage of Mr. Holmes's patronising estimate of Cézanne, in view of the almost complete unanimity of opinion among foreign critics in giving him a much more exalted position.

Towards Van Gogh Mr. Holmes relents a little. He is even now and again carried away with real enthusiasm, and forgets to correct his errors. But what does he mean by saying that the yellow background of the irises "renders the picture useless for the decoration of any ordinary room"? It would be

so much easier and more desirable to alter the room than such a picture as this. All through Mr. Holmes's criticism runs the question whether a picture is "serviceable" or not, a question which suggests an odd idea of the artist's function, as purveyor to the conveniences of the middle classes. It was certainly not so that these artists worked, nor so, I believe, that any noble or lasting creations were made.

Gauguin naturally gets rather good marks from Mr. Holmes. His qualities are, indeed, more easily estimated by the critic's measuring line than those of more elusive and spontaneous artists. Vallotton is, I think, much overpraised. To me he appears altogether too "serviceable," while the treatment of Matisse seems, to me, to show a misunderstanding of his aims. Mr. Holmes compares him somewhat contemptuously to Holbein, a comparison which is not really illuminating because of the complete difference of aim of the two artists. Nor has Mr. Holmes felt the importance of Derain's and Vlaminck's work. These seem to me to be among the most remarkable of all the contemporary men. Derain, in particular, shows a strange and quite new power of discovering those elements in a scene which appeal to the imagination with an immediacy comparable to that of music. His *Deserted Garden*, No. 118, expresses the essential emotion of such a scene, which the presence of any particularised or actual forms would inevitably weaken. It is here that I think we may find the main achievement of the Post-Impressionist artists, namely, that they have recognised that the forms which are most impressive to the imagination are not necessarily those which recall the objects of actual life most clearly to the mind.

POST IMPRESSIONISM[1]

I FIND a certain difficulty in knowing to whom I am to address myself in this lecture. The cultivated public is sharply divided by the question of Post Impressionism. I think that I may assume that there will be representatives here of three classes. First, those who, like myself, admire it with enthusiasm. Secondly, those who think that the exhibition is a colossal farce got up for the deception and exploitation of a gullible public. Some of these have expressed the desire that all the pictures now in the Grafton Gallery should be burned, and that I myself should be offered up upon the holocaust as a propitiation of the outraged feelings of the British public. Such expressions of opinion appear to me to be somewhat exaggerated, I might even have said hysterical, were it not that that is the word which has been applied to myself with a view to explaining the aberrations of a mind hitherto supposed to be fairly well balanced. Finally, there is the class of those who are frankly puzzled, and yet inclined to doubt the explanations of fraud or self-deception which are put forward by the second group. In the main, I mean to address myself to this last class, to the intelligent but doubting inquirer. But here let me put in a plea for tolerance. Suppose even, as is roundly declared by the adversaries, that there are in this exhibition paintings tinged with the sin of charlatanism, paintings executed by the artist, not from sincere conviction, but from a desire to flout and irritate the public. Let us suppose this for the sake of argument, even though personally I should be inclined to deny it. Now charlatanism is undoubtedly a sin on the part of an artist, it is a departure, and a lamentable departure, from the strict course of artistic probity, but even if it be a sin, it is one which is promptly punished; while there is another sin, another departure from the straight and narrow way, which is not only not punished, but constantly rewarded with titles, money, and social prestige, I mean the sin of compromising with the public demand for pictures which arouse curiosity or gratify sentimental longings. This sin is so frequently and so openly committed by the artists of modern times that we

Reprinted from *The Fortnightly Review*, 1 May 1911, 856–67.

1. This article forms the substance of a lecture delivered at the Grafton Gallery, at the close of the Post Impressionist Exhibition.

scarcely feel indignant at it, we certainly do not rush to denounce it in the papers in the way that has been done of late with regard to the works in this Gallery. Honestly, it appears to me a much more dangerous and insidious sin for the artist, and I would far rather be responsible for the hanging of works intended to flout the public than of any single painting in which I detected any desire to flatter it. In the main, then, I mean to address myself to the doubting inquirer, but first a word of consolation and encouragement to the adversaries. These think that an entirely fictitious, degenerate, and irrational mode of artistic expression is being foisted upon the public by means of advertisement and all those subtle arts of corruption which modern journalism has discovered, and that this iniquitous campaign is organised by a few speculative dealers. Now I do not believe that any such adventure can succeed, I believe that even in art, Abraham Lincoln's dictum holds, that you cannot fool all the people all the time—and we have an excellent example of this in the fate of that abortive movement known as *art nouveau,* which certainly had all the advantages which lavish advertisement in the more popular and less scholarly artistic reviews could give, and which has, nevertheless, so evidently and undeniably fizzled out. Let the adversary, therefore, take heart, if this movement is of the same kind I not only believe, but sincerely hope, that it will meet with a similar fate.

But naturally I do not think that it is of the same nature, that it is merely a new way of startling the public into attention and frightening it into purchasing these ingenious painters' catchpenny wares. I believe that even those works which seem to be extravagant or grotesque are serious experiments— of course, not always successful experiments—but still serious experiments, made in perfectly good faith towards the discovery of an art which in recent times we have almost entirely forgotten.

My object in this lecture is to try to explain what this problem is and how these artists are, more or less consciously, attempting its solution. It is to discover the visual language of the imagination. To discover, that is, what arrangements of form and colour are calculated to stir the imagination most deeply through the stimulus given to the sense of sight. This is exactly analogous to the problem of music, which is to find what arrangements of sound will have the greatest evocative power. But whereas in music the world of natural sound is so vague, so limited, and takes, on the whole, so small a part of our imaginative life, that it needs no special attention or study on the part of the musician; in painting and sculpture, on the contrary, the actual world of nature is so full of sights which appeal vividly to our imagination—so large a part of our inner and contemplative life is carried on by means of visual images, that this natural world of sight calls for a constant and vivid

apprehension on the part of the artist. And with that actual visual world, and his relation to it, comes in much of the painter's joy, and the chief though not the only fount of his inspiration, but also much of his trouble and a large part of his quarrel with the public. For instance, from that ancient connection of the painter's with the visual world it comes about that it is far harder to him to get anyone, even among cultivated people, to *look* at his pictures with the same tense passivity and alert receptiveness which the musician can count on from his auditors. Before ever they have in any real sense *seen* a picture, people are calling to mind their memories of objects similar to those which they see represented, and are measuring the picture by these, and generally— almost inevitably if the artist is original and has seen something with new intensity and emotion—condemning the artist's images for being different from their own preconceived mental images. That is an illustration of the difficulties which beset the understanding of the graphic arts, and I put it forward because to understand the pictures here exhibited it is peculiarly necessary that you should look at them exactly as you would listen to music or poetry, and give up for once the exhibition attitude of mind which is so often one of querulous self-importance. We must return to the question of the painter's relation to the actual visible world.

I am going to assume that you will all agree with me in saying that the artist's business is not merely the reproduction and literal copying of things seen:—that he is expected in some way or other to *mis*represent and distort the visual world. If you boggle at the words misrepresent and distort, you may substitute mentally whenever I use them, the consoling word idealise, which comes to exactly the same thing. Now it is when we come to consider how far this distortion ought to go that our difficulties begin. Mr. Sickert, in his lecture here, suggested that the distortion should be entirely unconscious, due mainly to the incapacity of the artist to reproduce visible things exactly, though he characteristically suggested that the artist ought to draw in such a manner as would inevitably produce the greatest amount of distortion—the method of drawing from point to point. At the same time, Mr. Sickert pointed out that this distortion was precisely what characterised any work of art as opposed to any machine-made object. To me there seems something of Jesuitical casuistry about this: "Distortion is inevitable, and it is even desir- able as a characteristic of a work of art, but it must be always unwilling and unsuspected. Therefore, put yourself in such a position that you cannot pos- sibly avoid it, and then try your utmost to prevent its occurrence." Is not this rather like the Quaker's advice to his son: Thee must not marry money, but thee had better marry where money is.

The question of how much distortion—how much unlikeness to the to-

tality of appearance—is allowable to the artist has always been a difficult one, and has been answered very differently at different times. I can remember a very sensitive judge of art, himself an artist, who belonged to the generation of Leighton and Frederick Walker, and who knew Italian art well. To him Titian and Raphael represented the minimum of naturalism possible. Being a very humble-minded man he used sadly to admit that there must be something in Botticelli and Mantegna, but for him the incompleteness of their representation was a fatal bar to accepting their revelations.

Our generation has moved on a step further in appreciation. It no longer finds any difficulty in understanding the symbols of the Italians of the fifteenth century. Rather it fully and freely enjoys them. This much distortion of nature—and do not forget that it is already a very great distortion—is perfectly allowable. We have even got, by means of a kind of archaeological imagination, to give lip-service to the real primitives, to Cimabue and the Byzantines, and to the French sculptors of the twelfth century. I say lip-service because I notice almost always a kind of saving clause in people's admiration of these things—a way of saying how wonderful they are considering the time when they were produced—how interesting as a foretaste of the great art that was to follow, and so forth. Now this way of looking at a work of art, this evolutionary method, is, I think, entirely fallacious. It is the result of false analogies taken over unconsciously from our habits of thought when dealing with science. The work of a physicist of fifty years ago—say of a man like Joule—in so far as it is true, is completely absorbed in the works of more recent physicists. It is completely subsumed in the later work, and the later work replaces it entirely. It would make no difference now to mankind if every word Joule wrote were completely effaced. The law of the conservation of energy would none the less be the accepted basis of our thoughts about physics. But if the works of Giotto were destroyed, the fact that we still possessed the works of Raphael and Titian would afford us no sort of consolation or recompense. The human inheritance would be forever definitely impoverished. A work of art can never rightly be regarded as a means to something else, it is only rightly seen when regarded as an end in itself.

It so happens that the period of art that students generally concern themselves with—the period from 1300 to 1500—is one which, as well as producing many great masterpieces, shows a continual and fairly steady progression towards the more complete science of representation. To those who undertake the paradoxical task of teaching art, this progression appears as a godsend. Among all those terribly elusive realities of human passion and feeling of which art is the triumphant but hardly decipherable record, here at

least is a thing capable of easy and lucid demonstration, one upon which one may even set examination papers and give strictly judicial marks. And so art is conceived as a progressive triumph over the difficult feat of representing nature; a theory, which, if it were really believed, would put Meissonier above Raphael and Alma Tadema above Giotto. The fact is that changes in representative science are merely changes in the artist's organs of expression. These are not the changes that matter most. The changes on which we ought to fix our attention are the changes in the feelings and sentiments of humanity, and I firmly believe that if perspective had never been invented, the art of the eighteenth century would have differed as profoundly from the art of the thirteenth as it actually does; and I am confirmed in this by the fact that Utamaro's prints, with their rudimentary perspective, belong just as decisively to the eighteenth century as the paintings of Boucher or Fragonard.

For the sake of argument I have perhaps exaggerated a little the indifference to the essential purposes of art of representative science, the naturalism which the artist makes use of. In reality it is not quite so simple as that—first, a certain amount of naturalism, of likeness to the actual appearances, of things is necessary, in order to evoke in the spectator's mind the appropriate associated ideas. If I have to express the idea of a tiger attacking a man, it is essential that the spectator should realise the animal to be a tiger and not a hippopotamus—if, however, the given idea is merely a wild animal attacking a man, such doubts are indifferent, and all that is necessary is the expression of ferocity and wildness. There is, therefore, varying according to the idea to be expressed, a real minimum of naturalness allowable—though I believe it is a very low one and corresponds fairly closely with the amount of natural appearance called up to the mind by words. But there is also a limit in the other direction. One may have too much naturalism for the expression of a particular idea. Let me take an example. Suppose the artist wishes to describe an armed crowd attacking a palace from which an emperor escapes in a carriage, dressed as a woman. Supposing he adopts a method of more or less complete naturalism which we are familiar with in modern art, he will be troubled by the fact that the policeman in the foreground, even if he does not obscure the principal actors in the drama, will occupy a quite disproportionate area of the composition. And this difficulty has made the composition of all ceremonial painting either impossible or ridiculous in modern times. But if the artist supposes himself to be suspended above the scene, and represents all the figures as seen from above, he may be able to get a composition expressing coherently the whole effect of the action; but then each individual will be seen from a very unusual and frequently ridiculous point of view, certainly one which will take away from the expressiveness of the figure. But

if the artist frankly gives up any strict following of the laws of appearance, and groups the figures as though they were seen from above, and yet draws them as though seen more or less on a level, he will have a really adequate method of narrative composition. And such was the method employed by Japanese artists, and frequently by the miniature painters of mediæval times. We see here, then, the case of a dramatic idea which is much better and more lucidly conveyed by disregarding the laws of appearance than it could be by following them.

We come, then, to this, that it entirely depends upon the nature and the character of the sentiment which he wishes to convey, how much or how little naturalism the artist should employ. And I think we may say this, that those sentiments and emotions which centre round the trivialities of ordinary life—that kind of art which corresponds to the comedy of manners in literature—will require a large dose of actuality, will have to be very precise and detailed in its naturalism: but those feelings which belong to the deepest and most universal parts of our nature are likely to be actually disturbed and put off by anything like literal exactitude to actual appearance. It is not really the absence of naturalism which disturbs us, when we are disturbed, in an artist like Blake, but the introduction of a false and unfelt realism. But this is not all. When a high degree of completeness in the representation of things seen is demanded of the artist, his energies are usually exhausted in the mere process of representation. This becomes, indeed, a feat so difficult that its mere accomplishment rouses wonder and admiration at the artist's skill, and public and artist alike, left gaping at this wonderful tight-rope performance, forget that it is only a means to some quite other end, that art ought to rouse deeper and far other emotions than those with which we greet the acrobat or billiard player.

And this worship of skilful representation has had several bad effects upon art. It has caused the artist to abandon technical skill in the strict sense of the word. Technique is usually now applied simply to skill in representation, but I mean here the actual skill in the handling of the material, the perfection of quality and finish. And if in that point the artists whose works are here exhibited compare unfavourably with the artists of early ages, the fault must be set down, at least in part, to the exigencies of that representative science which has resulted in the loss of the tradition of craftsmanship.

However, in every century a few men actually do come through the ordeal which our rage for representation has imposed; these men do succeed in actually saying something. Hence the worship of genius. Genius alone has the right to exist in the conditions of modern art, since genius alone succeeds in expressing itself through the cumbrous and round-about method of com-

plete representation. The rest remain, not what they should be, definite minor artists, but often in spite of much talent and individuality, entirely ineffectual and worthless. They do not produce beautiful objects, but only more or less successful imitations.

But supposing the artist to be freed from the incubus of this complete representation—suppose him to be allowed to address himself directly to the imagination—we should get a genuine art of minor personalities, we might even attain to what distinguishes some of the greatest periods of artistic production, an anonymous art.

Now it is precisely this inestimable boon that, if I am right, these artists, however unconsciously they may work, are gaining for future imaginations, the right to speak directly to the imagination through images created, not because of their likeness to external nature, but because of their fitness to appeal to the imaginative and contemplative life.

And now I must try to explain what I understand by this idea of art addressing itself directly to the imagination through the senses. There is no immediately obvious reason why the artist should represent actual things at all, why he should not have a music of line and colour. Such a music he undoubtedly has, and it forms the most essential part of his appeal. We may get, in fact, from a mere pattern, if it be really noble in design and vital in execution, intense æsthetic pleasure. And I would instance as a proof of the direction in which the post impressionists are working, the excellences of their pure design as shown in the pottery at the present exhibition. In these there is often scarcely any appeal made through representation, just a hint at a bird or an animal here and there, and yet they will arouse a definite feeling. Particular rhythms of line and particular harmonies of colour have their spiritual correspondences, and tend to arouse now one set of feelings, now another. The artist plays upon us by the rhythm of line, by colour, by abstract form, and by the quality of the matter he employs. But we must admit that for most people such play upon their emotions, through pure effects of line, colour, and form, are weak compared with the effect of pure sound. But the artist has a second string to his bow. Like the poet he can call up at will from out of the whole visible world, reminiscences and remembered images of any visible or visually conceivable thing. But in calling up these images, with all the enrichment of emotional effect which they bring, he must be careful that they do not set up a demand independent of the need of his musical phrasing, his rhythm of line, colour, and plane. He must be just as careful of this as the poet is not to allow some word which, perhaps, the sense may demand to destroy the *ictus* of his rhythm. Rhythm is the fundamental and vital quality of painting, as of all the arts—representation is secondary to that, and

must never encroach on the more ultimate and fundamental demands of rhythm. The moment that an artist puts down any fact about appearance because it is a fact, and not because he has apprehended its imaginative necessity, he is breaking the laws of artistic expression. And it is these laws, however difficult and undiscoverable they may be, which are the final standard to which a work of art must conform.

Now these post impressionist artists have discovered empirically that to make the allusion to a natural object of any kind vivid to the imagination, it is not only not necessary to give it illusive likeness, but that such illusion of actuality really spoils its imaginative reality.

To take a single instance. In the first room of the Gallery there hangs a picture by Manet, the bar at the Folies Bergères, in which there is a marvellous rendering of still life—marvellous in the completeness and the directness of its illusive power. In that there is a circular dish of fruit. Now the top of a circle seen in perspective appears as an ellipse, and as such Manet has rendered it. In a *nature morte* by Cézanne, hanging close by, there is also a dish of fruit, but Cézanne has rendered the top as a parallelogram with rounded corners. This is quite false to appearances, but a comparison of the two paintings shows one how much more vivid is the sense of reality in the Cézanne. I do not pretend to explain this fact, but it would seem that Cézanne has stumbled upon a discovery which was already the common property of early artists. Both in Europe and the East you will find the wheels of chariots, seen in perspective, drawn exactly in this way. It occurs in Japanese paintings of the thirteenth century. And you will find St. Catherine's wheel drawn in the same way by Siennese painters of the fourteenth.

Or compare the girl in the Folies Bergères with Cézanne's portrait of his wife. In the first the modelling is elaborately realistic, however brilliant the short-hand in which it is expressed. In the second there is very little attempt to use light and shade, to give illusion of plastic relief. But none the less, I find that Cézanne's portrait arouses in my imagination the idea of reality, of solidity, mass and resistance, in a way which is altogether wanting in Manet's picture.

I do not pretend altogether to explain these facts; we have to find out empirically what does impress the imagination, the laws of that language that speaks directly to the spirit.

But there is perhaps one fairly obvious reason why the imagination is not readily impressed by anything approaching visual illusion, namely, that the illusion is never quite complete, never, indeed, can be complete, for the imaged reality has not the same proofs of coherence and continuity which ap-

pertain to actual life; it follows that recognizing how near to actuality the illusive vision is, the mind inevitably compares the picture with actuality and judges it to be less complete, less real. It has for us only the reality of a reflection or echo. Now the world of the imagination is essentially more real than the actual world, because it has a coherence and unity which the actual world lacks. The world of the imagination, though more real, is much less actual, and the intrusion of actuality into that world of imagination tends to disturb the completeness of our acquiescence in it.

A great part of illusive representation is concerned with creating the illusion of a third dimension by means of light and shade, and it is through the relief thus given to the image that we get the sensual illusion of a third dimension. The intrusion of light and shade into the picture has always presented serious difficulties to the artist; it has been the enemy of two great organs of artistic expression—linear design and colour; for though, no doubt, colour of a kind is consistent with chiaroscuro, its appeal is of quite a different order from that made when we have harmonies of positive flat colour in frank opposition to one another. Colour in a Rembrandt, admirable though it is, does not make the same appeal to the imagination as colour in a stained-glass window. Now if it should turn out that the most vivid and direct appeal that the artist can make to the imagination is through linear design and frank oppositions of colour, the artist may purchase the illusion of third dimensional space at too great a cost. Personally I think he has done so, and that the work of the post impressionists shows conclusively the immense gain to the artist in the suppression or re-interpretation of light and shade. One gain will be obvious at once, namely, that all the relations which make up the unity of the picture are perceived as inhering in the picture surface, whereas with chiaroscuro and atmospheric perspective the illusion created prevents our relating a tone in the extreme distance with one in the near foreground in the same way that we can relate two tones in the same plane. It follows, therefore, that the pictures gain immensely in decorative unity. This fact has always been more or less present to the minds of artists when the decoration of a given space of wall has been demanded of them; in such cases they have always tended to feel the need for keeping the relations upon the flat surface, and have excused the want of illusion, which was supposed to be necessary for a painting, by making a distinction between decorative painting and painting a picture, a distinction which I believe to be entirely fallacious; a painting of any kind is bound to be decorative, since by decorative we really mean conforming to the principles of artistic unity.

But in regard to this question of three dimensional space in the picture, another curious fact becomes apparent when we look at the pictures in the

Grafton Gallery. We find, for instance, that a painter like Herbin, who goes to the utmost extreme in the denial of light and shade and modelling, who makes all his tones in perfectly frank flat geometrical masses, actually arouses in the imagination the idea of space more completely than those pictures—of which we may take Valtat's and Marquet's as examples—in which the gradations of tone, due to atmosphere, are taken as the basis for the design. I confess that this is a result which I should have never anticipated, but which seemed to me undeniable in front of the pictures themselves.

It appears then that the imagination is ready to construct for itself the ideas of space in a picture from indications even more vividly than it accepts the idea when given by means of sensual illusion. And the same fact appears to be true of plastic relief. We do not find, as a matter of empirical fact, that the outlines with which some of these artists surround their figures, in any way interfere with our imaginative grasp of their plastic qualities— particularly is this the case in Cézanne, in whom the feeling for plastic form and strict correlation of planes appears in its highest degree. His work becomes in this respect singularly near to that of certain primitive Italian artists, such as Piero della Francesca, who also relied almost entirely upon linear design for producing this effect.

Many advantages result to art from thus accepting linear design and pure colour as the main organs of expression. The line itself, its qualities as handwriting, its immediate communication to the mind of gesture, becomes immensely enhanced, and I do not think it is possible to deny to these artists the practice of a particularly vigorous and expressive style of handwriting. It is from this point of view that Matisse's curiously abstract and impassive work can be most readily approached. In his "Femme aux Yeux Verts" we have a good example of this. Regarded as a representation pure and simple, the figure seems almost ridiculous, but the rhythm of the linear design seems to me entirely satisfactory; and the fact that he is not concerned with light and shade has enabled him to build up a colour harmony of quite extraordinary splendour and intensity. There is not in this picture a single brush stroke in which the colour is indeterminate, neutral, or merely used as a transition from one tone to another.

Again, this use of line and colour as the basis of expression is seen to advantage in the drawing of the figure. As Leonardo da Vinci so clearly expressed it, the most essential thing in drawing the figure is the rendering of movement, the rhythm of the figure as a whole by which we determine its general character as well as the particular mood of the moment. Now anything like detailed modelling or minute anatomical structure tends to destroy the ease and vividness with which we apprehend this general movement;

indeed, in the history of painting there are comparatively few examples of painters who have managed to give these without losing hold of the general movement. We may say, indeed, that Michelangelo's claim to a supreme place is based largely upon this fact, that he was able actually to hold and to render clear to the imagination the general movement of his figures in spite of the complexity of their anatomical relief; but as a rule if we wish to obtain the most vivid sense of movement we must go to primitive artists, to the sculptors of the twelfth century, or the painters of the early fourteenth.

Now here, again, the Post Impressionists have recovered for us our lost inheritance, and if the extreme simplification of the figure which we find in Gauguin or Cézanne needed justification, it could be found in this immensely heightened sense of rhythmic movement. Perfect balance of contrasting directions in the limbs is of such infinite importance in estimating the significance of the figure that we need not repine at the loss which it entails of numberless statements of anatomical fact.

I must say a few words on their relation to the Impressionists. In essentials the principles of these artists are diametrically opposed to those of Impressionism. The tendency of Impressionism was to break up the object as a unity, and to regard the flux of sensation in its totality; thus, for instance, for them the local colour was sacrificed at the expense of those accidents which atmosphere and illumination from different sources bring about. The Impressionists discovered a new world of colour by emphasising just those aspects of the visual whole which the habits of practical life had caused us to under-estimate. The result of their work was to break down the tyranny of representation as it had been understood before. Their aim was still purely representative, but it was representation of things at such a different and unexpected angle, with such a new focus of attention, that its very novelty prepared the way for the Post Impressionist view of design.

How the Post Impressionists derived from the Impressionists is indeed a curious history. They have taken over a great deal of Impressionist technique, and not a little of Impressionist colour, but exactly how they came to make the transition from an entirely representative to a non-representative and expressive art must always be something of a mystery, and the mystery lies in the strange and unaccountable originality of a man of genius, namely, Cézanne. What he did seems to have been done almost unconsciously. Working along the lines of Impressionist investigation with unexampled fervour and intensity, he seems, as it were, to have touched a hidden spring whereby the whole structure of Impressionist design broke down, and a new world of significant and expressive form became apparent. It is that discovery of Cézanne's that has recovered for modern art a whole lost language of form

and colour. Again and again attempts have been made by artists to regain this freedom of imaginative appeal, but the attempts have been hitherto tainted by archaism. Now at last artists can use with perfect sincerity means of expression which have been denied them ever since the Renaissance. And this is no isolated phenomenon confined to the little world of professional painters; it is one of many expressions of a great change in our attitude to life. We have passed in our generation through what looks like the crest of a long progression in human thought, one in which the scientific or mechanical view of the universe was exploited for all its possibilities. How vast, and on the whole how desirable those possibilities are is undeniable, but this effort has tended to blind our eyes to other realities; the realities of our spiritual nature and the justice of our demand for its gratification. Art has suffered in this process, since art, like religion, appeals to the non-mechanical parts of our nature, to what in us is rhythmic and vital. It seems to me, therefore, impossible to exaggerate the importance of this movement in art, which is destined to make the sculptor's and painter's endeavour once more conterminous with the whole range of human inspiration and desire.

INTRODUCTION TO THE
CATALOGUE OF THE SECOND
POST-IMPRESSIONIST
EXHIBITION

THE scope of the present Exhibition differs somewhat from that of two years ago. Then the main idea was to show the work of the "Old Masters" of the new movement, to which the somewhat negative label of Post-Impressionism was attached for the sake of convenience. Now the idea has been to show it in its contemporary development not only in France, its native place, but in England where it is of very recent growth, and in Russia where it has liberated and revived an old native tradition. It would of course have been possible to extend the geographical area immensely. Post-Impressionist schools are flourishing, one might almost say raging, in Switzerland, Austro-Hungary, and most of all in Germany. But so far as I have discovered these have not yet added any positive element to the general stock of ideas.

In Italy the Futurists have succeeded in developing a whole system of aesthetics out of a misapprehension of some of Picasso's recondite and difficult works. England, France, and Russia were therefore chosen to give a general summary of the results up to date.

Mr. Clive Bell is responsible for the selection of the English works and Mr. Boris von Anrep for the Russian. The selection of the French works fell to my lot.

Reprinted from the catalog of the *Second Post-Impressionist Exhibition*, 1912.

"THE GRAFTON GALLERY:
AN APOLOGIA"

HOWEVER well-fitted to criticise the present exhibition at the Grafton Gallery I may consider myself, I can hardly suppose that my claim to do so would be accepted. This, then, must be taken as a speech for the defence, not a judicial summing up.

The prosecution has had time to develop its ideas with volume and vehemence. There is something admirable in the reckless courage with which a large section of the press has damned the Post-Impressionists. It shows that British Philistinism is as strong and self-confident and as unwilling to learn by past experience as ever it was, and doubtless these are among the characteristics which have made us so proudly and satisfactorily what we are. For in spite of the fact that one or two of those critics whose learning and reputation give them something of a position of leadership have been either favorable, or at least respectful—Sir Claude Phillips, for instance, with a candor and courage worthy of his sincere devotion to art has withdrawn the suggestion of charlatanry made against Matisse—in spite of facts such as these which might give a less expert critic pause, the generality of critics have given vent to their dislike and contempt in unequivocal terms. One gentleman is so put to it to account for his own inability to understand these pictures that he is driven to the conclusion that it is all a colossal hoax on the part of the organisers of the exhibition and myself in particular. However flattering to my powers of persuasion such a theory is, I fear I must decline the honour of going one better than Captain Köpenick.

One feature of the attacks is of peculiar interest. Two years ago Cézanne's works drew down the most violent denunciation. He was "a butcher who had mistaken his vocation," a bungler who could never finish a picture, an impostor, he was everything and anything that heated feelings and a rich vocabulary could devise. This year Cézanne is always excepted from abuse. He, at least, is a great master; but whatever advantage might be given by this concession is instantly taken back by the statement that he is not a Post-Impressionist, and has nothing to do with the rest. It is an old and well-worn

Reprinted from *The Nation*, 9 November 1912, 249–51.

device, but I doubt if it will do Matisse any more harm than the recent hurried canonisation of Gladstone has done to Mr. Lloyd George.

In any case, as to Cézanne, we are not happily all agreed, and I can only rejoice at the rapidity of the conversion. Perhaps two years more will see Matisse and Picasso on the same pedestal.

But however imposing this vigorous attack of the general run of critics may be as a moral spectacle, it shows, I think, a curious intellectual and aesthetic weakness. The exhibition provokes a number of very interesting and difficult questions in æsthetics, and yet no writer for the prosecution has taken the trouble to discuss them or to give reasons for his dislike. Almost without exception, they tacitly assume that the aim of art is imitative representation, yet none of them has tried to show any reason for such a curious proposition. A great deal has been said about these artists searching for the ugly instead of consoling us with beauty. They forget that every new work of creative design is ugly until it becomes beautiful; that we usually apply the word beautiful to those works of art in which familiarity has enabled us to grasp the unity easily, and that we find ugly those works in which we still perceive the unity only by an effort.

Many critics, too, have exaggerated the destructive and negative aspect of this art, affecting to find in it a complete repudiation of all past tradition. I certainly should like to hope that it will be destructive of the great mass of pseudo-art, but it is destructive not by reason of its denials but of its affirmations. By affirming the paramount importance of design, it necessarily places the imitative side of art in a secondary place. And since it is true that the demand for mere imitation and likeness has, in the last five hundred years or so, gradually encroached upon the claims of design, this art appears to be revolutionary. But in its essentials it is in line with the older and longer and more universal tradition, with the art of all countries and periods that has used form for its expressive, not for its descriptive, qualities. So far from this art being lawless and anarchic, it is revolutionary only in the vehemence of its return to the strict laws of design. If it is not too rash to try to coin a single phrase to explain a very varied movement, I should say that it is marked by the desire for organic unity in a work of art, as opposed to that search for casual and factual unity which attempted, but unsuccessfully, to satisfy the public of the last century.

There is much work of immature or minor artists in the Grafton Gallery, work which has, I think, great promise for the future, but I must confine myself in the present article to the work of two men who stand out at the present moment as leaders—Henri-Matisse and Picasso. No sharper contrast can be imagined than exists between these two men, and it is, indeed, one of

the hopeful signs of the present movement that it allows of such striking diversity. It is easier to speak of Matisse, for he has achieved something like a definitive form, something complete in its way, and his whole development has proceeded by such clear and logically related steps that one need not forecast any striking or bewildering change in his methods. He is indeed a singularly precise and methodical artist—one whose intelligence keeps pace with his sensibility, making clear to him at each point the next position to be gained. There is absolutely nothing fantastical or whimsical about Matisse, nothing, when once one has seized his method of expression, that is bewildering or disconcerting. All proceeds by singularly clear and deliberate steps towards a definite end. As an illustration of his method the four busts of a woman are peculiarly instructive. In the first state he has rendered the head more or less naturalistically. In each successive state he has amplified the forms, working always towards a more complete and inevitable plastic unity; one in which the relations, only dimly apprehended in the first study, become entirely explicit. The final result is from a purely descriptive point of view monstrous and repellent. I mean that, if taken as a likeness of an actual woman, we should speak so of the model from which it had been copied, but judged as pure form it has an intensity, a compactness, an inevitability which gives it the same kind of reality as life itself.

In his painting, no less than in his sculpture, we find the idea of equivalence by means of amplification. In order that each form may have its full significance in the whole, may hold its own in the equilibrium of all the forms, it must be as ample and as simple as possible. It is because he has followed out this scheme so fearlessly that his designs have their singular compelling power. This is particularly observable in the great decoration of the *Dance* where the rhythm is at once so persuasive and so intense that figures that pass in front of it seem to become part of the rhythmic whole. The rhythm passes out of the picture and imposes itself on its surroundings. Matisse has himself noticed this, and again and again in subsequent compositions, parts of the *Dance* are woven into the background; the pattern of actual things and the pattern of the painted figures fusing to form a new synthesis.

Matisse is essentially a realistic painter: that is to say, his design is not the result of invention, but almost always comes out of some definite thing seen. In a sense he is always trying to make his works like the thing seen, but not like in the literal sense. What he does is to draw out to its last and final explicitness the effect of things seen upon his sensibility. In his earlier work he still modelled with light and shade, and how vigorously one may judge from the *Pose du Nu* (No. 9), but he soon found that color and line expressed

more clearly his conception. He began then to translate contrasts of shade into contrasts of pure color, as in *Le Madras Rouge* (No. 31). Finally, he has learnt to dispense even with this, and to give to each figure its volume and mass without any perceptible color contrasts. Thus in his latest work the same identical color may be used to express a number of distinct planes and different objects, and that without confusion or loss or spacial definition, thanks to the increased amplitude and simplicity of the design. This use of pure flat masses of color without degradations or transitions enables him to give to color a purity and force which has scarcely ever been equalled in European art except by some of the French glass designers of the thirteenth century.

Matisse's art is singularly aloof, singularly withdrawn from the immediate issues and passions of life. Even in his *Dance* there is nothing Dionysiac, but rather a perfect equilibrium of motion. In his *Conversation* there is no dramatic tension. This commonplace event is seen with epic generalisation. It becomes placid, monumental, and sedate, like some early Assyrian sculpture. At first sight it is grotesque. That is because of our inveterate habit of translating images back into life instead of regarding them simply and passively. In looking at early art we have learned this passive attention because the act of translation is difficult to us; we know too little of the actual life which gave rise to the image. It needs some familiarity with such a decoration as the *Conversation* to do this, but when once it is done, the strange impressiveness of the design, the perfect rightness of the relations, becomes apparent, and in the end one is inclined to agree with Matisse that the mood his art inspires is one of serenity and repose.

It is dangerous and difficult to speak of Picasso, for he is changing with kaleidoscopic rapidity. There have been moments when his art seemed stable, when he seemed to have established a definite form, but instantly the balance has broken down and a new conception has begun to emerge. It is difficult then to judge of his achievement, though it is easy to show the fertility of his work in its influence on other, less restless, less adventurous spirits. He is the most gifted, the most incredibly facile of modern artists. No *tour de force* of imitative art would have been difficult to such an eye and hand. But the very facility that might have made him the darling of the Academies has stood in his way in the line of advance he has chosen. Again and again he seems to have dreaded its effect on him, and to have deliberately countered it by adopting some more abstract and unrepresentative idea of form.

Because the latest developments of Picasso's art have in this way come to take on geometric form, some have supposed him to be a pure theorist, working out abstract intellectual problems of design. This seems to me to be

a mistaken view; one has only to look at the quality of his work, to mark the nervous sensitiveness and delicacy, the rare distinction of his touch, to see that his sensibility is his most salient characteristic. And he is unlike Matisse in that this sensibility is not controlled by a clear and methodical intellect. Hence his continual experimenting. He reaches out in any direction which his instinct dictates for the possible expression of his sensibility to actual objects. As I have said, his art is rarely complete; generally it seems to be in labor with a new idea, and almost always before the new idea has been completely realised, another possibility is beginning to dawn. It may be doubted if such is the character of the greatest artists, but it is typical of great originators and inventors. In Picasso's early work there is more than a trace of sentimentality. As though conscious of this danger he threw aside all those means by which the associated ideas of a picture may interfere with percep- tions of pure form, gradually reducing his shapes to a geometrical abstract. But the quality of his temperament comes through, even in such pieces as the *Têtes de Femmes* (Nos. 64 and 66). In the still-life pieces of this period (Nos. 60 and 63) Picasso seems to me to come nearest to complete realisa- tion. He has the power of building up out of the simplest objects designs of compelling unity and precision. And more than in his other work we feel in these the concentrated passion, the almost tragic intensity of his mood. For all the remoteness from natural form, the abstract and musical quality of his designs, Picasso's temperament is less serenely remote than Matisse's. It has the gloomy force and intensity of the Spanish genius.

As to the latest works of all, those in which Picasso frankly abandons all direct reference to natural appearance, I confess that I take them to some extent on trust, a trust which is surely justified by his previous work. They certainly have the beauty of intensely organised wholes, but I apprehend the unity almost dispassionately and intellectually. I find that they move me only by the charm and distinction which is inalienable from everything that Pi- casso does. The idea seems to me intelligible enough, namely, the construc- tion of a fugal arrangement of forms out of the elements given in any natural object, without taking those elements in the same order or relation that they have in actual life. It is, of course, possible that we are not yet sufficiently accustomed to interpreting the meaning of such purely abstract form for us to feel to the full the effect of these compositions. It is also possible that they are but an intermediate stage on the way to a clearer and more explicit form.

3
REFINING AND DEFINING:
THE POST-IMPRESSIONIST
ERA

AT the same period that Fry was promoting and defending his "Post-Impressionists," the regular reviews he contributed to journals like the *Nation*, the *Burlington*, and the *Athenaeum* applied the lessons of French modernism to developments in the English art world. These reviews, then, help to place Fry's essays on Post-Impressionism in their English context, illuminating, for example, the cross-currents of nationalistic rivalry that rippled through European debates about aesthetics even before the outbreak of World War I and revealing, as well, the complexity of Bloomsbury's relationship to English contemporaries like Walter Sickert.

For readers interested in a detailed history of formalism, moreover, Fry's reviews from the Post-Impressionist era chart the development of his ideas through their application to the events and personalities of his day. These often-overlooked texts parallel the essays on Parisian modernism, collected in the previous chapter, and reveal a pattern of similar interests and aspirations. Reiteration is not, however, necessarily redundancy, and the reviews assembled here are worth study as a record of Fry's attempts to generate a vocabulary for formalism. Specifically, terms like "plastic" and "classic," which scholars have cited as central to Fry's philosophy, are inaugurated and defined in the essays collected in this chapter. Read together as they are presented here, Fry's reviews offer an impression of his work somewhat different than the tidy philosophic model created by commentators who excerpt a word here and a phrase there. Far from revealing the systematic development of a coherent theory, these reviews trace Fry's often haphazard and tentative attempts to counter reactionary and often xenophobic attacks on modern art by creating a vocabulary with claims to a richer historical pedigree.

Fry's recourse to history is typical of his colleagues in the Bloomsbury group. Lytton Strachey contrasted the Victorian "age of self-complacency and self-contradiction" with the Enlightenment, "Age of Diderot, Rousseau, and Voltaire." Leonard Woolf fought fascism by appealing to a notion of civilization traced back to ancient Greece and betrayed only by the "intellec-

tual quacks—many of them famous men—of the 19th and 20th century."
Clive Bell's *Art*, expanding on remarks in Fry's early essays defending Post-
Impressionism (in chapter 2), is structured as a historical overview that con-
cludes with the new art reaching over the morass of post-Renaissance imag-
ery to "shake hands across the ages with the Byzantine primitives and with
every vital movement that has struggled into existence since the arts began."[1]
By the same token, Fry deploys both "plastic" and especially "classic," not to
mark precisely defined new concepts, but to claim the attributes of depth,
solidity, and tradition for the new art that was commonly dismissed as super-
ficial and without history.

That Fry's rhetoric of classicism appears, from some postmodern perspec-
tives, inflated with all the privileges of authority reflects something of the
success of Fry's strategy. Similarly, Fry's division of the public into the mi-
nority "formalists" and the majority "class . . . who dwell on content" is to-
day denounced as a symptom of his bourgeois contempt for the working
classes supposedly championed by such realist painters as Walter Sickert. In
addition to misrepresenting Sickert,[2] this view is undermined by a return to
essays like "BLAKE AND BRITISH ART" and "A NEW THEORY OF ART," in
which Fry clearly identifies mainstream opinions about art as the ideology of
a ruling class he is anxious to challenge. Taken together, the essays collected
in this chapter—and, indeed, throughout this book—rebut common carica-
tures of Fry as a snobbish aesthete out to enforce a rigid system of aesthetic
evaluation. On the contrary, what emerges is the passion of an activist ambi-
tious to wrench the art from ideological and institutional control of the
establishment.

The iconoclastic origin of Fry's formalism may be most obvious in the
embattled tone of his reviews following the first Post-Impressionist exhibi-
tion. Many of the critics most hostile to the show had attacked it on nation-
alistic grounds. The well-known illustrator Charles Ricketts, writing in the
Morning Post in November 1910, for instance, assured his readers that the
high quality of English art had hitherto prevented the incursion of Post-
Impressionism, which he characterized as a "cult" with "its organized head-
quarters in Paris, its prophets in America, and its cosmopolitan travellers in
Germany." A week later in the same paper, the painter Sir William Blake
Richmond asserted that Post-Impressionism—an "invasion of depressing
rubbish"—was, "thank Heaven, new to our island of sensible and, in their
own fashion, poetic people," and constituted "an insult . . . to the taste of the
English."[3] Fry responded to this kind of xenophobia by inverting it. A few
months after the close of the Post-Impressionist show, following a trip with
the Bells to Turkey, Fry wrote

After some time spent in a town in Asia Minor, where the Turks, for all their alleged cruelty, have never applied the torture of the picture gallery, and where the people show in all the interests of daily life a vital sense of beauty and color and design, to return to England to find . . . the country cousins gloating over the sticky slabs of sentimentality which the keepers of our artistic conscience have just been handing round at the annual feeding time, all this is a trying experience, and it requires some weeks to recover the innocent belief that any good can come of talking and writing about art in a country which seems so well adapted for other activities."[4]

For Fry at this period even laudatory reviews became opportunities to skewer the English art establishment. "AN ENGLISH SCULPTOR" of January 1911 begins by asserting that talents in sculpture "seem to have been given with a niggardly hand to our race." The "Pacific islanders," the "workmen of Benin," and "even the native of the Congo to-day" share "the language of sculpture," but in England only Eric Gill has an "instinctive and natural" understanding of "plastic imagery"—and this in spite, and not because, of his national heritage. In "PLASTIC DESIGN," also from the spring of 1911, Fry extends his critique from English sculpture to painting, citing the same "peculiar disadvantage of our national temperament, as regards the arts of design." In contrast to English favorites like P. W. Steer, "the better among the modern French painters"—Fry's example is Pierre Bonnard—manifest far superior abilities. Antagonistic as he obviously was toward the English art establishment, however, Fry concludes the essay by praising Walter Sickert and William Rothenstein as two English artists who equal their French counterparts.

The distinction between Fry's disdain for the titled champions of the Royal Academy and his admiration for contemporaries like Sickert is worth noting. His anger at the Royal Academy, especially over its suppression of modern art, went back at least as far as 1903, when he publicly challenged the Academy's misadministration of the Chantrey Bequest, which was intended to support young artists but was redirected to benefit established Academicians (see chapter 5). Although Fry was clearly eager to challenge the Academy, however, his published writings do not support the charge that he puffed his friends among the Bloomsbury painters and promoted Post-Impressionism at the expense of other anti-Academic artists, Sickert in particular.[5]

It was not Fry who dismissed Sickert as old-fashioned, but Sickert himself who claimed the ground of spokesman for an older generation. Sickert's review of Fry's first Post-Impressionist show rejected the younger generation

of modernists by comparison with his French contemporaries. In this review, Sickert proclaimed his status as an insider in the circles of Degas and Cézanne, larding his comments with Parisian anecdotes and French phrases. At the same time, he attacked the works of younger painters, like Picasso and especially Matisse, as "patent nonsense," concluding that "not all the remainder biscuit of Manet's great studio can induce us to swallow Matisse as next-of-kin."[6] Far from dismissing Sickert, Fry, writing just six months later in "MR. WALTER SICKERT'S PICTURES AT THE STAFFORD GALLERY," acknowledged that he "differ[ed] from Mr. Sickert's views on art," but nevertheless praised the artist, saying: "amid all the pretentions and deceptive promises of more exciting and ambitious art which have attracted our attention from time to time, we have all the time had a real master among us." If Fry and his Bloomsbury colleagues inherited the mantle of the avant-garde from Sickert, it was a willing exchange on both parts, as the older painter staked his reputation on a conservative claim to defend French Impressionism against the onslaughts of the young.

Sickert's relationship to the Bloomsbury group may be gauged, not just by what Fry says about the artist, but by how he says it. Sickert, who was Whistler's student, adopted something of his teacher's dandyish manner of witty condescension. Fry once said that if he imagined Bloomsbury as a group portrait, the background would show "Walter Sickert coming in at the door and looking at us with a kind of benevolent cynicism" (*Letters*, 423). Clive Bell—who had his dandyish side, as well—fondly recounted how Sickert

> made the best, or worst, of both worlds. He jeered at Roger Fry (Rouchaud recalls having once asked him why he kept a peculiarly idiotic German picture on his mantelpiece and having received for answer "pour emmerder Fry" [to piss off Fry]) and at the same time poked fun at the self-appointed defenders of orthodoxy.[7]

Fry's witticisms in "MR. WALTER SICKERT'S PICTURES AT THE STAFFORD GALLERY"—his comparisons of Sickert to such old-guard institutions as "the Throne, or the Bank of England, or the Civil Service Stores," for example— seem an attempt to respond to Sickert's persona in kind.

Following these introductory verbal sallies, however, Fry's respect for Sickert is evidenced by the way his vocabulary seeks to admit Sickert to formalist acceptability: "Things for him have only their visual values, they are not symbols." Like Eric Gill, Sickert was, for Fry, one of the few English artists whose practice was defensible in the same terms as the Parisian modernism he so admired. Perhaps the best corrective to the historical oversim-

plification of Sickert and Fry as bitter antagonists is the fact of their fire-places, which suggest a more complex relationship in which a measure of competitive public jousting was undergirded by basic mutual respect. Where Sickert hung his German picture to annoy Fry, what Fry kept over his mantel was a large painting by Sickert.[8]

Fry's commendations of individual English artists like Sickert and Gill, as they leavened Fry's general anger at his contemporaries, may be the only thing that, at this period, distinguished his embattled public persona from the Whistlerian stance of complete isolation he had earlier criticized (see chapter 1). Indeed, his closest brush with Whistlerian notoriety came in 1913, when a few weeks after the second Post-Impressionist exhibition closed, his flippant obituary, "THE CASE OF THE LATE SIR LAWRENCE ALMA TADEMA, O.M.," characterized this lionized painter as depicting ancient Rome as if it were "made of highly-scented soap." As with Whistler, the element of insight in this insult only increased the fury of official response, with knighted artists including Philip Burne-Jones riding to their colleague's defense. In Virginia Woolf's account, "Sir William Richmond summed up" by announcing that Fry "'must not be surprised if he is boycotted by decent society.'"[9] Many years later, after a dinner with a college friend, Fry remarked in a letter "how curiously far I have travelled away from the standpoint of my own generation" and "how much I'd joined a younger generation" (*Letters*, 629). In fact, Fry was only five years younger than Philip Burne-Jones, but where Burne-Jones looked backward toward the generation of his eminent Victorian father, Fry was determined to look ahead to Post-Impressionism and beyond.

Fry's reviews concurrent with the Post-Impressionist shows are most interesting, however, not for their vituperative (if amusing) barbs, but for the insights they offer on the evolution of his formalist aesthetics. In these essays Fry introduces and elaborates—often in surprising ways—terms such as "plastic" and "classic," which have been the focus of subsequent debate over the meaning of formalism.

In both of the essays from the spring of 1911 that are reprinted here, Fry lays great emphasis on the representation of volume, which he designates with the term "plastic." Late in life, looking back at his writings, Fry reported he was "rather shocked at the horrible repetition of words like 'plastic', but what is one to do if one has to make clear one's exposition?"[10] Chiming in to defend Fry, Clive Bell argued that "if such terms as 'plastic sequence' [and] 'plastic unity' keep cropping up, that is because they are the only symbols available for subtle and complex things which themselves keep cropping up."[11] The predominance of the term marks the importance of

volume in Fry's formalism, a point worthy of note because as formalism was adapted and applied by other writers through the decades it became strongly identified with prescriptions of flatness. Just as historians of photography have recently shown that the Russian "formalism" of Alexander Rodchenko was, in fact, the antithesis of the American "formalism" of the 1950s—though the Russian radicals were frequently invoked to create a historical justification for the Americans[12]—so I am drawing attention to a profound disjunction between Fry's 1910s formalism and the 1940s–60s formalism associated with Clement Greenberg, which are so often assumed to be contiguous.

Throughout Fry's career, he looked for a quality that he once phrased rather loosely as, "the greatest possible amount of interplay between the volumes and the spaces both at their three dimensionalest." In an attempt to explain, he gave an example:

> It means that both volumes and spaces function to the utmost against one another. . . . If you'll look at a Raphael and then at say a Titian, perhaps you'll see what I mean. The Titian's full of vacancies, recessions which have no relation to volumes, and volumes which are inadequate to the recessions. (*Letters*, 518)

This penchant for clear three-dimensional structure is manifest in the paintings Fry owned—both his own and those by other artists—where, in landscape after landscape, lines of trees march cleanly back to vanishing points, while still lifes and figure paintings are resolved into crisp pyramidal compositions.[13] In contrast, looking at the Impressionists' paintings, with their all-over spots of color, Fry criticized "the absence in their work of structural design" (*V&D*, 287). Fry's later doubts about Cubism began with the premise that "the effect on the mind of flat forms is feeble in comparison with the effect of forms that either present or represent relief in three dimensions" (see "PICASSO," in chapter 7). Perhaps most revealing is his overreaction to Clive Bell's 1914 *Art*, which Fry misreads as advocating flat abstract painting in its claim "that a picture might be completely non-representative" (*V&D*, 295). Fry insisted that "this last view seemed to me always to go too far since any, even the slightest suggestion, of the third dimension in a picture must be due to some element of representation" (*V&D*, 295). The fact that Bell does not actually call for flat abstraction may be less significant than Fry's rush to make three-dimensionality the center of his aesthetics.[14]

To signify this emphasis on volume, the term "plastic" enters Fry's vocabulary with his translation of Maurice Denis's essay on Cézanne in 1910. Here we read that Cézanne was "seeking for plastic beauty" [cherchant la beauté

plastique], though it was preeminently the Symbolist painter, Odilon Redon, who achieved "the plastic equivalents of his emotions and dreams" [les équivalents plastiques de ses émotions et de ses rêves] and "the *plastic* expression of the ideal" [expression *plastique* de l'idéal].[15] Defending the first Post-Impressionist show later that same year, Fry's "POST-IMPRESSIONISTS—II" (in chapter 2) applies the term to Matisse—and significantly not just to his paintings, but to his sculpture, which "shows a singular mastery of the language of plastic form."

Up to this point, however, "plastic" was far from central to Fry's vocabulary, appearing only occasionally and with no special emphasis. Perhaps it was the literalization of plasticity in the three-dimensionality of Matisse's sculpture that pushed the term to the forefront only six weeks later, when in "AN ENGLISH SCULPTOR" Fry praised the work of Eric Gill. Here Fry grafts "plastic" onto both the term "expression" and the concept of primitive art, both of which were already current in his defenses of Post-Impressionism. A few months later in "PLASTIC DESIGN" the term takes its central place in Fry's aesthetics, defined broadly in opposition to the realm of "the pictorial" and the work of "the illustrator or delineator."

That Fry's definition of "plastic" is vague is the most specific analysis we can make of it. Originally applied to Matisse in Fry's defenses of the first Post-Impressionist show, this application was repeated in "THE GRAFTON GALLERY: AN APOLOGIA," which accompanied the second exhibition: Matisse's increasingly abstract busts of a woman, Fry says, work "always towards a more complete and inevitable plastic unity" (see chapter 2). Yet in Fry's catalog essay for this show, we read: "In opposition to Picasso, who is pre-eminently plastic, Matisse aims at convincing us of the reality of his forms by the continuity and flow of his rhythmic line, by the logic of his space relations, and, above all, by an entirely new use of color" (*V&D*, 240). If the plasticity of Matisse's sculpture grows as he works less "naturalistically," but his paintings are un-plastic in comparison with Picasso's Cubist portraits—which, Fry says, "attempt to give up all resemblance to natural form, and to create a purely abstract language of form" (*V&D*, 239)—"plastic" comes to be defined operationally as a quality that is the opposite of realism yet that retains an emphasis on three-dimensionality to distinguish it from flat pattern.

It is a similar story with the word "classic." Although histories of British art often imply that Fry originated the application of "plastic" and "classic" to Post-Impressionist art, a fairer assessment of his accomplishment is that he successfully transplanted the vocabulary of French modernism to England. Again, an obvious source is his 1910 translation of Maurice Denis, which

begins with a definition of classicism ideally suited to Fry's agenda. Denis contrasts classic art to the "pitiful novelties" of academic painting, "the dry analyses and thin coloured photographs of our gold medallists . . . bought in the annual salons according as studio intrigues or ministerial favour decides." For Fry, as a veteran of battles with the British Royal Academy, Denis's appeal to the grand sweep of history over the authorities of the recent past had obvious appeal, and indeed echoed his own 1903–4 essays on the "THE CHANTREY BEQUEST" (in chapter 5).

In the 1910 "POST-IMPRESSIONISTS—II," Fry follows Denis in labeling Cézanne "the great classic of our time," with classicism exemplified in the artist's portrait of Madame Cézanne, which manifests "that resistance and assurance that belong to a real image, not to a mere reflection of some more insistent reality" (in chapter 2). This comes straight from Denis, who defined the classic as associated with "synthetic order" or "unity in composition and colour," as opposed to the academics' "illustrations to popular novels or historical events" that "seek to interest us only by means of the subject represented." When Denis goes on to compare Cézanne to Chardin, so does Fry. What Fry brought to London with his first Post-Impressionist show, in short, was not just French modern art, but the critical apparatus that sustained it through an appeal to a notion of classicism defined in opposition to conventionally realistic art.

In the catalog to *The Second Post-Impressionist Exhibition*, Fry emphasized the term and defined it:

> I do not mean by Classic dull, pedantic, traditional, reserved, or any of those similar things which the word is often made to imply. Still less do I mean by calling them Classic that they paint "Visits to Aesculapius" or "Nero at the Colosseum." I mean that they do not rely for their effect upon associated ideas, as I believe Romantic and Realistic artists invariably do. (*V&D*, 241–42)

Virtually the same definition reappears in "BLAKE AND BRITISH ART" two years later, where Fry experimented with the idea of this turn-of-the-(previous)-century artist as England's equivalent to the French "classic" Cézanne. Where Cézanne found both a place in a native classical tradition and a following among younger artists, however, Blake's historical isolation points up what Fry sees as the poverty of the English context.

If Fry succeeded in challenging—perhaps even overcompensating for— English insularity by bringing Maurice Denis's vocabulary to anglophone aesthetic debates, this accomplishment was not without problems. Like "plasticity," "classicism," as Fry used it, is a negative term, one defined pri-

marily by what it is not: conventional realism. In Denis's usage, historians of aesthetics have noted, "oxymoron abounds," with Cézanne described as "instinctively" and "spontaneously" classical.[16] My introduction to chapter 2 drew attention to the tension between the personal and the universal in Fry's early defenses of Post-Impressionism, which we now see to be a reflection of Denis's oxymoron, the instinctual classic. In his "POST-IMPRESSIONISTS— II," accompanying the first exhibition, Fry's difficulty with his French sources on Cézanne is explicit: "As I understand his art, and I admit it is exceedingly subtle and difficult to analyze," Fry says, going on to paraphrase Denis's argument that Cézanne transcended Impressionism by "re-creat[ing] form from within," so that his paintings are more than mere records of momentary appearances; they achieve spontaneously the qualities of classic art.

Within a few months of this paraphrase, Fry collided directly with the contradictions of spontaneous classicism, significantly when he came to compare Cézanne's art with Denis's own work. The occasion was the purchase by the Finnish national museum of two paintings from the first Post-Impressionist exhibition, Denis's *Ulysses* and a Cézanne landscape known as both *Les maisons jaunes* and *Le viaduc à l'Estaque*. The purchase offered Fry a major institutional endorsement of his views, which he lost no time in publicizing in the *Burlington Magazine* under the title, "ACQUISITION BY THE NATIONAL GALLERY AT HELSINGFORS." Here he emphasized the fact that the new acquisitions would join an already established collection of Van Goghs in Helsinki—this amassed at a time when the British National Gallery refused to accept even a Degas as a gift.[17] In describing the two artists, however, Fry confronted two models of the classic: Denis, with his "scholarship and taste" thoughtfully invokes "the great classic tradition of France," yet it is Cézanne who, without imitating the past, manages to be "intensely and profoundly classic." Given his choice of classicisms—one erudite and historical, the other intuitive and creative—Fry clearly prefers the "magic art" of Cézanne, in which classicism is not dependent on historical reference but defined as "the power of finding in things themselves the actual material of poetry and the fullest gratification for the demands of the imagination."

Subsequent scholars have overlooked the second half of this definition to claim that the invocation of classicism in Fry's vocabulary marked a systematic evolution in Bloomsbury formalism away from "Expressionism" and toward the "abstract," away "from the artist and toward his product" in a way that "constrain[ed] the personality to the expression of one thing: significant form," and, finally, away from "Denis's claim that one can be emotionally expressive and classical all at once" and toward a "more logical" idea that the artist must consciously "impose an order or 'design'" on his vision. All of

these formulations suggest a progression toward the formalism of the 1940s and after, and Fry's perceived shift has been assessed in this light. Scholars have variously hailed this shift as Fry's belated recognition that "the best contemporary art was at that moment submitting itself to a very strict discipline," attacked it as an example of Fry's "sleight of hand" and "guile and equivocation" in generating "a normative terminology . . . devoid of any outside, moral application," and, finally, presented it as "in Denis's terms, a step backward toward academicism, to conceive the classical as a purely technical model" rather than a way of being.[18]

However they are evaluated, these generalizations are not sustained by Fry's texts, which continue to emphasize imagination, passion, and expression. His 1911 essay on the Helsinki purchase clearly privileges Cézanne's classicism, as it embodies "the intensity and the spontaneity of his imaginative reaction to nature." In Fry's catalog essay for the 1912 *Second Post-Impressionist Exhibition*, classic art is defined as the record of a "disinterestedly passionate state of mind" (*V&D*, 242), a formulation as expressionistic as anything said about the first Post-Impressionist show, and as blithely oxymoronic as anything Denis ever wrote. The description of Picasso in the 1912 "GRAFTON GALLERY: AN APOLOGIA" (in chapter 2) makes clear how far Fry was from the "purely technical" and "rigid doctrine of significant form" now attributed to him. In this piece, Fry opposes the view that Picasso is "a pure theorist working out abstract intellectual problems of design," arguing, "one has only to . . . mark the nervous sensitiveness and delicacy, the rare distinction of his touch, to see that his sensibility is his most salient characteristic." The same values animate Fry's comparison of the sculptors Brancusi and Epstein at "THE ALLIED ARTISTS" in 1913, and return again in his comments on Christopher Nevinson in "TWO VIEWS OF THE LONDON GROUP" the following year.

If Fry's texts promoting Post-Impressionism demonstrate the tenaciousness of the old expressionistic vocabulary, his reactions to competing avant-garde movements likewise document the overlapping of moral and aesthetic values that reveal Fry's formalism to be neither mechanical nor hermetic. His 1912 review, "THE FUTURISTS," begins by observing "their strangely Nihilistic creed" and ends by insisting that "great design depends upon emotion . . . of a positive kind, which is nearer to love than hate." Similarly, in the 1914 "TWO VIEWS OF THE LONDON GROUP," Fry's reaction to the Futurist-derived Wyndham Lewis betrays the lingering power of expressionist values when he complains that Lewis "does not invite us to feel as he felt." As the social philosopher Berel Lang noted thirty years ago:

The aesthetic experience, Fry wants to say, is autonomous, independent, unique. But it is any or all of these, he holds, because the qualities which accrue to it during the creative process make it so; and *these* qualities . . . we recognize . . . from elsewhere, from our experience and knowledge of emotion, for instance; and they seem in that case inevitably to escape the bounds of formal vision.[19]

It may seem odd to defend Fry from his critics by, in effect, emphasizing his muddleheadedness—though I hasten to say that it is no odder than recent attacks on Fry for being too logically compelling or for developing his theories too rigorously. It is only through the retrospective filter of formalism's later sway over the arts that Fry's tentative and inconsistent writings have come to seem systematic and rigid—and even calculated or cunning. Later formalists overlooked Fry's inconsistencies in favor of a narrative of coherent evolution toward pure abstraction. Now the art world is currently reacting—perhaps overreacting—against the perceived rigidity and authority of later formalists who rode the wave of American cultural and economic hegemony after World War II.[20] For example, recent critiques of Fry's "domination" of the "market for avant-garde art" "which Bloomsbury commanded" in London in 1912 seem strongly inflected by the heady history of a later era when formalist aesthetics were embedded in a high-stakes art market;[21] Fry's venture into the artistic entrepreneurship with the Omega Workshops ended in financial disaster so complete that in 1919 he lost his house. In a postmodern era, when subjectivity, contingency, and deconstructive openendedness are celebrated in contrast to the supposed certainty of modernist hierarchies, we might benefit by a return to the original documents of Fry's formalism to reexamine their textual strategies and his self-consciousness concerning critical tone and authority.

As was noted in the previous chapter, Fry's subjectivity—including his doubt—is central in his formalism, which he always emphasized was "a tentative expedient" (*V&D*, 285), contingent on new experience. Even in his sixties, Fry could be found in the Louvre, as he reported, "forgetting all my theories and all I've ever written and thought and trying to be absolutely passive to my impression" (*Letters*, 566). This insistence on subjectivity amounted, Fry's contemporaries complained, to a virtual "horror of systematic aesthetics."[22] In his own mind, however, this refusal of closure was at the heart of formalist practice: in contrast to the "snobbism" Fry defined as the "blind acceptance" of aesthetic judgments, his performances of openmindedness demonstrated the kind of critical viewing he asked that his readers perform so that they might experience the "emotions aroused by

form," which were the basis of all formalist claims.[23] Fry's method in the reviews assembled in this chapter is frequently to offer his own sequence of inquiry and experience for the viewer to retrace. Far from demanding rigid formalist formulae—or even complete abstraction—Fry manifests surprise at artists who leave figuration completely behind. Of the Cubist Picassos he brought to London for the second Post-Impressionist show, Fry wrote in "THE GRAFTON GALLERY: AN APOLOGIA," "I confess that I take them to some extent on trust," for, he said, it was "possible that we are not yet sufficiently accustomed to interpreting the meaning of such purely abstract form for us to feel to the full [the] effect of these compositions" (in chapter 2; cf. *V&D*, 239). Fry's review of Kandinsky's work in "THE ALLIED ARTISTS" is especially interesting in this regard, for Fry here presents his own process of accepting first the landscapes, and only afterward the "pure improvisations." The contradiction between Fry's theoretical conviction that the formal basis of Kandinsky's paintings "is really true of all art" and his initial unease with the abstractions is openly negotiated.

Here a contrast may be drawn between Fry's formalist exposition and its popularization by Clive Bell in the highly influential 1914 book titled, simply, *Art*. Fry had turned down Chatto and Windus's offer to codify his aesthetics in book form, suggesting Bell for the project instead. Where Fry throughout his life favored the transient insight of the brief essay, Bell was attracted to the potential for definitive and comprehensive overview implied by a book, originally conceiving *Art*—itself a "joy-ride," in Fry's term, "from Sumerian sculpture to Cézanne"—as just part of a longer treatise on "The New Renaissance."[24] Fry's review of the text, "A NEW THEORY OF ART" emphasizes this difference, noting Bell's manifestation of "an assurance denied to me." Fry's self-consciousness about critical tone, going back to his differences with Whistler (see chapter 1), is clearly at issue here, though he concludes optimistically that Bell's "pugnacity" is "good-natured" enough to avoid alienating his antagonists. Fry, however, cannot share Bell's confidence, and his doubts presage much in later critiques of formalism. He both doubts the purity of formal aesthetics and wonders about its relation to the purposes of the artist. Ultimately, Fry emphasizes the critic's subjectivity. Bell argues through "pious belief" rather than "reasoned conviction," Fry says. "The real gist of his book" lies in Bell's trust of his own feelings.

In both his review of Bell's *Art* and his "BLAKE AND BRITISH ART," Fry falls back on subjectivity, establishing a typology of "sensibilities and temperament" that divides viewers into "two classes": the rare "formalists," "who feel aesthetic emotion," and the "most numerous class" who want art to "echo . . . the emotions of ordinary life called up by appropriate imagery."

To this dichotomy of viewers, Fry applies nomenclature of classicism and romanticism, arrogating for his own group the status of "classic." The irony—as has been noted both at the time and since—is that this claim to classicism draws on a profoundly Romantic notion of the artist as an isolated individual striving to express a unique and personal genius, which can only be recognized by similarly rare and sensitive souls.[25] Such Romantic hierarchies can be used to defy or to reinforce social hierarchies,[26] and in Clive Bell's later writings—especially his 1927 *Civilization*—the latter is undoubtedly the case, as critics have been quick to point out. By then, however, Fry had long since split with Bell, describing him as "an admirable journalist" but "a terrible snob"—in fact, the terms of Fry's late essays on "snobbism" and its threat to the arts are applied in his private correspondence very directly to Bell (*Letters*, 519–20, 570).[27] In 1914, however, it was *Art*'s applicability to the program of aesthetic and social renewal that earned Fry's praise. Arguing from his experience of "aesthetic emotion," Bell approaches the "idols of culture" and "just knocks one head off after another." "What a breath of fresh air," Fry exclaims, "what masses of mouldy snobbism he sweeps into the dust heap."

Such passages are indicative of Fry's consistent efforts to link formalism to broader challenges to the dominant culture. For him, Post-Impressionism was not just an episode in the history of art but "a pictorial language appropriate to the sensibilities of the modern outlook" (*V&D*, 238)—a very broad concept. Fry's efforts to bring this modern aesthetic off the canvases, out of the galleries, and on to the streets and stuffs of daily life is a necessary corollary to his vision of a new art for a new world.

<div style="text-align:center">∽∾</div>

NOTES

1. Lytton Strachey quoted in Quentin Bell, *Bloomsbury* (1968; reprint, London: Weidenfeld & Nicolson, 1986), 80; Leonard Woolf, *Quack, Quack* (London: Hogarth Press, 1936), 119; C. Bell, *Art* (New York: Frederick A. Stokes, 1914), 44.

2. Sickert was never a spokesman for the masses. On the contrary, he justified his work in purely visual terms, vehemently resisting any suggestion of sympathy for his working-class models. Moreover, nothing in Sickert's images of brothels and music halls—subjects he drew from French Impressionism—challenged his public's conception of working-class life as violent and sordid. The distortion of Sickert's practice in, for example, Charles Harrison's *English Art and Modernism, 1900–1939* (London: Allen Lane, 1981, 24–26) is enabled by Wendy Baron's *Sickert* (London: Phaidon Press, 1973), which, in its chapter "Sickert's Attitude to His Subject Matter," outlines a virtual blueprint of the Impressionists' dandy or *flâneur* persona, without noting its status as a convention in the avant-garde of the day. On the *flâneur*, see Robert L.

Herbert, *Impressionism: Art, Leisure, and Parisian Society* (New Haven, Conn.: Yale University Press, 1988), 33–40.

3. Charles Ricketts, "Post-Impressionism," and Sir William Blake Richmond, "Post-Impressionists," are reprinted in J. B. Bullen, ed., *Post-Impressionists in England* (London: Routledge, 1988), 106–8, 114–17.

4. Roger Fry, "Artlessness," *Nation*, 20 May 1911, 287.

5. Harrison, *English Art and Modernism*, 47, 149; S. K. Tillyard, *The Impact of Modernism, 1900–1920* (New York: Routledge, 1988), 217.

6. Walter Sickert, "Post-Impressionists," *Fortnightly Review*, January 1911; reprinted in Bullen, 154–66.

7. C. Bell, *Old Friends: Personal Recollections* (1956; reprint, London: Cassell, 1988), 15.

8. Fry acquired Sickert's *Queen's Road Station* in 1916, and it is recorded above the fireplace in the living room of his house in Camden Town in the 1920s (F. Spalding, *Roger Fry: Art and Life* [London: Granada, 1980], 223). The painting is now in the Fry Collection at the Courtauld Institute Galleries.

9. V. Woolf, *Roger Fry: A Biography* (1940; reprint, New York: Harcourt Brace Jovanovich), 186.

10. Quoted in V. Woolf, *Roger Fry*, 257.

11. C. Bell, *Old Friends*, 75.

12. Abigail Solomon-Godeau, "The Armed Vision Disarmed: Radical formalism from Weapon to Style," in *The Contest of Meaning*, edited by Richard Bolton (Cambridge, Mass: MIT Press, 1989), 86–107.

13. I address Fry's collecting in more detail in "The Roger Fry Collection at the Courtauld Institute Galleries," *The Burlington Magazine* 132 (November 1990): 766–69.

14. Bell argues that good design is "architectural"—"mass piles itself on mass, forms balance each other masonrywise"—and he explicitly rejects "imposed" design that "hangs itself in exquisite festoons along the wall" (*Art*, 235–36).

15. Maurice Denis, "Cézanne," *L'Occident*, September 1907; Fry's translation appeared in *The Burlington Magazine* (January and February 1910) and his introductory note is reprinted in chapter 2.

16. R. Shiff, *Cézanne and the End of Impressionism* (Chicago: University of Chicago Press, 1984), 133.

17. Frank Rutter, *Art in My Time* (London: Rich & Cowan, 1933), 114.

18. Benedict Nicolson, "Post-Impressionism and Roger Fry," *The Burlington Magazine*, January 1951, 10–15; S. K. Tillyard, *The Impact of Modernism*, 185–87, 229, 243; R. Shiff, *Cézanne and the End of Impressionism*, 144. The most thoughtful of these commentators, Shiff, nevertheless misreads Fry here, citing Fry's adoption of Denman Ross's mechanical theories of design, but Fry in his "Essay on Aesthetics" specifically says that pictures are "too complex for geometrical proof." Moreover, Fry here isolates the artist's process of "merely gratifying our demand for sensuous order and variety" through felicitous composition from the much more important process where the artist "arouses our emotions" by "the emotional element of design" (*V&D*, 32–33). On the whole, as Shiff's extended analysis shows, Fry constantly wavers between this kind of emotional subjectivity and a desire to legitimate modern art through a rhetoric of conscious purpose and analytic clarity. Both tendencies are

frankly coexistent in all periods of his writing, and, indeed, within individual essays. In this, Fry is much closer to Denis than subsequent commentators have allowed.

19. Berel Lang, "Significance or Form: The Dilemma of Roger Fry's Aesthetic," *Journal of Aesthetics and Art Criticism* 21, no. 2 (Winter 1962): 167–76.

20. This book is not the place to analyze at length the writings of the preeminent later formalist, Clement Greenberg, whose citations of Fry are few and superficial— though late in life, in a talk at Yale University, Greenberg listed Fry as one of the two or three critics worth reading. For a comparison of Fry's "ecelecticism" to the "systematic" Greenberg, see Charles Harrison, "Modernism and the 'Transatlantic Dialogue,'" in *Pollock and After: The Critical Debate*, edited by Francis Frascina (New York: Harper & Row, 1985), 217–32. John O'Brian has argued that Greenberg's criticism was in fact more "provisional" than subsequent commentators have allowed, though even O'Brian acknowledges that "Greenberg's willingness to be provisional diminished during the 1950s." See O'Brian's introduction to *Clement Greenberg: The Collected Essays and Criticism*, vol 3 (Chicago: University of Chicago Press, 1993). Greenberg's claims to tentativeness and subjectivity are clearly contradicted by his repeated insistence that his taste is authorized by history as correct. This strategy is apparent as early as Greenberg's 1939 "Avant Garde and Kitsch"—"there does seem to have been more or less of a general agreement among the cultivated of mankind over the ages as to what is good art and what bad"—and it grew stronger over time; in 1953 he announced, "After all, the best taste agrees in the long run" (quotes in *Art and Culture: Critical Essays* [Boston: Beacon, 1961], 13, 124). For a thoughtful analysis of this "conflict" by one of Greenberg's admirers, see Sidney Tillim, "Criticism and Culture," *Art in America* 75 (May 1987): 122–28. Any comparison of the rhetorics of authority in the writings of Fry and Greenberg must acknowledge the historical context. Where both authors flourished in wartime—Fry's was "Great," where in Greenberg's heyday it was "Cold"—their complicity with the authority of official culture of their eras was very different. On the political context of Greenberg's work, see O'Brian, along with essays by Max Kozloff, Eva Cockroft, and David and Cecile Shapiro in Frascina's *Pollock and After;* as well as Robert Storr, "No Joy in Mudville: Greenberg's Modernism Then and Now," in *Modern Art and Popular Culture: Readings in High and Low*, edited by Kirk Varnedoe and Adam Gopnik (New York: Museum of Modern Art, 1990), 161–90.

21. Tillyard, *The Impact of Modernism*, 218–21.

22. Herbert Read, review of *Last Lectures*, by Roger Fry, *The Burlington Magazine*, November 1939, 215.

23. See Fry's "Culture and Snobbism" (*Trans*, 74–88).

24. Clive Bell, dedication to *Civilization* (London: Chatto & Windus, 1928).

25. The gamut of critics who have recognized the romantic nature of Fry's classicism runs from D. S. MacColl, "A Year of Post-Impressionism," *Nineteenth Century*, February 1912; reprinted in Bullen, 263–84; to Simon Watney, "The Connoisseur as Gourmet: The Aesthetics of Roger Fry and Clive Bell," in *Formations of Pleasure* (London: Routledge & Kegan Paul, 1983), 66–83.

26. For an argument on romanticism's origins as an "attempt to overthrow an authoritarian and elitist cultural hegemony," see Nina Athanassoglou-Kallmyer, "Romanticism: Breaking the Canon," *Art Journal* 52 (Summer 1992): 18–21.

28. Simon Watney's otherwise astute "The Connoisseur as Gourmet" fails to rec-

ognize that Fry's essay on "snobbism" takes aim, not at the "general public" (70) that was after all his readership, but at figures like Bell and, for example, the eminent society hostess Sybil Colefax. In the consistent conflation of Fry's thought with quotations from Bell, Watney fails to heed his own advice that scholars of Bloomsbury be "attentive to conflicts within the group itself" (69).

AN ENGLISH SCULPTOR

THIS paradoxical heading needs justification; for, indeed, those apti-
tudes that go to make a sculptor seem to have been given with a nig-
gardly hand to our race. Even in the Middle Ages, when sculpture was the
most universal mode of artistic expression, we produced no masterpieces at
all comparable with the finest paintings and drawings by native artists. From
the Middle Ages to modern times we scarcely made the pretence to sculpture
of any kind, and the admirable furniture makers of Elizabethan and Jacobean
times displayed ignominious fatuity when they endeavored to cover their
high mantelpieces with figured decoration. Alfred Stevens alone can be cited
in the nineteenth century, and as far as scholarship and taste could take him
he went, but even he showed no aptitude to the discovery of fresh and vital
relations of pure form. This is odd, for the language of sculpture seems to be
a simple one, essentially simpler and more easy to articulate then the symbol-
ism of line and color. Very simple people have it. The Pacific islander who
executed the monstrous image which greets one on the steps of the British
Museum knew at least its rudimentary grammar; they had the sense of scale,
the sense of the sequence of planes, the feeling for amplitude of form. The
workmen of Benin had it, and in a very high degree, for all the crudity and
barbarity of their civilisation. Even the native of the Congo to-day has it. All
these people can make idols, and to make a real idol implies control of plastic
expression, for the idol must impress one with a sense of its own independent
reality. It must be self-consistent and expressive of its own imagined inner
life, in order to arouse in the spectator the attitude of acquiescence and self-
surrender. It would be a long speculation to discover why this particular gift
of expression, the most fundamental effort of the creative will, has been de-
nied to us, but I think that a dispassionate review of our history will show
that it has been.

This makes the appearance of Mr. Gill's work at the Chenil Gallery an
astonishing phenomenon, for here is certainly a sculptor, one to whom the
language of plastic imagery is instinctive and natural. And he proves it all the

Reprinted from *The Nation*, 28 January 1911, 718–19.

more conclusively by reason of his complete ignorance of the knowledge, and his innocence of the appliances, of the sculptor's atelier.

He is, in the first place, a stone-cutter. The sculptor is usually anything but that; he is one who models in clay, and, by the help of elaborate machinery and an Italian workman, gets his model translated more or less successfully into stone. This method of modelling and translation into stone is inevitable where a high degree of exactitude in the rendering of nature is demanded; it was practised by the Greeks, and the Italians of the Renaissance, but the great school of medieval sculpture was one of real stone-cutters, men whose conception was controlled and inspired from the beginning by the qualities of the material in which its external form was destined to live. Michael Angelo alone of modern sculptors seems to have attained to the conception of the intimate relation of the material to the idea.

Mr. Gill, then, is a stone-cutter—in all that belongs to the technique of stone-cutting he is an expert, and the exquisite quality and finish of his surfaces bear witness to this no less than the perfection of those incised inscriptions for which he has long been celebrated. Indeed, his long apprenticeship in a purely abstract and formal art, that of handwriting and letter-cutting, seems to have given him all the assurance, the judgment of eye, and the certainty of hand, which are supposed to be cultivated only by the incessant practice of the studio. And they have given him what the efforts of the modern artist at representation do not always provide, a sense of scale, a power of co-ordination and rhythm, which are the first essentials of great artistic expression. When Mr. Johnstone [Edward Johnston] set out to recover and to teach the lost art of the scribe, it might have seemed that he was bound upon a mission of futile antiquarian revivalism, and yet here, already, in these living, powerful images of Mr. Gill's, his justification is apparent. We see at once the immense advantages of the craftsman's training of the Middle Ages over the studio training of our own days. The craftsman, with his unerring skill of hand, his instinctive judgment of interval and scale, has already the means of expression at hand, and if, like Mr. Gill, he happens to be a man with a burning desire to express himself, neither ignorance of anatomy nor unfamiliarity with the figure will stop him for long.

One realises before Mr. Gill's simple, sincere, and deeply-felt images what a profanation is the teaching of art as it is usually understood; the teaching, as dead facts, of that which each student should discover for himself as the result of an imperious need for expression. We can see Mr. Gill finding out about the structure of the figure, and each discovery is given to us, not as a fact, but as a vividly apprehended emotional experience. And,

owing to his technical skill, each discovery is rendered with unhesitating certainty and power.

The result is that these figures are not more or less successful copies of that desperately unreal and fictitious thing, the model posing in the studio, but positive creations, the outcome of a desire to express something felt in the adventure of human life. And Mr. Gill, having a religious faith in the value and significance of life, has said what he thinks of the acceptance and the rejection of nature, the worship and the denial of the Lucretian Venus, in two extraordinary reliefs. One, the "pale Gallilean," not crucified, but stretched in voluntary self-immolation upon the Cross; the other, a mœnad, in all the insolent splendor, not indeed of her beauty, but of her unquenchable will to live. It is evident from this that Mr. Gill approaches his art from an unusual standpoint—that his works are the external realisations of ideas grasped with intense emotional fervor; that beauty, if it occurs, in his work will be an accident, a by-product, and not the central aim. But if not the aim, it seems to be the inevitable accompaniment of such impassioned expression as Mr. Gill's.

ACQUISITION BY THE NATIONAL
GALLERY AT HELSINGFORS

THE Trustees of the National Gallery of Helsingfors acquired recently at the Grafton Gallery two pictures, one the *Ulysses* by Maurice Denis, the other *Les Maisons Jaunes* by Cézanne. Van Gogh is already well represented in the Helsingfors Gallery. These two pictures are admirably chosen as representative of the most striking, and one believes the most promising, of all recent artistic movements. The *Ulysses and Calypso* of Maurice Denis is certainly among the best recent creations of this sympathetic and scholarly artist. If his work lacks the spontaneity of the earlier pioneers in the movement, it shows none the less the advantages of scholarship and taste. It is not a little surprising indeed to find that one of the chief exponents of a movement which is generally accused of being revolutionary should be among the most learned of all modern artists. How many reminiscences we find here of the great classic tradition of France, the tradition of Poussin, Ingres, and Puvis de Chavannes, a tradition which no movement in France, however revolutionary it may appear, ever loses sight of for long. But with all his scholarship Maurice Denis has a certain witty gaiety of manner, a command of fantastic narrative invention which is admirably shown in this example. If one were inclined to be critical, it might be to point out the use of so definitely naturalistic a rendering as that shown in the distance where the squall of rain passes across the blue Mediterranean, in a design the general scheme of which is so far removed from the illusion of actual appearance; but none the less in itself, this motive is beautifully and subtly rendered.

Cézanne's work, *Les Maisons Jaunes,* is in a very different category. Without any reminiscences of the classic tradition of France, Cézanne is, in fact, one of the most intensely and profoundly classic artists that even France has produced, and by classic I mean here the power of finding in things themselves the actual material of poetry and the fullest gratification for the demands of the imagination. Certainly nothing at first sight could appear more banal, more trivial, less worthy of an artist's deliberate care than the little wayside scene in the South of France which Cézanne has taken for his mo-

Reprinted from *The Burlington Magazine,* February 1911, 293.

tive. A short strip of road crossing a small gully and turning the edge of a hill by some houses which are without any picturesque interest, a few trees, telegraph posts, the slope of a wooded hill, and the sky beyond—there is the material, in itself so matter-of-fact and apparently insignificant, out of which Cézanne's magic art distils for us this strange and haunting vision. The composition, apparently accidental and unarranged, is in reality the closest, most vividly apprehended unity. Out of these apparently casual rectangular forms, from the play of a few bare upright and horizontal masses, a structure is built up that holds the imagination. To the inquiring eye new relations, unsuspected harmonies continually reveal themselves; and this is true no less of the subtle, pure and crystalline colour than of the linear construction of the pattern. In the history of painting one comes but rarely upon pictures which have, like this, an inevitable unity that baffles all analysis and explanation. However different this may be in the absence of all direct suggestion of romantic imagery, it has for me at all events something of the fascination, something of the inexplicable mystery of Giorgione's *Tempest*. The building of a design upon horizontal and upright lines is a task that has rarely been successfully accomplished, but when as here it has been achieved, the result is of surpassing beauty. Cézanne has produced many landscapes of more striking and obvious beauty than this, but few I think which reveal more truly the intensity and the spontaneity of his imaginative reaction to nature.

PLASTIC DESIGN

IN drawing or painting the artist may use his contour either to define areas or to create volumes. In the former case, however accurately the areas are defined, we get at best a likeness to some more vivid reality, in the latter we may get the embodiment of an idea of form. There are, of course, all degrees of intensity and coherence in such embodied ideas, degrees which take us from the greatest to the slightest of artists, but I believe any drawing or painting, which has definite creative power, must possess in some degree this voluminous and plastic design. It is the peculiar disadvantage of our national temperament, as regards the arts of design, that this plastic structural imagination is so little developed. This reacts almost as disastrously on our painting as upon our sculpture. Our pictures suffer from our excessive fondness for the pictorial. We are, indeed, exceedingly anxious to make pictures, but this desire, however admirable, often defeats its own end, since great pictures result from certain definite feelings about the material or visible world, rather than from the desire to create works of art. This lack of the sense for plastic design sometimes nullifies special aptitudes and talents, which with its aid would come to full fruition. When once the plastic relations are duly established in a design, when once the relations of each volume to the other are ascertained, everything takes its due place "in the picture," even though the artist may choose to disregard the niceties of tone and color values, even though his proportions are obviously inaccurate as representation. Whereas, without this fundamental quality nothing can truly be said to take its place in the picture, since there is no really constructed ideated space for them to exist in. This power of evoking voluminous and plastic ideas of form seems, indeed, to distinguish more than anything else the artist from the illustrator or delineator.

Now the better among the modern French painters have this power of creating definite plastic ideas and, at the International Society's Exhibition at the Grafton, though there were no masterpieces and even the few artists represented were not always shown at their best, the work of men like Denis,

Reprinted from *The Nation*, 10 June 1911, 396.

Maufra, Bonnard, and Bussy stands out from its surroundings pre-eminently by this fact. M. Bonnard's Etude No. 117 is remarkable in the way in which, in spite of rather vague atmospheric color, the figure asserts itself. It becomes credible and has a life of its own, so that we realize as much of the sitter's character and daily life as we might from the opening chapters of a novel. Here it is true the idea of character is not intended to be very profound, it is rather a witty incisive rendering of the superficial aspect, but it has this arresting quality of reality and credibility. For all his delicate elusiveness of method, M. Bonnard imposes a definite idea and creates an illusion of reality, and this, I think, largely because of his plastic feeling for form.

Compare with this Mr. Steer's *End of the Chapter* at the New English Art Club. The subject is similar—the girl instead of playing with a dog, as in M. Bonnard's Etude, has just laid aside her novel, and leans forward to warm her hands at the fire. Both pictures are pure *genre* pieces, with no higher aim than what may be revealed in a trifling everyday situation, but in M. Bonnard's we guess at the whole of a life, we feel the reality of the interior; that the room has been actually lived in, that it reflects the lives and characters of its inhabitants and moulds them in its turn. Mr. Steer's picture gives us no hint of the life behind and beyond what is actually seen. It is a *nature morte* deliberately arranged so as to include within the limits of the composition as many agreeable and charming objects as possible. It is somehow clear to us that Mr. Steer's lady never existed in that situation, that the novel is a fiction, and her attitude a pose. All here is subservient to the picture-making instinct of the artist. There is no sign of abandonment to any feeling, no subjection to reality on the artist's part. And this indifference makes itself felt precisely through the want of any plastic reality in the design. The drawing is only a competent delineation of the areas of vision occupied by each object; it creates no illusion of real form, stimulates to no imaginative apprehension. Strangely enough this brings with it a loss of some of those qualities which were so pre-eminent in Mr. Steer's earlier work; nothing here takes its place in the picture; there is no grasp of relative value, every detail of the marquetry pattern on the furniture is done with the same placid uninspired competence as the profile; there is no longer atmosphere nor expressive handling of paint. With unconscious irony Mr. Steer has called his work the *End of the Chapter*—one hopes, indeed, that it is the end of a chapter, the saddest one in a story of great and genuine achievement, and that he may have the energy to turn the page.

In contrast to this I would call attention to Mr. Walter Sickert's *Ebony Bed* in the same exhibition—dull enough in content—a figure sitting on a cheaply upholstered bed in a dowdy French bedroom; this is *genre* without

any of the charm with which Mr. Steer has sought to enliven his composition, nor has it anything of M. Bonnard's witty sensibility. We are brought down to bare facts of vision, but these are stated with such a fine understanding of their relations, the forms are realized with such plastic feeling, that instead of the depression which the dowdy familiarity of the room would in actual life arouse, we feel a shock of surprised delight that, after all, this vision of it has such a curious recondite beauty.

Few British artists have aimed so consistently at this creative plastic idea of drawing as Mr. Will Rothenstein, and at last he seems to be reaping the fruits of his labors. His two pictures of Indian life at the New English are, I think, the most impressive things in the whole exhibition, and their impressiveness comes from the fact that he has surrendered himself so entirely to the essential plastic relations of things. In the *Morning on the Ganges* he has expressed the solidity and mass of the great marble wall rising sheer from the river bank into the blazing light. To make this vivid to the imagination may seem a simple thing; in reality it is only by the rare and hardly-acquired gift of creative draughtsmanship that it can be done, and here the illusion of solidity, of resistance, and of height, is vivid and irresistible, and it is by the grasp of these elementary ideas that the figures gain a singular impressiveness and dignity, so that without any sentimental exaggeration, any wilful emphasis the whole scene impresses one as belonging to a statelier, less ephemeral, less feverish civilisation than our own. Here, at last, an artist has brought back to us from India a credible vision and no mere scenic marvel.

The drawings which Mr. Rothenstein made during his tour in India are on view at the Chenil Gallery in Chelsea. These show conclusively that Mr. Rothenstein must be considered one of our very few real draughtsmen. There is a total absence of cleverness and brilliance of touch which so often passes for the test of draughtsmanship; instead there is an almost labored sincerity and intensity of vision. But the line has the quality of creating form, of arousing the sense of volume and mass, and by this means something is conveyed of the real independent life of the figures. One feels that the artist has had no idea of bringing back Oriental curiosities or *carnets de voyage,* but that he has succeeded, even in so short a visit, in submitting himself to the reality of what was before him, and rendering the life of his figures, and not only their appearance.

MR. WALTER SICKERT'S
PICTURES AT THE STAFFORD
GALLERY

M R. Walter Sickert seems to have been obsessed throughout his life by
an odd idea, namely, that it is a painter's business to paint. This is
curious, especially in England, where the desire for illustration is so persis-
tent, and lies in wait even for the purest artists, when once they attain to
fame. If the English artist escapes that, he generally desires to be a poet, or a
critic, or an aesthete, but Mr. Sickert has never, it would seem, wanted to do
anything but paint. With him this passion is so strong that he is almost
indifferent as to what he paints, his care being altogether for the manner of
it. I have always had the pleasure of differing from Mr. Sickert's views on art,
and I still think that there are other concerns that may well occupy a painter's
mind than just painting; but the show of his pictures at the Stafford Gallery
in Duke Street, St. James's, though rather a miscellaneous and accidental
grouping of his work, convinces me that I have never done him justice. Mr.
Sickert has been an institution for so long that one came insensibly to regard
him like the Throne, or the Bank of England, or the Civil Service Stores,
one of those unchanging and ultimate realities that one accepts, but that one
does not criticise. Year after year he exhibited work of much the same kind,
never an "important" picture, never anything from which conversation or
copy could be extracted, nothing with any sort of subject to it. Generally it
was the same corner of a street at Dieppe, that one had seen many times
before, or a new model, as uninteresting and as little pretentious as the last.
One always knew vaguely that these pictures were very well painted, much
better, indeed, than the work of almost all his contemporaries; but somehow
the matter ended there, except that Mr. Sickert, in his engaging manner,
became mildly amused at critics and criticism, and continued to be exactly as
before. One realises now that the narrow intensity of his passion, his love of
mere painting, has done what larger interests have often failed to do, has
kept his work absolutely pure. He seems never to have made any special
effort, nor to have cherished any high ambition; but he knew that there were
two kinds of painting, good and bad, and that by some good fortune of

Reprinted from *The Nation*, 8 July 1911, 536.

temperament, of education, his work was of the good kind. When now we see his work collected together, we have to admit with something of shame, perhaps, that amid all the pretentions and deceptive promises of more exciting and ambitious art which have attracted our attention from time to time, we have all the time had a real master among us, and have made no stir about him. Fervor of penitence might prompt me to call him a great master, but this would be untrue; indeed, with a surprisingly clear consciousness of his own powers, Mr. Sickert never seems to have aimed at greatness, and after all, how many masters of any kind can we boast of in the arts?

By calling him a master I mean that everything he produces is really done; he does not make shots at things; the particular thing that he sets out to do is actually and almost infallibly accomplished. He knows his trade; one will not find inspired and uninspired moments in his work, but rather a certain and easily maintained level of good workmanship, so that every picture by Sickert will always be an indisputable Sickert beyond cavil of connoisseurship. This means that he has a habitual personal vision, and that he has acquired the art of expressing it with nice assurance.

His vision is curiously detached, not only from the commonplace, utilitarian values of every-day life, but also—and herein lies his peculiarity and his limitation—from the values of the imaginative life. The particular harmony of muted tones that he seeks can be found in almost any scene, and if he attains his harmony of spacing, composition, color, and tone, he is satisfied. Things for him have only their visual values, they are not symbols, they contain no key to unlock the secrets of the heart and spirit. It is almost as if the fancy had taken him to believe, what its author never really did, Whistler's Ten o'clock.

But if we are content to accept this purely visual attitude, to forego the imaginative overtone of things, what a fine discretion, what a rare, almost precious quality Mr. Sickert's work possesses! The perfection and refinement of his taste is evident in the exquisite choice, none the less perfect that it seems to be half-unconscious, of the few tones of violet-grey, dull maroon, orange, and green, out of which he builds his color schemes. I can imagine him saying that he painted what he saw, but it is evident that a process of readjustment of all the tones takes place, whereby all sudden and sharp contrasts are eliminated and each tone takes its relative place in the peculiar sombre scheme which is personal to the artist.

The same taste, the same unemphatic discretion is apparent in his handling of paint. This always gives one the pleasure of a rapid and well-controlled handwriting with just that *désinvolture* which gives vitality and a distinction to an artist's style. Something of an attitude to life, a very uncon-

scious and little defined one it is true, comes through the impassive mask of Mr. Sickert's imperturbable manner; an odd refusal to have any dealings with the material of romance, a persistent devotion to the banal and trivial situations of ordinary life, at times even an attraction for what is squalid. All this seems to belong to his supreme and splendid indifference to anything that does not concern the artistic vision in its most limited sense. One might, perhaps, build a philosophy even out of Mr. Sickert's negations, but I would prefer to leave the task to some German Kunstforscher of a remote future.

THE FUTURISTS

AT the Sackville Gallery is to be seen a small collection of work by this group of Italian painters. The catalogue contains a manifesto of their aims and beliefs. This, at least in the English translation, is by no means closely reasoned or clearly expressed; it might have been better to allow us the assistance of the original Italian.

It is interesting to find painters who regard their art as a necessary expression of a complete attitude to life. Whatever one thinks about the content of their strangely Nihilistic creed, one must admit that they hold it with a kind of religious fervor, and that they endeavor to find an expression for it in their art. Fortunately, too, their dogmas appear to allow of great variety of treatment or method, so that, as yet, no stereotyped formula has been evolved, and each of those artists pursues his researches along individual lines. None the less, admitting as one may the sincerity and courage of these artists and their serious endeavor to make of art a genuine expression of spiritual experience, I cannot accept without qualification their rash boast of complete and absolute originality, even supposing that such a thing were in itself desirable. Rather what strikes one is the prevalence in their work of a somewhat tired convention, one that never had much value and which lost with the freshness of novelty almost all its charm, the convention of Chéret, Besnard, and Boldini. It is quite true that the Futurist arranges his forms upon peculiar and original principles, breaking them up into fragments as though they were seen through the refracting prisms of a lighthouse, but the forms retain, even in this fragmentary condition, their well-worn familiarity.

Apparently what is common to the group is the belief in psychological painting. The idea of this is to paint not any particular external scene, but, turning the observation within, to paint the images which float across the *camera obscura* of the brain. And these images are to be made prominent in proportion to their significance, while their relations one to another have the spacelessness, the mere contiguity of mental visions. Thus, in rendering the state of mind of a journey, the artist jumbles together a number of more or

Reprinted from *The Nation*, 9 March 1912, 945–46.

less complete images of the home and friends he is leaving, of the country seen from the carriage window, and of anticipations of his journey's end.

These pictures are certainly more entertaining and interesting than one would expect to result from such an idea, and one or two of the painters, notably Boccioni (in his later works) and Severini, do manage to give a vivid pictorial echo of the vague complex of mental visions. If once they give up preconceived ideas of what sort of totality a picture ought to represent, most people would, I think, admit the verisimilitude of several of these pictures— would own that they do correspond in a curiously exact way to certain conditions of consciousness. Unfortunately, the result is much more of a psychological or scientific curiosity than a work of art, and for this reason that the states of mind which these artists investigate are not really at all interesting states of mind, but just those states of quite ordinary practical life when the images that beset us have no particular value or significance for the imagination.

The idea of painting from the mental image is no new one, though it is one that artists might well practise more than they do. Blake roundly declared that to draw from anything but a mental image was vain folly; but he drew from mental images only when, stimulated by some emotional exaltation, they attained to coherence and continuity of texture. Probably a great many of Rembrandt's sketches are the result of distinct mental imagery, but it was a mental imagery stimulated by reading the poetical prose of the Bible. The fact is that mental visions, though they tend always to be more distinctly colored by the visionaries' own personality than external visions, are almost as various in their quality, and are, as often as not, merely accidental and meaningless. Doubtless the Futurists aim at giving them meaning by their relations to one another, and in this they aim at a direct symbolism of form and color. Here, I think, they have got hold of a good idea, but one which it will be very hard to carry out; as yet their work seems for the most part too merely ingenious, too scientific and theoretic, too little inspired by concrete emotion. It is the work of bold and ingenious theorists expressing themselves in painted images rather than of men to whom paint is the natural, inevitable mode of self-revelation. One artist of the group, Severini, stands out, however, as an exception. He has a genuine and personal feeling for colors and pattern, and the quality of his paint is that of an unmistakable artist. His *Pan Pan* is a brilliant piece of design, and really does, to some extent, justify the curious methods adopted, in that it conveys at once a general idea of the scene and of the mental exasperation which it provokes. For all its apparently chaotic confusion, it is not without the order of a genuine feeling for design. Here, as elsewhere, the worst fault is a tendency to lapse into an old and commonplace convention in individual forms.

His *Yellow Dancers* is another charming design. The statement in the catalogue that it exemplifies the destruction of form and color by brilliant light, shows the curious scientific obsession of these people. Such a fact is aesthetically quite irrelevant, and the picture is good enough to appeal on its own merits. The same is true of his *Black Cats,* a novel and curious color harmony, which gains nothing from the purely autobiographical note in the catalogue. Whether Signor Severini arrived at his design by reading Edgar Allan Poe or not is immaterial; the spectator is only concerned with the result which, in this case, is certainly justified.

No amount of successful exposition of theory will make bad painting of any value, and, on the other hand, a good picture is none the worse because the artist thinks he painted it to prove a theory, only in that case the theory has served its turn before the picture was painted, and no one need be troubled with it again.

Apart from individual failures and successes, one result of these efforts stands out as having some possibilities for the future of pictorial design, namely, the effort to prove that it is not necessary that the images of a picture should have any fixed spatial relation to one another except that dictated by the needs of pure design. That, in fact, their relation to one another may be directly expressive of their imaginative importance.

In thus endeavoring to relate things not according to their actual spatial conditions but according to their imaginative purpose in the design, the Futurists are, no doubt all unconsciously, taking up once again the pictorial language of early art, for it was thus that Cimabue arranged his diminutive angels around the vast figure of the Virgin in the Rucellai *Madonna.*

What the Futurists have yet to learn, if their dogmas still retain the power of growth, is that great design depends upon emotion, and that, too, of a positive kind, which is nearer to love than hate. As yet the positive elements in their creed, their love of speed and of mechanism, have failed to produce that lyrical intensity of mood which alone might enable the spectator to share their feelings.

THE CASE OF THE LATE SIR
LAWRENCE ALMA TADEMA, O.M.

IT is a curious case. If it were not for the familiarity of its general outline, one would call it incredible, but its oddity was brought home to me by an incident. I was talking to a leading politician who has taken up the question of the nation's relation to art with characteristic energy and public spirit, and an allusion was made by him to the late Sir Alma Tadema. The word "late" struck oddly upon me, and without thinking of what a ridiculous position I put myself in, I said: Is he dead? So little had be been alive to me that though I had undoubtedly seen his death in the papers, I had completely forgotten it. And this was the artist whom of all others the nation delighted to honor, and I was a man of average intelligence, whose chief business in life was the pursuit and study of art.

The historian of this time will have to take note of the fact, then, that there exist, side by side, two absolutely separate cultures, so separate that those who possess one culture scarcely ever take any notice of the products of the other. The converse of my lapse of memory occurred the other day. In the "Times'" review of the year, under the rubric Art, the writer stated that there had been no noteworthy exhibition held during the year, that the public had "done" the galleries with a weary sense of duty. Apparently he was quite oblivious of the fact that the Post-Impressionist Exhibition had drawn a far larger public than any recent exhibition of modern art.

And so the two cultures go on side by side, every now and then expressing their mutual incompatibility, but for the most part ignoring each other.

The culture of which the late Sir Alma Tadema was so fine and exuberant a flower may perhaps be defined as the culture of the Sixpenny Magazine. It caters with the amazing industry and ingenuity which we note in all Sir Alma Tadema's work for an extreme of mental and imaginative laziness, which it is hard for those outside it to conceive.

This culture finds its chief support among the half-educated members of the lower middle-class. Its appeal to them is irresistible, because it gives

Reprinted from *The Nation*, 18 January 1913, 666–67.

them in another "line" precisely the kind of article which they are accustomed to buy and sell.

Sir Lawrence's products are typical of the purely commercial ideals of the age in which he grew up. He noticed that, in any proprietary article, it was of the first importance that the customer should be saved all trouble. He wisely adopted the plan, since exploited by the Kodak Company, "You press the button, and we do the rest." His art, therefore, demands nothing from the spectator beyond the almost unavoidable knowledge that there was such a thing as the Roman Empire, whose people were very rich, very luxurious, and, in retrospect at least, agreeably wicked. That being agreed upon, Sir Lawrence proceeded to satisfy all the futile inquiries that indolent curiosity might make about the domestic belongings and daily trifles of those people. Not that he ever makes them real people; to do that would demand an effort of imagination on the part of his spectators altogether destructive of the desirability of the article. He does, however, add the information that all the people of that interesting and remote period, all their furniture, clothes, even their splendid marble divans, were made of highly-scented soap. He arrived at this conclusion, not as a result of his profound archaeological researches, but again by reference to commercial customs.

He noticed that, however ill-constructed a saleable article might be, it had one peculiar and saving grace—that of "shop-finish." The essence of this lies in the careful obliteration of all those marks which are left on an object by the processes of manufacture. This grace is often a difficult one to obtain. It requires great ingenuity and inventive skill, for instance, to remove completely the marks made upon a vessel by the potter's hands. But I believe that no piece of pottery is worthy to be presented to the general public until this has been done, and the surface reduced to dead mechanical evenness.

Sir Lawrence set his active brain and practised hand to the problem, and learnt to lick and polish his paint, so that all trace of expression, all remnants of vital or sensitive handling that there may have been—the drawings make it seem unlikely that there ever were—were completely obliterated. He gave his pictures the expensive quality of shop-finish.

And like many another industrious and capable commercialist, he had his just reward. We can tell from his work, from the consistently high achievement of those qualities which he did ensue, that he had admirable force of character. We know that even when his wares had taken the public fancy he refused to trade on a name, that he always conscientiously supplied the article up to sample.

His work is like very good, pure, wholesome margarine, and for all we know, Sir Lawrence put it forward as such, and never had an opportunity of

correcting the little misunderstanding on the part of the public which insisted on calling it butter.

Now, that so honest and capable a commercialist should be rewarded by a fortune is what we all expect and rejoice over. But what we really should protest against, if we were not so accustomed to contemporary topsy-turveydom, is that he should get not only the due rewards of the good tradesman but also the rewards meant for the artist. Artists can have no kind of quarrel with Sir Lawrence Alma Tadema himself any more than with the Tottenham Court Road firm which so appropriately owns a number of his works, but they have a right to protest against the remissness and indifference of the governing classes, who, instead of enforcing the Adulterated Foods Act, when they notice that a particular brand of margarine has attained to unprecedented sales, proceed to stamp it all over with the Government stamp, indicating that it is guaranteed to be the best dairy-made butter.

As I say, this would be astonishing if we could get enough outside of contemporary habits of thought to make some sort of true valuation of spiritual things; as things are, the case of Sir Lawrence Alma Tadema is only an extreme instance of the commercial materialism of our civilisation. Against that, the artist is and must always be in revolt, and while it lasts, he must be an Ishmaelite. He must expect a quite instinctive but none the less reasonably grounded suspicion and dislike from the social organism which is governed by a desire to prolong its life.

Another explanation of the case, of course, occurs to one, and would rise naturally to the lips of the successful trader in art, namely, that the artist is a duffer, and his indifference to the glorious career of an Alma Tadema but the expression of his affected belief in the sourness of the grapes. Doubtless most real artists covet honestly enough a tithe of Sir Lawrence's money. That does not smell. But his honors! Surely by now, that is another thing. How long will it take to disinfect the Order of Merit of Tadema's scented soap?

THE ALLIED ARTISTS

THE Allied Artists are celebrating their sixth exhibition at the Albert Hall. The early struggles are over, and general recognition seems to be at hand. Their chief danger was not antagonism but indifference, but even that, formidable though it becomes in July, seems to be yielding to the persistence and energy of the promoters. Antagonism there could hardly be, since, by their very nature, the Allied Artists stand for no one artistic creed more than another. They stand merely for equal treatment of all or any. It is, therefore, as impossible for them as a body to be revolutionary as it is to be academic. Their one and only *raison d'être* is to put each artist into direct touch with the public without submitting his work to the censorship of brother artists. And few artists, however doubtful they may feel of their competence to criticise their own work, are convinced of the qualifications of others who may be hostile, incompetent, or else unfairly prepossessed in their favor. Indeed, when once this principle is fairly brought home to the artist, it would seem that the Allied Artists is the only general exhibition where he can exhibit without some loss of dignity, the only place where no one pretends to dispense to him reward or blame—no one at least but that vague, inarticulate abstraction, the public, and the contradictory voices of contemporary criticism.

Perhaps it is nothing but our familiarity with the examination system which has kept alive so long the mischievous or futile activity of the jury. Artists covet the honor of being accepted where thousands are refused, of being hung on the line when most are skyed; it gives them a position; they are fortified in addressing the public by these certificates from fellow-artists; they can say with some confidence, "You don't like my picture? But at least you know you ought to do so when you consider its excellent testimonials and references." The Allied Artists, while they appeal to the artist's just pride in his profession, to his responsibility and conscience as a worker, do not therefore appeal to his vanity as the diploma-giving juries do. They merely put the artist on his honor. If he shows bad work, he can shelter behind no verdict of his *confrères*.

Reprinted from *The Nation*, 2 August 1913, 676–77.

Their attitude to the public is no less courageous. The Allied Artists call on the spectator for an effort which he is little accustomed to in contemporary exhibitions. He is forced to leave at the door the crutches of snobbism and social prestige with which he has hobbled round the Academy and the Salons. No friendly hand is held out to lead him up to this or that "picture of the year," no prominent finger points the way to facile enthusiasm over this or that centre piece in the weltering mass of art. He knows that the luck of the ballot may have placed the best work in the corner of the n^{th} cubicle, indistinguishable by any mark but its intrinsic merit from all the *croûtes* which jostle it. It is a hard test, and the novice suffers like the faith-healer's patients; but in the end he may learn to walk alone.

Anyhow, a visit to the Albert Hall, alarming as it is, is profoundly interesting, even to those whose aesthetic sense is vague and dim. I can imagine the social philosopher finding here his proper field for investigation. Here, more than anywhere else, he may realise for himself the incredible jumble of conflicting ideals and aspirations of the modern world. Side by side with Kandinsky, pushing forward his fascinating experiments into a new world of expressive form, he will find some dear old friends of his childhood, sailors in sou'-westers and oilskins with the carefully painted grey reflections on their wet surfaces, helping in the rescue of a wrecked schooner, "Mother's darling!" "Love me, love my dog!" and all the other *clichés* of a sentimentality which by now has the faint and pleasant perfume of long forgotten, old-world things. Side by side with Brancuzi's and Epstein's audacious simplifications he will find the last gasps of the enthusiasm for Roman *pastiches* of Greek art, or the tired and laborious photographic realism of the nineteenth century. Here he can trace the expiring efforts of lost causes, and forecast the menace of creeds that are not yet formulated.

But, naturally, the spectator who is more immediately concerned with art will turn with most interest to those works which would not pass the censorship of any British jury, and which, but for the Allied Artists, would never come to his notice. I have mentioned already the two names that interested me most. Constantin Brancuzi's sculptures have not, I think, been seen before in England. His three heads are the most remarkable works of sculpture at the Albert Hall. Two are in brass and one in stone. They show a technical skill which is almost disquieting, a skill which might lead him, in default of any overpowering imaginative purpose, to become a brilliant *pasticheur.* But it seemed to me that there was evidence of passionate conviction; that the simplification of forms was no mere exercise in plastic design, but a real interpretation of the rhythm of life. These abstract ovoid forms into which he compresses his heads give a vivid presentment of character; they are not

empty abstractions, but filled with a content which has been clearly and passionately apprehended. I wish I could say the same of Epstein's exquisitely executed and brilliant deformation, the carving in Flenite. I can only say that my admiration of his skill and of his alert critical sense is unaccompanied, in my own case, with any warmer feeling. I should have to give him the highest marks if I were an examiner, but I should withhold my sympathy.

Of the paintings in the arena, Wyndham Lewis's *Group*, No. 998, is remarkable. It is more completely realised than anything he has shown yet. His power of selecting those lines of movement and those sequences of mass which express his personal feeling, is increasing visibly. In this work the mood is Michaelangelesque in its sombre and tragic intensity. Mr. Lewis is no primitive. Thérèse Lessore's *Market Day at Amiens* is a praiseworthy attempt at composition on a monumental scale and by means of large masses, but it lacks accent in the color oppositions. Her *Village Shop* on a small scale in the Balcony has real charm.

As usual, Mr. Walter Sickert's pupils make a brave show in this part of the exhibition. They nearly all attain to a certain high level of solid accomplishment, and the women attain at least as high a point as the men. Mr. Sickert has reduced teaching to a fine art. He can push his pupils through all the preliminary stages of their art with unfailing accuracy and dispatch. And that, perhaps, is all a teacher can do. The rest he must leave to the gods, and I am not sure that they have yet sent him the material he deserves. Mr. Gore is already distinguished; Miss Sands in her *Venetian Interior* has gone as far as a refined and discriminating taste can go; but for the most part these artists seem too much preoccupied with the *métier* of painting to become definite creators. Still, the influence of their conscientious and honest craftsmanship makes itself felt, and makes the general average of competence higher at the Albert Hall than at any other annual exhibition. This group of artists alone suffices to prove the contention of the Allied Artists. But by far the best pictures there seemed to me to be the three works by Kandinsky. They are of peculiar interest, because one is a landscape in which the disposition of the forms is clearly prompted by a thing seen, while the other two are pure improvisations. In these the forms and colors have no possible justification, except the rightness of their relations. This, of course, is really true of all art, but where representation of natural form comes in, the senses are apt to be tricked into acquiescence by the intelligence. In these improvisations, therefore, the form has to stand the test without any adventitious aids. It seemed to me that they did this, and established their right to be what they were. In fact, these seemed to me the most complete pictures in the exhibition, to be those which had the most definite and coherent expressive power.

Undoubtedly representation, besides the evocative power which it has through association of ideas, has also a value in assisting us to co-ordinate forms, and, until Picasso and Kandinsky tried to do without it, this function at least was always regarded as a necessity. That is why, of the three pictures by Kandinsky, the landscape strikes one most at first. Even if one does not recognise it as a landscape, it is easier to find one's way about in it, because the forms have the same sort of relations as the forms of nature, whereas in the two others there is no reminiscence of the general structure of the visible world. The landscape is easier, but that is all. As one contemplates the three, one finds that after a time the improvisations become more definite, more logical, and closely knit in structure, more surprisingly beautiful in their color oppositions, more exact in their equilibrium. They are pure visual music, but I cannot any longer doubt the possibility of emotional expression by such abstract visual signs.

There are a good many examples of cubism in the gallery. Among the best of these are Per Krohg's *Carnaval* and Wadsworth's *La Route*, but there are also a number of pictures in which a cubist formula has been imposed upon a very ordinary photographic vision. I do not know that this process spoils the work, but it certainly does little to help it, and the pictures remain to all intents and purposes the same as if they had been made up for the Royal Academy instead of the Albert Hall.

Phelan Gibb is an artist whose work has never appealed to me hitherto, but I felt that his *Etude Gothique* had a definite personal character which I could not trace in his more realistic *Huit nus*. I have never seen anything before by Miss Estelle Rice that seemed to me nearly so complete and personal as her *Early Rising* in this exhibition, though the other works she shows are on her more usual level of stylistic accomplishment.

BLAKE AND BRITISH ART

THE questions raised in this controversy are so interesting that perhaps a more leisurely consideration of them than is possible in the form of a letter may be allowed, even after the correspondence has been closed. I shall try to treat them in no controversial spirit, so as not to appear to be unfairly prolonging the fight, after the editor has sounded the "cease fire."

Of late years, more people even than usual have been trying to discover what this odd activity called art really means. We note that no amount of proof of its inutility prevents its continuance. We note that while the mass of mankind can proceed happily through life without taking any serious concern in it, the minority, who do care about it, is so determined and wilful, that the majority tacitly accept their statement of its importance, even to the extent of paying very large sums every year for its maintenance and encouragement.

The real point of departure for this renewed interest in the question is Tolstoy's "What is Art?" Since that became known, it has been generally admitted that the function of art is the expression of emotion, and that if a work of art conveys information, it does so merely as a means to an emotional end.

Now, in the graphic or plastic arts, in so far as definite objects are represented, information will be conveyed. Let us take as an example the *Death of Procris* in the National Gallery. Let us leave out all that might be conveyed by the title and by a knowledge of the legend, as being outside the actual work of art. There is still this much information conveyed, that, in a wide open country, near an inlet of the sea or a broad river, there is lying a young woman who has just died of a wound in her throat, and over her head bends a kneeling man with goat's legs, whilst a dog watches his movements.

Now all this information might be conveyed in representation in innumerable different ways, with innumerable different arrangements of the forms, which would yet all conform exactly to the description here given.

We should admit that every artist in the world might have painted this picture, and that every picture would have been a different and distinct work

Reprinted from *The Nation*, 7 February 1914, 791–92.

of art. Everyone would also, I believe, admit that these different dispositions of the forms through which similar information was conveyed would have a direct influence on our feelings, would put us in various moods as we passed from the contemplation of one to another version of the subject. Now let us suppose that a number of people, all of whom have some familiarity with imaginative life, look at the various pictures of the same subject. They will be seen to belong to two classes. One class will feel vaguely and unconsciously the effect on their general state of spirit of the dispositions of forms and colors, but will consciously dwell almost entirely on the emotions of pity, tenderness, remoteness from ordinary experience, or what not, that this particular collocation of phenomena produces. The other class will feel so acutely the effect of such and such dispositions of form, such and such quantities of color, related in such and such a particular way, that they will think of the dead woman, the fawn, and the landscape only, as it were, out of the corner of their minds.

There will be, in fact, a great difference in the focussing of consciousness between these two classes of people. The first class will demand of the formal arrangements that they be such as to predispose them to a vivid perception of the feelings aroused by the images. The second class will demand of the images that they be such as to enable them clearly to grasp the disposition and ordering of the forms.

It is probable that the emotions felt by these two classes of people will be different. The first class, those whose consciousness is fixed on the content, will probably be able to give some kind of vague definition to their emotions, will be able to indicate, at least roughly, the general complexion of their states of spirit, by words like tragic, pathetic, gloomy, weird, uncanny, and so forth, while those whose consciousness has been fixed all the time upon the form, will have had emotions to which no verbal description applies; they could only get at them, if at all, by wild shots, by similes and metaphors, and they would probably content themselves, in the long run, by saying that they felt the beauty of the work of art.

Now, in the dispute that will ensue between these two sets of people, the first and most numerous class, the class of those who dwell on content, will have some awkward questions to answer if they accept at all the general verdict of artists as to the relative value of works of art. They will have, for instance, to explain why almost total absence of emotional power in the content is possible in a great work of art. Why a picture of pots and pans, by Chardin or Velasquez is profoundly moving. Why Rembrandt's "flayed ox" is a more serious and impressive work than a great many of even his own Crucifixions. And at present I do not see what answer they could make.

On the other hand, the formalists will have put to them the awkward question of why it is that artists have, at all events till Picasso appeared, always represented some kind of object or another.

I can see several possible answers to this; as, for instance, that the artist lives in a world of non-artists, and has to count on their admiration and support, and so has learned to exercise his special faculty, as it were surreptitiously, and under cover of doing something quite different. Or that, finding mostly the stimulus and suggestion of any particular formal harmony in visible things, he has allowed the point of origin to remain apparent. Or, again, that the representation of objects, while it undoubtedly exposes us to the danger of going off at a tangent from formal considerations, yet will (if the temptation be resisted) enable us to co-ordinate and correlate the formal order more rapidly and easily.

I have tried on a previous occasion to give to these two groups the well-worn names of romantic and classic, calling those romantic who dwell most easily and consciously on the associated ideas of images, and those classic whose deepest feelings are aroused by the form.

And when I said, somewhat provocatively and contentiously no doubt, that Blake was the only classic British artist, I stated what from this point of view is a general truth. For Blake does seem to be almost the only British artist who has created dispositions of form which are so significant, so definitely and purposefully ordered, that they do arouse vivid and profound emotions without reference to what they represent. Certainly I found that when I was looking at his amazing series of designs for the "Divina Comedia" at the Tate Gallery, I was never once tempted to think of Dante, nor did I ever want to fit the design to my recollection of the poem, so entirely satisfactory to me, so eloquent, was the language of form as conceived by Blake.

On the other hand, nearly all British art has been concerned with content. I do not mean that British artists have neglected form entirely; they would not be artists at all if they did, but that they have always regarded it as a kind of condiment or sauce for the main dish of representation. They have never pursued those profound and concentrated researches into the nature and significance of form, which have distinguished the great Florentines of the fifteenth century or the great Frenchmen, such as Poussin, Claude, and Ingres. They have never dwelt long enough or intensely enough upon form to find out how it could be made immediately expressive; they have taken refuge in providing a varied and interesting content in the hope to touch the emotions by that easier and more generally understood appeal.

And why not after all, since it is more easily appreciated and more generally understood? For this reason, that those who are sensible to form find

that the kind of emotions derived from the contemplation of it, while they may not be as intense as the emotions of ordinary life, or even as the echoes of those emotions aroused in romantic art, yet are of so peculiar and precious a quality that they are willing to undertake great pains and make great efforts for the enjoyment of them, so that a small number of people do continue to maintain from generation to generation and from age to age the extraordinary value of these quite vague, undifferentiated, universal emotions. They feel, I think, that the emotions aroused by form are more intimately connected with our fundamental, spiritual nature than any others, though I doubt whether they can give proof of this feeling.

Here, then, are two rival theories of the graphic arts, towards one of which people are likely to gravitate according to the nature of their sensibilities and temperaments. One, that the essence of art lies in the echo of the emotions of ordinary life called up by appropriate imagery. According to this view, while form is necessary, it is only necessary as a predisposing cause and condition of appreciation. The other theory is that the essence of art lies in form and the emotions which that arouses.

There is left a possible third view, namely, that while form is the constant and predominant element in all works of art, and while the nature of the content is entirely irrelevant and unimportant (so that a saucepan will serve quite as well as Apollo), yet that the essence of art does lie in the fitness of the form to this neutral and ineffective element in the compound.

I have indeed sometimes a suspicion that this may come nearer to the truth of our aesthetic experience than any other analysis. If it should prove so, it would however, leave the classic theory of art almost, though not quite, unaffected.

A NEW THEORY OF ART

THOSE questions of aesthetic theory which at any time in these last four years have ruffled the pages of *The Nation* are treated in a new book[1] with such intensity of feeling and in such a vivid style as to claim general attention more insistently than ever. Mr. Clive Bell's book is as simple and suggestive as its title. He sets out to state a complete theory of visual art. He says in his preface that he differs profoundly from me. I feel bound, therefore, to do my best to return the compliment. But I can do it but half-heartedly, for although I have never stated a complete theory of art, my various essays towards that end have by very slow steps been approaching more and more in the direction which Mr. Bell has here indicated with an assurance denied to me. It needs some courage to state a complete theory of art, and leave it there for all the aesthetes to have a shy at. And perhaps it is the high courage, the good-natured pugnacity and outspokenness of its author, that make this book the most readable of abstract treatises. Mr. Bell hits out freely all round, and trails his coat as he goes along, but in so gay a spirit that one thinks that none of his victims, Academicians, artists, critics, experts, men of science, or even the general public, will bear him a grudge even if they take up the challenge. And he has a gift of terse and lucid explanation which has enabled him in this short book not only to state his complete theory of visual art, but to show its implications, metaphysical, ethical, social, religious, and even historical. This last is perhaps the most thrilling and exhilarating part of Mr. Bell's aesthetical joy-ride, for he runs us through from Sumerian sculpture to Cézanne, from 3000 B.C. to 1900 A.D., at breathless speed, and with some sharp turns and shattering jolts for the cultured. But it would be a mistake to suppose that because the book is so pleasant and exhilarating to read, because the author keeps us entertained and either delighted or irritated from beginning to end, that it is flippant or superficial. Whether we agree with it or not we must take the argument seriously, for it is meant in all sincerity, and stated with a cogency that claims close attention.

Reprinted from *The Nation* 7 March 1914, 937–39.
1. *Art*, by Clive Bell (Chatto & Windus).

He begins by inquiring what quality is common to all works of visual art and peculiar to them. He finds it to be the possession of "significant form." How do we recognize significant form? By its power to arouse aesthetic emotion. The reader will probably at this point ask: What is aesthetic emotion? And Mr. Bell will reply, the emotion aroused by significant form. Which seems to bring us full circle. But we have really got somewhere. For consider the concrete cases Mr. Bell gives. What is the quality common to Sta Sophia, a Persian bowl, a Chinese carpet, Giotto's frescoes at Padua? Now, if thinking of Giotto's frescoes, we begin talking of the emotions of pity, love, tenderness, and what not, we are pulled up over the Persian bowl and Sta Sophia, where certainly this class of emotion does not occur; so that we are driven to suppose that, however valuable or desirable the expression of these emotions may be in a particular case, it is not the fundamental and universal quality of works of visual art. We have separated out the emotions aroused by certain formal relations from the emotions aroused by the events of life, or by their echoes in imaginative creations. This is one of Mr. Bell's most important contributions to the question. But it is at this point that I wish Mr. Bell had been more ambitious and more comprehensive. I wish he had extended his theory, and taken literature (in so far as it is an art) into fuller consideration, for I feel confident that great poetry arouses aesthetic emotions of a similar kind to painting and architecture. And to make his theory complete, it would have been Mr. Bell's task to show that the human emotions of "King Lear" and "The Wild Duck" were also accessory, and not the fundamental and essential qualities of these works.

Perhaps Mr. Bell rightly felt that this would demand another book to itself. I hope he will undertake it in order to round off his theory, and if he should succeed in making this good, as I believe may be done, it would open up the possibility of a true art of illustration, which Mr. Bell at present refuses to contemplate. Since, if in words images may be evoked in such an order, and having such a rhythmic relation, as to arouse aesthetic emotion, there is no apparent reason why images may not be similarly evoked by painting having a similar formal relation. This would be, as in literature, not a visible, but an ideal form. If, on the other hand, it cannot be shown that the essence of poetry is also one of formal relations, but is due to an admixture of form with content, then there would be nothing surprising in discovering that the art of painting was of a similar composite nature.

Song, again, would appear to be in exactly the same position as painting as ordinarily understood. For here we have the formal relations of music, and the content of ideas conveyed by words. Is there, then, a true art of song? Can we get a pure aesthetic emotion from this mixture? Probably, in propor-

tion as people feel keenly the aesthetic quality of the music, they are content to let the words pass unheeded. I suspect, however, that most people feel aesthetic emotions so slightly that they treat them merely as stimulants to those echoes of the emotions of life which the words of a song arouse, and here, too, we should find the explanation of why many people are moved by pictures without having any keen aesthetic perception of form.

Mr. Bell expresses rather a pious belief than a reasoned conviction that the aesthetic emotion is indeed an emotion about ultimate reality, that it has, therefore, a claim as absolute as the religious emotion has upon those who feel it. The real gist of his book is a plea that to those who feel the aesthetic emotion, it becomes of such importance, so intimately and conclusively satisfying to their spiritual nature, that for them to have it interfered with by any other considerations, by the intrusion of any human emotion, however intense and valid it may be, is to miss the greatest value of art. His book is in praise of contemplative as against practical virtue.

Let us turn to another objection to Mr. Bell's theory, which is likely to arise. He himself admits that the artist has very rarely set out to create significant form; that the early Christian masters set out to express dogmatic theology, the fifteenth-century Florentine and the Impressionist to state laws of optics, Giotto and Rembrandt to express human emotion. Indeed, he considers that few things are more disastrous to the artist than the desire to create significant form in the abstract. It leads to naked and empty aestheticism. The artist, Mr. Bell rightly says, must have something to get into a passion about. But surely this significant form, with all its possible implications of ultimate reality, this form about which Mr. Bell himself rises to genuine artistic passion, is a thing of passionate import. Why, then, should it not suffice better than anything else for the artist? Mr. Bell has a theory about the artistic problem which I will not state, because I do not fully understand it, but it seems to me to be in the nature of a buttress run up to support a weak patch in the wall of his argument. It is just here, indeed, that I feel that the ultimate nature of aesthetic experience still eludes Mr. Bell and all of us, as indeed it may well do for some centuries to come.

Why must the potter who is to make a superbly beautiful pot not think only of its significant form, but think first and most passionately about its functions as a pot? Why must the architect get excited about engineering, as all great architects have, and why must the painter begin by abandoning himself to the love of God or man or Nature unless it is that in all art there is a fusion of something with form in order that form may become significant. And is it not just the fusion of this something with form that makes the

difference between the finest pattern-making and real design? For the most ingenious and perfect pattern—a pattern which we judge to be absolutely impeccable—has not significance, while some quite faulty and stumbling efforts possessing this other thing in them move us profoundly. We should have to admit that this something, this x in the equation, was quite inconstant, and might be of almost any conceivable nature, but I believe it would be possible, applying Mr. Bell's logical methods of deduction, to restate his answer to the inquiry what is common and peculiar to all works of art in some such way as this: The common quality is significant form, that is to say, forms related to one another in a particular manner, which is always the outcome of their relation to x (where x is anything that is not of itself form). I throw out this horrible mathematical formula as a possible suggestion for future investigation, to those at least, whom Mr. Bell's brilliant logic and persuasive eloquence still leave incompletely satisfied.

It would need a separate article or perhaps a separate book to deal with our author's historical survey of art. It is certainly one of the most brilliant, provocative, suggestive things that have ever been written on the subject. It is in a way a complete vindication of Ruskin's muddle-headed but prophetic intimations of the truth. For here at last the whole history of art, as it has been taught by extensive lecturers and text books for ages, is just turned upside down. Barbarian becomes *Blüthezeit,* and *Blüthezeit* complete decadence. Dark Ages become points of shining light, and Renaissance merely prolonged putrefaction.

This revaluation is not, of course, entirely new; the process has been gradually going on for many years; even the despised collectors and archaeologists have done something towards it. Did not the late Mr. Morgan pay more for some Byzantine enamels than for an Alma Tadema? But the implications of this turn of taste have never been so freely accepted, and certainly never stated with such passionate conviction. No one yet has ventured to push over the ancient idols of culture with so light and unconcerned a touch. It is this that dates the work; we of an older generation have felt qualms about the worship of culture, have carped at this or that reputation, have pushed in a query here and a caution there, but we have always had a sense of the awful responsibility of profaning the temples; we have been apologetic and deferential even while we were undermining the foundations.

But Mr. Bell walks into the holy of holies of culture in knickerbockers with a big walking-stick in his hand, and just knocks one head off after another with a dexterous back-hander that leaves us gasping. Many a bounder has been in before and had a cock-shy at the reverend figures, but

precisely because he was a bounder his missiles have had no effect. But Mr. Bell knows the ritual of culture better than the pious hierophants. It is that that makes him so deadly in his aim.

No doubt, if I were to go through his history in detail, I should try to set up a good many of his victims on their pedestals once more, try to repair with pious hands some of what seems to me unnecessary damage. But what a breath of fresh air this iconoclast brings in with him, what masses of mouldy snobbism he sweeps into the dust heap, how salutary even for the idols themselves—those at least that survive at all—is such a thorough turning out! It will be seen that this is a book that all who care for art must read; the surprising good fortune that has befallen them is that it is so eminently readable.

TWO VIEWS OF THE LONDON
GROUP: PART I

THE London Group is a new body. It has just opened its first exhibition at the Goupil Gallery. Its natural history is curious. And first it must be noted of the natural history of almost all artist groups that, like the protozoa, they are fissiparous and breed by division. They show their vitality by the frequency with which they split up. The London Group is in part the result of such a vital process. But there is also a phenomenon known to men of science as symbiosis by which is denoted the coming together for the needs of life of two quite separate organisms, which give each other mutual support in an unkindly world. The London Group is an interesting case of this, for it includes two quite distinct organisms, the old Camden Town group of neo-Realists and other followers of Sickert and the newly-formed Futurist-Cubist group, who have already found the parent envelope of Post-Impressionism too irksome. Perhaps this is as good a way of organizing an exhibition as another, and since the two groups dwell together to satisfy common needs, and not because of any artistic agreement, there is no reason why they should split up. To the public, however, it is possible that the collocation of pictures of such entirely different aim may be puzzling.

Of the Camden Town half of the new compound it is not necessary to speak; we all know how admirably solid and well-grounded their painting is, and how little they endeavor to break new ground. Mr. Gore has never done more to my liking than in his delicately atmospheric canal. Mr. Ratcliffe, who showed an admirable interior lately at the Little Gallery, seems in what he shows here to have caught the infection of dirty violet monochrome, which so often obscures the atmosphere of Camden Town; but he is a talented artist.

The chief interest, for me at all events, lies in the other group. This shows most happily that the fermenting process of the new ideas of Post-Impressionism is still going on—that no particular formula or receipt is going to be stereotyped. Mr. Adeney, for instance, is using the Friesz-Marchand version of Cézanne's art, slightly dosed with Cubism, and it has

Reprinted from *The Nation*, 14 March 1914, 998–99.

set free in him a very genuine and personal feeling for Nature, enabled him to express his delicately contemplative attitude with a force and directness that would never have emerged through the older formulae, where masterly control of representation was a *sine qua non*, for Mr. Adeney is much more marked by the sincerity and delicacy of his feeling than by any pretensions to technical skill.

Mr. and Miss Etchells carry simplification a step further. Mr. Nevinson adopts the orthodox Cubist methods with something of the Futurist ideas of illustration. Mr. Lewis, who, I believe, calls himself a Futurist, is, in the designs he shows here, working out combinations of forms which are nearly as abstract as Picasso's; finally, Mr. Bomberg is developing a quite distinct type of abstract design.

This great variety of direction is indeed a most satisfactory and encouraging sign. It shows that the general idea of the new movement is capable of indefinite expansion in different directions. I know that the scoffer will say that when once you have thrown likeness to Nature away there is nothing to prevent anyone inventing any number of freak patterns, so long as the artist cares about nothing else than to shock the public with some novel monstrosity. As a matter of fact, even assuming such unscrupulous self-advertisement on the artist's part, it is very difficult to invent any new kind of design that hangs together at all, and mere incoherence would never succeed even in arresting attention.

It is quite easy to pick out among these artists those who have some original quality, and those who are merely working by receipt, the adherents of a new academicism. Mr. Nevinson, for instance, who is extremely able, and has considerable technical skill, seems to me entirely academic—which, by the way, is not by any means the worst thing that can be said of an artist. He takes over a formula ready-made and exploits it. His *Non-Stop* is almost a copy of a work by Severini. Like so many of the Cubists, like nearly all the Futurists, he shows little power of interpreting the forms he takes from Nature; his ingenuity comes in in the way he jumbles the jig-saw picture. Mr. Wadsworth, again, seems to me to work by receipt, and to add nothing of his own except a rather heavy, blatant color which his models would have avoided.

But here, I think, the list of merely derivative workers would end. Mr. Adeney has a genuine feeling which he expresses with courageous simplicity and disregard as to whether his picture has the kind of accomplishment which begets admiration. Mr. Lewis's originality is very different. He is by nature highly gifted, and by training highly accomplished, so that whatever he does has a certain finality and completeness. In front of his abstract de-

signs one has to admit their close consistency, the clear and definite organizing power that lies behind them. But it is rather the admission at the end of a piece of close reasoning than the delighted acceptance of a revealed truth. He makes us admit his power; he does not invite us to feel as he felt. So that one wonders what, after all, it was that he felt, unless, indeed, it was mainly the consciousness of his own exceptional ability, and that is likely always to interest him more than the spectator.

Of Mr. Bomberg it would be rash to prophesy as yet, but this much may be said, that he has the ambition, the energy, and brain power to strike out a line of his own. He is evidently trying with immense energy and concentration to realize a new kind of plasticity. In his colossal patch-work design, there glimmers through a dazzling veil of black squares and triangles the suggestion of large volumes and movements. I cannot say that it touched or pleased me, but it did indicate new plastic possibilities, and a new kind of orchestration of color. It clearly might become something, if it is, as I suspect, more than mere ingenuity. In one of his drawings, the purpose becomes clearer; this has a new and to me rather exciting plastic quality. Mr. and Miss Etchells seem to me the two artists of the group that have the most definite artistic sensibility; the only two, in fact, in which this quite spontaneous grace is clearly evident. In Mr. Etchells's case this invaluable gift is backed up by a greater degree of accomplishment, and perhaps a stronger intellectual power; but it is even more pure and spontaneous, more surprising in its unconscious certainty of expression, in Miss Etchells's work.

So long as an artist possesses this gift he cannot go far astray; one convention may ease his expression, another may clog it; but with whatever determination he sets out, however wrong-headed and obstinate he may be, his feeling is sure in the end to get the better of his will. Not that the convention in which these artists paint seems to me unfavorable to them, far from it. I only note how lightly they wear any particular fashion, how effortless and unstrained their movements are, so that among much that is rather vehement in its assertion, their pictures might appear at first almost insignificant in their want of calculated effect. But they count all the more in the long run.

Only two sculptors exhibit at the London Group, Mr. Epstein and Mr. Gaudier Brzeska. I will not repeat my admiring disparagement of Mr. Epstein. I wish I could change it to admiring enthusiasm. Mr. Brzeska is certainly one of the most interesting sculptors working in England. He is very brilliant and facile, and a master of his craft. At present he is very various, sometimes showing too great a reliance on his virtuosity, at others attaining to real directness and simplicity of expression. I am not sure that he is not

more inspired by contact with Nature than by abstract problems of plastic design. There is no fear of his being merely literal or imitative, he is clearly too pure an artist for that; on the other hand, when he is abstract, he may become too schematic. At least, I liked his little naturalistic torso as well as any of his exhibits.

Altogether, the first show of the London Group entirely justifies its formation. It will, for some time at least, provide a platform for the *jeunes féroces*. One may hope that it will remain open to new impressions for at least two or three years, and that is quite enough to justify the creation of an artist group. [Part II, by another author, is not presented here.]

4
ARCHITECTURE AND THE
DECORATIVE ARTS

ROGER Fry's professional life began in the late Victorian age, the end of the era of Aestheticism and the Arts and Crafts movement. Rooted in the moralistic writings of John Ruskin and exemplified by William Morris's medieval-revival workshops, the Arts and Crafts movement condemned the industrial revolution for its effects on the worker and proposed a return to guildlike methods of production. Aestheticism, personified by Oscar Wilde, cultivated broadly romantic notions of artistic sensibility removed from the practical imperatives of the everyday world. Taken together, Aestheticism and the Arts and Crafts harmonized as voices of dissent from the prevailing ethos of industrial capitalism. Indeed, despite the tendency of many historians to oppose the two movements, the Aesthetic refinement that rejected mass-produced consumer goods in favor of fewer, better things had much in common with the Arts and Crafts ideal of a simple life devoted to the production of highly crafted objects. What gave coherence to the two movements was their connection of aesthetic and social reform through the reimagining of the look of daily life. The essays collected in this chapter reveal Fry as very much a product of this era. Here the aesthetics associated with modernist painting find immediate application to architecture and the decorative arts.

To explain the culture that produced Roger Fry, it would be difficult to overemphasize the importance of Ruskin. Ruskin's writings were claimed as the theoretical groundwork for organizations ranging from the Labour Party to the system of working men's colleges that sprang up across England after 1854; indeed, the first such institution reprinted the chapter on "The Nature of the Gothic" from his *Stones of Venice* as its introductory pamphlet.[1] Here Ruskin described the highly ornamented products of England's new manufacturing centers as evidence of the massive poverty and exploitation attending the industrial revolution. Ruskin confronted his readers where they lived, challenging them to "look round this English room of yours," and analyzing the "perfectnesses" of its mass-produced contents as "signs of slavery in our England a thousand times more bitter and more degrading than that of the scourged African, or helot Greek." Following Ruskin, Morris claimed to read

in the look of modern houses the "hypocrisy, flunkeyism, and careless selfishness" that expressed "the very worst side of our character both national and personal."[2] As solutions, both proposed a return to the methods or production they associated with preindustrial guilds.

In the 1870s, Ruskin attempted to enact his ideals by founding a rural commune, modeled on a Gothic village. Saint George's Guild, as it was called, failed, although ancillary efforts to preserve woolworking on the Isle of Man and to found a national trust to preserve historic buildings were successful.[3] More than any of Ruskin's particular projects, however, his legacy was manifest in the guilds and workshops that sprang up under the direction of his followers. William Morris's Pre-Raphaelite Brotherhood of artists-turned-craftsmen, along with his later Morris and Company and Kelmscott Press, are just the best-known institutions of the Arts and Crafts. Others included the Century Guild, founded in 1882, the Art-Workers' Guild, formed in 1884, and the Guild and School of Handicraft, which ran from 1888 to 1907.

Although similar in their basic goals, the diversity of these institutions reflects the degree to which Ruskin's ideas permeated Victorian culture. The Century Guild, organized by A. H. Mackmurdo, was modeled on Morris's Pre-Raphaelite workshop as a federation of practicing artists, who were determined, according to the prospectus, "to render all branches of Art the sphere, no longer of the tradesman, but of the artist." The much larger and looser Art-Workers' Guild brought practicing artists together for lectures and discussions, becoming a center for the reform of art education.[4] Truest to the social aspirations of Ruskin and Morris was C. R. Ashbee, who in 1888, at the age of twenty-five, turned a class on Ruskin at Toynbee Hall, a workers' college in the London slums, into the Guild and School of Handicraft. Ashbee's project evolved from a classroom to its own London headquarters, and finally in 1902 it moved—with its 150 working-class participants—to a tiny village in the Cotswolds, where Morris had earlier dreamed of locating his firm in the abandoned silk mills.

Fry was involved in all of these Arts and Crafts institutions. His interests may have coincided most with those of Mackmurdo, who enlivened the often anglocentric Arts and Crafts circles with his deep appreciation of Italian art and culture, which he often wrote about in his guild's elegant *Hobby Horse* magazine. Fry was brought into Mackmurdo's circle as a historian of Italian painting, enlisted by Helen Coombe to design quattrocento-style decorations for a harpsichord Mackmurdo's workshop was building for the Arts and Crafts Exhibition Society in 1896. When Coombe and Fry were married two months after the opening of the exhibition, the circumstances of their courtship were

so closely linked with Mackmurdo, he—apparently incorrectly—believed he had introduced them.[5] Fry was also a member of the Art-Workers' Guild between 1900 and 1910.

Fry's closest connection to the Arts and Crafts movement, however, was his link with Ashbee and the Guild of Handicraft. Ashbee, a few years older than Fry, was one of his closest friends in college. While founding his guild, Ashbee wrote to Fry, urging him to leave Cambridge and join the cause: "As soon as you take the great leap on to the stern mountain of reality we shall inevitably climb hand in hand."[6] When, in January 1889, Fry did come to London to study painting, he became a drawing instructor in Ashbee's program. Although Fry eventually abandoned the teaching because of his resistance to the elaborate system of Pre-Raphaelite symbolism he was expected to espouse,[7] he and Ashbee remained friends and continued to collaborate on guild-related projects. Ashbee acquired Morris's Kelmscott Press for the guild, and in 1892 his fairy tale, *From Whitechapel to Camelot*, appeared with illustrations by Fry. Their most significant collaboration came two years later when Fry contributed the central mural to a house Ashbee designed as a showcase for his guild's work in wood, metal, and leather. When the house was opened to the press in 1895, it was featured in the Arts and Crafts magazine, *The Studio*, which praised Fry's floor-to-ceiling mural in the drawing room as a "most notable innovation."[8]

Fry's connections to the Arts and Crafts movement have sometimes been obscured by commentators anxious to distance Ruskin and Morris's socialist legacy from a bourgeois hegemony they see as embodied in modernism and therefore personified by Fry.[9] The essays gathered in this chapter, however, reveal Fry's Arts and Crafts roots, not only in his concern for architecture and design, but in his belief that the objects of daily life reveal and perpetuate the social and moral conditions of their creation.

Fry's essays on ceramics, the 1905 "WEDGWOOD CHINA," the 1914 "ART OF POTTERY IN ENGLAND," and the 1924 "ENGLISH POTTERY" clearly draw on Arts and Crafts precedents for their revisionary history. Against the reigning veneration for the Renaissance, Ruskin had condemned this era for allowing the mere "cunning" of realism to supplant simpler artistic techniques that left the earlier artist's "spirit . . . free to express . . . the reaches of higher thought."[10] As Fry himself noted in "A NEW THEORY OF ART" (in chapter 3), Bloomsbury's art historical stance vindicated Ruskin's revisionism, in which "Dark Ages become points of shining light and Renaissance merely prolonged putrefaction." Fry's essays on art, such as "THE GRAFTON GALLERY—I" (in chapter 2), follow Ruskin in rejecting the "too elaborate pictorial apparatus which the Renaissance established in painting"

so that art might once again "regain its power to express emotional ideas." Turning from painting to ceramics, Fry continues to echo Ruskin. Ruskin's famous chapter on "The Nature of the Gothic" asserts "the first cause of the fall of the arts of Europe was a relentless requirement of perfection."[11] Fry's 1905 piece attacks the drive for "mechanical perfection" that destroyed pottery as an art in England. In his second essay on ceramics, Fry similarly charts a downward spiral from the "noble and serious work" of the thirteenth and fourteenth centuries to the "cheerful brutality" and "empty elegance" of recent pottery. In 1924, he extends this analysis, suggesting that only the bankruptcy of contemporary culture could lead to the revival of interest in old English pottery, when "from an aesthetic standpoint it would be far better to study the contemporary peasant pottery of France, Italy, Spain, and Portugal"—though he notes that this is unlikely to happen while academic prestige is attached to "those who have long been dead" and are not around to speak for themselves.

This is the Fry who, upholding the housemaid's sensibility above her employer's (V&D, 291; quoted in chapter 2), saw formalism as a way of wresting art away from the upper classes. In "The Art of Pottery in England," Fry repeats Ruskin and Morris's claim to read in the division of fine from rough pottery "the profound division between the culture of the people and the upper classes which the renaissance effected." Such Arts and Crafts ideas suffuse Fry's writings from the period of the Post-Impressionist exhibitions. A 1910 essay on contemporary jewelry offers this description of the split between artist and artisan: "Among professional artists there is a certain social class-feeling . . . , a vague idea that a man can still remain a gentleman if he paints bad pictures, but must forfeit the conventional right to his Esquire if he makes good pots or serviceable furniture."[12]

"The Case of the Late Sir Lawrence Alma Tadema, O.M.," of 1913 (in chapter 3), likewise connects the "dead mechanical evenness" of mass-produced pottery to the finish of the academic painting favored by the bourgeoisie. The result of this "snobbish" taste is self-evidently bad for the poor craftsman, but in both essays Fry follows Morris in arguing that it is bad for the artist as well.[13] "In proportion as he has cut himself loose from the fundamental limitations and conditions of design he has lost his science and craftsmanship, has become clever, conceited, and unworkmanlike," Fry asserted in 1910. By 1913, Alma Tadema is inscribed as the (recently) living proof of this crisis in art, and the Post-Impressionist "revolt" against bourgeois "commercial materialism" is presented as art's salvation.

The legacy of Ruskin, Morris, and the Arts and Crafts is evident in Fry's essays, not just about the decorative arts, but also about architecture. A short

letter to the *Times* on "THE REGENT-STREET QUADRANT" encapsulates Fry's views. Again the "deadening" of art is linked to the ideology of the bourgeoisie, with its "snobbism" and its rhetoric of "sacrifice," which result in the "archeological humbug" of the historical-revival styles that typified so much Victorian and Edwardian architecture. And again, this perspective echoes Arts and Crafts sources,[14] but Fry here combines an Arts and Crafts attack on the "nonsensical forms" of conventional design with an explicitly modernist position in favor of the controversial new Kodak building, a structure often cited for its large windows and frank expression of structure as a harbinger of English modernist architecture (fig. 4.1). Fry's call for a new architecture, designed by engineers to respond to such practical concerns as shopkeepers' desire for plate glass vitrines, anticipates the functionalist rhetoric that came to be the basis of modernist design.

If time has rendered Fry's views on architecture conventional in our eyes, the tone of his 1912 letter marks his alienation from his contemporaries in the professional academies and their knighted leaders. His views failed to persuade the authorities who ultimately selected Sir Reginald Blomfield to rebuild the Regent Street Quadrant in a Beaux Arts revival style.[15] Fry expanded his critical analysis of the architectural establishment in an article several months after the letter to the *Times*,[16] and more substantially in a 1921 address to the Royal Institute of British Architects, which he subsequently published as a pamphlet with the provocative title, "ARCHITECTURAL HERESIES OF A PAINTER."

Ruskin's precedence is a leitmotif in this essay, with Fry three times invoking his authority as a critic, once challenging the "morbid" nostalgia for historical styles that was Ruskin's most apparent influence, and throughout combining detailed observation with vehement exhortation in a way that bespeaks his aspiration to affect British life as profoundly as his renowned predecessor. While Ruskin's name was venerated (often based on a rather selective reading of his work), however, Fry's warnings against "dressing buildings in historical styles" found no warmer reception in official culture than had his letter nine years before. When the *Times* interviewed Fry and Blomfield,[17] the leading professional journal of architects complained that even this even-handed treatment was inappropriate, for it encouraged "notoriety hunters" like Fry: "It is obvious that misguided persons will do what they know is wrong or absurd if they are only supported by sufficient notice, while a cold douche of absolute silence would free us from a plague of decadent writers, futurists, would-be revolutionists, and others." Fry reprinted this passage on the cover of the published version of his speech.

What will strike readers versed in architectural history is the degree to

4.1. Kodak House, designed by John Burnet, 1911; photograph from *The Architectural Work of Sir John Burnet and Partners* (Geneva: Masters of Architecture, 1930)

which Fry's remarks of 1912 and 1921 anticipate more famous manifestos of modernist architecture, such as Le Corbusier's *Vers une architecture,* first published in 1923 and translated into English in 1927 by one of Fry's original Omega Workshops artists, Frederick Etchells. Fry's language in arguing for a modern architecture based on "engineering beauty" as exemplified in "purely utilitarian structures in America, particularly vast grain elevators," presages Le Corbusier's celebrations of "the American grain elevators and factories, the magnificent first fruits of the new age." Fry brought to his analysis of architecture the rhetoric he had developed defending Post-Impressionist paintings and sculpture. Architectural "beauty," he said, was "the evident sign of an inward spiritual state" on the part of the architect, and "the expression of a plastic idea." On the same point, Le Corbusier said, "The Architect, by his arrangement of forms, realizes an order which is a pure creation of his spirit; by forms and shapes he . . . provokes plastic emotions; . . . it is then that we experience the sense of beauty."[18] As with his writings on art, Fry's

architectural principles, marginal at the time of their enunciation, in retrospect find a central place in the history of modernism.

Despite his prescience, Fry's interest in architecture is hardly known. The later modernist insistence on the "purifying" separation of the arts (discussed in chapter 6) offered no incentive to acknowledge the architectural career of an artist and theorist associated with painting. This tenet of later formalism, however, could not be more different than the attitude of modernists in the first decades of the twentieth century, when the Arts and Crafts movement's holistic synthesis of aesthetic and social reform sparked work across all disciplinary boundaries—it should be recalled that Le Corbusier, too, combined painting and architecture. Even readers well acquainted with Fry's writings on aesthetics are often surprised to learn of his architectural career, which extended not only to commentaries like those reprinted here, but also to actual buildings. In 1925, Fry designed a studio addition for Charleston Farmhouse, the home of Vanessa Bell and Duncan Grant, which today is preserved as a museum. Fry's enthusiasm over the economy, practicality, and simplicity of his plans—"if we can keep the builder from putting in knick-knacks and mouldings" (*Letters*, 564)—reveals the consistency in his architectural principles.

The most significant manifestation of Fry's interest in architecture, however, is Durbins, the house he designed for his family in 1908 (fig. 4.2). This house still stands in Guildford, outside London, where it surprised the historian of modern architecture, Nikolaus Pevsner, who compared it favorably to Adolf Loos's contemporary Austrian villas and dubbed it "one of the landmarks in the evolution of an independent contemporary style in English architecture."[19] Fry's own pride in the house he designed is evident in a letter to the painter, William Rothenstein, which demonstrates as well the Arts and Crafts linkage of art and life through the design of the domestic: "I do so want you to see this house. I think you will like it as an attempt to make a house very economical and yet expressive of the needs of our sort of life" (*Letters*, 327). Both the house and the ideology behind it, however, may be best known through an essay Fry wrote about the design, which he promoted as "A Possible Domestic Architecture: A Challenge to Self-Conscious Picturesqueness" (*V&D*, 272–78). This piece, which appeared in 1918 in the English edition of *Vogue*, was revised for Fry's first anthology, the 1920 *Vision and Design*. Both the house and the article describing it, reinforce the themes of "ARCHITECTURAL HERESIES OF A PAINTER."

The most striking feature of Durbins is its stark garden facade with two massive columnar windows that echo the commercial buildings of the period, such as factories or, most famously, Charles Rennie Mackintosh's contempo-

4.2. Durbins, designed by Roger Fry, 1908; photograph circa 1917

rary library for the Glasgow School of Art.[20] Clearly reflecting Fry's advocacy of "engineering beauty," the windows also suggest his iconoclastic stance toward the cultural norms of his day. Fry gleefully reported that his house was "regarded as a monstrous eyesore" in his "snobbish" neighborhood of "gentlemanly picturesqueness, houses from which tiny gables with window slits jut out at any unexpected angle" (V&D, 278). Against the standard Romanesque, Gothic, Jacobian, and Queen Anne "architectural 'features' which have been duly copied by modern machinery, and carefully glued on to the houses" (V&D, 273), Fry upheld the functional simplicity of his own stark design, with its simple brick accents. Explaining the two-story interior space corresponding to the fenestration, Fry declared his allegiance to continental European traditions, seizing the opportunity to topple one of the most sacred symbols of English national identity: "I hate Elizabethan rooms with their low ceilings . . . , and I love the interiors of the baroque palaces of Italy" (V&D, 276).[21]

Fry's assessment of historical-revival design as a manifestation of social hierarchy, his promotion of functionalism, his contempt for the preciousness of vernacular English architecture and admiration for the scale of continental design—all of these elements of Fry's house and the essay describing it find their correspondences in "ARCHITECTURAL HERESIES OF A PAINTER." Readers of Fry's essays on art will find a good deal more that is familiar here. For example, historical-revival styles are rejected as a form of "social symbolism" in the same terms that earlier served to repudiate narrative painting, while the platitudes of English patriotism are turned upside down in provocative displays of anglophobia that echo the writings on art. Other reverberations of Post-Impressionist principles include Fry's pronouncements that "real style is . . . the perfect adaptation of the means of expression to the idea" or "beauty is a relative quality which inheres in the forms of the object of art only in so far as it is an evident sign of an inward spiritual state on the part of the artist." And, of course, there is "Heresy No. 5—Aesthetic beauty in a building is essentially the same as that of sculpture. It results from the expression of a plastic idea."

Taken together, Fry's essays on pottery and architecture document his Arts and Crafts impulse to extrapolate from the study of painting and sculpture principles for the look of daily life. Fry's devotion to this broad notion of aesthetics is manifest most clearly, however, in the project that epitomizes his Arts and Crafts roots: the founding of his own guild, the Omega Workshops. Here, in what seems a consummately English reaction to modernism, Fry and his associates moved almost immediately from their first exposure to avant-garde French art to apply its new aesthetic to the decorative arts. As is evidenced in the OMEGA WORKSHOPS FUNDRAISING LETTER reprinted here, Fry began soliciting support for the scheme late in 1912, while the second Post-Impressionist exhibit was on display. Writing to moneyed individuals he thought might be sympathetic—the copy transcribed here went to George Bernard Shaw—Fry invoked the precedent of Morris's Pre-Raphaelite artists-turned-artisans, expressing his hope that the Omega would prompt people to resume "employing contemporary artists to design their furniture and hangings."

The influence of the Arts and Crafts movement on Fry's Omega Workshops is further demonstrated by the untitled publications reprinted here: the PROSPECTUS FOR THE OMEGA WORKSHOPS, which was prepared for the workshops' opening in 1913, and the PREFACE TO THE OMEGA WORKSHOPS CATALOG, which appeared a year later.[22] Morris is invoked by name in the prospectus, while his uppercase dictum, "ART IS MAN'S EXPRESSION OF HIS JOY IN LABOUR,"[23] echoes clearly through Fry's words in both

texts. The opening paragraphs of Fry's preface to the Omega catalog, more-over, are a virtual paraphrase of Ruskin's "The Nature of the Gothic," only substituting African artisans for Ruskin's primitivist idealization of Gothic craft. Where Ruskin urged his readers to "go forth again and gaze upon the old cathedral front where you have smiled so often at the fantastic ignorance of the old sculptors," Fry began from the observation that "if you look at a pot or a woven cloth made by a negro savage of the Congo . . . you may begin by despising it for its want of finish." Where Ruskin went on to turn the tables on his English audience's response to the roughness and invention of gothic carvings, warning, "do not mock at them, for they are signs of the life and liberty of every workman who struck the stone," so too Fry pro-ceeded, "If you will allow the poor savage's handiwork longer contempla-tion . . . it will become apparent that the negro enjoyed making his pot or cloth, that he pondered delightedly over the possibilities of his craft and that his enjoyment finds expression in many ways." Ruskin then condemned the capitalist economy where workers "have no pleasure in the work by which they make their bread, and therefore look to wealth as the only means of pleasure." So too, Fry explained that "the modern factory products were made almost entirely for gain, no other joy than that of money making en-tered into their creation." As an antidote, Ruskin ordered his readers: "Rather choose rough work than smooth work . . . and never imagine there is reason to be proud of anything that may be accomplished by patience and sand-paper." According to Fry, the Omega artists "refuse to spoil the expressive quality of their work by sandpapering it down to a shop finish."[24]

For Fry, as for Ruskin, the invocation of a cultural tradition perceived as primitive—whether Gothic or African—offered an alternative to conven-tional historical narratives that authorized the status quo through reference to the precedent of classical Greece, ancient Rome, and their Renaissance re-vival. Fry quite self-consciously set his workshop in the context of Arts and Crafts radicalism. The historical overview he offers in the Omega prospectus seeks to tie the Arts and Crafts movement to the history of painting he had earlier sketched to justify Post-Impressionism in its break from Renaissance convention (in chapter 2). Terms like "decoration" and "design" already per-meated his defenses of modern art. Now he simply shifted the emphasis of the argument with the claim that the aesthetics of realism had split art from craft by making artists "comparatively uninterested in abstract design." As in his history of painting, Impressionism—seen as a last gasp of realism—gets short shrift. But now Morris—replacing Cézanne—becomes a pivotal figure, as the first to exploit for the applied arts "the movement among art-ists . . . toward decorative design." The link Fry forged with Morris in these

promotional materials for the Omega was picked up in press accounts of the workshops, with Lewis Hind in the *Daily Chronicle* proclaiming, "Fry and his friends are wayfaring out on just such another gallant adventure as that on which William Morris and his friends voyaged forth years ago in Red Lion Square."[25]

Nor were the connections between the Omega and the ateliers of the Arts and Crafts purely textual, for the objects marketed by Fry's group drew on traditions associated with Ruskin, Morris, and their followers. In his *Stones of Venice*, Ruskin had challenged utilitarian notions of aesthetics by proclaiming that "the most beautiful things in the world are the most useless, peacocks, and lilies for instance,"[26] motifs that turn up repeatedly in Omega decoration—a lily actually graced the workshops' signboard, painted by

4.3. Omega Workshops, dining chairs, designed by Roger Fry, 1913; photograph courtesy of Hirschl and Adler Gallery

4.4. Guild of Handicraft, embossed silver tray with peacock design, design by
C. R. Ashbee, 1896–97; photograph courtesy of Victoria and Albert Museum

Duncan Grant. And where Morris's studio came to be identified with the
"Morris chair," the Omega marketed its red dining chairs as signature pieces
(fig. 4.3)—some even topped with a wooden omega (see illustration in "The
Artist as Decorator"). With their highly simplified, rectilinear profile,
the Omega chairs, designed by Fry, have little to do with Morris's cozy me-
dieval aesthetic. Fry's roots in Ashbee's Guild of Handicraft, however, are
evidenced in one of his Omega designs, featuring pairs of peacocks, their
oppositional placement repeating a motif found in one of Ashbee's designs
for a silver tray (figs. 4.4, 4.5).[27] Fry's description of one of Grant's designs
for an embroidered cushion made for the Omega might be taken to encapsu-
late the whole enterprise: "It was a mid-Victorian idea, but it was not treated
in a mid-Victorian manner."[28]

The "manner" of Omega design was, of course, the modernism associated
with the French avant-garde. Surrounded by the furniture, the knickknacks,
and the painted fabrics and murals that went on sale when the Omega
opened in July 1913, shoppers could imagine they had stepped into a paint-
ing by Matisse or Picasso. Comparisons with Matisse are clearest, for almost

4.5. Omega Workshops, design with peacocks, attributed to Roger Fry, circa 1913–14; photograph courtesy of the Courtauld Institute Galleries

all the props featured in his interiors of 1911–12 may be found realized in Omega objects from the first years of the workshops: the simple red furniture, the goldfish, the reclining nudes, the sketchy rugs, the abundance of flowers.[29] At the same time Picasso's influence is evident in pieces like this painted fan (fig. 4.6), and the Cubists' collage technique informs numerous Omega designs, which are sometimes indistinguishable from the collaged artworks Fry and his Bloomsbury colleagues experimented with at this period.[30] Collage—in the form of applied sheets of variably painted wallpaper—became a staple of Omega interior design, as described by Fry in "THE ARTIST AS DECORATOR." The influence of Cubism may be most striking in Fry's 1918 decoration of a harpsichord, which makes the irregular shape of the case the basic element in an abstract composition of angular forms (fig. 4.7). Fry's harpsichord, though, is emblematic of his historical position between the Victorian and French modernist avant-gardes, for under its resolutely French modernist exterior it is very much an Arts and Crafts product. Its maker was Arnold Dolmetsch, a pioneer in the revival of medieval music who, twenty-two years before, had built the harpsichord that Fry and his future wife decorated for Mackmurdo's Arts and Crafts Exhibition Society display.[31]

4.6. Omega Workshops, painted fan attributed to Duncan Grant, circa 1913; photograph courtesy of Victoria and Albert Museum

Despite its resolutely English heritage, however, the Omega was not, as is sometimes assumed, the first attempt to apply the aesthetics of French modernism to domestic design. Fry's initial OMEGA WORKSHOPS FUNDRAISING LETTER cited—almost in the same breath with Morris's Pre-Raphaelites—the precedent of Paul Poiret's École Martine, a contemporary Parisian workshop modeled on English Arts and Crafts enterprises that combined artistic and social reform. Poiret's school offered artistically inclined girls (ages twelve and thirteen) from working-class families a daily wage for designing murals, rugs, pottery, textiles, screens, and painted furniture, all of which were then marketed under the name of the atelier.

Fry followed Poiret's model in the financial structure of the Omega, where artists worked anonymously up to three half-days each week—no more so as not to compromise their primary vocations as painters and sculptors—for a salary approximately equal to that of a clerk, with a promise of eventual profit sharing.[32] Fry, however, did not seek to employ working-class girls but those of both genders he called "young artists": the English Post-Impressionists. The memoirs of his assistant, Winifred Gill, record that, although "the plight of young artists was very much a matter of consid-

4.7. Roger Fry, design for painted harpsichord lid, 1918; photograph courtesy of the Courtauld Institute Galleries

eration" with Fry around 1910, the specific catalyst for the Omega came when Duncan Grant, one of the painters he championed, was several days late for a portrait commission at Durbins because he lacked the necessary train fare.[33] Developed to relieve what Fry saw as the financial hardships of artists working in modes unfamiliar to the art-buying public, the Omega was the culmination of a series of projects Fry developed to secure employment for young modernists. In 1909, he was involved with the establishment of the Contemporary Art Society, which purchased works by young artists, and in 1911 he arranged for a group of Post-Impressionists to paint murals in the refectory of a working-class vocational school in London, the Borough Polytechnic—this latter episode, with its echoes of various Arts and Crafts projects,[34] is mentioned in the fundraising letter.

Fry's philanthropic emphasis on young artists, although it is comparable to efforts like Mackmurdo's Century Guild, differed from the stated goals of the major Arts and Crafts workshops, a distinction Fry noted in the Omega prospectus. Of the artists in the Omega, he said: "Less ambitious than William Morris, they do not hope to solve the social problems of production at the same time as the artistic." As the writings reprinted here show, Fry was deeply influenced by Arts and Crafts activists who combined social and aes-

thetic reform, yet he could not help also recognizing his predecessors' ulti-
mate failure to realize their ambitions. Morris's other social activism notwith-
standing, his own firm made the reputation on which it prospered not as a
workers' cooperative, but as a small consortium of what the original prospec-
tus described as "Artists of reputation" turning their hands to decorative
work. Even when financial success allowed the firm's expansion to a large
rural workshop with many employees, the traditional division of both labor
and profit remained unchallenged, and by 1910 Morris and Company had
become a typical commercial decorating firm.[35] Meanwhile, in contrast to
the prosperity of Morris's firm, the guilds that had been inspired by Morris's
ideals to challenge the prevailing structure of modern manufacture had failed.
The strongest of these, Ashbee's Guild of Handicraft, collapsed in 1907,
with its founder acknowledging it "ruined itself in an attempt . . . to
show . . . that standard of workmanship and standard of life must be taken
together and that the one is dependent on the other."[36] With the benefit of
hindsight, Fry was straightforward in acknowledging the limited aims of his
guild. Making no pretensions to turn laborers into artists, neither did it claim
to turn artists into craftworkers. "My idea [was] not to make the artist a
craftsman, at all events to begin with, but to give him the necessary knowl-
edge of technical processes to enable him to design for the craftsman," Fry
explained in a lecture on the Omega.[37] And despite the Arts and Crafts
rhetoric of "joy in creation" that marks the PROSPECTUS FOR THE OMEGA
WORKSHOPS and PREFACE TO THE OMEGA WORKSHOPS CATALOG, Fry
frankly distinguished the work "in which the artist can engage without spe-
cialized training" from the production of furniture, textiles, and rugs, which
were designed at the Omega and executed under contract by professional
firms and factories.

The difference between the social missions of the Omega and its Arts
and Crafts progenitors was more theoretical than practical, however. Some of
the Omega's artists came from working-class backgrounds, and, like Morris,
Fry tried to master the trades he designed for, taking instruction in pottery,
for instance. But he had little sympathy for the fixation on skilled technique
that characterized institutions like the Central School of Arts and Crafts,
directed by W. R. Lethaby, the cofounder of the Art-Workers' Guild who
earnestly sought to instill in his students a work ethic associated with
middle-class values. Lethaby compared art to naval engineering—and also to
Boy Scouting and "tennis in flannels"—as endeavors where "order, construc-
tion, beauty, and efficiency are one."[38] Gill recalled Fry joking, in the face of
difficulties with batik at the Omega, that one of the artists would have to
sacrifice and "offer themselves up" to the Central School to learn the proper

technique. Fry's humor marks his distance from Lethaby, whose earnest combination of craftsmanship and sportsmanship could not be further from the notion of art implicit in "THE ARTIST AS DECORATOR," which Fry wrote in 1917 to explain the work of the Omega.

Although Fry begins "THE ARTIST AS DECORATOR" by echoing Ruskin and Morris's critique of the social hierarchy that separates the artist from the artisan, he ends, not by making the artisan an artist, as his predecessors advocated, but by asserting the artist's suitability to do artisan's work. Downplaying the housepainter's steady and persistent craftsmanship, Fry upholds analogous Omega work as the product of the "real artist," who can be identified by his "feeling for pure design, . . . subtle sense of proportion and of colour harmony which will enable him to make a definite work of art out of an interior," and also, significantly, by the fact that he is "far more difficult to deal with" than the craftsman. In short, the Arts and Crafts emphasis on skilled technique is here dismissed in favor of Romantic notions of creative genius.

Fry's characterization of the artisan as a "more serviceable and subservient machine" would seem to betray Ruskin's impassioned pleas to rescue workers from their coglike role in industrial capitalism. Here and in other essays from this era,[39] Fry accords artists superiority over other members of the human race, asserting that they see, think, and act in specific ways. At this period, Fry also abandons Arts and Crafts notions of art as the expression of broad cultural forces, arguing in the 1917 "Art and Life" that the cycles of art and history are "in the main self-contained" with stylistic evolution in art "determined much more by its own internal forces" (*V&D*, 9).

In both of these developments, Fry may be seen replacing Arts and Crafts ideas with tenets derived from another faction of the Victorian avant-garde: the Aesthetic movement. His privileging of artistic individuality over the machinelike artisan echoes the sentiments of Oscar Wilde: "the moment that an artist takes notice of what other people want, and tries to supply the demand, he ceases to be an artist, and becomes a dull or amusing craftsman, an honest or a dishonest tradesman." Likewise Wilde insisted that art, "so far from being the creation of its time . . . is usually in direct opposition to it, and the only history it preserves for us is the history of its own progress."[40]

For some commentators, Fry's embrace of Wildean Aestheticism is interpretable only as a rejection of Arts and Crafts political commitment in favor of a contrary stance of apolitical elitism.[41] This view, however, reveals less about Wilde's ideas than about the susceptibility of history to stereotypes. Wilde's sensational trial and conviction have blinded historians to his allegiance to an Arts and Crafts movement defined by the hearty masculinity of

Morris, while clichés of homosexuals as an effeminate minority have precluded recognition of Wilde's engagement in politics, conventionally associated with male prerogative and the rhetoric of majority rule. Yet Wilde was quick to cite Ruskin and Morris as the intellectual progenitors of his Aestheticism and to promote Arts and Crafts institutions,[42] many of which straddled the line historians have subsequently drawn between the two movements. Mackmurdo's Century Guild, for instance, published Wilde and other Aesthetes in its *Hobby Horse* magazine, while Ashbee, sounding very much the Aesthete, warned of the dangers of socialist conformity for the individualism of the artist.[43]

Recently, moreover, Wilde's importance as a theorist of social and political life has been recognized by historians charting the development of the idea of gay community.[44] What their analyses enable us to recognize in the comparison of Morris and Wilde is not a split between the political and the apolitical, but rather two models of social critique that can be schematized as utopia versus subculture. Whereas Morris, like Ruskin, proposed utopias—benevolent hegemonies, designed down to the dress of their happy inhabitants—Wilde celebrated the potential of outsider identities, like the criminal and the artist, to sustain opposition to dominant cultural norms without relying on the promise of eventual popular acceptance.[45]

Wilde's position is stated most clearly in *The Soul of Man under Socialism*, which, while it enthusiastically asserts the need for the redistribution of wealth, in its description of "three kinds of despots" warns of the potential for totalitarianism:

> There is the despot who tyrannizes over the body. There is the despot who tyrannizes over the soul. There is the despot who tyrannizes over soul and body alike. The first is called the Prince. The second is called the Pope. The third is called the People.

Unless the new socialism is able to address the democratic tyranny of conformity, Wilde warns, "then the last state of man will be worse than the first." Capitalism, he argues, at least allows self-determination to a fraction of the citizenry, but "under a system of economic tyranny nobody would be able to have any such freedom at all." In an ideal socialist order, on the other hand, where "the true perfection of man lies, not in what man has, but in what man is," all will be free to realize in full what Wilde calls their "individualism" and art, Wilde says, "is the most intense mode of individualism that the world has known."[46]

Two decades later, Fry's "Art and Socialism," commissioned in 1912 by H. G. Wells and reprinted with added material in *Vision and Design* (55–

78), follows Wilde's argument point by point. Fry contrasts "bureaucratic socialism" which would "carefully organise the complete suppression of original creative power," with what he calls the "sane Socialism" of the Great State, which "aims at human freedom . . . out of which art grows."[47] Writing of Cézanne in 1917 Fry said, "In a world where the individual is squeezed and moulded and polished by the pressure of his fellow-men the artist remains irreclaimably individual" (*V&D*, 256).

The increasing presence of Wilde's influence in Fry's essays from the decade of the Omega must be seen in historical context. Although his aspirations to participate in a broad movement of social and artistic renewal had earlier led Fry to reject the isolation of an Aesthete like Whistler (see chapter 1), by 1917, the year of "THE ARTIST AS DECORATOR," Fry had reason to feel that his culture had acceded to bureaucratic tyranny without even the consolations of socialism. England was embroiled in a war that Fry passionately and actively opposed, his pacifism identifying him with a tiny and embattled minority. From a bustling harbinger of the new, the Omega had become an outpost of outsiders. Many of the workshop's artists had been expatriated as aliens, killed in battle, or sentenced to agricultural labor for resisting the draft, and Fry replaced them with conscientious objectors who had difficulty finding any other job in an era of vehement militarism. The same Bloomsbury memoirs that tell of the excitement and ferment surrounding the Post-Impressionist exhibitions record the despair and disillusionment brought on by the war. Leonard Woolf described the war as "the most horrible period of my life," saying it set back the progress of civilization "for at least a hundred years." Vanessa Bell wrote: "The excitement and joy had gone. The hostility of the general public was real now, no longer a ridiculous and even stimulating joke."[48] Fry's letters from the war years reflect his discouragement. "It is over with all our ideas and all the really important things for many years," Fry wrote a few weeks after war was declared. He wanted to close the Omega, but said, "I cannot dismiss all those who subsist by it just now (they would be destitute owing to the general crisis). So I shall try to carry on for a few months in the hope of a rapid end to the war" (*Letters*, 380).

In fact, Fry managed to sustain the struggling workshop through the four years of the war and for a few months after before it went bankrupt, forcing him to sell Durbins to pay off the debts. Near the end of the Omega, Fry complained, "By being abject for most of an afternoon . . . I have sold two chairs for £4, and that's all. It's too discouraging, and I see it's hopeless in this vile country" (*Letters*, 448). When, at about this period, Fry revised his essay, "Art and Socialism," he added a bitter section on the public's resistance

to new art and new ideas, suggesting that the "small minority" of innovators in either sphere will always have to see their work travestied through "compromise between it and the old, generally accepted notions" before it can be accepted into the dominant culture.[49] This sense of the artist as perpetual outsider clearly accords with Wilde's ideas, so it is fitting to find Fry in 1917 reading Frank Harris's biography of Wilde, and commenting that it "confirms all my beliefs in the impossibility of art in England" and shows what "would happen again if ever the British public could get its teeth into an artist."[50]

Virginia Woolf, in her biography of Fry, reports that he "was oppressed by the conviction that art after the war must be esoteric and hidden like science in the middle ages—'we can have no public art, only private ones, like writing and painting, and even painting is almost too public,' he wrote."[51] This kind of statement embodies what became the popular image of the Bloomsbury group: a reclusive cabal of the aesthetic elite. The essays collected here suggest that this image should be tempered by an awareness of Fry's highly public career in the spirit of Ruskin, Morris, and the Arts and Crafts movement in general. I have tried to suggest as well a historical context for Fry's writings in the spirit of Aestheticism, which put forward the notion of artistic personality to justify individual acts of resistance to the dominant culture. The Omega's founding documents express Fry's strongest enunciation of Arts and Crafts aspirations; the writings associated with the Omega's final years afford the clearest legacy of Aestheticism. What both movements had in common, and what Fry never abandoned, however, was the sense that aesthetic renewal has profound implications for the way we live, whether the "we" in that formulation is a whole society or an embattled subculture.

<div align="center">✥</div>

NOTES

1. John D. Rosenberg, ed., *The Genius of John Ruskin* (Boston: Routledge & Kegan Paul, 1979), 220; Kenneth Clark, ed., *Ruskin Today* (London: John Murray, 1964), 263.

2. John Ruskin, *Stones of Venice*, vol. 2, chap. 6, sect. 13, in *Works of Ruskin*, edited by E. T. Cook and Alexander Wedderburn (London: George Allen, 1905), 10:193; 16:345; W. Morris, "Making the Best of It," in *Collected Works*, edited by May Morris (London: Longmans Green, 1910–15), 22:85.

3. Jeffrey L. Spear, *Dreams of an English Eden: Ruskin and His Tradition in Social Criticism* (New York: Columbia University Press, 1984), 196–97; Catherine W. Morley, *John Ruskin, Late Work, 1870–1890: The Museum and Guild of St. George, an Educational Experiment* (New York: Garland, 1984).

4. Lionel Lambourne, *Utopian Craftsmen: The Arts and Crafts Movement from the Cotswolds to Chicago* (New York: Van Nostrand Reinhold, 1980), 36–58.

5. Frances Spalding, *Roger Fry*, (London: Granada, 1980), 57–9. The circumstances behind the commissioning of the harpsichord are described in Peter Stansky, *Redesigning the World: William Morris, the 1880s, and the Arts and Crafts* (Princeton: Princeton University Press, 1985), 113. The instrument was later illustrated, with Renaissance prototypes, in the Arts and Crafts magazine, *The Studio* (19 [1900]: 192–94).

6. Letter from C. R. Ashbee to Fry, 23 April 1888, quoted in Fiona MacCarthy, "Roger Fry and the Omega Idea," *The Omega Workshops, 1913–19: Decorative Arts of Bloomsbury* (London: Crafts Council, 1983), 9.

7. Alan Crawford, *C. R. Ashbee: Architect, Designer, and Romantic Socialist* (New Haven: Yale University Press, 1985), 36, 222; Virginia Woolf, *Roger Fry: A Biography* (1940; reprint, New York: Harcourt Brace Jovanovich, 1968), 64.

8. "The New 'Magpie and Stump'—a Successful Experiment in Domestic Architecture," *The Studio* 5 (1895): 67–74. The mural is described and illustrated in Crawford, *C. R. Ashbee*, 72–73, 238, 297–304.

9. For an overview of such art critics in the British press, see Simon Watney, "Critics and Cults," *Charleston Newsletter* 17 (December 1986): 25–29. As for scholarly books, Charles Harrison's *English Art and Modernism, 1900–1939* (London: Allen Lane, 1981) skews the comparison between Fry and Sickert, carefully advancing Sickert's few leftist credentials—"It is perhaps significant that he often visited William Morris during the 1880s, in company with his first wife, the daughter of Richard Cobden, Liberal politician and free trader" (24–25)—but never mentioning the Arts and Crafts work Fry was doing while Sickert was practicing Impressionism in France. This misrepresentation becomes the background for Harrison's ahistorical allegiance of Sickert with the working class and Fry with the bourgeoisie (see chapter 3). S. K. Tillyard's *The Impact of Modernism, 1900–1920* (New York: Routledge, 1988) follows Harrison's lead, mischaracterizing Ashbee's relationship to Fry as that of a "childhood friend" (37), although Fry turned twenty and Ashbee was twenty-two the winter they met. Obscuring Fry's Arts and Crafts origins allows Tillyard to present his use of the movement's vocabulary as a cynical attempt to "take advantage" of its market, "to engage, court, and secure that audience with more understanding, sophistication and dexterity than anybody else" (37, 250). The dissertation version of Tillyard's book acknowledges Harrison's guidance.

10. Ruskin, *Modern Painters*, vol. 3, chap. 4, secs. 10–13, in *Works of Ruskin*, 5:76–78.

11. Ruskin, *Stones of Venice 2*, chap. 6, sec. 25, in *Works of Ruskin*, 10:204.

12. Fry, "A Modern Jeweller," *The Burlington Magazine*, April 1910, 169.

13. See Morris, "The Beauty of Life," in *Collected Works*, 22:55.

14. See Morris's 1884 essay, "Architecture and History," in *Collected Works*, 22:296–317.

15. On Blomfield's design, see Richard A. Fellows, *Sir Reginald Blomfield: An Edwardian Architect* (London: A. Zwemmer, 1985), 114–20.

16. Fry, "Our Architecture," *The Burlington Magazine*, December 1912, 167–68.

17. Both interviews appeared under the headline, "Ugly Buildings," Fry's on 23 May 1921 (7), and Blomfield's the following day (13). Fry reiterated his admiration

for the Kodak building, as "the one building in London which partly fulfills my idea of a 'naturally' beautiful building. . . . Its construction arises largely from its materials. It is made of ferro-concrete, and the result springs naturally from the means." Blomfield disagreed, saying the Kodak building "is not even what Mr. Fry would call 'tolerable.'" In 1934, Blomfield published a sustained attack on modernist architecture under the title *Modernismus* (London: Macmillan, 1934).

18. Le Corbusier, *Towards a New Architecture*, translated by Frederick Etchells (London: Architectural Press, 1927), 33, 7. Fry's argument that the functionalism of modern architecture cannot replace the aesthetic sensibility of the designer is repeated in his "Sensibility versus Mechanism," *The Listener*, 6 April 1932, 497–99.

19. Nikolaus Pevsner, "Omega," *Architectural Review* 90 (August 1941): 45. The comparison with Loos is in Ian Nairn and Nikolaus Pevsner, *Surrey*, 2d ed. (London: Penguin, 1970), 289; the history of the house given here is riddled with errors.

20. Although Fry's domestic application of commercial architectural features is remarkable, the basic form of his Mansard-roofed townhouse takes its place with other designs of the late Arts and Crafts movement. Relevant comparisons are Norman Shaw's 170 Queen's Gate in London, which Fry cited approvingly in "Our Architecture," and Mackmurdo's 25 Cadogan Gardens. On the architecture of the period, see Alastair Service, *Edwardian Architecture* (London: Thames & Hudson, 1977).

21. Fry's emphasis on the central room, despite its Italianate twist, reflects Arts and Crafts principles, as explained, for example, in *The Studio*, where M. H. Baillie Scott advocated the benefits of what he called a "hall or house-place" as "a place where the family may assemble round the fire in the evening"; see Baillie Scott, "An Ideal Suburban House," *The Studio*, January 1895, 127–32; "A Country Cottage," *The Studio*, March 1902, 86–95. For Morris's historical case for the central hall, see his "Art and Socialism," in *Collected Works*, 23:199–200. Fry's habitual reference to the main room at Durbins as the "house-place" confirms his sources in the Arts and Crafts.

22. Both publications appeared as pamphlets headed only with a logo giving the name, address, and phone number of the workshops. The undated prospectus has been assigned to fall 1913, although it is not clear if it appeared in September, when the Omega contributed a sample room at the Ideal Home show, or in December, when the workshop officially opened. The catalog, which has been variously assigned dates between 1915 and 1918, was published in October 1914. See Judith Collins, *The Omega Workshops* (Chicago: University of Chicago, 1984), 47–54, 284.

23. Morris, "Art under Plutocracy," *Collected Works*, 23:173. Asserting his own roots, Morris says of this dictum, "If those are not Professor Ruskin's words they embody at least his teaching on this subject."

24. Ruskin, *Stones of Venice* 2, chap. 6, secs. 14, 15, 19, in *Works of Ruskin*, 10:193–94, 199.

25. C. Lewis Hind, "New Art and Newer Literature," *Daily Chronicle*, 24 March 1913 (clipping in Duncan Grant's scrapbook, Tate Gallery Archives).

26. Ruskin, *Stones of Venice* 1, chap. 2, sec. 17, in *Works of Ruskin*, 9:72.

27. On Ashbee's use of the peacock, see A. Crawford, *C. R. Ashbee*, 229–30. Two versions of Fry's peacock design are at the Courtauld Institute Galleries. True to Omega practice, Fry's design became the communal property of the workshops and was ultimately applied to a handpainted silk scarf. See Collins, *The Omega Workshops*, 90, illustration 41; MacCarthy, 77 (see n. 6 above).

28. Fry, quoted in M.M.B., "Post-Impressionist Furniture," *Daily News and Leader,* 7 August 1913, 10.

29. It is possible to overemphasize the degree to which Bloomsbury was indebted to Matisse. Having admired his work from their earliest exposure to avant-garde French art, Bloomsbury's artists were able to seize on the visual logic of his aesthetic, so that very quickly they were achieving effects he did not realize until years—even decades—later. Vanessa Bell's 1913 model nursery for the Omega, with its brilliant cutout animals and clouds, anticipates Matisse's much later decorations.

30. Collins, *The Omega Workshops,* 121–24, 127–28. The collage-style Picasso painting, *Tête d'homme* [*Head of a man*], which Fry purchased in 1913, although not itself a collage as Collins correctly notes (62), was in fact cut down from an ambitious assemblage involving newspaper arms and an actual guitar. See Christine Poggi, *In Defiance of Painting: Cubism, Futurism, and the Invention of Collage* (New Haven, Conn.: Yale University Press, 1992), 79–82, 88.

31. MacCarthy, 45. Fry described and sketched his decorations for the harpsichord in a letter (16 February 1918) to his daughter. There is a copy of this correspondence at Courtauld Galleries, which also holds the harpsichord.

32. Abigail Frost, "Omega Anonymous," *Crafts* 66 (January/February 1984): 40–44. This plan was realized only sporadically, with associated artists working at home sometimes paid on a piecework basis. Because there were never any profits, there was never any profit sharing.

33. Winifred Gill memoirs, Tate Gallery Archives. Compare Pamela Diamand, "Recollections of the Omega," in *The Omega Workshops: Alliance and Enmity in English Art, 1911–1920* (London: Anthony d'Offay Gallery, 1984).

34. Ruskin argued that collaborative work on "the permanent decoration of public buildings" was the best training for young artists and cited schools as the "most important kind of public buildings" for such projects. See *A Joy Forever,* lecture 2, sec. 104, in *Works of Ruskin,* 16:88–89. Morris, too, glorified "work not of individual but collective genius" and made the first major project of his Pre-Raphaelite brotherhood the murals for the Union Debating Hall at Oxford. See William Morris, "The Gothic Revival II," in *The Unpublished Lectures of William Morris,* edited by Eugene D. Lemire (Detroit: Wayne State University Press, 1969), 90. Ashbee laid the groundwork for his Guild of Handicraft by organizing the students in his Ruskin course to decorate the dining room at Toynbee Hall. See Crawford, *C. R. Ashbee,* 27–30.

35. Peter Floud, "The Inconsistencies of William Morris," *The Listener,* 14 October 1954, 615–17. Morris acknowledged that his workshops "could not do anything (or at least but little) to give this pleasure [of artistic creation] to the workman," explaining "it is impossible to work in that manner in this profit-grinding society." See E. P. Thompson, *William Morris: From Romantic to Revolutionary,* 2d ed. (London: Merlin Press, 1971), 105. Morris reiterated this defense in his private correspondence; see *The Collected Letters of William Morris,* edited by Norman Kelvin, (Princeton: Princeton University Press, 1984), 2:283–87.

36. C. R. Ashbee, *Craftsmanship in Competitive Industry* (1908: reprint, New York: Garland, 1977), 17.

37. Fry, "Applied Art and the New Movement," (1917?), King's College Library, Cambridge University.

38. W. R. Lethaby, "Town Tidying," in *Form in Civilization,* quoted in Peter

Fuller, "William Lethaby, Keeping Art Ship-Shape," in *W. R. Lethaby, 1857–1931: Architecture, Design, and Education,* edited by Sylvia Backmeyer and Theresa Gronberg (London: Lund Humphries), 32.

39. See Fry's 1919 essay, "The Artist's Vision" (*V&D,* 47–54.)

40. Oscar Wilde, "The Soul of Man under Socialism" and "The Decay of Lying," in *The Complete Works of Oscar Wilde* (New York: Harper & Row, 1966), 1090, 991.

41. Beverly Twitchell, *Cézanne and Formalism in Bloomsbury* (Ann Arbor, Mich.: UMI Research Press, 1987), 28. Twitchell's assertions that Aestheticism was "apolitical; its self-centered alienation turned elitist" and that it "defined itself largely in opposition to the bourgeois" are oxymoronic, since the bourgeoisie is a political category.

42. Citations of Morris and especially Ruskin permeate Wilde's lecture promoting Aestheticism in America, which were published as "The English Renaissance," "House Decoration," and "Art and the Handicraftsman," in *Miscellanies,* edited by Robert Ross (Boston Wyman-Fogg, n.d.), 243–308. Four of Wilde's articles promoting the Arts and Crafts Exhibition of 1888 are also in this volume, 93–109.

43. C. R. Ashbee, *Socialism and Politics: A Study in the Readjustment of the Values of Life* (London: Mssrs. Brimley Johnson and Ince, 1906), 7–8.

44. Jeffrey Weeks, *Coming Out: Homosexual Politics in Britain from the Nineteenth Century to the Present* (London: Quartet Books, 1977), 42–43; Michael Bronski, *Culture Clash: The Making of Gay Sensibility* (Boston: South End Press, 1984), 58–63. On Bloomsbury's relationship to various manifestations of gay identity, see my "Making History," in *Gay and Lesbian Studies in Art History,* edited by Whitney Davis (New York: Haworth Press, 1994), 189–224.

45. Ruskin, *Fors Clavigera,* in *Works of Ruskin,* 27:28; Morris's 1890 *News from Nowhere,* in *Collected Works,* vol. 16; Oscar Wilde, "Pen Pencil and Poison," in *The Complete Works of Oscar Wilde,* 993–1008.

46. Wilde, "The Soul of Man under Socialism," 1079–1104.

47. Fry's congruence with Wilde in this essay is more than coincidental. When he reviewed some of Wilde's writings in 1927, Fry described himself as "rather staggered and ashamed to see how little I did him justice, though I always admired the *Soul of Man under Socialism.*" Describing Wilde as "infinitely nearer to some kind of truth than all the noble rhetoricians, the Carlyles, Ruskins, etc., of the day," Fry said, "he has a way of being right, which is astonishing at that time, or any for that matter" (*Letters,* 601). That Wilde's manifesto was prominent in Fry's library is suggested by Nina Hamnett's anecdote of a party game she played at Durbins in 1916 involving quotations from *Soul.* See Denise Hooker, *Nina Hamnett: Queen of Bohemia* (London: Constable, 1986), 96.

48. Leonard Woolf, *Beginning Again: An autobiography of the Years 1911–1918* (London: Hogarth Press, 1963), 37, 197. Vanessa Bell memoir, in *The Bloomsbury Group,* edited by S. P. Rosenbaum (Toronto: University of Toronto, 1975), 83. Compare the remarks of these authors with those quoted in chapter 2 above.

49. The added section runs from the sentence, "This question of the creation and consumption of art tends to become more and more pressing" (*V&D,* 70), to the sentence, "Society, for example, accepts as much of the ascertainable truth as it can stand at a given period in the form of the doctrine of its organised religion" (*V&D,*

73). Similar ideas may be found in Fry's "Art in a Socialism," *The Burlington Magazine*, April 1916, 36–93.

50. Letter from Fry to Vanessa Bell, 16 February 1917, Tate Gallery Archives, 8010.5.676.

51. V. Woolf, *Roger Fry*, 238.

WEDGWOOD CHINA

LORD Tweedmouth's collection of Wedgwood china is now on view at Davis's Gallery. Besides the china itself, which is of exceptional quality, and contains several unique pieces, there are to be seen many of the original wax models by Flaxman and his school, from which the superposed figures in Wedgwood's plaques and vases were cast. These have so long lain hidden from public view in Lord Tweedmouth's Inverness-shire home that it has been at times supposed that the wax models were destroyed in the process of manufacture. Their history is curious, as it brings together such diverse geniuses as Josiah Wedgwood, Erasmus Darwin, and Charles Darwin. It was from the author of "The Origin of Species," who had inherited them from Erasmus Darwin, that Lord Tweedmouth acquired them in 1856, after a vain attempt to induce the authorities of the Victoria and Albert Museum to purchase them for the nation. They all show extraordinary technical skill, and are marked by a cold excellence and negative perfection. There is, too, an interesting equestrian portrait of Josiah Wedgwood, painted in enamel colours on a Wedgwood plaque by Stubbs, a careful, deliberate, and honest, but scarcely inspiring work. But it gives one an idea of the shrewd intelligence and resource of the man who accomplished what hardly any one else has—the feat of making a commercial success of fine-art pottery. As pottery, Wedgwood's work is beyond praise, though it probably contributed to the final destruction of the art, as an art, in England, since it set a standard of mechanical perfection which to this day prevents the trade from accepting any work in which the natural beauties of the material are not carefully obliterated by mechanical means. In fact, Wedgwood destroyed the craftsman's tradition by substituting the artist turned craftsman for the craftsman grown artist by experience and natural aptitude. Still, destructive as it proved, Wedgwood's performance was remarkable, and of great interest as one phase of the classic reaction at the end of the eighteenth century. Together with the Adam furniture and architecture, with which it perfectly agrees, it makes up the English analogue to the Empire style. Only in the vase (No. 48) with

Reprinted from *The Athenaeum*, 15 July 1905, 88–89.

designs by Lady Diana Beauclerc do we get a trace of the earlier, more free and easygoing eighteenth-century tradition. For the rest, the designs are confined to a rigorous and exact adaptation of classic models. In one interesting plaque the original has been an archaistic work, but for the most part the forms are those of late Græco-Roman art. Classic art for Flaxman's and Wedgwood's generation meant the Belvedere Apollo and the Portland Vase. That in itself was no harm. Almost all the great movements of European art have started by a reference to Græco-Roman, often to bad Roman originals; but both in twelfth- and fifteenth-century movements the intended copying led to a development of a quite original art, which far surpassed in beauty the models it proposed. In the eighteenth-century movement the intended copying really succeeded, with the result of almost complete sterility. The difference lies in the fact that in the earlier return to classic models, while the forms were borrowed, the content was entirely new, and the content changed and modified the forms, till they also became in effect an entirely original art. Flaxman, on the other hand, borrowed both alike, and having nothing new to say about Endymion or Pluto or Thetis, the utmost that could be hoped was a perfect approximation to his originals. The cold and lifeless precision which results from this attitude was really destructive. It existed solely for the exquisite perfection of its workmanship. The moment that relaxed, as it did on Josiah Wedgwood's death, nothing but a progressive degradation was possible. An art inspired by some vital idea has the power of adaptation and growth, which was entirely wanting in this particular return to classic models. That the reaction was inevitable one may guess from its almost simultaneous appearance in various countries. It produced its one genius in Piranesi, a wild romantic spirit, who poetized and dramatized in decorative and architectural form the spirit of ancient Rome. In France it produced the deadening tyranny of David. Ingres, ultraclassical though he was, was really in revolt from David's influence, or one might claim for the movement a second great master in him. In England we were perhaps fortunate, in that the reaction took the form of architecture, and such charming minor arts as Wedgwood's, and did not inspire any serious school of painting. The transition from Reynolds to modern sentimental realism was made without any turgid efforts at classical correctness.

The purely decorative part of Wedgwood's china displays essentially the same negative perfection as the figures. One admires the ingenuity and taste with which these extremely correct patterns are combined and applied. What a wealth of charming caprices, of living and elastic forms, the Florentine sculptors and Roman painters had quarried from the same mine! It was reserved for Wedgwood's artists to show that classic art contained, as well as

these, a mass of absolutely dead formal patterns, and to proclaim these truly classic. There are great ingenuity and infallible exactitude in Wedgwood's patterns, but they have not the same vivacity, the same spark of originality, which saves the work of the Adams. For all that, Wedgwood was a great potter, and, we have it on Gladstone's authority, a great man, and his work has what will ensure it a lasting interest, namely, within its narrow bounds, perfection.

The catalogue, which is written in a perfectly bewildering style, contains a great deal of interesting information, and above all an extract from a speech by Gladstone, who is always worth listening to on art. His *obiter dicta* on that subject should be collected as an appendix to an English edition of "Bouvard et Pécuchet."

THE REGENT-STREET
QUADRANT

To the editor of The Times

Sir,—

MAY I REMONSTRATE against the dangerous advice given in your leading article of last Saturday with regard to the Regent's Quadrant? The writer adjures us to make sacrifices for at, as though that were not the very root of all our aesthetic disasters. We all sacrifice to art, from the lodging-house keeper who fills her house with incredible ornaments to the millionaire who buys Old Masters that he does not like. It is the art that comes from such motives which is so deadening to all artistic impulse and efforts. Nowhere is this dreary aesthetic "snobbism" more devastating than in architecture. We make buildings for our need, and then, sacrificing our pockets to art, cover them with a mass of purely nonsensical forms which we hope may turn them into fine architecture.

Already such a piece of unreal pretence (very good of its entirely un-architectural kind) is before us in the Piccadilly Hotel. Let us now repent and go humbly to the shopkeepers. Let Messrs. Swan and Edgar and the rest be as vigorous in their demands for plate glass as ever they like, and then let a really good engineer solve them their problem. If the engineer has studied proportion he will suffice; if not, let an artist (perhaps even an architect) without altering the essential features give just proportions to the building. Thus we may get something really satisfactory instead of another piece of polite archaeological humbug. Fortunately there is already one building in London which reveals what may be done by honest methods—I mean the Kodak building in Kingsway, one of the few not unsightly things which have been set up in recent years. This admirable shop puts all its neighbors to shame by sheer reasonableness and good sense, for it has what they lack—essential dignity of style.

Yours faithfully,
Roger Fry

Reprinted from *The Times* [London], 3 October 1912, 7.

OMEGA WORKSHOPS
FUNDRAISING LETTER

DURBINS, GUILDFORD
Dec. 11, 1912

Dear Bernard Shaw

I AM INTENDING to start a workshop for decorative and applied art. I find that there are many young artists whose painting shows strong decorative feeling, who will be glad to use their talents on applied art both as a means of livelihood and as an advantage to their work as painters and sculptors.

The Post-Impressionist movement is quite as definitely decorative in its methods as was the Pre-Raphaelite, and its influence on general design is destined to be as marked. Already in France Poiret's École Martine shows what delightful new possibilities are revealed in this direction, what added gaiety and charm their products give to an interior. My workshop would be carried on on similar lines and might probably work in conjunction with the École Martine, by mutual exchange of ideas and products. I have also the promise of assistance from several young French artists who have had experience of such work: but in the main I wish to develop a definitely English tradition. Since the complete decadence of the Morris movement nothing has been done in England but pastiche and more or less unscrupulous imitation of old work. There is no reason whatever why people should not return to the more normal custom of employing contemporary artists to design their furniture and hangings, if only the artists can produce vital and original work.

The group of young artists who decorated the Borough Polytechnic a year ago have, I feel sure, the power to do this and have already formed the habit of working together with mutual assistance instead of each insisting on the singularity of his personal gifts. This spirit is of the utmost value in such decorative work as I propose, where co-operation is a first necessity.

I do not intend to begin on a large scale. I have selected a suitable house in Fitzroy Square with admirable workshops and storage cellars and good ground-floor show-rooms. By letting off a flat at the top I can secure the whole of this for about £120 a year.

From the George Bernard Shaw Collection, British Library.

I calculate that the total expenses of running this workshop will be about £600 or £700 a year. I require about £2,000 capital to give the scheme a fair chance; for at the end of three years it will be evident whether I am right in believing that there is a real demand for such work.

I propose to begin with those crafts in which painters can most easily and readily engage—the design of wall decorations in tempera and mosaic; of printed cotonnades; of silks painted in Gobelin dyes for curtains and dresses; painted screens; painted furniture. I hope to develop gradually the application of our designs to weaving, pottery and furniture construction.

All the products of the workshop will be signed by a registered trademark. This will insure the exclusiveness of our designs, and important point in view of the inevitable commercial imitation which follows upon the success of any new ideas.

In the matter of technical problems I have the promise of assistance and the use of workshops of a well-known London firm of decorative designers.

The business will be established on the following lines:—This first charge will be the payment of the workers and expenses of management; the next charge will be interest at 5% on the capital. A fixed proportion of the profits over and above this will be devoted to forming a sinking fund for the repayment of capital.

I shall hope to arrange later for a co-operative or profit-sharing scheme among the workers.

I shall myself contribute a fair share of the capital and shall devote myself very largely to the direction and artistic management of the workshops. In the business details I have the promise of assistance from Mr. Leonard Woolf.

Personally I do not doubt but that there is a demand for the kind of work which I have in view; and I believe that the young artists who have already worked with me in the past have among them as much talent for decorative design as any of those who in the last great artistic movement achieved universal recognition of the qualities of English taste and invention in applied design. I recognize, however, the speculative nature of such an attempt: and since there is no guarantee of its success, other than my own conviction and determination, I am asking for capital from those only who feel sufficient interest in the idea of employing artists in this way, to justify them in risking the loss of their money. For this reason quite small sums, the loss of which would not be seriously felt will be welcome.

May I ask you to be so good as to give me your advice, criticisim or support with regard to my scheme.

Yours faithfully
Roger Fry

PROSPECTUS FOR THE OMEGA WORKSHOPS

THE present is almost the only age known to history in which man has been forced to live among artificial surroundings which entirely disregard his natural aesthetic cravings. Until the 19th century (with the possible exception of the Roman Empire) men used for daily life objects which expressed the joy of the creator and the craftsman and conveyed a corresponding delight to the user. Modern industrialism has changed all this, and has substituted the machine for the craftsman and the plagiarist for the artist.

It has indeed effected a complete divorce between art and industry to the harm of both. The artist has become a specialized and frequently a subsidized professional whose work has lost the vivifying contact with practical needs, while the objects of daily life are either more or less skilful forgeries of ancient works, or, if they attempt novelty, bear the stamp of commercial origin.

This lamentable condition of the applied arts which affects our well-being at almost every moment of our lives, has of course been frequently recognized and as often deplored. Nor have there been wanting attempts to rectify it, of which the most notable was that of William Morris.

Any attempt to bring art and industry together must depend to some extent on the aims and predilections current among the artists of the day. From this point of view William Morris' attempt was fortunate in that the movement among the artists of his day was toward decorative design. Between his time and the present it was vain to attempt this reconciliation of art and industry, because the more serious and enterprising artists, absorbed in the study of natural appearances, were comparatively uninterested in abstract design. This was particularly the case with the Naturalists and Impressionists. But the most recent movement in art, which may be described under the inclusive title of Post-Impressionism, has brought the artist back to the problems of design so that he is once more in a position to grasp sympathetically the conditions of applied art.

The artists who have associated themselves together to found the Omega

This prospectus was circulated in 1913.

Workshops, Ltd., are by nature predisposed to the study of pure design. Less ambitious than William Morris, they do not hope to solve the social problems of production at the same time as the artistic. While deploring the extreme tyranny of mechanism in modern production they are willing to make use of it so far as it allows of the expression of their ideas. They take things as they find them and endeavour merely to discover a possible utility for real artistic invention in the things of daily life, convinced that whatever territory can be won back for creative talent from mere reproduction, mechanical or otherwise, is a gain both to the producer and the consumer.

In their workshops at 33, Fitzroy Square, W., they undertake almost all kinds of decorative design, more particularly those in which the artist can engage without specialized training in craftsmanship. Thus they carry out wall decoration in tempera, in wax medium, or in mosaic. At present most people imagine that to have the walls of a room painted is a very serious and costly undertaking. That is because the modern artist being unaccustomed to decorative design, only undertakes it with extreme timidity and after overcoming innumerable scruples. As a rule the more elaborate his preparations the more complete is his failure. The artists of the Omega Workshops, having practiced decorative design, are able to work together upon a roughly indicated plan with much greater freedom and certainty and are therefore able to carry out the painted decoration of a room, or a whole house, in a very short time and at a very much lower cost than has hitherto been thought possible. Indeed in certain cases the cost would probably not exceed that of the more expensive wall papers.

Actuated by the same idea of substituting wherever possible the directly expressive quality of the artist's handling for the deadness of mechanical reproduction, they have turned their attention to hand dyeing and have produced a number of dyed curtains, bedspreads, cushion covers, etc., in all of which they employ their power of invention with the utmost freedom and spontaneity of which they are capable.

In furniture they have not attempted and will probably not attempt actual execution, but they believe that the sense of proportion and fitness and the invention, which are the essential qualities of such design, can be utilized to create forms expressive of the needs of modern life with a new simplicity and directness. These designs are for the most part carried out by others, but the colouring and final decoration of the furniture is done by the artists themselves.

But as has already been said, they recognize the need of some reproductive work and they have a number of designs in printed linens for curtains and upholstery which have been specially executed for them by a firm of

French colour printers, who have specially adapted and modified the ordinary mechanical processes so as to retain as much as possible the freedom and vitality of the original drawings. Work similar to that done by the Omega Workshops is by now thoroughly appreciated on the continent, but hitherto no firm has ventured to hope for any change in our conservative attitude in matters of taste. Above all it has been thought that our peculiar national worship of mechanically perfect finish would stand in the way of recognizing the more vital beauty of artistic handling. The Omega Workshops have been started in direct defiance of these gloomy forebodings. They are convinced that the feeling for decorative and applied design is by no means lacking in English artists nor the taste for it in the British Public.

PREFACE TO THE OMEGA
WORKSHOPS CATALOG

I F you look at a pot or a woven cloth made by a negro savage of the
Congo with the crude instruments at his disposal, you may begin by
despising it for its want of finish. If you put them beside a piece of modern
Sevres china or a velvet brocade from a Lyons factory, you will perhaps begin
by congratulating yourself upon the wonders of modern industrial civiliza-
tion, and think with pity of the poor savage. But if you will allow the poor
savage's handiwork a longer contemplation you will find something in it of
greater value and significance than in the Sevres china or Lyons velvet.

It will become apparent that the negro enjoyed making his pot or cloth,
that he pondered delightedly over the possibilities of his craft and that his
enjoyment finds expression in many ways; and as these become increasingly
apparent to you, you share his joy in creation, and in that forget the rough-
ness of the result. On the other hand the modern factory products were made
almost entirely for gain, no other joy than that of money making entered into
their creation. You may admire the skill which has been revealed in this, but
it can communicate no disinterested delight.

The artist is the man who creates not only for need but for joy, and in the
long run mankind will not be content without sharing that joy through the
possession of real works of art, however humble or unpretentious they may be.

The Omega Workshops, Limited, is a group of artists who are working
with the object of allowing free play to the delight in creation in the making
of objects for common life. They refuse to spoil the expressive quality of their
work by sand-papering it down to a shop finish, in the belief that the public
has at last seen through the humbug of the machine-made imitation of
works of art. They endeavour to satisfy practical necessities in a workmanlike
manner, but not to flatter by the pretentious elegance of the machine-made
article. They try to keep the spontaneous freshness of primitive or peasant
work while satisfying the needs and expressing the feelings of the modern
cultivated man.

This catalog was issued in 1914.

THE ART OF POTTERY
IN ENGLAND

THE use of works of art as historical documents needs, no doubt, a certain care and circumspection. It would probably be a mistake to measure civilization by the excellence of artistic creation. There was a time, for instance, when palæolithic man was supposed to have had a highly developed civilization because he drew animals with a more photographic exactitude than any of our photographic realists; whereas it is more likely that he was enabled to draw so accurately because as yet he had not fully learned the vision-distorting art of speech.

Again, our æsthetic standards vary so much that what one age rejects as barbarous stammerings another finds to be the climax of human expression. There was a time when not only the Benin bronzes but the Elgin marbles were condemned in this way.

Probably the conditions that make for fine creation are infinitely various, and the particular combination of circumstances may arise under very different social conditions. One might even guess that they are more likely to arise in imperfectly organized societies than in highly elaborate ones. For all that, I suppose we should admit that the state of mind of fine creative effort in the craftsman and fine appreciation in the public are signs of a certain good, that they cannot arise freely in a wholly degraded and brutal society.

With these precautions in mind, let us consider what general impression is left on the mind by contemplating the section through English history which the exhibition of pottery at the Burlington Fine Arts Club offers us. First of all, we must premise that pottery is of all the arts the most intimately connected with life, and therefore the one in which some sort of connexion between the artist's mood and the life of his contemporaries may be most readily allowed. A poet or even a painter may live apart from his age, and may create for a hypothetical posterity; but the potter cannot, or certainly does not, go on indefinitely creating pots that no one will use. He must come to some sort of terms with his fellowman.

Now if these considerations hold, the aspect of the works at Savile Row is

Reprinted from *The Burlington Magazine*, March 1914, 330–35.

by no means consolatory. It is of a nature to make us wonder whether, after all, the historians are right in hinting, as they generally do, that it does always turn out for the best in the long run. It may be, of course, that the run has not been long enough, though from 1500 to 1900 is a considerable time.

For what we see is that during the 13th, 14th, and even 15th centuries one kind of pottery was made apparently alike for rich and poor; that even if there was a difference of elaboration there was only one quality; and that all this pottery is marked by a great refinement of taste, that it shows a real appreciation of form and texture, that it is expressive of what we instinctively recognize as a right state of mind.

After the 15th century there is a gap—only one Elizabethan piece standing for the 16th century; and when pottery again becomes evident in the 17th, 18th, and 19th centuries we find society split into two. There is the pottery for the people—the coarse Staffordshire slip ware—and there is the pottery for the well-to-do. Now whatever the social explanation of this curious fact may be, there can be no doubt that both kinds of pottery are so immeasurably inferior to the one kind of mediæval times that it is almost difficult to believe they were produced by the same people. Certainly, if one judged of men by their works, we should say that the 13th-century potters were men of serious and noble feelings and of a refined sensibility. We should have to say of the creators of the slip ware that they were gross, clownish, and without any faculty of detached contemplation, while those who produced for the aristocracy were content to become skilful imitators of an art that they were incapable of understanding.

Take as an example Plate I, B, a bottle from the site of Old Sarum. This is so like certain specimens of Chinese ware of the Tang dynasty, both in form and glaze, that it might almost be mistaken for one at a first glance. It has not quite the subtle perfection of rhythm in the contour, and the decoration is rather rougher and less carefully meditated. But to be able to compare it at all with some of the greatest ceramics in existence is to show how exquisite a sense of structural design the English craftsman once possessed.

Or take again Plate I, A, from Nottingham. Here there is not only a singularly noble and austere rhythm in the proportions of the whole structure, but the interpretation of a face is the work not of a clumsy and farcical imitator of nature, but of a real artist, of one who has found within the technical limitations of his craft an interpretation of natural forms expressive of life and character. What many moderns accustomed to an art of merely realistic description fail to understand is that deformation (without which there is no artistic expression) is of infinite kinds. Thus if we turn to Ralph Toft's dish [Plate II, D] we have a really crude, barbaric and brutally clownish

(A) ROOF ORNAMENT (?). 13¼ IN. HIGH. THE ART MUSEUM, NOTTINGHAM

(B) BOTTLE FOUND AT OLD SARUM. 10¾ IN. HIGH. THE SOCIETY OF ANTIQUARIES

(C) FIGURE OF A GIRL HOLDING A LARGE FISH, EXCAVATED AT WORCESTER, 1893. 7 IN. HIGH. MR. C. W. DYSON PERRINS'S COLLECTION

PLATE I A: Roof ornament (?). 13-1/4 in. high, the Art Museum, Nottingham; B: Bottle found at Old Sarum, 10-3/4 in. high, the Society of Antiquaries; C: Figure of a girl holding a large fish, excavated at Worcester, 1893. 7 in. high, Mr. C. W. Dyson Perrins's collection

PLATE II D: Reddish ware washed with white, decorated with orange, brown and red slips, yellowish glaze, Staffordshire, about 1680, diam. 18-1/4 in., Mr. C. J. Lomax's collection; E: Punch kettle, salt glaze enamelled in brilliant polychrome, green handles and spout, 7-3/4 in. high, about 1750, Hon. Mrs. Whateley's collection

idea of deformation, devoid of structural sense and vital rhythm, expressive only of a beery jocularity.

Or take Plate I, c, the little figure from Mr. Dyson Perrin's collection. Certainly this is not great sculpture—the English never had great plastic sensibility—but it is genuine sculpture; it shows a real feeling for the relation of planes and a real sense of life in the movement. It has, in fact, that inherent unity which is so terribly lacking in the high-spirited vulgarities of the later popular designs.

But, bad as the popular art of the 16th and 17th centuries is, it still retains a greater possibility of design than the elegant pastiches which were made for the upper classes, of which we may take Plate II, E, as a sample. Here the general form is without any particular feeling for proportion, and the imposed decoration is a clever adaptation of a Chinese design which had no significance for the artist except as an elegant exercise in an exotic style.

That the art of pottery in England which began with such noble and serious work should thus have degenerated into cheerful brutality on the one hand and empty elegance on the other is surely deplorable, and the indication of social conditions which it affords seems to suggest that the profound division between the culture of the people and the upper classes which the renaissance effected has been bad for both.

THE ARTIST AS DECORATOR

U NTOLD harm has been done to art by the rigid distinction between picture making and applied art. This distinction has grown up since the days of the Renaissance, and until our own time has been continually increasing. In the nineteenth century it became a fixed social and caste distinction. The man who painted anything within the four sides of a gilt frame might be, indeed probably was, a "gentleman"—the man who painted a wall or the panels of a door or carved the lettering of a tombstone could not be a gentleman. It has now become clear that there are too many pictures in the world and too many gilt frames, but, on the other hand, people's walls continually need painting or papering or decorating in some way. For everyone has walls, but no longer does everyone feel bound to put pictures on them, whether they like pictures or no.

The question arises whether the artist might not compete, and compete successfully, with the house painter.

The house painter has certain great advantages in this competition which we cannot overlook. He is accustomed to work very steadily and persistently for long hours for a small wage. He does not pretend to any taste of his own and will therefore do to the best of his powers exactly what he is told. He will match, or try to match, any given tint, and apply it to any part of the wall with perfect mechanical evenness, and finish the surface either glossy or matt, according to orders. He is usually master of the technical parts of his craft and knows exactly what ground is necessary, and how many coats of paint will cover any given surface. His manners are generally irreproachable.

The artist is usually far more difficult to deal with. His manners are sometimes charming, but usually uncertain—his hours are short and subject to sudden change—he has opinions of his own as to what will be best, not necessarily for his client but for the good of Art in the abstract. He expects to be more highly paid and more considerately treated than his rival. He frequently remains something of an improviser and experimenter in the technique of the craft.

Reprinted from *Colour,* April 1917.

So far, then, we may say that he has not a chance against his rival; what may we put down to his advantage?

First of all, supposing always that he is a real artist with a feeling for pure design, he will have a subtle sense of proportion and of colour harmony which will enable him to make a definite work of creative art out of an interior. I am assuming that we call in the artist, not in order to paint pictures on the walls after the fashion of the fresco painters of the Renaissance, but merely to paint the walls in some purely abstract and formal way. Now our artist may be able, merely out of the contrast of two or three pure colours applied in simple rectangular shapes, to transform a room completely, giving it a new feeling of space or dignity or richness. In fact, he can underline as it were the actual proportional beauty of the architecture or counteract its architectural defectiveness.

It is true that in applying the colours to the wall, the artist is likely to fail if he tries to produce the dead mechanical perfection to which the house painter has devoted years of study, but, on the other hand, he has control of a very much greater number of different qualities of surface.

As this point is of crucial importance to my mind as regards the practicability of the artist as house painter, I will give a particular instance of what I mean. In a flat for which the furniture was designed and painted by the artists of the Omega Workshops, the walls were to have been left in the plain distemper cream colour which had been put on by the last tenant, but when the new furniture was in place, it was evident that the walls were too dirty and discoloured to remain as they were. It is doubtful whether a house painter would have made a "good job of it" without a careful preparation of the walls and the application of two or three coats of distemper, and the whole proceeding would have taken a considerable time, and implied the removal of everything from the room.

But it was possible to artists, when confronted with such a problem to devise instantly a simple and agreeable colour scheme which could be applied by them in a single coat of transparent colour. The walls were spaced out with pilasters of a pale petunia colour, made with aniline dye, put on with a smallish brush—as the dye dries in instantly and the brush strokes overlapped, the result was a peculiar moiré effect, which relieved the pilasters against the flatter colour of the rest of the wall. This was done in pure raw sienna, also applied with separate brush strokes, which gave the whole surface an agreeable vivacity. Now, such a method depends on the employment of artists, since only an artist has the necessary free elegance of handling which will render such a transparent quality agreeable; the house painter

knowing his limitations would quite rightly refuse even to attempt such a proceeding.

A good many fashionable people now use "marbled" papers for their dining-rooms. They buy quite expensive block printed wall-papers, which imitate the accidental effects which can be got with infinitely greater richness and charm by artists, and at hardly greater expense.

Another method in which the artist's habits of free handling can be effectively employed is shown in the decoration reproduced here. Here a very simple scheme of panelling has been employed to give effectiveness and height to the proportions of a room. Now, so simple a scheme carried out in flat-tinted papers, such as one can buy at the upholsterers, would look thin and poor, but here the paper was first painted in size by artists quite roughly and rapidly, with no attempt to get a dead even surface. Each panel therefore differs very slightly, but still distinctly in quality from the next, and the whole surface has a play and vivacity which are essential to the effect of richness and solidity. The panel borders in this case were very roughly printed in size colours with a hand block.

There is no end to the variety and novelty of effect which can be got with the simplest and most inexpensive means by artists who have inventiveness and a love of the various possibilities of surface quality. I have seen lately rooms done at almost no cost by artists in their own houses and for their own pleasure, in which the most delightful and surprising possibilities were seen. In one case, one wall of a room—the window wall—was painted a quite different colour and tone to the rest of the room, in this case producing a greatly increased sense of space. Again, all kinds of semi-mechanically produced marblings of papers made by pressing one coloured paper on another different coloured paper while both were wet have been used with charming results. And all these effects require actually less costly materials than the commonest lodging-house wall paper and painting. The artist's time costs more, no doubt; but even so, the expense is not so great as either an elaborately printed wall-paper or a highly finished and varnished oil paint, and the expressiveness and charm of such interiors is out of all comparison greater. It is true that it is only of late years, and among the more modern artists, that all this interest in the decorative possibilities of paint and of architectural design has grown up. It is all part of the reaction against the photographic vision of the academic schools and of the new interest in pure design. But these things are having their effect on all the younger men, and a generation of artists is rising up who may fairly hope to compete in the honourable profession of house-painting.

Wall Decoration in hand-painted paper, by the Omega Workshops, Ltd.

A word of warning is, however, necessary to the public, if ever they should take to employing artists in this way. It is no use to hope that artists will do just what they are told. A general idea of colour, of whether the room is to look light or dark, grave or gay, and so forth, may be imposed, but in the actual details the artist must be free to use his own invention. He can only do what he sees, not what someone else has seen. It is a grave defect in the artist, distinguishing him from the more serviceable and subservient machine—but I fear it is ineradicable.

ARCHITECTURAL HERESIES
OF A PAINTER

The "Architect" says: "*The Times* devotes a half column to the report of an interview with Sir Reginald Blomfield on Mr. Fry's recent paper at the Institute. We think this is giving the subject too much importance. We believe if the Press would pass a self-denying ordinance and give absolutely no report of foolish sayings and doings that we might in a few decades purge our life from notoriety hunters. For it is obvious that misguided persons will do what they know is wrong or absurd if they are only supported by sufficient notice, while a cold douche of absolute silence would free us from a plague of decadent writers, futurists, would-be revolutionists, and others, who, as W. S. Gilbert put it, "would never be missed."

I AM come before you as a sheep to the slaughter, as a victim to the altar. If I am allowed to bleat for an hour or so before the sacrifice is consummated, I know that to be part of the ritual, and that it will only defer for a time the moment when I shall be utterly devoured.

I see that my fate is a foregone conclusion when I reflect that you have all studied and practised architecture as your life's work, whereas I am but a dilettante and an amateur. Still, I suppose some other purpose than suicidal mania must have drawn my steps here this afternoon, I must have hoped for some result other than my self-immolation. I think my hope is founded on the fact that, however much we may differ, you will probably agree with me that all is not well with modern architecture. And little as I can hope to maintain any theory of mine against your greater knowledge and experience, it is just possible that from my ignorant, disgruntled murmurings you may pick up suggestions which you can elaborate and complete far better than I ever could. At least I only hope it may be worth while for you to know how it strikes an outsider.

Well, then, let me plunge at once and fling my heresies at you, leaving myself time to extenuate and mitigate them later.

Heresy No. 1.—We have substituted for the art of architecture the art of dressing buildings according to the fashion.

The quotation given at the beginning of this piece originally appeared on the title page of the pamphlet, which was published by Chatto & Windus in 1921.

Heresy No. 2.—This phenomenon is more or less world wide. In the false architecture of modern Europe which results the English is distinguished by its lack of the sense of scale.

Heresy No. 3.—It is sometimes distinguished also by its good taste. Good taste in this sense is a social rather than an æsthetic virtue.

Heresy No. 4.—There are two possible kinds of beauty in a building: (1) What I call natural beauty, which is also the beauty of a locomotive or a panther, and this results from the clear expression of function. (2) Æsthetic beauty which results from the clear expression of an idea. We have so arranged that neither of these beauties occur in our buildings.

Heresy No. 5.—Æsthetic beauty in a building is essentially the same as that of sculpture. It results from the expression of a plastic idea. There has hardly ever been an æsthetic architecture in England and there has been even less sculpture.

Heresy No. 6.—Our architecture does not express plastic ideas but historico-social ideas.

Heresy No. 7.—It is founded upon social snobbery.

Heresy No. 8.—The vices of modern English architecture have almost always been inherent in the architecture of England. Modern conditions have brought out the rash.

Heresy No. 9.—Modern conditions and modern science have put into the hands of architects the greatest opportunity in the history of the world. They have missed it completely.

Heresy No. 10.—To a great extent this is not their fault.

What a list! But honestly I don't see how to make it shorter. Anyhow, we have got through the worst. I hope by amplifying my theses to mitigate and soften their horrid abruptness.

I turn to my first heresy, "We have substituted for the art of architecture the art of dressing buildings fashionably." We are almost always pleased by fashionable dress. But to please it must be exactly the last word of fashion: the same forms worn two years later just as well by just as beautiful a woman will be definitely unpleasing. This is because the forms of fashion are never regarded intrinsically, but always according to their social implications. Now I think you cannot fail to have noticed the same thing about modern architecture. Buildings which when they were just finished attracted by a certain air of pimpant novelty become outmoded in a few years, and like clothes of last year when they are dowdy they are done for. I am, alas! old enough to remember when St. John's Wood Avenue seemed to be an epoch-making discovery—baronial splendour was at last compressed into the limits of suburban convenience. I can remember when the Wagner-operatic effects of

Hans Place looked almost authentic, and hardly suggested *carton pierre*. Let me even confess that in my boyhood, bitten by Ruskin's style-mongering, I almost worked up an enthusiasm for, the then new, Law Courts. Then, tired of romance, we loved the coquetry of so-called Queen Anne. Very much so-called you will now admit. But where are the fashions of yester year? All this expensive stone costumery has become outmoded, tarnished, a painful reminder—we should be glad to put it somewhere out of sight like a soiled evening dress.

If I came down to later instances, I might, so ignorant am I of who built what—I might be unwittingly indiscreet.

But I think you must all be familiar enough with the experience I mean. At first some novelty of so-called style which is really the reference to some past epoch which has not been recently exploited has an air of chic, it arouses a faint curiosity and it suggests social alertness. But exactly as fashions instantly begin to be copied by each successively lower social level, so our new style, whatever it is, having started its career in the smart world, gradually descends to lower and lower social depths. I remember when a South African millionaire gave himself away by building a Perpendicular Gothic palace in Park Lane at a time when no one "in the know" would have tolerated anything but some form of Renaissance, preferably of French origin. Sham and very ornate Perpendicular long ago was modish, went the round, and the last I saw of it was in shops in Bloomsbury which were socially negligible. I believe it is coming up again in some provincial war memorials, with a vague idea, I suppose, of holiness and patriotism combined.

Let me quote another instance, not of dressing buildings, but of redressing them. A good many years ago Russell Square was like any other Bloomsbury Square, a sober, dignified, and not unpleasant specimen of our London Georgian building. Suddenly the Duke of Bedford's agent insisted that, as each lease fell in, the tenant should glue on to the front of his house certain marvellous terra-cotta trimming. Every window was to have its terra-cotta framework, vaguely suggestive of some Renaissance original. The forms had no kind of relation to the building as a whole, and took no heed to its proportions. They were even grotesque as pastiches of an older style. In fact, they were not only architecturally nonsensical, but they had just that faulty and unscholarly antiquarianism which is the special mark of "bad taste." I thought that some mistake had been made. I should have supposed that the original façades would tempt tenants. They certainly would have done a little further west. But the agent had gauged well enough the exact social level of his clients, and the houses let at higher rents and with far greater ease. The people who wanted houses in Russell Square were people in exactly similar

case to those who buy, not the fashionable, but the sham fashionable. Any one in the know would have despised these façades, not because of their inherent beastliness, or from any greater æsthetic sensibility, but simply because he would have known that they were not "the thing," but bad copies of what had been "the thing."

Real style is, I take it, the perfect adaptation of the means of expression to the idea. It results from ease of expression. Style, as it is understood in modern architecture, is essentially a social symbolism.

Let me give you an example of what I mean. At one time I was on the consultative committee of the Victoria and Albert Museum. At a meeting we had been considering the loans of objects of art to various manufacturing centres. After the meeting one of the members to whom I had confided my doubts about the value of this method of supplying manufacturers with models for imitation, replied that it was most important, and added we should have a wonderful art at once if only they can be taught to imitate the right models—if the potters would only see that they ought to imitate Ming china, and the silversmiths the best George II silver, and the furniture makers Chippendale, and so on, citing all the periods which happened to be the shibboleths of smart society at the moment.

Now this view of art is, I believe, fatal to creative efforts. It implies an idea that beauty is something material, absolute, fixed, and determined, like a chemical element which can pass from one combination to another unchanged and unaffected. Whereas in fact beauty is a relative quality which inheres in the forms of the object of art only in so far as it is an evident sign of an inward spiritual state on the part of the artist. That is the reason why nothing is so unlike an original work of art as a copy of it—since it inevitably is the expression of a totally different spiritual condition.

You will, perhaps, suppose from what I have said that I am against pastiche in architecture altogether, against all attempts to make use of the forms of past architectural styles. But the matter is not quite so simple as that. For a copy of an original work of art by an artist, though it is entirely unlike the original, may have great æsthetic value provided the artist remains an artist and does not become a copyist. It is quite possible for an artist so to assimilate the principles of a past style as to be able really to create something entirely new whilst using similar forms. But he must have got at the underlying principles, and not merely have learnt by heart the external evidences of those principles. He must be able to move freely, and of his own impulse, among those forms. He must *think* in the language, not merely *translate* into it.

Naturally the most obvious example of such a successful and creative

pastiche is the Renaissance architecture of Italy, where from the first the underlying principles were so firmly grasped that the adopted style grew continually into new and coherent forms like the unfolding of an organism.

But I will take a modern instance, a curiously isolated and singular one of a man who had a genius for pastiche, I mean Bentley. The only Gothic building I know of his—and I only know it from the top of a bus in the Hammersmith Road—is, I think, one of the few successful examples in modern times of the use of Gothic forms; and as for Westminster Cathedral—I say nothing about the outside nor about the details or ornaments which, in spite of their amazing ingenuity, can hardly be regarded as satisfactory—here he was up against insoluble problems of modern mechanical craftsmanship—but the general planning and disposition of the interior show, I think, just such a free creative movement along the lines of a past style as alone justifies pastiche.

But, alas! what is one to say to the incredible museum of pastiches which makes up most of modern London? Where the client and the architect are sufficiently smart, the translation into whatever language may be chosen is, I grant, fairly scholarly, and shows a general notion of the grammar and syntax as studied from outside. But God help us when we come to the more "*original*" adaptations. What a jargon, what a chattering of Babu and Pigeon English, what a scattering and smattering of incoherent and incompatible words, what a patchwork of odd phrases picked up here and there and stuck together anyhow as the hazard of momentary convenience suggests!

I need not labour the point, we must all be acutely conscious of this phenomenon. This practice of the pastiche, scholarly and exact or clumsy and "original" as the case may be, is more or less universal. At Munich you used to get out of the railway train into an imitation twelfth-century Veronese church, you walked a hundred yards and faced the Loggia dei Lanzi and various editions of the Propyloea and the Parthenon cropped up in odd places. The French have not, perhaps, played such wild chromatic scales up and down the archæological keyboard as we and the Germans have done; they have stuck more or less closely to some aspects of French Renaissance— they never had a Ruskin—but their adaptations of these styles have often been grotesque and extravagant. They have had a slight advantage in sticking a little more closely to a narrower range of tradition. On the other hand, they have developed the cruel efficiency, the hard brittle chic of the École des Beaux Arts; an instrument perfectly adapted to replace inspiration and sensibility by brilliantly self-confident mediocrity. On the whole, as we should expect, the French have more measure, more hold on tradition than any other people of modern Europe. Even when the eczema of *l'art nouveau*

spread from the offices of the *Studio* all over the world, the French gave to it a certain elegant sobriety, whereas in Germany it flourished into forms of colossal and nightmarish horror. For the Germans are nothing if not thorough. Nor have they the social alertness to understand the chic. Even when they are, like all of us, dressing buildings fashionably, their idea of fashion has a certain clumsy pedantry which defeats even this modest aim.

I seek, then, amid this grotesque welter of modern European architecture for the peculiar characteristics of our own brand and find it in two things: (1) The absence of the sense of scale, and (2) the presence of a certain kind of good taste.

First, as to the want of the sense of scale;—Ruskin once wrote that the English had always built rather for rats and mice than for men. We seem incapable in our architecture of a free or generous gesture. We are meek, timid, and meticulous. We cramp and skimp and cower. We finish our tiny details with short-sighted, ant-like industry. We invented, alas! the "cosy corner," and the cosy corner in one form or another marks most of our building. In the realm of imaginative form we, this great, imperial, adventurous race, appear as burrowing, furtive, obliterated creatures.

What is curious is that this characteristic seems deeply inherent in our civilization. One has only to compare our snug little Gothic cathedrals, built piecemeal and without any generous comprehensive plan, with the vast pretensions of French cathedrals, mostly built straight off under the impulse of a single all-compelling *élan*, or with the great bare emptiness of Italian churches of the same time, to see how true this has been.* But let me take modern instances. Heaven preserve me from wishing to praise modern French or Italian official architecture, but compare its badness with ours and you will see the curious distinction which we possess. You know the horrible Centro della Città at Florence, a ghastly expression of the civic pride of the modern Italian shopkeeper. But in spite of all its blazing vulgarity it has scale. Or take again the still more devastating Victor Emmanuel monument in Rome—unfinished when I was last there. You may, perhaps, be grateful that we have nothing like it, still it is designed with something of the amplitude and generosity of plan which a public monument demands if it is to express at all the common consciousness of a great city or people.

Or turn to France, the *Grand* and *Petit* Palais and the Pont Alexandre III over the Seine, with its vulgar pylons and gimcrack sculpture: trumpery stuff in detail, if you like, but the roadway spreads wide and inviting in its gentle

*Two things may be suggested as contributing to this—the small scale of English landscape and our comparative poverty in the Middle Ages.

curve, and the two palaces—don't think I don't know how bad they are—face one another across a proportionate space of roadway. And here, Portland Place is the only roadway in London that gives one room to spread the wings of one's civic consciousness. It isn't, of course, mere size that I want (though some absolute scale of size relative to our human dimensions is indicated), but like everything else in architecture or all art for that matter, it is proportion that counts, as witness St. Paul's, where the actually small space spreads itself for the subtly deceived eye so sumptuously that one can hardly believe one has stepped so quickly from end to end. Or Trinity Library at Cambridge, as vast, as massive, as overpowering as the Temples of the Nile. But then Wren is the one miraculous exception to all my generalizations about British architecture. He, indeed, was one of the greatest masters both of scale and of plastic expression that has ever lived.

The other distinction of our national architecture is its occasional—I fear very occasional—good taste. This, of course, is hardly ever displayed in official or public building, but only in what I call smart private building. But grateful as one is for this quality amidst the vulgarity of our modern cities, I have said enough to show why I regard it as much rather a social than an æsthetic quality. It is a negative good taste, which consists in not making mistakes of grammar, not being dowdy, slack, and unscholarly. It results in the correct composition of a good pupil, it cannot attain to the inevitable and unexpected harmonies of eloquence inspired by a great passion.

Heresy No. 4.—"There are two kinds of beauty in building, natural beauty which is the result of clear expression of function, æsthetic beauty which is the result of clear expression of an idea. We have arranged so as to have neither." Natural beauty results from perfectly adapted mechanism. I cannot altogether explain why this should be, but it does appear so frequently to follow that I think it may almost be taken as a general principle. The curves of a shell which record the continuous growth of the creature have the kind of harmony and sensual logic that I mean; but I find the same in many machines in which this adaptation to the stress of natural forces has arrived at perfection—in the lines of a man-of-war, or a racing yacht, or an aeroplane, or a steel bridge. Now, when an engineer has plotted the curve of a bridge by a purely mathematical calculation of structural needs, it is not unlikely that he has a sort of æsthetic recognition of its logical precision, and he may and sometimes does arrange so that nothing shall interfere with the evidence of this. Or he may go further and by the adjustment of unessential details of his structure—details in which he has a free choice—he may even underline and mark out for the spectator his recognition of this character. From such a proceeding the spectator may reap very considerable pleasure,

and at no time in the world's history has there been a greater opportunity of displaying this kind of beauty, because our strict scientific methods have led to a vast amount of such exact calculation of natural forces and exact adaptation to meet them. At least we could have a great deal of engineering beauty in our towns, but, alas! the engineer is intimidated by the pressure of social prestige. He, poor man, is not an artist, and society demands "art," so he has to allow an architect in to put on the art, or he may even himself have enough general knowledge of "styles" to put on the art himself.

To illustrate this, compare in your minds the spidery elegance, the economy of means to end, the logical exactitude of the *Pont transbordeur* at Rouen with the Tower Bridge. In the latter, a dismal reminiscence of vague feudal memories has covered up all sense of logical purpose and functional care, and from the result one can only feel a sense of disgust, or pity if one is philosopher enough to read the motives which led to such a monstrosity. Some time before the war I passed through the then new station at Metz. The engineer who built it must have had the pride of his calling. A vast curve of steel and glass spanned the whole wide space, and rested, not on iron acanthus leaves round iron capitals, but came to a series of steel points, each of which rested on a cube of rough granite quite near the ground. I know nothing of engineering, but the perfect functioning of every bolt, the exact economy of means to end, seemed to be self-evident, and gave me a singular emotional thrill such as for that matter I feel in some French thirteenth-century Gothic buildings, where also the most evident, though not the only, beauty is precisely this beauty of exact engineering. And then look at Waterloo Station, that miserable and interminable series of glass and iron hutches, built, no doubt, on the cosy-corner plan.

Or look at the many ferro-concrete buildings one sees springing up. Let me admit here that there are signs of improvement, but still, as a rule, the essential logic of adaptation is fumbled and messed over with "architectural features." There is scarcely ever a straightforward logical emphasis, but plenty of tasteful reminiscences of this, that, or the other period towards which our incurable archæological snobbery turns with abject reverence, until the word goes round that we are worshipping at yesterday's shrine, and ought to be hurrying on for fear we should be found on the wrong social landing.

Heresy No. 5.—"Æsthetic beauty in a building is essentially the same as that of sculpture, and results from the expression of a plastic idea. This expression of a plastic idea is very rare in our architecture, and almost unknown in our sculpture."

I come to much the most difficult part of my task here—how to explain what I understand by a plastic idea. I mean something like this, for in at-

tempting so difficult a task I shall very likely fail to give any precise verbal definition. I shall certainly be ready to accept any suggested improvements which will make the sense more clear. I mean, then, such a construction of three-dimensional shapes as satisfies the contemplation of their relations to one another and to the whole combination. Let me suppose I take a number of half spheres of different sizes and put them in turn on the top of a cube. Let us suppose both an artist and a mathematician to be assisting at this experiment. We may suppose, for the sake of argument, that our mathematician or logical contemplator finds that one particular sized hemisphere gives rise, in relation to the cube, to peculiar and interesting mathematical properties. Our artist or sensual contemplator might also find that a certain size of hemisphere gave, in relation to the cube, a satisfaction quite different from that which could be got from the other combinations. It might even be that he and the mathematician would find that it was the same particular hemisphere which satisfied each of them. But this would be merely an interesting fact for a psychologist, it would not affect in any way the nature of the artist's satisfaction which is immediate and direct, and of a totally different kind from the mathematician's interest. What we have, then, to recognize is that certain relations of solid shapes to each other do set up in the mind which contemplates them a peculiar condition of tension and equilibrium, which is the essence of the æsthetic emotion. And an object which has these relations that are satisfactory to æsthetic contemplation may be said to have plastic form.

Now it is evident that an object may be in three dimensions without having in this sense three-dimensional or plastic form. In fact, all buildings as all sculpture is three-dimensional, has mass and volume, but it may not have what I call three-dimensional form. That is to say, the relations of its parts together may be merely casual, the result of accident or outward necessity, and not self-explanatory, and apparently necessitated to the imagination.

It is clear that an architect's choice of plastic forms is not free. It is limited sharply by practical conditions. But he has generally at his disposal the rectangular block (I believe this is more properly called a rectangular parallelopiped), of which the cube is one variety, the cylinder, the hemisphere, the pyramid, and the prism or sections of these forms. Now the perfectly lucid expression of most of these forms on a considerable scale has already a certain effect on the imagination. The Pyramids are a good example. I have never seen them, but I can quite believe they possess a crude impressiveness. Ruskin somewhere describes approaching a town at dusk and being thrilled by the vision of what looked like a vast Temple of Vesta, until, on nearer approach, he saw a gasometer, whereupon he delivers a tirade

against modern iniquity. He was really impressed by a bare cylinder on a large scale, but his morbid historico-social over-sensitiveness prevented him from recognizing that what had impressed his imagination through his senses was so far as it went beautiful, and that its beauty ought not really to be spoilt by the unpleasant overtones of association. Or, again, the sheer undisturbed rectangular mass of a factory may, if its relation to the earth surface is fortunate, give one a sensation of the kind I mean.

But so far we are dealing only with the raw material out of which the language of plastic design in architecture can be made. It is when such forms are combined, when the superposition or interpenetration of two or more rectangular blocks, or of blocks with sections of cylinders, and so forth, is devised in relation to the earth surface and its possible plastic arrangement, that we begin to get the essentially æsthetic quality of architecture. Or, rather, when such interplay of these elemental forms is perfectly adjusted to the expression of an idea. How rare or how common this is, will, I suppose, be a matter for infinite discussion. In such a matter it would be ridiculous to suppose one could prove anything. One can only keep one's sensitiveness alert and one's mind free from prejudice and record one's impressions as honestly as possible. Clearly the sensibility to such plastic forms varies immensely with individuals (at least as much as their ears for musical relations), and still more, perhaps, the assiduity and persistence of their contemplation of such plastic ideas. I can only claim that such plastic expressions do give me intense and vivid pleasure, and that I find myself very rarely able to indulge in it as I go about London. I enjoy it more acutely in walking round St. Paul's than anywhere else. Or indeed in walking inside, since clearly these plastic relations have to be contemplated concavely as well as convexly, wherein lies the chief difference, perhaps, between architecture and sculpture. But I do maintain that in modern architecture I hardly ever get this sensation. I hardly ever can apprehend the three-dimensional development of the ground plan or its relation to the earth's surface, or at least my apprehension is not of that vivid nature which accompanies æsthetic apprehensions of purposeful design.

I do not think that most modern architects, preoccupied as they are with architectural costume and the ingenious application of styles of various kinds, ever make much of the possible play of these elementary plastic forms. I do not think they feel plastically, their minds do not move freely in three dimensions, they think and feel in the flat. I believe that if they did feel plastically they would discover all sorts of untried possibilities in the combinations of these forms and in the adaptations of them to particular ground plans and to peculiar situations. Our changed modern conditions and new structural pos-

sibilities would suggest to any such free plastic imagination innumerable new combinations of these elements. As it is I have seen photographs of purely utilitarian structures in America, particularly vast grain elevators and storages where you get a series of immense bare cylinders supporting a flat rectangular block which give me the idea of an essential plastic architecture much more vividly than any other modern buildings. I know that in these cases the co-ordination of the forms is dictated by practical not by æsthetic needs, but even so, such is the effect on the imagination of untroubled geometrical shapes, they actually seem more like the great things in ancient architecture than our copies. They remind me of the temples at Pæstum much more than, say, University College or St. Pancras Church. And here let me put in a plea for the much-abused and always-about-to-be-destroyed Charing Cross railway bridge, which, at least, has this beauty of large untroubled and easily apprehended shapes, with its massive cylinders supporting a plain rectangle. It is not intentionally a work of art, it is not nearly so fine as Waterloo Bridge, but it is vastly preferable to most of the deliberately artistic efforts at bridge building in London. What, then, would be the effect of such forms knowingly disposed by a mind capable of three-dimensional imagination?

Another reason that makes me suppose that modern architects have not grasped the possibilities of this fundamental structural design is just that so far from underlining whatever plasticity the mere necessities of the structure provide, they appear to me deliberately to obscure and overlay them. Thinking, as I believe they too often do, in terms of façades, they fail to realize that what may diversify and give relief to a façade considered as such may—I don't say it must—actually obscure and obliterate the plasticity of the whole mass. Let me give you a trivial instance. In Fitzroy Street there are a great many houses with mouldings round the windows and general enhancements of the façade, and some such houses occur at the corners of streets. They never give me a sense of volume or mass, but there is one house at the corner of Maple Street where the façades are absolutely bare—there is not a single moulding round any of the windows, no cornice, no projection of any kind, and the result is that this house alone gives one a sense of its plastic coherence and unity. A pilaster at the corner, however well it might look viewed as part of a façade, would, I maintain, really diminish the general plastic impressiveness. Flatness of surface may, in short, be dictated not from poverty of invention, but from a firmer imaginative grasp of the plastic whole. Mind, I am not suggesting any rule for or against pilasters, or whatever backwards and forwards movements in a façade may be desired, I only mean that unless these are conceived in relation to the whole mass they tend to destroy the most fundamental æsthetic property of architecture.

Such treatment, then, of façades, window and door openings, and so forth, is of course of infinite importance, but it must always be consequent upon the general plastic idea. It is evident, I think, that the mind works with great difficulty in three dimensions—we tend always to think in the flat. The mere fact that there is no more familiar or frequent word for rectangular blocks than rectangular parallelopiped, indicates how little we are accustomed to handle the general notion of such a form, however frequently we handle boxes.

And perhaps we as a nation are singularly limited in this respect. Certain it is that we have never had any significant sculpture, and that our painting has always lacked the comprehension of volume. It has always drifted away from realization into representation. At this moment there is a small and insignificant band of younger painters who have grasped the importance of this conception, and who are resolutely trying to recover the fundamental principles of structural design in volume and mass, refusing to be turned aside by literary allusions and poetical associations or a delight in merely decorative arabesques; but is there any similar movement among architects? I have a hope there may be, and that I shall get into touch with it this afternoon, but hitherto I have not had the luck to come upon it.

I go back for a moment to the treatment of the façade. What I notice in modern architecture, looking for the moment at the façade as a separate unit (and I admit that in town houses standing in long rows where there is no chance of designing a whole block of houses all of a piece—and they ought always to be so designed), under such conditions, the architect is bound to do what he can with a façade as an isolated whole. Well, even then I notice that a not uncomely disposition of proportions of floors and window openings to the whole rectangle is too often spoilt by what seems to me a purely haphazard choice of the relief of pilasters, mouldings, or what not. So that I cannot but think that the sensibility to proportion in the flat is with us much stronger than the sensibility to proportionate relief.

This relief is, of course, apprehended visually by means of the differing values of light and shade, and here again the analogy with painting holds. It is just there that our artists so lack the sensitiveness to relative values that the French painters have by tradition.

This question of light and shade is, of course, of supreme importance in architecture. It is only by the different presentation of planes to the light that we grasp the volume and mass of a building. From this consideration follows the great importance in the total plastic effect of the quality of the surface and the quality of the edges. On this ground architect and painter meet; for regarded thus, in its purely visual aspect, their problem is identical. This

branch of our arts may be described as the study of texture as opposed to design (though, of course, neither exists apart from the other). Now, to a painter, beauty of texture occurs when the texture supports and expresses the design. However charming it may be in itself, it fails if it does not fulfil this function. And I believe the same holds true of architecture. As an instance of what I mean by the importance of texture, compare in your minds an original Norman building with a modern restoration or imitation. You will recognize at once that in the original the actual cutting of the stone face and the mouldings does give a sense of mass to the structure which the tight mechanical edges and dead workmanship of the modern workman deny. A surface or an edge which has been, as it were, played over in every part by the sensibility of a human intelligence, retains the impress of life. The artist knows this well—a good general disposition of masses may be spoilt by dead handling, and a mediocre one may almost be held together by the sensitiveness of its surface. In both architecture and painting texture is almost always improved by the mere action of time.

We come here upon a grave difficulty for the modern architect which we painters don't have to face—namely, that the race of workmen trained to some kind of æsthetic sensibility is extinct. The mediæval architect could rely upon this *main d'œuvre;* the modern must go without. All he can hope for is a dead mechanical accuracy. Under these circumstances it would seem that the only policy to be adopted is just the reverse of that which is usually chosen. Instead of raking out of museums and albums samples of Gothic, Renaissance, or Louis XV ornaments, and having them translated into the dead journalese of the modern stone-cutter, it would seem that the architect should shun as far as possible any adornments of his surfaces; should rely as far as possible on the bare presentment of his great plastic divisions, or if, in order to express this fully he has to cut up a surface, he should rely on mere prominence and regression of the simplest possible forms. In fact, that he should never again potter about among the styles.

Instead of this, what we actually see is that modern architecture neglects the fundamental language of plastic form and is concerned with the more or less tasteful adaptation to the practical necessities of a modern building of the subordinate and merely accessory ornaments of styles. These styles were generally developed under quite different conditions of construction and to meet quite different conditions of life in past ages. These ancient styles are admired not in and for their æsthetic qualities, but as symbols of that historic past for which we have a peculiar reverence. They are for most of us rather souvenirs than works of art. To the æsthetic sense time is of no consequence whatever. The question of where and when a work of art was produced has

only a subsidiary interest. It in no way affects the æsthetic emotion which the work arouses. But it is not so with our attitude to past styles of architecture, these are felt for their associational value. Not only have religious and secular buildings their appropriate styles (no such distinction existed, of course, in the ages when "religious" architecture was created), but High Church and Low Church buildings are dressed as distinctively as High Church and Low Church parsons. This is what I mean by saying that our architecture expresses historico-social values.

That it is founded on snobbery is rather a disagreeable way of stating the inevitable fact that architecture is pre-eminently a social art, for snobbery is only an ugly word for one aspect of the herd instinct in man. But I will treat of this more fully when I come to discuss why it is not the architect's fault that architecture is as we find it.

I go, then, to Heresy No. 8, that what I call the vices of modern English architecture are no novelty, but have always been more or less inherent in our architectural tradition, and have only started into prominence with modern conditions. I know this is worse than heresy, it is blasphemy against our religious reverence for the past. But honestly isn't it apparent that a great deal of our English Gothic is precisely costume?

The essence of Gothic architecture was the purely engineering discovery of how to build a stone greenhouse. All its forms were dictated by the structural necessities that this implied, but our early English architects used these forms as fashionable ornaments. They continued to pierce wall surfaces instead, building with glass walls. It was hardly till the Perpendicular that they began to use the Gothic structure with logical certainty and freedom. The same thing happened with the Renaissance; the new fashion of mouldings and ornaments were used for long before there was any frank acceptance of them as expressions of a changed fundamental idea. This is clearly too big a subject for me to elaborate, but I think it is instructive as throwing a sidelight on what seems to me characteristic also of our modern architecture—its preoccupation with the adventitious and accessory, with the associational accompaniments of form rather than with form itself; with fashion rather than with design.

Heresy No. 9.—"That modern conditions and modern scientific methods have supplied as great an opportunity to architecture as any in the world's history and that that opportunity has been missed." Real æsthetic creation is, of course, a comparatively rare thing in the history of the world, but it has so frequently happened in the past that some new problem closely connected with an artist's work has provided the stimulus to such a creative outburst that one cannot help wondering why so violent a stimulus as that given by

new constructional possibilities in architecture has led to so disappointing a result.

Think of how great an impetus to æsthetic invention was given in Romanesque and early Gothic times by the working out of the problems of stone vault construction. Then every new invention was accepted eagerly and new forms invented to express and embody each structural advance. Whereas it seems to me that in modern architecture new constructional possibilities are accepted slowly and with a kind of grudging reluctance. Instead of inspiring the invention of new and appropriate plastic forms, the new methods seem to be slurred over and buried beneath the old stylistic conventions. Here and there one sees a timid attempt to accept the situation, but there is no concerted general effort. I miss the enterprise, the experimental courage, the *élan* which one thinks the immense possibilities of modern building methods might have inspired. Now I do find in some modern painting just this atmosphere of fervour, of passionate research, of adventure, of inquiry and eager expectation which marks a period of æsthetic achievement. How much greater that achievement would be if there were only a small group of architects who were ready to join in these voyages of discovery and to supply and receive mutual counsel and support. I am afraid it must have been a painter who said *"l'architecte c'est l'ennemi."*

Heresy No. 10.—"That it is not exactly the architect's fault." I fear lest this should seem the most insolent of all my heresies. But I think it results from a consideration of the circumstances. Architecture is a social and not an individualistic art. It requires for its realization the coming together and agreeing on the spot of a group of people. A poet can buy pen and paper and starve while he writes immortal lines. A painter can buy canvas and paint, and, before he more or less literally starves, can create works which will enrich a dealer and ultimately a nation. These need come to terms with no one but themselves. It only requires that one man should be sufficiently convinced. But an architect can buy a board and a ruler, and if he starves he leaves nothing but lines on paper which no one will look at again. He must come to terms with certain wealthy people who are probably profoundly ignorant of his art and almost certainly endowed with social vanity which they wish him to embody in the building. Worse still, to do great work, he must come to terms with a committee or a Government office. And always the architect has to convince by means of flat plans, which it is extremely difficult to translate on the imagination into three-dimensional reality. Now we have arrived at such a pass that almost the only works of art which are found to have permanent value are of a kind which when they are produced violently disgust the mass of mankind or at least leave them utterly indif-

ferent; whilst that which they like is generally found, often as soon as ever
the artist dies, to have no more value.

The history of art in the nineteenth century is filled with examples of this
truth. But going back further the instances become rarer, and in the Renais-
sance we find that the names of those we still revere were already acclaimed
during their lifetime.

What has changed? Human nature? I believe too much in the uniformity
of nature to think that this can have happened in such profound things as
aptitudes and sensibilities. But though human nature in its character barely
changes, institutions, manners, traditions do change. Art as a social institu-
tion is built on snobbery. It is needed by mankind as a symbolic currency of
social aspirations and values. Æsthetic feeling and æsthetic choice is in the
mass of mankind so feeble as compared with the vehemence of the social
instinct that the ordinary man accepts whatever society proposes for his ad-
miration. The men who execute works of art have, as a rule, keener sensi-
bilities, and they have developed these by the exercise of their art. They,
therefore, have strong preferences. In the periods of great social art these
professionals have managed to get power to impose what they considered
good on the general mass which accepted it with the suggestibility natural to
the herd.

But though the man in the street has but little æsthetic sensibility, he has
certain likes and dislikes. In the words of the poet—"We needs must love the
lowest when we see it." His untrained sensibilities are touched by what is
striking, sensational, and melodramatic, his social vanity is flattered by what
is fashionable. It is clear, then, that there is a great deal of money to be got
by appealing to these tastes. If once the professional opinion breaks down
and loses its solidarity and authority there will be a scramble among the
producers of art to give the public "what it likes," until finally the very bodies
which were founded to give authority to professional opinion will become
organizations to make money by exploiting the desires of the mass.

This, I believe, is what has happened within the last two hundred years.

The question for us is, can we build up again such a solid, authoritative,
scholarly professional opinion in the teeth of opposition, and in spite of the
great vested interests which will oppose it.

There is some hope to be gleaned from the fact that in Paris, at least,
such a solid professional opinion exists among painters, and actually imposes
its dictates on the snobbery of the *nouveau riche*, who finds himself com-
pelled by social pressure to buy pictures he dislikes, not daring to put on his
walls those he prefers. I know actual cases of this.

You will perhaps think, naturally enough, that in this paper I have been a

carping critic, unfairly severe on modern architecture; that I have picked out and underlined everywhere its defects without sufficiently considering the causes which explain and excuse them. But, in truth, I have no desire to scold or blame. I know how futile such an attitude is. I merely want clearly to face the situation in the belief that that is the first step to improvement. It is just the advantage of our highly self-conscious and critical age that we can by a deliberate effort change our character. We can fix our minds on those defects which from long inherited custom have become not only traditional but instinctive, and by so fixing our minds we may ultimately correct them altogether. I ask you to believe that, however wanting in tact my performance this afternoon has been, I have undertaken it in no spirit of ill-natured cussedness or sordid envy, but because I am the victim of a perhaps quite absurd faith—the faith, namely, that the æsthetic pursuit is as important in the long run for mankind as the search for truth.

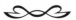

ENGLISH POTTERY

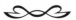

English Pottery: Its Development from Early Times to the End of the Eighteenth Century. By Bernard Rackham and Herbert Read.

THERE is a curious irony about the history of art. In an age like the present, when the archaeological sentiment is so widely diffused that the discovery of a Pharoah's tomb becomes "topical" enough for the music-hall stage, a peculiar illusion about the art of the past affects cultured people. Here, for example, is a finely got-up volume, full of excellent and elaborate reproductions, with a learned and searching history of the production of pottery in England. And yet almost all the artificers whose work now forms the material for learned study and extensive reproduction were thought nothing of in their day, and their works were for the most part regarded with as little respect as we now give to the saucepans and medicine bottles that we use. They were part of the ordinary household furniture. And what is more, if someone were to-day to make similar objects, he would receive just as little consideration. I have bought for twenty centesimi in Tuscany modern pots that are essentially more artistic than anything so elaborately enshrined in this expensive book, if one excepts a few of the mediaeval pieces.

These are, indeed, really fine works of art; they show a just sense of proportion and a rhythmical feeling for the galb; where decoration is applied, it is done with restraint and good feeling and without ostentation.

But when we come to what the authors call the English tradition, when we come to the great development of Staffordshire ware in the seventeenth and eighteenth centuries, I find myself wondering whether the contemporary purchaser of Toft's and Hugheson's productions was not right in paying no particular attention to these useful but essentially clumsy and ungainly productions. Sometimes, as in the Loving Cup in York Museum, the pieces were evidently made for show, and with the idea of a certain magnificence. But this only makes matters worse. The proportions become even more meaningless, the galb more clumsy and inconsequent, and the heavy ornament is arranged without any other idea that one can discover except to

This book review is reprinted from *The Nation and Athenaeum*, 21 June 1924, 382.

229

enrich every possible empty space by meaningless blobs and weals of clay. This is really barbaric art, but barbaric in a sense unknown to savages, and apparently only possible in certain civilized conditions.

It is natural enough, of course, that people should have turned to these pieces when they had once got thoroughly bored with the machine-made and soulless perfection of the "cultured" pottery of Wedgwood, and with the imitations of eighteenth-century French and German. These rough works were at least "quaint"; they had the charm of a certain *naïveté;* above all, they were a violent contrast to what had bored people before. That seems to have been enough; people began to collect them without looking to see whether they were the result of a genuine artistic sensibility or merely of a clumsy ingenuity and a vague desire somehow to create a decorative or at least decorated object.

But as serious pottery, and still more as serious plastic art, nearly all these works seem to me deplorable. From an esthetic standpoint it would be far better to study the contemporary peasant pottery of France, Italy, Spain, and Portugal, simply because it is so much better than seventeenth- and eighteenth-century English provincial ware. But there is one grave objection to such a proceeding. There is no difficulty in collecting all the information needed by word of mouth from the actual makers, whereas learned discussions as to the precise date and place of origin of the potters can be undertaken, if one confines one's studies to those who have long been dead.

It is time that the archæological illusion was dispelled. We shall never really understand the work of the past until we look upon it with exactly the same critical and unbiased apprehension which we ought to give to the works of our own day. We shall never do justice to the works of our own day until we have given up an exaggerated and purely romantic respect for the work of the past. Indeed, of the two distortions of perspective which the archæological illusion produces the unjust bias which it creates against the unconsecrated work of the present is the more serious and the more harmful. But to return to the subject of English pottery. An interesting chapter is devoted to the story of the introduction of tin glazes with coloured decorations. This the authors show was probably introduced directly into England by an Italian potter who had settled in Antwerp and fled thence to escape persecution. He settled first at Norwich and thence came to London. The earliest piece in this "Majolica" technique, which seems clearly to be of English origin, is dated 1602. All the earlier tin-glazed wares show this Majolica influence. Later on in the seventeenth century a fresh influence from Holland led to the use of Delft as a generic term for the glazed and painted ware. These are among the most agreeable of all the works reproduced in the book. It was

natural perhaps that English workmen should find the Dutch tradition of painted decoration more in harmony with their natural bent than the Italian, which they never seem to have mastered. Some of the British Delft of the eighteenth century has real beauty. Particularly fine is an elaborate punch-bowl, apparently made for a Swedish sea-captain, with a very spirited and admirably drawn rendering of his ship in full sail.

The Leeds pottery is of later development and did not begin till the time when pottery was becoming a more or less sophisticated art; but there is a distinction of proportion and design about the best pieces, not to mention the unrivalled quality of their glazes, which marks them out favourably among the productions of English pottery at the period just before the industrial revolution destroyed the tradition. At one period the Leeds factory of Hartley & Co. was in competition with the Wedgwoods, but, though their work is sophisticated, it avoided the deadly mechanical perfection and "tightness" of quality which marked the Wedgwood ware.

5

ART AND ITS
INSTITUTIONS: EXHIBITION
AND EDUCATION

I N the history of cultural institutions, the Bloomsbury group marks the
end of an era, "the last period in English history when a group of such
intellectual excellence could have assembled in London outside the uni-
versity system."[1] Inherited money—albeit modest—allowed Bloomsbury's
members to sustain themselves on the fringes of the institutional establish-
ment. Thus, although Fry's career intersects with the history of major art
journals, museums, galleries, and universities, he was not dependent on any
single institution, and he exploited this privilege to challenge conventional
institutional practices and to promote new forms of art exhibition and educa-
tion. Fry's accomplishment may be measured by the extent to which the
reforms he advocated became the norm, today subject to a subsequent gener-
ation's critique. The fact that Fry's writings on art institutions are now open
to critique, however, should not obscure the reformer's zeal animating the
essays reprinted here.

Early in his career, Fry established his reputation as an outspoken enemy
of the institutional establishment through his part in the controversy over the
Royal Academy's administration of the Chantrey Bequest, which funded
purchases of modern art for government museums. Although he testified at
the eventual Parliamentary inquiry, Fry was less a primary actor in this
drama than a publicist who used his regular columns in the *Athenaeum* to
support and promote D. S. MacColl's exposé of the Academy's diversion of
the bequest to benefit its own senior members. Between 1903 and 1904, Fry
devoted several columns to the matter.[2] His first volley was fired in May
1903, in a short notice headed "Fine-Art Gossip," which salutes MacColl's
attack on the Academy. Six months later, Fry resumed his challenge to this
bastion of official culture:

> We gather that if the matter were tested in a law court the position of
> the Academicians would be perfectly secure, but only at the cost of their
> open declaration that they consider [fellow Academicians] Mr. Frank
> Dicksee, Mr. Tuke, and Mr. Corbet so much greater as artists than
> Whistler or [Alphonse] Legros that it was of more importance for the
> encouragement of British art to purchase two works by each of the for-

mer than to acquire anything at all by the latter masters. When we have
this declaration on oath we shall, of course, be satisfied as to the honesty
of the trustees, though we shall condole with them more feelingly than
heretofore on their incapacity for the high position they occupy.[3]

Almost a year after the first notice, Fry was reviewing the "excellent and
public spirited" volume of documents MacColl had published about the
Chantrey Bequest. Although the evidence showed clearly that Sir Francis
Chantrey's "instructions have not been carried out," Fry observed that Mac-
Coll, aiming for "practical reform rather than recrimination," did not vilify
the trustees, but accepted their excuses of habit and oversight. Balancing tact
and skepticism, Fry concurs: "Such an explanation, at least, we prefer to any
idea of deliberate malpractice and conscious breach of trust."[4]

In addition to laying the groundwork for a career controverting
authority—including, ultimately, his own—Fry's articles on the misad-
ministration of the Chantrey Bequest are worthy of note as records of his
early attitudes toward the institutional construction of art. The two essays
reprinted here, both headed "THE CHANTREY BEQUEST," appeared during
the Parliamentary inquiry over the summer of 1904. They set the dispute in
historical context and examine possible reforms.

The first essay reveals Fry, once again, to be very much Ruskin's descen-
dant. Like Ruskin, Fry had an academic background in the natural sciences.
The methods and metaphors of science pervade the writings of both men,
who claimed for their revisionary ideas the authority of scientific order and
objectivity.[5] The brief history of aesthetic judgment offered in this piece
echoes Ruskin in using science to goad the art world from the ruts of con-
vention. Perhaps the most obvious legacy of Ruskin here, however, is the way
Fry invokes the middle ages to challenge more recent conventions. Fry un-
dermines truisms about the subjectivity of taste through a comparison with
that favorite Arts and Crafts institution, the medieval guild, which is pre-
sented as the collective voice of "competent masters in the art" against self-
serving artists and overweening patrons alike. Fry calls for the redemption of
modern art through a return to guild traditions of "sound craftsmanship," "a
thing no more inherently impossible than a tradition of good plumbing or
carpentering." Derivative of Ruskin, this evocation of the guild to imagine
alternatives to current art-world practices also anticipates Fry's writings from
the time he was founding his own guild-like institution, the Omega Work-
shops (see chapter 4). Ideas from this early article on the Chantrey Bequest
find their echo in, for example, the essay for the 1912 book, *The Great State,*
where Fry claims that the "average workman" retains a "bias in favour of
sound and reasonable workmanship" so that in the future "guilds might, in-

deed, regain something of the political influence that gave us the Gothic cathedrals of the Middle Ages" (*V&D*, 74–75).

The introduction to the previous chapter noted that the Arts and Crafts influence of figures like Ruskin blended, in Fry's writings, with principles associated with Aestheticism. This analysis is applicable here as well, for Fry's final essay on the Chantrey Bequest—written after the Parliamentary committee released its report recommending changes in its administration— takes up the conflict between the collective nature of institutions and an idea of art as individual self-expression. Here, as in *The Great State*, Fry attempts to reconcile the Aesthetic veneration for individualism with the cooperative structure of Arts and Crafts guilds by historicizing the present moment as one that has lost any sense of a "common tradition" in art and so, at least for now, must nurture individual efforts, a task best undertaken by other individuals. Fry's distrust of committees and collectives remained constant from at least 1902, when his article, "THE ADMINISTRATION OF THE NATIONAL GALLERY," denounced the acquisition of work by committee as ensuring that only "works of feeble and flaccid personalities" will be sufficiently inoffensive to arouse no opposition. Fry took the same position in his commentary on the Chantrey Bequest, and repeated it in *The Great State*.

In the essays on the National Gallery and on the Chantrey Bequest, Fry proposes museum directors as the individuals best suited to direct acquisitions policy. The specter of foreign competition—both Hugo von Tschudi of the German National Gallery and millionaires "from across the Atlantic"— hangs over Fry's discussions of institutional patronage, perhaps nowhere more strongly than in a note on "OUR NATIONAL COLLECTIONS," published early in 1906. Here Fry condemned the meager resources Britain endowed for its public collections, endorsing a sales tax on major private purchases of art to support acquisitions for the Tate and the National Gallery. By the time Fry wrote this piece, he was something of an expert on the pull of international capital in the art market. Events, beginning in 1904 and continuing through 1910, drew Fry's career into the network of international art trade, an experience that left him profoundly ambivalent about the merits of individual patronage and its effects on museums and galleries.

Early in 1904, Fry was deeply disappointed in being passed over when Charles Waldstein (later Sir Charles Walston) was appointed to the Slade Professorship of Fine Art at Cambridge. Fry, a Cambridge graduate, was believed to be the leading candidate for the job, as Waldstein had been relieved of the post just three years earlier. Fry had ruffled more than a few feathers in his career, however, and opposition to his candidacy was voiced, reportedly, from figures as eminent as the king and as influential as Sir Ed-

ward Poynter, director of the National Gallery and past president of the Royal Academy (this was at the height of the furor over the Chantrey Bequest). Fry was denied the position he had hoped would return him to his believed alma mater and bring him enough income to retire as a columnist for the *Athenaeum*—"these weekly snippets are ruining my mental digestion," he complained at this period (*Letters* 224, see also 222).

A few months later, Fry was summoned to New York, ostensibly as part of a scheme to raise money for the *Burlington Magazine*, but actually to be assessed for the post of assistant director of the Metropolitan Museum of Art, then under the autocratic management of its president, the millionaire J. P. Morgan. Fry was summoned to meet Morgan on a private railcar to Washington, where they dined with President Roosevelt. Initially Fry was enthusiastic; "It's better than going on being blocked and crabbed and buffeted at home," he wrote to his wife (*Letters*, 229). The post fell through, however, over just the issue that would continue to plague Fry through his continuing association with the Met: the potential for conflict of interest when a powerful trustee is also an ambitious private collector.[6]

Despite this failure, Fry continued, without salary or title, to recommend purchases for the Metropolitan, as well as for Philadelphia collector, John G. Johnson, whom he admired and liked—many of the pieces in the renowned Johnson collection at the Philadelphia Museum of Art were Fry's finds.[7] In March 1905, Fry was surprised to discover that he was one of two candidates under consideration to replace his nemesis, Poynter, as director of the National Gallery. But after interviewing with a government official who was concerned only with Fry's family connections, Fry heard nothing for months and finally gave up hope (*Letters*, 237, 241). In January 1906, he accepted the post of curator of paintings at the Met. As he sailed for New York, however, Fry received a telegram announcing that the new Liberal prime minister, now that it was too late, was offering him the National Gallery. Then his arrival at the Metropolitan a few days later was marked by a dispute over whether Morgan would adhere to the arrangements agreed to by his deputy concerning the duties of the curator. It was not an experience to inspire hope that either entrenched bureaucracy or untrammeled autocracy offered effective management of art institutions.

Despite this inauspicious beginning to his tenure at the Metropolitan, Fry quickly embarked on a plan to combat what he saw as the museum's major failing: that despite fine holdings in Near Eastern art, the European holdings were "a nightmare," revealing "stupendous and barefaced" cheating of American buyers by European dealers. "The blatant forgeries done by any hack Royal Institute man that [London dealer] Agnew could lay his hands on are

enough to make you stagger," Fry wrote to his wife (*Letters*, 228, 233). Fry's aim was to educate American eyes by replacing the flawed chronological displays with "a sort of Salon Carré, where all the real things will be seen in the hopes that it may throw a lurid light on the nameless horrors of modern art which fill the remainder" (*Letters*, 260).

A *Temporary Exhibition in Gallery 24* opened in April 1906, and featured forty-two paintings, including works by Nicholas Maes, Francesco Goya, and Puvis de Chavannes, that Fry had recently added to the museum's holdings.[8] It is clear from Fry's letters that his exhibition was intended to demonstrate new curatorial criteria not just in the selection of works exhibited, but also in their display. In contrast to the packed walls and velvet swags that marked the museum's standard displays, Fry spread forty-two carefully chosen works on a background that resulted from "heaps of experiments as to colour" culminating in walls of "a kind of grey gold which we were driven to because it had to be as light as possible and yet be a real background for oils" and woodwork of "pure raw umber and white over a burnt sienna stain" for a "wonderful *smalto* effect" (*Letters*, 260, 262–63). Ironically, Fry's reforms at the Met returned to New York the Aestheticism of the American expatriate, Whistler, whose sparse displays on grey or yellow walls were credited with revolutionizing the look of London's contemporary art exhibitions thirty years before.[9]

A month before his exhibition opened Fry published in the *Bulletin of the Metropolitan Museum of Art* an explanatory essay, "IDEALS OF A PICTURE GALLERY," which, offered a more tactful statement of his rationale than do his private letters. Here Fry again compares his room to the Salon Carré at the Louvre, where "we find collected together what were supposed to be the masterpieces of various schools and various ages." As Fry's phrasing here suggests, he is aware that the judgments behind terms like "masterpiece" are variable; "changes and revolutions of taste" cause some erstwhile masterpieces to be "looked upon with cold indifference" today. But he is confident that these are exceptions, and he advocates an installation of art that makes "apparent to each and all that some things are more worthy than others of prolonged and serious attention."

As with his early formalist essays, such as "EXPRESSION AND REPRESENTATION IN THE GRAPHIC ARTS" (in chapter 2) and its derivative "Essay in Aesthetics" (*V&D*, 16–38), Fry's arguments concerning museum installation cement his position in the vanguard of modernism. Ideas that were new in New York in 1906 soon came to define the modernist mainstream—and subsequently to attract a new generation's critique. Like Fry's influential early formalist essays, "IDEALS OF A PICTURE GALLERY" can be read to demon-

strate the contradictions inherent in the basic assumptions of modernism—in this case the oxymoronic notion of a formal language that claims to be universal but is neither widespread nor self-evident. Postmodernists are quick to challenge this "'universalist' approach as itself an historical phenomenon and inherently flawed" in the way it masks difference—whether historical, geographical, ethnic, economic, or sexual—by obscuring how cultural divisions alter the way art is both created and experienced.[10] When the standard is established by, in Fry's words, "the greatest expressions of human imagination which Europe has produced," it is not hard to see how the rhetoric of universality comes to mean the perpetuation of conventions associated with a white ruling class. Fry falls directly into the oxymoron of the acquired instinct. The "fascinating language of human emotion, the language of art," he says, is "universal, valid for all times and in all countries, but it is a language which must be learned." And the connoisseurial confidence that allowed Fry to set up his suite of masterpieces seems naive in the wake of later revisions—the attributed authors of six of Fry's eleven acquisitions exhibited in his gallery have since been questioned or discarded.[11]

As flawed and overconfident as it may now appear, however, the rhetoric of modernism was for Fry a call to renewal and reform. Museums like the Metropolitan were transcending their origins as cluttered storehouses of artifacts—including numerous replicas—designed to instruct a broad public in a narrow canon of Classical and Renaissance art. Acknowledging the gaps in the museum's holdings, Fry used them to justify a much broader and more inclusive history of art. Having eliminated the spurious Michelangelos and Leonardos from the Metropolitan's roster of "masterpieces," Fry presented his viewers with a history of art that ran from anonymous Florentine portraits, through lesser known Italian and Northern painters, to Manet.

Fry's reforms affected not only the range of exhibited work, however, but, more profoundly, the pedagogical goals of the museum. The Whistlerian ideas animating his installation invited a form of pleasurable attention very different from the practical response exhorted by the usual displays of recognized masterpieces—of necessity almost invariably copies—arranged to instruct an audience in a narrow canon of great art, and to improve viewers' skills as producers and consumers of commercial goods. In contrast, Fry was part of a movement at this period in which the rationale of "joy, not knowledge" became a watchword for museum acquisition and exhibition policies, supplanting the Victorian goal of practical instruction.[12] When, in "IDEALS OF A PICTURE GALLERY," Fry distinguishes between his "aesthetic" approach and the old "historical method," he phrases his position in this debate with a measure of tact reflective of the fact that copies of canonic works in Eu-

ropean collections were still being commissioned by the Metropolitan's director, Sir Caspar Purdon Clark, an Englishman hired from the South Kensington Museum, which was the exemplar of Victorian galleries organized for the promotion of commerce.[13]

The postmodernist critique of the modernist museum is not limited to the biases and contradictions in the notion of artistic universality, however. Historians now argue that the turn-of-the-century shift in public museums from the Victorian emphasis on replicas for practical instruction to the modernist shrine for the delectation of original works of art coincides with a shift in patronage from a broad swath of merchants and other civic-minded professionals to a narrow band of the fabulously rich, for whom—despite strategic nods at an educational mission—displays of unique objects served primarily to confirm for the public their vast wealth.[14] This, ultimately, was the stumbling block that pitched Fry out of his career at the Met. Throughout his tenure, Fry was exasperated by the way J. P. Morgan took for his private collection works Fry identified as potential acquisitions for the museum (*Letters*, 283–84, 288). In 1907 Fry traded in his post as curator for that of European advisor, which allowed him to remain at home. In 1909, however, even this connection was abruptly terminated when Fry challenged Morgan's seizure of a painting held by a dealer awaiting confirmation of the museum's purchase from Morgan's office in New York. Soon thereafter, Fry was fired.[15]

Although Fry's experience at the Metropolitan left him angry and prone to contemptuous asides about America and its millionaires, it would be misleading to review this period in his career without noting his enduring respect and fondness for one man who exemplified his ideal of an enlightened collector and museum patron. Fry's 1917 obituary notice for John G. Johnson (MR. JOHN G. JOHNSON, OF PHILADELPHIA) details Johnson's remarkable combination of attributes, culminating with the selfless detachment that Fry saw as the sine qua non of aesthetic life. That "he never bought like [a] great millionaire" was, after Fry's experience with Morgan, the greatest tribute he could offer Johnson. The bond between the two men was strengthened by their shared anguish over the illness of their wives. Ida Johnson died after a long illness in 1908 just as Helen Fry was entering what would become a lifelong hospitalization, the initial costs of which Johnson helped to defray; Fry's letters to Johnson equal only those to his mother in their intimacy about his wife's condition. It was an irony of Fry's situation that Johnson joined the trustees of the Metropolitan just months after Fry's termination.

Fry's break with the Metropolitan Museum in 1910 corresponds with the beginning of his career as an advocate for modern art; by the end of the year, he was embroiled in the controversy sparked by the first Post-Impressionist exhibition (see chapter 2). Although Fry continued to publish on art-historical topics, the focus of his attention moved at this period from conserving the past to preparing the future. Concomitantly, Fry's institutional commitment shifted from museums to workshops and schools. Between 1909 and 1914, Fry held a lectureship at the Slade School, where he taught art history to aspiring artists. His own Omega Workshops were conceived to support and promote young artists working in modernist styles (see chapter 4). Fry became convinced, however, that his work with adults was useless without fundamental reform in the way art was taught to schoolchildren. The contest between Victorian convention and modernist innovation, he saw, began with the child's earliest introduction to art, and he set about to create a generation ready for the art of the new age.

As early as the 1909 "Essay in Aesthetics," Fry had connected his aesthetics to what he saw as the natural characteristics of children's art:

> That the graphic arts are the expression of the imaginative life rather than a copy of actual life might be guessed from observing children. Children, if left to themselves, never, I believe, copy what they see . . . but express, with a delightful freedom and sincerity, the mental images which make up their own imaginative lives. (*V&D*, 20)

The following year, "THE POST-IMPRESSIONISTS" (in chapter 2) took aim at the institutional suppression of children's innate creativity: "Give them a year of drawing lessons and they will probably produce results which will give the greatest satisfaction to them and their relations; but to the critical eye the original expressiveness will have vanished completely from their work." Similar asides animate the 1911 "AN ENGLISH SCULPTOR" and the 1913 "ALLIED ARTISTS" (in chapter 3), but it was not until 1917 that Fry turned his concerted attention to children's art.

In 1917, casting about for exhibitions to attract buyers to the war-weary Omega, Fry mounted a display of work by the children of artists. This focus reflects the history of his approach to the topic, which began with his parental interest in the activities of his own son and daughter. Fry tried to arouse the interest of other avant-garde artists by soliciting the work of their offspring for the show, which brought children's art into juxtaposition with objects made by professional artists working in a modernist idiom. His 1917 essay on "CHILDREN'S DRAWINGS" effects a similar juxtaposition, illus-

trating a drawing by Augustus John's son, David, and analyzing it in highly formalist language for realizing "the snakiness of a snake." In both the exhibition and the essay, Fry presents modern art and children's art as mutually illuminating.

Although neither the senior John nor Fry's Bloombury colleagues shared his enthusiasm,[16] another visitor to the Omega made up for their indifference. Fry recounted in a letter to Vanessa Bell that a "little school mistress from the Black Country came to me—she'd been up in town to try to get a post in London and brought her class drawings. She'd been refused without a word and I didn't wonder when I saw what she'd been at."[17] This was Marion Richardson, a young art instructor at a girls' school in the West Midlands. While training at the Birmingham School of Art, Richardson had boarded in the women's hostel founded and supervised by Fry's sister, Margery, who had helped her brother raise his two small children and was well versed in his ideas about art. Fry wrote to his sister:

> I recognized in her a piece of your bread on the waters come back bearing its sheaves with it or something of that kind and realized a bit what you'd been up to all those years at Birmingham. It's a wonderful thing to make a person think and one never knows where it will end. (*Letters*, 410)

Richardson's autobiography records the cathartic effect of her meeting with Fry, who "made me feel that we were included in the wide range of his interests, and even part of the modern movement in art."[18] With the help of the Frys—Roger wrote four articles and two exhibition catalogs promoting Richardson's work[19] and, with his sister, provided her lodging when she first moved to London—Richardson became a key figure in the transformation of art education from Victorian principles of disciplined transcription to modernist ideals of creative self-expression. Eventually she came to oversee the bureaucracy that in 1917 had rejected her.

Fry was especially impressed by the way Richardson, as he told Bell, "invented methods of making the children put down their own visualizations—drawing with eyes shut, etc." In a burst of enthusiasm, he began a book on art education, featuring Richardson's methods.[20] Although the book was never finished, it informs Fry's 1919 article "TEACHING ART," which promotes Richardson's classroom techniques. A reformer's zeal is evident in Fry's first reaction to the work of Richardson's students:

> They're simply marvelous. Many of them are a kind of cross between early miniatures and Seurat, but all are absolutely individual and original. . . . Here's an inexhaustible supply of real primitive art and real

vision which the government suppresses at a cost of hundreds of thousands of pounds. If the world weren't the most crazily topsy turvy place one would never believe it possible.[21]

On first seeing this work in 1917, Fry immediately added selections from Richardson's portfolio to his exhibition in progress. Two years later, the Omega's final exhibition mixed works by Richardson's students with stage designs for the Ballets-Russes by Mikhail Larionov (see also chapter 6). The two essays on children's art reproduced in this chapter were originally published to publicize these shows.

Both essays couch Fry's analysis of children's art in the language of modernism, most obviously in their antagonism to prevailing standards rooted in Renaissance conventions of realism. More specifically, Fry's essays on art education reflect the modernist preoccupation with notions of the primitive. From Gauguin's rustic Bretons and South Sea Islanders, through Picasso's Iberian and African references, through the Abstract Expressionists' use of Native Americans, to the more recent infatuation with graffiti, modernism has proclaimed its perpetual renewal through an embrace of outsider imagery, which is perceived as simpler and more natural and passionate than conventional art.[22] Fry, in his first defenses of Post-Impressionism (see chapter 2), had invoked ideas of primitive art, using the loose definition of the term that was typical of his era to encompass proto-Renaissance, Byzantine, and Gothic work, as well as African art. Fry cites this roster of once-despised art in "CHILDREN'S DRAWINGS" to evoke in his readers "the kind of attitude which is necessary to an understanding of what children's art amounts to." In this expansion of the primitivist category to include art by children, Fry is once again revealed to be on the vanguard of modernism, introducing to London ideas that had recently animated the avant-gardes of Vienna, Milan, Berlin, and New York.[23]

The postmodern era has seen a sustained critique of the attitudes that prompted modernists to align children's art, along with the art of the insane, with non-European systems of representation and to class these highly diverse phenomena under the rubric of the primitive.[24] And despite modernists' protestations that "primitive" and even "savage" had no pejorative connotations for modernist artists and critics who praised the art they identified with such terms, Fry's essays suggest that the ambivalent connotations of this vocabulary were present from the beginning. Like other modernists, Fry claims the positive qualities of these terms to undercut the norms of industrialized civilization, in which "we think of life in terms of merit and reward of industry, discipline, achievement."

Less typically (because primitivism is often associated with anonymous

and collective art), Fry upholds the savage and the child as paragons of individuality in a culture of increasing standardization. The measured tone of his remarks in "TEACHING ART" masks the bitterness that characterizes an analogous passage in a letter written the same year to another teacher he admired, Marie Mauron:

> More and more I come to believe that the great distinction between people turns around this question of individual liberty. On one side there are the conformists who are not sickened by the statesmen's rhetoric, who love banquets and public occasions, and who believe the papers, and, on the other, a small minority. . . . For the time being, education is in the clutches of the conformists; if there were in any country a majority of educators thinking like you, one might have some hope for our poor humanity, but when will that be? (*Letters,* 472)

In contrast to this picture of the civilized, the primitive is a figure of virtue.

Like other modernists, however, Fry's praise for the primitive was couched in assumptions of the superiority, if not of all Western civilization, than at least of the speaker—a very different attitude than that he assumed toward adult European artists from Mantegna to Matisse. In both essays on children's art, Fry is quick to distinguish the intuitive art of the child and the savage from the "richer and more complete" art of the "civilized man" who consciously transcends his inheritance to return to more "direct" ways of seeing.

It is in the 1917 article on children's drawings that the ambiguities of primitivism are most apparent, for at the same time that children's drawings are praised for displaying "that kind of invention, just that immediate expressiveness, which we admire so much in primitive art," Fry cannot resist the chance to use the pejorative implications of the term against his old antagonists. "The modern descendant of the Primitive is the Academy painter of anecdotes," Fry asserts, reversing the criticism that condemned modernism as degenerate and childish (see chapter 2). The connotations of primitivism ricochet wildly through these passages that link the untutored spontaneity of the child to the naive record of "wonder and delight" demonstrated by medieval artist, the unselfconscious art of "the modern negro," and finally to the mindless mimesis of contemporary realistic painting. What all of these categories of artist shared was the absence of self-conscious purpose in the manipulation of form. Ultimately it is the figure of "the Formalist" who is neither child, nor rude craftsman, nor the mere illustrator of modern civilization, that alone transcends the primitive. The formalist is motivated no longer by the urge to record what fascinates him, but by "a passionate feeling

about form." As with other modernists, Fry exploits the identities he asso-
ciates with the primitive for their relevance to the high art of his own cul-
ture.

If today we are critical of the way Fry subordinated children's art and the
art of nonindustrialized peoples to the modernism of adult Europeans, we
ought, nevertheless, to acknowledge the power of such arguments in their
time. An obvious measure of their persuasiveness is the extent to which such
primitivism came to define a mainstream of modernist thought. Fry's ideas
should be assessed, however, not just by their eventual popularity, but by
their distance from the assumptions of his own generation. When Fry first
wrote about African carvings, he was virtually the first critic in England who
was willing to follow the French avant-garde in treating such objects as art at
all; Henry Tonks, his colleague at the Slade, exploded in a letter to Robert
Ross with a comment typical of reactions that met Fry's first investigations of
African art in 1910: "I say, don't you think Fry might find something more
interesting to write about than Bushmen, Bushmen!!"[25] In contrast to this
prevailing disdain for non-European peoples, Fry's ambivalent engagement
with "primitive" art—like the anti-imperialist activism of his Bloomsbury
colleagues, E. M. Forster and Leonard Woolf—supplants the self-serving
certainties undergirding the British Empire. Fry's texts contribute to the
twentieth-century project of conceiving a postcolonial world; analysis of the
limitations Fry's historical moment imposed on his vision is useful to the extent
that it opens debate over the analogous limitations in the theoretical formulation
of cross-cultural initiatives in Western schools and museums today.[26]

Toward the end of Fry's life, his interest in the institutions of art education
shifted from grade schools to universities and from art making to art history. A
1924 series on "Art and the State," combined and reprinted in *Transformations*,
marks the shift, with Fry moving from passionate attack on the suppression of
individuality in conventional childhood art classes (61), through a discussion
of museum acquisition and exhibition policies (67–70), to a discussion of
professional training in art history. Criticizing the haphazard schooling of the
current crop of museum personnel, Fry falls into a stuttering denunciation of a
culture that lacks even the language to describe his ideal:

> What I believe is of the utmost importance is a clearer recognition of the
> profession of the—and here the tell-tale fact obtrudes itself that we have
> no English word for it—the recognition of the—one has finally to fall
> back in desperation on the German—the *Kunstforscher.* . . . If one could
> but find an English word for *Kunstforscher* the battle would be half won.
> (*Trans,* 71, 73)

For Fry, the *Kunstforscher*—whose job is the assessment of aesthetic merit—"attains by another route something of the freedom of the artist, for whom the object in itself is everything."[27] Refusing to value any culture over another, the *Kunstforscher* offers "an antidote to the kind of orthodoxies and *a priori* judgements" that caused English museums to devalue the arts outside the European tradition.

In "Art and the State," Fry argued that the *Kunstforscher*'s profession is a branch of the humanities "and therefore could take its place in a liberal education more readily than many subjects which have none the less acquired a status in our Universities." By 1930, Fry's "THE COURTAULD INSTITUTE OF ART" was able to celebrate the inauguration of London University's program in art history. In this letter, Fry recalls his own early experiences fundraising for the *Burlington Magazine* and dealing with the trustees of museums during the century's first decade. "I think we may fairly pride ourselves on having done much to bring about that changed attitude towards art history of which the establishment of an art-historical faculty in London University is a culminating proof," Fry announced.

Typically, however, Fry rested on the laurels of victory only momentarily before turning this success into a goad for further reform. He presented the professionalization of art history as an opportunity to challenge the basic practices of the field. No longer would art historians be "the sons of wealthy parents" dominated by trustees who "think that the understanding of art is a heaven-descended gift which comes by the grace of God and not by study" and that "in reward for their successful business activities this particular grace has been accorded to them." No longer would art history be the enforced reverence for particular artists and particular eras. Instead, the open-minded empiricism of the new professional, trained in the "scientific" methods of connoisseurship, would continually prod art history away from the conventional canon: "To acquire the power of original enquiry and independent thought should be, I think, the chief aim of such a course of education as that contemplated in this scheme." If institutions oriented toward connoisseurship have not always lived up to Fry's iconoclastic ideals, that should not be allowed to mask the nature of his aspirations.

Ultimately, these values are at the center of all Fry's writings on art institutions. From his early efforts to broaden the range of modern art purchased for the national museums beyond the products of the Royal Academy, to his curatorial attempts to inculcate new habits of seeing that might break the Metropolitan's dependence on mercenary dealers and moneyed benefactors, to his promotion of methods of art education that emphasized self-

expression over transcription, Fry may be seen challenging entrenched institutional practices in the name of "original enquiry and independent thought."

The influence of the ideas Fry advocated now obscures their activist edge. He has been smoothly absorbed into the history of the very institutions he opposed, so much so that he figures in postmodernist criticism as a symbol of the authority of "Traditional Modernism" and even of J. P. Morgan.[28] Such schematization clearly responds to the activist impulses of postmodernism, but it remains a drastic oversimplification. As Raymond Williams argues, the Bloomsbury group's ethos of liberal individualism "carefully diluted" has proven highly susceptible to appropriation in defense of consumer capitalism, "but we have still to see the difference between the fruit and its rotting, or between the hopefully planted seed and its monstrously distorted tree."[29] As the personalities and ideas associated with postmodernism today accede to the institutional authority of museums and schools, it may be salutary to return Fry's ideas to their historical position as part of an agenda of reform in order to examine to processes of co-optation and dilution such institutionalization often requires. Concomitantly, in releasing Fry from the role of the staid guardian of convention that recent histories have forced him to play, we can recapture the activist heritage of modernism as we acknowledge the real complexities of theory and practice in the interaction of art and its institutions.

<div align="center">∽∾</div>

Notes

1. Robert Skidelsky, *John Maynard Keynes: Hopes Betrayed, 1883–1920* (New York: Viking, 1983), 248.

2. Although these columns are unsigned, I concur with Donald Laing's *Roger Fry: An Annotated Bibliography of the Published Writings* (New York: Garland, 1979), which assigns five related pieces to Fry. In addition to the three texts anthologized here, Laing identifies "The Chantrey Bequest" (*Athenaeum*, 7 November 1903, 621) and the review of D. S. MacColl's "The Administration of the Chantrey Bequest" (*Athenaeum*, 9 April 1904, 470–71).

3. Fry, "The Chantrey Bequest," *Athenaeum*, 7 November 1903, 621.

4. Fry, review of MacColl's *The Administration of the Chantrey Bequest*, 470.

5. Compare Fry's catalog of the elements of aesthetic response in "An Essay on Aesthetics" (*V&D*, 33–34) to Ruskin's famous chapter on "The Nature of the Gothic" from *Stones of Venice* (vol. 2, chap. 6, sec. 6, in *Works of Ruskin*, 10:184), in which he compares his method to the experimental chemist who charts the constituent properties of a mineral.

6. Contrary to the garbled and inaccurate account in Calvin Tomkins's *Merchants and Masterpieces: The Story of the Metropolitan Museum of Art* (New York: E. P. Dut-

ton, 1970), the specific reason Fry declined the post was that he insisted on a salary high enough to preclude the necessity of outside commissions from private collectors, Morgan in particular (*Letters*, 232–33).

7. Frances Spalding, *Roger Fry: Art and Life*, (London: Granada, 1980), 96–100.

8. Goya's *Portrait of Don Sebastian Martinez*, Maes's *Portrait of a Woman*, and Puvis's *Shepherd's Song* were among the fifty-four paintings purchased by Fry for the Metropolitan over the course of his association with the museum. For the complete roster of works in the temporary exhibition, see *Letters*, 255.

9. For a discussion of Whistler's theories of art exhibition contemporary with Fry's curatorial work, see Sadakichi Hartmann, *The Whistler Book* (Boston: L. C. Page, 1910), 115–20.

10. Irene J. Winter, "Change in the American Art Museum: The (An) Art historian's Voice," in the very useful volume, *Different Voices: A Social, Cultural, and Historical Framework for Change in the American Art Museum* (New York: Association of Art Museum Directors, 1992), 38.

11. These are the works cataloged as Giuliano Bugiardini, *Madonna and Child with Infant St. John* (reattributed to Fra Bartolomeo); Maître de Flémalle, *Virgin and Child* (workshop copy); Guardi, *Fête on the Grand Canal* (workshop copy, deaccessioned in 1980); Michael Mirevelt, *Portrait of a Lady* (deattributed, deaccessioned in 1992); Jan Steen, *Kitchen Interior* (reattributed to Peter Wtewael); Lorenzo Lotto's *Portrait of a Young Man*, purchased at Fry's recommendation before he became curator, has also been deattributed. The attributions are retained for the Goya, the Maes, and the Puvis cited above, in addition to the Michele Giambono, *Man of Sorrows*, and the Carlo Cagliari, *Allegorical Figures* (deaccessioned in 1973). This information was graciously provided by Mary Sprinson de Jesús, research associate, Department of European Paintings, Metropolitan Museum of Art.

12. Edward C. Banfield, *The Democratic Muse: Visual Arts and the Public Interest* (New York: Basic Books, 1984), 94–98.

13. "Museum to Get Copies," *New York Times*, 31 May 1906, 1. This article evidences also Clark's lack of support for Fry in a controversy over the cleaning of certain of the museum's works; see exchange on editorial page of this issue, as well as "Sir Purdon Won't Say Fry's Work Suits Him," *New York Times*, 30 May 1906, 7.

14. Banfield, 94–98, 105–6. See also Nathaniel Burt, *Palaces for the People: A Social History of the American Art Museum* (Boston: Little, Brown, 1977), 86–94, 235–55.

15. Spalding, 104–6; Tomkins, 108–10. Despite Tomkins's defensive assurance that "Morgan probably intended that his own proliferating collections would come eventually to the Metropolitan" so that "it is quite conceivable that in making a major acquisition he did not always distinguish clearly in his own mind between the museum and his private collection," Morgan's purchases never reached the Metropolitan, but remained in England to avoid American import taxes and were sold following his death.

16. Fry is quoted complaining of John's reaction (Judith Collins, *The Omega Workshops* [Chicago: The University of Chicago Press, 1984], 144) and Fry wrote plaintively to Vanessa Bell, "You've never sent the children's things. I'm hanging tomorrow" (letter from Fry to V. Bell, 15 February 1917, Tate Gallery Archives, 8010.5.675).

17. Letter from Fry to V. Bell, 7 March 1917, Tate Gallery Archives, 8010.5.678.

18. Marion Richardson, *Art and the Child* (Peoria, Ill.: Chas. A. Bennett, n.d. [1946]), 32. On Richardson's career, see Stuart Macdonald, *The History and Philosophy of Art Education* (London: London University Press, 1970), 349–51.

19. In addition to the two articles collected here, Fry introduced catalogs for the Omega's 1919 *Exhibition of Sketches by Mr. Larionow, and Drawings by the Girls of Dudley High School,* and for the Whitworth Art Gallery's 1928 *Exhibition of Drawings and Designs by Children,* as well as reviews of two of Richardson's later shows: "Children's Drawings," *Burlington Magazine,* January 1924, 35–41, and "Children's Drawings at the County Hall," *New Statesman and Nation,* 24 June 1933, 844–45.

20. The negotiations concerning Fry's proposed book, *Children's Pictures and the Teaching of Art,* are detailed in Gillian Robinson, "The Aesthetic Theories of Roger Fry: Their Significance for Art Education in the Primary School" (Ph.D. diss., University of London, 1989).

21. Letter from Fry to V. Bell, 7 March 1917, Tate Gallery Archives 8010.5.678.

22. For an overview, see William Rubin, ed., *"Primitivism" in Twentieth Century Art: Affinity of the Tribal and the Modern* (New York: Museum of Modern Art, 1984), 2 vols.

23. The pioneering Austrian art educator, Franz Cizek, brought children's art to Gustav Klimt's circle in the 1890s, although when he and the American Arthur Wesley Dow exhibited children's work in England at the International Art Congress of 1908, it was not as a buttress to modernist movements. Not until 1911 and 1912 did the Italian Futurists, Abraham Walkowitz and Alfred Stieglitz in New York, and the German Blaue Reiter group display children's work in a modernist context. On the importance of the "The Child Cult" to modernist primitivism, see Robert Goldwater, *Primitivism in Modern Art* (1938; reprint, New York: Vintage, 1966), 192–214. Fry's theorization of children's art in a modernist context is cogently summarized by Richard Shiff in his introduction to Fry's *Cézanne.* Shiff extends his argument in "From Primitivist Phylogeny to Formalist Ontogeny: Roger Fry and Children's Drawings," in *The Innocent Eye: Essays on Children's Art and the Modern Artist,* edited by Jonathan Fineberg (Princeton: Princeton University Press, 1995).

24. Sally Price's *Primitive Art in Civilized Places* (Chicago: University of Chicago Press, 1989) offers a clear presentation of postmodern critiques of primitivism. Maria Torgovnick's *Gone Primitive: Savage Intellects, Modern Lives* (Chicago: University of Chicago Press, 1990) offers a chapter on Fry's writings on African and prehistoric art. Despite the validity of Torgovnick's overall assessment—that Fry sometimes "recognizes and attacks contemporary prejudices" and "at other times, he speaks from within those prejudices" (88)—her conclusions about particular texts are often unsupported by the texts themselves, as she abrogates as her own critical insight exactly the points Fry was making (see esp. 89–92). This practice is explained—if not excused—by Torgovnick's acknowledgment that she reads "harshly" (95) and is inclined to the "least charitabl[e]" view (89), although her statements are indicative of the postmodern tendency to criticize all modernism through the person of Fry.

25. Henry Tonks, quoted in Spalding, 129; see also 233 (n. 7 above). For Fry's "The Art of the Bushmen," see *V&D,* 85–98.

26. That Woolf and Forster manifested an ambivalence toward the "primitive" similar to Fry's is argued in Gillian Workman, "Leonard Woolf and Imperialism,"

Ariel 6, no. 2 (1975): 5–21; and in Lilamani Chandra da Silva, "Imperialist Discourse: Critical Limits of Liberalism in Selected Texts of Leonard Woolf, and E. M. Forster (Ph.D. diss., University of North Texas, 1992). For a brief analysis of the way current theories of "multiculturalism" manifest the historical limitations of the late twentieth century, see David Rieff, "Multiculturalism's Silent Partner," *Harper's Magazine,* August 1993, 62–71.

27. This definition of the *Kunstforscher* as a connoisseur for whom "historical references" are of "no interest" underlies "Art History as an Academic Study," the essay introducing the methodology of the lectures Fry offered at Cambridge in 1933–34, which were published as *Last Lectures.* For another definition of the term, see Fry's 1928 "WORDS WANTED IN CONNEXION WITH ART" (in the conclusion).

28. The Royal Academy's recent catalog, *British Art in the Twentieth Century* (London: Royal Academy of Arts, 1990) dismisses Fry's accomplishment as so self-evident as to be unanalyzable: a "necessary corrective" to "the enfeebled state of British painting at the turn of the century," which "is beyond question" (15). It then offers several lengthy critiques of Fry's formalism, under Charles Harrison's rubric of "Traditional Modernism" (54), though none of the authors is tactless enough to engage the Royal Academy's institutional history in relation to either "enfeebled" turn-of-the-century British painting or the modern art it now exhibits. Harrison associates Fry with Morgan in *English Art and Modernism, 1900–1939* (London: Allen Lane, 1981), 51–52.

29. Raymond Williams, "The Significance of 'Bloomsbury,' as a Social and Cultural Group," in *Keynes and the Bloomsbury Group,* edited by Derek Crabtree and A. P. Thirwall (New York: Holmes & Meier, 1978), 63, 66.

THE ADMINISTRATION OF THE
NATIONAL GALLERY

W E hear that a new rule has been made by Lord Lansdowne in the
administration of the National Gallery, whereby no picture is to be
acquired without the consent of all the trustees. We need hardly say that we
deplore such a step. Matters have been going from bad to worse at the Na-
tional Gallery for many years, but such a rule as this will definitely prevent
any hope of our keeping pace with German public and American private
enterprise. Among the trustees are gentlemen with very various and in some
cases quite empirical tastes—one favours the elegances of eighteenth-century
French art, another is all for the primitives. It is evident that in these circum-
stances the only common ground whereon all can unite will be that of medi-
ocre work. Any work in which the characteristics of its own period are
strongly accentuated, any good work in short, will arouse the vehement op-
position of those trustees whose education in art has not enabled them to
appreciate that particular period and style. It will only be in the works of
feeble and flaccid personalities that the opposition will be lessened to the
point where compromise becomes possible. Compromise, which is the deadly
enemy of so absolute and definitely willed an activity as art, will rule all the
nation's acquisitions. We leave out of account here the serious practical diffi-
culty that, while a considerable body of men are being brought together to
see and discuss an important picture, and settle between their opposing
views, the private purchaser from across the Atlantic will probably, if the
picture is worth having, and no patriotic motives on the owner's part inter-
vene, have written a cheque on the spot and gone off with the object in
dispute.

We venture to think that any single man with absolute power, however
limited his tastes, however slight his special knowledge, would buy better
works than such a heterogeneous and disparate body as the Trustees of the
National Gallery. We have often felt it necessary to criticize adversely recent
purchases at the National Gallery, but it is an open secret that if Sir E.
Poynter had had the power which the director of a German gallery possesses

Reprinted from *The Athenaeum*, 2 August 1902, 165.

we should now have at Trafalgar Square several works of first-rate impor-
tance which he has been forced to pass over.

The question has a particular poignancy at the present moment, when
there is in the market a work of rare artistic quality, the fight of the Centaurs
and Lapithae by Piero di Cosimo, which we noticed at length in a previous
issue. It is long since an Italian picture of the fifteenth century of such capital
importance, both as a work of art and as an illustration of the characteristic
ideas of the Italian Renaissance, has been obtainable. The desire to acquire
this for the nation has been expressed with extraordinary unanimity by those
competent to form a just opinion of its merits. The suggestion put forward
by Mr. Claude Phillips in the *Daily Telegraph* and by Mr. D. S. MacColl in
the *Saturday Review* has been taken up by Sir Martin Conway, and pressed
on more general and literary grounds in a delightful letter by Mr. Edmund
Gosse, while in the *Times* of last Saturday there appeared an appeal to ac-
quire the work by public subscription signed by such prominent artists as Mr.
Legros, Mr. Furse, Mr. Charles Ricketts, and Mr. C. H. Shannon. Here,
then, is a case where the educated artistic opinion of the country is singularly
unanimous, and yet it is found necessary to appeal to the public to take upon
itself, without any proper organization for doing so, a transaction which, we
feel sure, almost any Director of the National Gallery, were his judgment
unfettered, would feel the necessity of undertaking. There could not be a
clearer object-lesson of the inefficiency of the present cumbrous machinery,
which the new rule will render almost incapable of functioning at all.

FINE-ART GOSSIP

D.S.M. in the *Saturday Review* is indefatigable in his attempts to reform the administration of official patronage of modern art. His latest revelations are of a surprising nature. Doubtless most people had assumed that the Chantrey Bequest was left to provide prize money for a few notable exhibitors at the Academy. It turns out that it is nothing of the kind. The money was left in order to purchase for the nation the finest works of art, judged solely on their merits, which had been produced in Great Britain; the artist need not be a living artist nor of British origin. When one thinks of the collection of masterpieces which should have been acquired had this trust been conscientiously fulfilled; when one thinks of the Rossettis, Madox Browns, of the early pictures of Millais, Whistler, Watts, and Legros, to mention only more or less contemporary artists, which might have been got together with the money spent; and when one goes to the Tate Gallery and sees the collection of pictures bought almost entirely out of the annual exhibitions at the Academy, one cannot but wonder at the singular notions of their responsibilities which the members of the Royal Academy have formulated. No one of them would, we imagine, as a private gentleman, have allowed personal interests to influence his administration of a trust in this extraordinary manner.

Reprinted from *The Athenaeum*, 23 May 1903, 665.

THE CHANTREY BEQUEST

A S we briefly recorded last week, the House of Lords has justified the criticisms which we and many other journals have from time to time made on the action of the President and Council of the Royal Academy in respect to the Chantrey Bequest. The debate in the House of Lords was remarkable for the fact that Lord Windsor and Lord Lansdowne, who spoke for the Government, while disclaiming any attempt to prejudge the issue, went beyond Lord Lytton's admirably worded and moderate appeal in their vigorous statement of the *primâ facie* case for inquiry. Still more noteworthy were the speeches of Lord Wemyss and Lord Carlisle, who, while accepting inquiry on behalf of the President and Council of the Academy, gave an outline of what their defence may be, and in this showed a surprising want of understanding of the terms of the will on the one hand, and of the possibilities which the picture market has afforded to the administrators of the trust on the other. Nor do we think that the attempt to show that the promised inquiry must end in failure was more successful. That it will be exceedingly difficult to arrive at any definite conclusions, still more at any absolute proof of what ought to have been done in the past and what should be done in the future, may be admitted, but we are not without hopes that the extraordinary unanimity which responsible art critics have displayed in this matter will tend to alter public opinion about the objectivity of the aesthetic judgment. The view of the ordinary educated man is that in matters of taste one man's opinion is as good as another's, and he shelves discussion with a *de gustibus*. Had Lord Salisbury been alive we might have had a defence of this point of view put with an epigrammatic effectiveness which even those who object to it most strongly would have admired for its artistic qualities. Nevertheless, it may be well to point out that this idea of the subjectivity of the aesthetic judgment has not always been held: it is merely an outcome of the present chaotic condition of the arts. An objective standard is attainable the moment one has a consensus of authoritative opinion, and there was a time when this consensus existed for the valuation of works of art. In the later

Reprinted from *The Athenaeum*, 2 July 1904.

Middle Ages and early Renaissance the contract between a patron and an artist was drawn with a clause that the work was to be done to the satisfaction of competent masters in the art, not, be it noticed, to the satisfaction of the patron. Moreover, all disputes between artist and patron were settled not in the law courts, but by the masters of the guild, whose business was quite as much to defend the public against imposture as the artists against extortion. At that period sciences such as medicine were in the chaotic condition that at present affects the arts, and one man's opinion was literally as good as another's as to the prophylactic efficacy of an owl's heart worn under the left armpit, or the tongue of an adder killed in the new moon. The sciences have won through to a certain objective standard, and though doctors still differ, no one doubts that there is a right and a wrong. But that objective standard is really based on a consensus of opinion just as much as in the case of arts or morals. The consensus of opinion is, it is true, easier to obtain in the sciences, but even there it often requires a long time and many and bitter controversies before it is established; and there is no inherent impossibility in the idea, however improbable, that science might lose again the power of compelling the belief of the laity which it possesses, while art might recover in some truly representative central organization the authoritative voice which silences objection and compels individual caprice to bow to a universally recognized standard.

That, at least, is what the decision of the artists' guilds in the fifteenth century implied, and, oddly enough, our academies are the descendants, though not in a direct line, of those guilds, and the pretensions of our Royal Academy, and the large measure of belief which it still imposes on the public, are perhaps in part an inheritance from the time when the guilds did really expound for the public the expert opinion of the entire craft they represented. But though the Academy is the lingering representative of the idea of a guild, it no longer performs its functions, it no longer represents even the average, still less the most scholarly, opinion among artists. It has become merely one among many societies contending for public favour and patronage, favoured, it is true, by its title of Royal and the gift from the nation of its buildings, but not endeavouring in return for this assistance to set a higher standard of artistic endeavour or to support a more learned and scholarly doctrine than would naturally find favour with the public, but, on the contrary, descending as low as its less favoured, and therefore more excusable, rivals in the bid for cheap and lucrative popularity. If we would picture an analogous state of affairs in morals to that which obtains in aesthetics, we must suppose the law to be organized mainly for the encouragement of the baser passions and animal instincts of mankind. Such a state of things would

not be tolerated for long in any matter which touches so nearly our actual life; but in the arts, which are still looked on as superfluous luxuries, and not as essential to human perfection, it has been accepted as natural. A closer analogy, however, may be found within the arts themselves if we suppose a theatre, endowed by the State for the production of classical drama, which pocketed its annual grant and proceeded to have thousand-night runs of 'Charley's Aunt.' It is true that Lord Lytton's inquiry will not affect the Academy as such directly, but it is not impossible that should the case which has been urged against that body in the matter of the Chantrey Bequest be held proven, there will come about such a revulsion in public opinion that in the future the Academy may be called upon to drop its pretensions to being more than the oldest and best-known group of artists in the kingdom, differing in no essential way from any of the other competing groups. Such a result is not impossible, and we venture to say that even this would be a great gain for national art but if we look far enough ahead, any such merely negative and destructive policy ought not to satisfy us. It would be already something if the vulgarest of our Trimalchios could no longer plume himself on having taste because his likings coincided with those of our *Royal* Academicians. But this ought to be only one step in the direction of establishing an effective organ of really scholarly and academic opinion, and, finally, of founding a tradition of sound craftsmanship, a thing no more inherently impossible than a tradition of good plumbing or carpentering. All this may sound at the present moment chimerical and vague; but unless those who are anxious for reform keep some such end in view, the accusation that they are moved only by dislike of a rich and powerful organization, and that their aims are merely destructive, will have at least an appearance of truth. It will only be very gradually that we can feel our way towards any such end; but it is well even for practical politicians to have some worthy and constructive ideal to inspire their activities.

THE CHANTREY BEQUEST

THE report of the Committee of the House of Lords on the administration of the Chantrey Bequest is as complete a justification of the critics of the Royal Academy as we could wish. Since both disputants, the Academy and their critics alike, welcomed the inquiry, both sides must have had reason to suppose that the Committee would be equitable and dispassionate, and no doubt the members of the Royal Academy will agree with us that the result of the inquiry is according to the facts of the case. The Committee find that the contention of critics that the Chantrey collection, "while containing some fine works of art, is lacking in variety and interest, and while failing to give expression to much of the finest artistic feeling of its period, includes not a few works of minor importance," is "approximately correct." They add that "the collection, in their opinion, contains too many pictures of a purely popular character, and too few which reach the degree of artistic distinction evidently aimed at by Sir Francis Chantrey."

An explanation of the mismanagement, an explanation which the entire press has been demanding in vain for years, came out in the process of the inquiry. It may be summed up in Lord Crewe's saying that "What is everybody's business is nobody's business." No one member of the Council seems ever to have taken the duties and responsibilities of the trust upon him. No serious discussion of the policy and methods which they ought to follow seems ever to have taken place. The procedure which in the early days of the administration the Council hit upon was for the Council to meet, after a list of pictures proposed by any members of the Council had been posted up for a week, and to proceed at once to vote first upon the order in which the pictures were to be considered, and then to vote for the purchase or rejection of each picture in turn. It is not difficult to see that by such a mode of procedure, in which no predetermined policy, no common line of action weighed with the individual voter, the decisions would represent the average of the prejudices and uncontrolled personal predilections of the members of the Council. Nor is it difficult, under these conditions, to understand how it

Reprinted from *The Athenaeum*, 20 August 1904, 248.

came about that the Council frequently bought a second work by a mediocre artist who was already represented. The explanation given agrees, it will be seen, to a great extent with the surmise made in these columns in a review of Mr. MacColl's pamphlet on the Chantrey Bequest. In discussing that we argued that the probabilities were in favour of gross neglect and indifference to the essential artistic merit of the works purchased, rather than to any deliberate and conscious perversion of the funds from their proper purposes to the advantage of the Royal Academy, and this is, in fact, the finding of the Lords' Committee which declares that "there is no ground for any imputation of corrupt or interested motives against that body."

At the same time it should be remembered that this neglect of artists outside the walls of Burlington House, this careful seclusion to their own following of the funds placed at their disposal, has been, to say the least of it, highly advantageous to the Royal Academy, and Sir W. B. Richmond's evidence proves that in one instance, at least, an artist was penalized for sending a picture elsewhere rather than to the Academy. Hence, although we fully agree with the Committee in supposing that no corrupt or interested motives were consciously present at any time to the members of the Council, their action has produced the same effects as if they had been so influenced.

What comes out most decidedly in the inquiry is the total incapacity of a large body like the Council of the Royal Academy to buy pictures with intelligence and discretion. We believe that in the present condition of the arts, where there is not one common tradition, but an infinite diversity of tendencies, ten men acting with the best will, the highest endeavour, and the most conscientious impartiality would always fail to buy pictures successfully. It is inevitable that the bias of one man should counteract an opposite bias of another, with the result that the only pictures on which they could find a common ground would be themselves in the nature of a compromise, and compromise is fatal to art. We therefore welcome the recommendation of the Committee to vest the administration in the hands of three men, one the President of the Royal Academy, one a Royal Academician appointed by the Council, and the third an Associate elected by the Associates. This is by no means the ideal administration we might imagine. We feel sure that one man would always be better than three, and that a man like the Keeper of the Tate Gallery, who stands outside the scrimmage of artistic rivalries and competition, would generally be better than one who is in the thick of it. But if we take all the circumstances into consideration, especially the natural reluctance to change more than is absolutely necessary of the provisions of a will, we cannot doubt that the suggestion is a sensible and practical compromise, and perhaps as strong a measure of reform as would be likely to find

acceptance. We note with particular interest and pleasure the definite posi-
tion given to the Associates. It is a step in the right direction. No sound
reform is likely to take place in the organization of the Royal Academy until
the position of the Associates is changed, until the inferior grade is either
abolished altogether, or at least given some considerable power in determin-
ing the policy of the whole body. As it is now, the Associate is kept in
tutelage until all reforming zeal has evaporated and his energy is sufficiently
reduced to make him a comfortable companion. We hope that the meaning
of this suggestion will not be missed.

What will be the effect of this report on the art of England, supposing its
suggestions are carried into effect? It is well not to have extravagant hopes,
and there is good precedent for supposing that after a few years of better
administration things will return to their former condition. The Academy is
a body which understands to perfection the supreme power of masterly inac-
tivity. It holds Burlington House itself in consideration of effecting certain
sweeping reforms in its constitution, which it has calmly postponed *sine die*.
The modern artist is intensely individualistic, and in proportion as he is an
artist he finds it difficult to combine with his kind for any ulterior purpose.
The Academy, on the other hand, has this great advantage, that to a large
extent its members are bound together by more convincing and less capri-
cious ties than those of sympathy on artistic questions. As a purely commer-
cial venture it will always command success, because it gives the half-
educated classes exactly what they relish. It is, of course, a serious blow to
genuine art, which has always maintained a precarious and sporadic existence
among us, that the Academy, in addition to its popular and commercial suc-
cess, has managed to secure to itself the prestige attaching to an academic
society. It is this that those who care for serious and really academic art in
England must always deplore. We do not grudge the Academy its success as
a popular entertainment, we lament that the same body should be allowed to
represent national art as a whole; and from this point of view the finding of
the Lords' Committee that there are too many pictures of a popular nature in
the Chantrey Collection will, one may hope, bring home to the public at
large what the critics have long proclaimed—that the one thing that the
Royal Academy is *not* is a body of *Academic* artists.

We must congratulate Mr. MacColl on this termination to a long and
arduous undertaking. The exposure of abuses is always a disagreeable and
invidious task. It lays the enthusiastic reformer open to misconstruction of
motives, and there has been no lack of insinuations of this kind on the part
of the other side. Considering the silent contempt with which Mr. MacColl's
criticisms were met, we cannot but think that he has shown remarkable re-

straint and courtesy in his necessary reiteration of the charges. His pertinacity in the performance of a public duty has at last been justified by the unanimous verdict of the members of the Select Committee of the House of Lords, to whom all lovers of our national art owe a debt of gratitude for the conscientious and equitable way in which they have performed their duties.

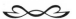

OUR NATIONAL COLLECTIONS

THE Rokeby Velasquez, whether or not it is acquired by the persistent and patriotic efforts of the National Art Collections Fund, has brought to a point the problem of our national collections. It has long been apparent that England is falling behind her competitors in the attempt to secure a share of the fast diminishing residue of great masterpieces. The sums voted by the Government are, it is evident, inadequate at a time when the price of rare examples has been multiplied tenfold, and a weighty article in the current number of *The Burlington Magazine* has called attention to a state of things which, if it be allowed to continue, will prove to all the world our indifference as a nation to this aspect of culture. Another contribution to the subject was published in an article in *The Daily Chronicle* of December 21st, and it is to this that we desire to call attention. The scheme there proposed is so perfectly feasible, so simple, and is likely to prove so efficient that one can hardly doubt that it will be put into practice. The scheme is to place a tax of one per cent, on all sales of works of art, the tax to be levied by means of stamps, without which the receipt will not be valid. It is further suggested that stamps of one colour should be used for transactions which refer to works of early art, say before 1820; and stamps of another colour in cases of the sale of modern works. The proceeds derived from the stamps for early works could be devoted to the National Gallery and South Kensington; while the income from the other stamps would form a much needed fund for the purchase of contemporary works of art. In this way the Tate Gallery— which we have always maintained should be under a separate administration from the National Gallery—might hope ultimately to fulfill some of the functions of the Luxembourg. Under good management such a fund might become a valuable educational influence upon contemporary taste, as well as afford a much-needed means of encouragement to artists of real, but not immediately recognized talent.

The ingenious author of this scheme—a well-known collector who has been unfailing in his generous efforts for our national collections—estimates

Reprinted from *The Athenaeum*, 6 January 1906.

that the total revenue from such a source would amount to something like sixty thousand pounds a year, even if, as seems advisable, transactions which concern sums under fifty pounds were exempted. And this large sum would be levied without inflicting a serious burden on any one. The rich collector who can afford to pay ten thousand pounds for a picture will not be deterred by having to pay another hundred to the State, accustomed as he is to paying far larger amounts in commissions to intermediaries. Nor should the artist who commands large prices for his pictures mind sacrificing a small fraction for the encouragement of younger and less popular talent.

The idea of the State levying toll on commercial transactions is in no way new or startling: we draw our cheques or stamp our receipts without grumbling at the small imposition, while larger transfers of property have to contribute increasingly large percentages to the State. The only novelty in the idea consists in ear-marking the toll on a particular class of transaction for a similar particular national expenditure. And this actually would render the tax less irksome. If the dealer has to pay a share of the State Commission, he knows at the same time that the money will increase State patronage of art proportionately, and that he may at any time himself benefit by that patronage.

One of the best features of this proposed tax is that it is levied only on those who have the means and the desire to gratify a refined taste, in order that the opportunities they enjoy may be given freely to all.

The idea seems so eminently practical, and the results of its adoption so beneficent, that we have strong hopes that it will be put into practice. If it be not accepted, and if we are content to go on as we have been going of late, we shall prove to the civilized world that as a nation we are totally indifferent to one of the richest modes of expression of human aspiration, as well as to a great national asset. Even on practical grounds one may say that the possession of great masterpieces of art has been a sign of national ascendancy, and that the constant depletion of our collections is taken as a sign of its opposite.

IDEALS OF A PICTURE GALLERY

W HAT does the "man in the street" expect when he leaves the street to enter a picture gallery? It may be anything; temporary shelter and warmth, trifling amusement, the satisfaction of an idle curiosity, an opportunity for the exercise of the historical imagination or the food of a deep and intense imaginative life. Which of all these desires should a great public institution like the Metropolitan Museum endeavor to gratify in its public, and how should it set about doing it? The private collector can set before himself a certain aim and within the limits of his purse he can realize it—the guardians of a public institution have no such complete freedom. None the less they may do well to formulate ideals even with the full knowledge that they will always remain ideals, only imperfectly translated into fact. Particularly is this the case with regard to the collection of paintings now in our Museum. These have been brought together by no fixed and determined law, they express the aim of no one intelligence nor even of what a museum may sometimes boast—a communal intelligence or tradition. Rather they are the result of generous and public spirited impulses springing up in the minds of very diversely gifted benefactors. As a result the uninstructed visitor can scarcely hope to acquire definite notions about the historical sequence of artistic expression, nor can he hope to increase his susceptibility to the finest artistic impressions by a careful attention, fixed with all patience and humility, only upon the works of the great creative minds. And yet these are surely the two great educational ends which justify a city in spending the money of its citizens upon a public picture gallery. And as both are desirable ends, either may become the basis for museum arrangement.

Of late years Signor Corrado Ricci has shown what can be done upon the former basis. He has rearranged the Brera, so that all the works of a particular school and epoch of Italian painters find themselves together in a single gallery. We can trace as we walk from room to room, the growth of the Lombard school, from its beginnings as an offshoot from Paduan art through the sincere but provincial efforts of men like Buttinone and Zenale to a

Reprinted from *Bulletin of the Metropolitan Museum of Art*, March 1906, 58–60.

greater decorative effectiveness in Bramante and Bramantino, till with the advent of Leonardo da Vinci, new and unattainable ideals lead the Lombard artists to forsake their native speech. The arrangement is, in fact, rigidly historical, a joy to the connoisseur, but sometimes a trial to the artist. Truth shines there with a clear and naked light, but Beauty sometimes shyly retreats from the glare. The experiment carried out with Signor Ricci's enthusiasm and knowledge was assuredly worth making and the impress of a clear and masterly mind is at least exhilarating to the student.

If we turn now to an older museum like the Louvre or the Uffizi before Signor Ricci began to repeat his idea there, we find no such clear statement of purpose. We find in each a single room, the Salon Carré in the Louvre and the Tribuna at Florence, arranged not historically, but at least in intention, artistically, in each we find collected together what were supposed to be the masterpieces of various schools and various ages. Some of them are now the changes and revolutions of taste looked upon with cold indifference, but the majority of pictures in either room are indisputably among the greatest expressions of human imagination which Europe has produced. In the remainder of the galleries a rough historical arrangement is adopted, in the Louvre the Primitives are in one group, the artist of the Cinquecento range along the gallery and we pass gradually to those of the seventeenth century without a rigid line of demarcation, and with occasional disregard of national distinctions.

In the National Gallery, the historical method is used as regards the rooms, there is a Tuscan, an Umbrian, a Venetian, a Dutch gallery; but the rule is not rigidly adhered to and within each gallery the arrangement is rather aesthetic or merely practical than strictly scientific.

What then, should be our aim here? Anything like a strict historical method is impossible since there is only one aspect of the art which is adequately represented and that is the sentimental and anecdotic side of nineteenth century painting. For the rest we can only present isolated points in the great sequence of European creative thought. We have as yet no Byzantine paintings, no Giotto, no Giottesque, no Mantegna, no Botticelli, no Leonardo, no Raphael, no Michaelangelo. The student of the history of art must either travel in Europe or apply himself to reproductions. It must of course, be the aim of our Museum direction to get as many as possible of these works, not indeed with the expectation of representing all these great names, since that is barely within the limits of possibility, but with the intention of acquiring as many of the connecting links of the kind as may come into the market.

But in the meanwhile, whether we will or no, we are thrown back for our

leading notion upon the aesthetic rather than the historical idea. We must, in fact, so arrange the galleries that it shall be apparent to each and all that some things are more worthy than others of prolonged and serious attention. It is only by some such emphasis upon what has high and serious merit, that we can hope in time to arouse an understanding of that most difficult but most fascinating language of human emotion, the language of art. It is a language which is universal, valid for all times and in all countries, but it is a language which must be learned though it is more natural to some than to others.

With this end in view, we need not fear to enlist other interests. The prevalent desire to follow an intellectual fashion will assuredly come to our aid and it is not after all wholly bad. In the young and uneducated at least, this is as much the expression of a proper reverence for what the wisdom of past centuries has approved as a desire to impose by an insincere pretention. Moreover, it is often fruitful of better things and of those that admire from affectation at least a few may stay to feel and understand. At all events the aim we should set before ourselves is the establishment of standards of truth and beauty, and the encouragement of a keener discrimination and a firmer faith. A discrimination between the bad and the good, and a faith in the existence of something more universal in art than a merely casual and arbitrary predilection.

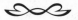

MR. JOHN G. JOHNSON, OF
PHILADELPHIA

SO many of those who generously helped the *Burlington Magazine* in its
early and arduous beginnings have lately died that the news of the death
of Mr. John G. Johnson comes to us with a peculiar sense of both personal
and public loss. Mr. Johnson had risen by his extraordinary talents from a
quite humble station in life. He became one of the greatest advocates in the
United States. With the increase of his practice he made in middle life a
large and increasing fortune, and with the opportunity thus offered him he
began to develop those sensibilities which until then had been suppressed by
the practical needs of a strenuous life. At first his taste led him to buy en-
tirely modern works of art, mostly by Italian painters, and I should suppose
of a rather melodramatic and obvious appeal, for he always spoke of this
beginning period of his artistic development with a certain deprecating and
humorous candour. The time came, however, when these works no longer
satisfied him, and he had the courage and simplicity to admit the imperfec-
tions of his taste and to scrap his whole collection with a financial loss which
warned him that bad art might be also a bad speculation. He then began to
amass that remarkable and peculiar collection which has made him famous
among art lovers throughout the civilised world. He lived in a comfortable
but not very large house in that part of Philadelphia which is so quaint an
imitation of 18th century London, though with a difference that adds to it a
certain piquancy. The house soon became entirely inadequate to his collec-
tion, for Mr. Johnson loved the acquisition of pictures almost to excess, so
that even many years ago there was no single wall-space in passage or bed-
room that was not covered, and in many rooms pictures were ranged one
behind another all along the bottoms of the walls or stood on easels and
chairs in every corner. Sundays were devoted almost entirely to the examina-
tion of these works, and a week-end with him at Philadelphia was a stren-
uous exercise, for his energy and enthusiasm were inexhaustible.

His purchases were always made with the greatest care, and always ex-
pressed his personal tastes and outlook. He never bought like the great mil-

Reprinted from *The Burlington Magazine*, May 1917, 203–4.

lionaire who accepts the celebrated and duly authenticated at its face value, who follows in the footsteps of the Popes and Princes of past ages. He liked precisely the works that such collectors overlook. He loved the *inédit*, the work that others had passed by, or that owing to some peculiarity would never appeal to the ordinary taste. He loved the curious in art almost to excess, and indeed this was natural, for with him the art-historical passion was stronger than either the social or the purely aesthetic motive of the collector. Thus it was that his collection was a mine of wealth for those who loved to inquire into unexplored byways of art history, for Mr. Johnson was always open to what was newlyfound and as yet unaccepted in ancient art. He did not stick to the highways of the great central traditions of Italian and Flemish painting, but was one of the first to see that the Burgundian, Provençal and the Catalonian schools were also deserving of investigation. He never, therefore, bought names and attributions, but always pictures. The result was a quite unique and particularly fascinating collection, varying from supreme masterpieces like his Botticelli series of the type of *The Magdalene*, which comprise what are perhaps the most profoundly felt designs of the master, the Hubert van Eyck of *St. Francis Receiving the Stigmata*, and others, down to works which could scarcely claim attention on aesthetic grounds. But these minor works were scarcely ever devoid of some peculiarity which rendered them interesting to the curious and speculative investigator, or else they illustrated some unsuspected and unusual phase of an artist's personality. One might say that Mr. Johnson never bought a dull picture; and this, considering that his collection numbered well over a thousand pictures, is a great tribute to his alertness of mind.

Certainly no one who ever once enjoyed a Sunday with Mr. Johnson can ever forget the delight and inspiration which his unbounded interest in and enthusiasm for art afforded, nor are they likely to forget the charm of his personality, his intellectual keenness and vigor, combined with a rare simplicity and unpretentiousness. To this we must add his extraordinarily wide human sympathies and his extreme generosity, which were after all the dominant traits of a singularly lovable and kindly nature.

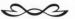

CHILDREN'S DRAWINGS

A N exhibition of drawings by children under twelve at the Omega Work-shops made more probable to my mind than heretofore certain spec-ulations regarding the nature of the artistic impulse and the possibilities of its cultivation or inhibition, some of which I have thought might interest even serious students of art. The majority of the drawings were by the children of artists, and these for the most part had received no regular instruction. But drawings were also received from schools, and here the distinction between those taught on conventional lines and those which were merely guided to express their own vision was most marked. It appeared evidently that the ordinary teaching destroyed completely the children's peculiar gifts of repre-sentation and design, replacing them with feeble imitations of some contem-porary convention. In putting thus briefly the case against the teaching of art as ordinarily practised I am of course assuming that the untaught child's work has artistic value. That this is so would hardly be doubted by any unprejudiced visitor to the exhibition. The fact is that almost all children's drawings have some merit, almost all have more aesthetic merit than all but the best art of the modern adult. I shall try in this article to make out an *a priori case* for accepting this sweeping statement.

In order to face the question fairly we have of course to get rid of certain persistent habits of criticism which distort most contemporary judgments on works of art. We have to recognise that our admiration of an artist's skill is not aesthetic. We have to admit that the merits of a work of art cannot be measured by the completeness with which natural objects are represented, nor by the science shown in that representation. We have to get rid of the idea that our favourable aesthetic judgment of a work of art is a kind of prize conferred on the artist for meritorious effort. It is perhaps unnecessary to enumerate these possible errors of judgment to readers of the *Burlington Magazine*. To students of the history of art who have gradually been forced by their critical faculty out of the narrow grooves of the old aesthetic ortho-doxy, and who have learned successively to accept with delight, first Gothic

Reprinted from *The Burlington Magazine*, June 1917, 225–31.

art, then the painting of the primitives and the early miniaturists, then the Byzantines, then early Oriental art, and finally Aztec and negro art—to such, a hint will be sufficient to indicate the kind of attitude which is necessary to an understanding of what children's art amounts to.

And to such I believe it will become evident that we have in our midst an inexhaustible supply of just that kind of invention, just that immediate expressiveness, which we admire so much in primitive art, and the loss of which in modern art inclines us perhaps even too much towards a retrospective and historical attitude.

When I say that children's drawings are genuine examples of primitive art I must be allowed to use the word primitive in a rather more precise and narrow sense than is usually done. By primitive is usually meant that phase in the artistic sequence of a civilisation which precedes the phase of more or less complete power of representation. Thus for the Italians primitive is almost equivalent to any painting previous to Leonardo and Fra Bartolommeo. I should like for the time being to apply the word primitive not so much to a period in time as to a particular psychological attitude which occurs most frequently in those periods which we call primitive, but which is not universal even in these periods. Thus I do not count Cimabue or Giotto as primitives, nor Fra Angelico, Ucello, nor Piero della Francesca—but I should count almost all the mediaeval miniaturists, the de Limbourgs, Van Eycks, Fouquet, and among the Italians the most typical primitive would be Pisanello in his paintings and drawings. Now, the distinction I would draw between these two groups, which I will call Primitive and Formalist, is that the primitive artist is intensely moved by events and objects, and that his art is the direct expression of his wonder and delight in them. That that expression takes inevitably rhythmical form, becomes beautiful, is due simply to the directness and unconsciousness with which he expresses his emotion. The Formalist also may be moved deeply by the contemplation of events and objects, but there comes a certain moment when his expression is no longer related entirely to that emotion, but is dominated by a passionate feeling about form.

The modern descendant of the Primitive is the Academy painter of anecdotes, or special objects, like the well-known painter who *did* marble, or the innumerable painters who specialise on sheep or birch trees or any other object which has aroused their interest. Only, unfortunately for the adult in our modern self-conscious civilisation, the primitive attitude is no longer possible. Whether this is due to the fading of the emotions of wonder and delight in objects or not I cannot say, but it is certain that no modern adult can retain the freshness of vision, the surprise and shock, the intimacy and

sharpness of notation, the *imprévu* quality of primitive art. And it is just here that untaught children have an enormous superiority. We can all of us recollect the time when we lived in an animistic world, when every object in the home had a personality, was either friendly or menacing, was on our side or against us. We can all remember the time when our visual life was so intense that the smallest change in the arrangement of a room, the smallest new object introduced into the house, was an event of thrilling import. This habit of attributing strong emotional values to all the objects surrounding them is what makes the visual life of children so much more vivid and intense than the visual life of almost all grown-up people. And if nothing is put in the way to hinder its expression the child translates these vivid visual perceptions with an extreme directness and simplicity, whereby it manages to convey to the spectator something of the emotional forces of its own perceptions. An example of such vivid directness of feeling about objects is such a drawing as that by David John (a son of Mr. Augustus John) reproduced here [D]. No one can miss the intensity with which the boy has realized the snakiness of a snake—the peculiar intimate sympathy and vitality of the reeding such as no cold observation could attain to. But perhaps the most remarkable instance of such power is shown by the work of Miss Jocelyn Gaskin, who at the age of 7 did the drawing of nursemaids and children [PLATE, c]. Here we see that a passionate interest in the *dramatis personae* of her daily walk has led to an astonishing power of visualizing very complicated forms with an ease that many a professional artist might well envy, and being completely untaught the child has recorded its mental image with such simplicity and ease that she has actually attained to a quality of line such as artists usually acquire only after years of assiduous practice. One thinks instinctively before this of the work of a Steinlen or Forain. I have seen later drawings by the same child which show that already the consciousness of the problems of art has dawned upon her with the result of checking the freedom of her record and blurring the clearness of her mental images. The drawings though still skillful have become tight and timid, and the intimate contact with objects, the vitality which is here so striking has disappeared. No doubt with a child so remarkably gifted as this such a process is inevitable. The same sensitiveness which led her to make such a drawing may well have led her to look too eagerly and admiringly at contemporary professional work which in reality she has already surpassed.

Indeed children art, like that of primitive races, the modern negro for instance, is singularly at the mercy of outside influences. Native races that produce almost unconsciously the most beautiful and tasteful work will throw them aside to make bad copies of the vilest products of modern European

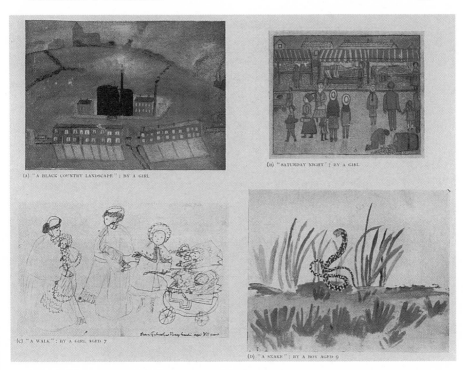

(A) "A BLACK COUNTRY LANDSCAPE" ; BY A GIRL

(B) "SATURDAY NIGHT" ; BY A GIRL

(C) "A WALK" : BY A GIRL AGED 7

(D) "A SNAKE" : BY A BOY AGED 9

PLATE A (upper left): "A Black Country Landscape" by a girl; B (upper right): "Saturday Night" by a girl; C (lower left): "A Walk" by a girl, age 7; D: "A Snake" by a boy, age 9.

industrialism, so little does their work result from any clear self-conscious principle.

But Miss Gaskin's drawing is not entirely typical of children's work, at least it has not so close a similarity with the work of early primitive artists though springing from the same emotional attitude. During the exhibition a series of drawings done by the girls at Dudley High School was bought to me by the mistress, Miss M. Richardson. These seemed to me to be extraordinarily similar to mediaeval miniatures. Miss Richardson has discovered a method of stimulating the individual perceptions and inventiveness of her pupils without ever imposing on them any artistic formula. The result is that her pupils, who criticize and discuss each other's work, have gradually developed a style of their own somewhat in the way in which some small Italian town in the 15th century developed a common characteristic manner. Miss Richardson's chief effort seems to be to train the children's power of fixing mental images and trusting to them implicitly so that their drawings are

almost literal renderings of inner visions. In order to evoke these visions she frequently reads poems to them, telling them to fix their minds on whatever scene in the poem has most struck them. One of the most remarkable series of such drawings was inspired by Matthew Arnold's *Forsaken Merman*. One of these, by no means the most technically accomplished, is one which shows how vividly and completely the scene is visualized by a child, and how admirably disposed the elements of the design are, with what a fine feeling for proportion, and with what interesting and curious contours to the divisions. Nearly all the girls had quite rightly visualized the poem from the sea looking to the land, and nearly all of these were remarkable for the definiteness and individuality of the visualization. The few who saw the scene from the interior failed to get any complete or original vision. Another drawing from the same school reproduced here was one of a series illustrating *Saturday Night* [B]; and yet another is a memorised *Landscape of the Black Country* [A], where I think the close parentage of this children's Art to the Art of the Mediaeval miniaturist comes out plainly.

As yet hardly anything has been done in the directions explored by Miss Richardson, but the results are already so surprising, the quantity and quality of the inventive design revealed in this one school is so surprising that I cannot doubt that if children were stimulated to create instead of being inhibited by instruction we should no longer need to complain as we do to-day of the want of creative imagination.

TEACHING ART

THE words sound wrong, somehow, like "baking ices," "polishing mud" or "sliced lemonade"; one has a suspicion that it is a fabulous monster. But for everyone who wants to learn there is a large number who want to be taught or want their children taught, and so there arises the profession of the "Art teacher" and institutions like the Royal College of Art, which for many decades has absorbed considerable amounts of public money, and has produced, not artists, but—it breeds true to type—only more "Art teachers." And apparently the more "Art teachers," the less art. And the less art the more clamour for getting Art taught; and again more "Art teachers."

What has been overlooked is the fact that Art cannot, properly speaking, be taught at all. One can teach conventions like the conventions of language; one can teach facts like the dates of historical events of the results of scientific experiment; one cannot teach a thing which does not exist. And the whole essence of Art being the discovery by the would-be artist of something that never has existed before in the whole history of the world, this unknown quantity cannot possibly be handed over to him by any teacher, however learned and sympathetic. This unknown thing is the reaction of the individual with all his emotional and sensual idiosyncrasies to vision. This does not imply that Art is a purely subjective affair, that it is bound to be personal. On the contrary, the best critics have almost always agreed that the greatest art is singularly objective and impersonal. But none the less the odd thing about Art is that this objective reality can only be attained by the artist exploring completely his own sensibility. What the artist does is to contribute to the general fund the record of that aspect of reality which is discernible from the particular angle of his own spiritual situation.

Everyone is potentially an artist, since everyone has a unique spiritual experience. This is too Christian a doctrine to be accepted: we are still too much dominated by moral concepts of life. We think of life in terms of merit and reward of industry, discipline, achievement. Art is therefore represented as a very difficult accomplishment (which is true enough, but for quite a

Reprinted from *The Athenaeum*, 12 September 1919, 887–88.

different reason), a kind of conjuring trick or acrobatic feat needing a strict teacher, the most persistent practice, and the closest adherence to rules. Our praise of the acrobat is our reward for the moral qualities he has displayed in overcoming difficulties by industry, perseverance, and obedience. The schoolmaster is naturally enough anxious about morals, and he always hopes to combine moral training with the subjects which he teaches in class. He frequently teaches Latin and Greek in such a way that the boys never will be able to read the classics, but will, it is hoped, have received much moral gymnastic exercise in passing along this intellectual and aesthetic blind alley.

And so art too, though a subject looked askance at by our upper-class schools as effeminate, can still be taught in such a way as to become amenable to moral praise and blame awarded through examination.

It is indeed very difficult to be an artist—much more so than the schoolmasters and men of goodwill who incite us to industry and application have any idea of. It is very difficult for a modern civilized man because it is so difficult for him to be himself, to retain under the immense compulsion of his surroundings the conviction of the value and importance of his own personal reaction. It is not difficult for savages and children to be artists, but it is difficult for the grown-up civilized person to be one. The whole process of education is in fact antagonistic to this personal reaction. Education consists, indeed, in extending the individual experience by communicating the accumulated stores of human experience. In face of the wealth and richness of this second-hand experience, the individual tends to lose sight of his own immediate contacts, so that it would be almost true to say that by maturity the average civilized man has replaced most of his sensations by opinions.

This process is obviously desirable in itself, and indeed necessary to prepare the individual for the complex and highly organized relations of civilized life. The question is whether there might not go on parallel with this another kind of education, the object of which would be the exploration and realization of the individual powers of reaction to experience. I know too little of education in general to know how far this idea is already at work modifying the methods in use, but for the question of art teacher it is vital and fundamental.

Could an Art teacher not *teach* anything at all, but educate the native powers of perception and visualization of his pupils merely by exciting and fixing their attention? The question was answered for me some years ago when I first came across the drawings done by the Dudley High School girls under the tuition of Miss Marion Richardson. I say "under the tuition" by mere conventional habit. "Intuition" would be nearer the mark, because Miss Richardson, being a peculiarly honest, hard-headed and sceptical young

woman, reflected, when she found herself appointed Art teacher to a large school, that she didn't know what Art was, and had certainly nothing that she could confidently hand over to her pupils as such. She therefore set to work to interest them in their own personal vision, especially the mental vision which occurs with the eyes shut, without giving them any hints as to what that vision should be. In this way she has encouraged in her pupils the most extraordinary acuteness and definiteness of mental imagery, so that a poem read to them or a description given sets up in their minds such vivid images that they can draw and colour them with an ease and sureness of hand and a logical use of their material that go far beyond the skill acquired by laborious practice in the ordinary way.

That the children get by this process an intense interest in Art and poetical imagery is surely in itself a satisfactory result, and one that can hardly be claimed for the orthodox methods of teaching. But I think what would surprise the schoolmaster most would be that, so far from Miss Richardson's complete abandonment of all ideas of discipline producing careless or casual work, every drawing that I have seen shows a passionate application, and often a research for new technical possibilities, such as could never be got out of the best pupil from a sense of duty. And when one reflects that most of these drawings are done in spare hours out of school, one cannot deny the efficacy of the method for the self-discipline of hard work. The fact is that the work the artist sets himself demands of him a much more concentrated effort than any that can be got out of a pupil by moral stimulus.

It is evident to any who have studied children's drawings that the majority of them are more or less artists until they begin to be taught Art. It is also true that most savages are artists. But both children and savages are so easily impressed by the superior powers of civilized grown-ups that they can, with the greatest case, be got to abandon their own personal reactions in favour of some accepted conventions. So that although they are artists they are weak and imperfect artists. The wider outlook and deeper self-consciousness which education gives to the civilized provide them at once with a richer spiritual material to draw upon and a firmer hold upon any direct experience which they may succeed in retaining. So that though it is, as I said, much more difficult for the civilized man to become an artist, yet when once he is one he is more sure of his ground, less affectible and less capricious; and, finally, having had to digest a much wider experience, his art is altogether richer and more complete than that of savages and children.

The problem for Art teaching, then, must be how to preserve and develop the individual reaction to vision during the time when the child is also receiving the accumulated experience of mankind, and so to enable at least a

few of them to pass from being child-artists to being civilized artists. That this would be the case with only a small minority is probable, but such a training as I have suggested would provide even the average child with a possibility of understanding and enjoying Art far more keenly than the ordinarily educated man does at present.

THE COURTAULD INSTITUTE
OF ART

Sir,—

I FEEL that the scheme for the foundation of a faculty of art-history in London University, which we owe to the initiative of Lord Lee and to the generosity of Mr. Samuel Courtauld, Sir Martin Conway and Sir Joseph Duveen, should be a source of particular satisfaction to those who have supported *The Burlington Magazine.* When more than a quarter of a century ago the Burlington struggled painfully for its existence, it had to meet a general feeling of despondent resignation to the incapacity of England ever to support a journal devoted to the study of art-history.

Even among highly placed museum officials this defeatist attitude was common. Against this despair a small group of students, generously supported by one or two collectors like Sir Herbert Cook, fought with ultimate success, upheld by a conviction that no great civilized country could afford to neglect this aspect of culture. I think we may fairly pride ourselves on having done much to bring about that changed attitude towards art-history of which the establishment of an art-historical faculty in London University is a culminating proof.

I do not doubt that even now some distinguished scholars will be inclined to doubt the value of such an institution. They will feel that they themselves have attained to proficiency in these studies by their own efforts, aided by great natural aptitude, and will believe that we can always get on by the same haphazard methods which sufficed in the past.

I think that this is a mistaken attitude. Most of those who have thus become acknowledged authorities have had some initial advantages by the accident of birth and previous training. Without such special advantages the task would have been almost hopeless and who will venture to declare that the specific aptitudes necessary to success in this line of research are providentially distributed only to the sons of wealthy parents? Nor do these critics recognize, perhaps, how much more rapid their attainment of proficiency might have been had the facilities for study lain nearer to their hands.

Reprinted from *The Burlington Magazine,* December 1930, 317–318.

It is almost certain that anyone who intends to make art-history or criticism a profession will avail himself of this proposed course of study, but it is greatly to be hoped that other students who do not desire to become professionals should also accept it as a not unimportant part of a liberal education. It is, of course, an evident fact that the opportunities of gaining a living by the knowledge of art-history are relatively few; that as a profession it might easily become overcrowded.

But we may believe that the mere existence of such a faculty will have, in the long run, a considerable effect. There are in England a number of posts which might be and should be filled by highly trained professional art-historians. I am thinking particularly of the curatorships of our provincial museums. As things are at present, every really competent art-historian would hesitate to accept such a post, knowing as he does that the members of the governing bodies of these institutions are apt to think that the understanding of art is a heaven-descended gift which comes by the grace of God and not by study. They also are generally convinced that in reward for their successful business activities this particular grace has been accorded to them.

The mere existence of a University degree in art-history would have a marvellously sobering effect on these public-spirited, but over-inspired patrons. They would feel something of the same hesitation in overriding the opinion of such a professional authority as they may now feel about neglecting the advice of their doctor. In the long run this might lead to our provincial galleries becoming centres of artistic influence comparable to the great provincial galleries of Germany and America. The difference that this would make in the cultural life of England is incalculable.

Besides this effect, it is not impossible that the standard of art-criticism in the Press might be sensibly improved, nor would there be anything but gain if those who intend to live by dealing in works of art were to avail themselves of the opportunity for a more scholarly and liberal understanding of these studies than they would have picked up in the course of trade. Decidedly there is plenty of work for the faculty to do.

In view of the fact that this event comes as the unexpected realization of a long cherished hope and that I have reflected a good deal on what it might be expected to accomplish, I venture to submit certain views to the consideration of those engaged in laying down the lines of study.

I should like to see such a faculty lean rather to the scientific than to the literary attitude. The future of what I may call applied aesthetics is rather, I believe, with the psychologist and the anthropologist than with the classical scholar.

In the first place, in a study so liable to subjective distortion as that of art,

the scientific discipline is of immense value. It is highly desirable that no dogmatic valuations, however respectable their traditional backing, should be allowed to pass unquestioned. It is essential that the art-historian should be able to contemplate any object which can claim in any way to be a work of art with the same alert and attentive inquisition as one which has already been, as it were, canonized.

For this reason, however intensive the specialization may become at the end of the course, there should be a considerable period of study in which the student is led to contemplate typical works of art of all periods and all countries in the same spirit of perceptive enquiry. Any signs of that disease which has been wittily named *centoninità* should be firmly discouraged. This tendency to regard all the work of one school and period as sacrosanct gives to those who yield to it a false sense of superior sensibility and is the most dangerous of labour-saving devices. It is only, I believe, by starting with a very wide outlook and by the comparison of a large range of different styles that this tendency can be checked. There is far more chance of a student doing valuable work when he comes to specialize if he has always in the back of his mind such a wide range of comparison. A fine and discriminating taste in works of art is of course a natural gift, but its effectiveness depends largely upon the extent to which it has been trained by constant exercise.

One other aspect of this problem of training in art-history occurs to me. University faculties tend naturally to lay down curricula which lend themselves easily to examination, and afford facilities for a rigid system of giving marks. In such a subject as this there is a great danger in this tendency and whilst examinations will no doubt be necessary at certain stages in the course, it would be desirable, I think, that in giving degrees, more weight should be given to the student's final thesis than to his response to questions admitting of correct or incorrect answers. To acquire the power of original enquiry and independent thought should be, I think, the chief aim of such a course of education as that contemplated in this scheme. Its ultimate effect on English culture will depend on the soundness of the tradition which is laid down in the beginning. But in any case, this scheme gives us a new hope for the future of art in England.

Yours faithfully,
ROGER FRY

6

LITERATURE AND THE
PERFORMING ARTS

AN anecdote related by George Bernard Shaw describes Fry at a luncheon in 1917 with the composer Edward Elgar.

Elgar talked music so voluminously that Roger had nothing to do but eat his lunch in silence. At last . . . Roger . . . began in his beautiful voice, . . . "After all, there is only one art; all the arts are the same." I heard no more; for my attention was taken by a growl from the other side of the table. It was Elgar, with his fangs bared and all his hackles bristling, in an appalling rage. "Music," he spluttered, "is written on the skies for you to note down. And you compare that to a DAMNED imitation." There was nothing for Roger to do but either seize the decanter and split Elgar's head with it, or else take it like an angel with perfect dignity. Which latter he did.[1]

This story reveals—in addition to Fry's equanimity—a belief, which remained consistent through his life, in the unity of the arts. Defending his ideas of "esthetic experience," Fry insisted, "We cannot hold our theory for music and architecture and drop it for poetry and drama" (*Trans*, 4). This conviction be traced to Fry's formative experiences in the Arts and Crafts and the Aesthetic movements (see chapter 4), both of which upheld an ideal of cooperation among the arts.

In introducing Fry's essays on architecture and the decorative arts, I suggested that the later modernist emphasis on the separation of the arts has inflected assessments of what was significant in Fry's career, prompting later readers' indifference to the scope of his wide-ranging interests. Clement Greenberg, in a famous essay, laid down the law of modernism: "Each art had to determine, through the operations peculiar to itself, the effects peculiar and exclusive to itself. . . . Thereby each art would be rendered 'pure' and in its 'purity' find the guarantee of its standards of quality as well as of its independence."[2]

In fact, like Fry, Greenberg's critical interests strayed across the boundaries between literature, poetry, and the theater, and Greenberg himself acknowledged Fry's equally broad range. Nevertheless, this manifesto of American formalism articulates the late modernist prejudice against an inter-

disciplinary approach to the arts. Fry's essays on stage design, dance, poetry, and prose reveal his engagement across a broad spectrum of the avant-garde movements of his day.

Fry's belief in the unity of the arts led him, as soon as he had generated some principle concerning painting or sculpture, to apply it to other arts. Shortly after the first Post-Impressionist exhibition, for example, Fry may be found extrapolating from modernist painting to stage design. "MR. GORDON CRAIG'S STAGE DESIGNS" echoes the language of Fry's writings on Post-Impressionism in its link of realism with mere comedy, while "abstraction and generalisation" are associated with the seriousness of Shakespearean drama. Realist painting, Fry told the audience of his POST IMPRESSIONISM lecture a few months br fore, could be appropriate for "that kind of art which corresponds to the comedy of manners in literature," but "those feelings which belong to the deepest most universal parts of our nature are likely to be actually disturbed and put off by anything like literal exactitude to actual appearance" (in chapter 2). Fry's belief that appropriate stage design might "express the idea of a play" follows from the goal, stated in the catalog essay for *Manet and the Post-Impressionists* (in chapter 2), of putting "a line round a mental conception." Finally, the list of tools available to the stage designer—proportion, scale, mass, inclination of planes, light and shade—tallies closely with the "emotional elements of design" enumerated in the 1909 "Essay in Aesthetics" (*V&D*, 33–34).

Given the connections Fry forged between the classicism of modern art and classic drama, it is ironic that when in 1918 he was invited to design for a West End play it was, in his own words, "a rather ordinary farce" about a society lady afflicted with, in the words of the title, *Too Much Money*. The producers commissioned the Omega to create a fashionable drawing room, which Fry did, combining new designs with pieces already in stock at the workshops.[3] *Too Much Money* ran for a month in Glasgow before coming to London for sixty-two performances. Fry's sets were so admired by the leading actress of *Too Much Money* that a year later he was engaged to design for her next play. He planned for "quite monstrous orchidlike flowers . . . phallic and *fumiste* [ridiculously exaggerated], but rather by implication than by direct statement."[4] This commission, however, fell through.

Although Fry was not able to realize his ideas for serious dramatic stage design in a full-blown West End production, his Omega Workshops experimented with avant-garde theater on a more modest scale. In "M. LARIONOW AND THE RUSSIAN BALLET," Fry celebrates the puppet show as a form of theater ideally suited to artists, because "the designer reigns supreme . . . the performers are his own handiwork and display an unfailing obedience to his

wishes." Few records remain to document the marionette performances that, along with recitations, concerts, and plays, took place at the Omega during the six years of its operation. The puppet shows seem to have been initiated when, to mark the New Year 1915, a group of Omega artists, using eight-foot-tall marionettes made by Duncan Grant, performed the last act of Racine's *Bérénice*, a tragedy solidly ensconced in the repertoire of serious drama. A few weeks later the Omega staged a benefit to raise money for Belgian war refugees, in which smaller puppets suggesting African figures danced to what was apparently the first orchestrated performance of Claude Debussy's *Boîte à joujoux*.[5] According to the memoirs of one Omega artist, another evening of puppetry featured a bawdy "*pas-de-deux* between a nymph and satyr. . . . The nymph danced 'avec un tel intention' [with such an intention] which was amply manifest."[6] Such sketchy descriptions, which are all that remain of these performances, suffice to show the Omega's ambitions to be part of the avant-garde performance circles of its day. Debussy was the composer of *The Afternoon of a Faun*, which, when it was choreographed by the Ballets-Russes in 1912, had created a scandal over the faun's "final phallic movement."[7] When Walter Sickert, who attended the Omega performance, is found referring in a letter to the "great success" caused by "the swinging appendage of a nigger figure" in the Omega's African marionette performance, it is clear that Fry's group aimed to replicate the Ballets-Russes' amalgam of primitivist eroticism and modernist aesthetics.[8]

For Fry and his Bloomsbury colleagues, the modernism of the Ballets-Russes was allied with the modernism of Post-Impressionist painting, and both were signs of a broader changes associated with the dawn of a new century. Leonard Woolf's memoirs typify Bloomsbury's attitude in its catalog of the reasons that made it "exciting to be alive in London in 1911" culminating with, "to crown all, night after night we flocked to Covent Garden, entranced by a new art, a revelation to us benighted British, the Russian Ballet in the greatest days of Diaghilev and Nijinski."[9] June 1911 saw the opening of the of the Ballets-Russes' first London season, with a repertoire including the ballet-opera, *Prince Igor*, featuring wild Russian folk dances in settings designed by Nicholas Roerich. Roerich's vibrantly painted flat backdrops shocked audiences accustomed to ranks of elaborate receding flats that created an illusion of sumptuous detail and great depth.[10] In its mixture of the exotic primitive and the avant-garde, the Ballets-Russes embodied the somewhat paradoxical claims for modernism Fry had already made for the first Post-Impressionist exhibition (see chapter 2). It is significant that when the second Post-Impressionist show opened in 1912, it included, as the three vital "Post-Impressionist schools," French, English, and Russian art. The

Russian section included eight paintings as well as designs for theatrical costumes by Roerich [Ruhrich].

Fry's connections with the Russian avant-garde were—like so much else—cut off by the war. Immediately following the Armistice, however, when Serge Diaghilev's troupe returned to London, Fry entered into negotiations for the Omega to provide sets for the Ballets-Russes. Although nothing came of this plan, Fry rushed to catch up on the Russians' new productions, publishing his observations the following spring in "M. Larionow and the Russian Ballet." By this time, Fry saw Roerich's prewar stage designs as "rather fusty romanticism" in comparison to the continually evolving choreography of the Ballets-Russes, which broke with the conventions of ballet by integrating, along with exotic folk dancing, sequences of highly stylized poses Fry called "heraldic." This was the signature style of Leonide Massine, who joined the Ballets-Russes as a dancer late in 1913 and reigned as Diaghilev's chief choreographer between 1915 and 1929. In September 1918, Fry attended Massine's *Les Femmes de Bonne Humeur* [*The Good Natured Ladies*]; "it was pure joy," he reported (*Letters*, 433). His delight increased with the opening of two more Massine dances produced with sets by a new designer, Mikhail Larionov, a painter who had contributed to the *Second Post-Impressionist Exhibition*. Fry called Massine and Larionov's *Contes Russes* [*Children's Tales*] "the most lovely spectacle that I've ever seen on the stage" (*Letters*, 442). After the opening of *Le Soleil de Nuit* [*Midnight Sun*], which was danced by Massine, Fry sent a detailed description to his daughter:

> It's a sort of peasant festival in honour of the midnight sun. Dances of peasant women in wonderful dresses with buffoons and the village idiot. Then [Lydia] Lopokova is the Snow Maiden and has a most strange and poetical *pas seul* expressing her longing for the midnight sun, Massine. . . . He rushes backwards and forwards across the stage, while the peasants keep up a ceaseless dance, very complicated and almost chaotic but very beautiful.

Even more than the scenario or the choreography, however, Larionov's sets and costumes were what fascinated Fry, and he included sketches, labeled with his impressions of the colors: Massine appeared in "dark scarlet, black and gold with two great golden discs," but the backdrop was "the most exciting colour, a deep blue background . . . not flat but all sorts of shades" (*Letters*, 440–41).[11] At this point, Fry moved immediately to organize an exhibition of Larionov's work at the Omega, securing from the artist in Paris a number of drawings including "wonderful designs for marionettes" (*Letters*,

447), which were hung concurrently with the exhibition of children's drawings from Marion Richardson's classes (see chapter 5).

"M. Larionow and the Russian Ballot" draws on all these experiences to promote the work of Larionov and his colleague Natalia Goncharova, who "accept with eagerness the new conception of heraldic dance, and whose natural inclination is to give to their designs an exactly corresponding transposition of the actual into a formal equivalent." This phase offers a succinct statement of Fry's formalism: not form for its own sake, but as an "equivalent" of other experience. The diametric opposite of later formalists' distillation of each art's individual essence, Fry's formalism emphasizes the connections—"equivalents"—among the arts and between art and life. Significantly, the conclusion of his article on the Ballets-Russes anticipates two related tendencies of Fry's late aesthetic theory, which drifted increasingly away for the formalist principles he generated in response to modernist painting. Discussing the illustrations of Jules Renard's texts, he initiates the comparisons of art and literature with which the rest of this chapter is concerned. At the same time his enthusiasm for the "double meaning" of Larionov's work—one "pure design" and the other "vague suggestions and flavours of time and place"—anticipates the "double nature" Fry, in his late writings, came to uphold as the goal of all art (see chapter 7).

No influence was more important to the development of Fry's late aesthetic theory, with its increasing emphasis on representation, than his growing interest in literature. As early as the 1914 "A New Theory of Art," his review of Clive Bell's *Art* (in chapter 3), Fry said, "I wish he had extended his theory, and taken literature (in so far as it is an art) into fuller consideration, for I feel confident that great poetry arouses aesthetic emotions of a similar kind to painting and architecture." Here Fry's ambition for a system of aesthetics predicated on the unity of the arts is at odds with his suspicion of literature's claim to artistic status. His own serious engagement with the challenge laid down here may be dated to the waning years of the war. As early as 1916, Virginia Woolf had announced, "I predict the complete rout of post impressionism, chiefly because Roger, who has been staying with us, is now turning to literature, and says pictures only do to look at about 4 times."[12] In diary entries of November 1917, Woolf moved rapidly from "I don't like talking art in front of him" to "taking splendid flight above personalities, we discussed literature and aesthetics." Woolf quoted Fry's contribution to the discussion: "All art is representative. You say the word tree, and you see a tree. Very well. Now every word has an aura. Poetry combines the different aura's [*sic*] in a sequence."[13]

This may be taken as the first record of a theory Fry developed through

his writings over the following few years. By 1919, in "MODERN FRENCH ART AT THE MANSARD GALLERY" (in chapter 7), Fry's observation that figuration is making a return in postwar French art leads him to expand upon the idea of harmonies of pure form and to speculate that "ideas, symbolized by forms, could be juxtaposed, contrasted and combined almost as they can be by words on a page." Having "translated" one of these new paintings into words, Fry exclaims, "I see, now that I have done it, that it was meant for Mrs. Virginia Woolf"—it is "almost precisely the same thing in paint that Mrs. Virginia Woolf is in prose." Fry's friendship with Woolf, which ripened during this period—after 1917, Fry becomes a central figure in her letters and diary—was crucial to his burgeoning interest in literature. That the influence went both ways is suggested by her letter to him following the publication of *To the Lighthouse* in 1927; Woolf says she wishes she had dedicated the book to him, for "you have kept me on the right path, so far as writing goes, more than anyone—if the right path it is."[14]

Despite Fry's close and productive relationship with Woolf, however, the author at the center of Fry's literary consciousness was the nineteenth-century French poet, Stephane Mallarmé. Fry saw Mallarmé as, in his words, "almost the purest poet that ever was in the same sort of way as Cézanne was, in the end, the purest of painters."[15] Together, these two figures from the avant-garde of his youth came to dominate the last decades of Fry's career. Around 1918, Fry began what became a life-long project of translating Mallarmé's poems into English.

AN EARLY INTRODUCTION to these translations, written in 1921,[16] begins with Mallarmé's own assertion "that he was the first pure poet." Although Fry clearly values something he calls "purity" in Mallarmé, the implications of the term—as the comparison with Cézanne suggests—are a long way from the Greenbergian segregation of the arts by medium. On the contrary, Fry's introduction compares Mallarmé's poems to still lifes and emphasizes the way the poet's work anticipates "the methods of some Cubist painters." Fry's notion of purity does not divide the arts one from another by medium or by level of referentiality, but rather emphasizes what they have in common: their appeal to a notion of aesthetic experience he defines as detached from the pressures and privileges of practical life.

The theory of literature that Fry proposes in his introduction to the Mallarmé translations is the same one Woolf recorded two years earlier in her diary. A poet, in Fry's view, arranges sequences of semantic "auras" the way an artist arranges forms, and his metaphors reinforce the connections he saw between the verbal and visual arts: the aura "takes shape in the mind," a subsequent aura affects the first by "expanding, contracting or colouring it,"

the poet's craft is to give each word "as completely visible an aura as possible." Later, Fry would use the phrases "psychological volume" and "plastic volume" to suggest the equivalence of verbal and visual imagery (*Trans*, 1–57).

As with Fry's writings on the visual arts, his theories of literature may be most valuable for the pleasures they provide. The counterparts of his detailed formal analyses of paintings are the close readings of passages by Mallarmé, Shakespeare, and Thomas Gray, in which Fry invites his readers to share his enthusiasm. That his ideas are less satisfying as a logical philosophy of art even Fry seems vaguely to realize. "AN EARLY INTRODUCTION" overcompensates in its protestations of faith in "those purely detached emotions which are peculiar to esthetic apprehension" for its comprehensive enumeration of what these emotions are not: although it is "essential to the poetic effect that the meaning of the words" be evident, Fry says, "the meaning of the phrase in the sense of its truth to fact, its value for life, its importance, its interest, does not enter into consideration." Yet it is hard to distinguish how Fry's examples of the semantic "auras" created by Shakespeare's use of the word "daughter," for example, are separate from the categories of meaning here ruled out of bounds.

The blurred border between these two senses of meaning—one crucial, one irrelevant—underlies the defensiveness with which Fry raises but dismisses the potential for a poetry of pure sound comparable to abstract painting. Clive Bell recalls Fry at this period earnestly experimenting with gibberish poems bearing a phonetic relationship to famous poetry,[17] but Fry's own example of listening to poetry in an unknown language more plausibly illustrates his contention that the effect of poetry depends on signification. Despite protestations to the contrary, the ultimate failure of the boundary between significance and form may be read in Fry's acknowledgment that "all works of art are more or less impure" and even that "it may be that the greatest art is not the purest, that the richest forms only emerge from a certain richness of content."

The unfinished state of "AN EARLY INTRODUCTION" may be indicative of Fry's logical dilemmas, which are emphasized by the fragmentary nature of the text. Fry's translations were not published as he had planned in 1921. He continued to work on them, after 1925 in collaboration with Charles Mauron, who, with Julian Bell, brought them to publication only after Fry's death. Although the Mallarmé translations continued to engage Fry's attention through the rest of his life, his interest was fitful, and he initiated no new literary studies. In the final analysis, what may be most interesting about Fry's essay on Mallarmé is the insight it offers into the development of Fry's

writing about art. Despite his assertions in this piece that poetry can be grafted onto existing formalist aesthetic theory, a rubicon was crossed when Fry embraced the representational nature of language. The effect of Fry's engagement with words was ultimately to admit issues of narrative into the analysis of painting. The following chapter documents the evolution of Fry's late aesthetic theory, culminating with the comparison of painting and opera in "THE DOUBLE NATURE OF PAINTING."

Fry's return to a theatrical metaphor in this last essay, with its echoes of the "double meaning" Fry praised in Mikhail Larionov, brings full circle the impulses traced in the writings collected here. Reasoning out from his analysis of painting, Fry's attention to theater and literature returned to enrich his understanding of painting, so that he could say that the opera, *Carmen*, "exactly illuminates my theory of the mixture of the arts."[18] Ultimately, it is an eclectic—even messy—theory, and neither Fry's late aesthetics nor the writings on poetry and stage design that informed the late theory were much valued by the generation of Fry's immediate successors, which pursued formalism to its logical ends. It may be, however, that the postmodern era will look more sympathetically on Fry's enthusiasm for the pleasures of spectacles and of texts, which caused him to reject the compartmentalization of the arts into rigidly defined disciplines.

∽∾∾

NOTES

1. G. B. Shaw quoted in Virginia Woolf, *Roger Fry: A Biography* (1940; reprint, New York: Harcourt Brace Jovanovich, 1968), 208.

2. Clement Greenberg, "Modernist Painting" (1960; rev. in *Art and Literature* [spring 1965]; reprinted in *Postmodern Perspectives: Issues in Contemporary Art*, edited by Howard Risatti [Englewood Cliffs, N.J.: Prentice Hall, 1990]), 13. The 1978 postscript Greenberg attached to this piece, which claims the passage quoted here as merely descriptive rather than prescriptive, is contradicted by the clear value judgments in the original essay. Likewise in the famous 1940 "Towards a Newer "Laöcoon," his "historical apology for abstract art," Greenberg describes painting influenced by literature as "perverted and distorted" and argues that modernist art is a steady evolution toward a "purity" in which "the arts lie safe now, each within its legitimate boundaries" (*Clement Greenberg: Collected Essays and Criticism* [Chicago: University of Chicago Press, 1986], 1:23–37). See Greenberg's "T. S. Eliot," in which he notes a decline in the "quality" of Eliot's criticism and poetry "when he stops being a 'pure' literary critic" (*Art and Culture: Critical Essays* [Boston: Beacon Press, 1961], 240–41). There is more than a hint of self-justification in the original version of this essay, where Greenberg asserts, "The man of superior sensibility and intelligence, having discovered new and valid truth . . . has to lay down the law" (*Collected Essays*, 3: 68).

3. Letter from Fry to Vanessa Bell, 14 February 1918, Tate Gallery Archives 8010.5.732; see also Judith Collins, *The Omega Workshops* (Chicago: University of Chicago Press, 1984), 157–58, illustration 89.

4. Letter from Fry to V. Bell, 20 January 1919, Tate Gallery Archives 8010.5.772. Fry is quoted elsewhere characterizing his design as "phallic Gauguinesque flowers" (Isabelle Anscombe, *Omega and After: Bloomsbury and the Decorative Arts* [London: Thames & Hudson, 1981], 100).

5. Collins, 102–4.

6. Winifred Gill memoirs, Tate Gallery Archives.

7. Peter Lieven, *The Birth of the Ballets-Russes* (1936; reprint, New York: Dover, 1973), 176. For the Anglo-American angle on this controversy, see Nesta Macdonald, *Diaghilev Observed by Critics in England and the United States, 1911–29* (New York: Dance Horizons, 1975), 74–81.

8. Collins, 102. No "appendage" is visible on the discreetly posed marionette illustrated by Nina Hamnett in *Laughing Torso* (1932; reprint, London: Virago Press, 1984). Even if Sickert exaggerated or fabricated this detail, however, his letter suggests the erotic nature of the Omega performance.

9. Leonard Woolf, *Beginning Again* (London: Hogarth Press, 1963), 37.

10. On Roerich's designs, see Lieven, 82; for illustrations, see Richard Shead, *Ballets Russes* (London: Quarto, 1989), 26–28.

11. Two minor errors in Denys Sutton's transcription of Fry's handwriting are corrected here. The illustrations are not reproduced in *Letters*.

12. V. Woolf, *The Letters of Virginia Woolf*, vol. 2, edited by Nigel Nicolson and Joanne Trautmann (New York: Harcourt Brace Jovanovich, 1980), 77–78.

13. *The Diary of Virginia Woolf*, vol. 1, edited by Anne Olivier Bell (New York: Harcourt Brace Jovanovich, 1977), 75, 80.

14. V. Woolf, *Letters*, 3:385. For an extended discussion of Woolf's formalism, see my essay, "Through Formalism: Feminism and Virginia Woolf's Relation to Bloomsbury Aesthetics," in *The Multiple Muses of Virginia Woolf*, edited by Diane F. Gillespie (Columbia: University of Missouri Press, 1993), 11–35.

15. Letter from Fry to V. Bell, 20 June 1933, in Frances Spalding, *Roger Fry: Art and Life* (London: Granada, 1980), 272.

16. My dating is based on the fact that Fry, in this draft, thanks André Gide and Paul Valéry for their assistance, which was rendered before or during 1921; he does not thank Charles Mauron, whose contributions by 1925 he had come to see as central to the project. Throughout 1921, Fry's letters report him working on the Mallarmé translations for immediate publication by the Hogarth Press, but the project lapsed until 1925 when he began working on it with Mauron.

17. Clive Bell, *Old Friends: Personal Recollections* (1956; reprint, London: Cassell, 1988), 76.

18. Fry, letter of 1927, in V. Woolf, *Roger Fry*, 275–76; see also *Letters*, 614–15.

MR. GORDON CRAIG'S STAGE
DESIGNS

THE malign influence of the theatre on drama has been long apparent. Yet clearly as we perceive that the theatrical is the enemy of the dramatic, we have not yet found a way out for our tragic actors, still less for our scenery. Mr. Poel indeed showed long ago that merely to get rid of scenery altogether was a great assistance. We saw that the expensive and much-advertised setting which was habitually arranged for Shakespearean drama, with its realistic and archaeological rendering of actual scenes, infected even the most demonstrative of actor-managers with its own unreality, and that merely to do away with this—to let the actors appear before a vague tapestry hanging—gave them a chance of convincing us of their humanity. But this was only a negative advantage; it still remained to discover setting which would not only not interfere, but which should actually impose upon the spectator the appropriate mood. It is here that Mr. Gordon Craig came in. He it was who had the brilliant idea, one of those supremely simple and apparently obvious ideas which are the prerogative of genius, namely, that it might be possible to design scenery to express the idea of a play instead of contradicting it. It is now many years since we have had the pleasure of seeing any actual stage-setting by him in England, but the few that he did showed that he was on the right track, and now that he has returned to England with a European reputation, it may be hoped that we shall know how to make use of his genius. In the interval he has perfected and simplified his methods in an extraordinary degree. His designs are now purified of any trace of the old picturesque conceptions of scenery which may have still clung about his earlier attempts.

Mr. Gordon Craig's concern is with poetic drama, and indeed it is only here that the problem of setting becomes difficult. Since comedy is upon the plane of ordinary life, since its emotional pitch is low, it needs no setting but what common-sense and a certain decency of taste supply. It gets its due effect by a more or less exact imitation of the actual scenes of modern life. But the poetic drama needs something other than this, and something diffi-

Reprinted from *The Nation*, 16 September 1911, 871.

cult of attainment in proportion to the elevation of mood. Mr. Gordon Craig realised, what Sir Joshua Reynolds had already pointed out in his "Discourses," that this elevation of mood which belongs to what Reynolds called the Grand Style, necessitates, above all, abstraction and generalisation, that any particularisation of forms tends to a lowering of the emotional pitch. Now, hitherto our stage artists had been laboring under the fallacy of the picturesque. The appeal of the picturesque is based upon the notion that certain things—say a palace at Verona, moonlight on a rocky shore, or an old English homestead—have an inalienable imaginative charm which will be evoked by any reminiscence of them, and that the more photographic the likeness of these things the more powerfully will the charm work. The idea of all great art is, on the contrary, that these things have charm because they possess in various degrees certain fundamental qualities which may be traced not only in them, but in almost all objects—hence the artist's apparent indifference to the subject of his design—and that it is his work to distil from things these emotion-compelling qualities. We have for so long been dominated by the tyranny of the imitative picturesque view that we are at present merely children spelling out the alphabet of this rational and fundamental method of appeal. But Mr. Gordon Craig has already managed to spell out a few words of it, and these have an almost magical effect upon the imagination.

We know, of course, the direction in which we have to look for this mysterious evocative power in things, that it has to do with proportion, with scale, both absolute and relative, with mass, with the inclination of planes one to another, with light and shade; but we have as yet only empirical and tentative methods applying these ideas. Mr. Gordon Craig shows that a few elementary rectangular masses, placed in certain relations to one another and illuminated by a diagonal light, will stir the mind to the highest pitch of anticipation, will inspire already the mood of high tragedy. Such a scene clears the mind of all accidental and irrelevant notions, and leaves it free to be filled with the tragic theme.

In such an art as this, abstraction and bareness may well be carried without danger to the extreme, even of emptiness; since it is the business of the scene to arouse only a vague indeterminate mood of wonder and awe, the precise color and content of the mood, the exact shade of each emotion, awaits the action for its complete realisation. It is an art concerned with the imaginative approach to things of higher import, not with their final consummation. It is like the narthex of a cathedral, the frame of a picture, the avenue to a great palace, and, as in all these things, something must be left out, its perfection depends upon its incompleteness. It must prepare the

mind but not entirely satisfy it. Certainly in most of Mr. Gordon Craig's models this is apparent. One is conscious of an almost impatient anticipation as one looks at them. One waits, hoping to see the slow-moving figure emerge from behind one of the monolithic masses, or descend slowly one of the convergent stairways which lead from mysterious depths of gloom. One knows that the moment the figure moves into sight we shall be in the midst of fatal memorable deeds.

It is almost incredible that, even from the point of view of a popular success, these thrilling scenes should not appeal to some theatrical entrepreneur. I understand that some actors complain of their perfection, and dread that there will not be room for them to make their particular personal effect. As Mr. Gordon Craig wittily remarks in the notes to his catalogue, they might at least as well complain that Shakespeare's verses left them very little to do. But perhaps, from their professional standpoint, they are right. If once we saw them in their proper setting for poetic drama, we should find their familiar idiosyncrasies too particular, too individual, and we should ask them, as the Greeks did, to hide their too emphatic features beneath the generalised forms of the tragic mask.

M. LARIONOW AND
THE RUSSIAN BALLET

IT is an ancient and time-honoured tradition of the British stage that its
décor should be expressed in an artistic formula which has long ceased to
have any meaning for painters or for the public which cares for art. There is,
therefore, to us something paradoxical in the idea of going to a theatre to see
experiments in the art of visual design—still more, experiments which indi-
cate new possibilities in the art of picture-making. Yet, thanks to M. Serge
Diaghileff's taste and enterprise, this incredible phenomenon may be seen at
the Coliseum. In Russia, the Imperial Ballet, as it then was, became long ago
the focus of national endeavour in all the arts. Dancing occupied for the
Russians almost the same position as the mother art that architecture did in
the middle ages. So that to the Russian mind there is nothing so surprising
in the employment of a really creative artist for theatrical decoration and for
the design of costume. For a long time, however, the Russian Ballet was
content with a *décor* which, though it could not be called old-fashioned or
reactionary, was by no means on a level with the conceptions of the great
original designers of Europe. M. Bakst was a most effective and ingenious
designer, sufficiently alert to pick up ideas from all sides, but he did not
himself stand in the front rank of creative designers. Probably the exact note
of compromise on which M. Bakst fixed, and to which he gave the coherence
of a personal style, was nearly exactly suited to M. Fokine's habitual methods
of choreography. But when M. Fokine, striking out a new line, created Pe-
trushka, it became apparent that the choreographic conception was far ahead
of the *décor*, and the same dissidence was even more apparent between the
extremely original and formal design of the dance in "Le Sacre du
Printemps" and the rather fusty romanticism of M. Ruhrich's scenery. It was
evident here that both dance and music had outstripped the scenic artists,
had arrived at a conception of formal unity which demanded something
much more logically conceived than the causal decorative pictorial formula of
the scenery.

The new ballet, of which the dancing is designed by M. Massine, actually

Reprinted from *The Burlington Magazine*, March 1919, 112–18.

increases the pace of development along these lines. For he has aimed at a conception of the dance which one might call "heraldic." In it the movements which express dramatic states are rendered within definitely restricted silhouettes. Moreover, the formal relations of movement in all the different parts of the ballet have become more and more distinct and evident—the whole pattern is keyed up to an intenser unity and the intellectual quality of the design is further intensified. In the case of "The Good-humoured Ladies," it was evident that M. Massine had left his scene-painter painting several laps behind him in the race. But with the appearance of the "Midnight Sun," and still more decisively of "Children's Tales," one saw with delight that the harmony of the three arts was once more established. Certainly in M. Larionow and Mme. Goncharova the ballet has discovered two designers who are able to accept with eagerness the new conception of the heraldic dance, and whose natural inclination is to give to their designs an exactly corresponding transposition of the actual into a formal equivalent.

Quite apart from the sheer beauty and logical completeness of the effect, what strikes one most is the way in which M. Larionow's designs support the choreographic design—the extent to which both form and colours underline and support the movement. Indeed I suspect that one secret of M. Larionow's success lies precisely in this fact, that for him the movement of the figure, whatever it be, is the fundamental fact of his design. As we shall see further on, he has treated animal forms, and in those he has seized on the specific movement as the key to his design; in treating of human beings he has an eye to the type of movement characteristic of the particular individual, or in the ballet the type of movement ordered by the designer of the ballet. Thus his designs are not merely decoratively satisfying; they also have a vivid expressive purpose. And that purpose is adjusted with exquisite tact to the *ensemble* of the ballet as conceived by M. Massine.

It is difficult to speak of colour, since the reproductions here given are all in half-tone, and there is perhaps the less need in that everyone is familiar with the performances at the Coliseum; but M. Larionow relies on its so much and exploits it with such originality and taste that it must be alluded to. Already in the Coq d'Or, M. Larionow's fellow worker Mme. Goncharova had shown us for the first time what could be done by a serious use of colour on the stage, and in the present examples of their art they have carried their ideas a stage further. In the Children's Tales the general scheme of each scene is admirably varied. In the Kikimora scene there is an almost crude vehemence of colour which sets just the right key by its reminiscence of Russian peasant art and children's toys. The colour here is treated playfully and, as it were, half ironically. In the scene of the Swan Princess all is

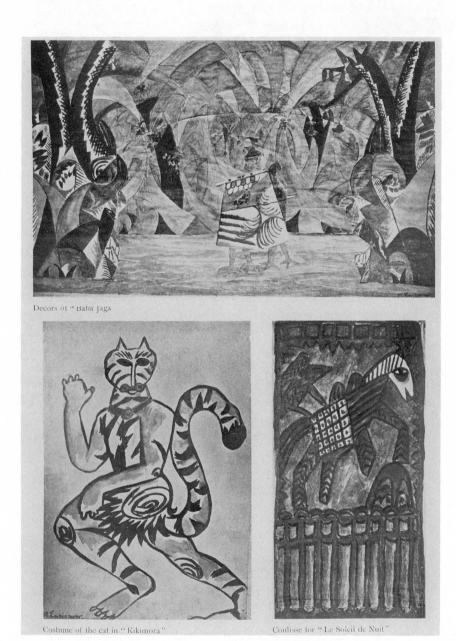

Decors of "Baba Jaga"

Costume of the cat in "Kikimora"

Coulisse for "Le Soleil de Nuit"

PLATE I: Designs by M. Larionow. Decors of "Baba Jaga"; Costume of the cat in "Kikimora"; Coulisse for "Le Soleil de Nuit"

changed to an almost monochrome scheme of mauve greys, pale dull blues and ochres beneath a greenish light. And here as so often M. Larionow gets a new and delightful effect by his use of white in spots and dashes in such a way as to give the feeling of intense and brilliant colour.

In the scene of the rescue of the Princess we go back to Russian local colour, but with something more sumptuous and Oriental. It is reminiscent rather of the richest effects of Persian art, and yet withal entirely modern and novel. And herein we find one of M. Larionow's peculiarities, his use of entirely modern discoveries in design with a certain retrospective allusiveness to the arts of other times and countries, and this without ever falling into anything approaching plagiarism. It is this power of using form and colour with a double meaning, first as pure design, and secondly as a means of evoking vague suggestions and flavours of time and place, that makes him so consummate a designer for the theatre.

Considering the inveterate customs which cling to the stage—customs which even the most enlightened director may scarcely feel able to defy—it is surprising how complete an idea of design comes through at the Coliseum. But for all that one is not surprised that, like other artists who have been employed in stage designing, M. Larionow should have cast longing eyes at the puppet show where the designer reigns supreme, where the performers are his own handiwork and display an unfailing obedience to his wishes. And it is clear that in his designs for the puppet show M. Larionow has been able to carry his ideas to a still further point. The reproductions of Plate II will give an idea of the curious and fascinating conceptions he has worked out. They are for the most part for performances adapted from Jules Renard's masterpiece, "Histoires Naturelles."

If space had permitted, it would have been interesting to place side by side with M. Larionow's interpretation of Jules Renard's animals those of M. Pierre Bonnard. It is not often that a good book inspires good illustration, but Renard has had the rare fortune to inspire two interpreters whose work is on totally different lines, and yet as one looks at the work of either, one can conceive for the moment no other possible interpretation of Renard's odd humour. The two artists stand at the opposite poles of modern art, Bonnard a last refinement on Impressionism, with an almost exasperated sensibility, incredibly alert to spot the characteristic note in whatever shimmering kaleidoscope of forms nature appears. The infallible rightness of his aim in this contest with nature's elusiveness gives one the sense of something just as wittily *intime* and sympathetic as Renard's prose. One would have thought it impossible to make a third in so happy a dialogue, but M. Larionow has come in from the other end of the street. By some mysterious process (in

PLATE II: Marionettes designed by M. Larionow. A: *Personnage* pour "La Marche funèbre," musique de Lord Berners (Tyrwhitt); B: *Le Mariage du Paon;* C: *Le Cygne;* D: *Le Martin Pecheur* pour "Histoires naturelles" de Jules Renard, musique de Ravel.

which Picasso's researches have much to say) M. Larionow decomposes his animals into shapes of an almost geometrical simplicity, and then recomposes those shapes so that they become not only the animal, but the animal as expressive of the human passions which Jules Renard's sympathetic imagination read into their behaviour.

Take as an example the Peacock. Here is Jules Renard:—

> Il va sûrement se marier aujourd'hui.
>
> Ce devait être pour hier. En habit de gala, il était prêt. Il n'attendait que sa fiancée. Elle n'est pas venue. Ellé ne peut tarder.
>
> Glorieux, il se promène avec une allure de prince indien et porte sur lui les riches présents d'usage. L'amour avive l'éclat de ses couleurs et son aigrette tremble comme une lyre.
>
> La fiancée n'arrive pas.
>
> Il monte au haut du toit et regarde du côté du soleil. Il jette son cri diabolique:
>
> Léon! Léon!
>
> C'est ainsi qu'il appelle sa fiancée. Il ne voit rien venir et personne ne répond. Les volailles habituées ne lèvent même point la tête. Elles sont lasses d'admirer. Il redescend dans la cour, si sûr d'être beau qu'il est incapable de raucune.
>
> Son mariage sera pour demain.

M. Bonnard gives in a few hasty scratches and blots of ink exactly the movement of a peacock mounting the steps of a garden terrace. So exactly characteristic of the appearance are these few lines that one can read into it what Renard read into nature, but no one would beforehand guess at the Indian prince.

M. Larionow [Plate II] gives us only slight suggestions of the actual appearance of a peacock, but out of certain geometrical forms, the suggestions for which are given by nature, he builds us a figure which has almost ridiculously the character Renard describes. It is, indeed, curious how convincing an idea of mood and character these abstract forms convey, how exactly for the peacock or the Indian prince.

In the original figure the colour is also at once non-natural and intensely suggestive of the character. It is in tones of intense ultramarine, vermilion, deep maroon, intense green, and, as the intensest accent of all, white in spots and half-circles. It is largely by the intensity of the accents of white that the whole movement is given.

Or take again the Kingfisher—here M. Larionow has taken black and white only, in which to suggest the flashing colours of nature, but how exactly he has caricatured his original with its heavy stumpy body that can fall

like lead or rush through the air with the impetus of a projectile. He has got the weight and the rapid jerkiness of the movement; and again what a delightfully humorous character, which is, by the by, his own invention, for here for once Jules Renard has no interpretation of character.

I may be thought to have over-emphasised this illustrational aspect of M. Larionow's art. I frankly admit its secondary importance, except for the purposes of the stage. These figures have the beauty of completely balanced and logical structure and suggestions of movement, quite apart from all that I have discussed, apart from any titles that one may give to them. But it strikes me as a curious and rather unexpected outcome of certain researches into purely abstract form that they should possess incidentally such a vivid illustrational value, for, as I suggested, M. Larionow's methods of analysis and recomposition are based on the experiments carried out by Picasso and others. For Picasso, as I understand it, the purpose of decomposition was mainly to arrive at what one might call a canon of form—the discovery in any given object of certain elementary units of form out of which he built up his total design by repetitions on various scales and in various positions. By this method a certain uniform quality of form was imposed on every part of the design. It is this intensification of the formal unity that M. Larionow has also adopted, but he has shown that by the use of such means it is possible to express, perhaps more vividly and poignantly, certain aspects of character and mood that hitherto all artists have tried to express by means more akin to those of M. Bonnard.

M. Larionow appears to have made most entirely his own the study of movements and the methods of adapting forms to its completest expression. It is this no doubt that has drawn him to the ballet, and it is this that has enabled him to place almost for the first time in modern history a real work of visual art within the frame of a proscenium.

AN EARLY INTRODUCTION

MALLARMÉ is reported to have said that he was the first pure poet. If we put it that he was the first poet to aim consciously and deliberately at purity we shall perhaps get a useful clue to understanding his poetry.

Almost all works of art are more or less impure; that is to say, they allow or even excite in the contemplator echoes of the emotions which are aroused by actual life, such as pity, fear, desire, curiosity. So that our reaction to such works is (at all events for a time) compounded of certain emotional states which are connected with life, together with those purely detached emotions which are peculiar to esthetic apprehension.

I wish to leave aside for the present the question of whether purity is desirable or not in a work of art, and will merely constate that in proportion as he becomes more conscious of his purpose the artist tends towards purity—tends to concentrate his attention and his powers on the detached esthetic emotions.

Mallarmé then may be an interesting case for esthetic theory, since we may distinguish more easily in his work than elsewhere the nature of pure poetic form. Our search must be for the fundamental necessary quality of poetry, for that without which a work cannot be said to be a poem. I scarcely hope to discover this completely, I only hope to disentangle certain elements and put them in a clearer light.

Every word carries with it an image or an idea surrounded by a vague aura of associations. This aura no doubt will vary as it were in shape and colour for every single individual, but for those who are familiar with a language there will be a general and substantial resemblance.

When a word is apprehended, then, this aura takes shape in the mind, and when a second word is joined to the first (as for instance in apposition, or as an adjective to a noun) this changes the aura of the first word, expanding, contracting or colouring it as the case may be, and the resultant complex

Written in 1921, and reprinted from *The Poems of Mallarmé*, translated by Roger Fry, with commentaries by Charles Mauron, edited by Mauron and Julian Bell (Chatto & Windus, 1936).

will again suffer a change as its relation with the total complex of the statement is made evident by the syntactical construction.

The purpose and nature of a sentence such as I have just written is to give as little emphasis as possible to the associations or auras of the words used. The result aimed at has been purely intellectual exposition and not esthetic pleasure. The essence of poetry, on the other hand, seems to be to use words in such a way that they attain the maximum of evocative energy. The poet so arranges that each word shall have as full, as rich, as completely visible an aura as possible, and that the changes which each word makes in the aural complex shall have such a rhythm that as we proceed each change tends to become more and more significant.

If we think of any moving phrase in the climax of a great drama we shall see that its impressiveness is due to the accumulation in the mind of such a complex. When King Lear says:

> Didst thou give all to thy two daughters,
> And art thou come to this?[1]

the word "daughter" has at this point in the play acquired a quite peculiar potency. In a thousand other contexts the same word might be entirely trivial.

It has often been noted that a certain quality of surprise, or at least unexpectedness, is essential to keep our contemplation at full stretch, but this surprise must be as continually resolved and harmonised with the total aural complex.

A word may make a sudden change, but the change must be rhythmically related to the sequence of preceding changes.

As a fairly good instance of this cumulative effect of the interaction of the auras of words, I take the beginning of the Epitaph in Gray's *Elegy:*

> Here rests his head upon the lap of Earth
> A Youth,

The mind has already been attuned by the preceding lines of the poem to a special emotional state about death and the posthumous life of fame. *Here rests*[2] is of course the conventional beginning of epitaphs, and produces if anything a certain emotional dreariness.

1. I have filled in the blank left by Roger Fry for a quotation to the best of my ability. There are other plausible lines in *Lear* that might be inserted, but this, to Edgar on the heath, seems the best illustration for the point.—J. B. [Julian Bell]

2. Roger Fry failed to make the (not very important) change needed in his comments after verifying his quotation and replacing "Here rests" by the correct "he rests." [—J. B.]

But we are brought up sharply when instead of the customary "the body of," "his head" shows us that "rests" is used transitively. The first effect of this is a slight suspense and anticipation, since the inversion compels us to wait in order to know exactly what the subject is. The other effect is that, since we already guess that the subject is the dead person, it gives an unexpected vividness and force to the image of the action.

Upon the lap defines and greatly heightens the effect of the gesture already visualised in the mind, and the whole complex is intensified and completed by the word *earth* with its implied personification and suggestion therewith of compassionate sympathy. Finally, *a youth* gives at once the touch of universality and undistinction as well as pathos, which is in key with the whole preceding poem.

It will be recognised that such a method of bringing out the full significance of word images by their relative positions as is here anlaysed belongs also to wit, and indeed wit and this quality of poetry are very nearly allied.

When Mallarmé's *Hérodiade* says:

> O femme, un baiser me tûrait
> Si la beauté n'était la mort,

we recognise that with a different intention such a phrase would become witty (*e.g.* capax imperii nisi imperasset).[3]

It is indeed by playing upon this similarity of form that parody gets its easiest effects, since it is only necessary to keep the form and alter the intention in an opposite direction.

Of language arranged in verse form, at least half, if one considers the mass of comic journals, has a witty rather than a poetical purpose. So that the association of poetry with the verse form, though generally true, is only half the truth, and the use of poetry as nearly conterminous with verse is misleading, even if we include bad poetry.

Both poetry and wit employ the verse form for the same reason, namely, that it increases the power of heightening the effect of verbal images by emphasising their interrelations. Rhyme also has particularly the power of arousing anticipation and surprised acquiescence, or it may be, in the case of wit, unresolved shock.

In the sentence already quoted from Mallarmé, the break of the verse at "tûrait" not only intensifies the violence of this word, but heightens the effect

3. Roger Fry also gives as an example, on the back of a rough draft:
 Ope thy mouth to its uttermost measure
 And bite us again. . . .—J. B.

of the descent on the conditional clause. Had the intention been witty, the break would have had a precisely similar purpose and value.

I suggest tentatively that the distinction between poetical and witty effects of language may be that in poetry the complex of word images and their associations tend to set up vibrations which continue in the mind, whereas wit brings the vibrations to a more or less sudden stop.

For instance, the Chinese 'Stop-short' is defined as the opposite of an epigram in that the words stop short, but the sense goes on.

It is evident that in witty verse any arresting melody of sound would be misplaced, since it would tend to arouse a mental state conflicting with the effect of the word-image complex. But where verse is employed for poetical ends, beauty of sound may not only not be impertinent, but may greatly heighten the effect of the words by producing a rich vague emotional state in harmony with the expression.[4]

Herein lies one of the crucial questions of any possible esthetic of poetry, for so great is the importance of this melodic effect that it frequently appears to be the most essential and fundamental characteristic of poetry.

Three possible explanations suggest themselves: (1) The word image-complex, which I have tried to describe above, is the fundamental quality of poetry, and melody is ancillary to that, being, as it were, a physiological aid to poetic apprehension. If this is so, Goethe was right when he said that the fundamental quality of poetry was capable of translation into another language. (2) The melody is the essential effect of poetry, and the verbal images merely, as it were, form a channel for the flow of the vague emotion aroused by the melody. (3) Both of these two things enter, as it were, into chemical combination. They are inseparable, and together make the single fundamental essence of poetry.

That the second hypothesis is wrong seems to me fairly evident. One must not, in order to test this, take Lear's nonsense verses, since these are no mere verbal melody; they have sequences of verbal images which for all their vagueness react upon one another precisely as in ordinary poetry. We must consider rather what esthetic emotion is aroused in us when we listen to poetry recited to us in a completely unknown language. We then have the melody, pure and simple, and its effect seems to me very slight indeed. Its effect is incomparably feebler than that of music, and scarcely calls for canalisation, such as I take to be the main effect of words in a song.

It is much more difficult to dispose of the third hypothesis, but I doubt the possibility of this complete identification of the two effects.

4. The rough draft reads: "a mental tune exactly fitted for the effect." [—J. B.]

One reason which makes me doubt whether complete combination takes place is that the melody taken by itself is more monotonous, has a lesser range of variation than the verbal image of sequence. Another reason is that what appear to me to be purely and completely poetical effects are sometimes found in prose writing and that not in prose where the melodic effect resembles that of poetry, as for instance in parts of the Bible, but in prose that has no strongly marked melodic effect at all. While admitting, therefore, the singular appropriateness of melodic rhythm to poetic effect, and its marked power of heightening the effect of the word-image sequence, I still incline to think that sequence of word-images and their auras is the most fundamental quality of poetry.

It is seen, then, to be essential to the poetic effect that the meaning of the words in the fullest sense, and including all their overtones of feeling, should be peculiarly evident. Nevertheless, the meaning of the phrase in the sense of its truth to fact, its value for life, its importance, its interest, does not enter into consideration. It is, for instance, quite irrelevant to the consideration of Dante's poetry that he presents a universe which contradicts flatly our own experience of the nature of things. Such meaning, then, as can be conveyed as well, or better, by quite other words, in a paraphrase, is not part of the poetical effect.

[5][If I am right, this beauty of sound is rather a favourable accompaniment than part of the essential quality. It may almost be described as a physiological aid to esthetic perception. If this is so, Goethe was right when he said that the essence of a poem was capable of translation. But though the meaning of the words and phrases is thus seen to be essential to the poetic effect, the nature of the meaning, its truth to fact, its value for life, its importance, its interest, do not enter into consideration. Such meaning as may be conveyed as well or better in a paraphrase is not part of the poetical effect. Any meaning in this sense, any content that is, is theoretically capable of becoming the nucleus for the crystallisation of a poetic whole, and from the point of view of pure poetry its nature is negligible.

If I am right in thinking that this cumulative effect of the auras of words is the essential quality of the poetic art, Mallarmé must be regarded as one of the poets who has studied it most intently and deliberately. It may, of course, be discovered that this conscious and deliberate focussing on the essence of an art is not fortunate for the artist. It may be that the greatest art is not the purest, that the richest forms only emerge from a certain richness of content, however unimportant that content may be in the final result. But, these are

5. The brackets mark a passage from the rough draft.—J. B.

questions which concern the psychology of artistic production, rather than the nature of esthetic perception. Certainly no poet has set words with greater art in their surroundings, or given them by their setting, a more sudden and unexpected evocative power.]

Mallarmé's preoccupation is then with the purely poetical relation of verbal images and ideas. His recognition of these relations is perfectly detached. He never takes sides: he is never tendentious. A great deal of poetry endeavours to force the poetical pitch of emotion by deliberately heightening and aggrandising the object contemplated. Such poets employ adjectives and similes which elevate the tone, and are more remarkable for their rhetorical effect than for their exact applicability:

> Nor dim, nor red, like God's own head,
> The glorious sun uprist.

When this habit becomes exaggerated it produces bombast, which has been reprehended ever since Shakespeare's day. But since the romantic epoch very little poetry is entirely free from it. It happens sometimes that in a violent revulsion from this fault writers fall into the opposite error of finding relations which degrade the object, as, for instance, Mr. Joyce when he talks of "the snot-green sea," where it must be admitted that the adjective is exact, but is even more disagreeable than illuminating.

6[Mallarmé said of himself that he was the first to write "pure poetry," and certainly he is the "purest" poet that we know. It is perhaps only another way of putting it to say that he is the least "poetical" poet, or again that he is the most classical. I take at random any one of our "poetical" poets, Mr. Lascelles Abercrombie for instance. In his *St. Thomas*, ships are described as "lean hounds."

Here the simile has already got its charge of emotion (heightened, of course, by the choice of language), and this is as it were imposed on the object described. It is not the result of a feeling about the object, it only creates an emotional atmosphere through which we contemplate the object. The poetical poet makes use of words and material already consecrated by poetry, and with this he ornaments and embroiders his own theme. Mallarmé's method is the opposite of this. His poetry is the unfolding of something implicit in the theme. By the contemplation of the theme he discovers new and unsuspected relations. He is not concerned that the theme itself, or the objects it comprises, should already have poetical quality, nor does he seek to find relations with other things already charged with emotion.] Mal-

6. The brackets mark a passage from the rough draft.

larmé is in this respect[7] singularly free from bias. His attitude is purely detached and objective and, as is natural to so pure a poet, the emotional quality of the theme is of no consequence to him so long as it provokes in him the impassioned contemplation of its poetic relations. It is of no consequence, that is, whether the subject is in its associations what is ordinarily called poetical; that is to say, noble and impressive, or entirely trivial and commonplace. Few poets have devoted so large a portion of their oeuvre to subjects which, were it a question of painting, we should classify as still-lifes. No one has given to the words for common objects so rich a poetical vibration—fenêtre, vitre, console, verrerie, pierrerie, lampe, plafond—and this by no forced note of admiration or willed ecstasy, but by an exact observation and deduction of their poetical implications. Perhaps he was humorously conscious of carrying this method to an extreme when he described a on a bicycle as "one who unrolls between his legs the image of an endless rail." But in this caricature we can see the essential quality of his method.

This desire to exhaust even in the most trivial themes the possible poetical relations, explains at once. Mallarmé's syntax and his so often resulting obscurity. For him it was essential to bring out all the cross-correspondences and interpenetrations of the verbal images. To do this it is often necessary to bring words into closer opposition than an ordinary statement would allow, or it may be necessary that a particular word should continue to vibrate as it were for a long time, until its vibration can be taken up by another word. Of course, in almost all poetry the need for this is more or less apparent, with corresponding inversions and distortions of ordinary diction, but in Mallarmé it goes to extreme lengths, and frequently causes the reader some laborious intellectual straphanging. In fact, with Mallarmé the theme is frequently as it were broken to pieces in the process of poetical analysis, and is reconstructed, not according to the relations of experience but of pure poetical necessity. In this he anticipated by many years the method of some Cubist painters.

In this method Mallarmé makes an extreme use of the possibilities of French grammatical construction, relying particularly on genders to reestablish the suspended connections between his word-images. This naturally occasions a great and sometimes insurmountable difficulty in translation owing to the more analytical nature of the English language. I have thought it desirable in this attempted translation of certain poems to add explanatory notes, and these will, I hope, make clear the essentials of Mallarmé's poetic method. But I have confined my explanations to the first literal sense of the

7. "This respect" is the choice of elevated or degrading comparisons.—J. B.

poems, leaving to the reader the task of following out according to his own ideas the secondary and metaphorical meaning which is, I think, always present.[8] Mallarmé's poetry has, I think, to an extraordinary degree the power of starting vibrations in the mind whose overtones ring through planes of thought and feeling quite remote from those with which the poem is ostensibly concerned. But there is a certain danger for the critic in laying down any precise line of thought. M. Thibaudet, in his large work on Mallarmé's poetry, follows him even into the recesses of the Hegelian dialectic. I have thought it wiser to leave the direction of these flights of the contemplative mind to the reader's own discretion. The notes, therefore, must be considered as helps only to the understanding of the immediate literal interpretation of the poems. In my translation I have aimed above all at literalness with so much of a rhythmic order in the sound as would not hamper that too much. Here and there, of course, literal-exactitude has had to give way to the exigences of a rhythm already established, and in these cases the reader is warned in a note of the failure to reconcile the two elements.

Mallarmé is so difficult that anything like a perfect translation can only be accomplished by incessant revision and the assistance of many minds. Like the Bible he should be translated by a Committee. This publication may serve to enlarge the membership of the Committee—but already I owe much help to many friendly advisers, to all of whom I tender my thanks. I must acknowledge in especial the following: Miss P. Strachey (who has, I think, deciphered more of Mallarmé's riddles than any one other person); M. André Gide; M. Paul Valéry, for heading me off one or two disastrous mistranslations and for some first-hand information about Mallarmé's "interiors"; and Mr. Eric Maclagan, who detected several howlers. Some howlers are sure to have escaped notice, so that the present issue must be regarded as only a preliminary essay towards a final translation.

8. This is, of course, written of the early version, before C. Mauron's commentaries had been added.—J. B.

7

REVISION AND DESIGN:
THE LATER ESSAYS

THE oft-told story of modernism that culminates with the triumph of Abstract Expressionism and Minimalism in America from the 1940s through the 1960s deals awkwardly with the years between the world wars. On the one hand, the cataclysm in Europe provided the immediate historical impetus for New York to replace Paris as the center of the art world. On the other hand, the legacy constructed by the champions of American modernism relied on a pantheon of turn-of-the-century artists arrayed according to an evolutionary logic from Manet through Cézanne to the Cubists. Harold Rosenberg in 1964 claimed that no modern artistic movement "made any startling contribution to the formal repertory of 1914. . . . The vanguard art of 1914 foresaw everything."[1] In this view, the clear current of the avant-garde mainstream before 1914 disperses during the period between the wars into a turbulent stretch of crosscurrents and under-tows, which only after the Second World War resumes its logical flow.

Fry's career reached its conclusion in the years between the wars. It was at this time that he finally acceded to the status of elder statesman in the art world, with all attendant opportunities for hardcover publication—with the exception of his 1899 volume on Giovanni Bellini, all Fry's books date from the 1920s and 30s. The 1920 *Vision and Design* offered an anthologized selection of his writings to date; it was followed in 1926 by *Transformations,* an anthology of equal scale devoted to the pieces that had appeared in the intervening six years. Fry also published a volume on Cézanne (1927) and surveys of Flemish (1927), French (1932), and British painting (1934), as well as a host of pamphlets and other short texts. Much of the misunderstanding of Fry today can be traced to the fact that his period of greatest publication coincides with an era overlooked in conventional accounts of modernism. The essays collected in this chapter, though they are not drawn from the relatively accessible major books,[2] trace the development of Fry's philosophy between the Armistice of 1918 and his death in 1934. Taken together, they offer a new perspective on one of modernism's central figures—one that leaves little doubt why this period was unattractive to those who believed in an evolutionary model of twentieth-century art. By the end

of his life, Fry had come to question or contradict virtually all the formalist principles that he—like his American descendants—made the foundation of modernism. The reader's sympathy for the tentative and provisional will, therefore, govern his or her reaction to these texts. In a period that rejects modernist claims to confident universality, however, we may return to these texts with a new measure of understanding and even of pleasure.

In many ways, Fry's late texts are typical of his era. Art history designates the period between the world wars with the term *"rappel à l'ordre"* [return to order], to signify the widespread crises of confidence in artistic innovation and the concomitant revival of figurative conventions that were abandoned by the avant-garde before World War I; Picasso's return to realism in his drawings after Ingres is only the most famous example.[3] The consternation and even despair of the French avant-garde during World War I was echoed in London. As has been noted in relation to the war's effect on the Omega Workshops (see chapter 4), the Bloomsbury group, with its pacifist convictions, was particularly devastated by what Fry described as "this atrocious muddle of lust and heroism" (*Letters* 384). Writing in 1917 about his dashed expectations that the modern age would bring social reform and aesthetic renaissance, Clive Bell blamed "the governing classes of Europe" for ruining his hopes "by getting into a war." Bell compared Bloomsbury's position in the conservative postwar era to its French equivalents a century before, those "stragglers from the Age of Reason, the old pre-Revolutionary people who, in the reign of Louis XVIII, cackled obsolete liberalism, blasphemed, and span wrinkled intrigues beneath the scandalized brows of neo-Catholic grandchildren." Contemplating this prospect, he concluded, "one becomes exceedingly sorry for oneself."[4] This may be, like so much of Bell's writing, felicitously phrased exaggeration, but it suggests some measure of the difference between the prewar avant-garde and the "return to order" of the period between the wars.

Even before the war, Fry's modernism, with its emphasis on the "classic" (see chapter 3) never abandoned the heritage of art-historical tradition. Nevertheless, evidence of his personal *rappel à l'ordre* is present in a comparison between his forward-looking texts promoting the Post-Impressionists as "modern men trying to find a pictorial language appropriate to the sensibilities of the modern outlook" (*V&D*, 238), and a passage from a 1924 article on modern French painting:

> And how traditional they are! . . . I like to think that Rubens would recognize his grandson in Matisse, just as Matisse should recognize his heritage, that Fra Bartolommeo would have understood immediately what Picasso wanted, . . . that the great designers of the seventeenth century,

Poussin primary among them, would have perceived how clearsightedly Derain has discovered their secret.[5]

When Fry, also in 1924, began his book on Cézanne, he reported, "What surprised me was the profound difference between Cézanne's message and what we have made of it. I had to admit to myself how much nearer Cézanne was to Poussin than to the Salon d'Automne" (*Cézanne*, 2). Far from seeing the movements of modern art as new frontiers, Fry's *Cézanne* describes both Impressionism and Cubism as mere "loop[s] in the curve of pictorial tradition," useful for bringing "back certain valuable material into the main current," but ultimately rejoining the flow, each movement having "abandoned a great deal of what at the time seemed of great importance to its exponents" (*Cézanne*, 31).

Fry's own experience of abandoning—or at least of modifying— principles that at one time seemed to him of great importance is explicit in the introduction to his 1926 *Transformations*. Defining "the meaning and purpose of representation in graphic art," Fry said:

> This has always been a crux of such a puzzling nature that I need have little shame in confessing that I have at various times put forward very different attempts at a possible solution. I have certainly varied from a position where I underlined what we may call the dramatic possibilities of painting to one where I have insisted on the pre-eminence of purely plastic aspects, and almost hinted that no others were to be taken into account. (*Trans*, 13)

Abandoning this strict formalism, Fry professes himself ready to "conciliate, or at least explain, these two apparently contradictory attitudes" (*Trans*, 14). This, then, is the project of Fry's late writings: to theorize modernism's reintegration into the broad current of art-historical tradition by synthesizing representation into the formalist paradigm without sacrificing the ideal of purely aesthetic experience.

The revisionary impulse that characterizes Fry's writings after the war is evident in his painting as well. Around 1914–15, Fry and his Bloomsbury colleagues eagerly participated in avant-garde experiments with collage and abstraction. By the end of the war, however, Fry's letters reveal a retreat from this position. A 1917 letter manifests surprise at the resurgent realism of his own work; a still life turned out "fearfully exact and literal though it began by a quite abstract scheme."[6] In 1919, he confessed to Vanessa Bell that "the only picture of yours which has gone thin on my hands is that big abstract business . . . which doesn't mean anything to me now" (*Letters*, 449). During this period, Fry organized an exhibition in which contemporary artists

showed copies of famous paintings from the past, and his dwindling interest in the avant-garde and abandonment of the term "Post-Impressionism" have been dated to this time.[7]

A series of articles on drawing from 1918 offers a convenient benchmark from which to trace the evolution of Fry's late writings. In February 1918, Fry reviewed for the *Burlington Magazine* an exhibition of drawings by celebrated artists of the past (*V&D*, 244–55).[8] At first glance, this review seems to toe the formalist line. The basic tenets of Fry's prewar aesthetics animate his judgment that, despite the fact that certain "great formalists" like Raphael "made deliberate efforts" to transcend simple mimesis in favor of "some abstract synthesis," most drawings between the Renaissance and the modern era were simply "demonstrating sheer skill of hand." Although Fry recognizes a "complex pleasure" in the contemplation of these works, he warns his readers not to mistake this for "aesthetic pleasure when in fact it is nothing of the kind." Fry was pleased enough with this piece to anthologize it in *Vision and Design*, and the passages praising pre-Renaissance art do convey an infectious enthusiasm for "drawing [that] was less descriptive and more evocative of form." Nevertheless, it is hard to avoid noticing that this essay is riven with anxiety. There are the false pleasures of Tiepolo's "calligraphic" brilliance to eschew, and there is the insistence that "one must face the slightly repellant quality of [Ingres'] oil paintings rather than allow oneself to be seduced by the elegance and ease of his drawings." For an aesthetic philosophy Fry always claimed was based on the free play of pleasure, formalism seems suddenly to imply as many rules and restrictions as a catechism.

Clearly reacting to this frustrating collision of modernist principles with premodernist pleasure, Fry tried to redeem his theories by applying them where they were more successful. His "LINE AS A MEANS OF EXPRESSION IN MODERN ART," published a few months later, opens with a reference to the earlier essay, and goes on to use its vocabulary to celebrate the drawings of Matisse, Picasso, and their contemporaries. But here too there is a tension between the licit pleasures of formal unity and the guilty pleasures of representational art. At first, Fry argues, now making Sickert the representative of premodernist practice, "it would be absurd to reject the extraordinary beauties of Sickert's drawing. . . . The calligraphic line is the record of gesture, and . . . we can follow it with the same kind of pleasure as we follow the movement of a dancer," even if it does not arouse "the pleasure derived from the suggestion to the mind of plastic form." Thus Fry at first avers, "It would be useless to decide between" Sickert's "older tradition" and "the more modern artist." Yet in the second part of the essay this open-mindedness is sacrificed to the rigors of formalism. The pleasures of gestural line "being

granted," Fry says, "one must admit the danger of too great a delight in calligraphy for its own sake, both among the artists and their patrons. It is clearly along the lines of ever closer and more essential structural design that the great discoveries of drawing are to be made." Predictably, it is the Parisian modernists who blaze the trail in this high-minded enterprise; Picasso and Modigliani personify "the modern effort to get to fundamental principles, to purge art of all that is accessory and adventitious."

In this essay, as elsewhere in Fry's writings, the Parisians exemplify his aspirations for modernism. Fry's 1919 review of "MODERN FRENCH ART AT THE MANSARD GALLERY" opens with a brutal comparison of the French and English art scene. Despite this element of continuity, however, this review is marked in several ways by the changes taking place in Fry's thinking. First, the extended comparison of art and literature reflects Fry's burgeoning interest in the relationship of the visual arts to the necessarily representational medium of prose (see chapter 6). This development, however, is here seen to be part of Fry's recognition that "the modern movement is dividing into two main streams of influence," one dealing with abstraction, and the other associated with a "Naturalism" where "the general structure of [a] design is built on the appearances of our familiar three-dimensional space." Although Fry confesses a "rather strong distaste" for the new Naturalist work, he now feels—in an abrupt reversal of his warnings about the pleasures of virtuoso drawing—that "a place may be found" for such illustrative art.

The conflicts and anxieties over the relationship of formalism to narrative, which astute readers could infer from Fry's essays on drawing, are explicitly confessed in a text of 1920: the autobiographical piece wrote to conclude his anthology, *Vision and Design*. Here Fry acknowledges, "I can count various occasions when my principles would have led me to condemn," but "fresh experience" had "the effect of making temporary chaos of my [aesthetic] system. . . . So that even in its latest form I do not put forward my system as more than a provisional induction from my own experience" (*V&D*, 285). In this essay, Fry describes what amounts to a methodology of doubt, which can be seen operating in his reviews of this period. The philosopher of aesthetics, Fry says, should study the "traditional verdicts" of past critics—"and I would allow him a slight bias in favour of agreement with tradition"—but then must "accept the verdict of his own feelings as honestly as he can."

This is the approach Fry enacts in his highly tentative 1921 review of the artist he correctly predicted would come to be considered "one of the most sublime originators in the history of art." The essay "PICASSO" is a record of self-doubt, starting from the straightforward confession, "to say what I think about Picasso is a task from which I shrink, simply because I find it so hard

to know what exactly I do think." Ultimately, it comes down to a loss of faith in abstraction: "We are intrigued, pleased, charmed, but hardly ever as deeply moved as we are by pictures in which representation plays a larger part." Fry had been among the first Englishmen to know of Picasso's return to the classicism of Ingres; a 1916 letter after a visit to Paris reports Picasso "doing some splendid things . . . among them an Ingres-like realistic drawing of Vollard" (*Letters*, 400). Unaware of Picasso's figurative paintings, Fry's review cites the work he has seen:

> Picasso has returned again and again to representation, at least in his drawings. Will he perhaps ultimately return to it in his large works? Return to it with the varied and enriched pictorial vocabulary which his abstract painting has given him. It would not surprise me, and I should expect that when he does he will prove even a greater artist than the painter of inexhaustible charm and invention that we already admire.

A few months after reviewing Picasso's London exhibition in 1921, Fry was in Paris and reported in an illustrated letter on the paintings he saw in Picasso's studio: "It's astonishing stuff. Rather what I hoped might be coming. Vast pink nudes in boxes. . . . They're larger than life and vast in all directions and tremendously modelled on academic lines almost. They're most impressive almost overwhelming things" (*Letters*, 504).

Fry's enthusiastic embrace of Picasso's return to figuration contradicts our current caricatures of the stern founder of formalism. It is not just our perception of Fry as an individual that needs to be challenged, however, but our understanding of formalism itself. For if formalism began in the era before World War I and ended in the era after World War II as a philosophical justification for abstract art, under Fry's influence during the period between the wars it aspired to something else. Fry's revisions of formalism may be grouped into two categories: efforts to create a role for representation within the formalist definition of aesthetic experiences, and the blurring of formal and moral categories across the boundary that Fry earlier delineated with the labels "art" and "life."

The vocabulary of formalist criticism always lent itself to extra-formal interpretation; terms like "classic" and "plasticity," whatever their given definitions, exploited their semantic associations with the imprimatur of history and the significance of depth, respectively. Where this semantic spread was controlled within tight limits in Fry's prewar formalism, however, his writings from the 1920s seem to court the confusion of visual and moral categories. The 1921 "PICASSO," for example, is nominally an assessment of art, yet when Fry expresses—albeit "tentatively and hesitatingly"—the feeling that

Derain is "a graver, more impressive figure," the impression is of a comparison between the two men as people, an effect that is heightened by Fry's assurance that his opinion comes from "knowing both."

The tension between art and life in Fry's critical assessments increases with his personal familiarity with the artist. It reaches a breaking point, at which Fry was impelled to address the issue, in a 1922 review of an exhibition by Vanessa Bell, with whom he remained deeply—if unrequitedly—in love.[9] Fry's "INDEPENDENT GALLERY: VANESSA BELL AND OTHON FRIESZ" (which is devoted almost exclusively to Bell) begins by defending his use of the term "honesty" to describe her work. While still asserting the validity of the old formalist separation of aesthetic and ethical categories, Fry dismantles the wall between them: "I cannot see how one is to deny certain moral qualities which are advantageous to the production of the best aesthetic work." This fusion of formal and social categories is demonstrated by comparing the terms of Fry's appreciation of Bell's art with writings about Bell herself. Fry's review asserts not just her "honesty" and "sincerity" as an artist; we read also that Bell is "not clever [and] never makes the slightest attempt to appear such," that she "follows her own vision unhesitatingly," that she "made no effort to acquire a more pleasing manner," relying instead on her "unconscious charm"; she is without "anxiety" and "never emphatic," while she "produces a refreshing sense of security and repose" and conveys the "feeling of grave, untroubled serenity." The rhetoric of personality is obvious here, but it is thrown into even starker relief by a comparison with Bell's daughter's memoirs of her mother, which assign to Bell as a person the same litany of traits Fry found in Bell's art: "She did not care deeply about abstract ideas, and was led by her sensibilities rather than her intellect"; "she was disinclined to spend her energy on small talk and gave the impression of being unapproachable, . . . threatening to turn her into that puzzling thing, a lovely woman who does not want to be attractive"; "Vanessa had a kind of stoical warmth about her, a monolithic quality"; to her family she "came to symbolize . . . reassurance and stability."[10] Fry's own letters to Bell offer both parallels with the language of his review and explicit acknowledgement of his connection to her life and art: "It is such a delight to come and see you amid your extraordinary performances both in life and in art"; "you give one a sense of security, of something solid and real in a shifting world. . . . You have genius in your life as well as in your art" (*Letters*, 416).

Such sentiments, whether in a private letter or a weekly magazine, mark the resurgence of an idea of good art as the product of a good life, an ideal that goes back in Fry's work at least to the 1905 INTRODUCTION TO THE *DISCOURSES* OF SIR JOSHUA REYNOLDS (in chapter 1) and his early devotion

to Arts and Crafts projects of reform (see chapter 4). Fry's first defenses of
modern art were, likewise, animated by Romantic notions of art as the sub-
jective expression of personality—before coining the term "Post-Impres-
sionism" in 1910, he had called the new movement "Expressionist,"[11] as in
the opposition suggested by the title of his 1908 "EXPRESSION AND REPRE-
SENTATION IN THE GRAPHIC ARTS" (in chapter 2). The reunification of art
and life becomes an important theme in Virginia Woolf's biography of Fry,
which suggests that "he survived the war" by insisting on their separation,
though Woolf argues:

> It seems as if the aesthetic theory were brought to bear upon the prob-
> lems of private life. Detachment, as he insisted over and over again, is
> the supreme necessity for the artist. Was it not equally necessary if the
> private life were to continue? That rhythm could only grow and expand
> if it were detached from the deformation which is possession. To live
> fully, to live gaily, to live without falling into the great sin of Accidia
> [here Woolf alludes not only to envy for material things, but also to Fry's
> unsatisfied passion for Vanessa Bell] . . . could only be done by asking
> nothing for oneself. It was difficult to put that teaching into practice. Yet
> in his private life he had during those difficult years forced himself to
> learn that lesson.[12]

This assessment, by one of Fry's closest friends and colleagues in 1940, re-
flects a shared effort in the period after World War I to preserve the activist
implications of formalist aesthetics as part of a way of life at odds with the
acquisitive imperatives of capitalism and the masculine privileges of patri-
archy.[13]

Fry's best known work from the 1920s—his *Cézanne*, written between
1924 and 1927—uses detailed formal analysis of the paintings to explore the
personality of the man who made them. *Cézanne* has been described as Fry's
attempt at the kind of psychobiography inaugurated by Lytton Strachey's
Eminent Victorians.[14] The opening pages present Cézanne's career as a pro-
cess of "discover[ing] his own personality," while the terms of description—
"Cézanne is so discreet . . . he is so immensely humble"—render the man
and his art interchangeable (*Cézanne*, 3). This emphasis on personality, how-
ever, does not supersede formal analysis. On the contrary, most of the book is
devoted to the kind of detailed studies of formal elements that attracted
generations of modernists to Fry. At his most engaging, Fry invites the
reader to join him in such formalist exercises as holding "an indiscreet finger"
over "the shadow cast by the half-open drawer" in Cézanne's *Le compotier* to
see how it "seems to check the horizontal and slightly diagonal movement of
the napkin folds and to lessen their suavity" (*Cézanne*, 47). Not perceived as

antagonistic methodologies, formal and psychological analyses coexist in Fry's attempts to read relationships of line, color, and mass as indications of extra-formal virtues.

Even in "THE ARTIST AND PSYCHOANALYSIS," a 1924 address to the British Psychological Society that sets out to defend formalism against what Fry perceived as the psychoanalysts' single-minded emphasis on symbolism, he is ultimately unwilling to seal off art as a closed system of purely visual values. As with "ARCHITECTURAL HERESIES OF A PAINTER" (in chapter 4), a forum of professionals outside the arts provoked Fry to insist on what he saw as art's definitive characteristic: the manipulation of abstract form. Passages from "THE ARTIST AND PSYCHOANALYSIS," therefore, recall the stricter formalism of the previous decade. Now, however, they come tagged with Fry's acknowledgement that they represent an "extreme statement" of his beliefs. Fry warns that he is being "dogmatic" when he "declare[s] that the esthetic emotion is an emotion about form," but he suggests that he is driven to such extremes by Freud's banal theorization of art as the simple encoding of narratives of wish fulfillment.[15]

Fry's critique of psychoanalytic approaches to art is informed not only by his knowledge of Freud, but also by his reading of Oscar Pfister, whose 1920 *Expressionism in Art: Its Psychological and Biological Basis* appeared in English in 1922. This book begins by attacking the "Philistines . . . who consider that when they have applied the epithets 'hideous, barbaric, clumsy, perverse, pathological' to the new tendencies in art, they have done their duty as artists and citizens." Despite this—for Fry—promising opening, however, Pfister concludes, not by defending "expressionist" art but by offering its antagonists a more specific medical vocabulary:

> This art movement floundered into introversion and came under the influence of autism which destroyed all proper rational and volitional relations to empiric reality, condemns expressionism to an ethically and intellectually sterile contemplation, left it in the lurch, and allowed often only a symbolical manifestation of its misery and demiurgic illusion."[16]

Fry refers to this kind of psychoanalytic practice, with its echoes of the pathologizing attacks on his Post-Impressionist shows (see chapter 2), when he tells his audience:

> To be called introverted and on the brink of being neurotic does not seriously affect me. Indeed, ever since I observed that the only people worth talking to . . . belong to the class that morbidly healthy, censorious people classed as neurotic and degenerate, these words have lost all their terror for me.

Despite his antagonism toward such vulgar Freudian incursions by medical professionals into the arts, however, it is significant that Fry in this essay resists the temptation to declare his field a realm apart. "THE ARTIST AND PSYCHOANALYSIS" ends by revisiting the definition of aesthetic emotion, this time to allow a connection to the other emotions of life. Pleasure in art, Fry argues, is not limited to the "mere recognition of order and inter-relation." Rather, "every part [of an art object], as well as the whole, becomes suffused with an emotional tone," which, though it "is not due to any recognizable reminiscence or suggestion of the emotional experiences of life," nevertheless, "get[s] its force from arousing some very deep, very vague, and immensely generalized reminiscences." Fry goes on to speculate, "It may be that art really calls up, as it were, the residual traces left on the spirit by the different emotions of life, without however, recalling the actual experiences, so that we get an echo of the emotion without the limitation and particular direction which is had in experience."

These are not the words of a man protecting a rigid formalist boundary around visual values—though formalist principles remain in this essay powerful tools to undermine the professional authority that continued to allow imputations of degeneracy to be attached to any departure from the conventional art of uplifting anecdote. In the last decade of his life, however, Fry was deeply concerned to prevent formalism from sealing art away from the other experiences of life. To take an extreme case, Fry at this period may be found reverting to highly Romantic notions of national personality that conflated the moral and aesthetic worth of whole cultures. Writing for a French audience in 1924—the same year he began *Cézanne*—Fry asserted:

> It is characteristic of German civilization to be oblivious to sentimental insincerity. . . . Although to a lesser degree, this sentimental insincerity has always infected, and continues to infect, alas, a great deal of English art. It is apparently almost impossible for a German artist, and very difficult for an English artist to recognize that it does no good to lie about what one has felt. . . . In general French art has shown itself more honest than that of other nations.[17]

While this projection of an idealized notion of French character, no doubt, allowed Fry to express a sense of alienation from his own culture, generalization on this level is virtually meaningless.

A more promising escape from the hermetic implications of formalism that Fry found increasingly constricting came through his work on literature, especially the translations of Mallarmé that occupied him after 1918 (see chapter 6). Fry's later writings on art, which are peppered with comparisons to literature, reveal the interest in language that prompted his reassessment of

narrative in the visual arts. Literature takes a central role in "Some Questions in Esthetics," the introductory essay to Fry's 1926 anthology, *Transformations*, in which he returns to the issues he had addressed in the influential 1909 "Essay in Aesthetics" (*V&D*, 16–38). Here Fry does not so much revise as clarify his earlier manifesto, attempting to shift the terms of debates that had arisen around his ideas. He stresses that formalist explanations of aesthetic pleasure do not rest on a simple delectation of agreeable "sensations" of color or sound, but rather rely on the recognition of controlled relations or sequences of emotions aroused by an object. This was the basic argument of "An Essay on Aesthetics," which emphasized the ordered variety of "sensations . . . so arranged that they arouse in us deep emotions" (*V&D*, 29–30); here Fry argued, "It depends upon the forms being presented to us in such a sequence that each successive element is felt to have a fundamental and harmonious relation with that which preceded it" (*V&D*, 33). In the 1926 version of this argument, literature appears—far from the antithesis of painting—as similar in its fundamental appeal to "the emotion aroused by rhythmic changes of states of mind due to the meanings of words" (*Trans*, 6). This formulation allows Fry to make a place for what had seemed hitherto inimical to formalism: subject matter in art. A rhetoric of "psychological volume," comparable to spatial volume, allows Fry to assign aesthetic value to narrative as well as to form, and "Some Questions in Esthetics" goes on to compare various paintings that combine these two systems of appeal in various ways: Brueghel is "purely literary" with "trivial and inexpressive" forms; Daumier uses form more successfully but still subordinates it to narrative; in Poussin, on the other hand, "our contemplation of plastic and spatial relations is continually rewarded," but "the psychological complex is of the meagrest"; El Greco, too, offers greater visual rewards to modern viewers, who often find the tenor of his narratives contradicted by the effect of his visual forms (*Trans*, 18–27).

The artist around whom Fry's late formalism pivots, however, is Rembrandt, whose "psychological imagination was so sublime that, had he expressed himself in words, he would, one cannot help believing, have been one of the greatest dramatists or novelists that has ever been, whilst his plastic constructions are equally supreme" (*Trans*, 27). Despite this praise, Fry's approach to Rembrandt reflects the intensity of his struggle with his own formalist legacy. Having received only passing reference in Fry's earlier writings, Rembrandt became a constant troubling presence in the late essays. Rembrandt's escape from formalist assessment is evident from Fry's first frustrated references to the artist in the series of articles on drawing with which this chapter begins. "Rembrandt always intrigues one by the multiplicity and di-

versity of his gifts and the struggle between his profound imaginative insight and his excessive talents," Fry wrote in 1917 (*V&D*, 253). The 1921 "PICASSO" characterizes Rembrandt as a "victim of [his] own extravagant endowment." On their face, these strictures are paradoxical, and so betray the anxiety that is explicit in Fry's letters. "I must write on Poussin and Rembrandt, but I've long been meditating something on these two. But they frighten me," he confessed in 1921 (*Letters*, 505). This pairing of artists—the preeminent formalist Old Master, exemplar of French classicism and model for Cézanne, contrasted with the renegade Dutchman—appears again in a revealing passage from Fry's correspondence: "I find myself back in blank adoration of Poussin again—following every stroke of his pictures with complete identification, almost as though I'd done it myself. . . . Rembrandt at his best I also follow absolutely but I receive it as a divine revelation, it's all beyond me" (*Letters*, 566).

Everything is here in this 1925 remark: the struggle with Rembrandt whose deeply felt accomplishment ("divine revelation") Fry is determined to integrate into his philosophy (what he can "learn"). An essay, "REMBRANDT: AN INTERPRETATION" which was published posthumously from drafts for a lecture probably written around 1927,[18] documents Fry's commitment to resolve his ambivalence toward an artist whose accomplishment challenged the basic tenets of his aesthetic principles.

Fry's "REMBRANDT" begins by trying to explain why he has taken so long to get to a painter generally seen as the paradigm for all artists. Indeed, the first reason Fry proposes for his neglect is Rembrandt's canonic status. The iconoclasm that animated Fry's interest in what others disdained—first Italian painting before the Renaissance, then the Post-Impressionists—is frankly, even proudly, confessed in his description of the Rembrandt "shrine," which is "already overlaid with offerings, many of them of doubtful taste, and one's view of the divinity is slightly troubled and obscured by the traces of so many previous worshippers."[19] The second barrier Fry acknowledges between himself and Rembrandt is his own alienation from his own northern European culture and his identification with lands around the Mediterranean. In the north-south split, which Fry identifies as Protestant against pagan, his sympathies are completely with the latter.

Beyond these issues of ideology and temperament, however, Fry goes on to engage the "real conflict" between formalist expectations for art and what Rembrandt accomplished. This again he presents as a manifestation of the division between northern and southern Europe. In the north, "they are more interested in the psychological expression of form than in form itself." And again, though less stridently, Fry's sympathies are with the south. Echoing

and augmenting the detailed analyses of the relative formal and dramatic merits of various images discussed in *Transformations* (28–31), the more comprehensive lecture-length essay reaches the same conclusion: it is only the late Rembrandt that Fry can ultimately admire. "Towards the end of the 1640s, a great alteration took place in Rembrandt," Fry reports; "He now began really to feel the relations of figures and volume to the space, and his manner became far less theatrical." This shift Fry presents in dramatic terms as Rembrandt's transcendence of his northern identity. Every step in the development of Rembrandt's "peculiarly rugged and expressive plastic feeling" led him further from the conventions—and hence from the rewards—of the Dutch art world.

More than a hint of Fry's own self-perception animates his description of Rembrandt:

> There are few spiritual adventures more enthralling than this the man who was so terribly endowed for a popular success, being forced by an inner conviction into poverty, disgrace and neglect, and yet finding with each step in his declining fortunes the inner impulse growing stronger— and clearer. He pushed on with unceasing energy to the realisation of something for which the world around him had no conceivable use.

These words appear with some alteration in two different places in Fry's drafts of the lecture, and hence twice in the posthumous publication. Both its repetition and its uncharacteristically melodramatic tone suggest the importance of this passage for Fry at the time. In retrospect, however, both these strategies of emphasis read as overcompensation for the doubts that were, by this time, besetting Fry's formalism. These doubts find explicit enunciation both in *Transformations* and in "REMBRANDT." In the latter, Fry says, "Rembrandt brings us up against two problems of pictorial art more violently than any painter"—these are "the position and value of the dramatic presentation of the appeal to the emotions of actual life" versus "to what extent we can afford to deny the picture surface." The parable of Rembrandt forsaking drama for form offers reassuring proof of the formalist belief that "aesthetic pleasure" is "more important and more ultimately satisfying" than what he calls "imaginative pleasure." But ultimately the relief is temporary. Fry himself was not able to live the plot he assigned to Rembrandt, one of "finding with each step in his declining fortunes the inner impulse growing stronger—and clearer." On the contrary, Fry's final years were a time of questioning and revision.

Far from gaining confidence in his own "inner impulses," Fry in 1926 confessed that "long study of the art of painting gradually undermines one's

native prejudices. One after another the great names justify their claims, and one becomes catholic in the end willy nilly."[20] Fry's reluctant admiration for a canon of art history he had earlier condemned coincided with a growing skepticism over the avant-garde he had previously championed. As early as the 1921 Salon d'Automne, Fry worried privately that the modernist pictures all looked the same: "They're nearly all capable *objets d'art*, almost any one would look well in a room, and there are so many alike in general tone and appearance that one despairs of finding one thing standing out from another." In contrast to the triumphal announcement in the catalog essay for the 1910 Post-Impressionist show that artists struggling against the "restraints" of the day "naturally looked to the mysterious and isolated figure of Cézanne as their deliverer" (in chapter 2), Fry eleven years later observed, "The fact is that a new *pompierisme* [academicism] has already been founded on Cézannian principles . . . so here we are back again in a backwash like that which followed Impressionism."[21] Another eleven years finds Fry even further from his prewar optimism. A 1932 letter confesses:

> I find myself more and more in the mood of some quite unfashionable schools such as the Dutch landscapists of the seventeenth century. I have entirely ceased to belong to my age and I feel myself more and more disappointed by the academic results of the Cubists and others— ultimately the *avant-gardisms* seems to me more and more nugatory. (*Letters*, 675)

True to Fry's professed commitment to forgo a priori philosophies in favor of "the verdict of his own feelings" (*V&D*, 285), his revised judgments of individual artists and movements led to new theories of aesthetics. A letter written on the last day of 1928 suggests something of Fry's relief at resigning as spokesman for a philosophy he found increasingly claustrophobic; it is a relief tinged with the old iconoclastic delight in flouting authority, though that authority is now his own. Commenting on a lecture he was writing on "Representation in Art," Fry reported:

> I propounded a few of its heresies at Vanessa's last night. She, poor dear, is deeply shocked but I believe I'm on a tack that will make things a little clearer and relieve the strain which I have felt of late on the other orthodoxy. One runs a theory as long as one can and then too many difficulties in its applications—too many strained explanations accumulate and you have to break the mould and start afresh.[22]

What follows is the encapsulated thesis of "THE DOUBLE NATURE OF PAINTING," a lecture not published until 1969, more than thirty years after Fry's death.[23] The fact that this essay has been ignored by modernists and

postmodernists alike suggests a common reluctance to come to terms with the complexity of Fry's career.

"THE DOUBLE NATURE OF PAINTING" begins by dividing the arts into "two groups." Music and architecture "are able to create great formal constructions which satisfy our aesthetic faculties." In contrast, poetry and "nearly all painting" "force us to recognize references to . . . an external reality or we shall not understand the work itself." The "heresy" of Fry's late theory is that painting is now grouped with poetry as essentially representational. Abstract art is here explicitly rejected as "lack[ing] the evocative power of appeal of the greatest representational works." Despite this drastic revision, Fry does not abandon his earlier formalism altogether. Rather, he returns to the methodology of his introduction to *Transformations*, measuring the relative importance of formal and narrative influences in the work of individual artists. Unlike the earlier survey, which ended in the vindication of formalism, however, Fry's overview in "THE DOUBLE NATURE OF PAINTING" culminates with paintings he calls "operatic" for their balance of abstract and narrative qualities, which go together like music and libretto. Here Rembrandt, no longer worriedly acknowledged as a late bloomer distracted by his dramatic abilities, emerges as "doubly a genius," the hero of an aesthetic suddenly opened to new forms of pleasure.

To some extent, the new aesthetic theory of Fry's late career marks a return to his origins, exemplified by the 1901 essay on Giotto that is the earliest essay reprinted in *Vision and Design*. In the 1920 anthology, this piece serves to demonstrate the skilled connoisseurship in proto-Renaissance painting with which Fry first made his reputation. Fry was troubled enough by the pre-formalist assumptions of the piece, however, to append a footnote acknowledging the essay's "variance with the more recent expressions of my aesthetic ideas," and disavowing any imputation "that the value of the form for us is bound up with recognition of the dramatic idea." In 1920 Fry insisted, "a more searching analysis" enables critics "to disentangle our reaction to pure form from our reaction to its implied associated ideas" (*V&D*, 131; see also 300–301). Here is the apogee of Fry's formalism, the confidence in the separation of the visual and narrative elements in art that allowed him to shock audiences into new ways of perceiving by describing "the agonised body of Christ upon the cross as 'this important mass'"[24]—this example is just one of many found in the memoirs of people who attended Fry's popular public lectures. By 1929, however, when Fry delivered a six-part radio address, "The Meaning of Pictures," he began with "TELLING A STORY," and his focus again returned to Giotto.

The formalist approach to narrative, which Fry developed in relation to

literature, here finds its clearest application to art. No longer does he dismiss subject matter as irrelevant; on the contrary, Fry's description of Giotto's narrative technique is detailed and evocative. A revived interest in narrative, however, does not lead Fry to embrace all anecdotal art; Victorian Academics like Luke Fildes remain objects of derision. The distinction now is not between formal and narrative art, but between types of narrative. Giotto, like Mallarmé (see chapter 6), "deal[s] only with the fundamental psychological facts of the story, the great oppositions and contrasts of the situation." The effect is to preserve the formalist belief in the attitude of detached or "disinterested" contemplation that Fry insisted characterized aesthetic experience, while abandoning the old dogma that only abstract form would provoke such a response. Fry, in his radio lecture, strained to clarify the difference between truly aesthetic and merely anecdotal narrative. In contrast to Giotto, who tells his story in such a way that it is "not entangled in the conflict of our desires and vanities," Fildes personifies an art that is not properly aesthetic. Three years earlier, Fry had described Fildes's painting, *The Doctor*, as "on the level of only our fifth-rate writers" (*Trans*, 35)—and then he claimed surprise that the copyrightholders would not allow him to reproduce the picture. The crucial distinction is that Fildes offers an "invitation to identify oneself" with his noble characters, providing "a certain moral satisfaction which we have done nothing to earn." This attitude—and even this example—go back to 1914 and Clive Bell's trenchant formalist manifesto *Art*, which proclaimed *The Doctor*, "worse than nugatory because the emotion it suggests is false. What it suggests is not pity and admiration but a sense of complacency in our own pitifulness and generosity."[25] Where Bell—like Fry at the time—had burdened the distinction between art and literature with this kind of moral evaluation, Fry's distinction now is between the aesthetic and the merely anecdotal in either medium. Despite this difference, the thread of consistency that links these two moments in formalism is Fry's unshaken determination that art should offer something more important than "a background to [the] radiant self-consciousness" of its complacent patrons (*V&D*, 57).

As Fry's reassessment of figures like Giotto and Rembrandt suggests, the last phase of his formalism opens the way for a new history of art—a history that, if it does not dispose of the old tale of illusionistic decline and Cézannian redemption, at least offers a viable counterpoint. That Fry understood—and even embraced—the new beginning marked by his abandonment of the old formalism, is shown by his last writings, which inaugurated what he planned to be a full survey of art history beginning with the Egyptians. The occasion was his long-awaited appointment to a professorship in art history,

which came finally a year before his death at the age of sixty-seven. Fry
remarked of the honor, with his characteristic iconoclasm, "It must be put
down mostly I think to the English worship of antiquity. If one lives long
enough one becomes a British Institution and they all love you whatever you
do."[26] His survey got no further than the Greeks and Romans before his
death. The lecture notes, revised by Kenneth Clark into essays, were post-
humously published as *Last Lectures.*

Rather than end with these inklings of an abortive new era, this survey of
Fry's writings will conclude with two late pieces, one about the figure who
dominated the last part of his career, and the other a return to a central
figure from the heyday of Post-Impressionism. Fry's 1934 "THE TOILET, BY
REMBRANDT" reveals him finally at ease with the artist whose accomplish-
ment had earlier troubled him so deeply. The formal analysis found in the
opening paragraph of this study coexists easily with an interest in subject
matter in a way that replicates what Fry saw as Rembrandt's dual accom-
plishment. Indeed the formal success of Rembrandt's evocation of "the infin-
ity and complexity of nature" Fry contrasts favorably to the work of "some
modern artists" who attain formal unity through mere "geometrical abstrac-
tion." Fry's delight over Rembrandt's treatment of his subject does not stop
with generalized references to the natural world and the human form; Fry
praises even the specific narrative elements in this depiction of Bathsheba at
a moment of "poignant psychological interest." Fry concludes with the di-
lemma that animated his whole postwar reassessment of formalism: "Let us
admit that a full understanding of the picture demands that we should feel
both the psychological motive and the plastic one. . . . but do the two plea-
sures combine into a single more intense feeling or do they remain separate?"
Fry has no conclusive answer, but he now seems at peace with his inability to
decide.

Like this late article on Rembrandt, Fry's *HENRI MATISSE,* written in
1930, accepts as its premise what he calls the "dual nature of painting, where
we are forced to recognize, at one and the same moment, a diversely coloured
surface and a three dimensional world, analogous to that in which we live
and move." Artists themselves, Fry argues, have "a double nature and a dou-
ble allegiance," and he embarks on what will by now be recognized as a
characteristic but compressed history of world art to demonstrate shifts in
the balances of these two principles. The history of painting that Fry pre-
sents in 1930 retains a starring role for the forebears of Post-Impressionism,
Manet and Cézanne, but the emphasis has changed since his original de-
fenses of these artists: "Literal representation had weighed so heavily on the
art of the nineteenth century that Cézanne's gesture was read mainly as rais-

ing the standard of revolt against that enslavement. We are only now beginning to see how one sided was that reading of Cézanne's heroic pose."

From Fry's new perspective, it was Matisse who, more than any of the other Post-Impressionists, saw beyond the simple appeal of abstraction and "troubled to imagine how that method could be reconciled with the tradition, which they had inherited, and yet determined somehow to recover for the painted canvas . . . the quality of an *objet d'art.*" Using again the kind of detailed description that convinced a generation to see as he saw, Fry now argues that "no one has ever played so many delightful, unexpected, exhilarating variations upon the theme of the dual nature of painting as he has."

Fry's study of Matisse, though it invites us to share his pleasures, ends on a note of caution that, finally, may be what is most typical of Fry's thought. His focus, implicitly, returns to the ideal of aesthetic detachment when he addresses the popularity of Matisse's work in Nice between 1920 and 1925. Before this period—in, for example, the concluding essay for *Vision and Design*—Matisse exemplified the kind of artist who challenged "the cultured public" with art that could be appreciated by anyone, since it relied on visual harmonies rather than the recondite iconography that turned art into "social assets" (*V&D*, 290–91). Now Fry distanced himself from the easy-to-enjoy oriental fantasies and "the spoils of inexhaustible Provençal gardens" in the Nice pictures, which seemed "delightfully to summarize the refined social life of to-day" while they blended with the decor of the "modern villa" and conferred on eager buyers "a social emanation." The old formalist rhetoric of "plastic evocations" returns in Fry's defense of Matisse's starker recent work, which "aims at a more arduous kind of expression." Fry here sounds an echo of the frustration expressed in his letters over the comfortable academicization of modernism in the art market of the 1920s and 1930s. For Fry, the continuing legacy of formalist aesthetics and Post-Impressionist painting was that they should constantly resist assimilation to the values of those he called "the governing classes."

Fry's essays written after World War I, and collected in this chapter, are the strongest testament to his determination to keep his critical practice from becoming, like so much else in the art world, a form of academicism, unchallenging and unchallenged. In the years between 1918 and 1934 he earnestly dismantled much of the critical structure that, in the years before the war, he had been at pains to create. The ultimate effect of Fry's career of doing and undoing, however, is far from nugatory. On the contrary, certain elements remain consistent in Fry's criticism throughout his career. The essays reprinted in this book exhort the reader to careful observation, honest self-assessment, skepticism over the social uses of art, and an irreverence for

authority—even when that authority is one's own. With these constants in mind, the vagaries in Fry's judgments of particular artists ultimately recede in importance. Indeed, his willingness to contradict his own judgments, which time and the art market have rendered authoritative, becomes the guarantee of what is most constant in his method. When Fry returns with a critical eye to movements and theories he played no small role in creating, his performance invites—even demands—that his readers match it with their own attention, honesty, skepticism, and even irreverence. A postmodern audience, bent on challenging the certainties of formalism, can do no less than acknowledge that that path has been trod before.

<center>∞</center>

<center>NOTES</center>

1. Harold Rosenberg, "1914," 1964; reprinted in *Discovering the Present: Three Decades in Art, Culture, and Politics* (Chicago: University of Chicago Press, 1973), 88–92.

2. Fry's *Cézanne* (1927), *Flemish Art* (1927), *Characteristics of French Art* (1932), and *Reflections on British Painting* (1934) have all been issued in various editions; for details, see Donald Laing, *Roger Fry: An Annotated Bibliography of the Published Writings.* (New York: Garland, 1979).

3. See Université de Sainte-Étienne, *Le retour à l'ordre dans les arts plastiques et l'architecture, 1919–25* (Sainte-Étienne: Centre interdisciplinaire d'études et de recherches sur l'expression contemporaine, 1975); and Kenneth Silver, *Ésprit de Corps: The Art of the Parisian Avant-Garde and the First World War, 1914–1925* (Princeton: Princeton University Press, 1989), 3–27.

4. Clive Bell, "Before the War," 1917; reprinted in *Pot Boilers* (London: Chatto & Windus, 1918), 253–55.

5. Et comme ils sont traditionnalistes! . . . J'aime à penser que Rubens reconnaîtrait son petit-fils en Matisse, tout comme Matisse doit reconnaître son héritage, que Fra Bartolomméo aurait compris tout de suite ce que voulait Picasso . . . que les grands constructeurs de XVIIe siècle, et Poussin tout le premier, auraient perçu avec quelle clairevoyance Derain a deviné leur secret. ("La peinture moderne en France," *L'Amour de l'art*, May 1924, 144–46.)

6. Letter from Fry to Vanessa Bell, 1 June 1917, Tate Gallery Archives 8010.5.691.

7. Judith Collins, *The Omega Workshops* (Chicago: University of Chicago Press, 1984), 152; Frances Spalding, *Roger Fry: Art and Life* (London: Granada, 1980), 211. As Jacqueline Falkenheim points out, "although Fry lived until 1934, he never became involved or even familiar with artists younger than Picasso"; see *Roger Fry and the Beginnings of Formalist Art Criticism* (Ann Arbor, Mich.: UMI Research Press, 1980), 96.

8. The footnote in *Vision and Design* that dates this essay to 1912 is incorrect.

9. Following their affair between 1911 and 1913, Fry's devotion to Bell persisted. A letter of 1922 professes, "I'm glad you like me still to be in love with you at

moments. I don't think you need be afraid of losing your hold on me. My attempts at putting up with other women seem only to make the difference more startling" (Letter from Fry to V. Bell, 7 October 1922, Tate Gallery Archives 8010.5.874).

10. Angelica Garnett quoted in S. P. Rosenbaum, ed., *The Bloomsbury Group* (Toronto: University of Toronto Press, 1975), 175; Garnett, *Deceived with Kindness* (London: Chatto & Windus, 1984), 24.

11. Desmond MacCarthy, "The Art Quake of 1910," *The Listener,* February 1945, 124.

12. Virginia Woolf, *Roger Fry: A Biography* (1940; reprint, New York: Harcourt Brace Jovanovich, 1968), 214–15. A provocative riposte to this analysis, deconstructing the disinterested pose of Fry (along with that of his contemporary, Marcel Duchamp), is offered in Rosalind E. Krauss, *The Optical Unconscious* (Cambridge, Mass.: MIT Press, 1993), 95–146.

13. This argument is expanded in my "Through Formalism: Feminism and Virginia Woolf's Relation to Bloomsbury Aesthetics," in *The Multiple Muses of Virginia Woolf,* edited by Diane F. Gillespie (Columbia: University of Missouri Press, 1993).

14. Beverly Twitchell, *Cézanne and Formalism in Bloomsbury,* (Ann Arbor, Mich.: UMI Research Press, 1987) 42.

15. Fry's characterization of Freud's approach to art is justified by reference to "Creative Writers and Day Dreaming" (1908), "Formulations Regarding the Two Principles in Mental Functioning" (1911), and "The Paths to Symptom Formation" (1917) (reprinted in *The Standard Edition of the Complete Psychological Works of Sigmund Freud,* edited by James Strachey [London: Hogarth Press, 1953], 9:143–53, 12:215–26, and 16:358–77, esp. 376–77).

16. Oscar Pfister, *Expressionism in Art: Its Psychological and Biological Basis* (London: Kegan Paul, Trench, Trubner, 1922), 1, 269. Freud replicated this contradiction in his reaction to the book, writing to Pfister:

> In private life I have no patience at all with lunatics. I only see the harm they can do and as far as these "artists" are concerned, I am in fact one of those philistines and stick-in-the-muds whom you pillory in your introduction. But after all, you yourself then say clearly and exhaustively why these people have no claim to the title artist. (Quoted in Ernst Gombrich, "Freud's Aesthetics," *Encounter,* January 1966, 34)

17. C'est une particularité de la civilisation germanique d'être inconsciente de la déshonnêteté sentimentale. . . . Bien qu'à un degré moindre, cette déshonnêteté sentimentale a toujours infecté et infecte encore, hélas, une bonne partie de l'art anglais. Il est apparemment presque impossible à un artiste allemand, et fort difficile à un artiste anglais, de croire que dans l'art il n'est point bon de mentir sur ce que l'on a ressenti. . . . En générale, l'art français s'est montré plus honnête que celui des autres pays ("La peinture moderne en France," 146–48).

18. On its posthumous publication, Fry's lecture was dated vaguely "towards the end of his life." My dating of around 1927 is based on the way the text, though deploying comparisons similar to the 1926 *Transformations,* evinces more comprehensive analysis and more confident conclusions, suggesting it is the result of further study; it seems to be the "detailed examination of [Rembrandt's] whole work" that Fry called for (*Trans,* 27). At the same time, the opinions expressed seem to precede Fry's ultimate resolution to accept the "double nature" of painting, a phase that began in 1928 (see below).

19. In a review of Arthur Hind's book on Rembrandt, Fry is more specific in castigating a German book, *Rembrandt as Educator*, in which Rembrandt was presented as "a kind of previous incarnation of Bismarck" ("The Real Rembrandt," *The Listener*, 25 May 1932, 758). The reference here is probably to Julius Langbehn's well-known *Rembrandt als Erzieher* (Leipzig: C. L. Hirschfeld, 1890).

20. Fry, "Musical Confessions of an Outsider," *The Music Bulletin*, May 1926, 138.

21. Letter from Fry to V. Bell, autumn 1921, Tate Gallery Archives 8010.5.845.

22. Letter from Fry to H. Anrep, 31 December 1928, in Spalding, 268 (see n. 7 above).

23. On its 1969 publication, "The Double Nature of Painting" was identified as the translation of a lecture given in French in 1933; this lecture is an abbreviated version of "Representation in Art," a talk Fry wrote over the New Year, 1926 (manuscript in Roger Fry Papers, King's College Library, Cambridge).

24. Quentin Bell, "Roger Fry" (1964; reprinted in *Bad Art* (London: Chatto & Windus, 1989), 67.

25. C. Bell, *Art* (New York: Frederick A. Stokes, 1914), 19–20.

26. Fry to Gerald Brenan, 19 March 1933, in Spalding, 270.

LINE AS A MEANS OF
EXPRESSION IN MODERN ART

SOME time ago, in reference to an exhibition of drawing by Old Masters held at the Burlington Fine Arts Club, I ventured to suggest that, since the Renaissance had established a certain norm of representation drawing had ceased to be possible as a complete means of expression, and that even great linear designers like Ingres, men whose supreme expression lay precisely in linear rhythm and balance—had only attained to full expression in painted pictures which allowed of a long process of elimination and restatement. I suggested that this was due to the assumption that in every drawing of the figure certain anatomical facts were held sacred,[1] that at whatever cost to rhythmical expression, or even constructional solidity, due reference must be made to these facts. It also seemed to me likely that the revolution in art which our century has witnessed would, precisely because it has released the artist from this particular bond of representational accuracy, enable the artist to find fuller expression in line drawing than has been the case since the 14th century. In this article I propose to show in what way this revival of the art of drawing has manifested itself, and also what dangers already appear inherent in the new tradition.

Cézanne, though so definitely the originator of the new conception, never seems to have seen the possibilities it implied for line drawing. Occupied so intensely as he was in the construction of coloured planes, he used drawing entirely as subsidiary to his painting, as a means of recording rapidly certain of the facts which he was going to rely on in his pictures, or as an experiment in the disposition of the leading planes of his design. With both Gauguin and Van Gogh linear drawing becomes more important and even at times a complete expression, but it is not till we come to the artists of the present generation that drawing is used in an entirely new manner prompted by the

Reprinted from *The Burlington Magazine*, December 1918, 201–8; February 1919, 62–69; plates are renumbered for this edition.

1. An amusing instance of this tyranny was the convention which ruled for a great part of the 16th century in Italy, according to which in any drawing of the figure the umbilicus had to be indicated, so that, in their anxiety to be correctly academic, many minor artists of the time—Vasari, for instance—took care to show the umbilicus even through the folds of drapery.

PLATE I. Pencil Drawings
 By Walter Sickert
 By Duncan Grant

new conception of what is implied in the artist's vision. It is in the work of
Henri Matisse and Pablo Picasso that we find these principles dominating
their linear designs, and both of them use drawing as an independent and
complete statement of an artistic idea.

The two drawings of Henry Matisse reproduced in the Plate [III] will
show that he practises two more or less distinct manners. In one case, that of
the glass of flowers, certain aspects of a rather complex vision are recorded in
a few lines which have the appearance of being, as it were, scribbled with
great rapidity and extreme freedom. In the portrait, the lines are forced into a
scheme of extreme simplicity. Merely to distinguish these methods (not to
define them) we may call them respectively calligraphic and structural.

The word calligraphic is perhaps unfortunate here, and needs some expla-
nation. For although perhaps the most striking thing about this drawing is its
astonishing beauty of line, nothing could be further removed than this from

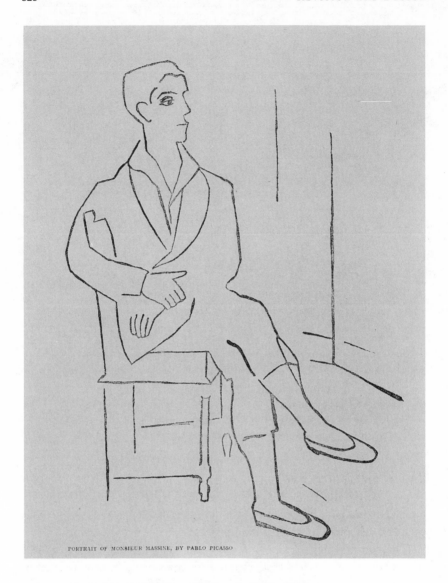

PORTRAIT OF MONSIEUR MASSINE, BY PABLO PICASSO

PLATE II. Portrait of Monsieur Massine, by Pablo Picasso

the bravura of the highly skilled artist who from long habit has become able to state the commonplaces of form with a desolating assurance and certainty. Here, though all is rapid in actual execution, the line has an almost exaggerated delicacy and sensibility. To an eye accustomed only to academic drawing it might even seem helpless and incompetent. Indeed, I remember, when some of Matisse's drawings were shown at the Grafton Galleries some years

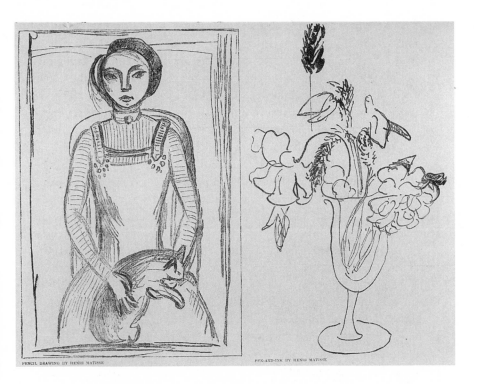

PLATE III. Pencil Drawing by Henri Matisse
Pen-and-Ink by Henri Matisse

ago, a certain artist had the temerity to reproduce his own version of one of them in a letter to the papers in order to show how futile Matisse's drawing was. As far as representation went, the copy was probably as near to, or as far from, accuracy as the original, but in every other respect it had no relation whatever to it, for the copy was, in fact, as its author alleged the original to have been, a dull, incompetent scribble; it was entirely null and void, whereas approximately the same forms drawn by Matisse had a tremulous intensity of life and a rhythmic harmony which fascinated one by its daring. The peculiar exhilaration, the sense of excitement as of watching some incredibly difficult feat of balancing which one gets from such drawing as this of Matisse's comes, I think, from the fact that with such bold simplification of natural form one feels that the mechanical, and merely schematic is always lying in wait.

For herein lies one of the great charms of drawing—namely, that the conflict between the infinite complexity and fullness of matter, on the one

hand, and the bare geometric abstraction of mind, is brought, not, indeed, to a point, but literally to a line. In art these two incommensurable aspects of the world are somehow reduced to a common measure, and in a drawing this reconciliation is seen in its simplest, most impressive aspect. For the purely ideal, intelligible and logical drawing would be a mere mathematical diagram of straight lines and known curves, and on the other hand the purely literal accurate drawing would be exactly as chaotic and unintelligible as nature. The great draughtsman does obtain a lucid and recognisable order without losing the fullness, the compactness and infinity of life. The quality of line which, while having an intelligible rhythm, does not become mechanical is called its sensitiveness. And here the most obvious thing is clearly that the line is capable of infinite variation, of adapting itself to form at every point of its course.

It clearly demonstrates Matisse's intense sensibility and it is for that reason that I called it provisionally calligraphic. The word calligraphic conveys to us a slightly depreciatory sense. We have never held calligraphy in the esteem that the Chinese and Persians did, we think at once of the vulgar flourishes of the old-fashioned writingmaster. But, in fact, there is a possibility of expression in pure line, and its rhythm may be of infinite different kinds expressive of infinite varieties of mood and condition. We call any line in which the quality aimed at is attained with complete assurance calligraphic, but this omits the really important point of what kind of quality is so attained, whether it is fine and sensitive or brutal and self assertive. So that in calling this drawing calligraphic I have not really damned it, since it happens that the quality of Matisse's line is so hyper-sensitive, so discreet, so contrary to all bravura or display, that, as we have seen, it actually deceives the innocent into supposing that it is simply incompetent.

I have dwelt thus at length on this question of calligraphy because in my next article I shall point out that Matisse's new and subtle rhythm, so curiously contradictory of the assertive rhythms of academic art, is in turn becoming a kind of standard of calligraphy for the modern artist.

If we turn to Matisse's other drawing we find a quite different treatment—here the line is much more deliberate, much slower in *tempo*, less exhilarating and attractive in itself. Sensitive it remains, but in this case we are much more concerned with the position of the lines, their power of evoking the idea of volume and mass than with the qualities of the lines in themselves. It is a more definitely plastic and constructive design. It is typical of the kind of synthesis which has become possible to the modern artist who regards no particular facts of nature as sacred, and who is free therefore to aim at the elimination of all but the essential forms, not of description but of

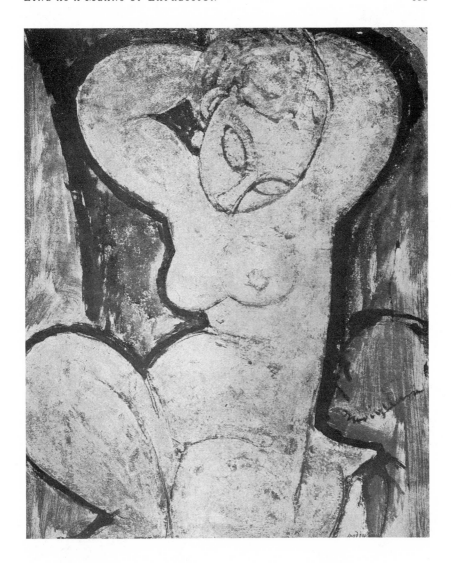

PLATE IV. Water-colour and pastel colour drawing by Modigliani

plastic construction. Such a design coheres not by the description of those forms which we know to be anatomically functional, but by the discovery of those ultimate elements which give to the whole vision its plastic validity, those lines, in fact, which are plastically, not anatomically functional. It is for this reason that such a drawing seems to me more complete as an expression of the passion for form than almost any drawing that one could name by the masters who followed the tradition of the Renaissance.

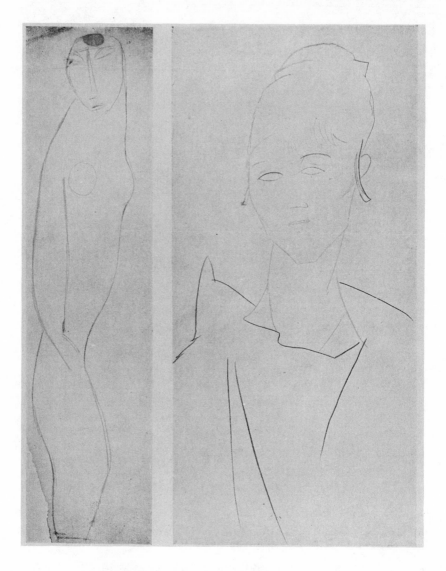

PLATE V. Pencil Drawings
 Nude woman by Gaudier-Brzeska
 Portrait of Mlle. G. by Modigliani

Similar in its aim, though with a note of particular characterisation which
distinguishes it, is Picasso's portrait of M. Massine [Plate II]. Here one
might guess, what is indeed the fact, that so quintessential a synthesis of
form, and one into which so much of the particular character of the original

has passed, could only be the final result of a long series of experiments. For Picasso is essentially a realist—the object fascinates him, and however abstract the final result may appear it is really compact of character. There is no willed imposition of the preconceived scheme of form upon the object. The form is arrived at inductively by the successive elimination of all accidentals, until the pure substance is revealed. There are here none of those convincing and endearing accidents by which we habitually recognise character, and which the ordinary portraitist seizes upon to convince us of the actuality of his work. Nothing is left but the purely structural and functional basis of the total vision—the form itself in its ultimate bareness.

It would be as absurd here to deny skill as it would be to admire it. For where the aim is so purely creative, the result of such a fortunate effort of what Rossetti called "fundamental brain work," to talk of skill is impertinent.

Such then are, as I understand them, the results of the modern attempts at linear design. First, a more closely knit synthetic construction of form—a unity more vigorous, precisely because the artist is not at the mercy of any particular facts of nature, but must determine afresh in each instance what is essential and what accidental. Secondly, this constructive design is expressed in terms of a rhythm which is freer, more subtle, more elastic and more adaptable than any of the rhythms that have obtained for some centuries. This change in the general quality of rhythm in modern drawing might perhaps be compared to the change from regular verse to free verse or to poetical prose.

By way of a contrast let us turn to Walter Sickert's exquisite drawing [Plate I] so as to make more clear the peculiarities of the modern idea, for Sickert's inspiration is penultimate, it dates back to Whistler. Now already, through Whistler, a more elastic, more discreet rhythm was imported into European design—from Japan, alas, rather than from China. So that, as regards the quality of his calligraphy, Sickert is not far removed from his younger contemporaries. But from the point of view of construction Sickert still belongs to the older tradition, for it is evident that his conception of the function of a drawing is different. It is pictorial rather than pictorially-plastic. He accepts from the totality of vision almost as much as a painter would, far more, indeed, then painters like Matisse or Picasso would. There is here a suggestion, not only of chiaroscuro, but of tone values of textures of the variations of light on different surfaces, almost, so nearly does he follow painting in all else, one might guess at hints of colour. Certainly he was not blind to colour while he drew. There is no attempt to extract the ultimate skeletal structure of form, its irreducible minimum; there is no analysis of vision into its components, and the synthesis is the result of an unconscious

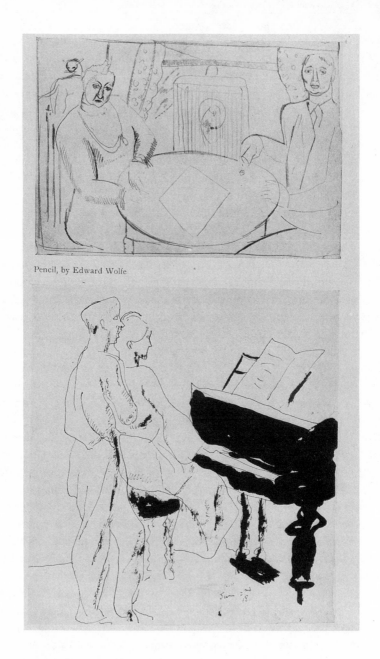

Pencil, by Edward Wolfe

PLATE VI. Pencil, by Edward Wolfe
Ink, by Nina Hamnett

and impromptu gesture. Synthesis is of course always made by a jump of the unconscious, but the materials out of which the synthesis is made are given by the conscious mind. Sickert provides his unconscious self with the total vision as detected by his richly experienced and marvellously aware sensibility. Picasso and Matisse hand over for the ultimate synthetic process a few quintessential extracts which they have distilled from the total vision by a long and conscious analytical study. Of course, when stated thus, the processes of art sound much more elaborately conscious than they really are; for the sake of making clear the distinction I have exaggerated and, as it were, caricatured them.

Now it would be absurd to reject the extraordinary beauties of Sickert's drawing. It has the singular delicacy and fineness which marked Whistler's drawings, but it has a sense of volume and mass, a robustness and vigour altogether unknown to that too exquisite being. Sickert's drawing has many beauties which are deliberately sacrificed by the more modern artist in the search for a more rigorous order. It would be useless to decide between them, they are different modes of expression, and all I am concerned with is to make clear the distinction.

[End of Part 1]

In the first part of this article I tried to show that there were at least two kinds of æsthetic pleasure to be derived from linear design—the pleasure of rhythmic sequence in the line itself, which I called the calligraphic element, and the pleasure derived from the suggestion to the mind of plastic form, which I called the structural element. One may say that the calligraphic line quâ line remains upon the paper, whereas the structural line becomes transposed into a three-dimensional space. The calligraphic line is the record of a gesture, and is, in fact, so pure and complete a record of that gesture that we can follow it with the same kind of pleasure as we follow the movements of a dancer. It tends more than any other quality of design to express the temperamental and subjective aspect of the idea, whereas in structural line the artist shows himself as more or less completely absorbed in the objective realisation of form.

Of course, in every drawing both of these elements of design are present, but they are present in varying degrees in the work even of the same artist.

I also suggested that modern developments of art had given a new impetus to drawing both by setting up a freer, more elastic idea of calligraphy and a more logical conception of the nature of plastic unity.

The drawings reproduced in this number are, I think, evidences of this revival of the art of drawing.

In the first article there was a reproduction of a drawing by a compara-

tively young artist, Duncan Grant [Plate I], which showed clearly by its contrast with the adjoining drawing of Walter Sickert wherein the new conception of drawing is affecting the present generation. Duncan Grant's drawing has not, it is true, the research for purely abstract plastic coherence that marked Picasso's drawing [Plate II]; it is definitely pictorial, and in its indications of planes tends towards painting, but the painting for which such a drawing might serve would clearly be much more purely plastic than the painting which Walter Sickert's drawing anticipates. It would renounce many aspects of vision that Walter Sickert accepts in order to concentrate more intensely upon certain essentials of plastic relief and relations of mass. No one would, I think, deny the great calligraphic beauty of Duncan Grant's drawing, the freedom, elasticity and ease of its rhythms. One might allow, perhaps, that structural unity was not pursued with the same passion that inspires the French artists, but at least such appreciations of volume and mass as the artist has are stated with a new lucidity and directness.

In the main, however, one has to admit that the tendency of English drawing, as compared with French, is to lean towards the calligraphic aspect, and this is no doubt an inherited tradition of English art. Beauty of handling and quality have always been so much admired in England that even the cheap substitutes for them, brilliance and audacity of touch, have had at times a greater prestige than was their due, as, for instance, when people mistook Raeburn for a serious artist. One suspects, indeed, that the charm which some of Gainsborough's vague and incoherent designs still exercise is due almost entirely to the peculiarly English sensibility of his handwriting.

Now, if we turn to the reproductions of the drawings of still younger artists, such as those by Nina Hamnet and Edward Wolfe, [Plate VI] we see still more clearly the same tendency. The calligraphy is of the new kind, far subtler, more discreet and unemphatic than the old, but it is the calligraphy that first strikes us. One is indeed surprised to find quite young artists drawing with such a delightful freedom from all self-consciousness, so entirely without bravura and display. These were too often the visible result of the old tradition which tended to make the virtue of drawing lie in the perfect performance of a task within certain specified rules. We see then the good result of freeing the artist from the inhibition of the idea that the notation of a certain set of facts is the *sine quâ non* of good drawing. Though there may be certain guiding principles, the problem of what to select from the total vision is presented afresh on each occasion, and every time the solution of what deformations will give the requisite salience and volume to the forms has to be discovered. But at least these artists know that the chance of discovering it lies for them along the lines of a free sensibility, ever alert to detect those

characteristics of form which make for its intensest unity and its most coherent mass. They know too how important it is that this sensibility should remain innocent, and how fatal to that is the self-conscious control that results from any idea of technical display. It is perhaps this new attitude which regards a drawing as the almost unconscious overflow of a vivid æsthetic experience rather than as a performance before an imagined public that accounts for the rapidity with which the artists of the rising generation have attained to a power of expression by means of line that was almost unknown in the recent past. But this being granted, one must admit the danger of a too great delight in calligraphy for its own sake, both among the artists and their patrons. It is clearly along the lines of ever closer and more essential structural design that the great discoveries of drawing are to be made. The drawing by the late Gaudier-Brzeska [Plate V], here reproduced, shows that had he lived he might have become a structural draughtsman. This certainly has a tense and functional line, and shows a desire to attain to that bare economy of statement which marks the greatest art. At the same time it must be said that it is an exception among the numerous drawings left by that gifted sculptor, and that for the most part his drawings are not only calligraphic, but that they tend to an exuberant and demonstrative effectiveness which reminds one only too much of the assertive and self-conscious calligraphy of the Japanese. But everything in Brzeska's career shows that he would have rapidly outgrown this as well as all other mannerisms into which he may have temporarily fallen.

In Modigliani's drawings [Plates IV and V] we see the tendencies of the new movement in Paris, and here once more there is no doubt that the structural is the predominant element. Modigliani has been mainly a sculptor, as one might guess from the mode, in which every form has been reduced, as it were, to a common denominator. His notion of plasticity appears here as uniform and unvaried. All relief has for him the same geometrical section, and his effect is got by the arrangement of a number of essentially similar units. But two qualities save Modigliani from the dryness and deadness which might result from so deliberately mathematical a conception of the nature of form. One is the delicate sensibility which he shows in the statements of this simplified form, so that in spite of its apparent uniformity it has none of the deadness of an abstract intellectual concept. The beautiful variety and play of his surfaces is one of the remarkable things about Modigliani's art, and shows that his sculptor's sense of formal unity is crossed with a painter's feelings for surfaces. The other saving grace that Modigliani has is the sense of movement and life which comes from the arrangement of his plastic units. In the portrait drawing [Plate V] one sees him accepting far

more from the actual vision, allowing much more variety in the forms with which he composes, but striving none the less to get out of the actual forms as clear and simple a common element as possible. Such a drawing is clearly more spontaneous and less profoundly elaborated than Picasso's portrait of Massine [Plate II], but it belongs to the same category. It too shows the results of the modern effort to get to fundamental principles, to purge art of all that is accessory and adventitious.

MODERN FRENCH ART AT THE
MANSARD GALLERY

IT is to be hoped that the holidays will not prevent too many people from visiting the exhibition at the Mansard Gallery. Nothing like such a representative show of modern French art has been seen in London for many years. It is indeed extraordinary how few opportunities are allowed to the English public of seeing what is being done in Paris. The fact is that there are scarcely any enterprising and intelligent dealers in modern art in London. Every now and then a small collection of some single artist (Marchand or Asselin) finds its way to the Carfax Gallery, but that is all. Knowing as one does how widespread is the interest in modern French art among artists and amateurs in London, one wonders why so large a prospect of financial gain—to put it on the lowest grounds—is persistently neglected. Anyhow, we have here in the Mansard Gallery a specimen of what ought to be due at least once every year.

It is not perhaps a fully representative collection. Some of the greater masters are seen in minor works, and there is an indisputable tail, but even this rather casual and unsystematic gleaning from the contemporary Parisian output is astonishing in its interest and variety. My general impression is that there are about ten times as many pictures that, on the face of it, are worth a careful study, that refuse to be dismissed at a glance, as there are in a good London Group Exhibition, and it would be affectation for me to deny that I think the London Group far the best annual show of modern work in England. It is not the big names, the Matisses, Derains, Picassos, that surprise me most here—but the general level of work, the individuality and sincerity of a whole crowd of younger men and women whose names are entirely new to me.

The moderns are accused of giving way to two vices—the love of *boutade* and the relapse into academism. Both accusations are frequently justified, and generally the same people are guilty of both sins, however contradictory their nature appears at first sight. But on the whole how little of either there is here! What a high standard of emotional honesty this exhibition shows! and

Reprinted from *The Athenaeum*, 8 August 1919, 723–24.

as a result what an extraordinary variety of presentments, what innumerable different visions, one can enjoy in this gallery! Great originality one can only expect about once in a century, so that it would be absurd to expect in these young artists the shock of an unforeseeable vision. There is no work that cannot be analysed into its constituent influences—so much of the general Cézanne tradition, such and such a dose of Rousseau, or of Derain (who once seemed derivative himself, but now takes his place as one of the definite centres of radiation), and so forth; but though we can analyse the constituents, the result is no mere mixture, but a new chemical compound brought about by the energy of some personal and individual imagination. Take Mlle. Halicka as an example. She makes no claim to great originality, she takes her goods where she finds them; from Derain something of the general scheme of design, the polarization, as it were, of his plasticity, with its stresses all in one direction; from Matisse the idea of oppositions of graded but unmixed colours; but the choice of material, the imaginative approach to life, the taste and sensibility are all her own, are in fact something new and individual. I think one could have guessed, for instance, that these pictures were done by a woman and by someone who was not French. But the main point is that being so unambitious, avoiding any pretence to be more than just what they are, Mlle. Halicka's pictures are real works of art. I should have to describe in similar terms a great many young artists here whose names are new to me: Solà, whose landscapes keep something of the luminosity of impressionists like Sisley; Fournier, who realizes with an almost brutal solidity his sombre and menacing landscapes; Darcy—still-lives painted with almost student-like fidelity, and a landscape reminiscent of Cézanne and Marchand, but very individual in sentiment for all that; Ramsey, who has a curious quality like that of hand-woven carpets, and a strangely deliberate logic of colour-construction. Any one of these would make something of a sensation in an English exhibition, and here they pass unnoticed until one has exhausted the well-known names. I cite them first because they show how vital and inspiring the modern movement still is, what power it has to set free the expression of individual sentiment even among minor painters, and it is rather in its demonstration of this pleasing fact than for its *chefs-d'œuvre* that the present exhibition is so interesting.

I find that the artists I have mentioned are all more or less naturalistic. It is clear now that modern movement is dividing into two main streams of influence—one which may be called Cubist, using the word in the vaguest and most generalized way; and the other Naturalist, though not of course the Naturalism of the nineteenth century. However much the Naturalists distort their vision, falsify perspective and change the proportions of objects, the

general structure of their design is built on the appearances of our familiar
three-dimensional space. The Cubists tend, on the other hand, to introduce
at some point a complete break of connection between ordinary vision and
the constructed pictorial vision. They may be highly realistic in detail, but
internal necessities of design dictate the relations of the parts *de novo*, and
not, as with the Naturalists, by a continued gradual distorting pressure upon
the relations presented by ordinary vision. It is particularly interesting in the
present exhibition to see two rather early works of Picasso in which the
naturalistic origin of the vision is still clearly present, but in which the pro-
cess of distortion and readjustment has gone so far that the next step (which
Picasso was himself the first to take) is already indicated. The break having
been once made and the idea of the construction of picture vision *de novo*
having been once realized, a curious thing happened. It was seen that the
complete break allowed the possibility of a new kind of literary painting.
Ideas, symbolized by forms, could be juxtaposed, contrasted and combined
almost as they can be by words on a page, and Futurism came into being.
That this idea was seized on, perhaps originated, by a group of rather crude
Italian journalists, and in all countries appealed to painters of a journalistic
turn, has stigmatized this offshoot of Cubism. But now it would seem that it
is returning to France to be taken up and explored by a very different type of
mind. A number of pictures by Survage in the Mansard Gallery give one an
idea of its possibilities in the hands of a man of refined and cultivated sensi-
bility, a man who is not a journalist but a very up-to-date poet—and how
much of modern literature is approximating to the same kind of relationship
of ideas as Survage's pictures give us!

Just for the fun of testing my theory of these pictures, I will translate one
of them into words; however clumsy a parody it may be, it will illustrate the
point:

THE TOWN

Houses, always houses, yellow fronts and pink fronts jostle one an-
other, push one another this way and that way, crowd into every corner
and climb into the sky; but however close they get together the leaves of
trees push into their interstices, and mar the drilled decorum of their
ranks; hard green leaves, delicate green leaves, veined all over with black
lines, touched with rust between the veins, always more and more mi-
nutely articulated, more fragile and more irresistible. But the houses do
not despair, they continue to line up, precise and prim, flat and texture-
less; always they have windows all over them and insides, bannisters,
cornices, friezes; always in their proper places; they try to deny the
leaves, but the leaves are harder than the houses and more persistent.

> Between houses and leaves there move the shapes of men; more tran-
> sient than either, they scarcely leave a mark; their shadows stain the walls
> for a moment; they do not even rustle the leaves.

I see, now that I have done it, that it was meant for Mrs. Virginia Woolf—that Survage is almost precisely the same thing in paint that Mrs. Virginia Woolf is in prose. Only I like intensely such sequences of ideas presented to me in Mrs. Virginia Woolf's prose, and as yet I have a rather strong distaste for Survage's visual statements. For all that, I feel the immense difference between this and the Italian use of a similar idea. It is possible that a place may be found, perhaps in illustration, for such a kind of literary picture. Of course Picasso himself has never become literary; indeed, in his Cubist work he is more purely plastic and less literary than he was in his early naturalistic days, and the main tradition of French Cubism remains severely formal. Braque, Juan Gris, Severini (who has returned from his Futurist venture to the classic fold), Maria Blanchard and all the rest, create forms which have no direct associations with ideas. Of this group the present exhibition hardly gives any idea. There are some charming and very accomplished essays by Marc[o]ussis, who follows Picasso's with little change, but with a personal taste of his own, and a Dutch artist who shows how rapidly the most revolutionary movements may be attacked by the parasite of academism.

I must leave to a second article the work of the well-known painters, but lest this article should give the false impression that the exhibition is made up entirely of the work of *les jeunes*, let me say that it contains examples of Matisse, Picasso, Derain, Utrillo, Friesz, Lhôte, and such a show of de Vlaminck and Modigliani as has never before been seen in England.

PICASSO

T HE exhibition of Picasso's work at the Leicester Galleries is a great artistic event. Although it is far from representing him completely in all the stages of his Odyssey, it affords the best chance we have yet had in England of understanding and appreciating the painter who has had more influence on modern art than any other single man. Every time one sees his work again one's first feeling is certainly of intense excitement in face of the expression of so vital, so exhilarating a personality as his. The pure visual charm of these creations is extraordinary. It is far harder when one goes beyond this to attempt any more thorough estimate of Picasso's art.

In fact, to say what I think about Picasso is a task from which I shrink, simply because I find it so hard to know what exactly I do think. There are a number of qualities in his art which stand out so clearly that, as it seems to me, only æsthetic blindness or wilful prejudice can deny them; such things, as his mastery of line, his exquisite sensibility, his unfailing charm, his scholarship, his seriousness, his great sense of style. About all these things his fellow-artists are in no doubt. But to admit, or indeed to proclaim, all this with conviction is only to approach the edge of the problem. The ease of Picasso is not like that of other artists. When we attempt the impossible feat of estimating the value of a contemporary artist, we generally take as a measure the case of some similar artist in the past familiar to us, the full trajectory of whose career time has enabled us to trace. But where in the past are we to find the likeness to Pablo Picasso? I daresay such an one exists, but the peculiar conditions of modern art prevent us from detecting the likeness. For here is an artist who has given rise to more schools of art, who has determined the direction of more artists, than any other one can think of. An artist, too, who has changed the superficial appearance of pictures more radically than any in the whole history of the world; for although, fundamentally, the latest Cubist abstraction is more like a landscape by Cézanne than either are to a Sir Joshua Reynolds, still on the surface and to the casual spectator there is far more likeness between the Cézanne and the Reynolds than between either of these and the abstract picture.

Reprinted from *The New Statesman*, 29 January 1921, 503–4.

We should say, then, on the showing of these facts, that we were in the presence of one of the most sublime originators in the history of art, and yet I doubt if anyone does say that. Perhaps twenty or thirty years hence people will say that, but for the present we do not; and that, I hope, not from want of courage, but from want of conviction. Somehow, with all this extraordinary inventiveness, with this almost miraculous delicacy of sensibility, above all with this vivid charm, Picasso does not seem in his own art to have quite the momentum which his effect on others would lead one to expect. Imagine, so as to make this clear, that at some future time all the authentic works of Picasso have been destroyed, that he has become a name like Wu Taotzu, and that enough of the works of the period have survived for us to trace all these innumerable branches converging towards their lost point of origin. I think that we should construct a vaster, more imposing figure of the lost Picasso than the figure presented to us at the Leicester Galleries.

To take a single example of what I mean. There is one very important period of Picasso's career, that in which the influence of Negro art was paramount, which is hardly represented at the Leicester Galleries at all. It is just adumbrated in Mr. Clive Bell's Still Life No. 15. Now, I believe that in this period Picasso discovered a certain system of forms which Derain seized upon, and became the point of departure for the whole evolution of Derain's art. Now, if we had Derain's work and not Picasso's, and if we argued by analogy with what usually happens in such cases, we should certainly suppose Picasso to have been a graver, more impressive figure than Derain, and yet, knowing both, I feel personally (though I should like to express it as tentatively and hesitatingly as possible) that it is the other way about, and that Derain, by pushing on along the road which Picasso pointed down only to turn aside, has arrived at a weightier, more moving conception of pictorial expression.

There, then, is what bothers one about one's estimate of Picasso. He is to the æsthetic investigator what Radium appeared to be in the realm of Physics—a body the activity of which was out of all proportion to its own mass and weight. This, of course, in no way affects the value and importance of that activity nor the preciousness in the world of modern art of this radio-active body. Whether the abstract picture succeeds in expressing and arousing emotion as fully and more purely than representative pictures or fails, the effort in either case has been of immense importance to art in throwing us back on the internal necessities of design. It has forced us to explore and understand those laws which artists are always tending to lose sight of under pressure of the interest and excitement of representation.

Many years ago, when first these abstract paintings were brought to our

notice, I said that it would be impossible to judge at once how far they would succeed; that we must wait to see how much our response to such abstract appeals to the visual sense could be developed. I think the lapse of time has shown that our sensibility in this direction is capable of development. At M. Léonce Rosenberg's gallery there is a succession of exhibitions by the younger Cubist artists, who all succeed more or less completely in developing, out of the materials which Picasso quarried, a personal style. That is to say, by an almost purely abstract use of forms they each succeed in giving a unique and personal expression. This shows, then, that there is nothing inherently impossible in the venture to create expressive form out of the minimum of representation possible, but when we come to consider the quality of what is thus expressed I confess that personally I feel some disappointment. When we consider the emotional effect upon us of non-representative form in architecture, how poignant and massive it is, how for the moment it envelops and controls the whole of our imaginative being, we might hope that a similar vehemence and persuasiveness might emanate from the abstractions of Cubist painting. But, somehow, hitherto this does not appear to have happened. We are intrigued, pleased, charmed, but hardly ever as deeply moved as we are by pictures in which representation plays a larger part. This may merely mean that the language of abstract form has not been sufficiently developed or that our response to it is still inadequate, or that no artist of sufficient emotional momentum has hitherto employed that medium.

One suggestion, however, occurs to me as a possible explanation of this result. For some reason the effect on the mind of flat forms is feeble in comparison with the effect of forms that either present or represent relief in three dimensions. Picasso himself is keenly aware of this, and nothing in his work is more remarkable than the extraordinary invention he displays in the discovery of new qualities of pigment calculated to suggest the relief of one surface upon another. Even in such a piece as the Nature Morte No. 14, where the linear design appears to suggest no relief at all, he has gained a certain plastic quality by the extraordinary contrasts of *matière*. In this direction he has enriched the vocabulary of pictorial art immensely. But although no one could possibly mistake his creation for flat patterns, although every resource of scholarship and invention has been called in aid, the obstinate fact remains that the limit of depth into the picture space is soon reached, that these pictures rarely suggest much more backwards and forwards play of planes than a high relief in sculpture. The immense resource of suggesting real distance and, perhaps even more important, the circumambience of space seems to be almost cut off, or at most reduced, in its power to persuade the imagination.

But to return to the problem of Picasso himself. It is hard to remember that he is still young as artists go; but that should warn us to be careful in our estimate. Some of the greatest artists—Rembrandt is the most striking example—have been more or less the victims of their own extravagant endowment. They have had to run through their gifts, trying each in turn, until they could discover their central quality. And Picasso suggests such a type. The earliest work here gives, it is true, little hint of Picasso's power. But then comes the so-called "Blue period," where he reveals an astonishing gift of psychological interpretation of a very peculiar kind—at moments he even threatens to become sentimental. Something of this power survives in the "Negro period" in such portraits as the Miss Stein—there is nothing corresponding to this in the present exhibition; then come the first attempts at more or less complete abstraction, and for the time being he scraps the most striking characteristics of the previous periods. This is a period of feverish and intense research. The forms are intricate and agitated and colour is reduced to a minimum—these, again, are hardly shown at the Leicester Galleries. Then he gains the power to organise abstract form in larger, more easy designs, and from then on he seems to me to have increased his power of expression steadily, inventing continually new oppositions of *matière*, new colour harmonies. The work has steadily become denser, richer, more solid. Fortunately of this period there are many fine examples to be seen. And all the time Picasso has returned again and again to representation, at least in his drawings. Will he perhaps ultimately return to it in his larger works? Return to it with the varied and enriched pictorial vocabulary which his abstract painting has given him. It would not surprise me, and I should expect that when he does he will prove even a greater artist than the painter of inexhaustible charm and invention that we already admire.

INDEPENDENT GALLERY:
VANESSA BELL AND
OTHON FRIESZ

THE first quality of Vanessa Bell's painting is its extreme honesty. I have been taken to task by "the adversary" for calling a painter's work honest on the ground that I am confusing æsthetics and ethics. But I cannot see how one is to deny certain moral qualities which are advantageous to the production of the best æsthetic work. They are not necessarily the same moral qualities as bring a man respect in common life, though it is not impossible that they may be combined. There is, for instance, a certain artist who is a thief and a lair in ordinary life. He will even pick his friend's pocket, which certainly is a breach of moral standards, but he is none the less *qua* artist moral in that his work is free from insincerity and humbug. On the other hand, there are many respected and honoured members of society whose word no one would doubt, whose debts are scrupulously paid, who are good husbands and fathers, and yet are immoral artists in that they take money for pictures which are not what they pretend to be. In their work they are not honest about their sentiments, making out that they are more interesting, impressive, noble or what not, than they really are.

Honesty in this sense, as in the other, is a relative term; every artist must at one time or another be tempted to cover up some gap in his design by a plausible camouflage, and even if he is in the main honest, he has probably more than once fallen. Now, it seems to me that Vanessa Bell comes very high in the scale of honesty, and in her case the virtue shines with a special brightness because she has no trace of what would ordinarily be called cleverness in a painter. I take cleverness to mean the power to give an illusion of appearance by a brilliant shorthand turn of the brush. Hals, for instance, is a very clever painter; Sargent was at one time, and how many more who have succeeded him in popular favour. This is the quality which of all others is the most rapturously acclaimed by the public, while artists themselves are not insensible to its charm. Now, Vanessa Bell is not only not clever but she never makes the slightest attempt to appear such. She follows her own vision unhesitatingly and confidingly, without troubling at all whither it may lead

Reprinted from *The New Statesman*, 3 June 1922, 237–38.

her. If the result is not very legible, so much the worse; she never tries to make it out any more definite or more vividly descriptive than it is.

It is the same with the quality of her painting. She has worked much with Duncan Grant, who is distinguished for the charm and elegance of his "handwriting." Her "handwriting," though it is always distinguished, is not elegant. It is slower, more deliberate, less exhilarating. But she seems to have made no effort to acquire a more pleasing manner; she realises that it is only the unconscious charm of gesture which counts in the end. She has, in fact, entirely avoided a mistake which almost always besets English artists at some period of their career, namely, the research for beautiful quality as an end in itself. She knows that "handling" and quality of paint are only really beautiful when they come unconsciously in the process of trying to express an idea.

Although the unfortunate obsession of quality as an end in itself is, as I think, peculiarly common in England, it is by no means unknown in France, and two pictures by Couture at the Burlington Fine Arts Club supply examples of the falsity and unreality which results from thus putting the cart before the horse. Anyhow, Vanessa Bell is singularly free from this artistic insincerity. One feels before her works that every touch is the outcome of her complete absorption in the general theme. So complete is this devotion to the idea that she seems to forget her canvas and her *métier*. In fact, she is a very pure artist, uncontaminated with the pride of the craftsman. How much harm, by the by, the honest craftsman has done to art since William Morris invented the fiction of his supposed humility!

To say that Vanessa Bell is not clever may perhaps give a wrong impression, for she is a very accomplished artist; there is nothing amateurish or haphazard about her work. The very absence of any anxiety about the effectiveness of what she does produces a refreshing sense of security and repose. She is never emphatic; she is genuinely classic in the sense that she allows the motive to unfold itself gradually to the apprehension. And the attention is held at once by the peculiar charm and purity of her colour and by the harmony of her designs. In these she always shows an admirable sense of proportion. I do not think she makes any great or new discoveries in design, but it is always rightly adjusted and almost austerely simple and direct. She shows, indeed, a keen sense of the underlying architectural framework. But adequate as the design is, it seems to me that in this direction her development is not yet complete: that in this she has not yet quite discovered her personal attitude. Among her early works I remember one or two that suggested a peculiarly personal feeling for the architectural opposition of large rectangular masses and bare spaces. There was a gravity and impressiveness in these which I miss in her present work. What she has gained in the

meantime is immense. It lies in the command of a far richer, more varied and more coherent, texture of tone and colour. It may well be that what I take to be her instinctive bias in design will again reassert itself now that she has gained the control of her means of expression. I suspect it is in this question of design rather than elsewhere that the influence of Duncan Grant's more playful and flexible spirit shows itself.

But, after all, it is as a colourist that Vanessa Bell stands out so markedly among contemporary artists. Indeed, I cannot think of any living English artist that is her equal in this respect. Her colour is extraordinarily distinguished. It has even more than her drawing and design measure and proportion. Look at the *Still Life* (No. 8) of aubergines and onions lying on a table before a grey wall. All the notes are curiously restrained; if anything the force of colour is understated, and yet, so perfect is the harmony of these softened notes, that the whole effect is resonant and rich. Or, take again one or two of the Paris sketches, views of the Pont Neuf seen from the quays. There are nothing but a few tones of warm grey and ochre lights, but how luminous and gay the result is. Vanessa Bell has indeed found that the secret of colour lies not in vehemence but in maintaining the pitch throughout. She never puts in a touch of merely non-committal or nondescript colour. However apparently neutral or unimportant a tone of grey shadow may appear, its pitch is as exactly found as if it were a piece of brilliant local colour. Every note has indeed its full resonance and effect in the total harmony.

It is curious how little the human figure makes its appearance in Vanessa Bell's work; her rooms are empty and her landscapes lonely. This suits, I expect, her habitual mood of grave but joyous contemplation. All the same, the three portraits shown, though two of them are only sketches, display a talent which she has not exploited much. For they show great power of characterisation. It is perhaps rather detached and external, but these figures are singularly alive and coherent in gesture and expression. The portrait of Mrs. M. is perhaps the most brilliant thing in the whole exhibition.

This exhibition ought, I think, to prove how high a place Vanessa Bell is entitled to in contemporary English art. I come back to the fact that the feeling of grave, untroubled serenity and happiness, which is the dominant mood of the exhibition, comes from the singular honesty and purity with which she accepts and expresses her vision.

In an adjoining room there is an exhibition of recent water-colours by M. Othon Friesz. I have so recently expressed my opinion about M. Friesz's talent that I need only add that in these works he shows all his astonishing command. I do not, however, think that he appears quite to such advantage in these as in his oil paintings. The qualities necessary for water-colour are

economy and directness of expression. Friesz certainly has these, but he has them, if anything, to excess. It is as though the medium justified him in the brilliant *résumé* of the motive which comes to him almost too easily. Personally, I like him better where the medium is not quite so pliable to his control, where there is imposed a little more time for meditation and revision. All the same, it may be imagined that for sheer power of directness and acuteness of statement these water-colours are very remarkable. In some quite recent views of the Seine, he shows his rapid grasp of the constructive elements of the design, and it is surprising how, with a few rapid washes, he builds up for us the essential spacial effect and hints at the complete recession of the planes.

THE ARTIST AND PSYCHO-
ANALYSIS

A S I am no psychologist, my presumption in addressing a gathering of
professional psychologists seems to call for apology. My defence is that
of late years you have managed to make yourselves so interesting to the world
at large that you have inevitably attracted the attention of outsiders. You have
let off too many fireworks in your back garden to wonder that strangers have
been looking over the wall.

Before the advent of Dr. Freud you worked for so long in a tranquil and
almost deserted solitude that this invasion of your privacy may be a strange
and disturbing experience. As an artist let me assure you that you will get
accustomed to it, for we artists have always been absurdly interesting to the
outside world, and are, a good many of us, by no means averse from these
self-invited guests in our workshops. And to be perfectly frank psychologists
are the latest disturbers of our rest and threaten to be not the least
importunate.

That is one reason why I thought it might be profitable if we arranged
together the terms on which you would be not only admitted, but welcomed.
Those terms are very simple, they consist of one clause, namely, that before
you tell us what we are doing and why we do it, we think you should take
the trouble to understand what we think we are doing and why we think we
do it. I know how impatient doctors are while the patient is going through
his symptoms but he does generally make that concession to human nature.
If after that, you can show us that we have got a mistaken notion of our own
activities, that we have unconsciously rationalized them and in doing so dis-
guised their true significance, we will listen in all humility.

What I have to suggest to you to-night is rather complicated. I will
therefore begin by summarizing briefly my main ideas.

(I) The words "art" and "artist" are simple enough, but alas they have no
sharply defined usage. Artists are a group of people of very different temper-
aments and some of them are actuated by quite different motives, and exer-
cise quite different psychical activities, from others.

Reprinted from the pamphlet issued by the Hogarth Press, London, 1924.

(2) I believe that two distinct aims and activities have got classed together under the word "art," and that the word "artist" is used of two distinct groups of men. One of these groups into which I would divide artists is mainly pre-occupied with creating a fantasy-world in which the fulfilment of wishes is realized. The other is concerned with the contemplation of formal relations. I believe this latter activity to be as much detached from the instinctive life as any human activity that we know; to be in that respect on a par with science. I consider this latter the distinctive esthetic activity. I admit that to some extent these two aims may both appear in any given work of art but I believe them to be fundamentally different, if not in their origins, at least in their functions.

To begin with let us get clear about the question of origins. No doubt the question of the origin of any phenomenon is of great interest and impor-tance, but it must always be borne in mind that the discovery of the origin is not an explanation of the phenomenon. Origins do not necessarily explain functions. The alimentary canal and the brain both have their origin in the epithelial tissue, but one would give an enquirer a strange idea of the func-tional importance of the brain in the economy of the body if one only stated that it was originally part of the skin.

So if you were to prove that art originated in the sexual feelings of man, that might be a very important and interesting discovery, but it would be no explanation of the significance of art for human life. Not what an organ came from, but what it has come to be, is the most important consideration, though what it came from, and the path it has taken in its progress, may throw a light on what it really is. As an instance take the case of language. Dr. Freud in his lectures quotes a theory of language which I am not quali-fied to criticize or approve but which sounds to me plausible—it is that when men began to work in groups at wood-cutting, building, or what not, they sweetened their toil by shouting together sounds that had a sexual sig-nificance and that gradually these sounds become dissociated from sex and associated with particular actions or objects, and thus the original roots of language came into being. Now to argue from this that language is merely a function of the sex instinct would be grotesque. Since it has come to be the vehicle for the whole discursive intellectual life of man—it has come to serve most of all precisely those activities which are most completely removed from the instinctive life. Indeed all human activities must presumably have their ultimate origins in some part of the purely animal and instinctive life of our earliest ancestors.

Science itself, the activity of the pure reflective intellect, no doubt comes from a gradual misapplication and distortion of what was once only a weapon

in the struggle for life. What was once hardly more than the animal inge-
nuity, which enabled man to contrive elementary devices for protection or
shelter, has become through that very process of misapplication the purely
reflective and disinterested intellectual power of an Einstein or a Freud, and
we can show almost every intermediate stage in this long process. Now if you
wanted to investigate the real nature of this truth-seeking passion of scientific
men, it might be important, no doubt, to discover when it first branched off
from the instinctive ratiocination of animals, but you could say nothing about
its significance unless you studied it beyond the point where it had lost all
traces of its subservience to the instinctive life. To understand the scientific
activity you must note that its essence is precisely this complete detachment
from the instinctive life, its complete uselessness, its abiological nature, since
it exists not to serve life but truth, and this is precisely why those who devote
themselves to this activity are constantly in conflict with the mass of man-
kind which is deeply concerned with life and completely indifferent to truth.

Now one of the pleas I want to make to you is that, if you wish to
discover something about the nature of artistic activity, you should study it at
a stage where it has thrown off the traces of its origin, has run clear, as it
were, of all these accessory accompaniments which surround and, perhaps,
cloak it in its earlier stages.

There is such a thing as impure or useful science, and, if you were to
analyze that activity, you would find all sorts of biological motives at work,
although the fundamental truth-seeking passion of pure science is distin-
guished precisely by its independence of, and its indifference to, biological
necessity.

Similarly there is an impure and, perhaps, useful art (though the use of
impure art is not so easily demonstrated as that of impure science); here too,
analysis would reveal a number of elements which really form no part of the
essential esthetic activity, and you will make a serious mistake if, after such
an analysis, you declare these to be constituent parts of that phenomenon.

If you have a substance which you know to be chemically pure it is clear
that you have a right to say that every element which you discover in that
substance by analysis is a constituent part of it, but, if you have any reason to
suspect an impure mixture, you know that any particular element which the
analysis reveals may be due to the impurity and form no part of the substance
which you are investigating.

Now that the esthetic activity does mix in various degrees with a number
of other activities is surely evident. Take for instance advertisements: many of
these show no esthetic effort and do not even try to afford esthetic pleasure;
they merely convey more or less inaccurate information about a particular

object. You can think of advertisements where not only are the merits of the objects enumerated but the object, let us say a bottle of Somebody's Beer, is depicted. Every detail of the bottle and its label is given so that we may recognize it when we see it in the bar, but there is no sign that in the manner of representation any thought has been expended for our esthetic pleasure. On the other hand I take certain advertisements in American journals, where advertisements are taken seriously and romantically, and I find a very genuine effort, in the proportion and spacing of the letters, in the harmonious consistence of the forms, and in the exact presentation of the object, towards esthetic pleasure. None the less this esthetic appeal is mixed with all sorts of appeals to other feelings than the love of beauty—appeals to our sense of social prestige, to our avarice, to our desire for personal display, and so forth.

Or take again the case of dress—here no doubt there is often a considerable care for pure beauty of line and harmony of colour, but such considerations have continually to give place to far more pressing concerns connected with social rivalry, in fact to all the complicated mass of instincts which go to make up what we call snobbishness.

These, then, are cases of obvious mixtures, in which the esthetic impulse has a part—but you will say these belong to applied art; if we take pictures which subserve no ultimate use we shall surely be safe. But alas the vast majority of pictures are not really works of art at all. No doubt in most a careful analysis would reveal some trace of esthetic preoccupations, but for the most part the appeal they make is to quite other feelings.

For the moment I must be dogmatic and declare that the esthetic emotion is an emotion about form. In certain people, purely formal relations of certain kinds arouse peculiarly profound emotions, or rather I ought to say the recognition by them of particular kinds of formal relations arouse these emotions. Now these emotions about forms may be accompanied by other emotions which have to do more or less with what I call the instinctive life.

The simplest examples of this can be taken from music. If, as frequently happens, an unmusical child strikes six notes in succession on the piano, the chances are that no one would be able to perceive any necessary relation between these notes—they have been struck by accident, as we say. But if I strike the first six notes of "God Save the King," every one who is not quite music-deaf recognizes that they have, as one would say, a meaning, a purpose. They occur in such a sequence that after each note has been struck we feel that only certain notes can follow and, as the notes follow one another, they more or less adequately fulfil our expectation, i.e., from the beginning the idea of a formal design or scheme is impressed on our minds, and anything which departed violently from that would be not merely meaningless,

but an outrage to our sense of order and proportion. We have then an immediate recognition of formal design, of a trend in every part towards a single unity or complete thing which we call the tune.

Now let us suppose that you hear "God Save the King" for the first time; it is possible that you would get an emotion from the mere recognition of that formal system. I do not say it would be a very profound or important emotion, but it might be an emotion, and it would probably stir up no image whatever in your mind, would be associated with no particular person or thing or idea. But those particular notes have become associated with many other things in our minds, so that when they are played we no longer can fix our minds on the form, we are instantly invaded by the associated feelings of loyalty, devotion to country, boredom from the memory of tiresome functions, or relief that we can now at least leave the theatre. We shall say that that particular formal design of notes has become symbolical of numerous other things with which is has become associated.

Now this simple case presents in easy form some of the problems which confront us in works of art of all kinds. The form of a work of art has a meaning of its own and the contemplation of the form in and for itself gives rise in some people to a special emotion which does not depend upon the association of the form with anything else whatever. But that form may by various means either by casual opposition or by some resemblance to things or people or ideas in the outside world, become intimately associated in our minds with those other things, and if these things are objects of emotional feeling, we shall get from the contemplation of the form the echo of all the feelings belonging to the associated objects.

Now since very few people are so constituted by nature or training as to have developed the special feeling about formal design, and since everyone has in the course of his life accumulated a vast mass of feeling about all sorts of objects, persons, and ideas, for the greater part of mankind the associated emotions of a work of art are far stronger than the purely esthetic ones.

So far does this go that they hardly notice the form, but pass at once into the world of associated emotions which that form calls up in them. Thus, to go back to our example, the vast majority of people have no notion whether the form of "God Save the King" is finely constructed and capable of arousing esthetic emotion or not. They have never, properly speaking, heard the form because they have always passed at once into that richly varied world of racial and social emotion which has gathered round it.

And what is true of certain pieces of music is even more true of the graphic arts. Here we have forms which quite visibly resemble certain objects in nature, and not unfrequently these objects, such for instance as a beautiful

woman, are charged for us with a great deal of emotion. When to this we add that people are far less sensitive to the meaning of visible formal design than they are to audible design, we need not be surprised that pictures are almost always estimated for qualities which have nothing, or almost nothing, to do with their formal design or their esthetic quality in the strict sense.

To satisfy this emotional pleasure in the associated ideas of images which the mass of mankind feel so strongly there has arisen a vast production of pictures, writings, music, etc., in which formal design is entirely subordinated to the excitation of the emotions associated with objects. And this is what we may call popular, commercial, or impure art, and to this category belongs nowadays the vast majority of so called artistic productions. On the other hand in each generation there are likely to be a certain number of people who have a sensitiveness to purely formal relations. To such people these relations have meaning and arouse keen emotions of pleasure. And these people create such systems of formal relations and do not sacrifice willingly or consciously anything of those formal relations to the arousing of emotions connected with objects in the outside world. Their whole attention is directed towards establishing the completest relationship of all parts within the system of the work of art.

It so happens that these systems of formal relations the meaning of which is apprehended by a comparatively few people in each generation, have a curious vitality and longevity, whereas those works in which appeal is made chiefly to the associated ideas of images rarely survive the generation for whose pleasure they were made. This may be because the emotions about objects change more rapidly than the emotions about form. But whatever the reason, the result is that the accumulated and inherited artistic treasure of mankind is made up almost entirely of those works in which formal design is the predominant consideration.

This contrast between the nature of inherited art and the mass of contemporary art has become so marked that the word "classic" is often used (loosely and incorrectly, no doubt) to denote work which has this peculiar character. People speak of classical music, for instance, when they mean the works of any of the great composers. It is significant of the rarity of comprehension of such formal design that to many people classical music is almost synonymous with "dull" music.

Now what I want to put before you is that the purposes and methods of these two kinds of art and of the two kinds of artist that produce them are so different—in so many ways so diametrically opposed that when you set out to analyze the nature and function of art by psychological tests, you must know

which kind you are dealing with and you must keep your results in separate pigeon-holes or else you will only make confusion worse confounded.

Before I go any further I will turn to what one or two of the psychological authorities have said on the subject. I quote the passage in his introduction to Psycho-Analysis in which Dr. Freud speaks of the artist. This is what he says:—

> Before you leave to-day I should like to direct your attention for a moment to a side of phantasy-life of very general interest. There is, in fact a path from phantasy back again to reality, and that is—art. The artist has also an introverted disposition and has not far to go to become neurotic. He is one who is urged on by instinctive needs which are too clamorous; he longs to attain to honour, power, riches, fame, and the love of women; but he lacks the means of achieving these gratifications. So, like any other with an unsatisfied longing, he turns away from reality and transfers all his interest, and all his Libido, too, on to the creation of his wishes in life. There must be many factors in combination to prevent this becoming the whole outcome of his development; it is well known how often artists in particular suffer from partial inhibition of their capacities through neurosis. Probably their constitution is endowed with a powerful capacity for sublimation and with a certain flexibility in the repressions determining the conflict. But the way back to reality is found by the artist thus: He is not the only one who has a life of phantasy; the intermediate world of phantasy is sanctioned by general human consent, and every hungry soul looks to it for comfort and consolation. But to those who are not artists the gratification that can be drawn from the springs of phantasy is very limited; their inexorable repressions prevent the enjoyment of all but the meagre day-dreams which can become conscious. A true artist has more at his disposal. First of all he understands how to elaborate his day-dreams, so that they lose that personal note which grates upon strange ears and becomes enjoyable to others; he knows too how to modify them sufficiently so that their origin in prohibited sources is not easily detected. Further, he possesses the mysterious ability to mould his particular material until it expresses the idea of his phantasy faithfully; and then he knows how to attach to this reflection of his phantasy-life so strong a stream of pleasure that, for a time at least, the repressions are out-balanced and dispelled by it. When he can do all this, he opens out to others the way back to the comfort and consolation of their own unconscious sources of pleasure, and so reaps their gratitude and admiration; then he has won—through his phantasy—what before he could only win in phantasy, honour, power, and the love of women.

I must ask you to believe that any criticism I make on this passage is not actuated by motives of personal pique. To be called introverted and on the brink of being neurotic does not seriously affect me. Indeed ever since I observed that the only people worth talking to, the only agreeable companions, belonged to the class that morbidly healthy, censorious people classed as neurotic and degenerate, these words have lost all terror for me. All the same I must declare that the portrait of the artist here given is drawn on the lines of a widespread popular fallacy about the "artistic temperament."

Most people lead dull, monotonous, and conventional lives with inadequate satisfaction of their libido and one of their favourite phantasies is that of the Bohemian—the gay, reckless, devil-may-care fellow who is always kicking over the traces and yet gets toleration and even consideration from the world by reason of a purely magic gift called genius. Now this creature is not altogether a myth—he or something like him does undoubtedly exist— he frequently practises art but he is generally a second-rate artist. He may even by a very brilliant and successful one, but he is none the less a very minor artist. On the other hand almost all the artists who have done anything approaching first-rate work have been thoroughly bourgeois people— leading quiet, unostentatious lives, indifferent to the world's praise or blame, and far too much interested in their job to spend their time in kicking over the traces.

Now all through this passage Dr. Freud is giving us the picture of such a brilliant, successful and essentially impure artist—I need not say that I use the words "pure" and "impure" in a strictly esthetic sense without any reference to sexual morality—i.e., he is an artist who realizes the dream world wherein he and his admirers find an ideal satisfaction of their unsatisfied instincts. He creates images and situations which belong to this dream world wherein we are free to play the rôle which we all think we have somehow missed in actual life.

It is quite true that this explains nearly all contemporary artistic creation. You have only to think of the average novel, especially the feuilleton of papers like the *Daily Mail* and the *Daily Mirror,* and others, which supply every day their pittance of imagined romantic love to hungry girl clerks and housemaids. In fact I believe the most successful and widely read of these (mostly lady) novelists do really day-dream in print, as it were; nothing else would account for their astounding productivity. These people have the fortunate gift of dreaming the average person's day-dream so that the wish-fulfilment which comes natural to them coincides precisely with the wish-fulfilment of a vast number of the population. Other less fortunate writers have deliber-

ately and consciously to concoct the sort of day-dream that they believe the public, want, and these can never be quite the best-sellers.

None of these conditions apply to any first-rate novel—the novels that have endured do not represent wish-fulfilment to any considerable extent. They depend on the contrary for their effect upon a peculiar detachment from the instinctive life. Instead of manipulating reality so as to conform to the libido, they note the inexorable sequence in life of cause and effect, they mark the total indifference of fate to all human desires, and they endeavour to derive precisely from that inexorability of fate an altogether different kind of pleasure—the pleasure which consists in the recognition of *inevitable sequences;* a pleasure which you see corresponds to the pleasure which we found in marking the inevitable sequence of the notes in a tune; in fact again a pleasure derived from the contemplation of the relations and correspondences of form. To give you instances—no one who hoped to get an ideal wish-fulfilment would go to *Mme. Bovary* or *Anna Karenina* or even *Vanity Fair.*

Another immense art industry of to-day is the Cinema, and here too wish-fulfilment reigns supreme. I remember an advertisement of a Cinema with the legend "Let us live a life in two hours." This was a clear appeal to the desire to realize ideally what reality had denied, and indeed there can be no doubt about the method and purpose of nearly all the films, at least such as are not definitely comic, since the comic introduces another problem which I cannot go into now.

By a process which is mere child's play in the dream life we instantly identify ourselves with the hero, and then what satisfaction we attain! With what incredible skill and what incredible good fortune we foil the villain's plot against the heroine, arrive in the nick of time to shoot him dead, and ride off with the heroine either insensible from fear or just able to cling to us for dear life as we cross terrible ravines on a fallen tree-trunk, scale precipices and crash through forests, and always with the certainty of ultimate and triumphant success! But I needn't labour the point; the theatre with its audience always clamorous for a happy ending is no less obvious a case.

What is more interesting is the question of the real artist's attitude to all this; for, in so far as he has to depend on his art for his living, he is under the hard compulsion of throwing a sop to the public, and therefore of giving some satisfaction to the dream-life in his creations. The whole question of the artistic conscience centres round this point. It so happens that some great artists have had rather easy artistic consciences. Dickens is a noteworthy case of this and you all know how he deliberately and consciously spoiled one of his novels by yielding to the clamour of the public and giving it a happy

ending, though by doing so he broke the sequence which he knew to be esthetically inevitable.

But the mere fact that there is such a conflict between the artist and the general public is a proof that, qua artist, the creator has other aims than that of wish-fulfilment and that the pleasure which he feels is not thus directly connected with the libido.

Freud, however daring some of his generalizations may be, is a man of scrupulous intellectual integrity, and he has generally avoided treating the question of esthetics and the artistic impulse, knowing I suppose, that he has not the necessary sensibility and understanding. But other Psycho-analysts have gone further. Dr. Jung devotes a chapter of his psychological types to the artist. I wish I could criticize this, but I frankly confess I do not understand what it is about. Nothing that he says corresponds to any kind of experience which I or, I suspect, any of the artists I have ever known have ever had. In fact, I can find no connection at all with real experience so that I must simply leave it on one side, merely noting by the way that, according to Jung, Western Art implies an extrovert attitude and Eastern Art an introvert attitude (Freud you will remember makes all artists introvert). Anyone who knows Oriental and Western Art at all intimately must shudder at the temerity of any such generalization.

I quite recognize that a certain positive turn of mind makes me unfitted to follow Jung's speculations and that I am perhaps unfairly neglecting him. I turn to Dr. Pfister and here too, I will confess to a certain prejudice. I find, according to him, that psycho-analysis can only be safely practised by Christians,—all other religions are dissolved by the destructive activity of psycho-analysis—but the Christian religion has the mysterious power of remaining insoluble. This hardly reassures me that Dr. Pfister possesses that intellectual impartiality which Freud so rightly claims as the chief weapon of the man of science.

Well, Dr. Pfister has a chapter on Psycho-Analysis and Art. He had the opportunity to analyze a youth of eighteen, who had apparently come to him for treatment and who was frequently disposed to paint pictures. I will read you a description of a typical example "The Bridge of Death."

"A youth is about to leap away from a female corpse on to a bridge lost in a sea of fog, in the midst of which Death is standing. Behind him the sun rises in blood-red splendour. On the right margin two pairs of hands are trying to recall or hold back the hurrying youth!"

Would you like one more, "Night's highest hope"?

"Night sits as a mother on a rock holding her child on high. Around her

lie 'spirits of the night' holding out their hands to her like praying Moham-medans. Rosy-tipped clouds announce the approaching dawn."

As a result of prolonged investigation of such works Dr. Pfister arrives at the conclusion that:—

"Artistic or poetic inspiration is to be regarded as the manifestation of repressed desires and, as such, formed in accordance with the laws by which Freud grouped the processes participating in the origin of neurotic symp-toms, dreams, hallucinations and related phenomena, save that a whole is created, the deeper psychological significance of which, however, is not per-fectly clear to the artist."

"Everything was present," he adds, "poetic creation, substitution, drama-tization. The most intensive use was made of symbolism."

"Everything was present," I should add, except the faintest glimmer of any artistic feeling. The one thing I should know about this interesting young man's drawings would have been the extreme improbability that he would ever be the least good as an artist.

Indeed from time to time my advice is asked about the drawings of un-happy and dissatisfied young men and women, drawings which are not alto-gether unlike the improvisations of this Swiss boy, and I invariably recommend them not to take up art, because I know that real artists, even if they are destined to paint highly imaginative works and to go mad in the end like Van Gogh, generally begin by making an elaborate study of an old pair of boots or something of that kind.

I do not for a moment doubt the value of Dr. Pfister's analysis from the point of view of understanding the nervous troubles of his patient. I should think, indeed, that they would be in effect as useful as the study of his dreams, but, precisely in proportion as they were valuable as indications of the patient's dream life, they were worthless as indications of the nature of real art.

For I come back to this, that nothing is more contrary to the essential esthetic faculty than the dream. The poet Mallarmé foresaw this long before Freud had revealed the psychological value of dreams, for in his poem in memory of Théophile Gautier he says that "the spirit of Gautier, the pure poet, now watches over the garden of poetry from which he banishes the Dream, the enemy of his charge." You notice that in this connection he calls him deliberately the pure poet, knowing that in proportion as poetry be-comes impure it accepts the Dream. You notice also that Dr. Pfister quite unknowingly betrays how little he knows what art is really about when he says of his patients' work that the most extensive use is made of symbolism. I

have elsewhere expressed the belief that in a world of symbolists only two kinds of people are entirely opposed to symbolism, and they are the man of science and the artist, since they alone are seeking to make constructions which are completely self-consistent, self-supporting and self-contained— constructions which do not stand for something else, but appear to have ultimate value and in that sense to be real.

It is, of course, perfectly natural that people should always be looking for symbolism in works of art. Since most people are unable to perceive the meaning of purely formal relations, are unable to derive from them the profound satisfaction that the creator and those that understand him feel, they always look for some meaning that can be attached to the values of actual life, they always hope to translate a work of art into terms of *ideas* with which they are familiar. None the less in proportion as an artist is pure he is opposed to all symbolism.

You will have noticed that in all these psycho-analytical enquiries into pictorial art the attention of the investigator is fixed on the nature of the images, on what choice the painter has made of the object he represents. Now I venture to say that no one who has a real understanding of the art of painting attaches any importance to what we call the subject of a picture— what is represented. To one who feels the language of pictorial form all depends on *how* it is presented, *nothing* on what. Rembrandt expressed his profoundest feelings just as well when he painted a carcass hanging up in a butcher's shop as when he painted the Crucifixion or his mistress. Cézanne whom most of us believe to be the greatest artist of modern times expressed some of his grandest conceptions in pictures of fruit and crockery on a common kitchen table.

I remember when this fact became clear to me, and the instance may help to show what I mean. In a loan exhibition I came upon a picture of Chardin. It was a signboard painted to hang outside a druggist's shop. It represented a number of glass retorts, a still, and various glass bottles, the furniture of a chemist's laboratory of that time. You will admit that there was not much material for wish-fulfilment (unless the still suggested remote possibilities of alcohol). Well, it gave me a very intense and vivid sensation. Just the shapes of those bottles and their mutual relations gave me the feeling of something immensely grand and impressive and the phrase that came into my mind was "This is just how I felt when I first saw Michelangelo's frescos in the Sistine Chapel." Those represented the whole history of creation with the tremendous images of Sybils and Prophets, but esthetically it meant something very similar to Chardin's glass bottles.

And here let me allude to a curious phenomenon which I have frequently

noticed, namely that even though at the first shock of a great political design the subject appears to have a great deal to do with one's emotional reaction, that part of one's feeling evaporates very quickly; one soon exhausts the feelings connected by associated ideas with the figures, and what remains, what never grows less nor evaporates, are the feelings dependent on the purely formal relations. This indeed may be the explanation of that curious fact that I alluded to, the persistence throughout the ages of works in which formal perfection is attained, and the rapid disappearance and neglect which is the fate of works that make their chief appeal through the associated ideas of the images.

At this point I must try to meet an objection which psycho-analysts are certain to raise. They will say that in my description of popular art I have used the word "wish" in the ordinary sense of a more or less conscious wish, whereas Freud uses wish of a desire which has been repressed from consciousness and remains active in the unconscious. The true Freudian wish is incapable of direct satisfaction. The typical kind of case is something like this. A middle-aged lady finds herself compelled at a certain hour of the day to go into a particular room and arrange all the objects in a particular way. She cannot explain the least why she does it and why she is compelled to perform this senseless act. By psycho-analysis it is discovered that in her extreme youth she was in love with her father and wanted to kill her mother, but that this desire was repressed from consciousness and came out later on in this peculiar and roundabout way. Perhaps both father and mother were dead at the period of her illness, and so any such fulfilment would be impossible but even if alive she has ceased to love her father or be jealous of her mother.

I admit that if you adhere strictly to the use of the word "wish" in this sense, it is quite possible that Cézanne's still-life pictures are a sublimation of some such repressed instincts. But you will notice that Freud himself when he talks of the artist neglects entirely his own definition of "wish." The wish in this case is the unsatisfied trying for "fame, power, money, and the love of women." Now these are not repressed wishes, they are, or may be, clearly allowed in consciousness, and they are capable of direct fulfilment. And he goes on to say that it is only because circumstances do not allow of their direct fulfilment that the artist takes refuge in the phantasy world. Similarly I can guess pretty clearly that Dr. Pfister's young man's inventions are inspired by unsatisfied sexual desire and this too is not repressed in the true Freudian sense. In fact I suspect that many difficulties arise from the habit of psycho-analysts of passing from the strict sense of wish to the ordinary sense without even themselves noticing how misleading the results may be. My criticisms,

therefore, are based on the use that they themselves make of the word in speaking of art.

Now let me assume that you have granted me my main theory at least, in its general outlines—that you admit that while there is an art which corresponds to the dream life, an art in which the phantasy-making power of the libido is at work to produce a wish-fulfilment, there is also an art which has withdrawn itself from the dream, which is concerned with reality, and art therefore which is pre-eminently *objective* and *dis-interested,* and which therefore proceeds in the opposite direction from the other kind of art. If you will admit this, the most interesting problems suggest themselves for solution. What is the psychological meaning of this emotion about forms, (which I will call the passion for pure beauty,) and what is its relation to the desire for truth which is the only other disinterested passion we know of—what, if any, are their relations to the libido and the ego?

And here I will indicate a possibility which will have to be considered, a possibility which has often occurred to me, but with regard to which I have never come to any conclusion. I have admitted from the first the great probability, to me almost a certainty, that all psychic energy is divided [derived] ultimately from the instinctive life and has its source in the satisfaction, at however distant a remove, of some instinctive need or desire. I suppose, but I do not know, that you would trace the love of abstract truth to the reality principle, although, in its higher forms, it has long lost any biological value and has become an end in itself.

I should not be surprised if you were ultimately to trace the love of abstract beauty to the libido, but, even if you should, I should expect you to notice that its relation to that instinctive need is very different from the simple relation of the phantasy-making, dream-like quality of impure, image-making art. For whereas dream-art, if I may use the phrase, is nearly akin to the day-dream and may almost be reckoned as part of the actual instinctive life, the love of beauty implies an almost complete detachment from personality and from the wishes made by our unsatisfied libido.

Even if it derives from the libido, it does not seek to satisfy it directly in any way. None the less the question occurs: What is the source of the affective quality of certain systems of formal design for those who are sensitive to pure form? Why are we moved deeply by certain sequences of notes which arouse no suggestion of any experience in actual life? Why are we moved deeply by certain dispositions of space in architecture which refer so far as we can tell to no other experience?

One thing I think we may clearly say, namely, that there is a pleasure in the recognition of order, of inevitability in relations, and that the more com-

plex the relations of which we are able to recognize the inevitable interde-
pendence and correspondence, the greater is the pleasure; this of course will
come very near to the pleasure derived from the contemplation of intellectual
constructions united by logical inevitability. What the source of that satisfac-
tion is would clearly be a problem for psychology.

But in art there is, I think, an affective quality which lies outside that. It
is not a mere recognition of order and inter-relation; every part, as well as the
whole, becomes suffused with an emotional tone. Now, from our definition
of this pure beauty, the emotional tone is not due to any recognizable remi-
niscence or suggestion of the emotional experiences of life; but I sometimes
wonder if it nevertheless does not get its force from arousing some very deep,
very vague, and immensely generalized reminiscences. It looks as though art
had got access to the substratum of all the emotional colours of life, to
something which underlies all the particular and specialized emotions of ac-
tual life. It seems to derive an emotional energy from the very conditions of
our existence by its relation of an emotional significance in time and space.
Or it may be that art really calls up, as it were, the residual traces left on the
spirit by the different emotions of life, without however recalling the actual
experiences, so that we get an echo of the emotion without the limitation
and particular direction which it had in experience.

But these are the wild speculations of the amateur. It is just here that we
are waiting and longing for you to step in with your precise technique and
your methodical control.

I do not pretend that either artists or art critics have made much of a job
of esthetics. We have started innumerable theories and abandoned them
again without getting at any very positive and assured results. But we have of
late, I think, been able to make a little clearing in the approaches to these
problems by analyzing a little more clearly than the older writers what goes
on inside us when we are confronted by different kinds of works of art and
by knowing, or trying to know, or thinking we know, what, as artists, we are
after.

I expect and desire that you will test everything which we say about
ourselves and our aims as ruthlessly as you test your patients' statements
about their own motives, but at least I hope I have shown that it is important
to know what class of objects we have in view when we talk of works of art;
to know that, if you analyze the pictures of let us say the Royal Academy,
your remarks may interest us on other grounds, but not for the light they
throw on the esthetic process in itself.

REMBRANDT:
AN INTERPRETATION

REMBRANDT has been called the Shakespeare of painting. This is one
of those phrases that produces a slight but very distinct feeling of
queasiness. The worst of it is that it has some truth. At all events one ap-
proaches Rembrandt with some of those mixed feelings that disturb the
critics of Shakespeare. One approaches a shrine already overlaid with offer-
ings, many of them of doubtful taste, and one's view of the divinity is slightly
troubled and obscured by the traces of so many previous worshippers. One
has to forget them and one has to resist even the subtle temptation to a
preliminary outburst of blasphemy which naturally offers itself as a way of
clearing the air.

There is another truth in the odious text of my sermon. Rembrandt
stands side by side with Shakespeare as protagonists in the battle of Ger-
manic culture against Mediterranean culture. We have these two to pit
against the imposing array of Mediterranean giants, and when we feel that
they stand the strain our admiration tends to become tinged with patriotic
idolatry. Now I know that I am a traitor to the North insofar as I am more at
home in the Mediterranean air. I know that before Northern art my admira-
tion is often extorted without my love being won. A well-known critic of
Italian art once said of Rembrandt, "I would as soon collect old boots as
Rembrandt's pictures". The saying is monstrous and abominable but let me
confess at once that I know something of the feeling which dictated it. I
hope I shall not yield to it.

The spiritual situation in Europe out of which the art of the 17th century
arose was due to the reaction of Northern Europe under the impact of the
Italian Renaissance. Catholicism allied itself with Paganism in order to sup-
press free thought; Protestantism, though putting very strict limits on free
thought, set its face entirely against Paganism. Rubens' art fitted in with the
new Catholicism, and predominately Rubens assimilated the essentials of
Italian culture. For Rembrandt Protestantism was inevitable and, though
some flavour of classical culture had found its way into Holland, it took the

Reprinted from *Apollo*, March 1962, 42–55. Reproduced by kind permission of *Apollo* Mag-
azine Ltd.

form of pedantic scholarship or, among the artists, as an absurd dressing up in the external trappings and decorative accessories of the Italian style.

Rembrandt's first master, Lastman, was one of these Italianisers *à la mode*, but the real basis of such culture as Rembrandt inherited was the native Gothic culture to which Protestantism had added, as it did in England, the intensive study of the Old Testament.

Rembrandt himself was clearly not a man of culture like Rubens; he had a few casts of busts from the antique, but he remained untouched by the essentials of Renaissance culture, untouched by the poetry of the classical literature.

Still, since Classicism was the vogue Rembrandt so far yielded to it as to paint several mythological pieces, but we can see from his picture of "The Rape of Ganymede" at Dresden in what a strangely mocking spirit. Nothing is more deadly to a poetical myth than to translate it into hard literal fact. Rembrandt argued that if Ganymede were taken up into Elysium by Jove's eagle the affair must have looked something like this. Ganymede is a fat baby boy who might win a prize in a baby-show but scarcely would have attracted the attention of so experienced a connoisseur as Jupiter. Rembrandt proceeds with the relentless exactitude of his knowledge of human nature to describe his state of squealing terror. He knew all about it and spares us no illusions. He knew even that under the influence of fear Ganymede would behave with that distressing indifference to grown-up conventions which babies so infallibly display at crucial moments. Certainly Rembrandt was no convert to neo-paganism. Nor was he much more interested in the form of Renaissance art than in the matter. It is true that he looked at Italian pictures and drawings and sometimes made use of them for his designs. But he also copied Moghul drawings. His curiosity was omnivorous and Italian art came in for its share but it was not for him the great exemplar as it had been for Rubens. He started from the beginning. He began directly on life. His vast and all-embracing sympathetic imagination provoked his unrivalled power as an illustrator; and he started by illustrating life as he felt it.

Besides life in general he had certain purely visual passions. Above all an intense love of jewellery, of gold, of steel, of everything that glitters. He loved with a quite peculiar intensity the irradiation of light where it strikes on any sharply reflecting surface. He was as it were hypnotised by these splashes of light and he loved to explore all round these explosive centres of light, to trace the irradiation till it became lost in the full surface of the object. There he gave up the search and as he had followed all the gradations from the highest light (but all transformed into the lower key inevitable where a flat painted surface replaces a metallic relief) he found himself

plunged into complete shadow where in nature there would be a dull uniform half tone. At this point he gave up interest. His excitement was then aroused again wherever within the shadow reflected lights produce once more a secondary and tempered explosion of warm light.

Thus his conception of form was as far removed as possible from the tactile drawing of the great Italians. Indeed, he may be said to have had no conception of form as a continuous sequence of planes; for him, form only existed where it received light either direct or reflected. In between the bosses which thus collect the rays he had no particular idea and refused for the most part to say anything. This I believe is the true account of Rembrandt's so celebrated *chiaroscuro*. Light is regarded by him no longer as form-revealing, but as itself the whole object of his interest. The darkness of his picture comes not from his loving darkness but from his loving glitter. Besides this he had instinctive feeling for spatial depth and envelopment; but even this rather for its dramatic effect than its aesthetic quality.

Besides these two qualities he had an instinctive feeling for the representation of space and for the relation of figures in three dimensional spaces, but this again rather for its dramatic effect than its aesthetic quality. I propose then the basis of his genius to be:

1. Sympathetic love of every manifestation of life, and his extraordinary power of finding form that expresses life itself.

2. His love of glittering lights.

3. His instinctive feeling for spatial relations.

The first, from his unique aptitudes, made him the greatest of illustrators. The second was not really an aesthetic quality (far less so than Rubens' instinctive rhythmic sense). It was just an odd passion that could only be satisfied by incessant painting of elaborately finished pictures, and that may be the cause of what happened to him later on. It did not imply, it even seemed to oppose, any conception of form such as appears essential to all great art. What happened was that he did arrive at a great sense of formal beauty at the end of his life. Rubens was a great illustrator particularly in that his powers of representation were so immense that he was never at a loss for the means to render any conceivable object or any aspect of an object—his mental imagery was copious and always ready to hand but the images with which it was stored were in a sense commonplace; they were the result of a shrewd genial outlook on life rather than of a profound one. What he saw in objects was no doubt more precise, more coloured and richer than what the ordinary man sees but it was not different in kind.

But Rembrandt was a great illustrator in another way. When he looked at men and objects they revealed to him something that the ordinary man does

not see at all—they revealed their inner nature, their ultimate essential character and this, too, modified in any way that might be by the circumstances of the moment. He saw them as expressive actors in the drama of life. It was this drama of character under the stress of a situation that fascinated him most and almost always he chose themes which gave a pretext for this profound play of character.

As an illustrator Rembrandt shows an imagination of that high order that seizes at once on the essentials and reveals them without any apparatus or adornment with such directness and simplicity that they come upon us at once with a delightful shock of surprise and a sense of their entire naturalness and inevitability. It is this quality which Rembrandt shares with Shakespeare and how few others. Both Rembrandt and Shakespeare have the almost miraculous power of creating and placing before us in all their fulness and solidity, credible living beings—as in Rembrandt's case, an "Elephant" (Fig. 1) and of doing this with an unparalleled economy of words or pen strokes. Shakespeare gives us what we call a character by a reply of half a line—Rembrandt by three strokes which indicate the turn of a head or the thrust of a hand. Both do this by a kind of creation from within, that is to say, by a method of intuitive sympathy rather than by external observation.

This power of getting out of one's self and moving about freely in other people's souls seems to me almost a peculiarity of the Northern imagination. I think there is a real conflict between this and the plastic imagination proper. If you compare Northern painting with Italian painting, you will notice from their early times that the early French and Flemish were more occupied with face than figure. The body as a whole plays a small part in their expression—everything is concentrated on the face. It simply means that they are more interested in the psychological expression of form than in form itself. Of course, whilst every part of the form is capable of revealing character, it is an undoubted fact that minute changes of the leg muscle have not the same feeling as change in the muscles of the face. Rembrandt had this power of sympathetic personation to the highest degree; and even inanimate objects, by a kind of pathetic fallacy became for him individuals, into whose souls he projected himself. He felt the stresses and strains which have left their marks, almost as intensely as much from within as it were a human being. He interprets its life history in its form, and his emphasis in form is always thus expressive of the whole inner life.

In his drawings of a "Mother and Child" the emphasis is naturally on expression. Think how a more purely plastic artist, a Raphael or Ingres would have explored sequences of planes of shoulder and arm; but for Rembrandt everything that is not immediately expressive of character and mood

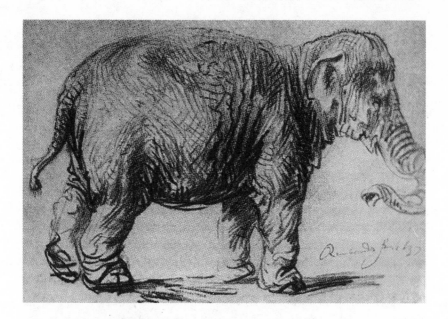

Fig. 1: "An Elephant," 1637. Albertina, Vienna

is merely indicated; notice in any of his typical drawings the beautiful expression of the mother, and the dramatic effect of the movement of the hand and head.

There is, I think, no doubt that Rembrandt was deeply moved by dramatic situations. He chose themes on account of their dramatic interest and treated them in such a way as to emphasise light above everything else. From the point of view of illustration the "Marriage Feast of Samson and Delilah" at Dresden seems to be a masterpiece. All the characters here are vividly conceived and exactly appropriate so that when one has once seen this picture, one cannot easily imagine them to be otherwise. Samson the good natured, rather garrulous strong man, so pleased with himself, so confident in his strength that he is giving himself away by his absurd riddles. Delilah placid in her consciousness of having got her man completely into her power—scarcely showing under her mock modest air, with hands so demurely folded, that she sees everything going on, and can do anything she likes with the formidable Samson. Every type is exactly right and expressing, not only the character, but the mood of the moment.

When we come to the design it seems to be adequate but subordinate to the theme. Rembrandt has with great skill brought out all the points that he wants by the concentration of light on the dramatic effect but it is still not, I

think, regarded as pure form or interesting design, nor as a very interesting discovery. The form in itself seems to me to serve its purpose when it has brought out in detail the dramatic propinquity of all his figures. There is also even here that peculiar sensual quality typical of Rembrandt; his love of glitter. You will see that, wherever possible, he introduces materials with gold and silver weaved into them, so as to get a mass of high lights into the composition.

Rembrandt, one ought to remember, was not a man of wide interests and culture like Rubens. His main reading was the Bible, but he read it with an extraordinary perception of the dramatic implications of the story. His early religious pictures show the particular kind of quality he gets out of his use of highly reflected surfaces, of the gold tassels and fringes and of the carved gilt of the legs. Later on this detailed description of points of light becomes, as it were, the substance of the texture of his painting. The illumination creates a highly centralised and coherent, but not a rhythmically moving, design, but suggestions of space increase the dramatic effect. Rembrandt's entirely fantastic baroque architecture is pictorially effective enough but, architecturally, horrible.

Although Rembrandt was always serious about the Bible, his was no conventional reverence. There was always a good deal of pomp and show in his attitude. In almost all older religious art, and, for that matter, in much modern religious art, the attempt is made to give an idea of the holiness of the story by idealisation, by some kind of unnatural grandiloquence. This was not Rembrandt's way. He starts afresh with the story and his vivid imagination conjures up the scene so exactly according to actual life that his version at once becomes convincingly real and replaces any other possible conception.

The "Decollation of John" generally is conceived as a rather splendid occasion with a good deal of conscious dignity on the part of John and diabolical hatred on the part of the executioner. It is usually rhetorical and not at all dramatic. Rembrandt knew how it happened. John was kept in the basement and when the order to cut off his head was whispered among the servants of the Palace, he knew they would all rush downstairs to see the event. The executioner is not particularly ferocious—he has no reason to be so. He is just doing his job like anyone else. John's figure expressed no particular emotion, and only the gaoler, who one supposes may have got to know his prisoner, looks uneasily aside and on his face there is a look of compassion. Rembrandt had so profound an insight into the ways of men that he always knew, not perhaps what did happen, but how such and such an event would be most likely to have happened.

Rubens, for instance, was a most brilliant and versatile illustrator, but the

quality of imagination he displayed was never profound or moving; his invention, though plausible enough, was always essentially commonplace. It revealed no striking insight into situation and character. Rembrandt, on the other hand, is not only a far more profound observer but the quality of his invention is proof of the highest kind of dramatic insight and imagination.

This art of drama, whether in words or in images, moves, as does the cinematograph, by calling up the passions and emotions of actual life. Its effect shares something of this poignancy. When it is in the hands of great creators like Shakespeare and Rembrandt, it also interprets and classifies these emotions. But the aesthetic emotion as such is not concerned with the passions of actual life. It takes us into a region of more contemplative delight. What then are we to make of this peculiar power of Rembrandt. How are we to relate this work with that of Raphael, for instance?

It is, I think, impossible to make a dramatic effect the purpose of pictorial art since this power is rare among great artists. Are we to say that it is a mere accident, a by-product of certain great artists, and if so is it a by-product that is helpful to the end of formal beauty or does it not rather stand in the way? Is there a fusion between the two kinds of emotion. Does each heighten the other or do they lead the mind in different directions? These are the kind of questions that Rembrandt's art put before us.

For the "Christ Before Pilate" in the National Gallery, London, for instance, the drama is conceived in very much the same intense way as in the drawings and carried out with extraordinary mastery. Unity is created entirely by the somewhat artificial placing of light, and the types are invented with such exact relevance to the story. Pilate is a weak, florid, bureaucratic gentleman, full of good intentions but without courage or force of character, horrified and disgusted at the unintelligible outbreak of fanaticism which inspires the High Priest and his followers. These invade him half menacing, half-cringing—they seize his state robes, they gesticulate, they clutch and shake his wand of office. They are amazingly understood as different types. The greasy pharisaical unction of the High Priest himself contrasts with the more disinterested but more bestial bigotry and ferocity of the others, but all are agitated and distraught with the same religious and political passion.

A later return to his dramatic interpretation of Biblical stories is to be found in "David harping before Saul" in the Mauritshuis, The Hague, and once more, I think, one feels the dramatic interest. It has indeed all his wonderful dramatic invention. The type of the old embittered, disappointed and disillusioned aristocrat with his gouty hands and ravaged cheeks is splendidly contrasted to the precocious and inspired Jewish boy who is playing to him and the motive of Saul's sudden softening mood is given by the aston-

ishing invention of his unconscious seizing the curtain to wipe his tears. As a drama, it is as moving and as pathetic as anything in Rembrandt's work and it has the great and purely artistic qualities that we associate with his late work.

Rembrandt's talent as a portrait painter was almost immediately recognised. His contribution was too striking to be missed. His method of emphasising the character and likeness were likely to make him welcome in this capacity and the 17th century Dutch had as fixed a mania for seeing themselves immortalised on canvas as modern society ladies. The only difference being that they wanted a vivid photographic likeness, not a sentimentalised and etherealised reminiscence. What Rembrandt gave in the early stages of his career was really almost as good as a photographic enlargement, and so long before the invention of the camera! Such work rapidly led to fame and money and Rembrandt moved from his father's mill at Leyden to the great centre of Amsterdam where commissions poured in and soon the Surgeons Guild ordered one of those group portraits of Corporations which were all the rage in Holland. These Protestant bourgeois were very different patrons from Rubens' Marie de Medicis who wanted mythological rhetoric and decorative charm. These worthy men wanted the hard facts of their plain faces and as many for the money as possible. Also, as each subscribed an equal share of the picture, each face must be an exact likeness and all of the same importance or as near so as possible. And so we have "The Anatomy Lesson of Dr. Tulp", one of the dullest of all well executed works. The dramatic motive for once is almost obvious and superficial. But this is the sort of picture that led to Rembrandt's disaster. It is, of course, interesting as one of the first of his big groups; but, I think, it is an exceedingly unsatisfactory design in every way; here, as is always the case, he had a perfectly clear sense of how to place things in space but he had no particular rhythmic sense of the relationships of the forms to the space they occupy.

In many of his portraits when there was more than one person, Rembrandt naturally sought some dramatic motive which would enable him to bind the figures together into some sort of coherence so here, in the case of the "Shipbuilder and his Wife" in the Royal Collection, he has introduced the motive of the domestic simplicity of their life. Unity is here, as always, I think, in his early pictures; and it is almost entirely one of dramatic situation.

At the height of his success, in 1634, he married a rich bourgeoise, Saskia van Uylenburgh who brought him a dot of 30,000 gulders. They set up house and Rembrandt's passion for glittering objects found a new pretext. Now we may turn to those smaller works in which he shows more intimately and expressively his genius. Thus we get a typical example of Rembrandt's

feelings at this period in "Simeon in the Temple" in the Mauritshuis, The Hague. This provides a peculiar case of creating the pictorial space illusion. Rembrandt helps to create that dark conception of the depth found in Rubens but what he gets by depth into his pictures is quite different from Rubens' achievement. Rembrandt used it to get a continuous plastic construction. He creates, or rather himself helps to create a Baroque conception of composition in three dimensions. Rubens used it to create a plastic sequence but here it is employed to create a mood by the isolation of small figures in a vast spatial hollow. Rembrandt had generally certain rather peculiar tricks for doing this; for instance, a diagonal line moving into the back, and something on the other side to act as a repoussoir to give the idea that the scene takes place some way off. The relation of volumes to space—in which Raphael showed so profound a plastic feeling is here not plastic at all but sentimental—designed to create mood, not to express form. It is essentially literary and dramatic; it reveals great mastery and originality but is in questionable taste—there is a note of melodrama or, at least, of theatricality in the bad sense, as compared with the genuiness in the actual treatment of the figures.

The "Night Watch"[1] in the Rijksmuseum, Amsterdam, was the turning point in Rembrandt's career. It is an elaborate composition in *chiaroscuro* with many figures disappearing into the gloom. This did not suit those subscribers who found themselves in the dark. There was a great outcry which was the beginning of his downfall. The artist's main support when he turns to portrait painting is based upon vanity, either corporate or individual. Unfortunately for Rembrandt (but fortunately for us) his genius, at this stage, was leading him further and further from any expression of form that could flatter the very ordinary vanity of his bourgeois fellow countrymen. They sought mainly pleasing likenesses of their own faces and in so far as they wanted pictures (and it was socially correct to possess pictures) they liked them to be of a kind that they could understand. They favoured the appearance of great technical skill with the utmost detail and the whole wrought to an even shining polished surface.

As Rembrandt developed his own peculiarly rugged and expressive plastic feeling, the taste of the day set in exactly the opposite direction; and almost all his pupils had the sense to unlearn his teaching and to adopt the polished elegance which had come into favour, so that Gerard Dou and others of his pupils made fortunes while Rembrandt was in great poverty. Rembrandt

1. The correct title of this picture is "The Militia Company of Captain Banning Cock". [*Apollo* ed.]

went in the opposite direction and throughout the 1640s he was rapidly changing his style; certainly he was losing his popularity.

Towards the end of the 1640s, a great alteration took place in Rembrandt. He now began really to feel the relations of the figures and volume to the space, and his manner became far less theatrical. There is the subtle balance of displaced symmetry as shown in the "Christ at Emmaus" in the Louvre, Paris. Clearly Rembrandt was becoming far more sensitive to the problem of design. There is change in plasticity. His forms, for instance, are far more evocative and less descriptive; masses are more evident and contours lost or rendered by merely general indications. The design plays an increasingly important part in a picture like "Joseph's Coat".[2] This shows an increased sense of volumes relatively to space and greater diffusion of lights and less of the lime-light effect for dramatic purposes. He is beginning to introduce a kind of plastic unity into the design, and drama is present though much less striking. Nevertheless, there is still the tiresome repoussoir to the left; but there is more continuity of plastic rhythm, but not great subtlety in its development.

Rembrandt rarely practised landscape painting though he was continually making drawings and etchings of Dutch scenery and though landscape plays a large part in some of his compositions. The "Winter Landscape" of 1646 (Museum, Cassel), is almost the latest of his pure landscapes and almost the only one not conceived in a romantic and rather artificial manner. It reveals his power of creating limitless spaces and situating his objects precisely in it; nevertheless the artifice of the repoussoir is rather evident and too isolated and disunited in silhouette. His instinctive attitude to landscape is seen in his drawings; there is no design but he was extraordinarily skilful in using line to indicate the recessions of planes and to construct an ideated space.

Saskia died in 1642 at the beginning of this crucial period of change in Rembrandt's art. She left a son, Titus, for whom Rembrandt was obliged to obtain a nurse. It was in this way that he came later on to employ Hendrikje Stoffels, who in 1652 became his mistress. Hendrikje's advent was the one piece of great good fortune that befell Rembrandt in later life. Her devotion to him was unfailing and when the final smash of bankruptcy came in 1655 she showed herself an astute business woman. Rembrandt was not only ruined but when everything was sold up, his debts were so large that anything he could earn by his work would be seized by his creditors. Hendrikje and Titus set up an art dealer's business and they employed Rembrandt as their

2. It is not clear to which picture Roger Fry is referring here; it is presumably the painting reproduced in the *Klassiker der Kunst* (1924, p. 303). [*Apollo* ed.]

expert adviser, and to pay him for this gave him board and lodging but with a prior claim on his earnings, which saved him from his creditors.

Hendrikje was also the best model Rembrandt ever had. He painted her almost as incessantly and with as tender a devotion as Rubens had painted his second wife. But this elderly love affair was carried on in a different way to Rubens', and in very different surroundings. Instead of Ruben's palace in Antwerp and his country house at Steen, Rembrandt had lodgings over Hendrikje's old curiosity shop in a remote and neglected quarter of Amsterdam. Here it was at the very end, when Hendrikje and Titus had both died, that Rembrandt himself died in utter neglect and complete destitution. It was probably in this room that Rembrandt executed all the works which established his lasting fame.

Thus in a painting like a "Woman Bathing in a Stream" in the National Gallery, London, which may represent Hendrikje, design becomes visibly coherent for the first time; we get a really exquisitely beautiful movement of planes. And the drawings of Hendrikje are no longer descriptive. Drawing has become intensely evocative, and Rembrandt secures the realisation of volume by means of lines denoting the back and the arms and the movement of planes between these and the breast. Notice, too, the hang of the drapery. A detail has thus become a sign of quality; it has the same richness and diversity of surface as his early brocades but what was then descriptive of elaborate patterns, here turns into a plastic surface. It has breadth and simplicity but it still retains richness and fulness of content.

Rembrandt's grasp of design had become so amazing that all other drawings seem a little empty beside one of the typical nudes of the 1650s. Raphael or Ingres have greater rhythmic perfection but they do not possess all the wealth of substance evident in this work. Because no other artist attained simplicity by so long a road, no other artist compressed—within the simple lines which he finally attained—the simple forms, so minute and detailed, with a sense of all its infinite variety and all its subtle possibilities of change. It is this living quality of Rembrandt's texture which is so intensely exciting to the imagination. There is an extraordinarily direct simplification of the contour, so that one conceives the whole construction and design of the figure at once and how splendidly it is simplified to a geometrical system.

By this time, the 1640s, Rembrandt was at least relieved of bothering about popular taste. He was poor but he was free, and he could paint whatever he wanted for himself. And he found the material for his new conceptions of form in odd and unlikely places, as in "The Slaughtered Ox" in the Hunterian Museum, Glasgow. The play of light upon almost any surface excited in him this intimate rhythmic feeling for its plastic qualities, its den-

sity, its resistance, its infinite play of surface—infinite but revealed to his practised instinct as coherent and inevitable.

Rembrandt attained to design by an indirect method. It was, one guesses, an almost unconscious habit rather than a deliberate and conscious aim. It seems as though he had to get tired of all the possibilities of graphic description before he found the greater significance of rhythmic plasticity. Raphael was an artist who designed consciously and deliberately with, of course, a great natural gift and his design was essentially an architecture of volumes; and to him the texture of surface was hardly a concern so long as it allowed of the clear evolution of his plastic sequence. But Rembrandt began at the other end. He started from texture as in the "The Bridal Costume"—the so-called 'The Jewish Bride' in the Rijks Museum, Amsterdam. It is the actual stuffs of things as revealed by light—the quality of hammered metal, of embroidered brocades, of carved wood and of the human skin. He explores these with a naive passionate sensual delight and he imitates them in all their variety. Gradually, however, he becomes absorbed by the variety of individual textures of objects but in texture as a kind of abstract universal quality of matter. This begins to reveal itself, therefore, not as the actual variable surface but as the whole mass and volume of the object; his mere texture becomes expressive at the end, not of the surface but of all the plastic properties of the object.

Thus he is able to build up the most massive constructions and to give all their three-dimensional relief without those violent illusions of light and shade on which he had relied in his youth. He can even reassert the flatness of the picture surface, not only without losing relief but with a vastly increased imaginative suggestion of relief mass and volume. Even in the composition he can afford to throw aside all the adventitious aids of repoussoir and diagonal perspective. He can compose almost as flatly as the great Italians and yet suggest convincingly all the surrounding space and the exact relations of the figures within it. His space is as free and ample as ever but in order to achieve his aim he no longer knocks a hole in the wall.

A word ought to be said about his colour—in particular its connection with his late "Self-Portrait" (at Kenwood). In his youth he had sometimes used positive colours but not, I think, with conspicuous good taste—but by the end of his life all his work has become almost a monochrome made up of dull earth reds, violets and greys. For all that Rembrandt is one of the great colourists; no one knew as he did how to play within this restricted scale such rich and enchanting harmonies. The changes of colour come as it were by mere accidents of the brush work—the same colour telling us warmer or colder according to the emphasis of the stroke and what underlies it. It ex-

presses with supreme perfection all the subtle changes of a local colour as it is turned at different angles to the light—all the greyness of the penumbra, all the saturation of the shadow all the bleaching of direct light. It is used in exact harmony with the subtle movements of plane of the changing surface; and, like his modelling, it possesses this mysterious and unanalysable quality of life in every particle.

Rembrandt then arrived at design through texture—through his intimate sensual feeling for surfaces in light, and when he reached design at the end of his life he imported into it all the rich content of his past experience. It is this that makes these late works so inexhaustibly delightful to those who understand the language of design.

Rembrandt brings us up against two problems of pictorial art more violently than any other painter. These are:

1. The position and value of the dramatic presentation of the appeal to the emotions of actual life.

2. Illusionism. To what extent can we afford to deny the picture surface—to realise so vividly the imagined vision as almost to forget that we are looking at a painted surface.

With regard to the first, Rembrandt's own development would seem to suggest that there is a certain conflict between dramatic expression and formal beauty—that when an artist is intent upon one he will to some extent sacrifice the other. It is evident that the artist who appeals to the emotions of life expresses, interprets and classifies them, and will make a far wider appeal than one who aims at pure formal beauty, since all can follow an appeal to these emotions and comparatively few have a vivid response to the other. I sometimes wonder if Rembrandt is not the only great artist that the world accepts!

It is evident that in drama those who have no feeling about form can enjoy an imaginative pleasure and I do not deny the immense value of this pleasure when I maintain that all the same the other aesthetic pleasure is in some ways more important and more ultimately satisfying as it is less conditioned and more universal in its nature. Admitting then that these two experiences of dramatic and formal art are different in kind and are separate, the question is—can they be united? If so, do they multiply each other, do they add up or do they subtract? Here I have no answer ready. The emotions of life even when called up in imagination, are so poignant that they tend for the time to obliterate all other feelings but they lose their effect more rapidly; they tend to evaporate as we become familiar with the work of art. The formal emotions are less poignant and more lasting, permitting of a more prolonged contemplation. This is why works of formal beauty take so long to

be recognised and ultimately outlive the more exciting dramatic works; therefore, if the dramatic appeal is very strong it will tend to obscure formal beauty; if it be vague and generalised it will not interfere and may become a half conscious undercurrent of our more vivid aesthetic feeling. With Rembrandt drama came first and it was only at the end of his life that formal beauty began to assert its claims.

As for illusionism—we have strong feelings or repugnance to the *trompe l'oeil*. It seems like an insult to our intelligence, as though the artist feared we could take nothing for granted; and it is the opposite of a witty allusion to the thing represented which is undoubtedly one of our pleasures in art. It also destroys the picture as an *objêt d'art*; it loses all decorative charm; and if it hangs on the wall it breaks the wall and has no relation with its surroundings. It is a world isolated by the frame. This is in truth a minor consideration—perhaps we ought not to look at pictures on our walls—perhaps they should be seen one by one as the Chinese look at them or in the perfect isolation with which one regards lecture slides! But I think there is a deeper objection. Our highest pleasure in the contemplation of form depends on some co-operation of our own. We must be inspired ourselves to some imaginative activity. The picture ought to excite a more vivid apprehension of form in our spirit than what we actually see before us. Rembrandt was the most extreme of illusionists but he himself provides the answer by his abandonment of it in his later work, by his decided reassertion of the picture surface. It is fitting that with so dramatic a spirit as Rembrandt's the story of his artistic life is itself most excitingly dramatic. There are few spiritual adventures more enthralling than this of the man who was so terribly endowed for a popular success, being forced by an inner conviction into poverty, disgrace and neglect, and yet finding with each step in his declining fortunes the inner impulse growing stronger—and clearer. He pushed on with unceasing energy to the realisation of something for which the world around him had no conceivable use.

Rembrandt was first a great man; then he was the most obstinately passionate lover of the practice of painting. It was only, as it were, by a process of perpetual trial and error, and almost as it were, by chance, that he became what he was in his later or final years—a great artist.

Towards the end of his life, Fry gave a lecture on Rembrandt, of which the text exists in two versions—one complete, the other less so. This slightly shortened text consists of the first, although a few passages from the second have been interpolated. It is published by permission of Roger Fry's daughter, Mrs. Diamand. [Apollo ed.]

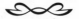

THE DOUBLE NATURE
OF PAINTING

WHEN we take a general look at all the arts—poetry, music, painting, etc.,—we are immediately forced to the conclusion that they all fall clearly into two groups. In one group great use is made of the representation of objects, of people and situations and even of ideas such as are found in everyday life. In the other group representation of these things is often totally rejected or else of minor importance. Thus, music and architecture are able to create great formal constructions which satisfy our aesthetic faculties almost in the same manner as a mathematical proposition satisfies our intelligence, that is to say, without reference to anything outside the construction itself. The constructions contain all the data and all the solutions to the problems involved. These are self-sufficient and stand without external support. In contrast to this, poetry and painting force us to recognize references to such an external reality or we shall not understand the work itself. This is surely true for all poetical works and nearly all painting.

We have admittedly seen a heroic attempt on the part of painters of to-day to escape from this rule and to create a pictorial art almost entirely devoid of any natural representation. We call it abstract art. I think I was one of the first critics to come to the defence of this venture; I even hoped, more than twenty years ago, that it would lead to new artistic revelations, but in spite of the fact that a few most gifted artists, especially Picasso, succeeded in making skilful, well-balanced constructions, these lack the evocative power of appeal of the greatest representational works. I must confess that I find the appeal made by these visual constructions much less moving than those of similar constructions in sound forms that we find in music. This may well surprise us when we reflect that by the disposition of a few visual forms, cylinders, cubes, and spheres, etc., architecture produces effects which are as exciting to our emotions as music itself. One must, however, take into ac-

Reprinted from *Apollo*, May 1969, 362–71. Reproduced by kind permission of *Apollo* Magazine Ltd. A note on the original publication reads: This lecture, which is of considerable importance to the evolution of Fry's theories, has not hitherto been published. It was delivered in French in Brussels during the autumn of 1933. It has been translated from the French by Pamela Diamand, Roger Fry's daughter, and has been abridged. [*Apollo* ed.]

count the fact that architecture works in three dimensions while abstract painting possesses only two. Herein I think lies the real cause of the lack of emotional appeal of abstract painting, since it is evident that any suggestion of depth of space given by a flat canvas is due to an effect of perspective, that is to say to the representation of something outside the work of art. One cannot construct either volume or space on a canvas without having recourse to representation. So I revert to my idea that, in spite of these attempts at abstraction, painting has always been, and probably will remain, for the greater part a representational art.

Now, arts that do not reject representation run a risk which non-representational arts such as music avoid, for it may happen that the very accurate and life-like portrayal of a person or an object can suggest to us the idea that the object thus evoked is more real than its pictorial image. The object may thus compete with the image, as is sometimes the case with a photograph, which often makes us forget the image altogether and only think of the real thing it recalls. In this case the picture is reduced to an echo, a reflection of something more intensely real, so we are unable to concentrate our contemplation upon it.

Even poets acknowledge this danger and Mallarmé strongly advises the lyrical poet to exclude the real from his poetry "because its too precise meaning cancels your vague literary expression".[1]

But the danger is much greater for the artist than for the poet, for words only call up vague and generalized images, whereas the painter is forced to be more precise. Thus, the painter cannot say, as the poet might, dog, tree, man; he is forced to say dog of a certain breed, tree of a certain species, man of a certain age and in a certain posture.

Let us then summarize this question of representation in art; on one hand, it must be admitted that representation is almost essential to the art of painting, on the other hand that if in a picture something persists solely as representation this destroys the unity of the work of art; for we shall be ready to admit that each part of a work of art must play an effective part in the whole, and that if in a picture one part has no other justification than to represent something that exists outside it, then that part is pointless. This, then, is the real problem of painting—how is one to represent the outside world in such a way that it enters completely into the pictorial unity. And at this point another question arises: what sort of part is it to play?

1. Charles Mauron says in connexion with this in "Mallarmé l'obscur," 1968: "Les vocables directs sont éliminés; l'écrivain vise volontairement juste à côté du but; chaque terme frôle ce qu'il veut évoquer, et la phrase poursuit sa course, se dissout, sans que rien de précis ni de lourd soit venu l'entraver".

What happens in the case of literature? Obviously it does not act through the physical forms of the object since the object is only evoked in words and so in a vague and comparatively inexact way. To some extent the poet uses the sound form of the object's name; he may mention names like hippogriph or minotaur that are endowed with an immediate evocative power, but the poetic representation of Nature works chiefly through the mental associations to which the object alluded to gives rise in our consciousness. In painting, on the contrary, the object represented by the painter may function very well by its forms and its colours, which imprint themselves clearly on the consciousness of the spectator, but it must be pointed out that the same object can also function through the associated ideas it suggests.

There are, then, two roads open to the painter. He can consider the objects he represents as volumes developing in an ideated space—and thus he places himself alongside the architect who also disposes volumes in a given space but with the difference that in architecture the space is real and in painting only imagined. Or else the painter can consider the objects he represents chiefly from the point of view of their associated ideas, and in this case he is much closer to the poet. This ambiguous situation of pictorial art is, I think, the source of many of the misunderstandings which exist in aesthetics.

From the earliest periods onwards art criticism has been the work of men of letters, and these men have naturally made the literary point of view prevail. This is already noticeable among the Greeks, especially in Lucian, and the story of the painter Timanthes became a commonplace of all art criticism. The story goes that Timanthes, being required to paint the subject of the sacrifice of Iphigenia, had exhausted all the resources of his genius in depicting the grief of the spectators as they watched Iphigenia approach the altar, so that when he came to describe the emotion of Agamemnon, her father, his means failed him and he painted him with his head covered by a veil.

Cicero, Quintilian, Eustathius and, in fact, all the art critics of antiquity repeat this story as being the most conclusive evidence of the nature of pictorial art; and it was taken up again by almost all writers on art in the seventeenth and eighteenth centuries. A hundred years ago it had become so threadbare that I should never have dared to relate it. Towards the end of the eighteenth century the subject of the sacrifice of Iphigenia was naturally set to the students of the Royal Academy and poor Sir Joshua Reynolds, in his commentary on the sketches, remarked plaintively that not one student had forgotten conscientiously to veil Agamemnon's head.

Ut pictura poesis erit–painting must be like poetry, said Horace. This

phrase has become a catchword, but even two thousand years ago it lacked originality.

The eighteenth-century English critic, Jonathan Richardson, is most illuminating in this respect. He undertakes to instruct the artist on a manner of treating such and such a subject. Should he portray the woman taken in adultery, the artist must not select the beginning of the action, the accusation by the scribes and Pharisees, because at that moment they play the major part; he must not paint Christ writing on the ground because then His posture would lack dignity; he should even avoid the final scene—"go and sin no more"— because only two figures would not suffice to fill a canvas. There remains only the moment when Christ turns on His accusers—no other will do.

It is in the writings of Diderot, above all, that we find the most instructive judgments. He begins his reflections on painting by these words "One finds poets among painters and painters among poets," and he exhausts all his richness of invention, all the seduction of his style, to make us feel the dramatic and poetic power of the paintings he admired. His predilection for Greuze can be largely explained by the irreproachable morality that his pictures displayed. Referring to the picture L'accordée du Village by Greuze, representing the betrothal of a farmer's daughter, he tells us what the venerable father is supposed to be saying in such a situation, what each of the guests, according to him, might be feeling, but at the end he takes the artist rather severely to task because he leaves us in doubt as to whether one of the party is the sister of the betrothed or merely an obscure servant, which, he says, would embarrass many of the spectators and so would mar an otherwise worthy work of art.

Elsewhere Diderot tells us one cannot find a good painting without moral significance; yet when he criticizes Chardin's still-lifes he forgets this principle and fortunately does not try to extract a moral from them; with no apology he falls back on another aesthetic principle—resemblance to Nature. This inconsistency does not appear to disturb him in the least. It was natural that men of letters should be pleased that artists accepted their poetical theory, for this procedure allowed them to elaborate effortlessly upon all the literary implications which the picture could only suggest. What may surprise us more is the docility of the painters under this literary tutelage.

I think the first artist who attempted to rebel against the dominance of literature was Courbet. Doubtless there were always many artists like Chardin who plied their trade without bothering about theories of art, but they did not claim to stand up against the big wigs of the Academy. But modesty was not Courbet's weakness: on the contrary he had the self-assurance of a rather uneducated mind. He added to his remarkable gifts as an artist vigour

and stubbornness which he drew from his rustic origins. Thus, it was Cour-
bet who launched a vigorous attack on the literary tyranny. True, he put
forward nothing new; he relied on that other principle—verisimilitude—
which, as we saw, Diderot himself accepted without much heed, slipping it
surreptitiously into his aesthetic theory. For Courbet, fidelity to Nature was
the only principle of good painting. He condemned wholesale all ideal or
imaginative constructions as being essentially false; the painter can only ren-
der what he sees under his eyes, his only duty being to do this task well. This
was an oversimplification and a too rudimentary theory to satisfy superior
minds, but, as a symbol of the painter's rebellion against literature, it marks a
stage—and, as a matter of fact, we notice that after this date it became very
rare for one of the better artists of the nineteenth century to attempt an
imaginary composition.

Impressionists proclaimed no philosophy of painting but only a method,
but this method did not fail to have serious repercussions on the theory of
art. Their fundamental idea was that the painter should express his visual
experiences by means of touches of colour juxtaposed on a flat canvas. Our
surroundings, as perceived by our consciousness, on the contrary, consist in a
system of solid objects existing in a space of a certain depth; only we know
that these objects and this space are not given directly by our vision. What
we really see is likewise a flat mosaic of coloured blobs; however, from our
infancy the necessities of life have taught us to interpret these blobs in terms
of objects situated nearer to or farther from our eyes. And we have learnt this
lesson so well that is it very difficult for us to recover the innocent and
inexperienced eye of a new-born child.

This, however, was actually the task undertaken by the Impressionists.
They refused to go beyond such purely visual impressions, or to be influenced
by knowledge otherwise acquired, by the sense of touch, for instance. They
concentrated all their attention on appearances without defining them in
terms of the object.

This method undermined the whole edifice of literary art, for it denied
the validity of all the concepts of everyday life. The object was reduced to its
constituent sensations and consequently could no longer act as a nucleus for
associated ideas. No doubt it was permissible for the spectator to reconstruct
an object from the coloured spots on the canvas but, as the artist had deliber-
ately painted from the standpoint of not recognizing the object, there was
little chance that he should have imparted to it the accents and character that
literary art demands. In general, the great concern of the Impressionists was
the new colour harmonies which their method had revealed to them. Until

their time, what are called atmospheric colours had remained unperceived, masked as they were by local colour—the specific colour of the object.

With Cézanne, who rubbed shoulders for a long time with the Impressionists, the harmonious *ordonnance* of volumes in space was an ever-growing passion. He noticed how nebulous and vague the compositions of his contemporaries appeared beside the solid and imposing structures of Poussin and the great Italians; and he sought to give a similar architecture to the Impressionist idiom. For him, therefore, the object was at least partly reintegrated, but it should be noted that it was not the object as a vehicle of associated ideas but as a plastic volume. He thus remained as far as possible from all literary notions of art. Thus, the influence of Cézanne has been of great importance in modern aesthetics and it is from the study of his work that what I call the architectural theory of painting, as opposed to the old poetic theory, has little by little been built up. Here it is no longer the men of letters, but artists with an inclination to speculation, who have undertaken the creation of an aesthetic theory of painting. Maurice Denis, as evidenced in his article on Cézanne,[2] is one of the precursors in this field, and I have devoted many of my studies to the elaboration of its principles, being helped above all by discussions with artists.

This theory seeks to explain painting rather by its analogies with non-representational arts, such as music and architecture, and stresses the difference between painting and literature. It does not aim at absolute principles or at a metaphysical basis. It accepts as data the fact that our aesthetic sense finds satisfaction in music through a series of rhythmic and harmonious relations of notes and in architecture in the rhythmic and harmonious relations of volumes in space and it states that what is essential in painting is to be found also in systems of relations of volumes and spaces in a two-dimensional visual context and that, compared with this aspect of painting, any appeal to the associated ideas of the objects represented is negligible. Here then is the confrontation of the two theories of painting, each claiming for itself the entire territory of painting.

One, the literary theory (*ut pictura poesis*), is, as we have seen, of a respectable antiquity with more than two thousand years to its credit; the other, the architectural theory, is of quite recent formation; foreshadowed in the nineteenth century, it has only taken shape in the last twenty years, and here am I already starting to modify it.

As I said, each of the adversaries laid claim to the whole of painting, but

2. Denis's essay, translated by Fry, was published in *The Burlington Magazine* in January and February 1910.

perhaps each claims too much. Maybe painting is not an integral and indissoluble entity. Are we not perhaps like chemists trying to determine the atomic weight of an element, who find a slight deviation at each endeavour, until they suspect that they are dealing with two very similar elements of differing atomic weights. Such things have happened, you know.

Let us at least ask the question whether there are not two categories of painting. One can be called pure painting, appealing to our emotions through plastic harmonies, as in architecture, and chromatic harmonies, as in music. The other category would contain pictures which make their appeal by the associated ideas and emotions called up by the representation of objects in a manner corresponding to literature.

On reflection we should not be too shocked by this hypothesis, for we are quite accustomed to this situation in music, where we find, on the one hand, what musicians call absolute music and, on the other, the opera and song where literature combines with music.

Having reached this point you will ask me, no doubt, for some examples. (1) of a pure painting, (2) of an entirely literary painting, (3) of a painting which combines the two characteristics. That is not as easy as it might seem, for, on the whole, we have to deal with a mixture of both systems, but we shall see as we go along what to make of it.

Le verre d'absinthe by Picasso at least is a more or less pure painting in the sense that as there is no recognizable object we cannot look for associated ideas. We have here a system of more or less geometric forms arranged in a very complicated manner. I venture to add very skilfully arranged, suggesting an idea of reciprocal movements as if the planes were interlocking. The space suggested is necessarily very limited, for a flat canvas cannot give the idea of volume and space without the representation of more or less natural objects.

On the other hand, Poynter's picture *Faithful unto Death* is devoid as far as I can see of any architectural value. One may search in vain for a balance in the composition, for significant relationships between the volumes and the space or for harmonies between the forms.

I come now to the most difficult consideration, that of works in which we find both elements that we have been trying to contrast, works which appeal to us by a plastic harmony on one side and move us by the associated ideas of the objects represented on the other.

Do such works exist? The supporters of both theories, in fact, admit it, although grudgingly. On this point Diderot is very explicit. In speaking of a picture by Greuze he observes, in parenthesis, that the figures compose a group which is most pleasing to the eye, adding, however, that it is of no importance so long as these figures express by the gestures the emotions required by the

situation, but if, by sheer luck and without thinking about it, the artist achieves a harmonious arrangement of forms it gives him a personal pleasure.

On the other hand, those who enthusiastically uphold the theory of pure painting, whose mouth-piece I have sometimes been, assert that the only value of painting is inherent in plastic, spatial and chromatic harmonies. However, we admitted that we discerned a tendency in certain pictures to suggest psychological situations by the gestures or expressions of the faces, adding that this does not concern us or even that it rather spoilt our contemplation of visual harmonies.

When I discovered that our attitude corresponded so exactly with Diderot's, only seen from the opposite point of view, I suspected that we were reasoning as badly as Diderot and it is hard to reason worse than Diderot when he sets about it.

Such grudging testimony from both those who favoured a moral interpretation of art and from those who support pure painting seemed to me to prove that there exist works in which both elements would be found, plastic and literary.

But we should inquire what is the nature of such works. It seems to me that they result in fact from the co-operation of two distinct arts; that they are therefore analogous to dancing or drama and, above all, the opera. Furthermore, I believe that this double nature of most paintings only eludes us because the same man conceives and creates these two elements and uses the same media in both arts.

To acquire a better understanding of how this happens, let us examine briefly the familiar case of the combination of music and words. Here, too, a single person expresses both the musical harmonies and the poem through one medium—the voice.

Here we discover mixtures of the two elements in varying proportions. At one end we have what the Greeks called melodrama, where the words were spoken against a vague musical accompaniment, as happens sometimes with recitative. Then it is evident that the words play the major part, while the music is reduced to a kind of emotional stimulant. At the other end of the scale we find vocal trios and quartets in which the various voices sing different words at the same time; in this case we hear but odd snatches of verbal lines now and then and concentrate all our attention on the musical element.

I have said nothing about the nature of such composite works. Are they simply mixtures, or can they be compared with chemical compounds? I can say nothing categorical about this: it is a matter which still requires much research. I have often asked musicians whether true songs exist; by "true song" I mean a song in which the specific effect of the poem is enhanced by

the music and the effect of the music enhanced by the words. If you consider how irresponsibly different words are set to the same tune or divers melodies to the same words one is very doubtful, but most of the musicians I have consulted are of the opinion that true songs do exist, but that they are very rare. For my part, I also believe that there do exist paintings in which the literary element and the plastic element enter into a very intimate combination, so to speak, a sort of chemical combination. However, I also think that this is a comparatively rare occurrence.

Let us now look at some pictures from this point of view. We will begin with a few still-lifes, for still-life raises the question of literary values in a very definite way. We have already seen that Diderot, the enthusiast for moral and psychological values in painting, was somewhat puzzled to account for the still-lifes of Chardin. In dealing with a bowl of fruit, he comments on how ripe and juicy the peaches are and explains the value of the picture by the longing it stirs in us to eat those very peaches. What would he have said if he had looked at this *Still-life?* Perhaps he would have demonstrated to us how good a meal would prove made from the chicken and onion that he has selected so carefully. But really this pleasure is too illusory for us, and above all the state of mind to which this composition gives rise is altogether different. There is in it something very sober, almost solemn. It would seem that these common-place familiar objects have an extraordinary significance simply through their positions in space and the way they receive the light. Of course, this feeling is very vague and we can never really find words to define it, but the same applies to the emotions aroused by music and architecture. The point is that these plastic harmonies arouse movements in our subconscious being.

Cézanne, too, speaks in this plastic idiom in the *Still-life with a basket* with an accent that is perhaps even graver and more austere. By what magic does he give to these elementary forms such an effect of importance and grandeur. Cézanne goes even further than Chardin in his scorn for the imitation of sensuous objects. No one, I think, would feel like eating his apples; they function only as volumes receiving the light in a particular way, becoming the occasion for particular plastic harmonies. Cézanne removes these objects from our world; they are transposed into a purely spiritual world in which by means of their harmonies and contrasts they achieve a visual symphony endowed with a deep and inexpressible eloquence. So we wonder if all still-lifes may not be purely plastic works. In answer we have this rather curious case of a *Still-life* by Goya, who was above all a master of psychological values. And, in fact, it seems to me that the inspiration behind this work of Goya was the tragic, almost macabre, impression produced on him by the

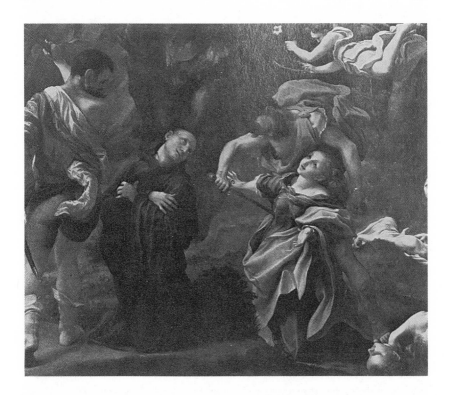

Fig. 1: *Martyrdom of Saint Flavia and Saint Placid* by Antonio Correggio
(1489/94–1534). Oil on canvas, 160 × 185 cm. Pinacoteca, Parma

fowl on the kitchen table. He has underlined this effect and the turkey plays
a dual part, firstly as an illuminated volume in a certain environment and
secondly as a creature brutally deprived of life. Goya painted a series, *De-
sastres de la Guerra;* here he shows us a disaster of everyday life.

Now let us go on to compositions where the artist has more opportunities
for expressing psychological values.

Correggio's *Martyrdom of St. Flavia and St. Placid* (Fig. 1) is one of the
most interesting examples in support of my contention, for it seems to me
that here the two elements pull in opposite directions. It is a scene of ex-
treme violence and brutality, but it is expressed in forms that compose a
harmony which is not only melodious but voluptuous. It is as if one were to
play *Othello* to the music of *Cosi fan tutte*. What an admirable ballet scene;
you would think the executioners have just come on stage performing a gay
and elegant *pas de deux*. The fact is that Correggio's habitual plastic rhythms
were incapable of adaptation to the psychological and dramatic expression of

such a scene; he allowed himself to be carried away by his tendency towards the voluptuous and exuberant.

For my part I take it as proof of the double nature of pictorial art when we find both elements, literary and plastic, as clearly opposed to each other as they are in this instance where I disregard the dramatic expression to delight in the marvellous plastic melodies rather as when one listens to an opera in which the words are altogether silly. Ostade's *Peasants in a tavern* is a work in which the two elements contradict each other but in quite another way. The scene itself is utterly vulgar and trivial, a group of peasants in a tavern; but to express this idea Ostade has found a most impressive disposition of volumes and play of light. There are here an amplitude and a plastic harmony which are strangely elevating. It makes us think rather of the great events or heroic situations that Giotto or Masaccio would have imagined. Here the plastic expression rises well above the psychological data. But most people are so much more accessible to psychological appeal that they speak of Ostade as a very minor painter of trivialities. In this there is a rather pleasing irony: among those great painters of the seventeenth and eighteenth centuries who imagined themselves to be great masters because they painted great historic events—the Lebruns, the Pierres, the Deshays, the Lagrenées and many others whose names we no longer remember—not one was able to hit upon such a discovery in composition and in chiaroscuro as that of this poor haunter of taverns whom they would so surely have despised.

From our point of view Poussin is very odd. We know from his letters that he believed himself to be a painter of moral values and that he boasted of finding not only the poses expressive of all the sentiments that the characters in his story ought to experience, but also poses suitable for expressing the nobility and greatness of soul of beings distinctly superior to our contemporaries; for like all men of his period he believed in the superhuman virtue of the ancient Romans.

Well, we do see the figures in his *Baptism* making emphatic gestures; but these gestures are too conventional, too formal to convince us of the reality of such over-theatrical beings. He hardly arouses in us the idea of the inner life of his characters, but on the other hand what deep feeling emanates from the general *ordonnance* of his forms, what equipoise there is between the two sides of his composition, how well all the directions of the limbs balance and echo one another. What unshakable unity results from this diversity! And how greatly this boldly conceived landscape, so harsh in its great lines and arid wastes, adds to the significance of the figures. No, Poussin never moves us by his frigid demonstrations of antique virtue, but he is one of the great composers of plastic and spatial harmonies.

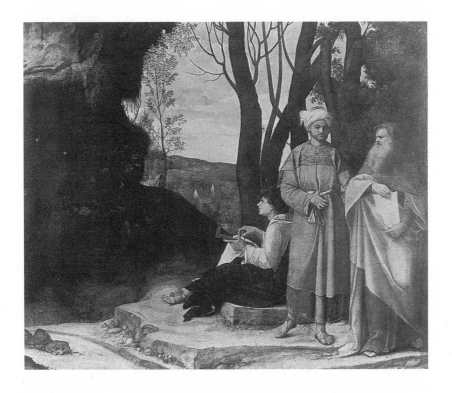

Fig. 2: *The Three Philosophers* by Giorgione (c.1476/78–1510). Oil on canvas, 123.8 × 144.5 cm. Kunsthistoriches Museum

We are justified in saying that he is the inventor of a kind of visual counterpoint, a counterpoint for which he discovered the most rigid principles, almost unique in their precision.

We must proceed at once to search, if possible, for works in which the psychological and plastic values act together harmoniously; we must in fact find the pictorial analogue of the song or the true opera.

Among the great masters there are two that come to my mind in this connexion: Giorgione and Rembrandt.

It was when looking at *The Three Philosophers* (Fig. 2) in Vienna that for the first time I became sharply aware of how much it is necessary to invoke the double function of art in order to explain all that I experienced.

First of all we are struck with the amplitude of these forms, by the disposition of these figures both so unexpected and so inevitable in so strange a space. This very disposition induces in us a heightened frame of mind, a state in which we expect some mysterious revelation. This effect, produced by the

disposition of forms, prepares us to meet beings far removed from our everyday life, to hope for something unknown and fateful, and Giorgione does not disappoint us. He has created people that appear to come from far away, from out of another world, men who proclaim by their looks and the sweep of their gestures which have an imposing gravity that they are the repositories of an almost divine wisdom.

So it is through his psychological imagination, akin to that of great poets, that Giorgione was enabled to create these strange characters. And such psychological values only serve to complete and enrich the emotion already produced by the arrangement of the volumes in space. Here then, as I see it, is a picture in which the two elements combine and enrich each other. One might call it a true operatic picture (not of course in the ordinary sense of the word, but simply to indicate its double nature). One must therefore acknowledge in Giorgione both a great master of plastic harmonies and a great romantic poet.

Rembrandt[3] shows such a deep understanding of human nature that we can assert that if he had not been a painter he would have been one of the greatest dramatic poets of the world.

I have shown only two examples of an artist simultaneously attaining to an extreme poetic exaltation and achieving a great plastic construction and bringing about, moreover, a complete fusion of the two. Surely there exist many others, but we must not be astonished if in all the history of art it should only very seldom happen that one and the same man should thus be doubly a genius.

3. Fry summarized, at this juncture, the points made in his lecture on Rembrandt. See *Apollo*, March 1962, LXXVI, pp. 42–55. [This essay appears in this anthology, pp. 366–79]

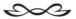

THE MEANING OF PICTURES
I—TELLING A STORY

THE wireless has done so much to help people to a fuller appreciation of music that it has been thought desirable that some attempt should be made to do the same for art. It is obvious, however, that until television becomes general, art must be badly handicapped. Still, with the assistance of *The Listener* we are going to see what can be done by putting before you reproductions of the pictures about which I shall be talking. But with all the help that can be given I am aghast at the difficulty of the task before me. We have to work with small reproductions which at best must give a very imperfect idea of the original pictures, and which leave out altogether the important element of colour. But even if we could stand together before the original pictures, and I could point out one thing after another so that it would be easy to follow my indications, even then what I want to do would be very difficult, because although we should all be looking at the same picture no two people would see the same picture. This sounds absurd, but it is not so if you reflect that seeing is not merely a question of what sensations may occur, but of what the mind makes of those sensations. Even if there were no individual differences in people's eyes, the differences in their minds, their characters, and their past life would all affect what they would see. Each one of us has his own private personal way of dealing with what is before his eyes, and this largely determines what he sees, making one man blind to one whole set of visible signs, another man blind to another.

Now, the artist actually spends more of his time in looking at things than anybody, and he looks more intently and more attentively, but he does not look at the same kind of things as other people, and this is one of the reasons why it is so hard for people who are not artists to know what artists mean by their pictures.

Now, if you will reflect upon it you will at once recognise that you very rarely look for the mere pleasure of looking. Almost always we look in order to find out some fact which is of interest or importance to us. We want to

This lecture, originally broadcast 25 September 1929, is reprinted from the BBC guide, *The Listener*, 2 October 1929, 429–31.

find out whether the half-crown which we got in change is a good one—we want to know whether we are buying butter or margarine, whether the apples are ripe· or unripe, and we read or try to read these interesting facts by the look of things. The moment we have read it we cease to look.

It is true that there are some things at which we look for the mere pleasure of looking—they are nearly always brightly coloured things—flowers, sunlit meadows, sunsets, and in looking at these we do see more as the artist does. Only the artist does not need to be attracted by bright colours; he is always looking even at the drab ordinary things of everyday life, and he looks not merely to enjoy, though he must also enjoy, but in order to find certain general qualities in the appearances of things.

We may put it like this. Most of us when we look, look for the marks and signs on things by which one thing is distinguished from other similar things; but the artist, when he looks, looks most for what is general and universal in appearances, what visible things have in common. Artists have tried at times to express this in words. The sculptor Rodin said: "A woman, a horse, a mountain, they are all the same thing to the sculptor". This rather mysterious saying of Rodin contains a clue to the understanding of the sculptor's, and also of a great part of the painter's, art. He meant something like this: that whatever object he was looking at he was always seeking to recognise in its forms some pattern or rhythm, some principle of harmony, and that in a sense all objects which revealed this harmonic principle counted as the same to him. And certainly this is what every great artist does. He looks at things with intent, contemplative, gaze. He must be detached from all personal interests in the objects as such. He seeks in them and in their relations to one another some formal principle, some visible tune, which appeals to his nature, which bears for him a quite special meaning, and he really paints his picture in order to make this special meaning clear.

Pictures then, like all other works of art, afford the means to us of grasping such special meanings, and thereby sharing the experiences of the great artists of all times, of entering into intimate communion with the most sensitive, the most profound, the most passionately contemplative spirits of mankind. But they only afford the *means* for this communion. In order that it may take place we must be able to vibrate in unison with the special note of each artist. The artist is as it were a transmitting station; we are the receivers when we look at his pictures. But the receivers must be attuned. The study of art is really the tuning of our own special receiving set, so that it can respond in turn to all the great transmitters of past and present times.

The Listener for September 25 contained a picture by Giotto of Christ appearing to Mary Magdalen, [Fig. 1], and I had hoped also to have shown

Fig. 1: *Jesus Appearing to the Magdalen*, by Giotto [originally appeared in *The Listener*, 25 September 1929]

for comparison a picture at the Tate Gallery called "The Doctor", by Luke Fildes [Fig. 2]. Unfortunately I discovered rather late that the owners of the copyright would not allow us to reproduce it. This is very unfortunate, because "The Doctor" is one of the best pictures of its class, is indeed much better than "Harmony", by Sir Frank Dicksee, which was substituted for it. However, as I believe I can rely on most of you being familiar with "The Doctor", and as in any case the description I shall give will be sufficient for the purposes of the present talk, I shall begin by a comparison of the Giotto which you see before you, and "The Doctor" by Luke Fildes. In many respects what I say of "The Doctor" applies also to "Harmony".

Now the picture by Giotto has been regarded for many centuries by those who have studied art as one of the greatest works of pictorial art in the world, and on the other hand I do not suppose you could find to-day a single

Fig. 2: *The Doctor*, by Luke Fildes [Tate Gallery; not in original publication]

serious student or critic of art who would consider "The Doctor" as a great work of art.

Of course, this does not prove that Giotto's is the better picture—we must always remember that in art we cannot hope to prove anything with the same completeness and certainty as it is possible in science to prove that one theory corresponds to the facts and another does not. If at the end of these talks any one of you still feels that "The Doctor" is the better picture of these two no one can gainsay him. He *may* be right and the general consensus of opinion of lovers of art of each generation for centuries *may* be wrong. But at least we can by looking carefully at these two pictures make clear what is the difference between them, what each of these artists meant by his picture, and why he did it as he did.

No doubt the first thing that will strike you is that "The Doctor" or any similar modern picture is much more like an actual scene than the Giotto. It is full of an immense number of details, every one of which you can recognise at once; and not only are all the objects clearly and minutely described, they are situated in a recognisable room and we understand how they were lit. We see at once that the room is illuminated by the lamp, but that the light of dawn is beginning to tell in the window.

The Giotto is quite different—one would never say of these figures how

wonderfully like. They have, of course, some likeness to human beings; we recognise them at once; but they lack all those minute convincing details which make us say, "How true!" to any stroke of "The Doctor". They are almost blank abstractions of human figures, nor are all their poses perfectly rendered. Look at two of the sleeping soldiers. We see that Giotto meant to show their heads as fallen backwards in the relaxation of sleep, but that he had great difficulty in drawing features seen in such sharp foreshortening. And again, the landscape, even allowing for the fact that this part of the picture is damaged, is almost like a child's early efforts—a zig-zag for mountains, an upright stroke and a few scribbles at the top for a tree, and so on. Also it would be impossible to say that there was any special lighting, to say what time of day was intended, in fact, everything is as blankly abstract, as little particularised as possible. We are in the presence of these large bare contours of figures situated in a rather vague no-man's land.

We have to admit then that Giotto does not do a great many things that Luke Fildes does. And some of those things Giotto tried to do, could not, and would have liked to do. He would certainly have liked to be able to make the foreshortened faces of his soldiers look more natural, or to draw the soldier lying down so that you realised how the body was relaxed. Now Giotto was at least as skilful as anyone of his day; but the fact is that a great many facts about the appearances of things were not known in his day and have been gradually discovered since, so that the feeblest modern art student can do a hundred things in the way of representing appearances exactly which Giotto had no idea of. Are we to say then that art, like science, has progressed, each generation doing better than the last, because each began where the last ended? Certainly as far as the power of making things look like, there has been progress from time to time, but even then the artist has been finally beaten by the camera. If the business of art were to make things like, art should already have been superseded by photography. But this notoriously has not happened. On the contrary, the period since the invention of photography has been one of great activity. It has witnessed the most intense interest and an almost feverish activity in art. No, there is no competition whatever between art and photography because they set out to do different things, and it is evident that if we decide that we admire Giotto's picture more than Luke Fildes', it will not be because Giotto could make things more like.

Now let us consider the pictures from another point of view. Each picture tells a story. Now Giotto was able to rely on the fact that his public knew the gospel story of the Magdalen and the risen Christ by heart; but Luke Fildes has no help from outside other than the title, "The Doctor". It is astonishing

with what ingenuity he finds ways of hinting at the situation. We can see that the parents are poor (the chairs belong to odd sets), but observing the cleanliness of everything we guess that the sick child had to be put on a makeshift bed, because no room but the kitchen was warmed. Then, by the glimmer of dawn we guess that it has been an all-night vigil, and we think, with a glow of moral approval, of how the doctor has sacrificed his night's rest in the effort to save the child's life, and we guess from the painting of the home that he does this from compassion and devotion to duty, and not for gain. As I say, the ingenuity with which so much of the lives of those people is hinted at in a single situation is remarkable, nor can we deny that all the emotions described are worthy ones; but all the same there is something profoundly wrong. For all the mass of details which are correctly described for us there is something false about the whole thing: the dice are loaded: these people are too noble, they would not be like that unless we were looking on. They are keeping a noble pose. They ought to show traces of other feelings. In the doctor, in particular, there might be something of a purely professional scientific tension; he could not be, should not be, so purely, so nobly pitiful. I am trying to suggest some of the possible causes of a certain nausea and disgust which not only I, but almost all those who care for the great masters like Giotto, feel before such pictures as this. And one more point which I must try to make clear, though it is very difficult to express in words. We feel here an invitation to identify oneself with the doctor; we feel that we, too, are capable of this devotion, and we get a certain moral satisfaction which we have done nothing to earn. I suspect that a great deal of the attraction of sentimental art and sentimental stories comes from an indulgence in this fictitious sense of one's moral worth.

And now turn to the story of Giotto's picture. Here the artist relied on the fact that all those for whom he painted the picture knew the story by heart. The story as it is told in St. John's Gospel of how, early in the morning of Easter Sunday, Mary Magdalen came to the Sepulchre, and saw "two angels in white sitting one at the head the other at the feet, where the body of Jesus had lain. And they say unto her, 'Woman why weepest thou?' She saith unto them, 'because they have taken away my Lord, and I know not where they have laid Him'. And when she had thus said, she turned herself back, and saw Jesus standing and knew not that it was Jesus. Jesus saith unto her, 'Woman, why weepest thou? Whom seekest thou?' She, supposing Him to be the gardener, saith unto Him, 'Sir, if thou hast borne Him hence, tell me where thou hast laid Him, and I will take Him away'. Jesus saith unto her, 'Mary'. She turned herself and saith unto Him, 'Rabboni', which is to

say, Master. Jesus saith unto her: 'Touch Me not; for I am not yet ascended
to My Father.'"

Because Giotto's public knew that story by heart they were ready to ap-
preciate every point of his rendering of it. Without that knowledge it would
be hard here to guess exactly what the meaning of this strange situation was.
As it is, one must admit that the essential point of the story is given with a
strange intensity. The gestures of those figures are profoundly expressive of
their natures, and of the emotion which the situation has called forth in
them. The soldiers, in spite of Giotto's incapacity of rendering certain diffi-
cult aspects of foreshortening, are sufficiently clearly felt to be asleep. We feel
that they are shut out completely from the dramatic situation. The angels,
though at first you may feel a slight shock at the extreme naïveté with which
they are posed on the edge of the sepulchre, are expressive in their stern,
haughty features, the awful indifference and serenity with which they watch
the scene. The centre of the dramatic tension is between Christ and the
Magdalen, and here the expression of emotion rises to strange intensity. We
feel by the way that the Magdalen has suddenly dropped on to her knees and
thrust out her eager hands at once, the desperate anxiety to find the body of
her Lord which had tormented her, and the overwhelming shock of recogni-
tion which has so dramatically and supernaturally replaced it; and this pas-
sionate eagerness is met only by the evasive gesture with which Christ slides
away from her touch. According to the Gospel account, this mysterious in-
terview took place in the twilight of dawn; and although Giotto is very far
from suggesting any special effect of light, it is hardly fantastic to see that his
design does produce an effect of loneliness, isolation and mystery which may
well have arisen in his mind from the memory of this fact.

Now we notice that, in contradistinction to Luke Fildes, Giotto tells his
story without any accessory details; he fixes his attention entirely on the
broad outlines of the essential features and the relative positions of the fig-
ures. The stage is almost entirely bare, everything is focussed on the actors.
Even their dress is of an extreme simplicity, mere vague wrappings which
seem to reveal the action of the limbs in large simple visible shapes. We are
dealing only with the fundamental psychological facts of the story, the great
oppositions and contrasts of the situation, and we see that such a bleak,
abstract treatment, shows us the fundamental drama with incredible force.
We are never distracted from the contemplation of that by any trivial details.
We never think how clever the artist was to make it so "like", but how
wonderful to have made vivid to our imagination just what was most signifi-
cant, most sublime in the dramatic moment. And yet a further point. For all

its dramatic intensity we are not asked to come so close to the action as we are by Luke Fildes. We watch it taking place in a world which is somewhat removed from the actual world, a world which we cannot enter into— wherein we shall never be actors. We cannot identify ourselves with these people; the scene remains there for our contemplation rather than for any immediate personal contact. I believe that this is of the greatest importance in all imaginative art. However real it is, it must remain at such a distance from our own personal actual life that it is not entangled in the conflict of our desires and vanities. It is the want of this distance which is the mark of the sentimental appeal which is made by most popular literature, and by popular painting such as Luke Fildes' "Doctor" and only too many other works in the Tate Gallery and our provincial museums.

HENRI-MATISSE

EVER since Caravaggio threw his searchlight on to the face and shoulders of some heavily built Roman model the art of painting has had to face a problem for which it can probably never find a final conclusive solution. It was of course really an older problem posed again with new insistence. It is a problem inherent in the dual nature of painting, where we are forced to recognize, at one and the same moment, a diversely coloured surface and a three dimensional world, analogous to that in which we live and move. It is this equivocal nature of painting that is at once its torment and its inspiration. The artist himself has a double nature and a double allegiance. He longs on the one hand to realize his vision, on the other to be a maker; he longs to tell of his experience and also to create an object, an idol, a precious thing. And almost always the vision and the precious thing,—the *objet d'art,*—are at variance. His vision and his craft pull different ways and his orbit is determined by their relative powers and proximities. In the long history of painting we may study many varieties of such dually determined orbits; we can find arts where one or other of these controlling powers has been reduced almost to zero. Thus, with Paleolithic man, the vision was all in all; no other care seems to have occupied him. But ever since Neolithic man in making pottery tasted the joys of the artificer, the maker has tended to share with the seer the artist's preoccupation. Indeed in certain period and schools this has tended to become the dominant control. In the final periods of Graeco-Roman art the vision carried even to the extent of the *trompe l'œil* had no doubt become the chief delight of the vulgar rich clientele who exercised the patronage of the day. But the growth of Christian art and the increasing use of symbolical expression, together perhaps with some idea of the sanctity of the object itself by transference from the sacred beings it represented, brought back the full influence of the "artificial" impulse (if we may be allowed the convenience of using the word artificial in this strict sense). Byzantine art fixes for centuries the compromise between the vision and the *objet d'art* so strongly on the side of the latter that we may perhaps

Reprinted from *Henri-Matisse* (London: A. Zwemmer, 1935).

be allowed to use Byzantine as a term generally expressive of the recovery of the *objet d'art* from the predominance of the representative side of pictorial art. Most of the arts that sprang from the Byzantine such as Russian, Bulgarian and Armenian, in spite of their local and national variations held to the general formula which Byzantium has consecrated. Italian painting almost alone of the Byzantine family of arts began, from before the end of the 13th century, to revert to the representation of an ideated world of three dimensional space peopled by clearly realized volumes. For the six centuries which lie between the years 1300 and 1900 the history of European art may be described very largely in terms of the increasing power of realizing the ideated space of the picture and the plastic perfection of the volumes it contains. It is the history of a gradual realization of all the complexities of interaction of these in virtue of their qualities of form and tone and colour and of the influence of the luminous atmosphere with which our actual three dimensional space is filled.

An inevitable result of this process was that with every fresh advance in the power of realizing the vision of an ideated world, comparable in every way with the actual world, the artificial impulse was continually being baulked of its purpose, continually baffled by the apparent hopelessness of recovering a clearly recognizable surface unity. Many painters whose artistic sensibility was rudimentary in comparison with their naïve interest in the amusing game of representation, did indeed abandon this aspect of the picture altogether, but throughout the whole period the more genuine artists were never altogether unconscious of the conception of the picture as an *objet d'art*, and we can match every advance in representative power with some fresh attempt to find a new compromise between the two controls.

In that long history of representative design Caravaggio's searchlight exercised an influence altogether out of proportion to the feeble aesthetic gifts of its projector; for of all the aspects of the visible world those that are included under the term of *chiaroscuro* are perhaps the most destructive of the picture surface. Were we not influenced by a hundred other considerations than the beauty of our walls, who would ever dream of hanging upon them the inscrutable darkness of certain Rembrandts. Chiaroscuro in which representation realizes its completest, most illusive triumphs, so powerful as almost to compensate for the non-stereoscopic nature of the painted image—chiaroscuro has been an anxious problem to all artists in whom the artificial instinct is not wholly atrophied.

But that searchlight has another importance. In the art of the high Renaissance, however completely the ideated world may have been realized, vision admitted the assistance and control of non-visual—specifically of

tactile—experiences. The sculptor, not to mention the anatomist, had always had his say in the painter's procedure. But in the 17th century artists began to trust to purely visual experience, to rely on purely visual values whereby to realize the plasticity of their volumes. That movement once initiated, there was no halting place on the road to complete Impressionism. For in Impressionism the eye, by an act of supreme renunciation, succeeds in purifying itself of all those inductions from the visual image which the whole business of life requires us to make before we leave our cradles. In Impressionism the artist's eye deliberately recovers the long lost naïveté of the new born baby's. But by a charming paradox the artist, who has succeeded in seeing the actual world as a meaningless mosaic of flat patches of colour, finds, when he records this vision on his canvas, that the flat surface takes on the whole curvature of the visual hemisphere and objects spring into clear relief. Never before was the flat surface of the picture more completely suppressed. Except, indeed, in one respect, namely that since atmospheric colour was the special preoccupation of those artists, by a deliberate choice, they avoided effects of strong chiaroscuro where colour was likely to be devoured by the impact of light or drowned in depths of shadow.

I trust my reader will see by now that I have never once lost sight of M. Matisse throughout this long approach and will have patience yet a moment whilst we analyse a little the painting of the 60's and 70's, the capital era of Impressionism. For indeed many elements of design converge here, and much that is decisive for the 20th century begins to emerge. And first for Manet, seeing how much he counted. His art is full of paradox. His first and I think his most profound inspiration is that of Caravaggian Spain, of Velasquez, even more perhaps of Ribera, that is to say, form seen immersed in an illusive chiaroscuro. But Manet had a deep, perhaps unconscious, concern for the picture surface and he soon learnt to swing the source of illumination round till it was behind his own head. In those circumstances the more intense the light the flatter became the modelling of all the lighted planes of, say, a head seen full face, as was his wont. For now the shaded planes, being only those which recede in rapid perspective, become reduced almost to a dark contour around the flatly illuminated mask. Thus with scarcely any transition Manet passed from the extreme of illusionist representation to a kind of flattened relief with heavy outline. It was this that made Daumier say of him "il nous ramène à Lancelot", i.e., to the style of a playing card.

And yet another paradox, it was out of Manet's immediate circle of followers that Monet and Pissaro devised that completest destruction of surface organization which alone sufficed to express their vision of atmospheric colour and in the end forced Manet altogether out of his natural bent into an

imitation of their methods. It was also his ardent admirer and would-be follower, Cézanne, whose work was dominated by acute anxiety about the dual function of the painted surface. On the one hand there is his desperate research into the principles of plastic construction of volumes with his theoretic shots at a guiding idea—the famous cone and cylinder—his desire to realize, and on the other his horror of verisimilitude ("il est horriblement ressemblant"); his equal horror of chiaroscuro, his hope of finding some method by which a vigorous plastic construction might be built out of pure values of colour without light and shade, in short all that was implied in his ambition to create something durable, something with the quality of an *objet d'art*. The result as seen in his work is indeed one of the most fascinating and surprising of all the many resultants of our two controlling forces. On the one hand he pushed the systematic understanding of plastic form, as ascertained by unaided vision, to lengths that perhaps Rembrandt alone had attained, and on the other his record of this analysis was so pure, so little encumbered with the apparatus of mere verisimilitude that the total result, for all its intense reality, appears strangely unlike the texture of actual appearance, becomes indeed intensely anti-photographic. Our sense of plasticity is no doubt richly appealed to but it is as it were by implication; it demands the active cooperation of the spectator's imaginative power. And thus once more, though plastic values pervade every part of the design, the surface is not utterly violated.

Literal representation had weighed so heavily on the art of the nineteenth century that Cézanne's gesture was read mainly as raising the standard of revolt against that enslavement. We are only now beginning to see how one sided was that reading of Cézanne's heroic pose. That to his immediate followers, that was the important thing is made abundantly clear in the art of Gauguin and van Gogh.

External circumstances aided in imposing on the younger generation this new direction of effort. The discovery of the Japanese print, the new horizons which were clearing and enlarging the taste of the amateur, leading to a tardy recognition of Byzantine and early oriental art and the overthrow of the age-long tyranny of the standards of Graeco-Roman sculpture, all these influences helped the artists, towards the turn of the century, to a new conception of the importance for painting of the artificial impulse. And colour too, with the extended scale which it owed to the plein-air Impressionists was to play a new rôle, was to become of prime importance in pictorial expression, for in Gauguin and van Gogh already the separate notes of a chord are once more heard in their simple unbroken purity. Here then was the situation as it faced the generation of artists who were growing to maturity in the 90's of

last century among whom Henri Matisse was destined to occupy so leading a position.

Henri Matisse was born on Dec. 31, 1869 at le Cateau in the department of the Nord in that border country between France and Flanders which, for some reason, has been singularly fertile in artists. Nor does Matisse's personality belie his origin. He has the homeliness and the methodical practice of those countries. He feels himself at home in the world and though he is willing to take risks he is never extravagant or chimerical, never the victim of a too abstract passion. He never forgets that, at some point, art must be related to daily life and must conform to its exigencies. After studying law for a year in Paris and after an abortive attempt to become a lawyer's clerk, his passion for art overcame all resistance and he came again to Paris, this time to study art at the Ecole des Beaux-Arts. In time however he was fortunate enough to find his way to the classes of Gustave Moreau, who was undoubtedly the most inspiring teacher of his day.

There he made friends with many of the best artists of his generation. Moreau's influence was at once traditional and vital and Matisse became, like all the so called revolutionaries, a devoted student of the old masters, whose works he copied assiduously at the Louvre.

In 1896 he sent thirteen canvases to the Salon du Champ de Mars which was the home of the non-official art of the day, and had a position analogous to that of the Salon d'Automne at the present time. His work had a gratifying success and won the favour of the celebrated art-critic Roger Marx who exercised his influence in his favour.

If we are to picture to ourselves the state of mind of an artist, beginning his career and facing the problem of his own sensibility at this date, we must not suppose him to have realized the situation with the clearness which our retrospective glance makes possible. We must rather suppose him sharing with the more intelligent of his contemporaries the restlessness and uncertainty which resulted from the evident waning of the Impressionist inspiration. We must suppose him, like them, excited by the revelation of Japanese prints with their proof of what flat masses of pure colour can effect, but at the same time troubled to imagine how the method could be reconciled with the tradition, which they had inherited, and yet determined somehow to recover for the painted canvas—though no one could imagine how—the quality of an *objet d'art*.

His canvas of the next year revealed a culmination of his previous efforts. It was the celebrated "Desserte" now in the Freudenburg collection.[1] It rep-

1. This is *The Dinner Table*, 1879, private collection—Ed.

resented a servant putting the finishing touches to a table, laid for luncheon, loaded with fruit and flowers and glittering with silver, glass and porcelain. It was a modern application of all that he had learned from his copies of Chardin: it had the illusionism of a full chiaroscuro together with a new gaiety and intensity of colour. Very few artists of twenty-seven would have had the courage to turn their backs on so conspicuous a success as this. Here indeed was a line of activity with an assured position. But it was not the solution of the problem which exercised him and for the first of many times Matisse showed the high quality of his ambition, his refusal of any incomplete expression of what he felt it in him to bring out.

He met Signac and for a moment Seurat's strange alternative solution of how to conciliate the Impressionist vision with a strongly organized picture surface tempted him. Again he succeeded and inspired among the Divisionists the hope of a great convert and a new leader; and again Matisse turned his back.

He joined the fearless group of experimenters who were nicknamed *les Fauves*. He was perhaps the only one of that group who had some clear consciousness of whither their experiments in the application of pure, crude, paint-box colour might tend or what lessons could be learned from them. He was gradually becoming conscious of what kind of a synthesis his sensibility demanded.

He took up the idea of his famous "Desserte" and translated it into the new idiom in which plastic values were replaced by flat patches of colour. He had found the essential terms of his pictorial synthesis.

I have hopes that at this point my reader will realize that my apparently irrelevant introduction has not been vain since it enables us to put our finger at once on the fundamental quality of Henri Matisse's art, just the quality which distinguishes him from other artists of to-day and gives him a very singular position in the long sequence of the European tradition of painting. Henri Matisse's style is based on *equivoque* and ellipsis. So far as I know in the history of European art no one has ever played so many delightful, unexpected, exhilarating variations upon the theme of the dual nature of painting as he has. Take for instance Fig. 1 and note how Matisse manages to pass from one end of the canvas to the other telling us all about the various patterns, the pattern on the carpet which lies at such and such an angle to the eye, the pattern on the wall which lies at quite another angle, the pattern on the pot which is a curved surface; then he comes to an elaborately modelled Venetian glass mirror on the wall and he tells us all about this without changing the rhythm and quality of his handling. We do not doubt its solidity but we take it too as a pattern. The same thing happens to the plant in

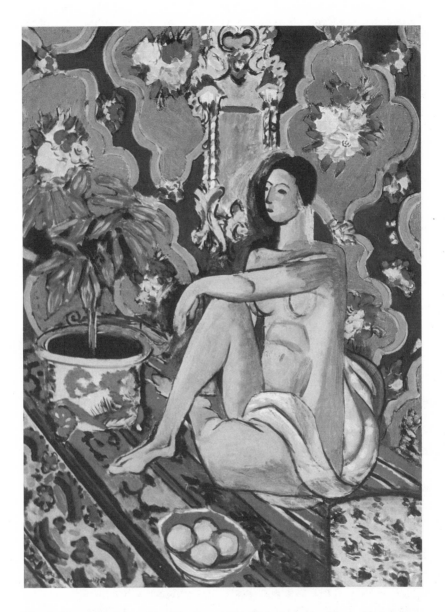

Fig. 1: *Decorative Composition* [dated to 1925–26; now at the Musèe National d'Art Moderne, Centre George Pompidou, Paris]

the pot; its solid forms build but a variation on the pattern of the wall-paper and the bowl of lemons in the foreground seems merely to bring us back to the general quality of the wall paper, though its relief is clear at once. Even the figure enters into the pattern sequence with the folds of drapery that carry on the arabesque of the wall paper, the pattern-like divisions of the anatomy and the wilful line of the back which recalls the upright of the mirror.

One can see the figure in all its relief with all the free play of direction, of the limbs, its volume and mass, but at the very same moment we see it as joining in the swaying dance-like movement of all these flat linear patterns. By the magic of an intensely coherent style our familiar every day world, the world where the model sat on a carpet, in front of Matisse's easel, has been broken to pieces as though reflected in a broken mirror and then put together again into a far more coherent unity in which all the visual values are mysteriously changed—in which plastic forms can be read as pattern and apparently flat patterns are read as diversely inclined planes.

It is an art which, in its constant reference to our age-long pictorial tradition, can afford endless reservations and ellipses. An art which dares to rely on the spectator's realizing all that is sub-understood and merely hinted at or implied. Hence perhaps only an artist can fully estimate the miracles of tact, of inventive fertility, of suppressed pictorial science which this allusive, elliptical method implies. And it is only because of Matisse's extraordinary gifts that such a method becomes possible. But it is not only the magnitude of his gifts, it is their peculiarity which is essential. Let us try to enumerate them; first of all we must place an astonishing sense of linear rhythm, a rhythm which is at once extremely continuous and extremely elastic, that is to say it is capable of extraordinary variations from the norm without loss of continuity. The phrase can be held on to through all its changes. Imagine the rhythm rendered the least bit tight and mechanical in its regularity and the whole system of allusion and ellipsis would break down and become ridiculous. Secondly, and this is perhaps Matisse's most obvious gift, an impeccable sense of colour harmony. But here, too, we must distinguish clearly. Matisse has in the first place the gift that we note in almost all Mohommedan art, the gift of finding rich new and surprising harmonies of colour notes placed in apposition upon a flat surface. And like the best of Oriental craftsmen Matisse is never content with a perfect accord of all the colours, there is always with this an element of surprise, there are always appositions which make us say to ourselves "How the Devil did it ever occur to him that that colour would fit into that scheme and yet how perfectly acceptable it is." It is this element of surprise that gives its extraordinary freshness and vitality to

his schemes even viewed as pure decoration, viewed as we might view some rare Persian rug.

But Matisse's colour has further quality without which his equivocal method could never have its full effect. He has an almost uncanny gift of situating each colour in its place in the scheme viewed as a vision of plastic reality, as a world of volumes in a space. That is to say, the colour of, let us suppose, a painted window shutter seen on a house in the distance out of a window as in [Saffron Roses in Front of the Window],[2] remains at the distance from the eye which the whole design indicates; and the colour of a pot or a flower on the table is just the due amount nearer to the eye. At each point its colour holds the plane in its due position. What is peculiarly uncanny about this gift is that Matisse can give the most wilful interpretation to natural colour—making a distant bridge bright magenta perhaps—and yet not violate the plastic consistency. It is in this power that he goes far beyond the pure decorator. The Persian rug which he paints for us will function equally well as a vision of an ideated space and the equivoque gains thereby a new evocative potential.

But this dual function of Matisse's colour brings us back to his line, for here too the same applies. For his purpose line must not only have its quality of flat melody, it must be able to evoke volumes with incredible power. That power is great just in proportion as the pattern system is strong and demands extreme economy. Matisse cannot afford to lose time so to speak upon describing and evoking his volumes because to do so would arrest the sequence of his surface design.

It is I think from a, perhaps unconscious, perception of this necessity that he has developed his deformations of the figure. I would not deny that at times even Matisse may have slipped into a certain wilful exaggeration but in the main the purpose is clear. These deformations increase the bare economy of his evocations of volumes. They are epigrammatic, Tacitean, short cuts to the necessary evocation. They render the general movement of the figure more obvious, more easily handled by the spectator's imagination. They increase the clarity and legibility of the design—which indeed serves to remind us of another outstanding characteristic of Matisse's work, namely that in spite of his methods, which seem bound to cause confusion by the violence of his paradoxes, the brevity of his allusions, the incessant equivoque, in spite of this, Matisse is nearly always legible at a glance. No one is in doubt as to what anything is or exactly where it is in the picture space even though the design is built on the strangest, most unfamiliar appositions, the oddest turns

2. Dated to 1925, this is in a private collection in Switzerland—Ed.

of nature's kaleidoscope. There is, it is true, one example in this book, [*The Moroccans*]³ to which this does not apply. At all events, without the colour, it is doubtful if the ordinary spectator would recognize the turbanned Moslems prostrated in prayer on a carpet on the left hand bottom corner. But such conundrums are rare. Matisse never I think has indulged in the foolish pleasure of mystification. He is far too much in earnest for that. Of that earnestness he has again and again given proof in his evident anxiety not to exploit his own successes. Matisse has shewn a great capacity for self-criticism. At any moment he is capable of turning round on his own productions and refusing to follow the path of least resistance. He has again and again put his whole art in question, unbiased by his past achievement. We have already noted some cases of this in his early evolution but Matisse is never satisfied, he can always challenge his own conclusions, and even in his maturity he has more than once started afresh, giving away the advantage of his momentum along a certain line. So that if any of his admirers feels, as I confess for my part to have felt once or twice, that Matisse is making repeated use of some too charming pictorial synthesis they may reassure themselves. Matisse himself is sure to scent danger in good time and to throw away a suspiciously convenient tool.

The latest of such proofs of the high quality of Matisse's ambition has occurred in recent years, and is likely enough to put a strain on his popularity. For Matisse's great popularity is based mainly on the work of the years 1920–1925. At this period in the clear light of his atelier at Nice, amid an oriental *décor* and the spoils of inexhaustible Provençal gardens, he developed richer more alluring arabesques of gay and sonorous colour than ever before. His work had a certain note of elegance. It was exquisitely mundane. A picture of this period seemed as delightfully to summarize the refined social life of to-day as the 18th century painters had done that of their contemporaries. Only the Matisse fitted far more nicely into the epicurean simplicity of a modern villa than a Fragonard could and yet had as choice a social emanation. In their delight at such an etherialized expression of their own aspirations, the more cultured rich succumbed at last to his spell. Matisse, indefatigable worker though he is, could never have satisfied the clamorous demand which arose from both sides of the Atlantic. But if the new converts to Matisse's art had forgotten the early Matisse, whom they had wondered at but never liked, M. Matisse himself had not. He had shown himself the creator and consummate exponent of a modern rococo style. But there was another Matisse, a Matisse who responded to quite a different kind of appeal

3. Dated to 1916, this is at the Museum of Modern Art, New York—Ed.

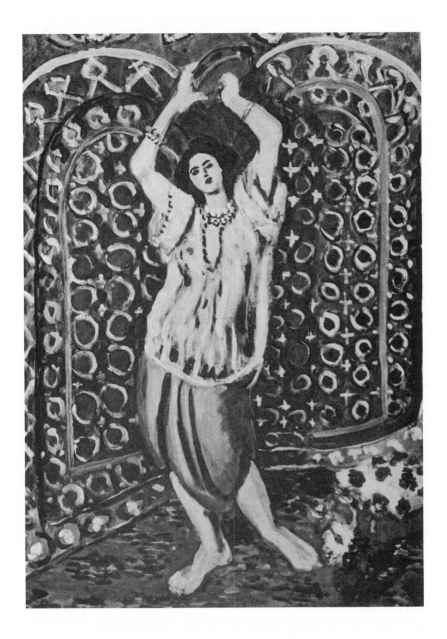

Fig. 2: *Dancer with Tambourine* [dated to 1926; private collection]

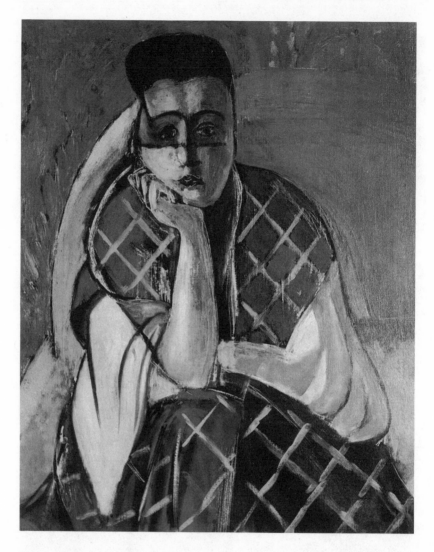

Fig. 3: *Woman with a Veil* [dated to 1927; now at the Museum of Modern Art, New York]

from the visible world. A Matisse who felt the appeal of a stark, structural architecture, who loved above all a bare economy, who would, for the austerer delights of such forms willingly sacrifice the intricate charm of his dancing arabesque. It would be wrong to suppose that there is anything morose or oppressive about this aspect of Matisse's personality, for he is always serenely joyful, always utterly free from neurotic complications or repressions,

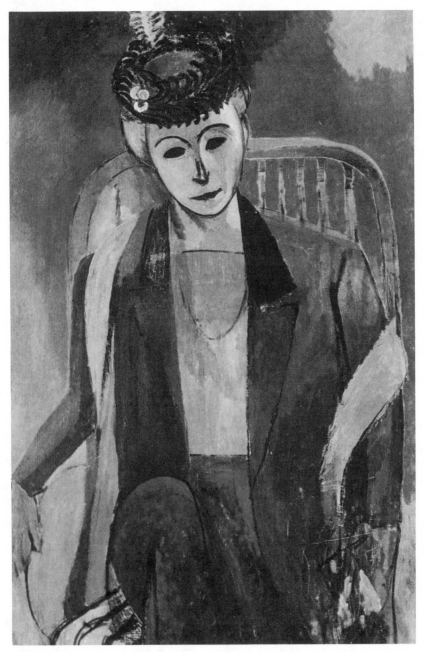

Fig. 4: *Portrait of Madame Matisse* [not in original publication; dated to 1913; now at the Hermitage, Saint Petersburg]

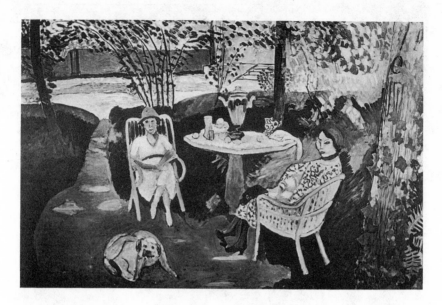

Fig. 5: *The Garden* (from the collection of Michel Stein) [also known as *The Tea*, this painting is dated to 1919; private collection]

always responsive to sensual delights. It is only that this other aspect of his genius aims at a more arduous kind of expression, one in which plastic evocations play a larger part, one in which, though he never loses sight of surface organization, this is effected by the relation of large geometrical units, which attain a more architectural, more monumental unity. In this mood Matisse seeks above all a plasticity of volumes which is at once more complete and more concentrated, held together by more clearly inevitable sequences. To understand the difference between those two directions of Matisse's creative energy the reader may compare Fig. 2 and 1 with such an example of his more recent work as Fig. 3 (Woman with veil). It will be apparent too that to find analogies with the later works we must go back to the years before 1917, in particular to the portrait of Mme. Matisse [Fig. 4]. It will be seen that the later portrait is at once richer more vital and more complete in its apprehension of plasticity and also more masterly in its synthetic quality. If I may be allowed the expression of my personal predilictions I would say that to my mind one of the most complete expressions of Matisse's highest powers is to be seen in Fig. 5 where the play of broadly simplified arabesques, light on dark and dark on light are contrasted with the most surprising felicity and where a familiar scene of every-day life takes on an air of almost monumental grandeur without any sense of rhetorical falsi-

fication. The shock of the word rhetorical in relation to Matisse proves, by the by, the fundamental simplicity and sincerity of his attitude to life.

What I look for now with sure confidence is a new series of works in which Matisse will find a scheme capable of expressing his sense of the profounder implications of form in terms of monumental amplitude and yet enriched by all that wealth of pictorial science which he has garnered from the intervening years. For Matisse is of the kindred of the great masters who are capable of continuous growth, whose genius flowers most exuberantly in the years of ripest experience.

"THE TOILET," BY REMBRANDT

THE picture by Rembrandt in the Louvre to which I have given the title 'The Toilet', for reasons which will appear later, must be known to many of my readers.[1] There are many interesting things about this picture, and if I begin by saying that it is square you may think I am stating what is the least important fact about it. But this is not so. Square pictures are really very uncommon and for the simple reason that it is peculiarly difficult to make a good composition in a square. In any other rectangle but a square the artist is helped at once to find the dominant direction which will be either upright or horizontal according to the way he turns his canvas. But in a square, vertical and horizontal lines will tend to compete and destroy the sense of unity which is essential to our pleasure in any design. And the curious thing is that here it would be difficult to say whether we feel most the vertical or the horizontal pull, so that we should expect to be confused, and yet I feel that the unity is somehow satisfactory. It is difficult to say quite how that is done. I think it is partly done by the opposition of two main answering curves—one goes round the model's left thigh and is continued, by a subtle device, into the marked edge of the brocaded drapery on the bed behind, and this curve is echoed by the line of the stomach; the other is the curve that defines the left arm and is carried through into the head. These curves seem to hold our attention fixed on the nude figure, and this was clearly for Rembrandt the main interest. He has set about painting one of the completest, most intensely realised representations of a nude figure seen strongly illuminated against a dark background that has ever been achieved.

Reprinted from the BBC radio guide, *The Listener*, 19 September 1934.

1. I fear that only those who do know the original or have access to a really good photograph or photogravure will be able to make much of the remarks that follow. All pictures suffer a good deal from the half-tone process which has to be employed in papers like *The Listener*, but Rembrandt's work, depending, as it does, upon the effect of infinitely subtle gradations of tone, suffers more perhaps than any other. The present reproduction gives no idea of the transparent depths of gloom behind the figure, the figure itself has been terribly flattened out, only a small fraction of the modulations having survived, and there is no suggestion of the handling of the linen cloth in the right foreground which in the original is of transcendent beauty. In fact one sees here only a ghost of the original work.

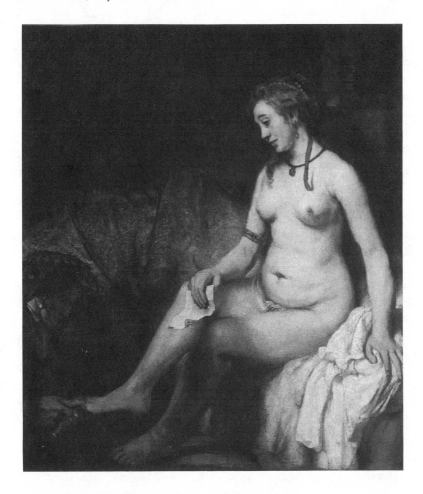

The Toilet, by Rembrandt

Rembrandt was not, I think, very much interested in what is usually called beauty. Whether a person or a thing was beautiful or ugly in itself did not interest him very much because he was so excited by what happens whenever light falls on a solid object, by all the complicated irradiations and reflections which that situation reveals that, for him, almost every lighted object was in inexhaustible wonder and delight. None the less he liked best those objects where the play of light and shade produced the richest and most intriguing effects. He loved, therefore, metallic surfaces or the still richer effects of gilt and silk brocades, as you can see in the background of this picture, where all the glitter and gloom of an old rich brocade is painted

at once with minute detail and great breadth of effect, so that we are never distracted by the detail.

But of all substances human flesh responded to light in the way that fascinated Rembrandt most. Its power of reflecting light so strongly as to make it seem at times to radiate light; its nacreous pallor which makes it sensitive to the faintest reflected light in the shadows; and perhaps most of all its complicated structure by reason of which the surface is modulated in every part—these were the qualities that so excited and thrilled Rembrandt that he could never stop painting, these were the qualities that he has expressed so marvellously in the Louvre picture.

Perhaps it was all the better for Rembrandt's purposes that his model was not a type of classic beauty, certainly not a modern athletic girl with well trained muscles and firm flesh. Her flesh is, indeed, just a little flaccid and relaxed everywhere, but that, I think, gave Rembrandt his fullest opportunities. See, for instance, with what delight he has followed the everchanging contour of the model's left arm, here coming to an almost definite edge where the flesh covers the bone less, and there fading off into the background with imperceptible gradations—and yet with all this variety how simple and strong the general effect is, how clearly we feel the slight pressure on the hand even in this relaxed pose. Or see again how perfectly he has realised the effect of gravity on the torso, which falls, as it were, for support on the pelvis, or with what delight he has followed the subtle modelling round the breast with all its incessant changes of direction and illumination. And with all this how large and simple the whole effect is, how easily the eye follows all these sequences. Rembrandt has achieved here one of the greatest triumphs of art, namely, to express in terms of evident simplicity all the infinity and complexity of nature, its essential concreteness. It shows us, too, what a crude and elementary affair is simplicity, as it is understood by some modern artists, as a kind of geometrical abstraction compared with this simplicity which is the crowning result of an intense and impassioned contemplation of the inexhaustible visual material of natural forms.

One of the reasons why Rembrandt could attain unity in a figure like this was his profound intuitive understanding of human nature. It is, I think, impossible to attain a perfectly harmonious and consistent movement in any part of a figure merely by external observation and description, however accurate. The last subtleties of the direction of a limb or the inclination of a head upon which such a harmony depends will almost certainly slip through such an observer's net. It is only by understanding a pose, as it were from within, and by a sympathetic imagination of the state of mind it expresses, that this last refinement, on which all depends, can be attained.

Here, I think, everyone will feel that the pose is completely established, that the tensions and relaxations throughout the figure are the result of a single consistent mood, that all emanate from one mental state. And this leads us to the questions of the title of the picture which I have called "The Toilet," and which is really called "Bathsheba." I have done this on purpose because for a great many years I stopped before this picture and looked at it with ever-increasing delight without ever bothering to read the label. When at last I did, I saw that Rembrandt had, besides painting a marvellous nude study, told a story. Bathsheba holds in her hand a proposal from King David, and whilst her old servant is busy washing and drying her feet she is pondering what she has just read and the decision trembles in the balance, though no one could doubt which way it will ultimately go. It is a moment of poignant psychological interest, of which the anxious eyebrows and the relaxed right hand give us a hint in a way that only Rembrandt could have done.

This raises an interesting question. Let us admit that a full understanding of the picture demands that we should feel both the psychological motive and the plastic one. Yet my own experience shows that one can enjoy intensely the plastic and pictorial appeal of this picture without ever becoming conscious of the psychological situation. When I do, I get another shock of pleasure, but do the two pleasures combine into a single more intense feeling or do they remain separate? That is a question which I have never quite been able to answer.

Both psychologically and formally the servant is an accessory figure, but one which assists in the formal unity as well as having great beauty in its subordinate way.

Who shall say whether the point of departure, the fundamental inspiration here, was the Bible story as Rembrandt read it or the sight of his mistress's nude figure? I would hazard a guess here that it was the latter, though often enough in Rembrandt's work one cannot doubt that the dramatic theme was the point round which his vision crystallised. But from whichever angle Rembrandt did or we ourselves do approach the total unity it cannot fail of its profound appeal.

CONCLUSION: NEEDED
WORDS

I N 1928, Roger Fry contributed a short text to an anthology titled after
its lead essay, "Needed Words," by Logan Pearsall Smith. An expatriate
American who had been Fry's friend for thirty years, Smith was a
member of the earnest society devoted to improving the English language
that published the anthology, and it was, no doubt, he who solicited Fry's
contribution. "Words Wanted in Connexion with Art" takes the form
of an almost-alphabetical list of terms that in his view were lacking or mis-
used in discussions of the arts. Ranging vertiginously from narrowly technical
definitions to broad philosophical propositions, this brief text encapsulates
the breadth of Fry's interests and thus makes a fitting conclusion to this
collection of his essays. At the same time that "Words Wanted" sums up
Fry's career, moreover, it offers intriguing intimations of the future. This text,
with its abandonment of linear logic and assumption of the linguistic basis of
cognition, may reveal Fry in a mode that is most sympathetic to post-
modernist readers. Virtually unremarked by his contemporaries or his imme-
diate descendants, "Words Wanted in Connexion with Art" exem-
plifies Fry's awkward fit into conventional histories of modernism.

As a summary of Fry's career, "Words Wanted in Connexion with
Art" is quite complete. Fry the conscientious art historian is present in the
definitions of technical terms, such as "chiaroscuro" and "grisaille." At the
same time, Fry the zealous reformer appears in a renewed call for an English
equivalent to the German *Kunstforscher*, a profession, he says, that "is hardly
recognized in England, largely for want of a name" (see chapter 5). Fry the
speculative philosopher of aesthetics dominates the discussions of words like
"art" and "beauty." Indeed the definition of "art," with its distinction between
painting "with aesthetic purpose" and "the merely useful or commercial ac-
tion of inscribing forms and colours on a flat surface," echoes Fry's "point of
departure—quite immediate and indignant departure" in the 1908 "Expres-
sion and Representation in the Graphic Arts," the earliest statement
of his formalism (in chapter 2). It is Fry the iconoclast who is given the last
word, however, with the French term *pompier* moved to the end of the alpha-

421

bet so that the glossary can conclude with a call for a derogatory term for
"the art of the official salons," such as the Royal Academy.[1]

The simultaneous presence of Fry's several authorial personae in "WORDS
WANTED IN CONNEXION WITH ART" underlines what has been a persistent
theme of this collection: the variety of Fry's roles and writings, which con-
stantly escape the modernist straitjacket imposed on him by history. Where
the generation of Fry's modernist admirers simply excluded from his legacy
what appeared at the time to be the irrelevant and contradictory aspects of
his career, we may today be ready to appreciate in Fry what J. L. Borges
praised (à propos of an earlier English eclectic): a personality that "abounded
in happy curiosities." Borges' essay, "The Analytical Language of John
Wilkins," has become something of a staple in the postmodernist canon
through its celebration in the introduction of Michel Foucault's *Les mots et les
choses* (literally, *Words and Things*, but published in English as *The Order of
Things*). Both Borges' and Foucault's essays turn on a common source: an
apocryphal Chinese encyclopedia that organized the animal kingdom into
fourteen categories:

> (*a*) belonging to the Emperor, (*b*) embalmed, (*c*) tame, (*d*) suckling pigs,
> (*e*) sirens, (*f*) fabulous, (*g*) stray dogs, (*h*) included in the present classi-
> fication, (*i*) frenzied, (*j*) innumerable, (*k*) drawn with a very fine cam-
> elhair brush, (*l*) *et cetera*, (*m*) having just broken the water pitcher, (*n*)
> that from a long way off look like flies.

And both use the apparent disorder of this system of classification to con-
sider the way language structures cognition.[2]

If Fry's tidily random catalog of wanted words has something of the qual-
ity of the Chinese *Celestial Emporium of Benevolent Knowledge*, our reaction
to it may echo that of Foucault, who found that his laughter "shattered, as I
read the passage, all the familiar landmarks of my thought—*our* thought, the
thought that bears the stamp of our age and our geography."[3] Today, when
conservative critics attack postmodernism by proclaiming that a "link be-
tween high culture and high seriousness [has] been a fundamental tenet of
the modernist ethos,"[4] we may find ourselves surprised to be laughing as we
read Fry. Yet the disruptive power of laughter, as Foucault describes it, coin-
cides with Fry's aim to shatter the commonplaces of his culture. This goal
lies behind every essay in this book. Proposing a new vocabulary as the basis
for new kinds of perception, a remarkable number of Fry's essays seek new
words for the discussion of art. This is true, not only of the writings that
self-consciously introduce terms like "classic," "plastic," or, for that matter,

"Post-Impressionist," but also those that argue by implication for new definitions of art and, thus, of its institutions.

If Foucault's disorientation at the Chinese encyclopedia entries caused him to recognize that cultural conventions "establish for every man, from the very first, the empirical orders . . . within which he will be at home," a corollary analysis suggests that a fundamental alienation from his "home" culture might have caused Fry to generate the kind of glossary of subversion represented by "WORDS WANTED IN CONNEXION WITH ART". Not just in his writing, however, but also in the style of his painting, Fry propelled himself outside his native dialect, identifying himself with the languages of foreign lands. His historical position as the preeminent English translator/advocate of European modernism is nowhere clearer than in this text.

Although (as evidenced by Borges) postmodernists are not the first to notice the always incomplete and indeterminate nature of the languages that structure thought, it is nevertheless clear that a fascination with the fragmentary, the unresolved, and the disparate characterized the current era. If this sensibility encourages us to look with renewed interest at a text like "WORDS WANTED IN CONNEXION WITH ART," it might also prompt a new generation to consider the totality of Fry's career. Fry is not, of course, a postmodernist; his intellect was formed at another historical moment and in response to a different set of imperatives. Nevertheless, today's readers may find, in Fry's consistent foregrounding of his personal subjectivity, in his antagonism toward authority, and, finally, in his doubt, a figure far more sympathetic than we have been led to expect.

<center>∽◆∾</center>

NOTES

1. It is significant of the need for such a term that, when in 1939 Clement Greenberg waged a similar war on American shores, he was forced into a similarly incongruous mingling of continental languages, for the now-famous opposition of "The Avant-Garde and Kitsch" (in *Art and Culture: Critical Essays* [Boston: Beacon, 1961] 3–21).

2. Jorge Luis Borges, "The Analytical Language of John Wilkins," 1941, in *Borges: A Reader,* edited by Emir Rodriguez Monegal and Alastair Reid (New York: Dutton, 1981), 141–43; Michel Foucault, *The Order of Things: An Archeology of the Human Sciences* (New York: Random House, 1970), xv.

3. Foucault, *The Order of Things,* xv.

4. Hilton Kramer, *Revenge of the Philistines* (New York: Macmillan, 1985), 8.

WORDS WANTED IN CONNEXION
WITH ART

Art. At present used of any kind of aesthetic creation, but also quite equivocally in a special way of painting and sculpture, and, at times, architecture, e.g., The Royal Academy of Art.

It is very desirable that it should be confined to its general sense so as to bring into line all aesthetic creation.

This sets up the need of a word for the visual arts as a whole in opposition to music and letters, and also words for each of the three main visual arts, *painting, sculpture, architecture.* These are on the whole satisfactory, since we have words to distinguish the activity when applied aesthetically and when applied to other ends—at least we have for the last two.

Thus, *sculpture, sculptor* = *carving, carver* with a view to aesthetic satisfaction; *architecture, architect* = *building, builder* with an aesthetic purpose—or at least in these cases a fairly vigorous use might easily get accepted.

Painting is more difficult. As at present used, *painting* and *painter* both suggest the aesthetic purpose. The French distinguish the "artiste peintre," and we might adopt that usage and talk of an "artist painter." But it is very desirable that distinctive words should be found for distinguishing the aesthetic from the merely useful or commercial action of inscribing forms and colours on a flat surface.[1]

Artist. It is most desirable that this word should lose its narrower usage of aesthetic painter, and should cover all kinds of aesthetic creators. It would then be at the service of all the arts alike and might enable men of letters to distinguish between aesthetic and non-aesthetic writers, and similarly for music.

Artifact. At present used to denote any object made by man to distinguish primitive works like flint instruments from natural products. It is most desirable that a new word should be found for this idea so as to leave

"Words Wanted in Connexion with Art," Reprinted from *Needed Words,* by Logan Pearsall Smith and Roger Fry (SPE Tracts; Oxford: Clarendon Press, 1928).

1. Suggestion:—*Graphic* = the activity with aesthetic purpose as opposed to *painting* and *drawing. Artist painter, artists draughtsman* for those who practise aesthetically—or even perhaps *graphist* or *grapher* (cf. photographer) or *limner* for both aesthetic painting and drawing.

artifact for any kind of object into the making of which an aesthetic purpose enters.[2]

Author. Similarly it is desirable that this general word implying the originator or creator of any kind of aesthetic construction should not be captured by literature, but acquire a general significance, so that of a self-portrait we could say, portrait of the author. This would have the effect of bringing the different arts more into line.

Beauty. It would be a great advantage if the different uses of this word could be distinguished. At present it means what gives pleasure through vision and is used indifferently of natural objects and artifacts (in the sense suggested above). It would be well either to find a new word for objects deliberately created for aesthetic satisfaction or for natural objects of pleasing appearance.[3]

Blütezeit. English equivalent needed.

Chiaroscuro. Was much used in eighteenth century, but always as a foreign word; an English form (? *clear-obscure*) is desirable.

Eclat. English equivalent needed.

Ecriture. Has a special sense in regard to painting, and refers to the rhythm of the handling of paint. *Handwriting* has hardly acquired this use, but perhaps might be adequate.

Einfall = the synthetic moment of an aesthetic creation. *Intimation* has been suggested, but conveys a slightly different idea.

Grisaille = a monochrome painting in black, white and grey. A simple word would be very useful.

Kunstforscher. A single word for those who make a profession of the study of art history as contrasted with aesthetics would be of great use. The profession is hardly recognized in England, largely for want of a name.[4] *Art-expert* has a distinctly commercial suggestion.

Nuance. The question is how to anglicize this—to do so thoroughly, a definitely English spelling is desirable, as otherwise readers will boggle over the question of which way to pronounce it. This always renders a word awkward in use.

Panne. The same applies here but with less force, *patine* would be more conclusive, if possible.

Impasto may perhaps be allowed as English, without change.

2. ? *Manufact,* for any object made by man.

3. Suggestion:—To keep the word *fair* for natural objects of pleasing appearance (*blond* would then monopolize the other meaning of the word). *Beauty, beautiful* might be then used indifferently for all works giving aesthetic satisfaction whether visual or not.

4. *Art-researcher* is suggested but is a little clumsy, though I have nothing better to propose.

Matière, in the special sense of the quality given to his pigment by an artist. A special word is wanted for this.[5]

Méplat = a flattened plane, either in sculpture or painting.

Milieu, though not specifically to do with art, is frequently needed in art-history. The question is what English form to give it.[6]

Œuvre. An artist's work, considered as a whole—the body of an artist's works.[7]

Terrain is used, I believe, by military writers. It is much needed in art criticism for describing the disposition of foregrounds and backgrounds in landscape.[8]

Pompier, applied generally nowadays to the art of the official salons, implies that the work in question appeals to the general public rather than to those familiar with the principles and methods of serious art.

It is certainly desirable that some word should be discovered which would classify so-called works of art which are made to please the average public and generally merely for gain.

As the same problem arises in literature over the "best-seller," it would be a good thing if a general term could be found that would cover all similar instances, and distinguish works created mainly for immediate gain from works which aim at serious aesthetic expression.

In music the terms *classical* and *popular* almost effect this—but we cannot afford to waste the word classical in this way. It must be kept for opposition to romantic.

5. Perhaps *mattere* on the analogy of *morale.*

6. *Ambience* is more easily anglicized and serves perhaps sufficiently well as a substitute.

7. *Œuvre* is very difficult to anglicize; *oover* is likely to be resented. ? *Corpus,* but this is very awkward and has unfortunate affinities.

8. *Ground,* unfortunately, means the general surface of the earth, not a particular section of it. I would suggest *terraine* (cf. moraine).

ILLUSTRATION SUMMARY

CHAPTER 2

Illustrations from Maurice Denis, "Cézanne," *The Burlington Magazine,* January and February 1910:

PLATE I (p. 77): *Portrait of the Artist,* by Cézanne. In the collection of M. Pellerin.

PLATE II (pp. 78, 79), fig. 1: *L'Enfant au foulard blanc,* by Cézanne. In the collection of M. Tabbri; fig. 2: *Woman with a Boa* [Portrait of a Woman], by Cézanne. In the collection of M. Bernheim Jeune.

PLATE III (p. 80), fig. 1: *The Bathers,* by Cézanne. In the collection of M. Bernheim Jeune; fig. 2: *The Satyrs,* by Cézanne. In the collection of M. Bernheim Jeune.

CHAPTER 4

4.1. (p. 172) Kodak House, designed by John Burnet, 1911; photograph from *The Architectural Work of Sir John Burnet and Partners* (Geneva: Masters of Architecture, 1930).

4.2. (p. 174) Durbins, designed by Roger Fry, 1908; photograph circa 1917.

4.3. (p. 177) Omega Workshops, dining chairs, designed by Roger Fry, 1913; photograph courtesy of Hirschl and Adler Gallery.

4.4. (p. 178) Guild of Handicraft, embossed silver tray with peacock design, design by C. R. Ashbee, 1896–97. Photograph © The Board of Trustees of the Victoria and Albert Museum.

4.5. (p. 179) Omega Workshops, design with peacocks, attributed to Roger Fry, circa 1913–14; photograph courtesy of the Courtauld Institute Galleries.

4.6. (p. 180) Omega Workshops, painted fan attributed to Duncan Grant, circa 1913. Photograph © The Board of Trustees of the Victoria and Albert Museum.

4.7. (p. 181) Roger Fry, design for painted harpsichord lid, 1918; photograph courtesy of the Courtauld Institute Galleries.

Illustrations from "The Art of Pottery in England" *The Burlington Magazine,* March 1914:

PLATE I (p. 204), A: Roof ornament (?). 13-1/4 in. high, the Art Museum, Nottingham; B: Bottle found at Old Sarum, 10-3/4 in. high, the Society of Antiquaries, C: Figure of a girl holding a large fish, excavated at Worcester, 1893. 7 in. high. Mr. C. W. Dyson Perrins's collection.

PLATE II (p. 205), D: Reddish ware washed with white, decorated with orange, brown and red slips, yellowish glaze, Staffordshire, about 1680. diam. 18-1/4 in. Mr. C. J. Lomax's collection; E: Punch kettle, salt glaze enamelled in brilliant polychrome, green handles and spout, 7-3/4 in. high, about 1750, Hon. Mrs. Whateley's collection.

Illustration from "The Artist as Decorator" *Colour*, April 1917: (p. 210) Wall Decoration in hand-painted paper, by the Omega Workshops, Ltd. [original gouache painting used for illustration, photograph courtesy of the Courtauld Institute Galleries].

CHAPTER 5

Illustrations from "Children's Drawings," *The Burlington Magazine*, June 1917:

PLATES (p. 269): A (upper left), "A Black Country Landscape," by a girl; B (upper right), "Saturday Night," by a girl; C (lower left), "A Walk," by a girl aged 7; D (lower right), "A Snake," by a boy aged 9.

CHAPTER 6

Illustrations from "M Larionow and the Russian Ballet," *The Burlington Magazine*, March 1919:

PLATE I (p. 292): Designs by M. Larionow. Decors of "Baba Jaga"; Costume of the cat in "Kikimora"; Coulisse for "Le Soleil de Nuit." All images © 1995 Artist Rights Society (ARS), New York/ADAGP, Paris.

PLATE II (p. 294): Marionettes designed by M. Larionow. A: *Personnage pour* "La Marche funèbre," musique de Lord Berners (Tyrwhitt); B: *Le Mariage du Paon*; C: *Le Cygne*; D: *Le Martin Pecheur pour* "Histoires naturelles" de Jules Renard, musique de Ravel. All images © 1995 Artist Rights Society (ARS), New York/ADAGP, Paris.

CHAPTER 7

Illustrations from "Line as a Means of Expression in Modern Art," *The Burlington Magazine*, December 1918 and February 1919:

PLATE I (p. 327): Pencil Drawings by Walter Sickert and Duncan Grant.

PLATE II (p. 328): Portrait of Monsieur Massine, by Pablo Picasso. © 1995 Artist Rights Society (ARS), New York/SPADEM, Paris.

PLATE III (p. 329): Pencil and Pen-and-Ink drawings by Henri Matisse.

PLATE IV (p. 331): Water-colour and pastel colour drawing by Modigliani.

PLATE V (p. 332): Pencil Drawings: Nude woman by Gaudier-Brzeska; Portrait of Mlle G. by Modigliani.

PLATE VI (p. 334): Pencil, by Edward Wolfe; Ink, by Nina Hamnett.

Illustration from "Rembrandt: An Interpretation," *Apollo*, March 1962: Fig. 1 (p. 370): "An Elephant," 1637. Albertina, Vienna.

Illustrations from "The Double Nature of Painting," *Apollo*, May 1969:

Fig. 1 (p. 389): *Martyrdom of Saint Flavia and Saint Placid* by Antonio Correggio (1489/94–1534). Oil on canvas, 160 × 185 cm. Pinacoteca. Parma.

Fig. 2 (p. 391): *The Three Philosophers* by Giorgione (c. 1476/78–1510). Oil on canvas, 123.8 × 144.5 cm. Kunsthistoriches Museum.

Illustrations from "The Meaning of Pictures—Telling a Story":

Fig. 1 (p. 395): *Jesus Appearing to the Magdalen*, by Giotto [in *The Listener*, 25 September 1929].

Fig. 2 (p. 396): *The Doctor*, by Luke Fildes [Tate Gallery; not in original publication].

Illustrations from *Henri-Matisse*. All figures © 1995 Succession H. Matisse, Paris/Artists Rights Society (ARS), New York:

Fig. 1 (p. 407): *Decorative Composition* [dated to 1925–26; now at the Musèe National d'Art Moderne, Centre George Pompidou, Paris].

Fig. 2 (p. 411): *Dancer with Tambourine* [dated to 1926; private collection].

Fig. 3 (p. 412): *Woman with a Veil* [dated to 1927; now at the Museum of Modern Art, New York].

Fig. 4 (p. 413): *Portrait of Madame Matisse* [not in original publication; dated to 1913; now at the Hermitage, Saint Petersburg].

Fig. 5 (p. 414): *The Garden* (from the collection of Michel Stein) [also known as *The Tea*, this painting is dated to 1919; private collection].

Illustration from "The Toilet, By Rembrandt," *The Listener*, 19 September 1934:

(P. 417) *The Toilet*, by Rembrandt

INDEX

Italicized page references refer to illustrations.